Universal Limited Art Editions

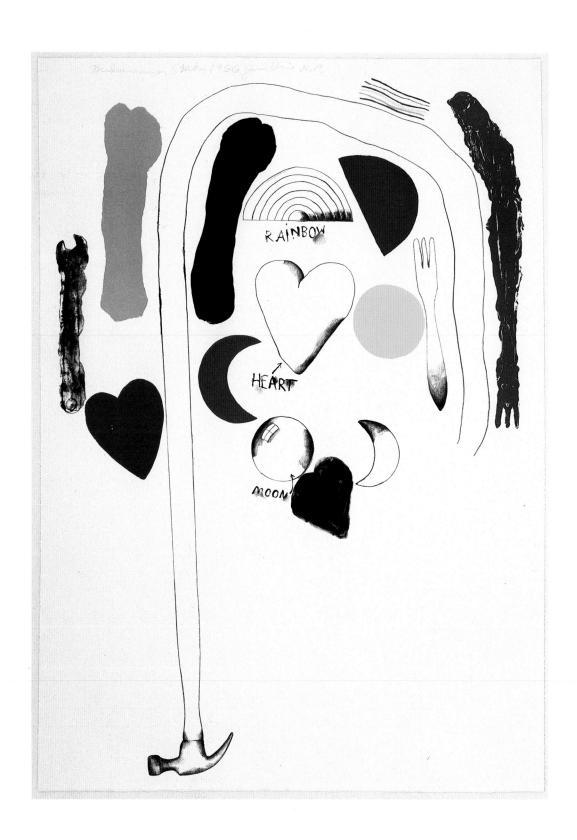

Universal Limited

A History and Catalogue: The First Twenty-Five Years

Art Editions

By Esther Sparks

The Art Institute of Chicago and Harry N. Abrams, Inc., Publishers

This catalogue was produced through grants from the Florence
and Noel Rothman Foundation and the Henry R. Luce Foundation

The Art Institute of Chicago:
Editor: Terry Ann R. Neff
Project Assistant and Photo Editor: Valerie Foradas

Harry N. Abrams, Inc.:
Project Director: Margaret L. Kaplan
Designer: Darilyn Lowe

Frontispiece: Jim Dine, *Midsummer Wall* or
Midsummer Study, 1966. See cat. no. 19

Library of Congress Cataloging-in-Publication Data

Sparks, Esther.
Universal Limited Art Editions: a history and catalogue, the
first twenty-five years / by Esther Sparks.
p. cm.
Bibliography: p.
Includes index.
ISBN 0-8109-1732-7
1. Universal Limited Art Editions (Firm)—Catalogs. 2. Prints,
American—Catalogs. 3. Prints—20th century—United States—
Catalogs. I. Art Institute of Chicago. II. Title.
NE508.S67 1989
769.973′074′014725—dc19 89–260

Published in 1989 by Harry N. Abrams, Incorporated, New York
All rights reserved. No part of the contents of this book may be
reproduced without the written permission of the publisher and
The Art Institute of Chicago, Publications Department,
Michigan Avenue at Adams Street, Chicago, IL 60603
A Times Mirror Company
Printed and bound in Japan

Contents

Foreword

In 1980, Esther Sparks, associate curator of prints and drawings, and the late Harold Joachim, curator, became convinced of the unique quality and historical importance of the prints that had, since 1957, been published by Tatyana Grosman's Universal Limited Art Editions (ULAE). Indeed, some ULAE prints had already entered the department's collection through an acquisitions policy that traditionally has been responsive to developments in contemporary art. However, it had become evident that, in the case of ULAE, the entire published work represented more than the sum of its individual parts, however splendid these were.

ULAE had become legendary because of its leadership in reviving the interest of artists in printmaking, because of specific artists who had been involved in its activities, and because of the unique and vital working relationship that Tatyana Grosman, with the assistance of her artist-husband, Maurice, had fostered between artist and printer. A phenomenon in the history of post war art, the achievement of ULAE could only be comprehended and appreciated by having access to the full range and breadth of its output in a single location. In 1980, this was possible only at the Museum of Modern Art in New York. Therefore the Art Institute began negotiations for the purchase of Mrs. Grosman's personal collection of ULAE's entire production.

The Art Institute was finally able to make this purchase thanks to a challenge grant from Mr. and Mrs. Thomas H. Dittmer, which was met by a group of over one hundred donors committed to the museum's ongoing involvement in the major movements in contemporary art. This generosity was responded to in kind by Mrs. Grosman, who, in May 1982, made a personal gift to the Art Institute of over 4,200 drawings, trial proofs, working proofs, and other unique archival materials that document the history of ULAE.

Having become the preeminent repository of the works produced by ULAE during its first twenty-five years, the Art Institute recognized its scholarly responsibility and Esther Sparks made plans to begin a catalogue of the collection. Funding for the research and presentation of the catalogue was provided by generous grants from the Florence and Noel Rothman Foundation and the Henry R. Luce Foundation. Esther Sparks has, after a number of years of intensive research, done justice to this challenge. It is with gratitude to her and to the many people who supported all aspects of this project, and in memory of the generosity and vision of Tatyana Grosman, that we enthusiastically welcome a volume devoted to this outstanding press—to its founder, and to the artists and printers who have contributed to its excellence.

JAMES N. WOOD
Director
The Art Institute of Chicago

Acknowledgments

I should like to thank those people who were actually a part of the history of ULAE. Bill Goldston, who now directs the presses and fortunes of ULAE, guided me throughout the preparation of this manuscript with endless patience and generosity. To him and to the artists who agreed to be interviewed and later read pertinent sections of text, I am primarily and profoundly grateful. Tony Towle's diary and incredible memory for detail have been indispensable. His history of ULAE, as yet unwritten, would flesh out this version.

I have attempted to treat Tatyana Grosman's private and business affairs with her own level of discretion. But even the most astringent chronicler must interpret, and in this precarious task I have been assisted and encouraged by many of her personal friends: Dr. Louis Aledort, Armand Bartos, Jr., Riva Castleman, Mr. and Mrs. Joseph Fearer, Barbara Fendrick, Helen Getler, Mr. and Mrs. Stanley Helfgott, William S. Lieberman, John Powers, Dr. Joseph I. Singer, William Spieller, William van Straaten, and Amei Wallach. Members of Mrs. Grosman's staff, past and present, have answered questions with a frankness and gravity that were in themselves a homage to their former doyenne: Frank Akers, Steve Anderson, Robert Blackburn, Keith Brintzenhofe, Thomas Cox, Emanuel Edelman, Fred Genis, Eileen Kapler, John A. Lund, Zigmunds Priede, Juda Rosenberg, James V. Smith, and Donn Steward. Scores of curators, dealers, and friends have responded generously to my requests for assistance, especially the staff of the Print Department of the Museum of Modern Art, New York, who also made its records available to us.

The acquisition of Mrs. Grosman's personal collection by the Art Institute was undertaken during the tenure of the late Curator of Prints and Drawings Harold Joachim and energetically supported by Director James N. Wood. Under the guidance of the Prince Trust Curator of Prints and Drawings Douglas Druick, Valerie Foradas has made an invaluable contribution to the cataloguing and photography of the prints described in this book. Without the help of Richard Q. Livingston, no part of the research and documentation could have been completed so efficiently. The task of accommodating and documenting almost five thousand pieces was cheerfully shared with me by members of the museum staff, including Anselmo Carini, David Chandler, Mark Pascale, and Gloria Teplitz, as well as by a group of dedicated volunteers, including Selma Flesch, Sara Ellen O'Neill, Marjorie Pochter, Florence Rothman, Katherine Shea, Marcia Wagner, and Mary Young.

I would like in particular to thank Terry Ann R. Neff for her thorough editing; the book's clear and efficient organization is due in great part to her. I am also grateful to Cris Ligenza, secretary in the Publications Department, who typed the manuscript; to Susan F. Rossen, executive director of publications, who helped reduce this project to manageable proportions; to Margaret Kaplan, executive editor at Harry N. Abrams, for her long-standing faith in this book; and to Kathleen Aguilar of Chicago and the staff of the museum's Department of Photographic Services, especially John Mahtesian, for their fine photography.

In this sometimes perplexing but always joyous task, everyone who took even the smallest part was touched by two great spirits, Harold Joachim and Tatyana Grosman. It is to their memory that this book is gratefully and affectionally dedicted.

ESTHER SPARKS

Maurice and Tatyana Grosman, 1960

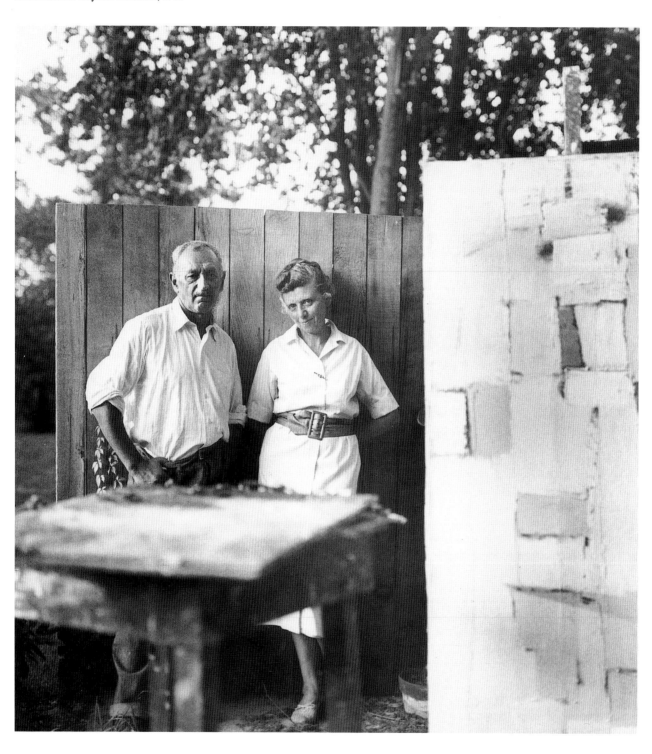

Tatyana Grosman:
A Memoir

Amei Wallach

It was Tatyana Grosman's great gift that she could be whoever it was we needed her to be. To Edwin Schlossberg, poet and designer, who began making books with her when he was twenty, "Tanya seemed to reach and recognize exactly the you you always wanted someone to know—to respect it, to nourish it, to give it a full range."[1] To the artist Jasper Johns, "One of Tanya's great skills, one of the things she suffered from, was making a completely different world for each artist. . . . It's very hard to know what she wanted that the artists didn't want. She always acted as if she wanted more —more fancy, more severe—whatever she thought you had in mind. She didn't mind exaggerating."[2] To the artist James Rosenquist, she "had a wealth of information that made me feel very young, but it also made me feel very free."[3] He, however, "never ever wanted to feel like her boy. My relationship with her was that you could talk to her like another man. I told dirty jokes, anything. 'You are like a Russian soldier,' she said to me. 'You come, you sleep, you eat, you work, you leave.'" To the printer, now Universal Limited Art Editions (ULAE) director, Bill Goldston, she "gave me a reason for being alive. She always took the chance. But she always gave *anybody* who was with her the chance. . . . The one she gave me when I came here was the possibility to be anything I could be."[4] "She was a Russian muse for some, Jewish mother for others, and nagging wife for all of us," is the crisp assessment of Riva Castleman, chairman of the Department of Prints and Illustrated Books at the Museum of Modern Art.[5]

This chameleonlike quality was not so much the gift of an actress—although Tatyana Grosman *was* that, and proud of it. It was the essential attribute of what she said she was until the age of fifty-one: a *femme d'artiste.*

Until 1955 I just poured tea and I never spoke. I was a femme d'artiste. *It's a profession almost. You are everything. You are the muse, the inspiration. You hope you are until someone else walks into the place. You are the participant, the audience. You share the life of the artist which is very unpredictable, unstable. He relies on himself. You are very protective, promoting. You try to take the burden— most of the time the artists aren't providers. You don't marry for that reason. Great belief, great faith, great destiny. Everything would be glorious and fine.*

For most of her life, Mrs. Grosman defined herself by what she was to someone else. That has contributed much to the confusion and the myths that have accrued upon her story. Those who saw an oddly exotic Russian lady with a quaintly imperious manner could not comprehend the magic of the good mother who gave the imagination permission. Those who succumbed to the "very feline glint in her eye," which, even when she was in her seventies, could be "seductive in making [one] enraptured with her,"[6] were not always grateful to discover that they had fallen into the hands of an implacable muse.

It was her work that defined her during the twenty-five years at the end of her life, when she presided over ULAE. All her passion and self-sacrifice, her faith in a great destiny for herself, and her irritatingly persistent ways of making it come about were focused now on her papers, her presses, and especially upon her artists. The ways she knew were Russian ways. There were Chekhovian pauses in the years it might take for a print to come to fruition. There was Tolstoyan ambition in her insistence on the best: the best paper, the best artist, the best printer, the best collector, the best museum. There was a nineteenth-century gentility in her concept of what would render an artist most susceptible to inspiration: a chauffered car for the long drive east from Manhattan, lace tablecloths and favorite food, the subtle flattery of total attention.

Tatyana Auguschewitsch was born in Ekaterinburg (now Sverdlovsk) in Siberia, on June 30, 1904. By the Russian calendar, the date was June 17, and that was the day on which she celebrated her birthday. Her father, Semion Michailovitch Auguschewitsch, had been sent by the Russian government to Ekaterinburg as a twenty-one-year-old typographer "to start a newspaper so they would know what was happening in Siberia."[7] He was also a brilliant businessman. The newspaper was a great success, and the family lived in a house so grand that during the 1917 revolution an entire wing was commandeered as a prison for political prisoners without noticeably affecting the routine of the family. The Auguschewitsch household included eleven kitchen servants, two governesses—one for Tanya, one for her brother, Victor—and two servants to stoke each of the stoves that stood between every two rooms to heat them for the nine-month winter.

There was in all this a dissonance: all the accouterments—and pride—of bourgeois life in a frontier town whose inhabitants were "adventurers, deportees, miners and people who had been political prisoners in Siberia."[8] The main street was dirt and turned to dust in summer. Much of what went into the making of Tatyana Grosman's myth may be traced to a childhood spent in luxury with life lived on a grand and ambitious scale in a town where it was always necessary to improvise.

Also, both Tanya's parents were Jews who had become Christians. Her father converted "politically, on paper" because Russian laws made life difficult for Jews. "He didn't go to church, he didn't cross himself." On Sundays he napped on the couch while his wife took their children to the Greek Orthodox church a block and a half away. Her mother, who "needed company, . . . acted very Christian,"[9] and Tanya was made to wear a cross. Semion was an orphan, but his wife's family was outraged at their conversion.

Tanya's mother, Anna de Chochor Agovschevitch, came from a Russian family that had immigrated to Bavaria in the nineteenth century. She never became fond of her new address. And Tanya believed strongly that she was never happily married: "She was so unsatisfied and longed for something. I don't know what it was. Perhaps it was a big love. My father was a convenience. She had to marry him."[10]

While Anna could be charming, she was also "stern, a tyrant. She was a completely energetic, driving woman."[11] Anna made no secret of the fact that she was disappointed in her "very unsocial, very withdrawn" daughter. "I was a very introverted person as a child . . . not the young lady they wanted," Tanya remembered.[12] Still, Tanya loyally and respectfully trotted along behind her mother, as a daughter should, relishing the moments she might have on the train or sick in bed after eating too much at Christmas to read, read, read —Tolstoy, Pushkin, Dostoyevski, Turgenev. Books gave her solace and direction. In books, Tanya found a means of believing that perhaps, after all, she was the daughter her father would have wanted. In Pushkin's *Eugene Onegin* there is a Tatiana. "I think my father wanted me to be like her":

> *Sauvage, sad, silent*
> *As timid as the sylvan doe,*
> *In her own family,*
> *She seemed a stranger . . .*
> *Pensiveness her companion*
> *Even in cradle days.*

It is not difficult to understand why Tanya would conclude, "I love men—more than women somehow. Everyone thinks men have no feeling, no fear, but they are human beings." Pushkin's Tatiana became her model. "Tatianas are always close to men and they want to help, but they are not lionesses."[13]

Tanya herself was an artist. Drawing lessons were part of her childhood education, but

she preferred performing. Her very first memory is of seeing a play by Gogol. Later she attended Kabuki and Max Reinhardt's spectacles. She liked to say her role at ULAE was that of a director, making it possible for her actors —the artists—to realize their interpretations. But her whole life was a performance—and she saw it in that way.

Life as she played it had to be perfect in all its details—from setting (always, even in their poorest days, she and her husband provided lace tablecloths and tea for guests) and costume (she dressed with a "Parisian elegance"[14] and would invent costumes of incomparable élan), to text (her stories, honed and polished for maximum emotional effect) and delivery (always in her soft, thickly accented English derivative of Russian, hands fluttering in gestural annotation). There is no question that she chose her role, although it was not until her twenty-fifth year that she did so. First the destiny in which she came so firmly to believe took a hand.

In 1918, when Tanya was fourteen, Czar Nicholas II was executed in Ekaterinburg in a boarded-up house Tanya passed constantly. After a time, as the Red Army grew stronger, it seemed wise for the family to flee—temporarily, the Auguschewitsches told themselves. By Trans-Siberian Railroad, they traveled east to Vladivostok, where her father converted his devalued Russian money into jewels and precious metals, and then to Shimonoseki, Japan, their destination.

Tanya loved Japan. She loved the Kabuki theater. She enjoyed school at the Sacre Coeur Convent in Tokyo, although there she contracted hepatitis, which scarred her liver and was to undermine her health for the rest of her life. "[After] all this turmoil of the revolution," Japan was "very calm and beautiful, and I think I learned [there] a certain kind of meditation." Certainly, one of the most seductive aspects of ULAE would be this meditative sense of "a master's house. Everything is done with a purpose. . . . It was like [stepping] into this quiet place out of a storm."[15] Robert Motherwell put it best when he wrote of "the ambience of her workshop, where it [was] simply assumed that the world of the spirit exists as concretely as lemon yellow or woman's hair, but transcends everyday life."[16]

But by 1919 Tanya was back in the storm again. A fifty-eight-day boat trip brought the family to Venice, theoretically en route to a new home in Switzerland. However, Swiss visas were not forthcoming; they settled in Dresden, where Anna's sister lived.

Tanya hated Dresden. In addition, her family situation had become very unhappy, and she was depressed. She disliked the George Grosz aspects of Germany. It was "so crude. . . . Boys in crew cuts working in their father's uniforms, wearing their father's boots which were falling off their feet, hungry. I wanted to keep my Japan intact in some way."

For two years, she uttered only the most functional words. She lost herself in books. After graduating Dalcrose boarding school in Hellerau, outside Dresden, and taking a trip with her mother to several European spas, she began "to search for something." At Dresden's Academy of Applied Arts, where she studied drawing and fashion design, she found some of "the calm and beauty"[17] she remembered from Japan. In 1928 she received the highest design prize for an Oriental costume and posed in silk and Japanese parasol, looking remarkably as she would at ULAE. And then, in 1929, at the age of twenty-five, she met Maurice Grosman.

Maurice was a Jew from Poland, very Yiddish, impecunious, frolicsome, unconventional. He was, in fact, the exact opposite of everything Tanya's mother valued. Tanya said, "I was never in a temple, [but I] wanted to be Jewish. And then, when Maurice came along, he personified everything. He was poor, bohemian. He had no future."[18] He was, at twenty-nine, divorced with a son. They met at the

Academy, where Maurice, who had graduated and was building a reputation, had a studio of his own.

Maurice was irresistible to Tanya. She loved his "radiant character." Being with him was like playing, and then his needs were so great. "He needed love, he needed attention, because, you see, a poor artist—he had affairs, very flamboyant affairs, mostly with dancers." He offered her a ready-made purpose in life. "I cannot live without Maurice. I have to take all the consequences."[19]

Her decision prompted a series of ugly scenes in her family. Tanya was banished; she "left her jewels, she left her furs, and [Maurice and she] lived together in an attic in Dresden."[20] And when friends offered the young couple an apartment, Tanya's mother threatened them. He was Jewish, she told them. She would put it in all the papers.

Tanya best described the intensity of her mother's avenging fury when she spoke of her father's suicide: "There was no limit. . . . She would step on you and over you."[21] In contrast to her feeling for her mother, Tanya adored her well-educated, elegant father.[22] He had survived flight from revolution, a new life in Japan and then Germany, and he had succeeded in rebuilding the family fortune. In 1938, just as life was becoming particularly threatening in Germany and impossible with his wife at home, he committed suicide.

The Grosmans were married on June 27, 1931. It was Tanya who determined in 1932 that the time had come to leave for Paris. Paris was "the artists' city, and Germany was very afraid." Maurice was reluctant, but, as Tanya put it, "I dragged my husband." This became the pattern between the *femme d'artiste* and her artist. She was silent, she listened to him, "she worried about him, she catered to him, she wrapped a scarf around his neck."[23] But it was often she who made the big decisions.

Paris meant a one-room studio in Montparnasse, where Maurice painted and they ate

and lived. It meant a café life, associating with Jacques Lipchitz, Chaim Soutine, and Ossip Zadkine. Often, despite the tiny stipend Tanya's parents reluctantly sent each month, there was not enough to eat; yet, if Maurice sold a painting, there would be a celebration with all his friends.

On January 31, 1933, a daughter, Larissa, was born to the Grosmans. Tanya had saved money for this event. Maurice, as was his habit, spent it all on a party. So Tanya and the baby waited on the cold hospital stairs while Maurice made the rounds of friends trying to raise the money for a taxi to take them home. Sixteen months later, Larissa was dead. It happened suddenly, and Tanya never completely understood how. Maurice would often later say that "God took the child. We could never have crossed the Pyrenees with a child."[24]

If, in her life with Maurice, Tanya did indeed learn to lead by indirection, perhaps the most astounding example of this is the telephone call with Bill Goldston in 1971 when his daughter was born. He and his wife, Susan, had expected a boy and they were not prepared with a girl's name. Did she have a suggestion? She replied, "If I had a daughter, I would have named her Larissa."[25]

In November 1940, two days before the Nazis marched into Paris, Tanya and Maurice fled in a truck with their concierge, assorted other adults, and eleven children. The story of their three years of flight, of life underground, of narrow escapes, and, once again, of Tanya's indomitable determination, has been told in detail.[26] The climax was their walk over the Pyrenees: Tanya in her fur coat, Maurice with his easel, but not a toothbrush between them. The journey lasted three weeks. Toward the end, when they had reached Spain but were still too near the French border, they spotted an officer from the Guardia Civil. Maurice began painting; Tanya did her nails. They had purposefully left behind all their identification except the permission from the Louvre

Maurice had once secured in order to copy Velázquez's *Infanta*. It sufficed.

By the time they reached Barcelona, Tanya had lost several toenails to frostbite; for the rest of her life, she would have trouble with her feet. But she loved that walk across the Pyrenees. "I felt extremely in my element," she would say. "I felt beautiful. Maurice—he was more frightened at first than I was, but then he found the rhythm." Tanya functioned best in such moments. She attributed this to the Siberian in her.

In Barcelona friends and American officials made a great fuss over the couple. "They treated us like miracles, like big heroes." The visa to America, which had been problematic, was granted immediately. With the help of the Hebrew International Aid Society, they reached New York on May 23, 1943, and moved into a one-room, fifth-floor walk-up on Eighth Street.

There Maurice painted, taught, got himself a gallery, and began now and then to show and sell. Eventually he stopped relying on his grab bag of Yiddish, French, Polish, and German and learned to make himself understood in something approaching English. Tanya resumed her role of *femme d'artiste*.

Eunice Fearer, who met the Grosmans in the early 1950s, remembers visits to the studio to buy paintings. The Fearers were among a growing group of supporters who wanted to "do something" for the Grosmans; later they would buy prints. "Tanya presented Maurice's paintings on an easel the way she would later show her prints," Fearer related. "She became an actress. She used her hands. . . . I would have called her shy, although she was always glamorous. Maurice was the strong one in that family."[27] And then in 1955 Maurice had a heart attack.

The Grosmans had already bought the tiny house at 5 Skidmore Place in what was then Bay Shore and is now West Islip, Long Island. The story of how they found the house one sweltering day in 1944—quite by chance and by the grace of two Dominican brothers—has been told elsewhere.[28] To Tanya, it was another mark of destiny, as though "an angel passed." The house was not winterized, but there was no question of staying any longer on Eighth Street. Maurice could not climb the four flights of stairs.

Tanya regularly glossed over this part of her marriage, which had everything to do with how ULAE came to be. Usually it sufficed to say her husband could not work anymore and it was now up to her to make a living. The truth was somewhat different: Maurice never had been particularly good at making a living. But this was the first time Tanya faced what that meant and its consequences. She determined to become herself:

> *That was the moment when I said, "As long as he is healthy, that's it." It became a different relationship. . . . Maurice was never able to develop. He had a philosophy [that] there was something wrong with you if you are successful. You must be prostituting yourself. I would consider Maurice successful if he would paint to his heart's content and make a living of his painting. But Maurice starved as a painter. . . . Before it was Maurice and his art. Today it's Maurice, and his art I leave to him. I cannot do it for him. I would hurt him, I won't say destroy him.*

When she first began to take matters into her own hands, it was merely to expand one of the avenues Maurice had already begun to explore in New York. He was making silk-screen reproductions of works by artists like Picasso and Grandma Moses and selling them to Marlborough Books. "I have to do something really where I can give myself completely," she decided. "Everything that I am, my heritage, what I know, what I love. Books interest me,

images interest me. So it should be books, art-ists, and then writers and poets working together." In the last years of her life, she added that she had felt indebted to people whose names she did not even know, "through this illegal life in France, Spain and so forth. . . . And so I had to do some kind of mission or something. And so I start to work."[29]

She knew hardly anything at all about the making of books, or prints, for that matter. She approached an artist, the sculptor Mary Callery, who lived in nearby Huntington, and asked her for something—it turned out to be a gouache—that could be made into a print. When Tanya took the completed silk-screen reproduction to William S. Lieberman, then curator of the Department of Prints and Illustrated Books at the Museum of Modern Art, New York, he admired its quality but not the fact that it reproduced a prior work of art. Carl Zigrosser, then curator of the Department of Prints at the Philadelphia Museum of Art, told her something similar. It seems that at first she was not listening. She persisted with the silk screens until she persuaded the artist Larry Rivers and poet Frank O'Hara to collaborate on a lithographic book, and from that moment the history of ULAE began.

Much of who Tanya Grosman was seemed eccentric at first then became part of her myth. Tanya had always worn expensive, hand-tailored clothes. At the Dresden Academy, she had learned about style, about the fitness of things. This was a lesson she wanted to bring to the studio: craftsmanship not only in an Old World sense, but in an aristocratic sense. But as collectors, curators, critics, and television crews discovered Tanya and ULAE, she too dis-covered what it was about herself that fasci-nated them. After a time, according to Jasper Johns, "she, like the rest of us, saw what was useful in her personality and exaggerated it. It seems to me she developed a sense of theater in the sense of her own being."[30] At first, in the studio, she would be around, hovering, direct-

ing mostly by praise. Later she learned to ask telling questions. Keith Brintzenhofe, then a printer and now studio manager, remembers how, when shown a proof, she might say, "Do you think the green is right?"[31] Perhaps the green was right. But by making one reanalyze, by tangling the skein of one's complacency, she restarted the creative and critical process anew.

There was a difference between her rela-tionship with artists and with printers. "She was," as Edwin Schlossberg noticed right away, "in love with her artists."[32] An artist, she believed, was different, special, relying only on himself. She was in the habit of calling Larry Rivers, the first artist who made lithographs with her, "my firstborn." Not all the artists took kindly to this kind of coddling. Claes Oldenburg told her he already had a mother.[33]

The printers were children to her too, but not her children. They were aspects of the impractical Maurice and of herself as she once was. At first her relationships with printers were stormy, in part because she never knew whether she would have money to pay them. Once ULAE was established and there was a rhythm to the work, she gathered together a staff of young men, mostly in their twenties, who were hungry for what she could give them and did.

As Tanya grew and changed, so did her relationship with Maurice. As Johns relates, "She was far more modest when I first knew her. I think she was more uncertain what would interest then and so didn't come forward so much. They were poor. Maurice was still help-ing with the printing. He taught me how to mix inks, tried to insert himself into the studio scene. . . . Gradually, he was pushed out by Tanya, and also by the artists."[34]

The intensity of their relationship did not change, however. After Maurice died in 1976, the will to live appears to have gone out of Tanya. And there were other blows to her sense of herself. She had always been distracted in

her bookkeeping; it took her far too long to hire competent professionals to do it for her, so that her finances "were a mess." Tanya thought it was more important to lavish time, food, and materials on an artist at work than to make sure that an artist whose work was completed and sold should be paid at once. Usually there was not enough money to do both. Most of the artists were patient. One or two were not. Rosenquist, for one, at a moment when he was "feeling very mortal" after a terrible automobile accident, asked her for a contract.[35] Tanya believed her integrity was being questioned. It was what mattered to her most.[36]

During the last years of Tanya's life, Bill Goldston fought to keep both her and the studio alive. But she was not wholeheartedly battling the illnesses that were overcoming her. Honors accumulated: a Doctor of Fine Arts degree from Smith College in 1973, a Doctor of Letters from Dowling College in 1977, a Brandeis University award for outstanding achievement in the arts in 1981. In her final months, Tanya stayed upstairs in her sun porch, taking stock of her life, while downstairs the artists worked and the presses ran:

All these people [at the studio] are quite young. I heard that the cathedral will be built by the men, by the builders, who know they will never see the masterwork, the finale of it. So I think about the work I'm doing the same thing. That it will go further and beyond me.

Tanya Grosman died on July 24, 1982. The work is going further and beyond her.

Notes:

1. Schlossberg at the memorial service for Tatyana Grosman, 5 Skidmore Place, West Islip, October 14, 1982.
2. Wallach, Johns interview, 1985. Unless otherwise noted, all quotations are from conversations with the author. Tanya Grosman's statements are from conversations with the author between 1971 and 1982.
3. Rosenquist at the memorial service (note 1).
4. Goldston at the memorial service (note 1).
5. Castleman at the opening of the Tatyana Grosman print gallery, The Museum of Modern Art, New York, September 11, 1985.
6. Sparks, Aledort interview, 1985.
7. Gilbert and Moore, 1981, p. 11.
8. Ibid.
9. Taped, unpublished, and unedited conversations between Tatyana Grosman and Gaylen Moore, West Islip, Long Island, 1982.
10. Ibid.
11. Wallach, de Chochor interview, 1985.
12. T. Grosman and Moore (note 9).
13. T. Grosman to Wallach, Stanhope Hotel, New York, May 14, 1979.
14. Guest, letter to Sparks, July 10, 1985.
15. Wallach, 1979, p. 12.
16. Motherwell, 1972, unpaged.
17. T. Grosman and Moore (note 9).
18. Ibid.
19. Ibid.
20. Wallach, de Chochor interview, 1985.
21. T. Grosman and Moore (note 9).
22. Wallach, de Chochor interview, 1985.
23. Wallach, Fearer interview, 1985.
24. T. Grosman to Wallach (note 2).
25. Wallach, Goldston interview, 1985.
26. Tomkins, 1976; Gilbert and Moore, 1981; Wallach, 1972 and 1982; Fuller, 1982.
27. Wallach, Fearer interview, 1985.
28. Tomkins, 1976; Wallach, 1972.
29. Camera Three, 1976.
30. Wallach, Johns interview, 1985.
31. Sparks, Brintzenhofe interview, 1983.
32. Wallach, Schlossberg interview, 1985.
33. Sparks, Oldenburg interview, 1985.
34. Wallach, Johns interview, 1985. Jim Dine, on the other hand, told Sparks (1985) that Maurice "was such a pleasure to go out and talk to. . . . I think I would have stopped going out there earlier if he hadn't been there."
35. Wallach, Rosenquist interview, 1985.
36. "She was," said Buckminster Fuller, "an angel of integrity." It was not about business he was talking (Fuller at memorial service [note 1]).

Tatyana Grosman and Donn Steward at
Universal Limited Art Editions, West Islip,
Long Island, 1968

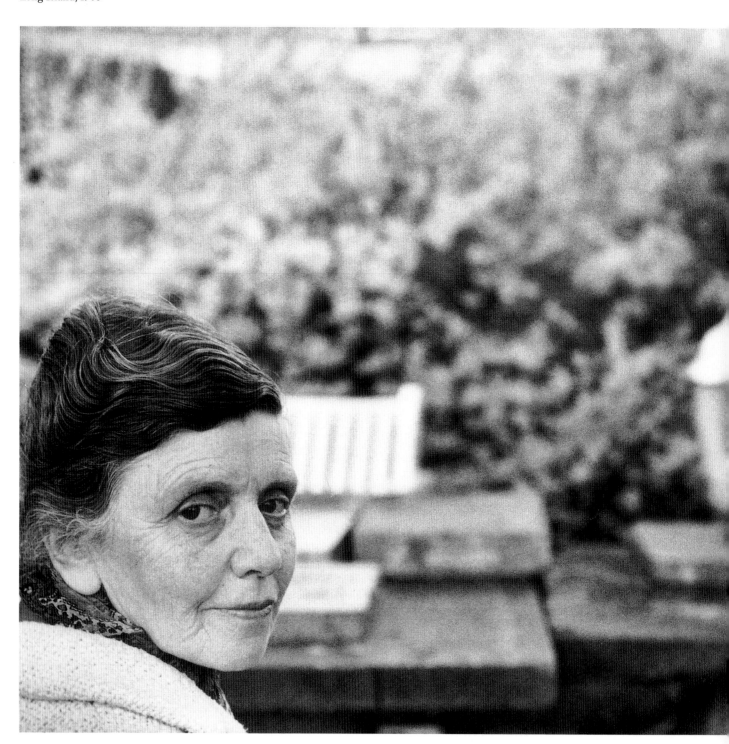

A History of Universal Limited Art Editions

Esther Sparks

The story of Tatyana Grosman's Universal Limited Art Editions (ULAE) has become one of the art legends of our century. Only seven years after she installed a secondhand press in her living room, ninety-seven ULAE prints were chosen for the "American Painters As New Lithographers" exhibition, which inaugurated the new galleries of the Museum of Modern Art, New York. It was an unprecedented honor for a young publishing house and an unprecedented event in an art market that had for so long consigned lithographs to souvenir shops. To Tatyana Grosman, the exhibition was another sign of her fate. Throughout her life, she believed herself blessed with friendships and coincidences that straightened her path and reinforced her will to create beautiful things.[1]

The story of Tatyana Grosman's career as a publisher began in the Grosmans' studio apartment on Eighth Street in New York. Her husband, Maurice, was an unsuccessful artist who took students, did a bit of commercial work, and even tried framing to supplement their meager income. Sometime in the early 1950s, he taught himself screenprinting to reproduce works of art by others. Even though she objected to the screenprints (perhaps it was the smell of the chemicals, perhaps the implication of failure), Tatyana packed them in portfolios and took them out to sell. In the spring of 1955, Maurice Grosman had a heart attack. He could not climb the four flights to their apartment, so they moved everything to their summer cottage on Long Island.

Among the earliest mementoes in Mrs. Grosman's files was a small piece of handmade paper with the words *Limited Art Editions / 5 Skidmore Place / Bayshore, N.Y.* printed in black, and inscribed in her hand *BORN / 11.16.55.* "I had to do something," she said. "There was no time to learn anything, any craft."[2] Maurice Grosman was strong enough to print. Tatyana did all the outside work: solic-

iting original paintings and drawings to repro-
duce, keeping the accounts, and developing a
clientele.

The art that Maurice Grosman repro-
duced came from private collections and deal-
ers and ranged from works by Henri Matisse to
Grandma Moses. At the end of 1955, the
Grosmans started to ask artist-friends for origi-
nal works to reproduce. The first ones came
from Mary Callery, an artist and collector
whom they met through the dealer Curt
Valentin. For each edition, Mrs. Grosman
bought a small dime-store notebook to record
the price of each print, who bought each
impression, and what costs were incurred.
Expenses were high, since Mrs. Grosman
always insisted on the finest materials; the
profit on the first Callery print was $6.19. How-
ever, the expense column included a printer's
fee for Maurice Grosman. They were on the
right track.

When Mrs. Grosman wrote to artist
Max Weber in 1956 to ask him for a drawing,
their infant enterprise had a new name.[3] Seven
months after Limited Art Editions was "born,"
the Grosmans went to Suffolk County Court-
house. While waiting for the clerk, Mrs.
Grosman called Dr. Harold Kovner, director of
Park East Hospital, who had become a friend
and adviser. She told him that she wanted to
change their business name to International
Limited Art Editions. Dr. Kovner thought for a
minute and said, "Tanya, if I know you, you'll
have prints on the moon!"[4] The business was
reregistered as Universal Limited Art Editions.

In the spring of 1957, Mrs. Grosman sum-
moned the courage to take their prints to
William S. Lieberman, then curator of prints
and illustrated books at the Museum of Mod-
ern Art. Lieberman asked her why she both-
ered to make reproductions when commercial
firms did better and cheaper work. She
defended them, saying that she and Maurice
asked artists to design original drawings so
that he could reproduce them. Lieberman

replied, "I can think of no great work of art
that was not designed for itself, but designed
to have a reproduction made of it."[5] Mrs.
Grosman recognized the truth: her path had to
change. By wondrous good luck, two fine
Bavarian lithographic stones were discovered
in the Grosmans' front yard. A neighbor had
an old press he was willing to sell for $15.
Friends told the Grosmans about factories
where abandoned stones could be had for the
asking. The artist Max Weber lent them a few
plates to restrike; a local printer, Emanuel
Edelman, showed them how to use the litho-
graphic press.

The most important step was taken in the
summer of 1957. Monroe Wheeler had
lamented the fact that almost all of the great
livres d'artistes, collaborative books by artists
and poets, had been made in France. Tatyana
Grosman decided that contemporary American
artists and poets could match the classic
French work and that she would be their pub-
lisher. Two artists seemed likely candidates for
such a venture. The first was Larry Rivers, with
whom she had discussed poetry and illustrated
books on a transatlantic trip in 1950. The other
was Robert Motherwell; she had seen his
recent painting and was excited by the fact that
he used painted words as imagery. Motherwell
liked the idea of doing a book and proposed
using verses by Marianne Moore. But Mrs.
Grosman did not want to use existing text; she
wanted to publish "spontaneous expressions of
two artists."[6]

She wanted two artists, one drawing and
one writing, to make stones together. She
asked Barney Rosset, whose Grove Press was
known for poetry, if he knew of someone who
would work well with Rivers. He suggested
Frank O'Hara, whose second book was about
to be published by Grove. When the Grosmans
went to Rivers's studio to tell him whom
Rosset had suggested, Rivers called upstairs
and Frank O'Hara came down. To Mrs. Gros-
man, it seemed like Providence. Using the two

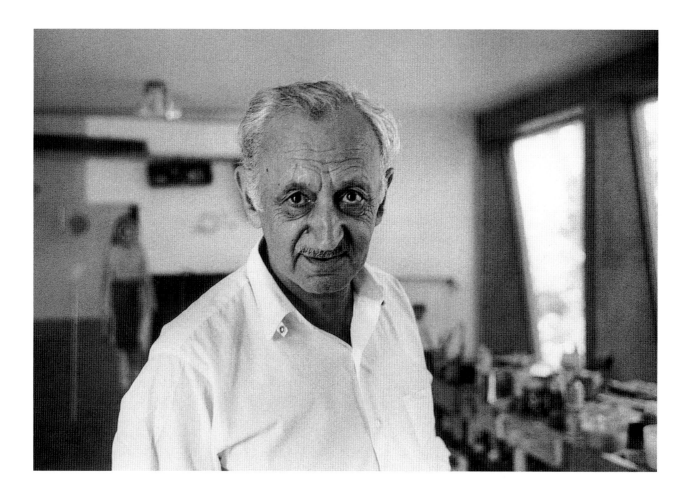

Bavarian stones from the front yard, Rivers and O'Hara worked together, passing the crayon back and forth to create the book they titled *Stones* (Rivers, cat. nos. 11-24). Prophetically, those twelve pages took two years to finish.

There were many reasons why it took so long. Rivers and O'Hara had many other claims on their time and attention. Mrs. Grosman could not always afford to bring a professional printer from the city. But the real reason was her intractably romantic attitude toward materials. In the years to come, each artist reacted to this near-obsession in a way that revealed as much about himself as it did about the workshop. Sam Francis shared her love of the feel, look, and weight of the stone. On the other hand, Robert Rauschenberg and James Rosenquist were more than willing to work on metal plates. Mrs. Grosman clashed with Lee Bontecou, Claes Oldenburg, and Jim Dine about paper and retreated. Buckminster Fuller and Edwin Schlossberg challenged the accepted ideas of what a book could be. The process of designing and making boxes and

portfolio covers could be ruinously expensive, sometimes delaying publication for months or even years. If there were only a few sheets of the "perfect" paper, then Mrs. Grosman simply accepted the fact that the edition would be bad for the balance sheet, but right for the artist. Artists were known to grumble and critics to scoff about her obsession with paper, but only a few prints left the studio on less than the best.

While *Stones* was in progress, Rivers's first single prints were made in a highly irregular way. First they waited for the paper, made at a snail's pace by Douglass Howell. Then Mrs. Grosman insisted that printer Robert Blackburn ink the *edges* of the stones; she thought it looked more "natural," more respectful of the stone. Howell's sheets were not consistent, the printing was not uniform, and the signatures depended on Rivers's mood. Rivers worked impulsively, which she found very moving.[7] In the meantime, Rivers drew on other stones. Before ULAE had published its first book, it was well launched in the business of producing single prints.

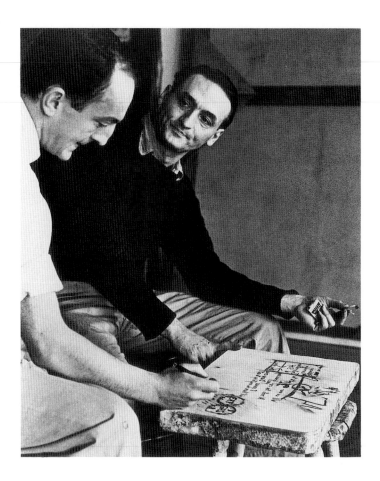

Mary Callery, who helped the Grosmans buy a larger press, introduced the Grosmans to Fritz Glarner and his wife, Lucie. The Grosmans and Glarners became fast friends. Glarner's cool abstractions were the second group of prints to appear with the ULAE seal; they were a perfect counterbalance to Rivers's dashing sketches. The differences between the two artists illuminated the most important question for every impresario: who should be invited to play the starring role?

One factor that has been neglected in almost every description of the studio at West Islip, but universally reported in the interviews for this book, was the influence of Maurice Grosman on his wife. It was Maurice who guided the choice of artists. He went constantly to galleries and museums, he watched young artists emerge, and he listened to the talk where artists congregated. His judgment was all the more remarkable when one considers the sad contrast between the work he recommended and the work he himself produced. The Grosmans chose artists with astonishing prescience. Larry Rivers's description of Jasper Johns and Robert Rauschenberg may be applied to the entire roster of artists who came to work at ULAE in the 1960s: "At this time their rise in the firmament was a little above the horizon, promising, but nowhere near its eventual position."[8]

The Grosmans also listened to the advice of artists and art-world figures they respected. Rivers recommended Grace Hartigan, Helen Frankenthaler, and Marisol. Rivers's dealer, John Bernard Myers, recommended Robert Goodnough. Frank O'Hara suggested Tony Towle. Mrs. Grosman met Robert Rauschenberg through Jasper Johns. Rauschenberg and Johns recommended Jim Dine. Rauschenberg brought Cy Twombly. Johns recommended James Rosenquist and Edwin Schlossberg. William S. Lieberman suggested Barnett Newman. Schlossberg brought Buckminster Fuller.

One might also consider who declined: Willem de Kooning, Franz Kline, Robert Morris, David Smith, and Jean Xceron, as well as the writers Edward Albee and Susan Sontag. De Kooning was a major disappointment. In 1960 Harold Rosenberg spoke to de Kooning on Mrs. Grosman's behalf. Another friend, the lawyer Lee Eastman, tried again in 1964, reminding de Kooning that he once said he wanted to illustrate Dostoyevski's *Notes from the Underground*. Mrs. Grosman offered to set up a press in his studio, publish the book in any languages he wanted, and order special paper with his signature as watermark. "It would be in the great tradition of Vollard," urged Eastman, "and I think would not only be completely new for you but a great . . . contribution to our century." As a friend, he added, "I am also told that spring is a wonderful time to do it because lithographs dry better in the spring, and I rather suspect you flow better in the spring."[9] But de Kooning was not, at that moment, interested in lithography.

Almost invariably Mrs. Grosman

approached new artists with the idea of collaboration. Although none of the artists had ever worked in tandem with a poet, most of them were aware of the historic precedents of such collaborations and were intrigued by the prospect of experimenting and creating with contemporaries they admired. In the relatively small New York art world of the 1950s, it was possible to know most of the other artists (at least those of one's own stylistic persuasion), to see their shows, to read the books and columns that everyone was talking about. Like the Parisian avant-garde in the 1920s, New York's avant-garde in the 1950s represented a convergence of many kinds of artists: writers, painters, dancers, as well as people in theater and film. According to John Bernard Myers, a literary-man-turned-art-dealer, "No gathering [of

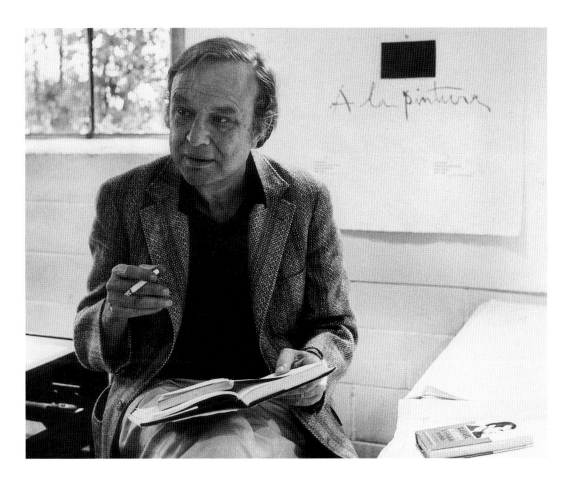

Robert Motherwell at Universal Limited
Art Editions, West Islip, Long Island, 1971

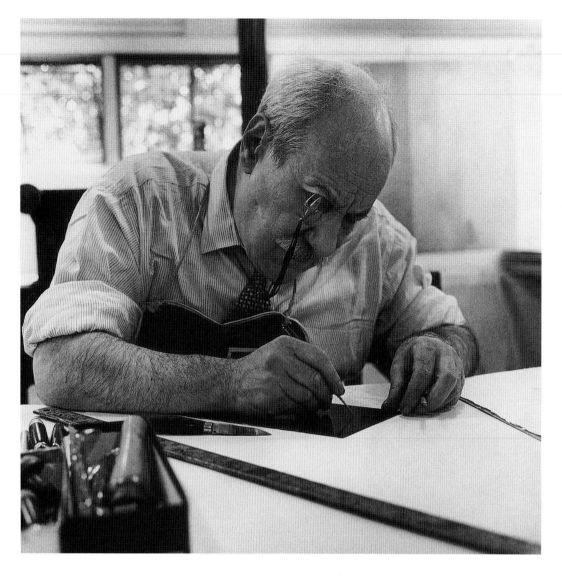

Barnett Newman at Universal Limited Art
Editions, West Islip, Long Island

artists] was complete without poets."[10] Often
the prominent poets in the New York School
were friendly with ULAE artists. Frank
O'Hara's poetry appeared in Rivers's and
Johns's prints. Tony Towle wrote poetry for
Lee Bontecou's book *Fifth Stone, Sixth Stone*
(cat. nos. 11-20). Grace Hartigan's *The Archaics* (cat. nos. 7-13) was inspired by Barbara
Guest's poems. Guest contributed to a book
about Robert Goodnough.[11] Kenneth Koch, a
friend of Jim Dine and others, wrote text for
both Dine (*Kenneth Koch Poem Lithograph*,
cat. no. 20) and Rivers (*Diana with Poem*, cat.
no. 57). James Schuyler, who wrote sympathetic reviews about several ULAE artists,

inspired Helen Frankenthaler's *Post Card for
James Schuyler* (cat. no. 8). A Frankenthaler-
Bill Berkson collaboration came within a hair-
breadth of completion.

ULAE artists also collaborated with poets
who were not part of their circle. Rauschenberg
worked with Voznesensky (*Darkness Mother
Darkness Mother*, Voznesensky, cat. no. 1) and
Liberman (*Nostalgia for the Present*,
Liberman, cat. nos. 1-20), and Motherwell with
the Spanish poet Alberti (*A la pintura*, cat. nos.
15-38). Two writers who also wrote film scripts
became involved: Alain Robbe-Grillet worked
with Rauschenberg (*Traces Suspectes en Surface*, cat. nos. 54-89) and Terry Southern with

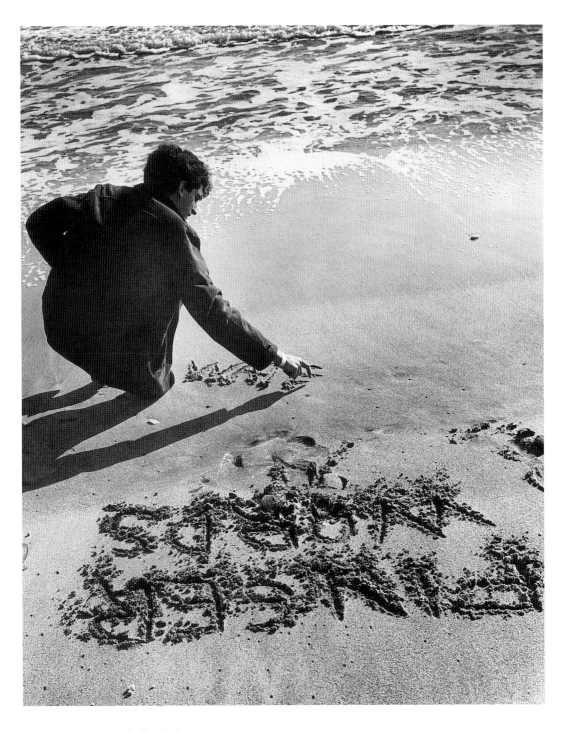

Edwin Schlossberg at the beach, Long
Island

Larry Rivers (*The Donkey and the Darling*, cat. nos. 59-115).[12]

Tatyana Grosman was instinctively drawn to artists who loved poetry, music, and dance and to young people who were creative in more than one sphere. Many of the ULAE artists designed costumes and sets for the stage. Johns and Rauschenberg have been active in contemporary dance. Dine once spent several months away from his easel writing poetry. Rivers has written for and acted in films and has played in jazz bands since his teens. Schlossberg and Voznesensky are poets who became artists at ULAE. Oldenburg, Marisol, Bontecou, and Liberman are sculptors; Rivers, Dine, Newman, and Rauschenberg have done important three-dimensional work. Motherwell and Newman wrote distinguished criticism. Oldenburg and Dine were in the forefront of the Happenings movement. For ULAE artists, the years from 1957 to 1982 were an era of experimentation, of the breaking down of barriers between the arts. For Mrs. Grosman, these years were like pouring old wine—the broad culture of her own background—into new bottles.

Because of his meticulous nature, Jasper Johns may be credited with having brought order to this extraordinary outpouring of creativity. Except for the numbering of edition prints, there were no systematic curatorial records at ULAE until the mid-1960s. In the beginning, Mrs. Grosman was not interested in the minutiae of administration; creative work took up her time and resources. She hired part-time help (often artists, poets, or students) to assist with the printing, not to do record-keeping. Moreover, she did not feel compelled to account to anyone for the drawings and proofs that were part of the printing process (although she was dismayed to learn that printer's proofs, artist's proofs, and even edition prints had been given away as gifts or sold to pay debts).

Jasper Johns wanted an orderly account

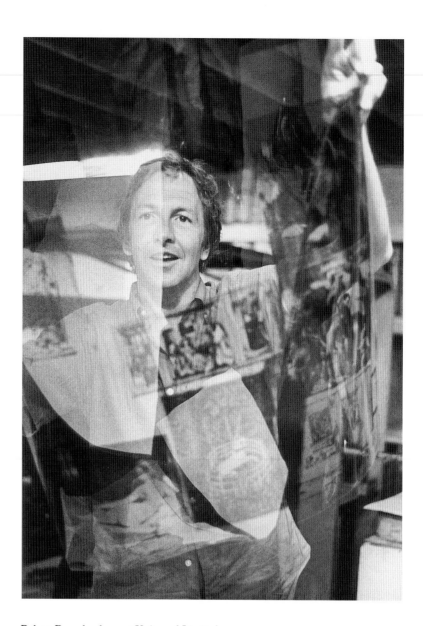

Robert Rauschenberg at Universal Limited Art Editions, West Islip, Long Island

of what he made. The first complete set of trial proofs to be recorded at ULAE was made for his *False Start I* (cat. no. 10) in 1962. Starting in 1966, he worked out a system that was scrupulously followed for his prints (but was not used by those artists who did not want a complete record of their working process): Two proofs of every stone or plate were printed in black and another in the color used in the edition; two progressive proofs of each stage were printed, with number "1/2" given to Johns and number "2/2" to Mrs. Grosman. Terms were standardized: "trial proofs" were those with only printed work on the sheet; "working proofs" were trial proofs, with additions of crayon, pencil, watercolor, or collage by the artist. "Artist's proofs" were identical to "impressions." To date, little of this archival material has found its way into the market. Other artists varied the terminology or were less consistent in the disposition of their proofs and other interim-stage material. But Mrs. Grosman heeded Johns's example and henceforward tended her own archival collection with an eye to its historic value.[13]

In March 1961, Mrs. Grosman prepared studios for Frankenthaler and Motherwell (who were married at the time) to come to West Islip and work on the same day. It had been a house rule to have only one artist in the studio at a time. The first commandment of the studio was that the artist rules. In a production-oriented workshop, immediate need dictates the day; plates or stones once editioned are put to other use. But at ULAE, the artists could store anything they wanted. Materials were luxurious and unstinting; assistance and privacy were provided in any combination; food, music, and hours were the artist's choice. When Rauschenberg came to work, often with friends and animals, he rarely started until late in the day. Printers happily worked through the night with him, while the Grosmans did their best to keep pace. Bontecou wished to spend several hours swimming and snorkeling before start-

ing work in the studio. For Motherwell, printer Donn Steward carefully prepared the studio by covering the walls with the proofs, drawings, and collages the artist had created during his previous session. Larry Rivers enjoyed Gypsy music. For Buckminster Fuller, there was steak, spinach, and Jell-O ready at all hours and a bone-weary crew when he left. Above all there was, as printer Robert Blackburn recalled, "as much time and as many visits, as many trials and experiments," as the artist desired.[14] And no edition was printed until both artist and publisher were satisfied with the work.

Frankenthaler's first three prints were finished in time for ULAE's first exhibition. Twenty-nine lithographs were shown at the Cape Cod Festival in Hyannis, Massachusetts, in the summer of 1961, and, with the addition of Motherwell's first two lithographs, the same group made up ULAE's New York debut at the Kornblee Gallery in December. It was a sign of the times and of the stepchild status of prints that the *Herald Tribune* critic said that the prints at Kornblee were interesting but essentially only "a means of popularizing" the artist.[15]

Mrs. Grosman was working on other ways to put her artists before the public. The public-relations firm Ruder and Finn, agents for the Rockefeller-Hilton-Uris group that was developing the New York Hilton, was looking for contemporary prints for the hotel's 2,400 rooms. Mrs. Grosman would not provide the large editions they requested but was delighted to send lithographs by Rivers, Glarner, Hartigan, Goodnough, and, at the last moment, Rauschenberg's first print, *Abby's Bird* (cat. no. 1). When the Hilton prints were shown at the Whitney Museum of American Art in 1963, critic Russell Lynes dismissed them as well as the developers' motives: "Where there is a Rockefeller you may be sure that Culture is not far away."[16] But Cleve Gray, writing in the same publication, cheered them on and described the show as "one of the most distinguished

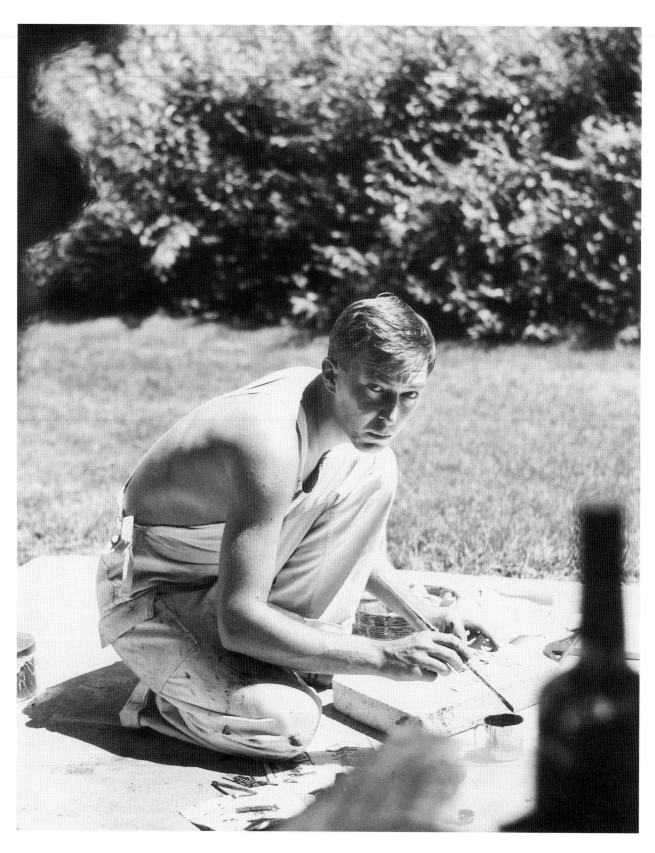

Jasper Johns at Universal Limited Art
Editions, West Islip, Long Island, 1962

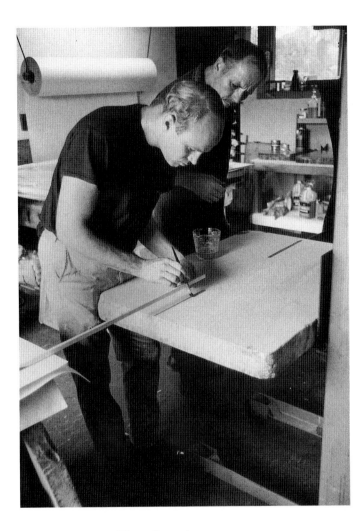

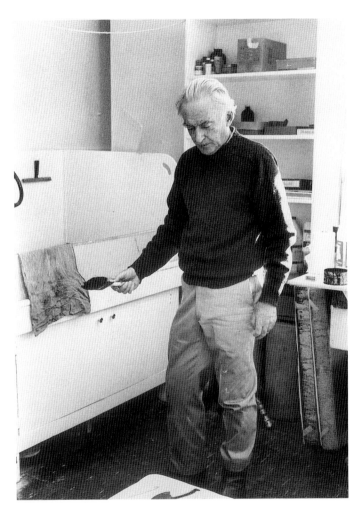

James Rosenquist and Donn Steward at
Universal Limited Art Editions, West Islip,
Long Island, 1967

Alexander Liberman at Universal Limited
Art Editions, West Islip, Long Island, 1977

and largest collections of contemporary American prints in the world."[17]

From every point of view, 1962 was a year of progress. Dine, Bontecou, and Rauschenberg made their first prints at ULAE. There was positive response from the media and the exhibition circuit. In January, James Schuyler's article in *Art News* was certainly among the first, if not the first, to put a name to the print revival in America.[18] One of several poets writing for Thomas Hess's influential magazine, Schuyler was understandably captivated by the Rivers-O'Hara *Stones*. *Stones* was as fine as Picasso's *Buffon*, he said, and ULAE was the unrivaled leader of the print revival. A dealers' survey reported that ULAE prints, ranging from a then-impressive $65 to $200, were being "snapped up" by museums.[19] Rauschenberg was commissioned to make a print and poster for the Dylaby Exhibition in Stockholm; Johns and Rauschenberg were invited to the Tokyo Biennial, where Rauschenberg won the Grand Prize. A strong group of prints represented ULAE in the Print Council of America's traveling show "American Prints Today" (1962-63).

With Rauschenberg the element of true collaboration entered the workshop at West Islip: not only a free give-and-take between artist and printer but, more important, the use of materials and chance events as an essential part of the printmaking process. From the first, Rauschenberg treated the stone as a stage on which any object in his ken might perform; he was always doing something new. In 1963 he insisted on printing from a stone that had broken in the press. He called it *Accident* (cat. no. 9); it won the Grand Prize at the Biennale in Ljubljana, Yugoslavia, then the most prestigious international exhibition of printmaking. He liked the patterns that were left on old printing stones and the unpredictable way that magazine illustrations behaved when they were transferred to the stone. When Mrs. Grosman finally persuaded him to make a book, he

brushed aside her beloved papers and printed on pedestrian Plexiglas.

Recognition began to come at a rapid pace. Rauschenberg's *Shades* (cat. no. 18)—not a book but a lithographic object—became a pioneer of the multiples movement of the 1960s. In 1964 William Lieberman opened the newly renovated galleries at the Museum of Modern Art (MOMA) with "American Painters As New Lithographers." All of the prints in the exhibition, except for three by Sam Francis that had been published in Switzerland, were made in West Islip. Mrs. Grosman was especially pleased that First Lady Mrs. Lyndon B. Johnson was present at the opening.

Mrs. Grosman had many reasons to be grateful to "Dear Mr. Lieberman" (despite her seniority and his protests, she would never use his first name). In 1962 Lieberman had arranged for a series of grants from the Celeste and Armand Bartos Foundation so that the museum could purchase the first print of every ULAE edition. The Bartos gifts were "an immense thing" for Mrs. Grosman, coming at a moment when she "didn't know what to do about money, what to do about anything."[20] In addition to the edition prints, a number of important archival and unique pieces have been added to MOMA's collection over the years. Until the Art Institute of Chicago acquired Mrs. Grosman's collection in 1982, MOMA's was the largest collection of ULAE prints in the world.

After the exhibition at MOMA, Mrs. Grosman realized that she could no longer manage the stage and the backstage alone. On Frank O'Hara's recommendation, she hired Tony Towle as her secretary and general assistant. A poet, Towle was part of the well-knit enclave of artists, writers, and performers of the New York School. For the next twelve years, Towle served as Mrs. Grosman's secretary in the European sense of the word, taking part in all the work and in most of the social activities of the house. Perhaps most

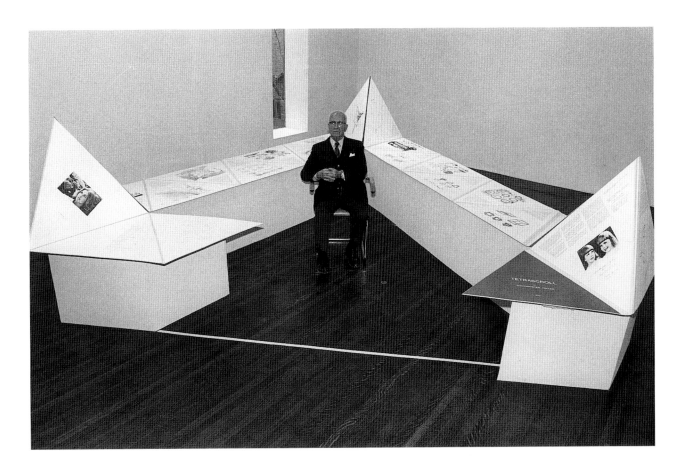

R. Buckminster Fuller with *Tetrascroll*, at
Ronald Feldman Fine Arts, Inc., New York,
New York

important, he was what she described as her
"ghost writer."[21] Although her Russian phrase-
ology often flickered through the cracks of
Towle's more disciplined English, ULAE's lit-
erary products—letters, prefaces, colophons,
even captions—owe much of their grace and
precision to him.

The mood of the next few years was
expansive. James Rosenquist and Marisol
made their first prints in 1964. ULAE publica-
tions were seen in the most important of the
invitational exhibitions abroad as well as in the
United States: Ljubljana, Tokyo, Santiago.[22] In
1964, Mrs. Grosman asked Jim Dine and
Theodore Stamos to make stones that would
then be sent out to be printed as List posters in
a commercial shop.[23] But she stopped short of
putting the ULAE seal on the posters: too
much of the work had slipped into other
hands. Although she approved of the List pro-
gram in principle, and the artists' designs in
this case, the issue was quality control. As she

often said to Bill Goldston, "The key is to do
everything ourselves."[24]

Stamos's poster for the List program also
brought into focus the issue of reproductive
printing. The print boom of the 1960s encour-
aged many publishers to blur, if not actually
conceal, the distinction between handmade
originals and signed photographic reproduc-
tions. After much discussion with her lawyers,
Mrs. Grosman declined an offer to give a com-
mercial publisher the right to reproduce a
Larry Rivers print. She also declined to go
through the necessary procedures to solicit
copyright permissions from the artists and to
add such officious-looking documentation to
the paperwork that accompanied the prints. It
would "disturb the working atmosphere" for
artists and collectors, she said.[25] According to
many of the Grosmans' friends, she bridled at
the mention of the word *business* in connec-
tion with ULAE; it was their *work*.

In the December 1965 issue of *Art in*

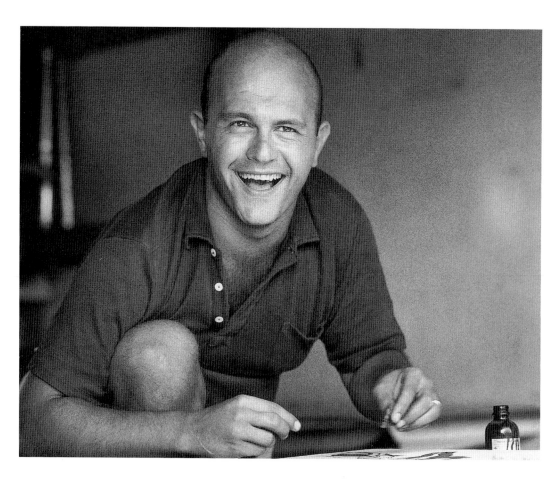

Jim Dine at Universal Limited Art
Editions, West Islip, Long Island

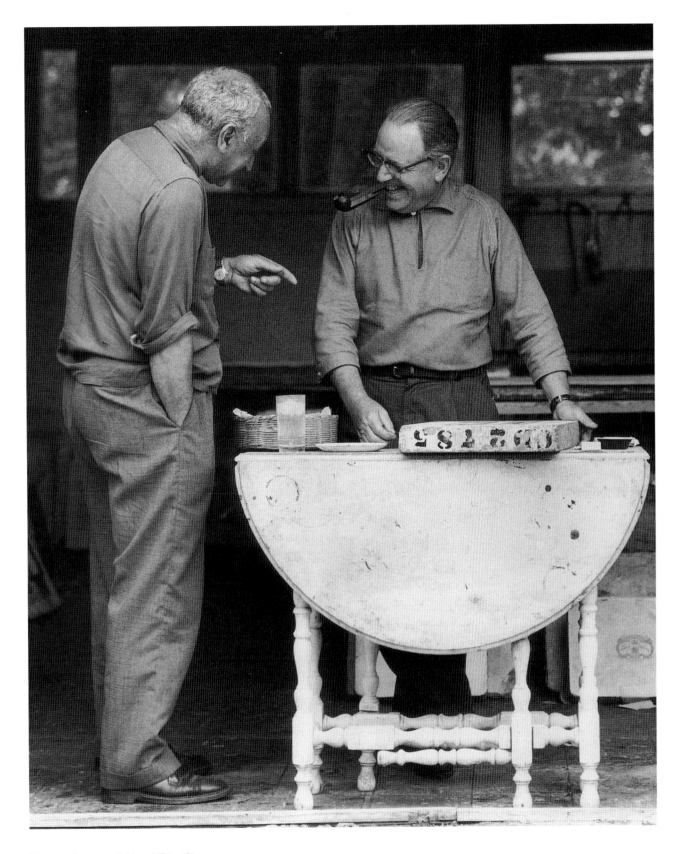

Maurice Grosman (left) and Fritz Glarner
at Universal Limited Art Editions, West
Islip, Long Island

Lee Bontecou and Zigmunds Priede (left) at
Universal Limited Art Editions, West Islip,
Long Island

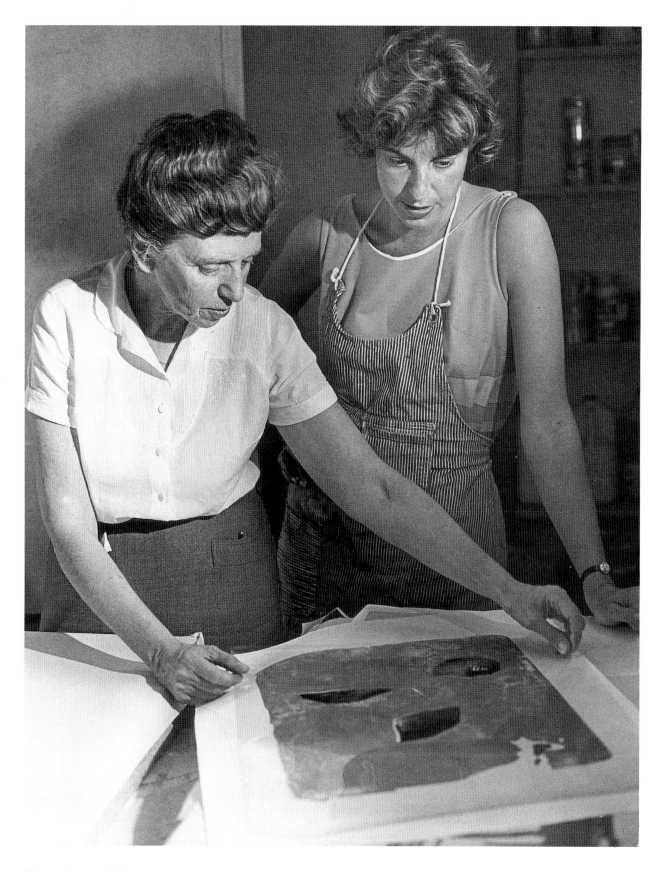

Tatyana Grosman (left) and Helen
Frankenthaler at Universal Limited Art
Editions, West Islip, Long Island

Andrei Voznesensky at Universal Limited
Art Editions, West Islip, Long Island, 1977

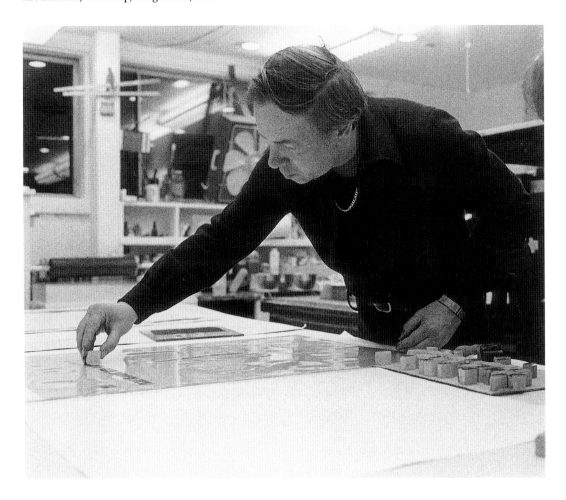

America, Cleve Gray pointed out another essential ingredient of ULAE's "working atmosphere": Mrs. Grosman declared, "I never go over to a second day for printing an edition. We do as much as we can in *one day*; after that the printer's touch is different—everything changes."[26] Thirteen years later, she revealed the romantic and psychological basis for the rule. "Because the next day to start, he would have been copying the emotions of the first day. So it becomes something mechanical . . . but a stone a day, I love that."[27] Writers loved it, too, and even though the rule was not

invariably enforced in later years, it became part of the lore of the studio, and few people wanted to separate the ideal from the real work. In this house and workshop, creativity was paramount, including that measure of creativity contributed by the printers.

Ten years after Tatyana Grosman had scrimped to pay Robert Blackburn a day's wages, the studio had two exceptional master printers. Zigmunds Priede, who flew in from the University of Minnesota on holidays and weekends to print, was, by his modest disclaimer, self-taught. Often the Grosmans came

Marisol at Universal Limited Art Editions,
West Islip, Long Island, 1977

home from an evening in the city to find him
still at the press. Using the same crayons that
the artist of the day had used, he scrupulously
experimented on his own stones before print-
ing theirs.[28]

Donn Steward's arrival was another exam-
ple of luck and timing. When he came to inter-
view in July 1966, several stones happened to
be "in trouble." As part of his "interview," he
saved and printed them. Later, Mrs. Grosman
told Steward of her visit to the Metropolitan
Museum of Art Print Room and how she
wished that ULAE could make etchings.[29]
Steward reminded her that although he had
been hired as a lithographer, he was primarily
an intaglio printer. Before the year was out, the
National Council for the Arts had approved a
$15,000 grant for ULAE to set up an etching
studio. A Charles Brand Etching Press was
installed in a new "etching basement"; in Feb-
ruary 1967, Steward became ULAE's first mas-
ter printer for intaglio. Within five months,
ULAE's first etching, Larry Rivers's *Down-
town Lion* (cat. no. 47), was released. Within
the year, Johns, Bontecou, Frankenthaler,
Newman, Marisol, Rosenquist, Motherwell,
and Cy Twombly had taken up the etching
needle at West Islip.

For some of the artists, simple intaglio
was not attractive. Rosenquist abandoned it,
Johns and Rauschenberg immediately exe-
cuted photoengravings, and Rivers returned to
lithography. But Motherwell, Bontecou, and
Newman were captivated; all have credited
Steward for their enthusiasm. Bontecou's book
Fifth Stone, Sixth Stone was founded on an
essentially unaltered use of Steward's aquatint
grounds. Newman based his monumental
Untitled Etchings on the densest black that
Steward could provide.

The crowning achievement of the etching
press was Motherwell's *A la pintura*. As
Motherwell frequently and graciously acknowl-
edged, Steward's sensitivity, skill, and patience
were visible in every element of the book. They

had perhaps the most intense artist/printer relationship at ULAE. Steward's creativity, although supremely valuable to Motherwell, was not really in Mrs. Grosman's scheme of things. Although Mrs. Grosman often praised her printers and took a maternal interest in their affairs, they quickly learned that she believed in a definite hierarchy: Printers were not encouraged to rise above the rank of artisan; the artist was supreme, without doubt or rival. Next stood Mrs. Grosman—the artist's interpreter, monitor, and friend.

From the beginning of the press, acquaintances became friends and friends became collectors. Mrs. Grosman's collectors came to believe in what she did, to have confidence in her future, and to share her risks. It was an added privilege to become acquainted with the artists and to follow prints as they were being made. The collectors enjoyed another advantage, unexpected at first and later on resented by dealers. When demand for the prints outstripped supply, ULAE's old friends usually had the right of first refusal. Their advance payments were often Mrs. Grosman's very lifeline. Moreover, their appreciation was often her warmest satisfaction. And, finally, these collectors contributed generously to museums and temporary exhibitions that were extremely important in Mrs. Grosman's unrelenting efforts to place her artists' work in the best possible circumstances.

Two examples from the mid-1960s show this extraordinary combination of affection, respect, and personal commitment. Dr. Joseph I. Singer, a Long Island neighbor, met the Grosmans in 1960 and soon became an intimate of the household as well as a generous adviser. In 1966 Dr. Singer joined Mr. and Mrs. Stanley Helfgott (who later gave ULAE prints to the Whitney Museum of American Art, New York) in arranging an exhibition at the Awixa Pond Art Center in Bay Shore, Long Island.

One afternoon in 1963, Dr. Singer went to West Islip to meet John McKendry, then a young assistant curator in the Department of Prints and Photographs at the Metropolitan Museum of Art, New York. Dr. Singer, impressed with McKendry, was dismayed to hear that the Metropolitan had no funds for contemporary prints. He immediately offered several ULAE prints as gifts, which McKendry accepted and promptly installed in his galleries. There was general surprise: few people knew that the Metropolitan wanted prints by living artists. Other donors soon followed suit. Long before 1976, when the Singer gifts were given a special exhibition at the Metropolitan, McKendry acknowledged his patron's catalytic role in building the museum's collection.[30]

The collectors John and Kimiko Powers found other ways to help ULAE. The publisher Harry N. Abrams, who owned many ULAE prints (and later distributed Barnett Newman's *Untitled Etching #1*, cat. no. 40A), took the couple to West Islip around 1964. "Tanya," said John Powers, "always seemed a little alone and baffled by things [other than] art."[31] To give her the capital she needed for a new press, in 1964 the Powers improvised a kind of subscribers' fund, through which contributors were offered prints as they were published. The Powers's own collection grew apace, and the other subscribers invariably bought more than they expected. In 1966, the Powers arranged an exhibition of ULAE prints at the Aspen Institute in Colorado.

During this period, ULAE prints were included in scores of exhibitions, from Toronto and Geneva to Tokyo and Ankara. In the "8th International Exhibition of Graphic Art" at Ljubljana (1969), eight ULAE artists were awarded prizes; Rosenquist won the Grand Prize, and Johns had a retrospective exhibition as part of his Grand Prize from the previous biennial. In Minneapolis, Dayton's Gallery 12 hosted "Contemporary Graphics Published by Universal Limited Art Editions" (1968), an exhibition of 144 prints, the most comprehensive to date. At the Metropolitan Museum,

Cy Twombly

Mary Callery (far right)

John McKendry organized two exhibitions for the museum's hundredth anniversary. Of the nine artists whose prints were included, eight were from ULAE.[32] The Metropolitan proffered another honor: Rauschenberg was invited to design its centenary poster, to be published at ULAE.

Despite ULAE's growing reputation, its finances were still grim. Except for entertaining artists and collectors and attending concerts and lectures they thought essential, the Grosmans indulged in no luxuries. Mrs. Grosman's letters were riddled with apologies for late payment. Yet she continued to indulge collectors who "had a reverence" for the work,[33] and she refused to compromise on time or quality. On several occasions, Rauschenberg asked the cost of various papers or methods, perfectly willing to choose the least expensive. She refused to tell him. "Some of us tried to protect her," he said.[34]

She began to listen when Bill Goldston and others talked about buying an offset press. Her prejudice against the offset as an artist's tool continued. But Goldston was inquisitive and determined. With a bit of modification, he thought, the offset could produce high-quality posters and books. These relatively popular publications could then support ULAE's limited editions. Eventually they could publish the catalogues Mrs. Grosman had never been able to afford. Jasper Johns suggested that a print or two be set aside from each edition as a benefit print for the catalogue project, with a separate corporate identity to handle them; a number of impressions were so designated. Tony Towle suggested that the new business be named "Trigram." The name was changed when Jim Dine came back from Europe with books of his poetry that had been published by a British press named Trigram. Edwin Schlossberg offered another name—Telamon Editions—and the new enterprise was incorporated on July 8, 1969.

Bill Goldston was the first to devote him-

Jacques Lipchitz in his studio at
Hastings-on-Hudson, New York, 1959

self to intensive technical experimentation at ULAE. He had been a student of Zigmunds Priede at the University of Minnesota. When Priede introduced him to Mrs. Grosman, she was interested to learn that he had printed on an offset press in the army. Priede brought Goldston to work with him at ULAE in the summer of 1969. Spending long days at the handpress, they did extensive experimentation and produced editions for Frankenthaler and Rosenquist. Their most immediate task was to find a better way to photosensitize stones for Rauschenberg's *Tides, Drifts,* and *Gulf* (cat. nos. 38-40). By the end of the summer, they had developed many techniques that were of critical importance for the 1970s.

The Mailander offset press on which Rauschenberg's Metropolitan poster had been printed was for sale; Mrs. Grosman's printers urged her to buy it. A second workshop was set up five minutes away in Bay Shore, where Juda Rosenberg was at work on the Vandercook letterpress that had been bought to print the text of Motherwell's *A la pintura.* The plate-glass window of the Bay Shore shop had been taken out in 1970 to install the Vandercook; it came out again in May 1971 for the Mailander. After three months of Goldston's freewheeling experimentation—sometimes systematic, sometimes playful—the Mailander was a new instrument. Its precision and versatility were vastly improved. Sensitive, hand-fed, and expensive to operate, it was no longer a machine to turn out large, profitable, carefree prints. But no one at ULAE was really concerned with cost or practicality; the issues were versatility and visualization. Goldston had printed for Rauschenberg, Johns, and Rosenquist since 1969. He was convinced that the offset, properly modified, would be a better way to provide what he believed they wanted in their prints.

Just after Johns had printed the first stone for *Decoy* (cat. no. 108) in 1971, Goldston took him to see the new equipment. Johns

asked printer James V. Smith, who had come to ULAE with the Mailander, if one could draw on an offset plate. Smith was encouraging, but Mrs. Grosman was not; she was afraid that the drawing might be lost. It was *his* drawing, Johns replied, and picked up the crayon. In May 1970, Mrs. Grosman told Paul Cummings that printing from metal plates was only a "convenience."[35] In the next few years, through such prints as Rosenquist's *Off the Continental Divide* (cat. no. 17), Dine's *Flaubert Favorites* (cat. nos. 23-30), and the great majority of Johns's work of the 1970s, she came to accept offset lithography as necessary—because the *artists* wanted it.

It seemed as if the offset press could be used in several ways for a most important and exciting project. In a few years, ULAE would be fifteen years old. In November 1969, Renato Danese, a curator at the Corcoran Gallery in Washington, D.C., proposed a ULAE retrospective. It would be splendid, said Mrs. Grosman, to stage our anniversary celebration in the nation's capital. With their offset press, ULAE could produce its own catalogue. The artists began to make large prints for the Corcoran's large-scale galleries: Dine's *2 Hearts (The Donut)* (cat. no. 31), Frankenthaler's *Lot's Wife* (cat. no. 20), Motherwell's *Samurai* (cat. no. 11), Marisol's *Diptych* (cat. no. 12), Rivers's *For Adults Only* (cat. no. 52), and Rosenquist's *Off the Continental Divide* (cat. no. 17).

Unfortunately, this exhibition was not to be. Through the murk of polite correspondence (considerably illumined by Tony Towle's diary), it became clear that, for once, the timing was wrong. In 1971 and 1972, there were paralyzing conflicts between the Corcoran's director, Walter Hopps, and his chief curator, Gene Baro. Announcements were made; postponements followed. The costs of the catalogue mounted. When a new director, Roy Slade, decreed that the prints would be hung according to lender—not by artist or date— Mrs. Grosman withdrew. Six of the "Jubilee

Editions"[36] were shown at the Whitney Museum's "Oversize Prints" exhibition in 1971.[37] In the end, only three prints were embossed with the "15 Years" seal: Rosenquist's *15 Years Magnified Through a Drop of Water* (cat. no. 16), Rauschenberg's *Tanya* (cat. no. 45), and Schlossberg's *Fragments from a Place* (cat. no. 21).

Beginning around 1955, Mrs. Grosman had started to collect and file clippings and publications on art, dance, poetry, fashion, chess—a wide variety of events and images that related to her interests as well as to the activities of her artists. Tony Towle continued but refined the files after 1964. By the turn of the decade, what the *Wall Street Journal* called "The Great Graphic Boom of the '50s and '60s"[38] made it impossible to keep abreast of even the press coverage directly relating to ULAE artists. Not only had the "Great Graphic Boom" crested, it had begun to go slightly sour. Many experts, primarily curators

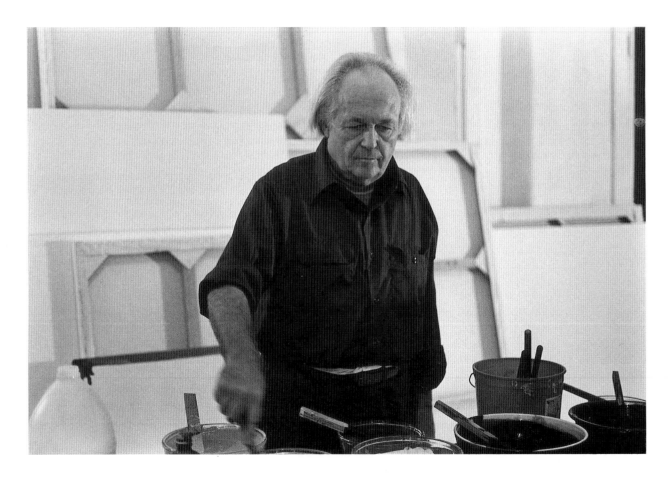

Sam Francis

and dealers in the upper reaches of the market, were well satisfied by the new esteem that prints enjoyed in the art world. But the lower-priced market was suffering a backlash. Some curators and collectors were worried about the long-term effects of overproduction and popularity. Magazines and newspapers reported cases of overpromotion, marginally legal tax-shelter schemes, and the vociferous complaints from people who had been lured into buying prints for investment. ULAE could not be deaf to these unsavory developments. Its market, however, was largely insulated by its reputation for quality and the eminence of its artists.

The exhibitions of the early 1970s had the unmistakable flavor of robust maturity. For example, the Hofstra University exhibition of Johns's *Decoy* was an intensive examination of that landmark of lithography, its archives, and related paintings.[39] Marisol's 1973 exhibition at the New York Cultural Center was essentially a retrospective of her work at ULAE. Morton and Carol Rapp, collector-friends of long standing, lent part of their collection of ULAE prints to York University in Toronto. Six years later, the Rapp Collection, enlarged and handsomely catalogued, was shown at the Art Gallery of Ontario.[40] At the Metropolitan, John McKendry presented "Motherwell: A la pintura: The Genesis of a Book" as the museum's first exhibition of a contemporary artist's book.

In the 1970s, there were many honors for past achievements and fresh projects to keep the studio at work on the future. Both Johns and Newman received awards from the Whitney Museum. Rauschenberg received the Gold Medal of the American Institute of Graphic Art. Tony Towle won the Frank O'Hara Award for Poetry and a CAPS Award from New York State. Mrs. Grosman was awarded an honorary doctorate from Smith College. In 1974 she was invited to be part of a panel presented by the Museum of Modern Art in conjunction with the twenty-fifth anniversary exhibition of the founding of its Print

Grace Hartigan

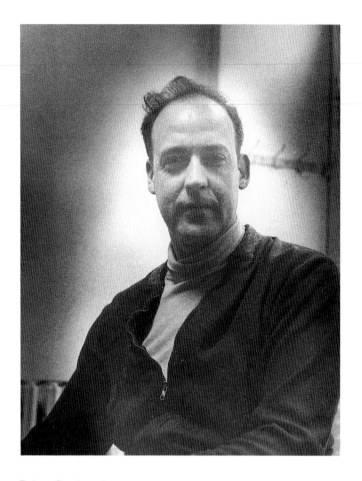

Robert Goodnough

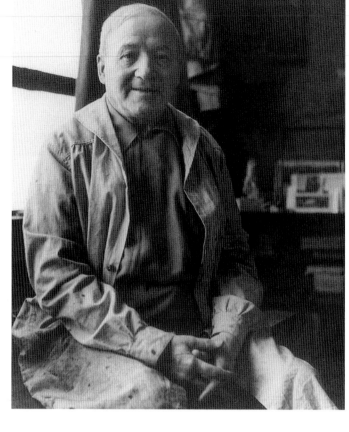

Max Weber, 1952

Study Room.[41] At the close of the afternoon session, Curator William S. Lieberman read the preface Barnett Newman had written for his *18 Cantos* (cat. nos. 1-21), a moving tribute to Mrs. Grosman and her great love of books. She had succeeded in realizing her ardent and initial hope—to bring the image and the word together. At this moment, there was a new outpouring from ULAE of artists' books. Dine's *Flaubert Favorites* had met with great success; Rauschenberg's long-distance collaboration with Robbe-Grillet was proceeding, and the Rivers/Southern *Donkey and the Darling* was slowly moving forward. Saul Steinberg and Buckminster Fuller worked at ULAE for the first time.

There was neither space nor time to add artists as often as in the 1960s, but the spirit of innovation was still alive. Two diametrically opposed technical additions were made in 1973. The first was a third workshop, to house a formidable battery of photographic equipment. The large negatives and sheer versatility

of the photographic setup became indispensable tools for Rauschenberg's subsequent work. In its first year, he used it for the *Veils* series (cat. nos. 46-49) and the extremely complex lithographs *Treaty* and *Kitty Hawk* (cat. nos. 50, 51).

The second addition was the world's most venerable printmaking medium, relief printing from wood. For many years, Helen Frankenthaler had loved *Ukiyo-e*, the traditional woodcuts of Japan. Early in 1973, she called Mrs. Grosman to tell her about an *Ukiyo-e* exhibition she had just seen at Sylvan Cole's Associated American Artists Gallery in New York. Mrs. Grosman urged her to try her hand. In a few days, Bill Goldston stood in a lumberyard, wondering what materials to buy for the experiment. Rough plywood was his answer: twentieth-century materials for a twentieth-century artist. Frankenthaler attacked the plywood with gusto and, with Juda Rosenberg and Goldston at hand, doggedly solved the problems of a new medium. It is commonly held that Franken-

Claes Oldenburg

thaler's woodcuts *East and Beyond* and *Savage Breeze* (cat. nos. 25, 29) inspired the revival of woodcuts in the United States in the late 1970s.

ULAE published no more woodcuts[42] until 1981, when Dine produced *The Big Black and White Woodcut Tree* (cat. no. 35), a stunning contrast, in the tools and scale, surface qualities, and emotional expression, to Frankenthaler's two pioneer prints. It is often said that every workshop has a recognizable "look"—hi-tech, smoky, subdued—but the ULAE woodcuts of 1974 and 1981 illustrate a range that baffles the viewer searching for a "ULAE look." Frankenthaler's interest in prints was peripheral, her approach exploratory, and her results both restrained and elegant. Dine, on the other hand, had been working almost exclusively on paper for several years. His interest in prints was at its peak. Every rasping gouge and gash in *The Big Black and White Woodcut Tree* reveals his protean energy and superb draftsmanship. By

1981 Dine had worked with Aldo Crommelynck in Paris and other master printers in England and the United States, always stimulated by the process of breaking traditions even as he learned them. The *Woodcut Tree* was a new direction for ULAE, not only in its technical improvisation but in its expressionist style. Both woodcuts stand as evidence that the workshop's standard was quality and its strategy creative improvisation.

In many workshops of the 1970s, printers and publishers competed to make the biggest, the most complicated, and the most daring prints they could devise. Other print publishers, particularly Gemini in Los Angeles, took the lead in producing prints whose size ranged from overwhelming to environmental. About 1970, however, ULAE prints began to get bigger. Two events—rather, Mrs. Grosman's plans for two events—marked the change. First, she had been approached about an exhibition of oversize prints scheduled for the Whitney Museum of American Art in 1972—just as the Corcoran Gallery's proposed retrospective had already inspired a change in scale. More important, 1972 would be the fifteenth anniversary of ULAE's first publication. Mrs. Grosman wanted to commemorate the anniversary with prints of extraordinary, and perhaps monumental, character. But she had neither the technology nor the peculiarly American appetite for impact or for size per se.

While there were indeed technical innovations at ULAE, on a print-by-print basis, technology was deemphasized rather than publicized. For example, printer Donn Steward became curious about an aquatint grain he had seen in a print by Edgar Degas at the Metropolitan. Steward was particularly intrigued by Degas's inscription: *Here is the liquid aquatint.* Steward researched the old etching manuals, did not find what he wanted, and finally solved the problem in his own methodical way. The result was Frankenthaler's *Message from Degas* (cat. no. 31). When Steward

left ULAE to start his own workshop, Frankenthaler wrote of him: "He is very careful, and pure, and at the same time whimsical and sensitive, and is in love with his work."[43]

Buckminster Fuller went to West Islip in 1975, brought there by Edwin Schlossberg. Fuller needed a new challenge; Schlossberg knew that nothing would invigorate him more than making something new, doing something unprecedented. In a matter of hours, Fuller's thirty-six-foot *Tetrascroll* (cat. nos. 1-26) was designed, and Fuller was drawing on his first stone. From the beginning, Fuller's drawing-reading-dictating-printing sessions threw the studio into a turmoil. He worked with the energy of ten men, took short naps while the staff carried out his instructions, and woke to put them all back to work again. Whenever Fuller left the studio after a working session—usually to meet a backbreaking schedule of lectures and consultations—the whole staff had to rest for several days.

Everyone who knew Tatyana Grosman has described a curious, chameleonlike quality in her character. She could be warmly affectionate, maternal, intensely concerned with her friends, artists, printers, anyone. She could also be evasive, distant, and what Larry Rivers called "mysterious." There were few people she trusted completely and few whose advice she respected. One of the first was William S. Lieberman. After 1963 there was John McKendry, curator of prints at the Metropolitan. McKendry's death in 1975 cast a pall over her spirit. In the small output of the studio in that year—Claes Oldenburg's only print, the long-postponed publication of Twombly's etching plates, and Buckminster Fuller's project *Tetrascroll*—one senses a lessened energy and perhaps a premonition of death.

With no real warning, Maurice Grosman died on February 12, 1976. He had been in the city for his usual game of chess and collapsed at the Jewish Cafeteria. Bill Goldston took him to Lenox Hill Hospital. Mrs. Grosman moved to a hotel to be near him during these last few days. For months after the funeral on February 15, she was profoundly depressed and attended to her duties with the greatest difficulty.

For Mrs. Grosman's sake as well as that of the studio, Bill Goldston and the rest of the staff did their best to persuade her to work. Important events were scheduled for the year and, for these, she marshaled her energy. CBS completed a two-part film on ULAE. There was a tremendous bustle: equipment and crews filled every corner. Various artists appeared briefly in the film, and the well-known lecturer Rosamond Bernier, who was both interviewer and commentator, exhibited her customary aplomb and style.

The rate of publication slowed appreciably during the next two years while the studio was absorbed in work for three major books: Buckminster Fuller's *Tetrascroll*, Rauschenberg and Robbe-Grillet's *Traces Suspectes en Surface*, and the Rivers/Southern *The Donkey and the Darling*. As Mrs. Grosman emerged from deepest mourning and began to resume her duties, she could no longer conceal the symptoms of her final illness. After she left the hospital in July 1977, Dr. Louis Aledort engaged a small suite for her at the Stanhope Hotel. It seemed inordinately luxurious for the publisher of a marginally solvent press to live at that elegant address. But had she gone home, the frequent medical appointments in the city would have exhausted her and made it impossible for Goldston to conduct the business that paid for her care. At the Stanhope, she enjoyed short visits from friends, curators, and interviewers without great demands on either visitor or patient.

Important events took place during Mrs. Grosman's illness: Jasper Johns's retrospective at the Whitney Museum in 1977 and Jim Dine's exhibition of etchings at the Museum of Modern Art in 1978, the Singer Collection at the Metropolitan, and the "Tribute to Maurice Grosman" at the Grey Art Gallery, New York

Saul Steinberg

University, in 1977. In 1978 the University of California presented "Words and Images," an exhibition of ULAE books that, from the most personal point of view, compensated for the earlier Corcoran disappointment. It complimented Mrs. Grosman in the most profound way by connecting her publications to classic illustrated books in Western art. It also included a selection of single prints as examples of the other aspect of ULAE's work.

A sense of closure marks the last collaborations that Mrs. Grosman arranged. For many years Tatiana Liberman, the Russian-born wife of the artist and editor Alexander Liberman,

had made their apartment a salon and refuge for visiting Russian artists. Mrs. Grosman was invited to meet Andrei Voznesensky at the Libermans' on October 28, 1977. Within the next few weeks, she realized a lingering ambition to work again in the language of her youth. Two books resulted from that meeting: the Liberman/Voznesensky *Nostalgia for the Present* and the Voznesensky/Rauschenberg series beginning with *Darkness Mother Darkness Mother.*

Just after 7:30 on the evening of June 17, 1982, Mrs. Grosman attended a reception at the Museum of Modern Art in honor of her

seventy-eighth birthday (according to the Russian calendar) and in celebration of twenty-five years' work. Dressed in long, black satin and an elegant fur, leaning on the arm of her successor, Bill Goldston, she paused at the entrance while the assembly greeted her with smiles and applause. Curator Riva Castleman, who had succeeded William S. Lieberman, hung a small exhibition of ULAE prints in galleries wrung from the museum's reconstruction. On the following Sunday, Grace Glueck wrote in the *New York Times*: "In the print world, the name of Tatyana Grosman is virtually sacred. So revered are the contributions to printmaking made by this devoted Russian born *animateur*…that no less than two museums and a number of private galleries, both here and in Europe, are currently mounting exhibitions in tribute to the 25th anniversary of Universal Limited Art Editions."[44]

Long before she died on July 24, 1982, Mrs. Grosman realized her uniquely creative role in the establishment of printmaking as a major art in our time. There were other places, such as Margaret Lowengrund's Contemporaries Gallery in New York and June Wayne's Tamarind Workshop in Los Angeles, where contemporary graphic artists found missionary fervor and skilled technology. But history cast its shadow over Tatyana Grosman, shaping her decisions through a sense of predestination and stretching her sensibilities toward the future. For her there was a magic in the meeting of artist and the lithographic stone, not only because of her almost superstitious feeling about the stone itself but also because of its capacity to receive, reveal, and disseminate creativity. "It was at ULAE," concluded Calvin Tomkins's obituary, "that printmaking lost its stigma as craft—as minor art—and became a legitimate form for the highest aesthetic ambitions."[45] These ambitions would have come to nothing if she had not known another magic: to have chosen stars instead of comets from the firmament of young talent. She seemed seduc-

tive and patient to some, obdurate and glacier-slow to others. But whatever reserves of cajolery and tenacity were needed to kindle creative fires, she had them.

Given her love of words, it is fitting that a poet should speak last. These are the thoughts of Edwin Schlossberg, written for her memorial service on October 14, 1982:

> *To be human you recognize other people. To be supremely human you recognize the deep and creative parts of other people and talk to that rather than to the superficial wool of daily life. Tatyana was supremely human and she talked with and to the deepest parts of us, especially those of us who were lucky enough to have had a creative conversation with her.*
>
> *Tatyana seemed to reach and recognize exactly the you that you always wanted someone to know—to respect it —to nourish it—to give it full range to be what it was and could be. Not only did her touch make it possible for beautiful and complex things to happen at the studio, it made the rest of one's life and work more rich. Tatyana was in love with the people with whom she worked.*
>
> *There are many kinds of inspiration in the world—some which inspire you to improve in comparison with others— some which seemingly make you feel good. Tatyana was genuinely inspiring in more ways than most people I have met. She did not draw that attention to herself—she listened and was with you. She was not an idea, she was intensely human and she created a context where human feelings could be exchanged. The objects that were created were and will remain beautiful as signposts.*
>
> *She used to say to me, "Listen and care, darling. Come, sit down, tell me what you are doing."*

Notes:

1. Tatyana Grosman's desire to make artist's books was inspired in part by Monroe Wheeler's *Modern Painters and Sculptors As Illustrators*, a catalogue for a 1936 exhibition at the Museum of Modern Art, New York (T. Grosman, letter to Wheeler, December 19, 1966).
2. Cummings, T. Grosman interview, 1970.
3. T. Grosman, letter to Max Weber, June 24, 1956.
4. Sparks, Goldston interview, 1983.
5. Sparks, Lieberman interview, 1985.
6. Hempstead, Long Island, 1970.
7. Cummings, T. Grosman interview, 1970; Sparks, Goldston interview, 1985.
8. Rivers, 1982, p. 102.
9. Eastman, letter to de Kooning, March 24, 1967 (cc: Tatyana Grosman).
10. Myers, 1981, p. 146.
11. Guest and Friedman, 1962, unpaged.
12. Sparks, Johns interview, 1985.
13. Ibid.
14. Sparks, Blackburn interview, 1985.
15. Burrows, 1961, unpaged.
16. Lynes, 1963, p. 61.
17. Gray, 1963, p. 124.
18. Schuyler, 1962, p. 18. The article was a good turn that Mrs. Grosman never forgot. On January 13, 1972, she wrote to compliment Hess on a current issue and reminded him that Schuyler wrote "the first article about our venture."
19. New York, MOMA, 1964.
20. Cummings, T. Grosman interview, 1970.
21. Ibid.
22. Woodward, 1967, unpaged.
23. Stamos's poster read: "West Side Artists, New York / Sep 27 - Nov 3 / Riverside Museum, New York." Emanuel Edelman proofed the stones, and an edition of 930 (on 80 lb Mohawk Superfine paper), plus 125 on Fabriano paper for the signed edition, were printed by Murphy. Only one other List poster was printed, although not published, by ULAE: Jim Dine's *Creation* (Mikro, 1970, no. 33).
24. Sparks, Goldston interview, 1985.
25. T. Grosman, letter to Jack Kaplan (Greenbaum, Wolff and Ernst & Co.), May 25, 1965.
26. Gray, 1965, p. 83.
27. Jones, 1978, p. 13.
28. Sparks, Priede interview, 1985.
29. McKendry showed her the Rembrandts that converted her to etching, perhaps as early as 1964. In 1967 he showed her the mezzotints that were being assembled for the exhibition "Mezzotints from the Metropolitan Museum of Art."
30. Sparks, Singer interview, 1985.
31. Powers, letter to Sparks, October 15, 1985.
32. New York, Metropolitan Museum, October 1969; and New York, Metropolitan Museum, December 1969. The two exhibitions were then combined for an exhibition shown in eight museums.
33. Tony Towle's diary for February 8, 1969, notes a sale to a couple who said they would pay the first of *next* year. There were many similar instances.

34. Sparks, Rauschenberg interview, 1985.
35. Cummings, T. Grosman interview, 1970.
36. T. Grosman, letter to Armand and Celeste Bartos, August 23, 1972.
37. New York, Whitney, 1971.
38. Stevens, 1971, p. 14.
39. Hempstead, Long Island, 1972.
40. Toronto, York University, 1973; Toronto, Art Gallery of Ontario, 1979.
41. New York, MOMA, 1974. The other panelists were Lloyd Goodrich, Una Johnson, Jacob Kainen, Sylvan Cole, Robert Motherwell, and William S. Lieberman.
42. There was one exception: one of the three panels of Johns's *Scent*, 1975-76 (cat. no. 116).
43. Wallach, 1975, p. 11.
44. Glueck, 1982, p. H19.
45. Tomkins, 1982, p. 83.

The Artists

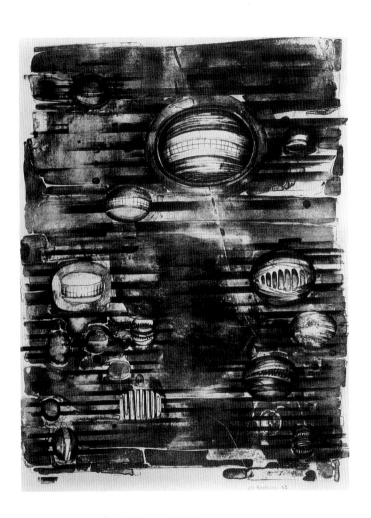

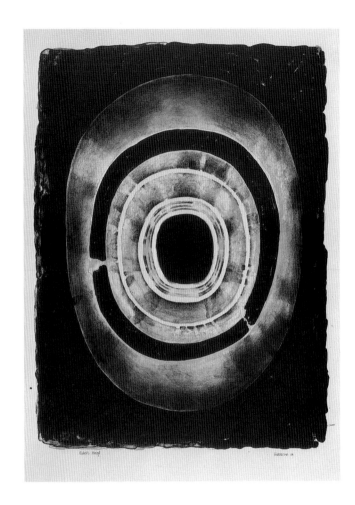

1. Lee Bontecou, *Fourth Stone*, 1963. See cat. no. 4. Bontecou's "dark manner," which prevailed in her sculpture throughout the 1960s, found monumental expression in *Fourth Stone*, as do the saw blades, grills, and other menacing-looking machine parts Bontecou found on the streets of lower Manhattan. The horizontal bands, or "cell bars" of this "prison," take their physical character from the lithographic tusche, which Bontecou used here for the first time.

2. Lee Bontecou, *Fifth Stone*, 1964. See cat. no. 5. *Fifth Stone* is the first statement of an image that was to dominate Bontecou's prints in the mid-1960s: an ovoid whose fissured and modulated bands advance and recede according to an inner logic. The ovoids can be seen as details of the projecting parts of Bontecou's sculptures, as printed versions of her related soot drawings, or as a repeated figure whose constancy sensitizes the viewer to changes in color, texture, and space.

Lee Bontecou

(American, b. Providence,
Rhode Island, 1931)

It was at Leo Castelli's New York gallery that
Mrs. Grosman first saw Lee Bontecou's sculp-
ture and drawings. In 1962, when she invited
Bontecou to make lithographs, Mrs. Grosman
spoke about how "interesting" it would be for
Bontecou to draw on stone. Bontecou liked
drawing very much; she felt (as did so many
who studied the Nicolaides method at the Art
Students' League in the 1950s) that drawing
was exploration rather than reportage and that
anatomy and perspective were old-fashioned
pedagogy. In 1957-58, Bontecou was on a
Guggenheim Fellowship in Rome, where she
was attracted by the "inartistic" objects she
found in the streets and in machinery. She
began to make sculpture with an extraordinary
range of materials: bronze, terra cotta, wire, old
clothes, wood scraps, plaster, anything at all.
And she drew—steadily, purposefully, addic-
tively.

 Bontecou's earliest cast sculpture was
quite unconventional. She started by making
an armature (usually in the shape of an ani-
mal), then created a "skin" by attaching small
plates of bronze or terracotta. By 1960, she had
abandoned the rigid plates, as well as any rep-
resentational intention. The armature itself
had become her "subject," filled with an
assemblage of cloth, metal, found objects, or
subsidiary structures that created cavities
emphasizing the blackness within.

 A number of elements in Bontecou's
sculpture were receptive to graphic translation.
First, though often massive in aspect, the
sculptures were actually a concatenation of
small-scale surfaces. Bontecou did not create
surface by carving or molding mass; rather, she
wired interstitial pieces to an armature and col-
ored them with a painter's eye for nuance. Sec-
ond, the absence of color in black-and-white
lithography was immaterial to her purposes.
(Color did not become an important factor in
her work until the late 1960s.) Third, the
greater part of her three-dimensional work was
designed to hang on the wall, to confront the

3. Lee Bontecou, *Fifth Stone, Sixth Stone,*
1967-68. See cat. nos. 11-20. *Fifth Stone,
Sixth Stone* began in 1965 with three
lithographs later published as *Seventh,
Eighth,* and *Ninth Stone* (cat. nos. 12-14). It
became a tripartite collaboration: a text in
honor of lithography written by Tony Towle
to accompany a suite of six intaglio plates
by Bontecou, done under the guidance of
Donn Steward, ULAE's first master printer
in the etching shop. As a sculptor in metal,
Bontecou was immediately drawn to the
copperplates. After many luxurious
experiments in paper, metal, and cloth,
Bontecou chose a cover of the same muslin
she used in her drawings and sculpture.

4. Lee Bontecou, *Pirates*, 1979-82. See cat.
no. 31. In this lithograph, Bontecou worked
for the first time in offset lithography and
in a collage method of partial images
rather than with a singly conceived
composition. The ultimate realization of
the image depended on a sensitive
collaboration with the printer. Because the
offset lithographer James V. Smith
contributed so much to this print, the most
complex Bontecou had yet attempted, she
invited him to title the image despite the
fact that in general she avoided titles,
preferring not to direct the viewer with a
particular suggestion.

viewer at eye level. And finally, lithography, like drawing and poetry, was "done with a pencil."[1]

In 1962, after making a persuasive telephone call, the Grosmans brought several stones to Bontecou's loft in New York. Confronting the stone was for her, as for most ULAE artists, a moment of creative retreat. Even though Mrs. Grosman described the stone to Bontecou as simply a finer way to draw, Bontecou's first lithograph reveals her timidity. *First Stone* (cat. no. 1) is no more than a diary of ideas for sculpture, an episodic cluster of fragments that draw the eye in restless eddies over the page. Like Jackson Pollock's all-over compositions, it implies that this is but a random section of something larger. *Second Stone* (cat. no. 2) is somewhat more assured. By the time she started *Third Stone* (cat. no. 3), Bontecou was ready to commit a finished composition to the stone and to execute it with an assurance that encouraged her to undertake new challenges.

Fourth Stone (cat. no. 4) required stones too large to be brought to Manhattan. Bontecou came to West Islip in 1964 to learn about painting with tusche and the more complex levels of conceptualization required for multistone prints. She used two stones for *Fourth Stone* and *Fifth Stone* (cat. no. 5), trying color for the first time in *Fifth Stone*. In the triad of *Sixth Stone* prints (cat. nos. 6-8), Bontecou used four and five colors and added colored paper and cloth to her repertory of printing materials. In 1965 she started several stones as "illustrations" for a text by Tony Towle. These were postponed because of an even more ambitious undertaking, the *livre de luxe Fifth Stone, Sixth Stone* (cat. nos. 11-20), and published as single prints in 1968 (cat. nos. 21-23).

In 1967 Bontecou returned to West Islip to try ULAE's new etching press. She was immediately captivated by the copperplate. The etching line looked rich to her; the aquatint grain seemed to have the tensility and dimensionality of metal. Bontecou completed six plates for the book *Fifth Stone, Sixth Stone*, a softground plate for the book cover, the superb *Etching One* (cat. no. 9), and *Untitled Etching* (cat. no. 10), commissioned by the List Art Foundation to commemorate the opening of the National Collection of Fine Arts in Washington, D.C.

Working in a new medium, Bontecou felt supremely fortunate to be "guided by the indispensable artistry and skill" of ULAE's Master Printer Donn Steward.[2] Her technique was straightforward. She was interested in the image and not, unlike other artists touched by the 1960s' passion for technology, intrigued by odd tools and methods. She started with a sketch on tracing paper, then reddened the back of the paper with crayon and traced a few lines onto the copperplate. Steward pulled a proof or two, which she would strengthen once or twice. She would usually hand-color one proof to indicate the strength of the aquatint for each area, and after relatively few adjustments, the plate was ready to edition.

Instinctively, Bontecou applied to etching the same skeleton-and-skin approach she had transferred from sculpture to lithography five years earlier. In lithography, she created the skeleton with crayon and painted the tonal sections primarily in tusche. In etching, she drew the skeleton with an etching needle and filled the interstices with various granulations of aquatint. She could accommodate small lithographic stones and large offset plates in her own studio. Large stones, tusche stones, and all intaglio plates were done in the Long Island workshop.

Bontecou's method was cautious. All of the prints using more than one stone exhibit many small changes distributed throughout the surface. Furthermore, successive states show that, with rare and unimportant exceptions, these incremental adjustments were her method of strengthening and fine-tuning: compositions were changed by addition, not by subtraction or major revision.

In 1965 Bontecou's sculpture began to move into a lighter and more open mode. *Eighth* and *Ninth Stone* are closely connected to those pieces that dominated her show at the Castelli Gallery in 1966.[3] These edgeless and billowing forms were particularly appropriate expressions of Bontecou's enthusiasm for Sputnik and the promise of extraterrestrial flight. The black cavities in her earlier sculptures had been "endless"[4]; in the black centers of *Seventh*, *Eighth*, and *Ninth Stone* (cat. nos. 21-23), a planet gleams. However, her confidence in the men and the meaning of space exploration soon collapsed. The robotized flower of *Tenth Stone* (cat. no. 24) is a symbol of her disenchantment. *Untitled Etching* (cat. no. 10), from 1967, was the first image in her new style to be published. Its delicate, spiky forms signal her new stylistic direction of the late 1960s and beyond.

In the late 1970s, Bontecou returned to ULAE to undertake a new series of lithographs. For the first time, drawings and prints had become her primary media. Illusion has been conveyed in a vocabulary of layers and tints. Some of the images are purely abstract, such as *Pirates* (cat. no. 31); others, such as *Study for an Untitled Print* (cat. no. 32), are clearly derived from natural phenomena. Yet, they still traverse the fantastic, drawn as they are from reserves of dream and delight.

Notes:

1. Towle, 1971, p. 25.
2. Field, *Johns Prints 1960-70*, p. 27.
3. Ashton, 1967, pp. 41-43.
4. Sparks, Bontecou interview, 1985.

Opposite:
5. Mary Callery, *Sons of Morning*, 1955-56. See cat. no. 2. Margaret Lowengrund, Mrs. Grosman, and June Wayne are considered the three pioneers of the American graphic revival of the 1950s and 1960s. Although it is presumed that Mrs. Grosman knew of the publications and exhibitions at Lowengrund's Contemporaries Gallery in New York, no communication between them has come to light. *Sons of Morning*, however, provides a link. An undated exhibition catalogue, *TODAY—Exhibition of Sculpture and Graphic Art*, from the Contemporaries Gallery, lists Callery's *Sons of Morning*.

Mary Callery

(American, New York
1903-1977 Paris)

From 1930 until the outbreak of World War II, Mary Callery lived in Paris, working as a sculptor and assembling a notable collection of art by Picasso, Matisse, Duchamp, and other artists she knew as personal friends. She was also a dealer, in an informal way, and was responsible for introducing a number of Americans to the pleasures of collecting contemporary art. After returning to America in 1940, she worked primarily in New York and spent several summers in a Long Island house that belonged to Mr. and Mrs. Armand Bartos. In New York as in Paris, Callery's circle included many expatriates. Among them was the distinguished dealer/publisher Curt Valentin, who introduced the artist to Tatyana and Maurice Grosman. In 1944, the year that the Grosmans fled before the Nazi invasion of Paris, Callery had an exhibition of her sculpture at Valentin's Buchholz Gallery in New York.

Callery proved to be a valuable friend to the Grosmans. She introduced them to Fritz and Lucie Glarner (who later lived in the Callery/Bartos house) and to William S. Lieberman, who, as curator of prints at the Museum of Modern Art, arranged for the Bartos Fund, which for many years enabled the museum to purchase ULAE prints. When the Grosmans started to publish screenprints, Callery asked the dealer Klaus Perls to lend the Grosmans a drawing by Picasso so that Maurice Grosman could reproduce it.

With Lieberman's advice to bolster her courage, Mrs. Grosman changed the focus of the screenprint business from reproduction to the publication of original designs. Although there is no record of who might have declined, it is most likely that Mary Callery was the first artist who was asked to contribute original work for the Grosmans' new enterprise. By the end of March 1955, Callery and Mrs. Grosman were settling the final details of Callery's first screenprint, *Sons of Morning* (cat. no. 2). The second drawing, for *Variations on a Theme of "Callery-Léger"* (cat. no. 1), was ready by the end of the year—even before Douglass Howell had finished creating a "corn-colored" paper for *Sons of Morning*.[1] The "corn color" was either not produced or not used, and Callery made her final drawing for *Callery-Léger* on a Howell sheet of warm gray. Mrs. Grosman was so pleased with the "Callery gray" that she used it for the studio's first printed labels.

Callery's last screenprint, *Tara* (cat. no. 3), was not released until 1959, several years after ULAE had forsaken screenprinting for lithography. In the interim, Maurice Grosman printed several greeting cards for Callery (not listed in this catalogue). Although she later removed both screenprints and Limited Art Editions prints from her official list of publications, Mrs. Grosman continued to promote Callery's prints until at least 1960.

Note:

1. Callery, letter to T. Grosman, February 27, 1956.

6. Jim Dine, *Brush After Eating*, 1963. See
cat. no. 11.

Jim Dine

(American, b. Cincinnati, Ohio, 1935)

Jim Dine knew in grade school he was destined to be an artist. He received formal training at the Cincinnati Art Academy, the Boston Museum School, the University of Cincinnati, and the University of Ohio, from which he received a Master of Fine Arts degree in 1958. Dine first became aware of lithography through Gustave von Groschwitz, then curator of graphic arts at the Cincinnati Art Museum. He worked for von Groschwitz in the summer of 1954, matting and packing prints for that year's biennial exhibition of color lithographs. At the University of Ohio, he began to draw and paint in a figurative and expressionist style. The strictures of the classroom, both academic and stylistic, were barriers he wished to demolish. He scavenged art magazines from the library, avid for the latest from New York. From 1956 to 1958, he went to New York once a month to see the work of his idols—de Kooning, Pollock, and Kline—as well as that of the young avant-garde—Johns, Rauschenberg, and Rivers. The poetry of Ashbery and Koch, the art criticism of O'Hara, the published lectures of Cage, and the pioneer Happenings of Kaprow were all familiar to Dine long before he actually met the principals.

In 1958 Dine and his wife, Nancy, left Ohio to live in New York. For the first few years, they managed on teaching jobs, but the important hours Dine spent painting and becoming part of the tumultuous New York art world. The period from 1958 to 1962 was one of vigorous exploration and winnowing through which Dine the painter and Dine the printmaker were molded. At first, he became part of a circle around Allan Kaprow. Dine heartily embraced Kaprow's advocacy of an art that "intended to replace habit with the spirit of exploration and experiment," not simply for shock value but to preserve "those qualities of personal dignity and freedom always championed in the West."[1] Kaprow's precepts in the end were bound to be subversive to any ortho-

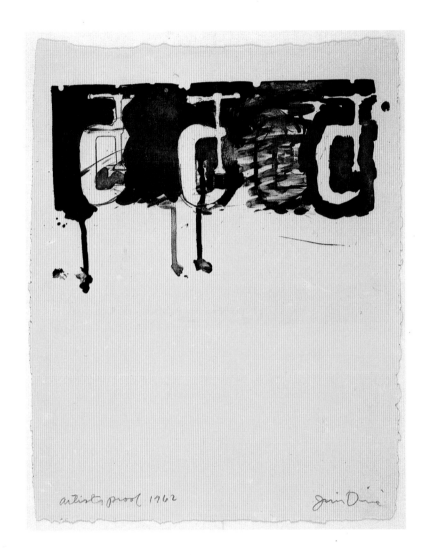

7. Jim Dine, *Four C-Clamps*, 1962. See cat. no. 2. *Four C-Clamps* is a modest variation on several large combine-paintings of 1962 in which actual tools are attached to the top of a canvas that is mostly bare with only small patches and flecks of paint.

8. Jim Dine, *Cut and Snip*, 1962-63. See cat. no. 7.

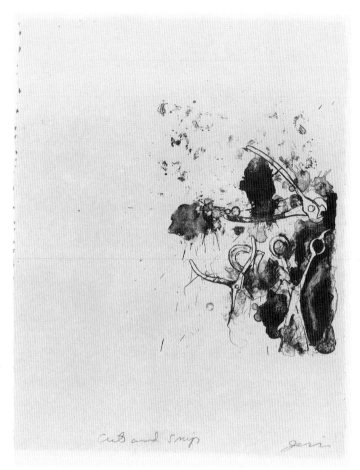

doxy, including his own. Finally breaking from his mentor, Dine asserted the traditional and humanistic basis for his own art. In a spirit utterly inimical to Kaprow's prescriptions, Dine converted his own Happening, *Car Crash*, into art objects: a painting and a suite of six lithographs (Mikro, 1970, nos. 1-6).

Rapidly, Dine became known as a talent, intellect, and personality to be reckoned with. By 1962 he had acquired a prominent dealer, Martha Jackson, had been represented in three

solo and a dozen group exhibitions (including ones in Milan and London), and could say farewell to the classroom. He was included in a special issue of *Life* magazine (September 14, 1962), subtitled "One Hundred of the Most Important Young Men and Women in the United States, 'The Take-Over Generation.'" Although success was heady, he was dismayed to find himself labeled "the Prince of Pop Art." Dine believed that the differences between himself and the canonical Pop artists

(among them Warhol, Lichtenstein, Rosenquist, Wesselman) were more significant than their similarities. Although Pop Art offered a cornucopia of liberating ideas, as a visual style, it was thin soup for Dine. And, more emphatically, Dine separated from Pop Art on humanistic grounds: He could not adopt an amoral attitude toward subject matter nor could he exclude private feeling from his art.

One summer day in 1962, Jasper Johns took Dine to the workshop in West Islip. In John Russell's words, "There was an immediate marriage of minds between Dine and Madame Grosman, with her intransigent feeling of quality, her readiness to experiment, and her total dedication both to the notion of the print, in itself, and to the particular gifts of the person who is making a print with her at any given time."[2]

The first print, *Pliers* (cat. no. 1), was a technically simple introduction: one stone printed in black on a standard white sheet. For the second, however, Dine dipped into Mrs. Grosman's stock of special papers. In *Four C-Clamps* (cat. no. 2), the tools seem to hang against the painterly background he favored in his canvases. "Working with Tanya Grosman at Universal Limited Art Editions has been the catalyst for everything," Dine told Tony Towle. "She made me aware of paper."[3]

In the lithographs he did during his first year at ULAE, Dine printed what he painted: tools and bathrooms. Like Rauschenberg, Dine was then making combine-paintings in which objects were attached to a canvas covered with vigorous Abstract Expressionist brushwork. His tools have been interpreted in many ways. On the most elementary level, they are nostalgic evocations of his family's hardware store, Dine's first aesthetic inspiration. They also carry symbolic freight as metaphors of masculine vigor, as object-disguises for specific people, and, finally, as stand-ins for the artist himself.

The next series, *Toothbrushes #1* through *#4* (cat. nos. 3-6), focuses on one element of an important group of combine-paintings then in progress. The paintings range in size from the seminal *Small Shower* (Morton G. Neumann Family Collection, Chicago) to the magisterial *Four Rooms* (Collection of the artist). Unlike the solemn *Four C-Clamps*, in the lithographs the toothbrushes are not presented face-front. Instead, expressing the lighthearted side of Dine's nature, they are scattered across the sheet as if by untidy children, awry amidst a splatter of ink, water, and "toothpaste."

Hardware was soon replaced by the tools of the painter's trade: brushes (the most erotic of his repertory) and the palette. From 1962 to 1964, Dine painted, drew, and printed an autobiographical exegesis by means of transformations of the palette. Perhaps the most contentious version is the painting *Two Palettes in Black with Stovepipe (The Dream)* (Private collection, Stockholm), in which two palettes and a black canvas are connected by an "el" of metal stovepipe. In contrast to the aggressive stance of the Stockholm piece, the ULAE lithograph *Flesh Palette in a Landscape* (cat. no. 14) uses a palette to salute the traditional pleasures of *plein-air* painting. When Dine took the background stone of *Flesh Palette* and used it alone for his next print, *Night Palette* (cat. no. 15), he made another, stronger historical connection, this time to Abstract Expressionism.[4]

With the bathrobes he began to paint in 1963, Dine found his next self-portrait image. Clothes had always interested him as much as tools. In 1959, his "debut" year in New York, Dine painted *Green Suit* (Collection of the artist), a work as autobiographical as Rauschenberg's *Quilt* of 1955 (Collection of Leo Castelli, New York).

Dine's first etchings were a series of images of ties done in 1961 with the Dutch printmaker Nono Reinhold. In 1965 Dine finished *Eleven Part Self Portrait (Red Pony)* (cat. no. 13), his largest print to date. Unlike the

9. Jim Dine, *Eleven Part Self Portrait (Red Pony)*, 1964-65. See cat. no. 13. Dine's first bathrobe painting was inspired by a clothing advertisement. The robe became the artist's most enduring and monumental image of self and self-examination. This first print of the bathrobe series was begun by Dine in his East Hampton house in the summer of 1964. The numbers that create its lighthearted, diagrammatic quality have no real meaning, and the subtitle "Red Pony" was an afterthought added because the washes reminded Dine of the coat of a dappled pony.

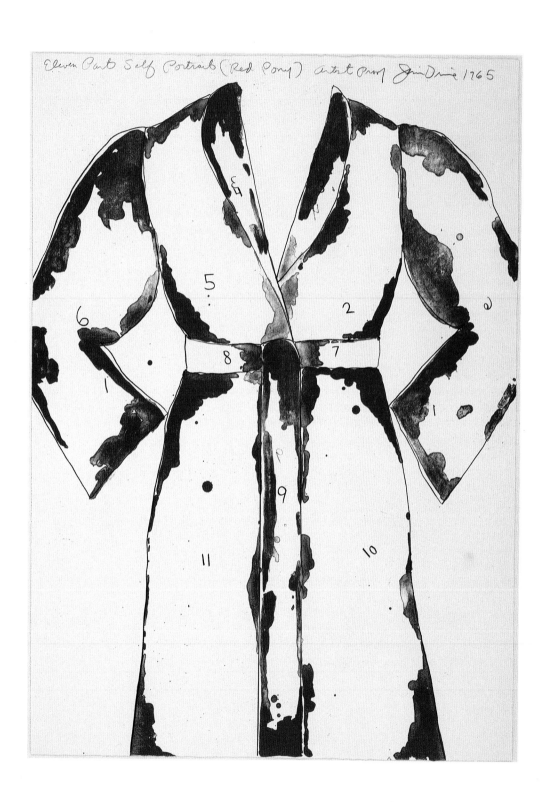

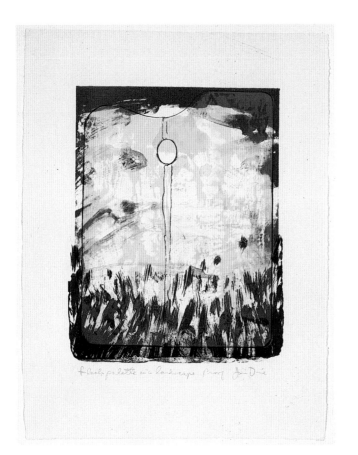

Left:
10. Jim Dine, *Flesh Palette in a Landscape*, 1964-65. See cat. no. 14. Although the primary image here is still that of the palette, this print marks the introduction of landscape as a motif to Dine's work.

Below:
11. Jim Dine, *Double Apple Palette with Gingham*, 1965. See cat. no. 16. Many of the objects Dine depicted in ULAE prints came from the Grosmans' kitchen and workshop. This unabashedly domestic print hung for many years above the table where the Grosmans and their guests enjoyed tea. After this edition was finished, Dine took home one of the impressions, added paint and collage, and then presented it to the Grosmans as a token of his affection.

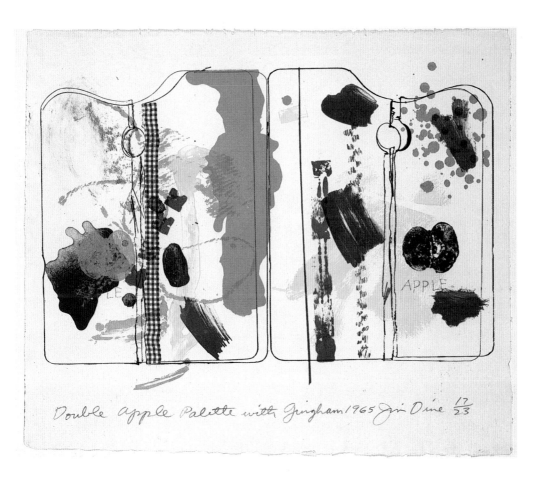

subject of *Green Suit*, the robe was not his own but was taken from an advertisement he saw in the *New York Times*. The robe became his autobiographical stand-in for more than a decade.

Both *Eleven Part Self Portrait* and *Boot Silhouettes* (cat. no. 17) continue the Pop tradition of depicting everyday objects. But there is a new twist—a confrontational, even ceremonial, personalism. Some thirteen years later, Dine described the change, saying that he wanted to "upgrade the content of the subject matter and instead of dealing with the obscure metaphor for the human figure...to deal with the human."[5]

In 1966, feeling disaffected with the art world in New York, Dine accepted an invitation from Paul Cornwall-Jones to make prints at Petersburg Press in London. During the next three years, he finished no paintings, devoting himself instead to making prints and to writing. He published some poetry (e.g., *Welcome Home Lovebirds*, London: Trigram Press, 1969), but the impulse soon faded. His long-term commitment to literature took another course: making prints for joint projects with friends who were poets, such as John Ashbery, Ron Padgett, Tim Berrigan, and David Shapiro.

All three "literary" works Dine did at ULAE were, as it happened, different sorts of collaboration. Dine suggested a collaboration to his friend the poet Kenneth Koch. They went to West Islip and, as Koch watched Dine draw on the stones, he wrote the line, "O scarf of paradise Blue sky is bread to the scarf," which was printed across the top in Cooper Black, a favorite typeface of the 1960s (cat. no. 20).

Midsummer Wall (cat. no. 19) came from a theatrical project. Dine had been invited to design sets and costumes for Shakespeare's *Midsummer Night's Dream*, to be produced by the San Francisco Actors' Workshop in 1966. Between Dine and the producer, John

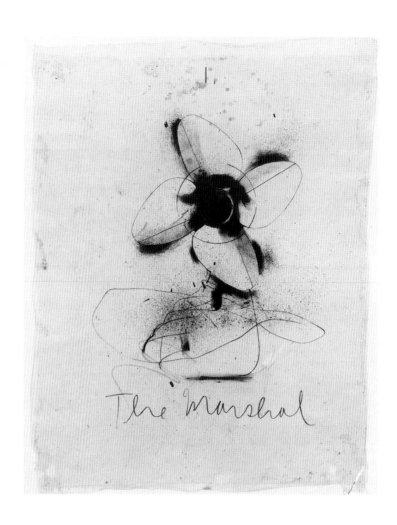

12. Jim Dine, *Flaubert Favorites, Edition A: The Marshal*, 1972. See cat. no. 23.

Hancock, the play was completely redesigned
with modern dress and iconography. The litho-
graph shows many of the motifs Dine pre-
scribed for the sets: the rainbow, heart, moon,
and stars that hung against a black vinyl back-
drop at the back of the stage. (Later, he
reworked these motifs into a host of other
works.) *Midsummer Wall* contains an assort-
ment of images: some from the San Francisco
set, a salad fork from the kitchen in West Islip,
and a comically elongated hammer that resem-
bles sculptures Dine was to exhibit in New
York at the Janis Gallery in November 1966.

Although Mrs. Grosman was never suc-
cessful in persuading Dine to collaborate on a
portfolio, in *Flaubert Favorites* (cat. nos. 23-
30), he did pay homage to a French writer he
had long admired. Here, had he wished to find
it, was an opportunity to put his superb drafts-
manship to the service of narrative. But Dine's
narrative has never taken novelistic form.
Instead, the brush, wrenches, fan, and bananas
are Dada titles, named by free association from
his memories of Flaubert's *Education senti-
mentale.*[6] According to David Shapiro, Dine
was "never an obscurantist, but always
delighted in puzzles and puns of the most seri-
ous and contradictory variety."[7]

By the mid-1970s, bathrobes became *the*
Dine image, a new form of self-portrait. In the
summer of 1964, Dine worked intensively on
bathrobe paintings for exhibition in the fall.
West Islip was a short drive from his East
Hampton studio; a print was almost inevitable.
A ULAE lithograph (cat. no. 13) was his first
bathrobe print, as well as the first appearance
in his work of numbers as a decorative motif.

By 1975, with a few exceptions such as
Flaubert Favorites, Dine had decided to aban-
don the metaphor—the tools, hearts, and bath-
robes—and confront the figure directly. Even
in this new phase of his work, printmaking con-
tinued to be his favorite medium for experi-
mentation. It was, he said, "the only medium
in which, up until just recently, I felt free

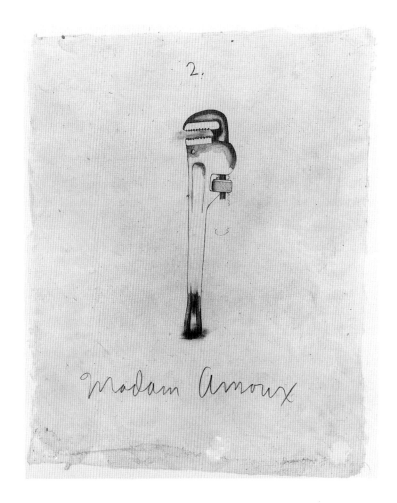

13. Jim Dine, *Flaubert Favorites, Edition
A: Madam Arnoux*, 1972. See cat. no. 24.

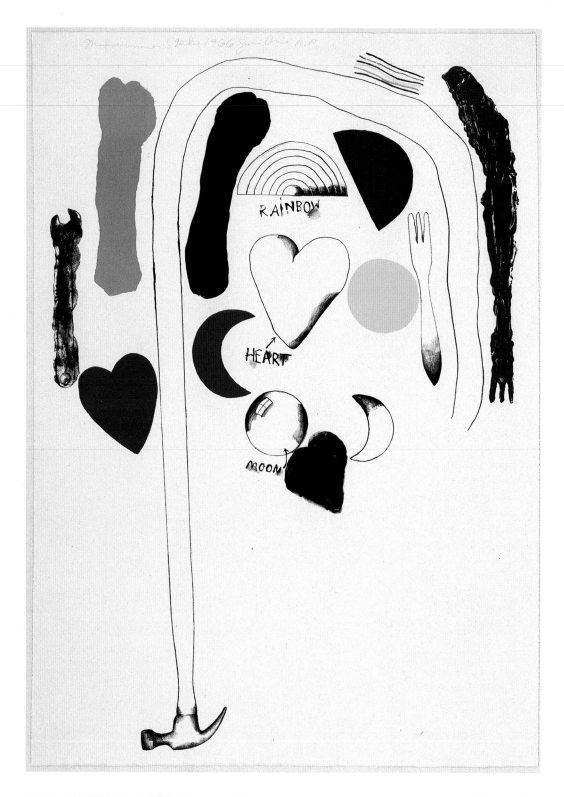

14. Jim Dine, *Midsummer Wall* or
Midsummer Study, 1966. See cat. no. 19.

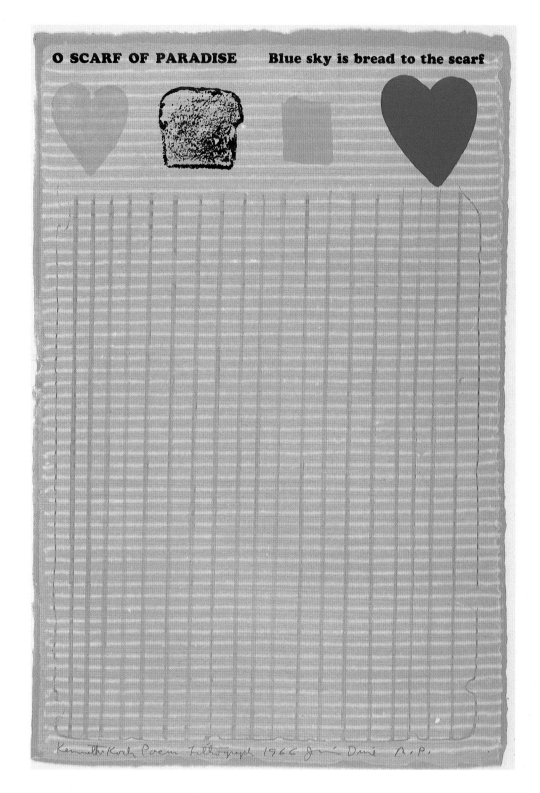

15. Jim Dine, *Kenneth Koch Poem
Lithograph*, 1966. See cat. no. 20. This
print has been called (Mikro) a collabora-
tion between an artist, a poet, and a
particularly challenging piece of beautiful
paper. Ribbed blue tissue was laminated
horizontally to a slightly grayer foundation
sheet, thus establishing a "lined paper"
suitable for text as well as pictures.

16. Jim Dine, *The Big Black and White Woodcut Tree*, 1981. See cat. no. 35.

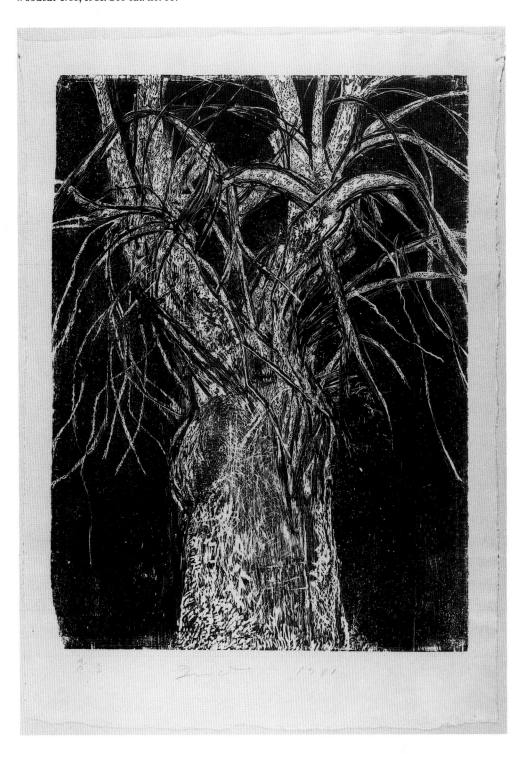

17. Jim Dine, *The Jerusalem Plant #2*,
1982. See cat. no. 37.

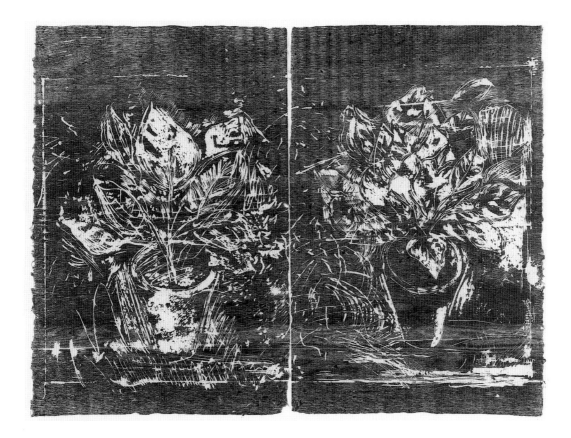

enough to be figurative when the pressure was
still on to make those field paintings with the
tools hung on them."[8]

 A Hand-Painted Self-Portrait of 1975 (cat.
no. 32) was a new technical phenomenon for
ULAE. Combining monotype and drypoint,
applying color by hand, and "sealing" it with
overprinting, Dine proceeded in the same lay-
ering sequence he has subsequently used in all
media. The plate was cut down, printed in
white on black paper and titled *Self-Portrait as
a Negative* (cat. no. 33), and then printed in
black on gray paper as *Positive Self-Portrait,
State 2* (cat. no. 34). A long series of trial proofs
(The Art Institute of Chicago) elaborates the
delicate and difficult problem of printing this
spectral image.

 There have been three parallel lines of
development in Dine's work since the bathrobe
paintings of the mid-1960s: figuration, an
increasingly expressionist painterliness, and a
growing technical complexity. His work at
ULAE in 1981 and 1982 shows the coalescence
of Dine the draftsman, painter, and print-
maker. Like Picasso, Dine has always enjoyed
playing the *enfant terrible* in the printshop,
foraging for unorthodox tools, learning time-
honored techniques only to contravene them.
For *The Big Black and White Woodcut Tree*
(cat. no. 35), he took an old drafting-table top,
drew on it with ink and crayon, and cut the
drawing into his "block" with an electric Dre-
mel grinding tool.

 For the lithograph *The Jerusalem Plant*

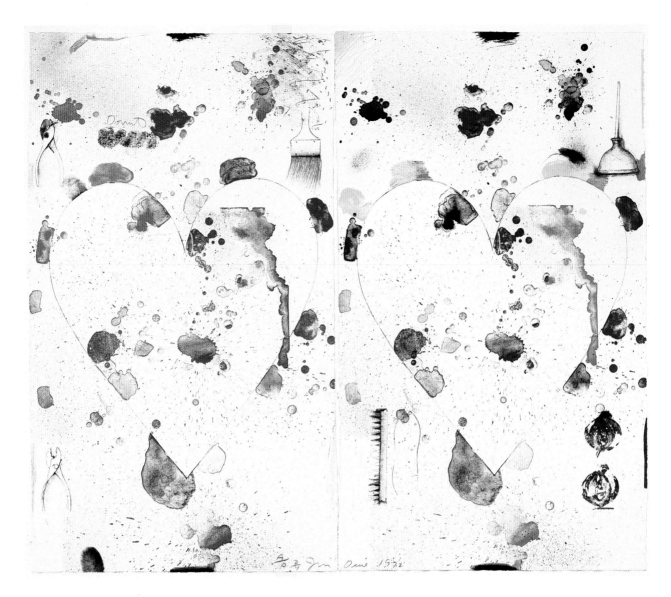

18. Jim Dine, *2 Hearts (The Donut)*, 1970-
72. See cat. no. 31. *2 Hearts (The Donut)*
was printed on two of the biggest sheets
Dine—or ULAE—had ever used. After
many proofs and even more changes, Dine
was still unsatisfied. One morning he found
what he ''needed'': one of Maurice
Grosman's bakery crullers, which Dine
dipped into lithographic ink to imprint
''The Donut'' on the stone.

#1 (cat. no. 36), Dine started with Bill Goldston's photograph of a drawing Dine made in Jerusalem in 1980. Goldston transferred it to the stone, and Dine reworked the image with the Dremel as freely as if the tool were a brush or crayon. He began again with the same drawing for *The Jerusalem Plant* woodcuts (cat. nos. 37, 38). Bill Goldston made a photosilkscreen of the drawing, transferred that to the woodblock, and Dine set upon it with the Dremel. These woodcuts, like *The Woodcut Tree*, are painterly works, far different from Dine's *Woodcut Bathrobe* of 1975 (Williamstown, 1977, 198) and from the mainstream of woodcutting started by Helen Frankenthaler's *East and Beyond* (Frankenthaler, cat. no. 25). In method and spirit, they are closer to Dine's own drawings than to the woodcuts of his contemporaries.

When Dine first came to work at ULAE, he was delighted to join artists such as Johns and Rauschenberg in forging a new meaning of the word "print." Mrs. Grosman's lavish attention to his artistic needs and Maurice's friendship and stimulation stood in marked contrast to both the spirit and practice of other presses Dine knew. ULAE did not provide, however, the artist-and-printer collaboration he subsequently found in other workshops, a collaboration that became increasingly important to him. In 1975 Dine decided to publish his own work; he has since made only a few prints at ULAE, and these have been printed by Bill Goldston, who has always provided successful solutions to Dine's ever-changing needs.

Notes:

1. Kaprow, 1966, p. 208.
2. Quoted in Mikro, 1970, unpag.
3. Quoted in ibid., unpag.
4. See Swenson, 1963, p. 25.
5. Robinson and Shapiro, 1976, p. 103.
6. Sparks, Dine interview, 1985.
7. Shapiro, 1981, p. 16.
8. Williamstown, 1977, p. 32.

19. Jim Dine, *A Hand-Painted Self-Portrait*, 1975. See cat. no. 32. While teaching at Dartmouth College in 1974, Dine made a series of self-portrait etchings that evolved from a single plate. Up to this point, Dine had approached his printing matrix as a draftsman; he treated *A Hand-Painted Self-Portrait* as if it were a painting. Dine printed the drawing as though it were a sketch, nearly obliterating it with great slashes of color, printing the plate again to seal the color, and then adding unique finishing touches to each impression.

20. Sam Francis, *Five Stone Untitled*,
1959-68. See cat. no. 3.

Sam Francis

(American, b. San Mateo, California, 1923)

When Tatyana Grosman introduced Sam Francis to lithography in 1959, he had just returned to New York after having lived abroad for almost a decade. He was renting a studio from Larry Rivers, where he was working on a large mural for the Chase Manhattan Bank at 55th Street and Park Avenue. It was a particularly productive period for him, the crest of a decade of increasing maturity and success. It was also, in retrospect, an odd moment in the heretofore unhurried evolution of his style. The three lithographs he made at ULAE in 1959 are, for several reasons, of interest in understanding Francis's career: as examples of a brief stylistic episode; as the introduction to a new way of layering color in paintings as well as in prints; and, finally, as the incunabula of a medium that became a permanent and important part of his life as an artist.

In 1950 Francis graduated from the University of California, where he studied under the eminent California painter David Park and had become aware of a wide range of abstract painting as it was then practiced in Europe and America. In three years (1947-50), Francis developed his own style, combining Arshile Gorky's late Cubist space with veils of color that drew equally from the works of Barnett Newman and Clyfford Still. The obvious next step for Francis, as for many ambitious young artists, was to move to New York.

Instead, Francis chose Paris, immersing himself for five years in its literary and social life but painting as if he were alone with its history and its light. He particularly admired the great French colorists of the past. He knew prominent young painters (Mathieu, Riopelle, van Velde), but only an enhanced palpability of the surfaces of his paintings revealed their influence. He was one of the few Americans of his generation whose work was seen by Europeans.

In 1956 Arnold Rüdlinger, director of the Kunsthalle in Basel, invited Francis to paint an enormous mural to be hung on three adjoining walls of the museum stairwell. Although this commission was ultimately not realized,[1] it led to a thirty-eight-foot mural, commissioned by Sofu Teshigahara, for the Sogetsu School of Flower Arrangement in Tokyo. The mural commission for Chase Manhattan followed in 1958, and Francis returned to New York.

Francis met Tatyana Grosman through Martha Jackson, whose gallery was one of the important showcases for new art in the 1950s. It took several months to persuade him to try printmaking. He said later that lithography "was, to me, a commercial process—and I didn't care about crafts."[2] In those days, the Grosmans' press was still in their living room, and they were in the habit of taking stones—at least, the first ones—to the artists' studios. It seems fitting that Francis was working in the studio of Larry Rivers, who had been the first artist to work at ULAE in lithography. The stone captivated Francis immediately.[3] It was, indeed, the mysterious surface that the persuasive publisher had promised: at once rough and smooth, luxurious and primordial, inert and inanimate, a rocky terrain for the preparation of transparent veils of ink. To his surprise and delight, lithography was replete with the oppositions and appositions that attracted him to Oriental philosophy.

The compositions Francis executed on ULAE's stones differ from both his paintings on canvas and his drawings of the same period. This was as much a matter of size and orientation as it was the physical nature of matrix and tool. He was accustomed to working standing up, to creating forms, spatters, and cloudlike images on the same vertical plane as his own. But stones are small, they rest on a table, and they have massive edges. Whereas Francis's paintings seem like slices of a vast universe, the compositions on his first three stones seem wary of their borders. Lines of flung and spattered ink serve to connect the principal forms. The first two prints relate compositionally to the small gouaches on paper that Francis

made during this stay in New York from late 1958 until early 1960: the gestures are atypically large in relation to the surface area and the lines of spatter play a distinctly minor role. Only in the last print, *Five Stone Untitled* (cat. no. 3), do the lines transgress the broad collar of white margin. The individual elements of the prints are closely related to forms the artist used in the Chase Manhattan mural, but they have been arranged to respect the territory of the paper.

When Francis had finished, the Grosmans brought the stones back to West Islip for Robert Blackburn to proof. Francis was in no hurry to release the prints. Mrs. Grosman called Blackburn to work only when she could pay him immediately, and so the editioning was postponed from week to week. When Francis left for Europe in early 1960, the Grosmans and he had not yet decided how the color stones would be used.

Francis became ill and spent many months in Switzerland, recuperating under the watchful eye of his friend Eberhard Kornfeld. Kornfeld, owner of a prominent international auction house, listened to Francis's enthusiastic account of the lithographic stones and arranged for him to work in the Zurich workshop of printer Emil Matthieu. By the time he left Switzerland in 1961, Francis was a committed printmaker. At this writing, he has printed in several lithographic workshops, including Tamarind Workshop, Joseph Press, and Gemini G.E.L., contributed to Walasse Ting's *1¢ Life* (published in 1963 by Kornfeld), and made a portfolio for the benefit of the Art Alliance of the Pasadena Art Museum. In 1970 he established his own press, The Lithoshop, in Santa Monica, California.

In 1967 Francis met Mrs. Grosman at an opening in New York and was surprised to hear that she still had the stones he had done eight years before. She urged him to come and finish them. According to Fred Genis, ULAE's master printer for lithography at the time, the stones were well preserved and there were no difficulties in opening them again and printing them.[4] Francis was confident that they could reconstruct his original plans, using bright colors in the graduated densities typical of his work in the late 1950s and early 1960s. From the beginning, Francis had realized—even though he had seen only black-and-white proofs—that lithography could provide opaque as well as transparent color and, further, that underlayers could be seen through successive layers of ink, if desired. He used this discovery at Matthieu's workshop and in all of his subsequent graphics.

When the three prints were ready to be signed and released, there was a small problem. Francis told Mrs. Grosman and Tony Towle that he wanted to title the blue and green one "First Stone" but had already given this title to the first lithograph he published in Matthieu's workshop. Towle suggested, only half in earnest, that he call it *Very First Stone*. Mrs. Grosman thought the title was not serious enough, but Francis liked it and so it was settled.[5]

Mrs. Grosman's approach to lithography stayed with Francis. Both believed in the mystery of the stone but entrusted the mysteries of technique to printers. As Francis has said: "I like to wash the stone, but I don't know what lithography really is, but perhaps from the stone I may find out who I am and what I am for."[6]

Notes:

1. The Kunsthalle did not purchase the triptych. The right panel was destroyed; the center panel was purchased by the Stedelijk Museum in Amsterdam; and the left panel was given by the artist to the Pasadena Art Museum, now the Norton Simon Museum of Art.
2. Selz, 1982, p. 249.
3. Sparks, Francis interview, 1985.
4. Sparks, Genis interview, 1985.
5. Sparks, Towle interviews and correspondence, 1982-85.
6. New York, Alexander, 1979, unpaged.

21. Sam Francis, *Four Stone Untitled*,
1959-68. See cat. no. 2.

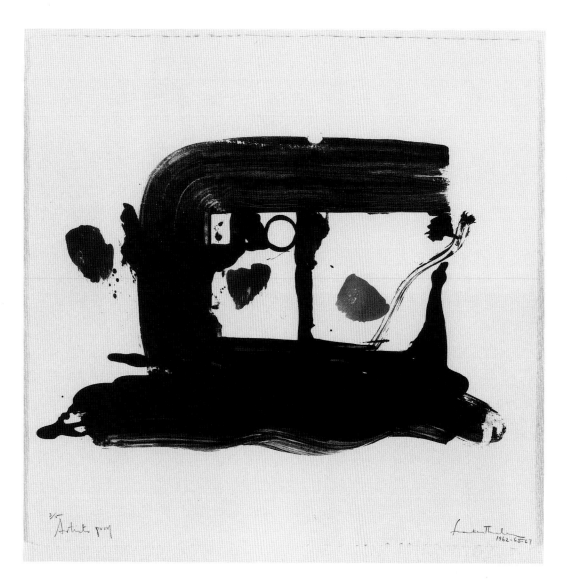

22. Helen Frankenthaler, *Post Card for*
James Schuyler, 1962-65-67. See cat. no. 8.

Helen Frankenthaler

(American, b. New York, 1928)

Helen Frankenthaler was, by nature and nurture, blessed at birth. She had intelligence, charm, and the advantages of a cultured and affluent background. Her family was delighted to encourage such a visibly gifted child. At the Dalton School, she was a favorite of the school's art instructor, Rufino Tamayo. In spring 1946, she enrolled at Bennington College and began to study with painter Paul Feeley. Whereas Tamayo had taught Frankenthaler how to stretch canvas and mix colors, Feeley shaped her way of thinking about painting. An evangelical Cubist, he led his students in an inch-by-inch analysis of the reproductions he brought to class, dissecting the devices artists used to create illusion on canvas. Frankenthaler thought long and hard about what she saw and decided to banish all representation of natural objects from her work.

Bennington offered a program that encouraged independent students like Frankenthaler and exposed them to distinguished professors such as Feeley and W. H. Auden. Writer Sonya Rudikoff, a close friend of Frankenthaler's at Bennington and later in New York, described the advantages of such proximity. The school taught, she said, "a certain way of regarding, initiating us into the life of art, the response to life within art....It was the response to feelings and articulating the response."[1]

There were other valuable teachers and mentors during these formative years: Vaclav Vytlacil at the Art Students' League in 1947, the Australian painter Wallace Harrison in 1948, the painters James and Charlotte Brooks, and, in the summer of 1950, Hans Hofmann in Provincetown. Eugene C. Goossen had been a family friend for many years. He taught at Hunter College and the City University of New York, wrote for the art journals, and curated exhibitions at the Whitney Museum of American Art and the Museum of Modern Art in New York. (In 1969 he would organize

Frankenthaler's retrospective exhibition at the Whitney Museum.)

In the spring of 1950, Frankenthaler met critic Clement Greenberg, one of the central figures of the New York avant-garde. Greenberg's circle of friends included artists Larry Rivers, Alfred Leslie, and Grace Hartigan, as well as poets Frank O'Hara, Kenneth Koch, and John Ashbery (names later familiar at ULAE).

The year 1951 marked the end of Frankenthaler's apprenticeship. Adolph Gottlieb had chosen her work for "Fifteen Unknowns," a notable exhibition at the Kootz Gallery in December 1950. The year 1951 brought more decisive exhibitions. The first was Frankenthaler's own debut as a professional at the Tibor de Nagy Gallery; the second was an exhibition of Jackson Pollock's new paintings at the Betty Parsons Gallery. Pollock was a revelation to Frankenthaler for he was a painter to whom painting was, as Frankenthaler described, a totality: "choreography, symphony, use of the mind, history, analysis, shoulders, censoring, the unknown, control, surprise, puzzlement, then the judging of the result on its own or by comparison."[2] Pollock also synthesized the best of Surrealism for her: the unconscious and accidental as well as the physical components of painting; the freedom from narrative as well as from representation; and, above all, the liberation of the scale of the image from the boundaries of the canvas itself.

In the summer of 1952, Frankenthaler went to Nova Scotia and Cape Breton. The landscape sketches she made were very free and exciting and spurred her to experiment further. Back in her New York studio, she laid a piece of unprimed cotton duck on the floor and poured paint directly on the cloth. She had worked with very thin paint before; she used it now to create an oil painting as translucent as her Nova Scotia watercolors. The painting made on that October day, *Mountains and Sea* (on loan from the artist to the National

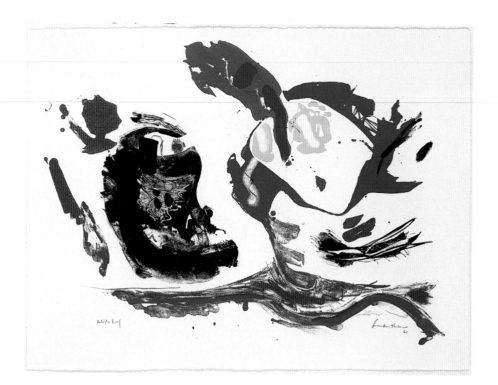

23. Helen Frankenthaler, *First Stone*, 1961. See cat. no. 1. *First Stone* and *May 26, Backwards* (cat. no. 2) conferred a new honor on the ULAE workshop: Frankenthaler's dealer, André Emmerich, lent the lithographs in 1966 to a modest program of contemporary exhibitions in the White House.

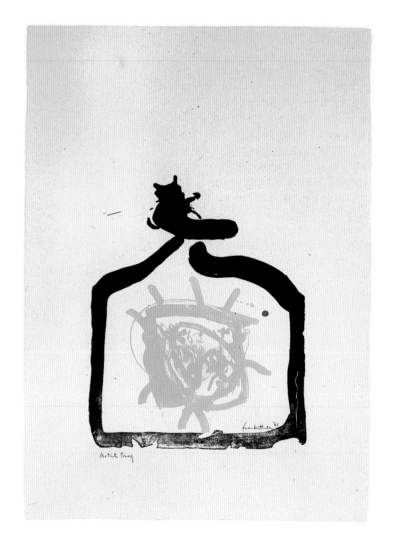

24. Helen Frankenthaler, *May 26, Backwards*, 1961. See cat. no. 2. According to Frankenthaler, the framelike shape of *May 26, Backwards* was a way to establish "a boundary and a limit" on the unfamiliar stone surface (Williamstown, 1980, p. 68). In retrospect, it also heralded Frankenthaler's compositions of the 1960s: whether centripetal or centrifugal, they were always organized with reference to their edges. This enframing motif also signaled that Jackson Pollock's arbitrary slice-of-infinity style had been replaced by Frankenthaler's own notions of pictorial space.

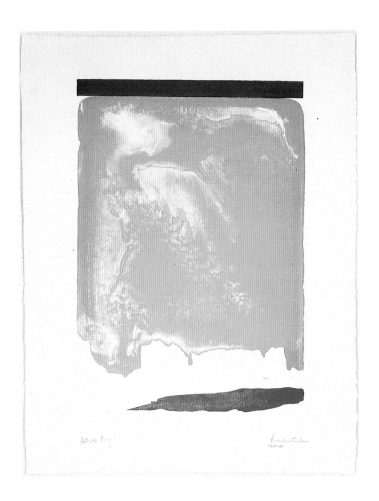

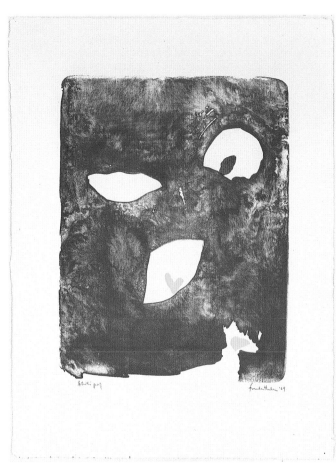

25. Helen Frankenthaler, *Solarium*, 1964.
See cat. no. 5.

26. Helen Frankenthaler, *Persian Garden*,
1965-66. See cat. no. 7.

Gallery of Art, Washington, D.C.), "became historical almost immediately."[3] *Mountains and Sea* was an Abstract Expressionist union of image and ground, of the touch of the artist's hand and the report of its movement. In the "soak-stain" technique Frankenthaler invented for *Mountains and Sea*, she joined the action of the painter to the blandishments of color.

At the outset of her career, Frankenthaler became a catalyst for others. According to Morris Louis, "She was a bridge between Pollock and what was possible."[4] Louis and Kenneth Noland, isolated in Washington, D.C., from the mainstream of Abstract Expressionism, came to New York hoping to meet Pollock. Had that been possible, painting in Washington might have taken a different course. In early April 1953, Greenberg brought them to Frankenthaler's studio to see the flurry of paintings that followed *Mountains and Sea*. They were inspired to find new ways to use paint and color. The Washington painters' experience was the most dramatic, but Jules Olitski and many others were also influenced by Frankenthaler to lesser degrees.

In May 1960, Mrs. Grosman wrote to Frankenthaler, inviting her to work at ULAE. At the end of June, the studio was preparing stones for her.[5] But it was not until February 1961 that she could say, "I am very excited and happy that next week you start to work on stones. I know your work will be very refreshing and very beautiful."[6]

The continual postponements are revealing. Mrs. Grosman was persistent, and her invitations were seconded by Larry Rivers and Grace Hartigan, who had already started to work at ULAE. But Frankenthaler considered herself a painter; for her the creation of art called for a union of mind and body, emotion and gesture, image and ground, process and goal. In printmaking, that trancelike immersion is broken at a hundred points. To Frankenthaler it seemed the process might

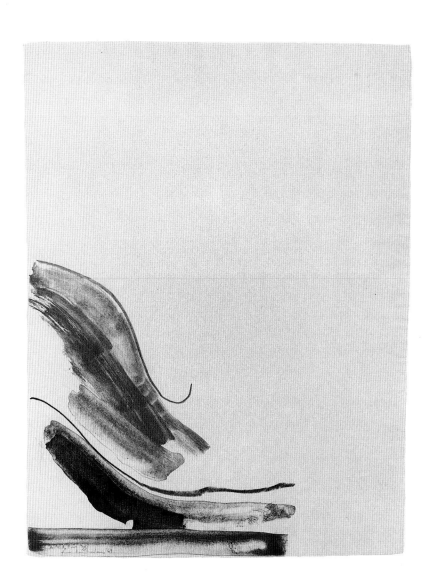

27. Helen Frankenthaler, *Southwest Blues*, 1969. See cat. no. 12.

imperil the spontaneity that was the essence of the long solitary hours she spent in her studio.

There was also the problem of scale. The huge canvases with which Frankenthaler and her generation dismayed a conservative public dwarfed even the largest stones that Mrs. Grosman could provide. Scale was also a matter of physical orientation. However, Frankenthaler had not only made small paintings, but she had been working above her large paintings for more than a decade. She was able to transfer her body involvement in the act of painting to the stones, using fingers-to-arm instead of larger, whole-body gestures. She attacked the problem of scale in her prints with the same virtuosity that brought her to the forefront of abstract painting.

On only one occasion at ULAE did Frankenthaler create a lithograph on the scale of a large painting. In 1968 Mrs. Grosman had all but completed arrangements with the Corcoran Gallery of Art in Washington, D.C., for a retrospective exhibition of ULAE prints. She asked Frankenthaler and several other artists to do unprecedentedly large prints appropriate for the occasion and for the tall, bright galleries of the museum's grand old building. Frankenthaler seized this opportunity to treat the print as a painting, utilizing the painting methods she had used for almost twenty years. As always, the artist's need was law at ULAE: For *Lot's Wife* (cat. no. 20), three large stones were muscled to the floor and laid side by side. Frankenthaler drew, painted, sloshed buckets of water on them, and the work was finished with lightning speed.

The second major difficulty, that of collaboration, Frankenthaler treated with a characteristic show of independence. In every medium she has undertaken, she has been an extraordinarily apt student. Frankenthaler's printers soon learned to take a far more passive role than they did with other artists. She often resisted Mrs. Grosman's suggestions regarding paper. She insisted on mixing her

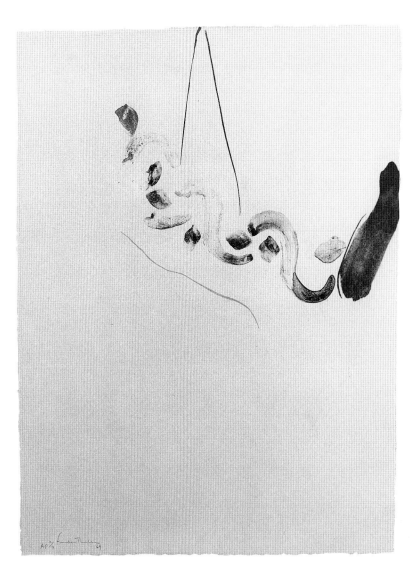

28. Helen Frankenthaler, *Venice I*, 1969. See cat. no. 16.

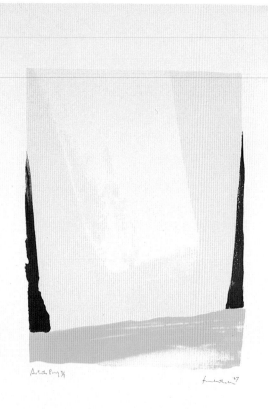

29. Helen Frankenthaler, *White Portal*, 1967. See cat. no. 9.

30. Helen Frankenthaler, *Yellow Span*, 1968. See cat. no. 10.

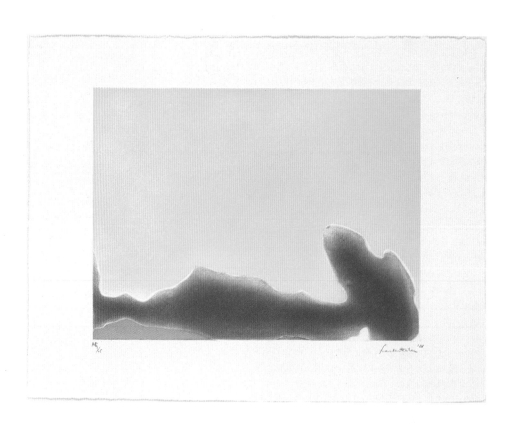

31. Helen Frankenthaler, *Lilac Arbor*, 1970.
See cat. no. 19.

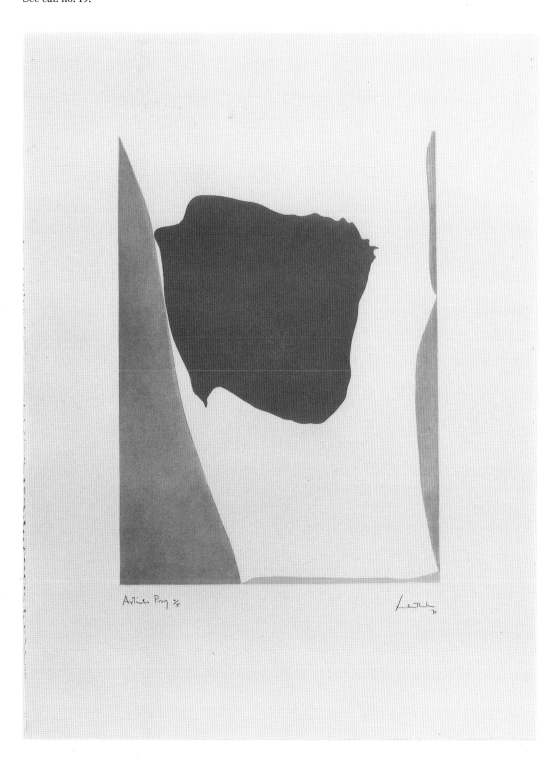

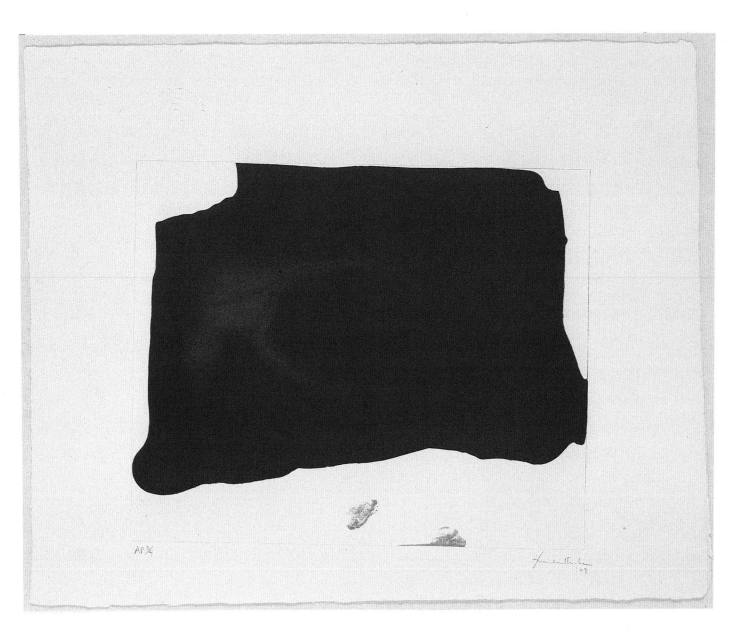

AP ¾

32. Helen Frankenthaler, *Variation II on Mauve Corner*, 1969. See cat. no. 14.

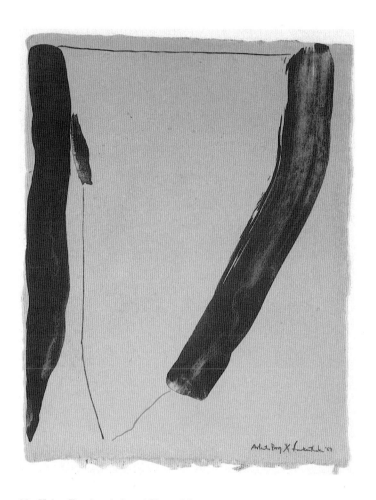

33. Helen Frankenthaler, *A Slice of the Stone Itself*, 1969. See cat. no. 15.

34. Helen Frankenthaler, *Weather Vane*, 1969-70. See cat. no. 18.

own inks. She was definitely not intimidated by the stone. Frankenthaler "poured, sponged, and painted onto limestone slabs and if an image displeased her, she left it and moved on, discarding stones like typing paper until she got it right. In early prints, Frankenthaler was not particularly involved in the proofing process."[7]

Her corrections in the margins of the trial proofs are unequivocal: "So try—but NO schmaltz pliz," "sour yellow out." More than any other artist who worked at ULAE, Frankenthaler sought to preserve the spontaneous, even impulsive, nature of her paintings. She reconsidered and reworked elements as well as complete compositions that she had previously set aside and which she then approved for publication. She rejected *Silent Curtain* (cat. no. 11), for example, in 1967 but allowed it to be released in 1969. Early proofs of *East and Beyond* (1973; cat. no. 25) were embellished with a small oval of paint and released as *East and Beyond with Orange* (1973-74; cat. no. 28); *Vineyard Storm* (1974-76; cat. no. 30) is essentially an incomplete version of *Savage Breeze* (1974; cat. no. 29).

From the beginning, Mrs. Grosman urged Frankenthaler to collaborate with a poet and produce the kind of book for which ULAE had been founded. Frankenthaler had been reading and writing poetry since she was in school. Her interest in words is revealed in the way she develops titles for her work, writing them down as they occur to her and creating a "reserve" to apply when appropriate. She numbered poets among her friends. Although illustration per se seemed a secondary sort of thing to do, she kept looking for the right text or poet. In the summer of 1962, when she was in Alassio, Italy, she and poet James Schuyler, who admired her work, had carried on a postcard correspondence. He sent cards with verses that Frankenthaler painted on and returned. She sent Italian cards that she painted on, and he added poetry and sent them back. In 1962

Mrs. Grosman persuaded Frankenthaler and Schuyler to plan a collaborative portfolio. Only one print, *Post Card for James Schuyler* (cat. no. 8), done with fingers, bottlecaps, scraping, and brushing, was executed. This was more in the nature of a memento of friendship than a direct collaboration.

Whenever she tried a new medium at ULAE—lithography in 1961, intaglio in 1968, and woodcut in 1973—Frankenthaler enjoyed a period of what she often called "productive clumsiness." Seven years after her first lithograph (cat. no. 1), she was persuaded by Mrs. Grosman to try etching in Donn Steward's new etching shop downstairs. Accustomed to painting in large, athletic gestures on yards of canvas, she resisted. Steward's shop "was like a little hospital pit," Frankenthaler recalled, "[with] every brush in order, everything immaculate, in place."[8] She thought beforehand that the stiff needle and the resistance of the metal would impede the freedom of her wrist. But Steward's mastery of aquatint provided the bridge. Frankenthaler could paint on the plate and, like other Abstract Expressionists, take advantage of accidents. The medium of intaglio soon became as fluid for her as watercolor.

After the gratifying experiences with lithography and intaglio, Frankenthaler responded eagerly when Mrs. Grosman suggested that she try making a woodcut. She had always admired Japanese prints and was intrigued by the possibility of transforming their basic principles of pattern and color into the language of abstract imagery. Of all her adventures into new media, woodcut was the most difficult. The jigsaw was the first problem: it can only "draw" by moving forward. The paper she liked had to be laminated, and still it stretched so badly in the press that almost half of the edition was rejected. For several months, attempts were made to keep the ink from soaking into the paper, which was finally achieved by underprinting with white. Frankenthaler

35. Helen Frankenthaler, *Crete*, 1969-72.
See cat. no. 22.

36. Helen Frankenthaler, *Lot's Wife*, 1970-71. See cat. no. 20.

37. Helen Frankenthaler, *Free Wheeling*, 1971. See cat. no. 21.

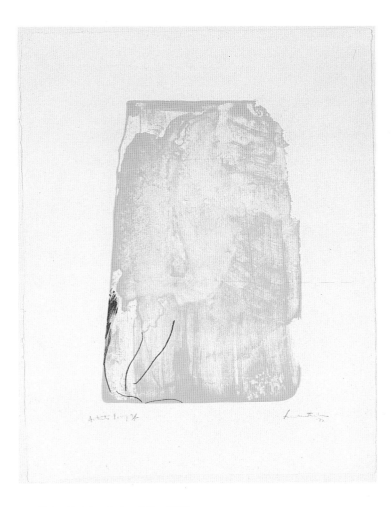

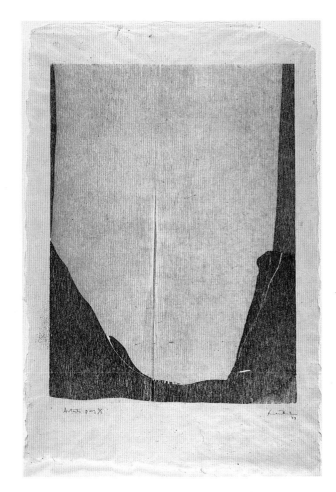

38. Helen Frankenthaler, *I Need Yellow*,
1973. See cat. no. 24.

39. Helen Frankenthaler, *East and Beyond*,
1972-73. See cat. no. 25. Frankenthaler's
East and Beyond is recognized as "the first
of the new breed of woodcut…a departure
so profound that virtually all subsequent
woodcuts incorporated the thinking it
embodied" (Field, 1982, p. 2). It was
printed in one intense and arduous five-
hour session. Unlike good printing paper,
which will stretch and absorb consistently
throughout the sheet, the Nepalese toilet
paper that had been chosen could scarcely
survive one pass through the printing press.
Finally, the tissue was doubled so that the
irregularities of fiber and edge became
active components of the woodcut.

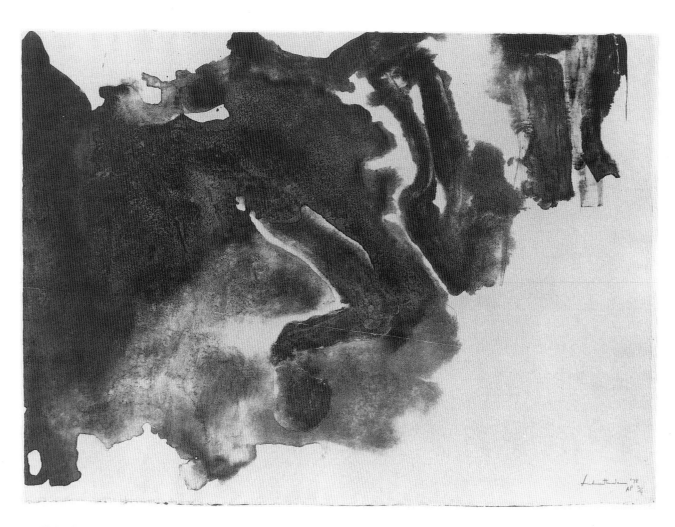

40. Helen Frankenthaler, *Altitudes*, 1976-
78. See cat. no. 33.

told Judith Goldman, "I think at any other workshop, they might have thought it's impossible to do what the artist doesn't yet know she wants to do. But they were very patient and, therefore, I found a solution."[9]

The stylistic changes of her ULAE lithographs provide a capsule retrospective of Frankenthaler's work. In the early 1960s, when she made her first lithographs, the percentage of unpainted or uncolored area in her pictures is at its maximum. The forms are relatively simple and sensuous, the paint often unmodulated, and the paintings often suggestive of landscape. *Sky Frame* (cat. no. 4) and *Orange Hoop* (cat. no. 6), closely related to her paintings of the mid-1960s in which the frame is the dominant compositional feature, have been seen as framed landscapes, although Frankenthaler demurs. While a few such images do include the word "landscape" in the title, primarily they are concerned with the problem of space, simultaneously intelligible and nonmaterial, within a defined boundary. Beginning with early static paintings such as *Buddha's Court* (1964; Collection of Mr. and Mrs. Donald Straus, New York) and lithographs such as *Persian Garden* (cat. no. 7), her images migrated outward, encompassing the whole surface. *Solarium* (cat. no. 5) is an early example of the color-flooded images that became increasingly frequent in her work in the next decade, dominating it thereafter. In the late 1960s, with compositions such as *White Portal* (cat. no. 9), the edges themselves take precedence over a central, silent space. These radical compositions have been interpreted as manifestations of Minimalism, which predominated in the 1960s.[10] They also feature the highly saturated color that influenced other artists in the 1950s. *Silent Curtain* (1967-69; cat. no. 11) and *Weather Vane* (1969-70; cat. no. 18) are stylistic companions of the "minimal" paintings Frankenthaler exhibited at the André Emmerich Gallery in the 1960s.

Emphatic line reappeared in the litho-

graphs *Southwest Blues* (cat. no. 12) and *Venice I* (cat. no. 16) in 1969, as well as in her painting at this time. In *Bronze Smoke* (cat. no. 32), *Altitudes* (cat. no. 33), and *Door* (cat. no. 34), minimal compositions were replaced by fields of drifting, multilayered color, as rich and satisfying as her work on a much grander scale.

It had been a superb fifteen-year collaboration. Time after time, Frankenthaler had achieved, in her own words, an artist's ideal: "a beautiful graphic that 'bleeds' his sensibility—his feeling, magic, head, heart—within the felt embrace of a sensitive workshop."[11] Of Mrs. Grosman, Frankenthaler said: "I always felt her silent help and advice...she was climate in herself."[12]

Notes:

1. Sweeney, 1980, p. B5.
2. Jacksonville, 1978.
3. New York, Whitney, 1969, p. 10.
4. Fried, 1971, p. 13.
5. T. Grosman, letter to Frankenthaler, June 24, 1960.
6. T. Grosman, letter to Frankenthaler, February 23, 1961.
7. New York, Whitney, 1981, p. 85.
8. Sparks, Frankenthaler interview, 1983.
9. Goldman, 1975, p. 31.
10. Jacksonville, 1978.
11. Sweeney, 1980, p. B22.
12. Sparks, Frankenthaler interview, 1983.

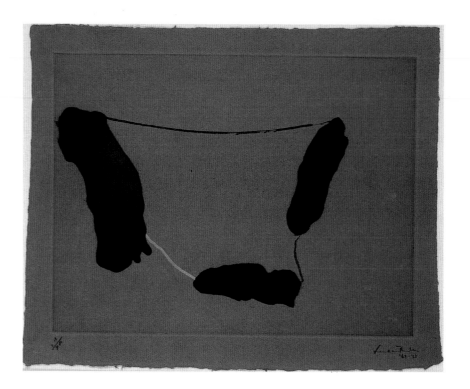

41. Helen Frankenthaler, *Connected by Joy*, 1969-73. See cat. no. 26.

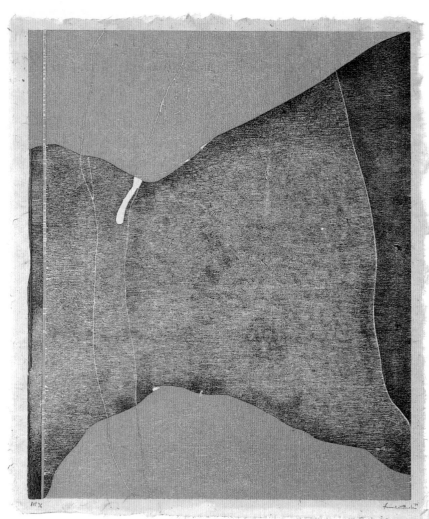

42. Helen Frankenthaler, *Savage Breeze*, 1974. See cat. no. 29.

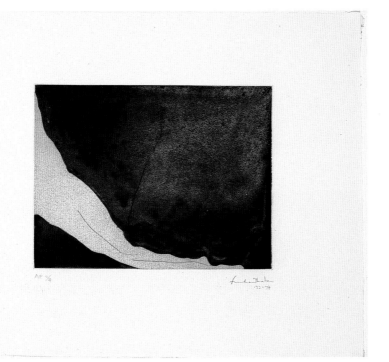

43. Helen Frankenthaler, *Message from Degas*, 1972-74. See cat. no. 31.

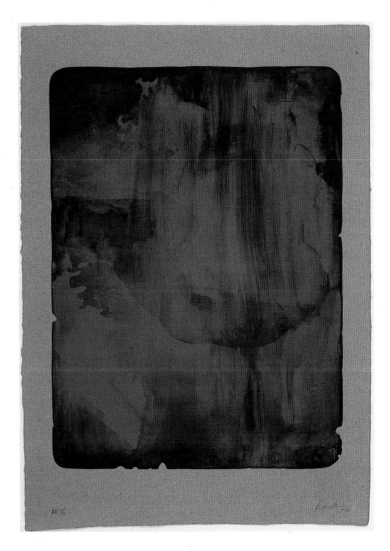

44. Helen Frankenthaler, *Bronze Smoke*, 1978. See cat. no. 32.

45. R. Buckminster Fuller, installation
photograph of *Tetrascroll*, 1975-77, at
Ronald Feldman Fine Arts, Inc., New York.
Courtesy Fendrick Gallery, Washington,
D. C. See cat. nos. 1-26.

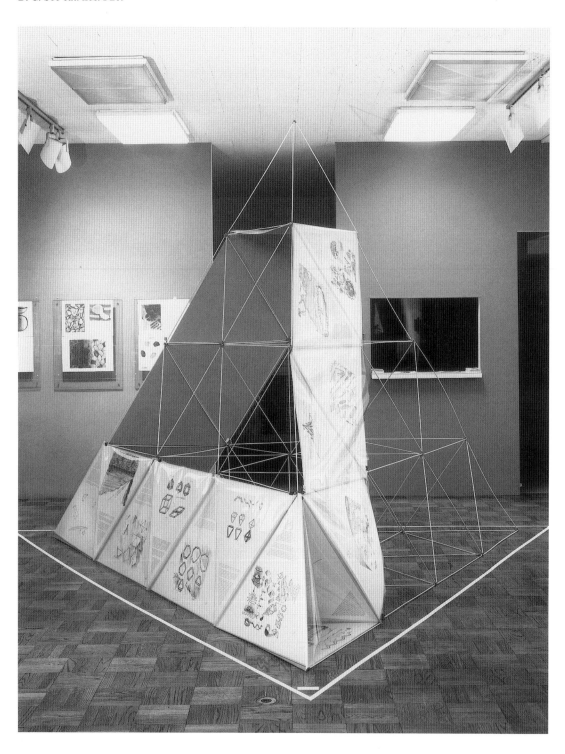

R. Buckminster Fuller

(American, Milton,
Massachusetts 1895-1983
Los Angeles)

On February 25, 1975, R. Buckminster Fuller —engineer, designer, architect, mathematician, poet, author, cosmologist, seer—went to West Islip to have tea with Tatyana Grosman. In temperament, background, interests, and style, they were worlds apart. Yet, before an hour had passed, each had cast a spell upon the other. Fuller knew little about contemporary art and nothing of Mrs. Grosman except what he had heard from their mutual friends Edwin Schlossberg, John Cage, and Jasper Johns. Schlossberg, who knew Fuller from the time when Schlossberg was studying physics, served as chauffeur and interpreter that day.

Fuller came from what he called "the mothball aristocracy" of New England. The intransigent independence, certainty in decision, and inherited obligation to use one's gifts for righteous aims—these and other Yankee traditions assumed a unique and legendary conformation in Richard Buckminster Fuller. He was sent to Harvard (routine for Fullers since 1760) but was expelled twice, once for spending his tuition money on a party for the Ziegfeld Follies cast and then for "lack of sustained interest" in his studies.

Learning to sail as a boy, Fuller picked up physics and geometry from the wind and canvas. He determined that the word "inventor" did not mean "dreamer" but someone who solved the problem at hand. Some fifty years later, he declared the sailor to be the primal father (Adam, who makes Eve out of the ribs of a ship), primal architect (modeling roofs after the same ribs), and primal hero (the Austronesian who leads his tribesmen to colonizing the continents).

In the Navy during World War I, Fuller concluded that man could no longer rely on what he learned through sight, sound, and the other senses. He observed that the Navy and, by extension, the war, were controlled by *invisible* radio waves. He concluded that it was only a matter of time before those who could manipulate abstractions would determine the scientific and political fate of humanity.

During the next few years, Fuller developed radically new ideas designed to prevent man from impoverishing his planet and exterminating himself. Although he often doubted his ability to understand and to lead others, Fuller never doubted his Maker or his mission.

After the age of thirty, Fuller's career zigzagged. He was appointed to important governmental agencies, corporations, institutes, and foundations. At times, he went into isolation to invent (he eventually took out twenty-six patents) or to pursue his increasingly idealistic research. These projects brought him the admiration of millions of listeners and readers who considered him a prophet, as well as the neglect of government officials and specialists who dismissed him as a crackpot. Even a partial list of his creations tells the story of his multifaceted genius: the Dymaxion car, the geodesic dome (Peter Ustinov called the Montreal Expo dome "Buckminster Cathedral"), synergetic geometry, a new cartography, the World Game, and designs for scores of things from bathrooms to cities.

Long before the first of his forty-three honorary degrees and dozens of medals, Fuller had become "Bucky," famous the world over for his marathon lectures. He spoke, he said, about 7,000 words per hour. Four hours was normal; ten hours did not exhaust him physically or verbally. Few could follow every example, digression, analogy, or technical vocabulary. But Fuller could not end a lecture until he had completed the galactic circle of his ideas. In 1972, when *Architectural Forum* celebrated its eightieth anniversary by devoting its January-February issue to him, Peter Blake described Fuller at the podium: "This dauntless figure of Bucky in the midst of his enormous thought world, spending himself beyond the limits of mortal probability on his task...cannot fail to move one in a human sense, even if the full import of his thought is not accepted or enjoyed."[1]

Though Fuller's style was complex, if not obscurantist, the theory of universal structure he developed had the elegance of classical physics. All matter, he said, may be understood by reference to nature's most efficient volumetric shape, the tetrahedron. In his view, simplicity was the cardinal principle of truth, and truth was beauty: "Nature is always doing whatever it does in the most economical ways, everything nature says is poetry."[2] While it is well and good, Fuller said, to understand simple systems such as gravity, continental drift, and phylogenetic recapitulation, they should *never* be studied *in vacuo*, for the interaction of simple systems produces phenomena that cannot be predicted from knowledge of the individual components. For Fuller, the key word is synergy. Synergy is not only a physical/chemical/cosmological fact, it describes the union of art and science in the creative act. Furthermore, Fuller was convinced that nature works in ways that can be made visible. *Tetrascroll* (cat. nos. 1-26), the creation that Fuller proposed over tea to Tatyana Grosman, was intended to be a three-dimensional embodiment of the theories he had evolved over a lifetime, setting forth his fundamental assumptions about the nature of the universe and of man, including the mysteries of atomic particles, genetics, truss construction, and celestial navigation.

In 1974, after fourteen intermediate books, Fuller had finished his *summa theologica*, a massive volume he titled *Synergetics*. He was not happy with it. According to his friend and collaborator E. J. Applewhite:

> *Bucky was partly alienated by the sheer massiveness of the work: its organization failed to sustain the narrative continuity of spontaneous exposition—like Bucky's lectures. This was perhaps an inevitable —and certainly calculated—price of the attempt to be exhaustive, to record all the geometrical ramifications.[3]*

In 1975 Fuller would soon be eighty years old. Edwin Schlossberg decided that the best birthday gift he could give his friend was a new project. He proposed a collaboration with Tatyana Grosman, who knew as little of Fuller's world as he knew of hers. She had seen Jasper Johns's thirty-three-foot long painting *Map Based on Buckminster Fuller's Dymaxion Airocean World* (1967-71; Dr. Peter Ludwig Collection, West Germany) and was aware of his reputation. But when Schlossberg sent her a roll of Fuller's diagrams, she was baffled. She returned most of them, but kept three childlike drawings Schlossberg had included in the roll.

The story of the meeting between Fuller and Tanya Grosman has often been told.[4] Fuller came for tea at 5 P.M. on a Thursday (February 25); by the time he left at 10:30, he had seen the treasures of the viewing room, had outlined the format for *Tetrascroll*, and started to draw on stone. He returned the next morning and worked until Sunday, starting each day with Mrs. Grosman across the breakfast table, saying good night to the exhausted printers about midnight. On Saturday, he started dictating text to Tony Towle and Schlossberg's friend the poet Paul Violi, while he continued to draw on the stones. They worked through the night on Saturday, and Goldston put him on the airplane to Philadelphia at 5:30 Sunday morning for a 9 A.M. appointment and an afternoon lecture there. Everyone at ULAE needed two days to recuperate.

Ten days later, Mrs. Grosman wrote to Jasper Johns:

> *His visit was a revelation. I feel as if a prophet passed by. I think also that the young men working here were deeply affected. He worked with the greatest sensitivity and intensity, and his vigor absolutely swept us off our feet. For myself, it gave me a great sense of confidence, optimism, and serenity.[5]*

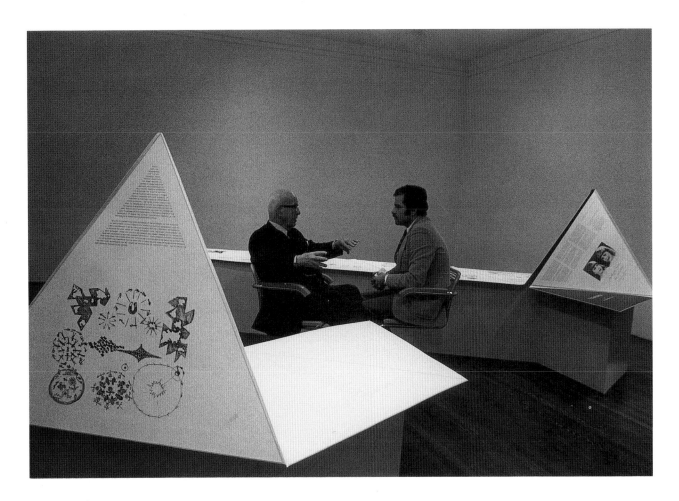

46. R. Buckminster Fuller, installation
photograph of *Tetrascroll*, 1975-77, at
Ronald Feldman Fine Arts, Inc., New York.
Courtesy Ronald Feldman Fine Arts, Inc.
See cat. nos. 1-26.

Fuller returned in May and June for two more all-night sessions. At the end of July, Fuller's daughter Alexandra went with him to sign the colophon pages.

Schlossberg had been right: a new project, a new format for his ideas, a new design for one of man's oldest inventions, the book, had recharged the legendary energies of R. Buckminster Fuller. He was (and this endeared him to Mrs. Grosman) enticed by the texture, granulation, and feel of the crayon gliding across the stone. As a boy he had enjoyed drawing but soon learned that Fuller men did not use their hands to decorate things; they used their brains to make things work. His first drawings for *Tetrascroll* are simple, almost crude. However, the last drawing, the gyroscope, is nicely modeled and quite assured.

ULAE was the perfect workshop for a man accustomed to dominating his milieu-of-the-moment; he enjoyed every amenity Mrs. Grosman could provide. Moreover, she skillfully encouraged Fuller the artist, praising his work as the drawings improved. At the party after the opening of the *Tetrascroll* exhibition at Ronald Feldman's gallery, Fuller said: "You can't go all the way to heaven and back. But you can go almost there when you go to Universal Limited Art Editions."[6]

Tetrascroll was conceived and made as a tetrahedron, composed of four equilateral triangles. As for the title, "tetra" came from its shape; "scroll" from Oriental scrolls. For Fuller, the scroll was a synergetic format for narrative, a form that corresponds because it incorporates time, the fourth dimension: the past rolls up as the future rolls out ahead. Each of the twenty-six "pages" is an equilateral triangle wrapped in Dacron sailcloth the color of a seagull's feather. The drawings and text were printed in dark blue (the color of blueprints, twilight, and the ocean) in Helvetica type (a Bauhaus favorite) on matching gray paper that was laminated to the sailcloth. The triangular pages were connected by cloth strips so that

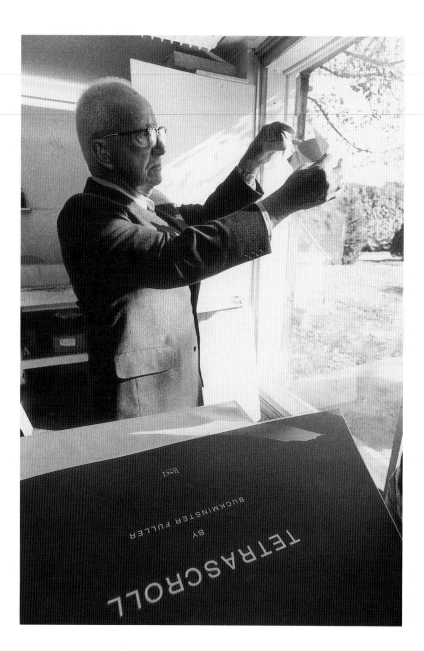

47. R. Buckminster Fuller, R. Buckminster Fuller and cover of *Tetrascroll*, 1975-77, at ULAE, West Islip. Courtesy Edward Oleksak. See cat. nos. 1-26.

they could take on various arrangements. Even the chapter titles were recast into "Tricaps": "tri" for triangle and "cap" for caption.

From the outset it was clear that *Tetrascroll* was too cumbersome for libraries and collectors and was not, after all, the vehicle to carry Fuller's ideas to the public. In 1981, ULAE published a bookstore edition of 350, titled *Tetrascroll Deluxe*. Hardcover and paperback editions were also published by St. Martin's Press.

In his introduction, Fuller said that *Tetrascroll* began many years before when his granddaughter Allegra asked him to tell her the story of Goldilocks and the three bears. He was reading Einstein at the time and decided to test his comprehension by disguising Einstein's theorems as variations on the old fairy tale. Fuller's version made "Goldy" the leader of a cosmic seminar; the three bears were the Big Dipper, the Little Dipper, and Cassiopeia; and the four became "events" in a nonsimultaneous tetrahedronal system. After Einstein, said Fuller, nothing can be truly analyzed according to the old static models, nor can an event be understood unless the observer becomes part of the observation and the past and future are joined to the present. Goldy teaches the bears about the principle of synergy. She quickly discards her childish disguise and warms to her didactic mission. "Few people," she reports with innocent surprise, "gravitationally cohered around precessionally steered planet earth comprehend either gravity or precession."[7] She demonstrates those principles, drawing examples from a truly Fullerian range of topics: snakes, ponds, electromagnetics, navigation, and the periodic table of elements. The tetrahedron, doubled into an octohedron, becomes an "omni-rational accounting system" that can be used to explain other phenomena: entropic loss and syntropic gain within the universe, photosynthesis, the double helix of genetic transmission, the motion of bicycles and planets, and

gravity itself. With faint distaste, Fuller describes light as "finitely closed and quantized packages."[8] But gravity—like the tetrahedron—is Fuller's all-present and eternally regenerative force. "Gravity is the omni-embracing, omni-pervasive perfection of comprehension. Gravity is cosmic love."[9]

After Goldy disposes of the problem of the construction of the universe, she moves to the history of the human race. Given the fabric of human physiology, she says, the only climate fit for man's emergence as a land-creature was watery and temperate Austronesia. In this Eden, where man still understood his place in the natural continuum, he made the first instruments of navigation that enabled him to sail to distant lands. Thus, Asia was colonized and the separation of the races began. The science of navigation (which had led Fuller to so many others) is proposed as the mother-science of mankind, indispensable to political and religious aggrandizement. Because of sea power, empires were founded and the Gospel of Christ spread throughout the Western world.

Next Goldy introduces mythology, cosmography, and linguistics through the story of Naga, the Sea-Serpent. But she quickly puts mythology aside to concentrate on the problem of sustaining life on Spaceship Earth. If we did not spend $200 billion a year on weapons, spying, narcotics, and crime, she says, if we could discard selfishness and ancient prejudices, the potential of humanity could be realized.

Fuller, through Goldy, ends buoyantly. Even if the adult world remains "preoccupied within the obsolete games of money and politics,"[10] the young people will lead humanity to its preordained greatness. The three bears thank Goldy with a dazzling celestial display, accompanied by a "John Cage-inspiring, symphonic masterpiece—the majestic silence of eternally regenerative cosmic integrity."[11]

There was no precedent for *Tetrascroll*. Mrs. Grosman had contracted with Richard Minsky of the Center for Book Arts to bind the

edition. The printed sheets were to be laminated to twenty-six rigid equilateral triangles measuring thirty-six inches on a side, all hinged together so that they could be displayed in one forty-three-foot line or in a variety of two- and three-dimensional configurations. Minsky and his assistant, Peter Seidler, set up a shop in lower Manhattan and began to work out the problems. For the rigid core, they experimented with binder's board, foam-core board, rag board, and plywood. For the seagull-gray cover, they tried a dozen combinations of cloth and paper, singly and in layers. A score of adhesives and tapes were tried and discarded. Whole editions of pages were reprinted. Materials failed to perform; manufacturers were unsympathetic. Models failed to fold, or stand, or stay rigid when constructed full-scale. In January, the pipes in Minsky's building froze and the cutting machinery stopped working. Each failure seemed darker as the weeks wore on.

The Museum of Modern Art had scheduled an exhibition of *Tetrascroll* on January 27, 1975. The art dealer Ronald Feldman planned an opening on January 29. On February 11, a *Tetrascroll* was to be presented to the Houghton Library at Harvard University. Two weeks before the opening, Tony Towle wrote in his diary: "In the meantime what is fast becoming the Minsky Brothers Bookbinding Circus is creaking to a start. He [Minsky] calls Bill Goldston twice a day, minimum."[12] Everyone involved in *Tetrascroll* had good reason to worry.

Mrs. Grosman, never one to count the cost, had always been especially lavish in the matter of bindings. The ULAE files contain scores of letters to craftsmen amending and polishing the design of boxes, covers, and wrappings. Prototypes were expensive, changes even more so, and repairs and shipping added costs she preferred to ignore.

Goldston called the binder on January 26

and was told that not one of the *Tetrascroll*s was ready. He and all the ULAE printers rushed to Minsky's workshop. A crew of six, with Goldston inventing solutions for still unsolved problems, worked nonstop for thirty-six hours. At 11 A.M. of opening day, a *Tetrascroll* was delivered to the Museum of Modern Art; the copy for Ronald Feldman was delivered at 10 that night. Months later, when Minsky and Seidler wrote an article on *Tetrascroll* for *Craft Horizons*,[13] the edition of thirty-four was still not finished.

Tatyana Grosman's "prophet" had created another milestone—a book, a multiple, a fairy tale, a scientific and cosmological discourse, a song of hope. In the *Epilever* (Fuller would not countenance the words "epilogue" or "colophon"), Schlossberg wrote: "Bucky weaves a story in the sky/Through the stars, in the oceans/Across our sense of the measure of earth/With threads we never/Even noticed/Into a cloth we can/Use in any whether."

Notes:

1. Blake, 1972, p. 56.
2. Fuller, 1982, p. 40.
3. Applewhite to Schlossberg, 1976.
4. For example, see Wallach, 1977; *Tetrascroll*, pp. I-XVIII; Hoelterhoff, 1977; Lada-Mocarski, et al., 1977.
5. T. Grosman, letter to Johns, March, 1975.
6. Fuller, 1981, p. XI.
7. Ibid., p. 34.
8. Ibid., p. 52.
9. Ibid.
10. Ibid., p. 130.
11. Ibid.
12. Towle, Diary, 1963-78, January 13, 1975.
13. Lada-Mocarski et al., 1977.

48. R. Buckminster Fuller, R. Buckminster
Fuller with *Tetrascroll*, 1975-77, at ULAE,
West Islip. See cat. nos. 1-26.

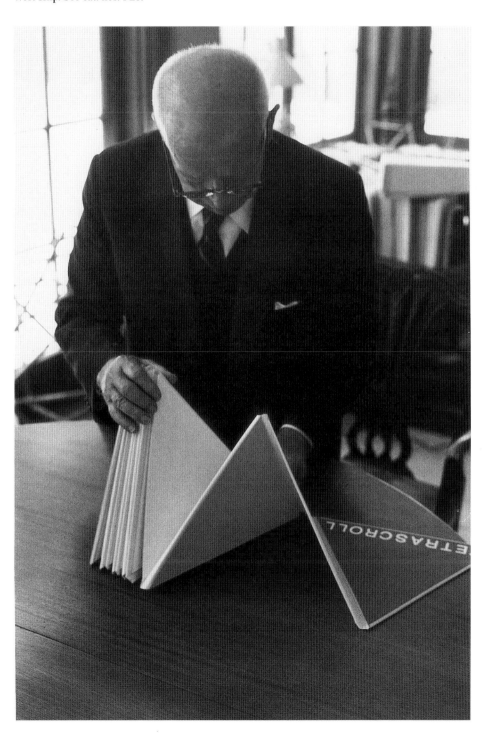

39/75 Fritz Glarner 1963

49. Fritz Glarner, *Color Drawing for
Relational Painting*, 1963. See cat. no. 9.
When Glarner returned to ULAE in 1963
after an absence of more than three years,
he was working on a commission to paint
the dining room walls and ceiling of
Governor Nelson Rockefeller's New York
apartment. This architectural project called
upon Glarner to utilize the innovative
approaches to interiors that had been
explored by the de Stijl artists. This was
Glarner's first lithograph in color.

Fritz Glarner

(Swiss, Zurich 1899-1972 Locarno)

The Grosmans and the Glarners had much in common. Fritz Glarner and Maurice Grosman had been artists in Paris before World War II. Lucie Glarner and Tatyana Grosman had both displeased their respective parents by marrying impecunious artists. The four shared a love of European music and literature. The men were excellent chess players. The women were artists' wives who played their roles with notable elegance. New York was their common refuge; the Glarners fled from the Nazis in 1936 and the Grosmans in 1943. Within a few years, both couples moved to Long Island. The Glarners took Mary Callery's house in Huntington; the Grosmans settled in modest West Islip. Callery, who introduced the two couples in 1960, was the first artist to give Maurice Grosman original watercolors to reproduce by screenprinting. Glarner knew other artists who had worked at ULAE: Grace Hartigan, Larry Rivers, and Sam Francis. The Glarners and Grosmans soon became "country companions." The men went clamming together, and Lucie cooked while Tanya arranged the table. After Glarner had a disabling accident on board the liner *Michelangelo* in 1966 and convalesced for a period in the United States, the Glarners moved to Locarno, Switzerland, and the friendship continued by mail.

Glarner was incontestably a Modernist but, for several reasons, had always taken a position tangential to the mainstream of abstract art. First, he was reserved and philosophic by nature, ill-suited for the battles of artistic revolt. Perhaps more important, he was a young provincial when he came to Paris in 1923, having received all of his formal training at the Regio Istituto di Belli Arti in Naples. Unlike his friends, who cut their teeth on successive waves of German and French radicalism, Glarner did not see a modern picture until he was twenty-four. Although he frequented their cafés and knew the principal abstract artists, he never felt that he was part of any of the

50. Fritz Glarner, *Colored Drawing*, 1963. See cat. no. 10. Although Glarner made no prints at ULAE in 1962, he did go to the studio so that Hans Namuth could photograph him at work. Glarner drew this tondo on a stone for the photographic session. The impressions were not released as an official ULAE publication but were given as gifts to friends. The print from the single stone was titled *Drawing for Tondo, Hors Commerce*. Five impressions were numbered "1/5" through "5/5"; another impression in the Art Institute is numbered "5/6"; thus, the correct edition for the single-stone lithograph is six. Additional stones supplied the colors.

new schools of painting—whether Surrealist, Purist, Synchronist, or Cubist. He did ask the poet Michel Seuphor to introduce him to Piet Mondrian in 1928, but, even then, Mondrian's influence did not become apparent in Glarner's work until more than ten years after they met.

Although Glarner stayed at arm's length from the various priesthoods of abstract art, his debt to their principles is clear. Relational Painting, the theory that Glarner developed and named, was firmly founded on two of abstraction's most utopian theories: the Suprematism of Malevich and the de Stijl of van Doesburg.

From 1958 to 1964, Glarner worked on *Recollection* (cat. nos. 12-28), a portfolio of lithographs at ULAE that was to be his autobiography on stone. In *Recollection*, Glarner revealed many of the sources of Relational Painting. For example, he advocated the de Stijl position that only vertical and horizontal lines are acceptable and that the palette must be restricted to the primary colors, red, blue, and yellow. The "point-center," a concept that appears on page two of *Recollection*, is a logical extension of an idea that Mondrian had adopted from the mathematician Henri Poincaré. Poincaré said, "It is only in the *relations* that objectivity is to be looked for...it is the *relationships* alone that can be regarded as objective."[1]

In 1932, Glarner returned to Zurich, where the sculptor Max Bill drew him into the circle of progressive Swiss and German artists who formed the group Allianz. Glarner still remained on the periphery: he joined Allianz, but only in 1937, one year after he left for the United States.

When the Glarners had visited New York in the winter of 1930-31, the artist met Katherine S. Dreier, founder of the Société Anonyme, who quickly arranged an exhibition of his work at the Civic Club. When they returned to New York in 1936, they found friends, work that enabled Glarner to make a living as a photographer, and modest quarters in which he could paint.

Mondrian came to New York in 1940. Much has been said about the relationship of Mondrian and Glarner, with Glarner usually placed in a dependent role, like so many other New York artists of the time. But the most thoughtful analysts of their interaction, Dore Ashton and Margit Staber, have found evidence of reciprocity: There are stylistic changes in Mondrian's work that parallel, but do not direct, changes in Glarner's.[2]

They agreed on many of the basic issues of abstract composition: the relation of color and form to the two-dimensional surface that is the proper arena of painting, the aesthetic that must guide such compositions, and the universal harmony that such painting expresses. Both wanted to create art that is not muddied by individualism or by the imbalance that Mondrian equated with tragedy. They also shared the misfortune of exile. Few critics and collectors in America sought them out until the furor of Abstract Expressionism had subsided in the 1960s.

Glarner evolved his theory of Relational Painting between 1923 and 1945. Despite his reluctance to speak in public, he polished his thoughts for two important lectures. The first was given on February 25, 1949, at Subjects of the Artist, a school founded by Robert Motherwell, Mark Rothko, David Hare, and William Baziotes (see Goodnough TK). He expanded on this short statement for a symposium at the Museum of Modern Art in 1950.[3] His principles of composition, applicable to his work in every medium, may be summarized as follows: The surface was divided into trapezoidal compartments, each trapezoid having one slanted side. A bar, or "magnet," was usually placed along the narrowest end of each trapezoid. Colors were confined to red, blue, yellow, and the range of grays from white to black. Textural differences were kept to a minimum.

51. Fritz Glarner, *Drawing for Tondo No. 4,*
1959. See cat. no. 6.

52. Fritz Glarner, *Recollection, Page 2: "Point Center 1941,"* 1964-68. See cat. no. 15.

There were other strictures that gradually eased through the years. By 1948 Glarner's Relational Painting offered a gamut of optical effects, aptly described by Natalie Edgar,[4] which made Glarner's compositions an inextricable mesh of form, color, and space.

In the mid-1950s, thanks largely to the faith and efforts of Glarner's dealer, Rose Fried, the pace of exhibitions and sales of his work began to escalate. This permitted him to move to Long Island in 1958 and retreat to his studio to work on his first major commission, a fifteen-by-forty-foot mural entitled *Relational Painting #88*, for the lobby of the Time-Life

Building. The building, designed by Harrison & Abramowitz and completed in 1960, was a splendid addition to New York. Glarner's lobby became a tourist attraction. Soon after, Glarner began another large commission, *Relational Painting #90*, to be placed in a two-story stairwell in the Dag Hammarskjöld Library in the United Nations Building.

The challenges Glarner faced when he went to ULAE in 1958 were not unlike those presented by the two murals: Lithography offered him a surface of unfamiliar shape and a new scale. In addition, he had to adjust to the stone; to draw in reverse; and to learn about

53. Fritz Glarner, *Recollection, Page 11:
"New York New York,"* 1964-68. See cat.
no. 24.

ink, registration, and all the laws and lore of
printing. He found that the stone is a seductive
surface and that each stone is different. The
fact that a composition is placed on a surface
not identical with it resuscitated for him the
old opposition between figure and ground,
destroying the mesh of space and form he had
so painstakingly evolved over the years.
Glarner solved the problem of the margin by
treating the lithograph as if it were a drawing.

For his first lithographic campaign—the
nine lithographs of 1958-59—Glarner confined
himself to black and white (with a few excur-
sions into tinted paper). He did not try color
until he returned to ULAE in 1963. The litho-
graphs he did then, *Color Drawing for Rela-
tional Painting* (cat. no. 9) and *Colored Draw-
ing* (cat. no. 10), are bolder than the 1958-59
group in several respects. Working with
Zigmunds Priede, Glarner tackled the prob-
lems of color registration. Compositionally,
Colored Drawing is unusually simple. Both
Glarner and Mrs. Grosman were so pleased
with the composition that they decided to print
small editions of the black stone alone, before
adding color.

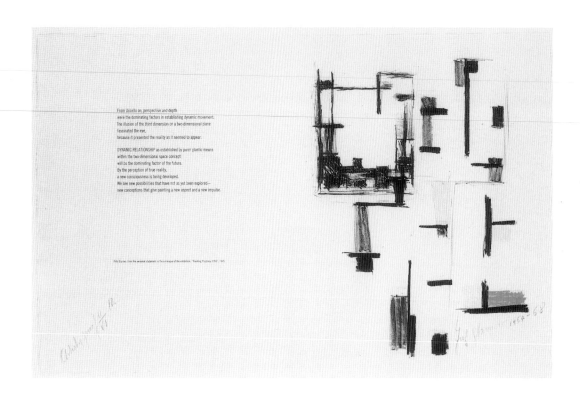

54. Fritz Glarner, *Recollection, Page 10:
"From Uccello on…,"* 1964-68. See cat.
no. 23.

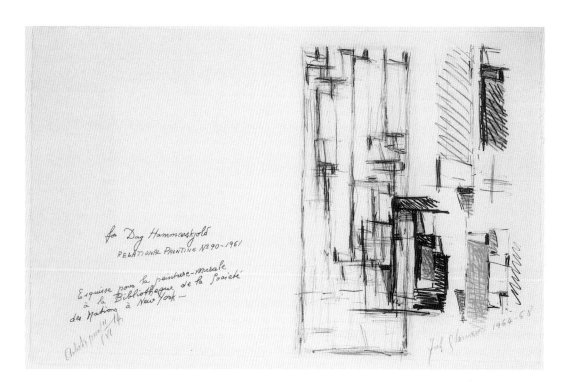

55. Fritz Glarner, *Recollection, Page 14:
For Dag Hammarskjöld,"* 1964-68. See cat.
no. 27.

Glarner's treatment of color is different in each of his favorite media—painting, drawing, and lithography. In the paintings, each trapezoid or compartment is an uninflected color, little distinguished from neighboring color areas by texture or density. As their titles announce, the lithographs are much closer to drawings than to paintings. The series of six *Tondo*s published in 1959 (cat. nos. 3-8), all printed with single stones in black ink, were presumably exercises in black and white. The crayon was used with such a variety of touch and texture that one experiences a sense of color without the fact of it. Had Glarner wanted to achieve tonal gradations of gray, his printer could easily have shown him how. Had he wanted the lithographed tondos to look like drawings, he could have employed the same consistent application as he did in that medium. But he maintained the presence of the drawing tool and the spontaneous marks that would have been polished over in a painting, and added a luxuriant use of texture that one does not find in his work in any other medium. Very quickly he came to Mrs. Grosman's view that lithography was a separate and distinct medium for making art.

Ever sensitive to the nuances of tone and texture, Glarner was easily persuaded to stray from straightforward white printing paper, to vary the size of the sheets in the series, and to vary the number of tondos on a sheet and their placement within the sheet. It is in this series that Glarner came to grips most successfully with the opposition of figure and ground. He did not concentrate the larger trapezoids at the top but distributed the forms more evenly over the sheet. This approach looked back to Neo-Plasticism and it paralleled a direction taken by many other artists of the 1950s and 1960s.

The single prints Glarner did at ULAE are individual works of art, created by a mature artist who was thoroughly at home in the medium. As an artistic autobiography, *Recollection* is unique in his oeuvre—and indeed in

the publications of ULAE. It starts with Glarner's earliest essays into pure abstraction and demonstrates each of the principles of Relational Painting as they developed over twenty years of his mature career, especially the point-center, the slant, and squaring the circle. *Recollection* differs, however, from orthodox Glarner theory in several respects: nonprimary colors were used, rectangles and tondos were integrated into the same composition, and text was combined with the drawings. The sequence of pages is not chronological, but the story begins with the influence on the artist of van Doesburg (*Page 5*, cat. no. 18) and extends to the impact of New York (*Page 11*, cat. no. 24). The two great achievements of his career, the Time-Life and United Nations murals (*Page 13* and *Page 14*, cat. nos. 26 and 27) are commemorated as a *finale*.

Glarner's experience at ULAE served an extraordinary range of artistic aims. He had not made prints before he went there in 1958. A few were started during the last years of his life but were never published. His first two lithographs, *Drawing for Tondo 1958* (cat. no. 1) and *Drawing for Relational Painting 1958* (cat. no. 2), show how quickly he learned, adopted, and exploited the nuances of the stone. For him, lithography provided a richer surface to work with than drawing did. Using the delicate interaction of a given ink on a given stone, Glarner could superimpose one ink-and-paper effect on another, play one quality of crayon against another, and manipulate ink colors and densities in ways that his theoretical ideas prevented him from employing on canvas.

Notes:

1. Poincaré, 1906, in Seuphor, 1962, p. 68.
2. Ashton, 1963; Staber, 1976.
3. Glarner, 1951, p. 10.
4. San Francisco, 1970.

56. Robert Goodnough, *The Chief I*, 1961.
See cat. no. 2.

Robert Goodnough

(American, b. Cortland,
New York, 1917)

While paging through old magazines in 1945, Robert Goodnough discovered Henri Matisse, Pablo Picasso, and Piet Mondrian. Goodnough had recently graduated from a conventional art program at Syracuse University and was making his life in the army somewhat more bearable by doing portraits. The discovery of modern art impelled him, as soon as he was discharged, to go to New York and enroll in the school of Amédée Ozenfant, the leading proponent of Purism in painting. As a pedagogue, Ozenfant was what B. H. Friedman called "a hard pencil and no erasing."[1] Among Goodnough's many teachers, it was Ozenfant who left the greatest mark on his standards of craftsmanship and instilled in him the conviction that a painting must have a rationale beyond the agreeable arrangement of forms on a surface. In 1947 Goodnough decided to seek a more sympathetic environment and went to Hans Hofmann's school in Provincetown for the summer. There, he met Larry Rivers, Alfred Leslie, and Clement Greenberg; he remained a part of their circle, taking an active role in the social and artistic life of the New York School.

In the fall of 1948, while in graduate school at New York University, Goodnough regularly attended the Friday night lectures organized by Robert Motherwell, Mark Rothko, and David Hare. Motherwell and others considered this series a school and titled it Subjects of the Artist—not by virtue of any consistent philosophic stance or physical organization but because it was, in Motherwell's words, "a physical place for everyone interested in advanced art in the United States to meet."[2] Glarner lectured one Friday night, as did Arp, Baziotes, Gottlieb, de Kooning, Cage, and Harold Rosenberg. Subjects of the Artist disbanded in the spring and was replaced in the fall by another series titled Studio 35 (the loft was at 35 East Eighth Street). Goodnough arranged to record many of the sessions and used the texts as the basis for his 1950 master's

57. Robert Goodnough, *The Chief II*, 1961. See cat. no. 3. *Chief II* is typical of the recognizably figurative work Goodnough was still doing in 1961, but its division into abstract panels is a foretaste of the direction his painting took immediately after his work at ULAE.

thesis for New York University, "Subject Matter of the Artist Derived from Interviews with those Artists Referred to as the Intra-Subjectivists."

In 1950 few galleries in New York showed the work of the second generation of Abstract Expressionists. The most adventurous was the Tibor de Nagy Gallery, which opened that year under the direction of John Bernard Myers. Goodnough's friend Alfred Leslie introduced him to Myers, who gave Goodnough his first important show in 1952. Larry Rivers was part of Myers's stable, as were Goodnough's future colleagues at ULAE Grace Hartigan and Helen Frankenthaler.

Just as Goodnough became recognized as a young Abstract Expressionist painter, the movement was given its classic description by Harold Rosenberg in an article for the December 1952 issue of *Art News*. With the fine disregard for public opinion that has always characterized his decisions, Goodnough changed course and turned away from many of the principles Rosenberg described as essential characteristics of the style. Goodnough wanted to separate himself from the Surrealist and subjective aspects of Abstract Expressionism. He wanted, instead, to "uncube the cube,"[3] to devote his entire attention to the geometrical relationships of color and form on a planar surface.

His work with collage also contributed significantly to Goodnough's antiexpressionist direction during the next few years. He used small pieces of paper to build layered compositions that were governed by his innate love of balance and much indebted to Mondrian's concept of dynamic equilibrium.

Throughout the next decade, Goodnough worked simultaneously in several styles. He did figurative paintings and drawings inspired by a variety of thematic material from prehistoric animals to romantic tales of the American West. He continued to create compositions in which constellations of explosive marks

seemed to hover in a vast ether of raw canvas or pale color. And, beginning in about 1960, Goodnough introduced the simpler geometric forms he called "color-shapes,"[4] which dominated his work in the 1970s.

He was a success, acclaimed by critics Fairfield Porter, Frank O'Hara, Clement Greenberg, G. R. Swenson, Irving Sandler, and Dore Ashton. Tanya and Maurice Grosman paid close attention to such critics and even more to the advice of artists they already knew and liked. In 1960, when the Rockefeller-Hilton-Uris agent asked ULAE to produce a large number of lithographs for the New York Hilton, Mrs. Grosman seized the opportunity to invite Goodnough to work at ULAE.

In many respects, Goodnough was well-prepared for lithography. He was an accomplished watercolorist and draftsman, not tied to large canvases. He had been working in collage for several years, and that additive procedure was a natural introduction to the step-by-step approach of printmaking. Mrs. Grosman did not want her artists to bring sketches of previous work to be reproduced on stone; Goodnough had never worked from sketches. Nor did he work in a prevailing color scheme that could have posed problems in matching ink to paint.

Goodnough's work at ULAE coincided with a most fluid and creative period of his career. All of the lithographs began with the Abstract Expressionist calligraphy he had mastered in the early 1950s. The collage technique and color-shapes he developed also appear. In contrast to his work in other media at the time, Goodnough's ULAE lithographs display a lively color and abstract emphasis that presage his work during the following decade.

Notes:

1. Guest and Friedman, 1962, p. 15.
2. Motherwell and Reinhardt, 1951, p. 9.
3. Wichita, 1973, p. 29.
4. Ibid., p. 35.

58. Robert Goodnough, *Three Figures*,
1961. See cat. no. 5.

59. Maurice Grosman, *From Jewish
Poems: Page V*, 1959-65. See cat. no. 7.

60. Maurice Grosman, *From Jewish
Poems: Page X*, 1959-65. See cat. no. 12.

Maurice Grosman

(Polish-American, Lodz, Poland
1900-1976 New York)

Painter, sculptor, teacher, printer, refugee, chess-player, advocate of the avant-garde, husband of Tatyana—Maurice Grosman lived on the fringes of success but never grasped it. At the age of twelve, he decided to be an artist, rented a studio that he shared with two friends, and managed to conceal the arrangement from his parents for almost a year. He enrolled in the Fine Arts Academy in Dresden at the age of seventeen and soon attracted attention, praise, and commissions. A German patron gave him money for a trip to Berlin. Grosman, with the improvident gregariousness that never left him, spent most of the money on a farewell party and gave the balance to friends who needed it more than he.

When Tatyana Auguschewitsch met Maurice Grosman, she was a student in the Berlin Academy of Applied Arts. She fell in love, broke with her family, and became Grosman's wife. Berlin in 1931 was no place for unconventional artists and no place for Jews. Thus, the couple moved to Paris and, for almost a decade, lived a bohemian life. Grosman had studied under Oskar Kokoschka and Carl Hofer in Germany. In Paris, he attended a few sessions in a school organized by Fernand Léger. But his great teachers were the examples of other artists, both living and dead. Within his circle of friends, he could count Jacques Lipchitz, Chaim Soutine, and Ossip Zadkine. Lipchitz advised him to stop working in the all-too-prevalent semi-Cubist style and to spend a year drawing and copying at the Musée du Louvre. Grosman exhibited each year in the Salon des Indépendants, in various galleries, and at the Exposition Internationale of 1937. His wife played a traditional role: She gave up her own artistic ambitions and took on the practical management of his career.

Two days before the Nazi occupation of Paris in 1942, the Grosmans fled. Although the details of their exodus varied with thirty years' retelling, the ending was a happy one: By 1945 they were settled in a one-room studio apartment on Eighth Street in New York in a building with other artists and writers. There they found friends from Paris, including a few who were willing to share their own beachhead on American life.

Grosman's work met with modest success. In 1945 he was included with other ex-Parisians in a group show at the Niveau Gallery and had one-person shows there in 1947 and 1949. Subsequently, he withdrew from Niveau, had no gallery for a while, then had a one-person exhibition at the Amel Gallery in March 1962. Caught in a downward spiral, Grosman tried to supplement their income by making frames until an accidental cut frightened his watchful wife. He gave one course in a Long Island public school, but it was a disagreeable experience; afterward, he taught in his studio, only one student at a time and only those he considered exceptionally promising.

After a heart attack in 1955 and the subsequent move to Long Island, Grosman taught himself screenprinting and began making reproductions that his wife sold to Marboro Book Store, the F.A.R. Gallery, the Contemporaries Gallery, and other shops. He reproduced paintings and drawings by Picasso, Matisse, Chagall, Dufy, Gross, Tamayo, Kleinholz, and Grandma Moses. Helena Rubinstein allowed him to work from originals in her collection; Mary Callery, Jacques Lipchitz, Adja Yunkers, and Max Weber gave him their own work to copy. They were rather free versions, tending noticeably in the direction of his own palette. Max Weber gave him several lithographic plates to reprint in small editions. By 1959 Grosman had abandoned screenprinting. (In July 1967, he wrote his cousin Isabel that he had done no screenprinting since 1956. Two prints, however, listed in a notebook, may have been printed after that date: Chaim Gross, *Four Acrobats*, edition 48, probably 1957; Adja Yunkers, *Encounter*, edition 20, probably 1959.)

Maurice Grosman's role in Universal Limited Art Editions will never be fully known. Witnesses' versions vary, although on one point all agree: In the late 1950s and early 1960s, Tatyana Grosman depended completely on her husband's aesthetic judgment. If he did not actually select the artists she invited to print, it is certain that no one was invited without his approval. At least a decade passed before Mrs. Grosman had the confidence to place her judgment before her husband's.

During the first few years of ULAE, Maurice Grosman good-naturedly helped printer Robert Blackburn when the need arose. In 1963, probably for his own book, he worked with Zigmunds Priede; in 1965 he assisted with Rauschenberg's prints. When the press broke down in 1964, he helped dismantle and repair it. Tony Towle's diary is filled with mention of other tasks Grosman performed: cooking, chauffering, and entertaining, as well as dealing with tradesmen when Mrs. Grosman thought a man's touch was valuable. Grosman's painting, teaching, and exhibiting continued, but his contribution to his wife's work, and his responsibility for her success, diminished through the years. He remained a resource for ULAE but was no longer a central participant.

Perhaps as early as 1955, Grosman received a grant to create a work (or works) on a Jewish theme. He did not start in earnest until 1959, when he chose thirteen Yiddish poems (written in Hebrew characters) as the text for a portfolio that he hoped would take its place among ULAE's distinguished list of *livres de luxe*. Grosman read widely in German, Polish, French, and Yiddish. Without notifying the authors, he chose the poems, then wove excerpts from them into his crayon and tusche compositions on stone. While lines of text were left intact, they were treated as raw material and not as literary achievements to be honored with subsidiary (or even parallel) artwork. Page VIII has only one line of poetry; most translate into a four-line verse in English.

Some of the images have figurative elements, such as the Chagallesque page X and the Dufyesque page XIII, but most pages are completely abstract. Grosman supervised much of the printing, but many of the printers who worked at ULAE during the six years helped with the production.

In the fall of 1965, the Grosmans' old friend and the first ULAE artist, Larry Rivers, wrote the introduction to *From Jewish Poems*. It was exhibited at the Jewish Museum in New York in May 1966 and offered by the museum as a circulating exhibition. *From Jewish Poems* was Maurice Grosman's only venture into original graphics. Grosman's drawings for his neon and Plexiglas sculptures, which he exhibited at the Hallmark Gallery in 1973, oddly enough, had revived his idea of publishing reproductive work but in an entirely new form. The Grosmans had taken museum curator William Lieberman's advice and stopped making screenprints. But, after ten years, it was clear that publishing original prints would never be a profitable business and reproductive work might provide a cushion of profit to offset the cost of handmade work. Telamon Editions, a separate business based on offset lithography, was established by the Grosmans and, in 1975, published Grosman's *Drawings I-X: For Neon and Plexiglas Construction*. The *Drawings* colophon described them as "Edition of 32 sets of reproductions." Only five sets were signed by the artist.

A few days after he died, Mrs. Grosman received notice that her husband had been given a grant by Collaborations in Art, Science and Technology for experimentation in neon. Ten of his sculptures were shown at the Grey Art Gallery, New York University, in 1977, prompting critic John Russell to observe that "somewhere in these stilled but never tentative statements a pure spirit is enshrined."[1]

Note:

1. Russell, 1977.

61. Maurice Grosman, *From Jewish Poems:
Page XII*, 1959-65. See cat. no. 14. Most of
the images in *From Jewish Poems* contain a
rectangular shape that takes various guises:
a book, a lithographic stone, a tablet of
inscriptions, or a picture frame. The
specifically illustrative elements are
confined to, or based within, these shapes;
the abstract elements are created from
specifically lithographic textures.

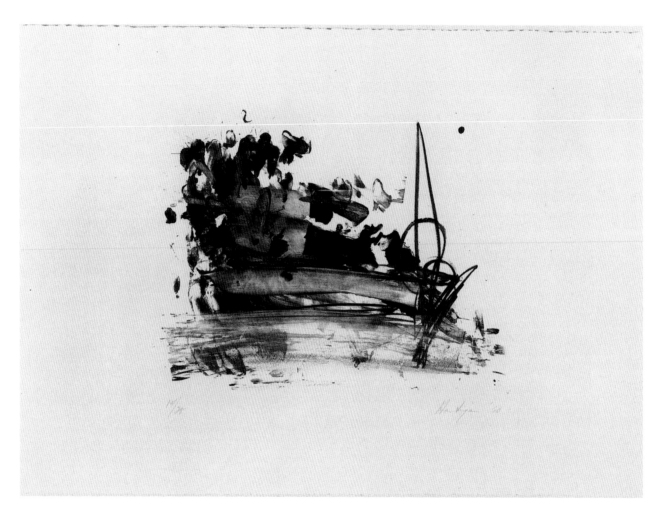

62. Grace Hartigan, *The Hero Leaves His
Ship IV (Ship)*, 1960. See cat. no. 4.

Grace Hartigan

(American, b. Newark,
New Jersey, 1922)

Twelve of the fourteen lithographs Grace Hartigan made at ULAE sprang directly from her lifelong devotion to the art of poetry. As a small child, she was most often to be found listening to her aunt and grandmother, who told her stories and sang songs from English and Welsh folklore. Confined to bed with pneumonia at the age of five, she taught herself to read; soon she began to keep a journal. The courtly figures that have intermittently peopled Hartigan's paintings first made their appearance in the sketches and jottings of her adolescence. But it was not until her early twenties, having decided that she could not be a writer, that she began to draw and paint in earnest.

In 1946 Hartigan went to New York. There she found the as-yet-undiscovered artists of the New York School drawn together by common ideals and ideas. The artists' community—in the late 1940s and early 1950s no more than a few hundred people—became an island of concentrated creativity never before seen in America. Within a very short time, Hartigan met Avery, Kline, Morton Feldman, Cage, Guston, Rothko, Pollock, and de Kooning.

Her friendship with Pollock and his wife, Lee Krasner, began casually when Hartigan and her fiancé, Harry Jackson, were invited to the Pollocks' in Springs, Long Island (where later they were married). Theirs was an important relationship, both personally and professionally, and it became close enough to survive many a heated disagreement about painting.

The meeting places and events of that time—then so familial, now historic—constituted Hartigan's daily life: the Cedar Street Tavern and the Eighth Street Club, Studio 35, and the Ninth Street Show. Two of the pivotal figures in the Abstract Expressionist movement, Meyer Schapiro and Clement Greenberg, selected her work for the Kootz Gallery's "New Talent Show" of 1950. This show was a milestone for Hartigan. Greenberg

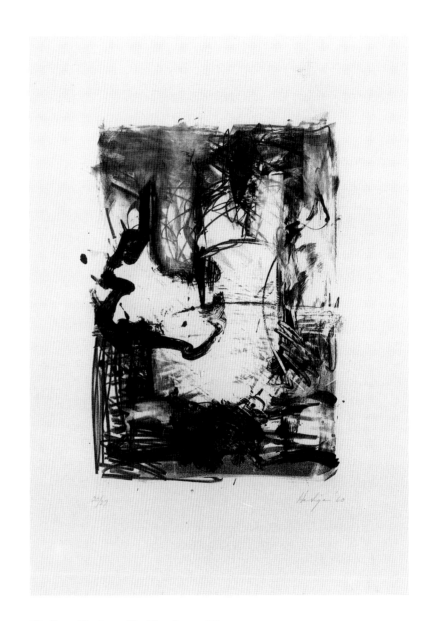

63. Grace Hartigan, *The Hero Leaves His Ship I (Hero)*, 1960. See cat. no. 1.

recommended her (and three others who later worked at ULAE: Larry Rivers, Robert Goodnough, and Helen Frankenthaler) to John Bernard Myers, who asked her to join the gallery he opened in 1951, Tibor de Nagy. For her debut exhibition, Hartigan used the pseudonym "George" Hartigan, in homage to George Sand and George Eliot.[1]

Myers was a man of incisive intelligence, unflagging enthusiasm for the avant-garde, and great powers of persuasion. As an editor for the Surrealist magazine *View*, he published screenprints by Hartigan and other artists to accompany work by Kenneth Koch, Frank O'Hara, and a long list of unknown poets and writers. Hartigan contributed screenprints to another short-lived magazine, *Folder*, edited by Richard Miller and Floriano Vecchi.[2]

Hartigan and her friends participated in a great variety of collaborative enterprises: The Actors' Studio, Kaprow's Happenings, Cage's heretical music, and a panoply of new styles of literary composition and exposition. The skein of artistic relationships entwined many complex and shifting alliances. In the 1950s, critics became part-time curators, painters became poets, and poets became regular contributors to art magazines and exhibition catalogues.

By 1959 Hartigan was known as "one of the prime, gifted swashbucklers of the Second Generation."[3] Myers gave her seven one-person exhibitions at Tibor de Nagy. In a 1959 exhibition called "Hartigan and Rivers with O'Hara," Myers also showed eight Hartigan "poem-collages" based on verses by O'Hara from his series titled *Oranges*. Editing freely, she combined his work and hers, sometimes writing out a complete poem, sometimes using just a phrase.

Early in 1960, Tiber Press asked Hartigan to contribute to an even more ambitious collaborative project: four volumes in a slipcase, each with poetry and images by contemporary artists. *Odes* features poems by O'Hara and images by Michael Goldberg; *The Poems*

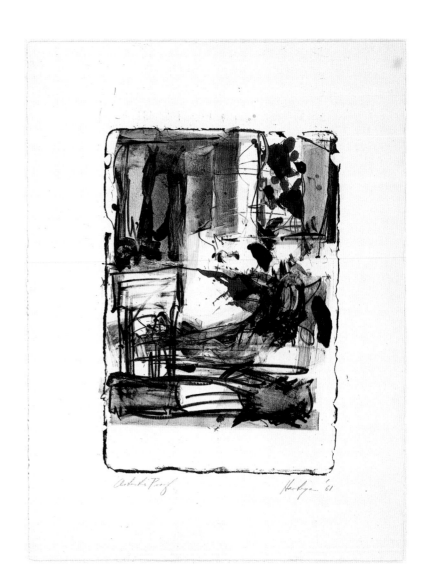

64. Grace Hartigan, *Pallas Athene*, 1961. See cat. no. 5. *Pallas Athene*, Hartigan's only color print for ULAE, was done at the same time as two paintings on the same theme. Unlike her other prints, which evolved from specific texts, it was inspired by the artist's thoughts of Athene herself. Ten proofs were printed from the black stone before Hartigan proceeded with the stones for color.

includes John Ashbery and Joan Mitchell; *Permanently* pairs Kenneth Koch and Alfred Leslie; and in *Salute*, Hartigan worked with James Schuyler. The eight artists knew each other's work. They had already worked together or would later cooperate on similar projects.

One other sort of collaboration preceded Hartigan's work at ULAE. Through Myers, she met the producer Herbert Machiz, who asked her to design sets for the poet Kenneth Koch's *Little Red Riding Hood*, produced at the Artist's Theatre in 1953. The production budget was $25. Hartigan bought large rolls of brown wrapping paper and painted them with gouache—abstract, of course. There was no money for stage furniture, so she included a few pieces from her studio. The actors were less than pleased: Koch's lines were too abstract to memorize easily and Hartigan's improvised sets were disconcertingly eccentric. But the audience (all friends) applauded vigorously.

While Hartigan's friends Rivers and O'Hara were working on *Stones*, Tatyana Grosman finally persuaded her to try lithography. Hartigan had little or no interest in prints then and still regards them as a very casual part of her creative activity. In early 1960, Maurice Grosman and Robert Blackburn carried a number of stones upstairs to Hartigan's studio. They left tools and materials but not a word of advice. After a few weeks, she started to work on the first four stones as she would canvas—painting, rubbing, scraping—with no thought of the "right" way to do it. Instead, she concentrated on the poem that inspired her, "The Hero Leaves His Ship," by her friend Barbara Guest. In the *Oranges* series, Hartigan had incorporated recognizable images relating to the text. In 1960, however, she was working in a purely abstract way, and so the poetry shaped the work much more indirectly, evoking a mood that materialized in abstract forms. The collaboration was emo-

tional, reactive, and classically Abstract Expressionist in tenor.

Work on the stones proceeded slowly— Mrs. Grosman gently prodding, Hartigan firmly insisting on her own pace—and on April 1 the stones were ready. By mid-October 1960, when Hartigan moved to Baltimore and married Dr. Winston Price, a research scientist at Johns Hopkins University, the edition was signed and released.

Mrs. Grosman was pleased with *The Hero Leaves His Ship* quartet, but she had always wanted Hartigan to go beyond black and white, to give her prints the fluency and substance of her paintings. She hoped that color would win her wholeheartedly over to lithography. Reluctantly, Hartigan agreed to try, and the Grosmans and Robert Blackburn set off for Baltimore, the car loaded with stones and supplies. They gathered in two remote rooms in the Baltimore Museum of Art, where Adlyn D. Breeskin, then director of the museum, gave them the use of a press. Hardly leaving the museum to eat or sleep, they produced Hartigan's only color lithograph, *Pallas Athene* (cat. no. 5). Soon after, Mrs. Grosman wrote to a friend that Hartigan "builded up the lithograph to six stones. It was most exciting."[4] Hartigan, however, was not converted. She found the conceptual reversals too awkward. The delays of inking, registering, and proofing impeded her creative momentum.

After *Pallas Athene*, the Grosman-Hartigan correspondence was animated by new possibilities: collaborations with Barbara Guest and other poets, an homage to Hartigan's recently deceased friend O'Hara, as well as single prints without reference to text. On April 30, 1961, the Grosmans delivered a new batch of stones to Baltimore, hoping for more lithographs in color.

After a summer's rest in Round Pond, Maine, Hartigan was eager to begin. "I have begun work on the *Archaics*, which is Barbara's title for the series of Greek

Poems . . . I need more stones."[5] They had originally planned a series of four. But now she spoke of a vast project: eighteen lithographs, six of them in color, to be published as a collaborative book with the poet's *Aeneid*-inspired text. By the following February, she had finished *Dido*, *Green Awnings*, *In the Campagna*, and *Palm Trees* (cat. nos. 8, 10-12). Meanwhile, Guest had published her poems; Mrs. Grosman felt that the integrity of the publication was thereby compromised. ULAE was in business to produce original works of art, and, in 1961, she construed the word "original" very strictly. (It was only later that she changed her mind and undertook collaborations such as Motherwell's *A la pintura*, which was based on a text Motherwell had found in a book.) Mrs. Grosman proposed publishing prints as independent works; Hartigan resisted, trying to keep the images and verses together.

Months passed without resolution; throughout 1962, Mrs. Grosman was absorbed in new projects and new artists. Late in 1962, Hartigan wrote: "I want you to destroy the stones for the color lithograph. I cannot have so great an interval between the original conception and its realization. I have now no idea of what I intended. I think until we work out some way of following through immediately stone after stone, we should not attempt color and every now and then I will do a black and white."[6]

In February 1964, *Archaics* had still not been published. Mrs. Grosman, evading a confrontation, wrote that she was "uncertain to be able to carry through the project to real satisfaction." She was "concerned about the right of using the quotations of the poems" and counseled patience, "time and the right moment bringing the decision."[7]

By the end of June 1964, Mrs. Grosman had persuaded Hartigan to publish the print without the poems. The proofs were readied for a newly installed press to print. This was done at the end of the summer, but Maurice Grosman did not take the last of the editions to Baltimore for signing until November 1966. A year later, they were featured in an exhibition at the Maryland Institute.

Although the course of their relationship had not been smooth, Hartigan's affection for "Dear Tatyana" never wavered. In February 1962, when *Archaics* was well under way, she wrote: "I do thank you for your care and understanding and above all for our close rapport in all our work together, as I said to you before lithography now has become for the rest of my life a very intimate part of my creative process."[8]

Eight years after her last work at ULAE was finished, Hartigan wrote to Mrs. Grosman: "I have such fond memories of those early days together, me with no technical knowledge but the willingness to attack the stone with passion, you with all the knowledge and determination to print it, if I did it. I'm so glad Jasper and Bob Rauschenberg found the medium so major an expression for their gifts. They could only have done it with you."[9]

Hartigan's collaborative work—confined mostly to paper—represents a small portion of her oeuvre. But it does, nonetheless, encapsulate the central question of her career: What relationship can abstract painting have to "real" sources of inspiration? Hartigan, having allied herself at first with Harold Rosenberg's Action Painters, should have been expected to subscribe to his credo: "Liberation from the object meant liberation from the nature, society and art already there."[10] But Hartigan, along with Rivers, could not give up the world. Even during the periods when her work appeared to be entirely abstract, she thought of those "pure" forms as distillations of real experiences, concrete sensations, psychological events. In 1956 she wrote for the Museum of Modern Art's exhibition "12 Americans": "I want an art that is not 'abstract' and not 'realistic'—I cannot

describe the look of this art, but I think I will know it when I see it."[11] Moreover, the experiences and poetry that moved her came from the disjunctions of modern life: the constant motion, the flickering television, the glut of images and sensations stored in Joycean fragments. She preferred "harshness. . . . It is a kind of power that sets me on edge to see if I can counterbalance it."[12]

The majority of the work Hartigan did at ULAE dates from the early 1960s, a period when her paintings appear to be abstract but were, in her view, built from nonconnotative forms arising from specific phenomena. She titled works with names of places, people, and events; unlike Frankenthaler, whose titles were applied *ex post facto*, Hartigan honestly declared her intended subject. The myths she chose for inspiration for her work at ULAE add to the authority of prints that are stylistically mature—distilling the essence of the things that inspired the artist—and enriched by an imagination deeply rooted in Western literature.

Notes:

1. Hartigan, letter to Sparks, January 19, 1984.
2. Hartigan, letter to Sparks, November 12, 1983.
3. Munro, 1979, p. 202; also see *Newsweek*, 1959, pp. 113-114.
4. T. Grosman, letter to Reis, June 11, 1961.
5. Hartigan, letter to T. Grosman, October 16, 1961.
6. Hartigan, letter to T. Grosman, December 27, 1962.
7. T. Grosman, letter to Hartigan, February 2, 1964.
8. Hartigan, letter to T. Grosman, February 24, 1962.
9. Hartigan, letter to T. Grosman, November 14, 1974.
10. Rosenberg in Geldzahler, 1969, p. 345.
11. New York, MOMA, 1956, p. 53.
12. Quoted in Nemser, 1975, p. 161.

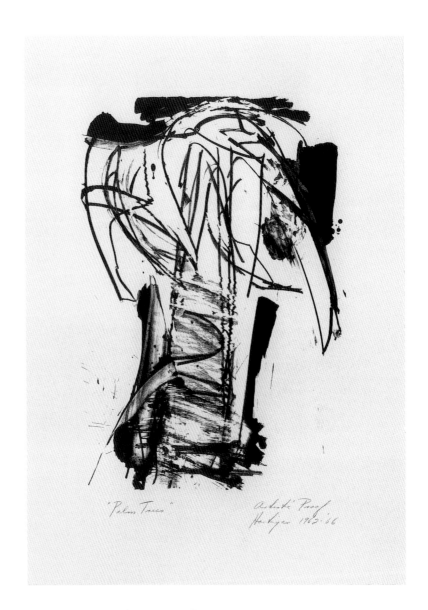

65. Grace Hartigan, *The Archaics: Palm Trees*, 1962-66. See cat. no. 12.

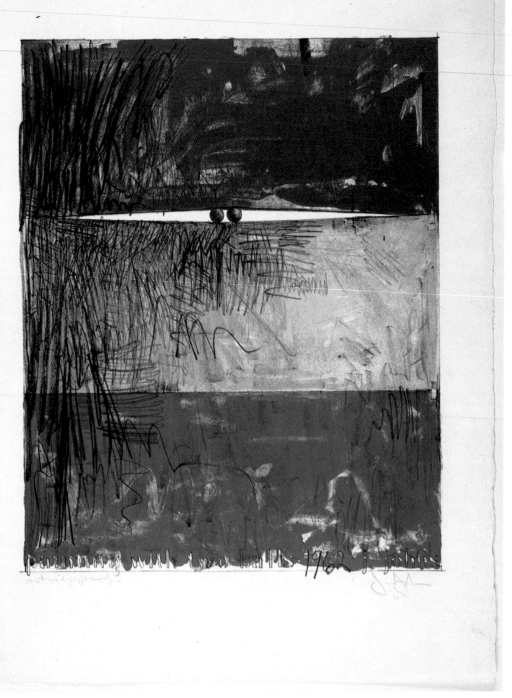

66. Jasper Johns, *Painting with Two Balls I*, 1962. See cat. no. 8. A number of Johns's paintings of the late 1950s are pictorial comments on Abstract Expressionism. In *Painting with a Ball* of 1958 (reproduced in Kozloff, 1967, pl. 38), he wedged a wooden ball into the center of the canvas, thus violating one of the basic principles of the Abstract Expressionists: the integrity of the picture plane. Johns chose primary colors for this, his first color print, and continued to use them until the *1ˢᵗ Etchings* portfolio of 1967-68 (cat. nos. 77-83).

Jasper Johns

(American, b. Augusta, Georgia, 1930)

The work of Jasper Johns, a man of few words, has inspired a critical literature of unsurpassed mass and density. Looking at what Johns diffidently describes as "interesting," critics of speculative bent have discovered strata of metaphysical reference, linguistic and visual conundrums, and, invariably, an art whose allure transcends casuistry.

The subtleties of Jasper Johns's work were magnetically attractive to Tanya Grosman. Who should be invited to work was the critical question if the Grosmans' infant enterprise was to succeed. Johns, aloof and adroit, captured her imagination. She saw his first one-person exhibition at Leo Castelli's gallery in January 1958 and the nine paintings included in the "Sixteen Americans" exhibition at the Museum of Modern Art in December 1959. When they met at Larry Rivers's house in East Hampton, she spoke to him about working at ULAE. He was noncommittal; as always, she was persistent. On August 7, 1960, Mrs. Grosman wrote to Johns, who was in North Carolina, to remind him of his friends who had worked at ULAE, "to stimulate [his] interest in working lithography on stone" and to invite him to visit. A postcard reply from Johns marks her victory.[1]

On the appointed day, the embroidered tablecloth was laid with delicacies, but the young man who walked down the path was not the face she remembered. No matter, a few moments convinced her she had made no mistake. Before the end of the month, there were three stones in his studio on Front Street. The delivery itself was a memorable event. Johns had a friend living on the floor below who helped carry the two smaller stones upstairs. The friend happened to be Robert Rauschenberg; the circumstance provided Mrs. Grosman with an introduction she had long desired. Johns had to pay a nearby vagrant to help carry the largest stone. After that struggle, he decided it would be easier to go to Long Island. The third stone, untouched,

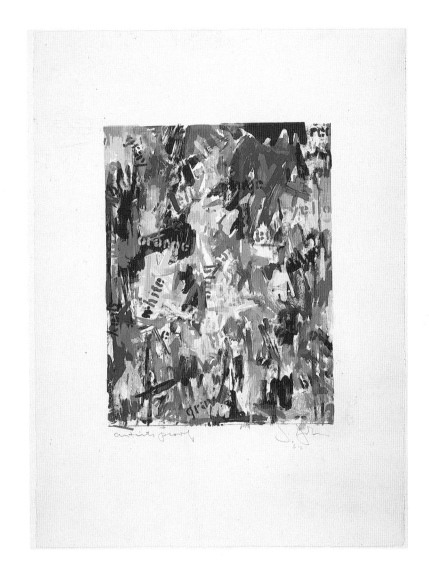

67. Jasper Johns, *False Start I*, 1962. See cat. no. 10. The imagery in Johns's *False Start* series is replete with contradictions: color names printed in the "wrong" colors, free brushwork with drawable outlines, an Abstract Expressionist "field" strewn with recognizable elements, and the ambiguous distinctions between seeing and reading. The title, taken from a dull sporting print in the Cedar Bar, bears no relation to Johns's decisive procedures in the printshop.

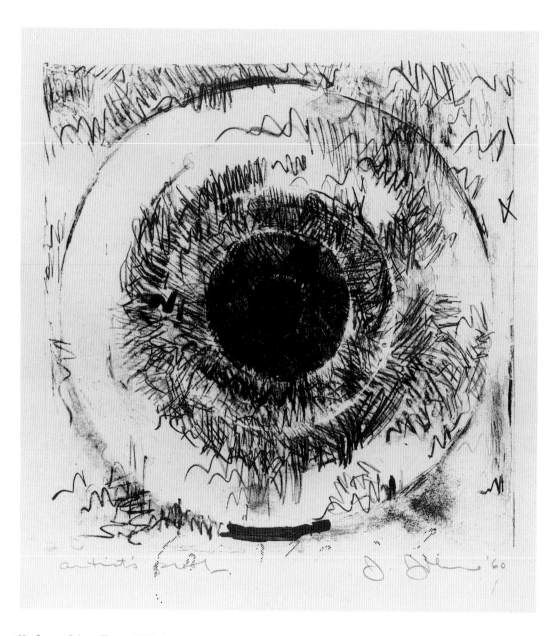

68. Jasper Johns, *Target*, 1960. See cat. no. 1.

was still in his studio when the building was demolished.[2]

Johns's encounter with the lithographic stone was one of the great miracles of Tatyana Grosman's life. First, he painted a large zero on one of the stones, then added a table of the ten numerals. On the next stone, with a crayon, he drew a target—very spontaneous and slightly smudged. The compositions were variations on old themes. Johns often said later that he started lithography to see what he could do to complicate the process. What stunned Mrs. Grosman was his immediate intuition of complications no one else had suspected. After the first proof, the printer confirmed his hunch. Yes, he could erase, and, yes, previous work could be included in the next work. This was important to Johns; he had preferred painting with encaustic because it "keeps the character of each brushstroke, even in layers."[3]

Lithographic ink was even more transparent, so that the zero drawn on the first stone could become a series of ten lithographs, in which each one could retain the memory of the preceding ones. Conceptually, the ramifications were interesting. The act of counting implies the fourth dimension, time, and only by taking the time to see and unravel the parts could the viewer really understand. The set is both a continuum and a closure. Also, when the eye has extricated one number from the web, that number seems to stand in front of the others. But only for a moment.

The work also brought disappointments. A second stone, painted in tusche as a background for the calligraphic *Target* (cat. no. 1), went flat. The *0-9* project (cat. nos. 17-55) took three years to publish. Each number had to be completed in three editions before Johns could rework the stone for the next one. The paper had to be handmade, Mrs. Grosman said, in the best quality and sufficient quantity so that only perfect impressions would be kept. As always, her standards extended far beyond her means. In the fall of 1961, Johns chided her from Edisto Beach, South Carolina: "[I] think we should at least finish the portfolio before the stone rots."[4] Time and again, through the next twenty years, her artists (who rarely cared as much as she did) were forced to wait until the "right" paper was ready.

Johns's gentle reproof was no more than a ripple on the surface of their affection and respect for each other. While stones "rotted," her letters were filled with talk of wildflowers, chess games, and books rather than the elaborate apologies she tendered to people who were not *sympatico*.

Deliberation, concentration, acuity— these marked Johns's work from the beginning. ULAE's first printer, Robert Blackburn, recalled that Johns was the most demanding, the most specific, and the most empirical of all the artists with whom he worked.[5] Other artists tended to respond to impulse, found objects, or the accidents of the day. Johns decided what he wanted to do and preplanned each of the steps along the way. Occasionally, he used trial proofs as sketches, adding chalk or crayon to test the next step. But he soon learned so much about the printer's craft that he could think and work in terms of the press. Johns was his own severest critic. Blackburn said that his "heart was broken" when half of the *False Start I* (cat. no. 10) prints were rejected and destroyed. But there was no question in Mrs. Grosman's mind or in Johns's that only first-rate work was acceptable.

The seven prints published in 1960 were essentially drawings. In 1962 Johns began to explore color and three-dimensional space. In *Painting with Two Balls I* (cat. no. 8), three bands of primary colors are open to accommodate realistically drawn wooden balls. In *False Start I* (cat. no. 10), eleven stones, some inked in more than one color, create a rapidly shifting, if not chaotic, space. In *Device* (cat. no. 12), the elliptical path of the tool refers to space, motion, and technique. *Red, Yellow,*

Continued on page 140

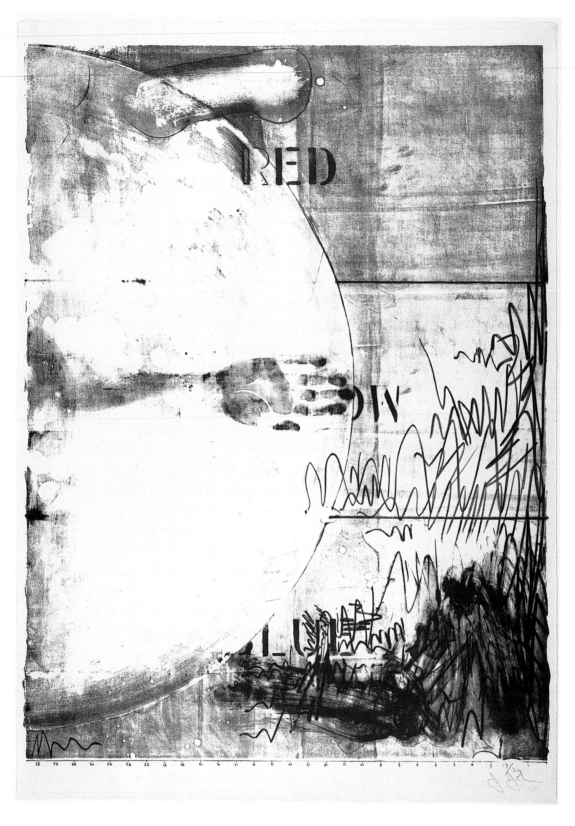

69. Jasper Johns, *Hatteras*, 1963. See cat. no. 15. The "device circle" in *Hatteras* was made by Johns's forearm, repeating the circular path of the beacon in the lighthouse at Cape Hatteras.

Above left:
70. Jasper Johns, *0-9: Edition C/C, Page 0*, 1960-63. See cat. nos. 43-55. In a group of small paintings of numbers done in 1955, Johns had imbedded fragments of secondary numbers in a substratum of collage and encaustic. Five years later, he took up the theme again in these three portfolios of lithographs, all produced from a single stone. He immediately recognized that, using this then-unfamiliar medium, he could create a sequence of numbers that would not only establish relationships among themselves but record their own history. It would be a classic exercise in Leonardo's question about the nature of perception—what the eye sees and what the mind knows.

The first *0* was proofed soon after Johns started at ULAE in 1960 and then set aside while he worked on single prints and the paper for the portfolios was designed and made. During the spring and summer of 1963, the groups were printed and assembled. The colored version C/C was printed first, then A/C in black and B/C in gray ink. Johns also made a second stone for each number, which he used to overprint one number in each series, to designate the edition number of each group of ten prints. The stone, after undergoing its myriad permutations, was sealed and presented as a gift to the Museum of Modern Art in New York.

Above right:
71. Jasper Johns, *0-9: Edition C/C, Page 1*, 1960-63. See cat. no. 46.

72. Jasper Johns, *0 Through 9*, 1960. See
cat. no. 4.

73. Jasper Johns, *0-9: Edition C/C, Page 2,*
1960-63. See cat. no. 47.

74. Jasper Johns, *0-9: Edition C/C, Page 3,*
1960-63. See cat. no. 48.

75. Jasper Johns, *0-9: Edition C/C, Page 4,* 1960-63. See cat. no. 49.

76. Jasper Johns, *0-9: Edition C/C, Page 5,* 1960-63. See cat. no. 50.

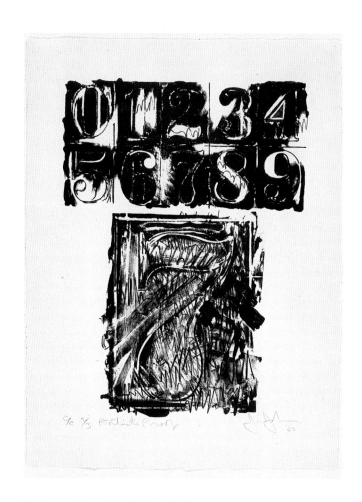

77. Jasper Johns, *0-9: Edition C/C, Page 6*,
1960-63. See cat. no. 51.

78. Jasper Johns, *0-9: Edition C/C, Page 7*,
1960-63. See cat. no. 52.

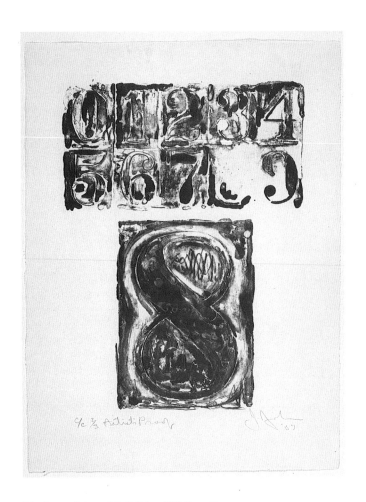

79. Jasper Johns, *0-9: Edition C/C, Page 8*,
1960-63. See cat. no. 53.

80. Jasper Johns, *0-9: Edition C/C, Page 9*,
1960-63. See cat. no. 54.

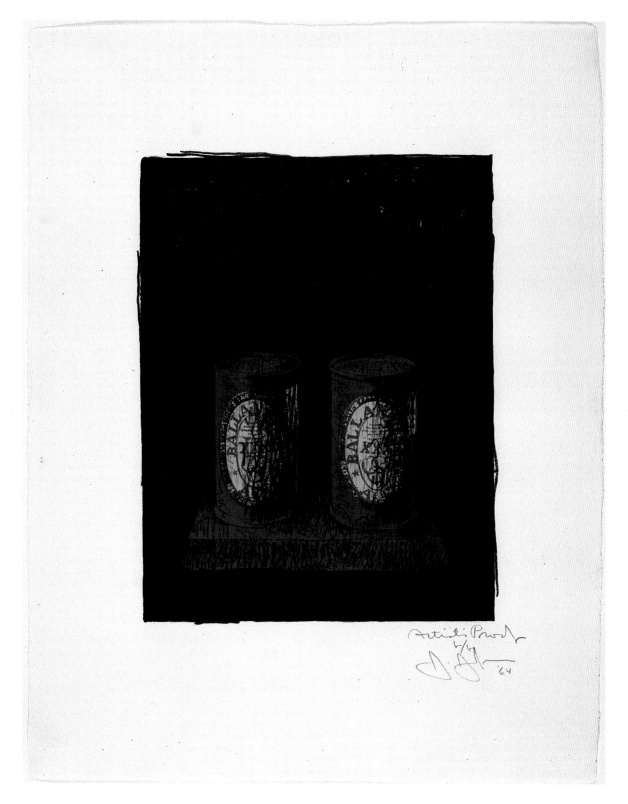

81. Jasper Johns, *Ale Cans*, 1964. See cat.
no. 56. This lithograph depicts Johns's own
painted bronze sculpture of his "signature
object," *Ale Cans* (Dr. Peter Ludwig and
the artist), made in 1960. This image is as
close as Johns came in lithography to
straightforward illusionism.

82. Jasper Johns, *Pinion*, 1963-65. See cat.
no. 58. When Johns began *Pinion* in 1963,
he set aside an area in red crayon for a
poem by Frank O'Hara. Johns marked the
stone with his hands, feet, and knee in the
configuration of a runner's take-off stance.
O'Hara's collaboration was not to be,
however, and Johns resumed work on the
print by himself, adding two new elements
to his lithographic repertory: a photo-
graphic plate as a printing matrix and the
"blended roll" as a method of applying
several ink colors with one roller pass.
Johns experimented with a number of color
schemes in the proofing process and chose
the one that made the still-life element
most ambiguous.

83. Jasper Johns, *Passage I*, 1965-66. See
cat. no. 65. It was Jasper Johns who
persuaded Tatyana Grosman to publish
prints from metal plates; *Pinion* (cat. no.
58) was the first such print published;
Passage was delayed because it was a more
difficult printing problem. The prototype of
Passage was painted in 1962, when Johns's
work was becoming more complex in com-
position, in technique, and in the cross-
references that are one of the salient
features of his art.

84. Jasper Johns, *Watchman*, 1967. See
cat. no. 68. Images of cancellation and
conflict dominate *Watchman*. In the
painted prototype from 1962, the plaster
cast, chair and board and ball are real
objects. In the lithograph, the body is
outlined but unfleshed, the plaster cast is
broken, the words unfinished, the color-
zones violated, the newspaper wiped out
by a swath of paint, and the swath itself
cancelled by drips of paint.

85. Jasper Johns, *Targets*, 1967-68. See cat.
no. 75. The strong orange and green target
in the upper area of this print creates an
after-image of a target in the open
rectangle below. In fact, however, a pale
ivory and white target is actually printed
in the open space, although optically it
becomes completely obscured by the
afterimage. Thus, *Targets* presents a real
image overwhelmed by an illusion.

86. Jasper Johns, *Flags*, 1967-68. See cat. no. 76. Johns's flags of the late 1950s were painted in primary colors; this lithograph is in complementary hues. For this print, Johns made a drawing of a flag, cut it into strips, and created a new flag from the destroyed one. The "drawing" lines are created by the unprinted crevices between the printed stripes. The gray flag below appears to be an uncolored version of the upper one, and the dots in the center are also negatives, one black and one white. More than any other of Johns's earlier multiple flag compositions, this image confuses the issues of scale, depth, and legibility.

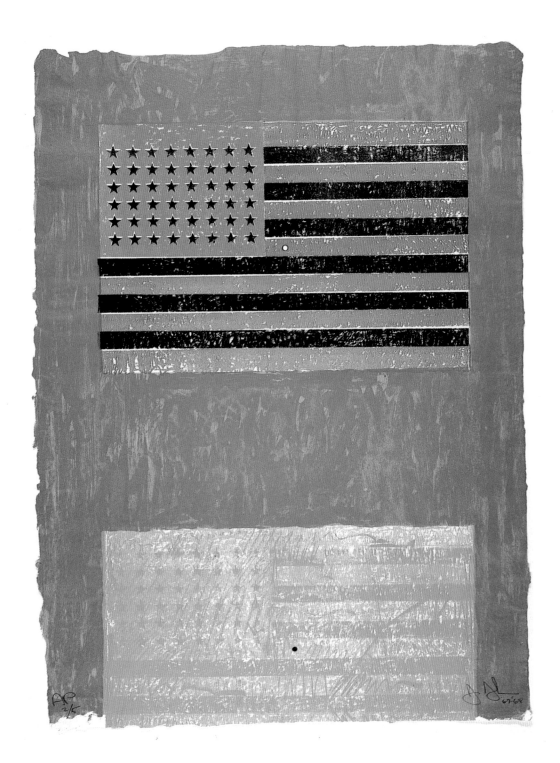

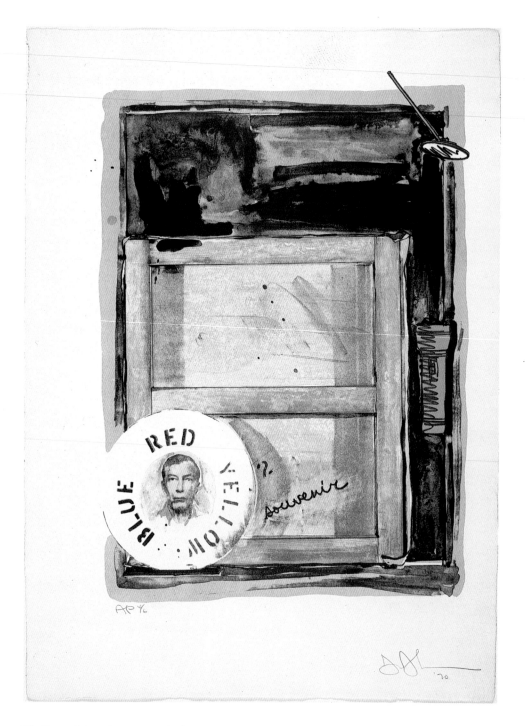

87. Jasper Johns, *Souvenir*, 1970. See cat.
no. 104. The plate with Johns's portrait is
a memento from a trip to Japan in 1964,
introduced in the painting *Souvenir* of 1965
(Mr. and Mrs. Victor W. Ganz, New York).
There are other souvenirs: a stretched
canvas, cheesecloth, and wood from the
studio, and the stenciled ''2,'' which is not
only a sign of purposive activity but a
stand-in for the positive-negative pairings
the artist favored. The print was commis-
sioned by the Philadelphia Museum of Art
for the retrospective exhibition of Johns's
prints in 1970.

88. Jasper Johns, *Decoy*, 1971. See cat. no. 108. No print in Johns's career has been more fully studied than *Decoy* (see, for example, Larson, 1974, and Hempstead, Long Island, 1972). Before this lithograph, all of Johns's prints had been variations on previous paintings, drawings, or sculpture. *Decoy* reaches back to paintings shown as early as 1958. In progress, this print was referred to as "Passage III," reflecting its origin in 1967 as a section of *Passage I* (cat. no. 65). The Ballantine cans are another form of memory: They have left their rim-prints in three places. In 1971 Johns resumed work on the *Passage* stone, rotating the image ninety degrees, then obscuring most of it with tusche. Even the palette marks a digression, featuring pastels instead of Johns's rather straightforward color schemes. As a final departure from his traditional practice, Johns began a painting based on the print even before the latter was finished.

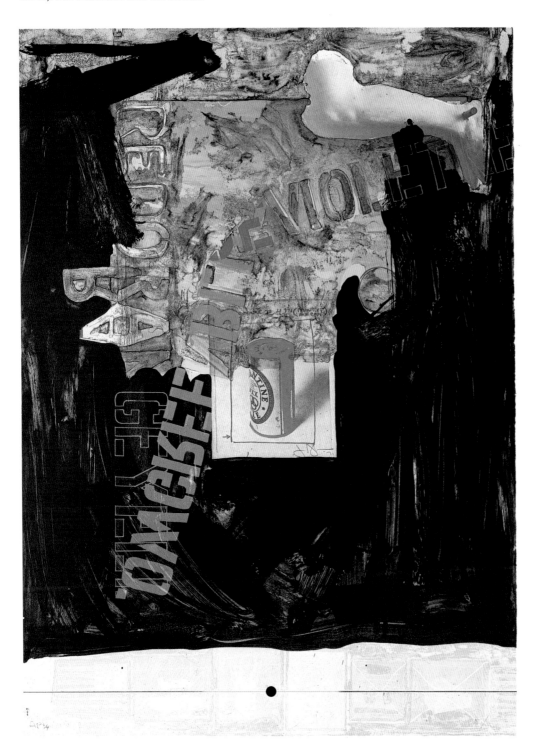

Blue (cat. no. 14) goes further: drawing simulates the wooden letters that Johns had attached to several paintings. Mrs. Grosman was delighted to see that these prints were much more readily accepted than the black-and-white ones had been.

During the 1960s, prints provided Johns with another medium in which to modulate themes he had worked with previously. Some subjects dated back to the 1950s, such as *The Critic Smiles* of 1966 (cat. no. 63) and *Numbers* of 1967 (cat. no. 69). Some were part of a gradual evolution, such as the *Two Maps I* and *II* of 1965-66 (cat. nos. 60, 61). Johns's first map was a small canvas of 1960; shortly after the ULAE *Two Maps I* and *II* were published, he started to work on his largest canvas to date, the *Map* (based on Buckminster Fuller's "Dymaxion Airocean World") of 1967-71, which was commissioned for the Montreal World's Fair of 1967 (now Museum Ludwig, Cologne).

Gently but firmly, Johns changed record-keeping at ULAE. Accurate records of trial proofs, working proofs, artist's proofs, and other noneditioned prints were not kept until the mid-1960s. A set of color separations for *False Start I* of 1962 (cat. no. 10) is the first evidence of his desire to document his own printmaking. It took almost five years to establish the system. *Voice* (cat. no. 67) was the first print to be fully documented. Thereafter, two complete sets of color separations (one in black, the second in color) and two sets of progressive proofs were printed. One set was done for Johns; Mrs. Grosman's set is now in the Art Institute of Chicago.

In his softspoken way, Johns overcame Mrs. Grosman's objection to using metal printing plates instead of stones. She wanted her artists to work where she was and to work on stone. Johns wanted to transfer images from paintings to lithographs through photoplates and then add drawing, tusche, letters, and body prints from stones. He prevailed and did many plates in his own studios. According to Tony Towle, the change occurred during the creation of *Two Maps I* (cat. no. 60).[6]

The stones for *Passage I* of 1965-66 (cat. no. 65) were proofed on the afternoon that Donn Steward came to interview for a position as printer. The title was prophetic for Steward (who became one of the finest craftsmen in the shop) and for a chain of artistic and technical events. Despite Mrs. Grosman's reluctance, Johns wanted to experiment with a photoplate. He sent a photograph of his 1965 painting *Passage* (Harry N. Abrams Family Collection, New York) with paint added to block out the area he did not want reproduced; a commercial shop was found to make the plate. With many transformations, *Passage I* became *Passage II* (cat. no. 66), then *Watchman* (cat. no. 68), and then *Decoy* (cat. no. 108), which was the first print to precede a painting of the same composition and title (Mrs. Victor W. Ganz, New York).

In creating *Decoy*, Johns was the first to use the new hand-fed offset proofing press, which had just been installed in a separate workshop. The offset eliminated many of the delays of the hand-printed stone and thereby allowed him to develop his ideas with greater spontaneity. It also facilitated the use of photographic elements so that they could be reversed, multiplied, and altered with the greatest ease and flexibility. Even as it was being made, *Decoy* became the most celebrated print of its time. A television crew filmed part of the process, Hofstra University exhibited it with related proofs and paintings, and every critical list of contemporary prints has included it. Its history, detailed in the Hofstra catalogue, reaches back to paintings and sculpture of the 1950s. After *Decoy*, Johns continued to explore the possibilities of offset, the most responsive and reliable of lithographic techniques.

In 1967 Steward introduced Johns to etching. In a reprise of his initiation to lithography, Johns started with *Target I* (cat. no. 72). He

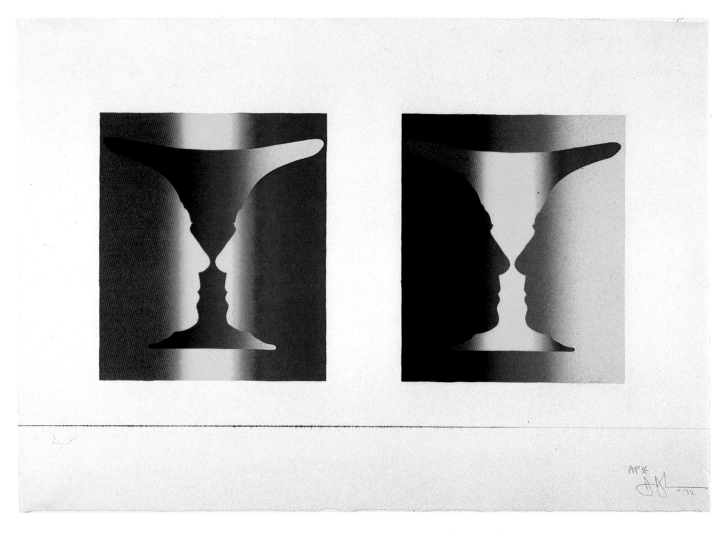

89. Jasper Johns, *Cups 4 Picasso*, 1972.
See cat. no. 112. This image is based on
Marcel Duchamp's 1958 collage *Self-
Portrait in Profile*. Johns had admired
Duchamp's work for many years and wrote
an essay on him in 1969. The blended-roll
inking renders the image even more elusive.

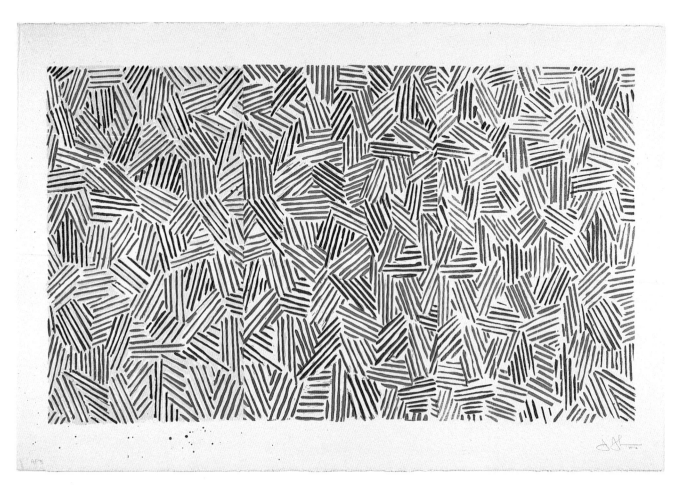

90. Jasper Johns, *Scent*, 1975-76. See cat.
no. 116. *Scent* is divided into three vertical
panels with each area displaying the
unique character of a particular technique:
offset, woodcut, and linocut, all unified by a
white that solved the technical problems of
printing in three media. The pattern is a
design Johns saw on a car in the Hamptons
and that became one of his signature
motifs. The prototype for this print is a
four-panel painting, *Untitled* (1972;
Museum Ludwig, Cologne), that has been
construed as Johns's homage to Jackson
Pollock's last painting, *Scent*.

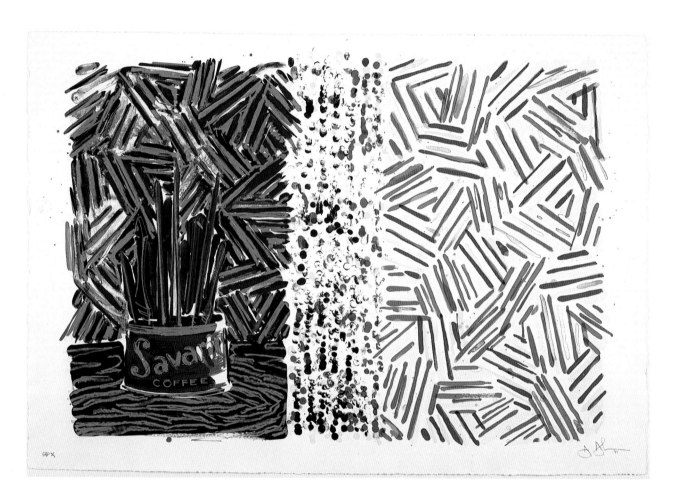

91. Jasper Johns, *Untitled*, 1977. See cat. no. 119. This three-panel design was created for the cover of the catalogue for the Whitney Museum of American Art's 1977-78 retrospective exhibition of Johns's work. The central panel, made by marking the plate with his fingerprints, was to be placed at the spine of the book; to Johns's dismay, the designer rearranged the image.

92. Jasper Johns, *Savarin*, 1977. See cat. no. 120. From his first Savarin can sculpture of 1960, the coffee can full of brushes was Johns's covert self-portrait. It was, therefore, a natural image for the poster for his retrospective exhibition at the Whitney Museum of American Art in 1977-78.

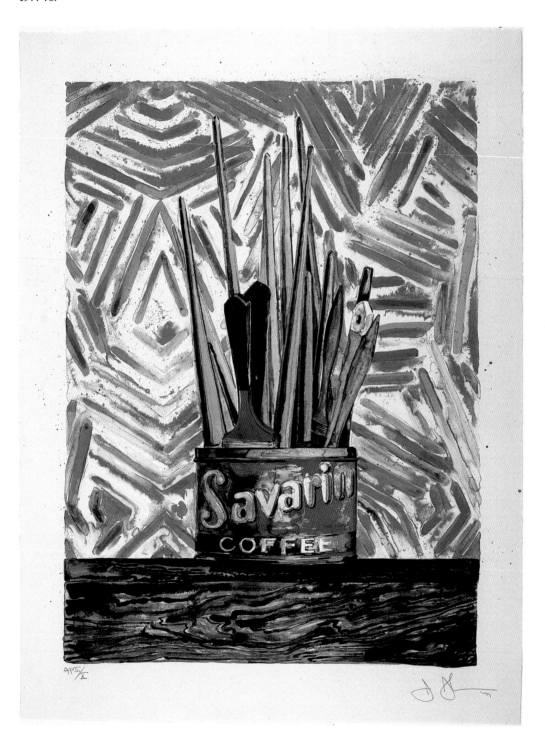

added a background tone in aquatint for the second state, *Target II* of 1967-69 (cat. no. 99), rectifying the failure of the tusche stone of 1960. Johns immediately began to work on an ambitious portfolio, *1st Etchings* of 1967-68 (cat. nos. 77-83). The portfolio is a review of his sculptural objects, each page bearing two plates. The smaller plate is a photoengraving; the larger is an etching, a caustic diagram of the object. Johns had easily mastered crayon, but he found the etched line to be wayward, seductive, distracting. When the etching plates were reworked for *1st Etchings, 2nd State* (cat. nos. 84-97), the discord between real (the photoengravings) and conceptual (the etchings) was stilled when the raw etching furrows were made verdant with varnish and aquatint and each plate was given its own page.

In 1975 Johns began to work on *Scent* (cat. no. 116), an image based on an all-over pattern of crosshatching he had introduced three years before in the painting *Untitled* (Museum Ludwig, Cologne). The painting has four panels, one of which is crosshatched. In the print, he extended the pattern throughout but created subtly varied panels by using different techniques: offset lithography, linocut, and woodcut. Johns again took advantage of a new press on the premises. Juda Rosenberg, the letterpress expert who had worked on Robert Motherwell's *A la pintura* and other typesetting jobs for ULAE, was called in to work with the artists who wanted to try the new press. Aside from the hands that produced the works, ULAE's letterpress prints have little in common. *Scent* and Frankenthaler's *East and Beyond* (Frankenthaler, cat. no. 25) are examples of the resolute individuality that prevailed.

In 1960 Johns made a small painted bronze sculpture of a Savarin coffee can filled with paintbrushes. As a bit of autobiography, he used it for the poster he made for his retrospective exhibition at the Whitney Museum of American Art, New York, in 1977-78 (cat. no. 120). The unabashedly luxuriant *Savarin* series

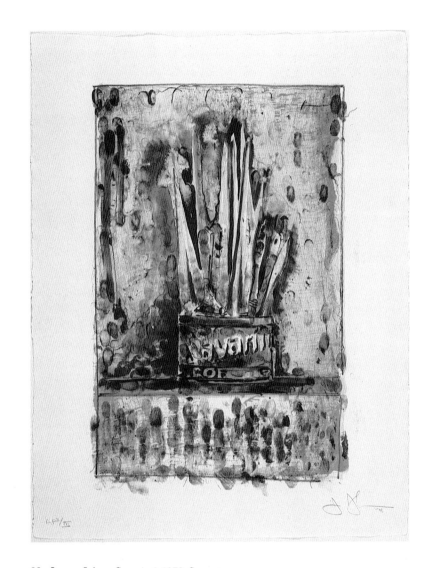

93. Jasper Johns, *Savarin 3*, 1978. See cat. no. 123. The six reds of *Savarin 3*, softened by imprints of cheesecloth and fingertips, create a surface of Venetian luxuriance.

94. Jasper Johns, *Coat Hanger I*, 1960. See cat. no. 2.

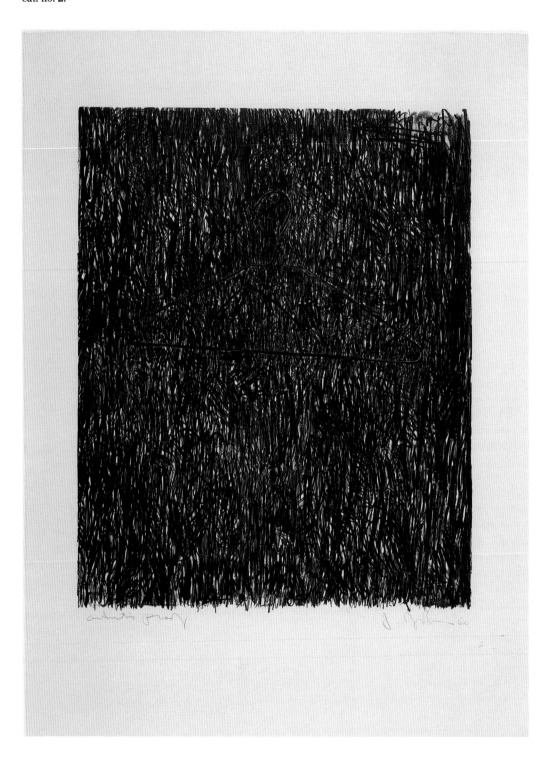

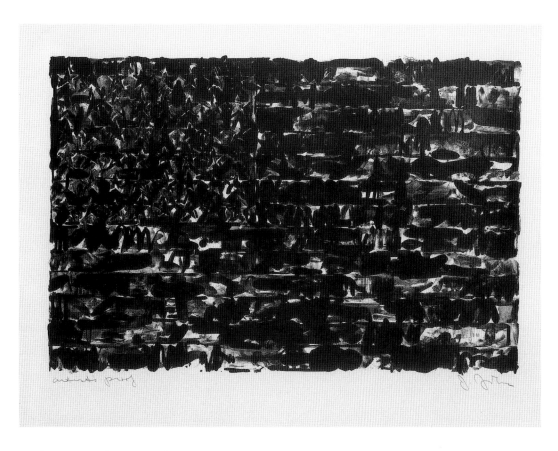

95. Jasper Johns, *Flag I*, 1960. See cat.
no. 5.

of 1978-79 (cat. nos. 121-26) includes some of
Johns's favorite images, from the spatial puz-
zles of *Savarin 2* (cat. no. 122) to the finger-
prints of *Savarin 3* (cat. no. 123). The familiar
crosshatched background of *Savarin 5* (cat. no.
125) reappears in the somber *Savarin (Grey)* of
1977-81 (cat. no. 129) and became the subject of
the *Usuyuki* prints of 1979 and 1980 (cat. nos.
127, 128). As poetry and challenge, the *Usuy-
uki*s are among the masterpieces of Johns's
graphic work.

 During the twenty-two years of their col-
laboration, Mrs. Grosman never failed to
rejoice in the part she had played in Johns's
career as a printmaker. She noted in her letters
the milestones they shared: his first European
exhibition, at the Galerie Rive Droite, in 1961;
an exhibition at Ljubljana in 1964 and prizes
there in 1965 and 1967; in 1968, inclusion in a
Documenta exhibition that toured eight Euro-
pean cities; retrospectives organized by Rich-

ard Field for the Philadelphia Museum of Art
in 1970 and Wesleyan University in 1978 (with
an extended tour); the Museum of Modern Art
exhibition and tour organized by Riva Castle-
man in 1970; the *Decoy* exhibition at Hofstra
University in 1972; the Whitney retrospective
of 1977-78, later shown in Cologne, Paris,
Tokyo, and San Francisco; and a tour of *Work-
ing Proofs* in Europe in 1979-80. She did not
live to see the monumental *Savarin*
monotypes of 1982, which were shown at the
Whitney in 1983.

Notes:

1. Johns, letter to T. Grosman, August 12, 1960.
2. Sparks, Johns interview, 1985.
3. Ratcliff, 1984, p. 65.
4. Johns, letter to T. Grosman, September 15, 1961.
5. Sparks, Blackburn interview, 1985.
6. Sparks, Towle interview, and correspondence, 1982-85.

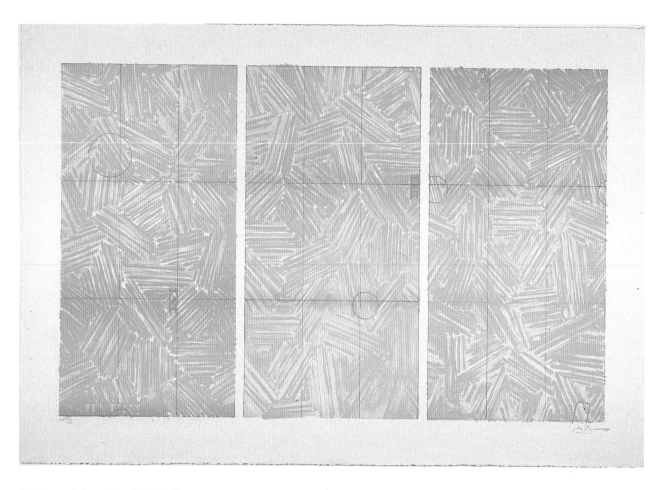

96. Jasper Johns, *Usuyuki*, 1979. See cat.
no. 127. Johns has read about Japanese
history and culture since 1951, when
he was sent to Japan by the U. S. Army.
"Usuyuki" is a word with many meanings
in Japanese: a light snow, something that
passes quickly, beauty, or a Kabuki play
that tells a love story. Johns's play of cross-
hatched pattern seems to oscillate cease-
lessly, conveying information in a fleeting
fashion (see Rose, 1977, pp. 151-53, and
Herrmann, 1977, p. 124).

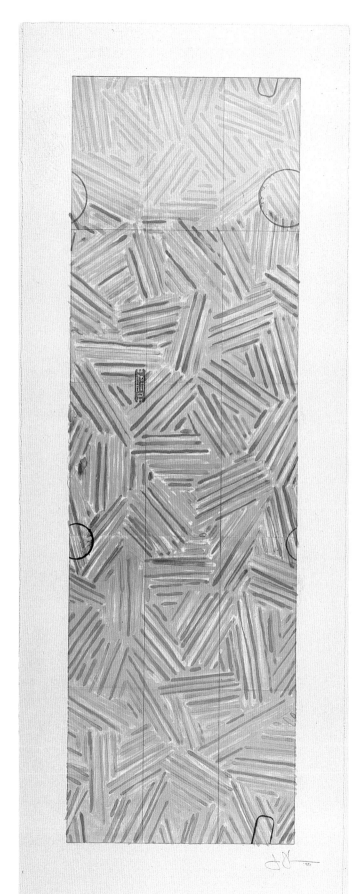

97. Jasper Johns, *Usuyuki*, 1980. See cat. no. 128. The three separate panels of the *Usuyuki* of 1979 (cat. no. 127) have come together in this single column of line, color, and pattern. The colors are even more transparent than in the previous version. Because of the "kiss" of the offset press, Johns was able to ink several colors on each plate and gradually build, in the Japanese definition of the word, "a light snow" of extraordinarily delicate color.

98. Alexander Liberman, *Nostalgia for the Present: Page 1*, 1977-79. See cat. no. 2.

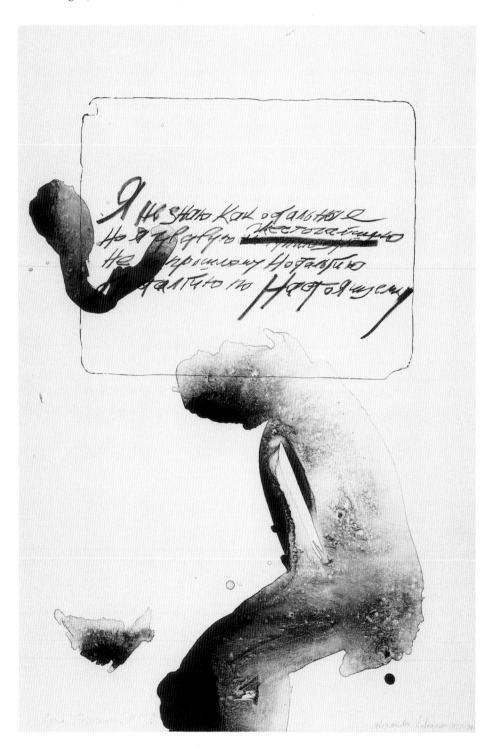

Alexander Liberman

(American, b. Kiev, Russia, 1912)

In many ways, Alexander Liberman was the ideal artist/collaborator for the end of Tatyana Grosman's career as a publisher. His personal and cultural history resembled hers in many respects. Liberman's enthusiasm for the creativity ignited by chance made him willing to risk a collaboration whose success was equally dependent on another artist.

Born in 1912, Liberman, like Mrs. Grosman, was the child of wealthy parents who imbued their children with a lifelong love of music and literature and a profound respect for creativity. The young Liberman, however, was encouraged to be an artist, a Bohemian, and a man of temperament and impulse. His father was close to Lenin (even though he had previously worked for the nobility), and he traveled throughout Russia and abroad representing Russia's lumber interests. Liberman's radical mother had a low opinion of schoolrooms and preferred to educate her son by doing everything within her power to nurture his obvious talent. Among her efforts in this direction was the establishment of the State's first children's theater.

Both parents were Utopians, his father dreaming of economic and moral miracles to be wrought by the Revolution, his mother commissioning Constructivist sets for her theater in the hope that the imagination of audiences would be liberated and aroused. In 1921 Liberman's father enrolled him in the first of two rigorous English schools, where he learned academics, carpentry, photography, and "good form." Three years later, he went to Paris, where he studied art, metalworking, literature, history, philosophy, and mathematics at the Ecole des Roches and then philosophy and mathematics at the Sorbonne. His parents and friends provided an inner circle from which he explored the lush tangle of musical, choreographic, literary, and artistic invention that was Paris in the 1920s and 1930s. After studying, and rejecting, André Lhôte's academic Cubism, Liberman painted and worked as a filmmaker and designer. He worked for the avant-garde magazine *Vu*, won a gold medal for design at the Exposition Internationale in 1939, and was called into the French army in the last desperate mobilization before the Nazi occupation of Paris. Like Tatyana and Maurice Grosman, Liberman escaped through Spain and fled to New York, where he found himself among friends.

Liberman's double life began immediately. His public career was direct and successful. He started to work as a photographer for *Vogue* magazine in 1941; by 1962 he was editorial director of Condé Nast Publications. In private, however, he lived the secluded life of a man of refined, quite European, tastes. He and his wife, Tatiana Iacovleff du Plessix Liberman, made their home a haven for artists in exile; Russian and French were heard more often than English and music and poetry discussed as vehemently as current events. After five years as an ardent spectator of the art scene in New York, Liberman began to paint again.

It was as if he had decided to paint his way through the twentieth century. He learned through imitation, producing canvases that looked like the work of van Gogh, Matisse, Soutine, Mondrian, and others. By 1950 this cathartic apprenticeship was over. Liberman found his own style, based on flat geometric forms executed with precision in industrial materials.

About a year after he began to work in his studio, Liberman again took up the camera. At first, the photographs were simply taken as "notes" of visits to artists' studios. It was a way of learning from artists he revered and exploring his artistic heritage. Ironically, his photographic homage to modern art made him famous several years before his own paintings were known to more than a small circle of friends. A choice selection of his photographs was published, with essays by the artist/photographer/writer, as *The Artist in His Studio* (New York, 1960).

In the 1950s, when avant-garde painting was dominated by the Abstract Expressionists, Liberman painted in a flat, hard-edge, geometric style. In the early 1960s, when Conceptualism and Minimalism were in the ascendant, Liberman again turned against the tide. He began to work in a painterly, expressionistic way. As he threw, poured, and pushed color across his canvases, his movements became metaphors for the random movements of all natural phenomena. Like Robert Motherwell, he believed in the value of chance, inspired by the French poet Stéphane Mallarmé's "throw of the dice." Jackson Pollock had a similar faith in the artistic fertility of Surrealist-derived automatism. Liberman's stance showed that he was essentially indifferent to fashion, despite its importance to Condé Nast. More important, he regarded these large, gestural works as the mature and material issue of his search for the cosmic meaning of the artist's labor. At least three times before, Liberman had experienced several block-and-breakthrough episodes in his career. In every instance, his solution was both theoretical and material: a new concept of the function of creativity expressed in a radically different use of media. It was this late style, providentially reviving the gestural mode to which Mrs. Grosman's young artists of the 1960s were indebted, that Liberman brought to his graphic work at ULAE.

From 1961 to 1966, he had made lithographs at Mourlot in Paris. The prints of 1961 were photographic reproductions of paintings, but in 1963 he worked directly on the stone. The European workshops, however, were vastly different from the white frame house in West Islip. The factorylike atmosphere in France was constraining, the language barrier was a problem in Rome, and neither had "that climate of mutual respect . . . that passionate care in paper, quality and printing"[1] that Liberman found at ULAE.

Tatyana Grosman and Alexander

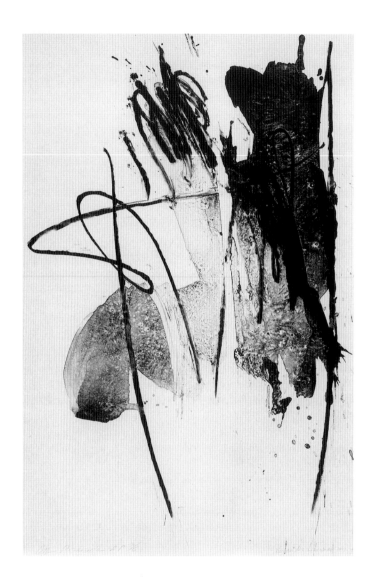

99. Alexander Liberman, *Nostalgia for the Present: Page 5*, 1977-79. See cat. no. 6.

Liberman had many artist friends in common
—Motherwell, Frankenthaler, Newman, Johns
—and had known each other for some years.
One evening in 1976, they found themselves at
a dinner party given for the Russian poet
Andrei Voznesensky. Liberman, with his typi-
cal modesty, described himself as being "hon-
ored" to be invited to the party.[2] He had long
admired Voznesensky's verse (which he had
read in the original Russian), as well as the
poet's political courage. During the evening,
Mrs. Grosman delighted them both by asking
if they would like to collaborate on a book. It
was decided that Voznesensky—a man of peri-
patetic and unpredictable habits—would select
the verses to be used and write them on plates
that could be printed by the hand-fed offset
press. Liberman would create his images inde-
pendently. Although she always preferred hav-
ing artist and poet work together so that the
poetry and the imagery were created in tan-
dem, most of the collaborations at ULAE actu-
ally started with a preexisting text. Hartigan's
Archaics was inspired by Barbara Guest's
poems, Motherwell worked from a book of
Alberti's verse, and Robbe-Grillet's verses were
set before Rauschenberg started on *Traces
Suspectes et Surfaces*. The new arrangement
seemed perfectly natural to the artist. In the
same spirit, Liberman has never made a sculp-
ture for a specific site, although many of his
sculptures have been placed against large
buildings and in public spaces.

As was her practice, Mrs. Grosman
brought the first aluminum plates to
Liberman's studio so that he could work on
them in privacy. Once they were under way, he
decided that Long Island would be a better
place to work. From a practical point of view,
the proofing and page layout could be done
only in the studio. From an aesthetic point of
view, Liberman knew that the stones were more
sensitive than aluminum plates. When
Liberman's images were complete, the real col-
laboration began. With Mrs. Grosman, Bill

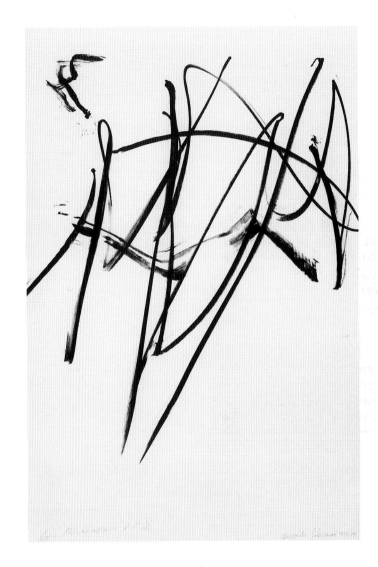

100. Alexander Liberman, *Nostalgia for
the Present: Page 7*, 1977-79. See cat. no. 8.

Goldston, and Keith Brintzenhofe in attendance, Liberman selected the paper, decided to ink the edges of the stone as a frame for the text, and began the agreeable task of combining the poet's and the artist's work for each page.

Liberman has always been lavish in his praise of other artists' work; his deference to Voznesensky is both graceful and subtle. *Nostalgia for the Present* (cat. nos. 1-20) has two kinds of calligraphy: Voznesensky's verses and Liberman's energetic crayon work. Where the poet wrote, the artist refrained from writing and only painted; the artist's writing appears only on pages with no text. Liberman's design for the box could not have been simpler: on a porcelain-perfect white container, a single stroke was printed, the shared and elemental act of draftsman and poet.

Notes:

1. Rose, 1981, p. 176.
2. Liberman, letter to Sparks, July 25, 1985.

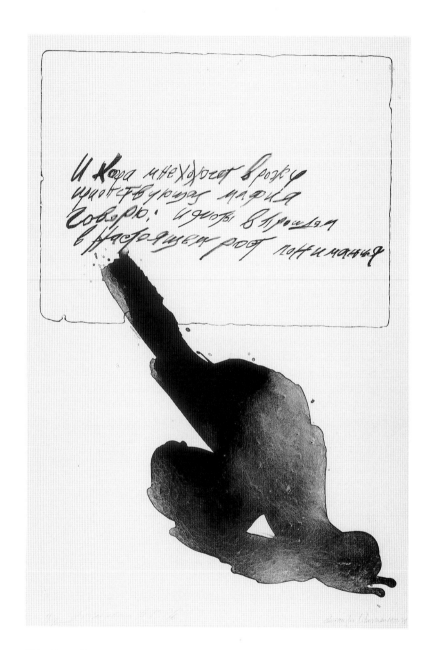

101. Alexander Liberman, *Nostalgia for the Present: Page 13*, 1977-79. See cat. no. 14.

Jacques (Chaim Jacob) Lipchitz

(Russian, Druskininkai, Lithuania 1891-1973 Capri, Italy)

Working in Paris as part of the generation that included Gonzalez, Picasso, Brancusi, and Archipenko, Jacques Lipchitz turned away from the naturalistic tradition of Rodin and Bourdelle to find inspiration in the subjectivity and formal power of primitive art. Like most of his friends and colleagues, Lipchitz was led by Picasso and Braque. His sculpture of 1915 to 1920 resembled nothing so much as Picasso's Synthetic Cubist canvases, the painted planes cast into three solid dimensions of bronze and the painted modulations of color rendered as softly textured surfaces. By the mid-1920s, Lipchitz's work became much more monumental. The individual elements were still quite angular but much reduced in number and polished to allow light uninterrupted passage across the surface. However simplified, these forms were then—as always in Lipchitz's work —clearly based on the human figure.

As émigrés from Paris to New York in the 1940s, the Grosmans and Lipchitz had much in common. They had moved in the same circle in Paris, and when the Grosmans arrived in New York, Lipchitz invited the couple to stay in his apartment until they found quarters of their own. Lipchitz exhibited at Curt Valentin's Buchholz Gallery from 1942 to 1952, as did many other expatriate Europeans. Mary Callery, who later befriended the Grosmans, was also a Buchholz artist. In 1952 Lipchitz's sculpture and drawings were shown by Frank Perls, who is said to have loaned the Grosmans a Picasso drawing to reproduce by screen-printing.

Lipchitz had always believed that an artist learned by working in techniques that were not his principal métier. As a student, he learned the habit of drawing as naturally and regularly as a dancer might practice. Drawings were often included in his exhibitions of sculpture and, on occasion, presented alone. In 1942-43 he studied engraving with Stanley Hayter, whose Atelier 17 (both in Paris and New York) was the center for technical innovation in intaglio printmaking for two generations of graphic artists. Stimulated by Hayter, Lipchitz experimented in both intaglio and lithography but stopped abruptly when he felt that printmaking distracted him from his sculpture.

In the early 1960s, Lipchitz took up lithography again, working directly on stone in workshops in Florence and Los Angeles. As before, his printmaking activity was an outgrowth of his drawings, a means of multiplying those images rather than exploring unfamiliar territory.

Several of the Grosmans' friends in the art world helped them by providing drawings for Maurice Grosman to reproduce by screenprinting. Mary Callery, a mutual friend, was the first to contribute a drawing of her own, and it is likely that the drawing for this screenprint was an instance of similar generosity on the part of Jacques Lipchitz.

According to a memorandum dated January 24, 1967, written in Maurice Grosman's handwriting, labels for *The Couple* were printed by Douglass Howell on handmade paper.

We have not been able to locate an example of this print.

102. Marisol, *Pappagallo*, 1965. See cat. no.
3. *Pappagallo* is among the boldest of a
group of drawings of 1963-66 in which
purely geometric patterns are played off
against outlines of body shapes. Before and
after this brief period, Marisol's abstract
forms have a much more organic, even
anthropomorphic, character. Using color
here for the first time in lithography,
Marisol emphasized the negative spaces
that add an element of mystery to all her
graphic work.

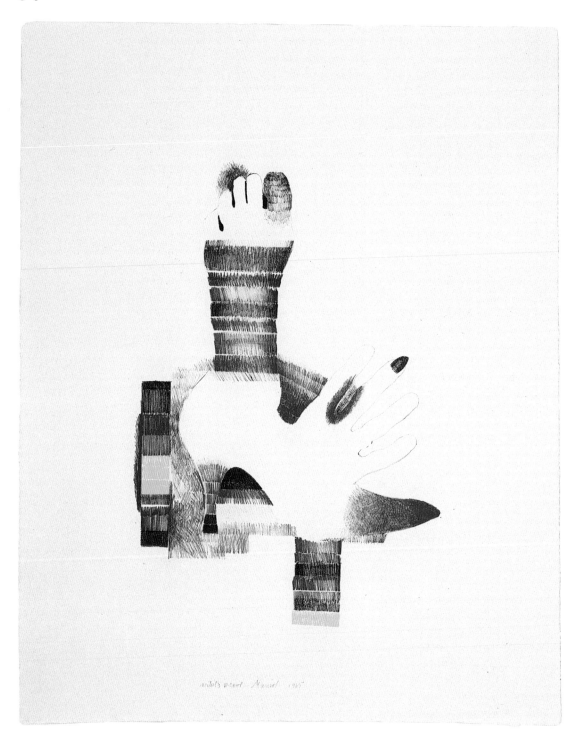

Marisol (Escobar)

(American, b. Paris, 1930)

Marisol has always resisted categories: no national, stylistic, or interpretive niche has ever quite contained her personality or her art. Latin America has claimed her because her parents were Venezuelan. In 1968 the Venezuelan Pavilion at the Venice Biennale held a one-person exhibition of her sculpture; museums in Latin America have shown and purchased her work. These native honors confirmed, but did not establish, her reputation. Like Matta, Wifredo Lam, and Mauricio Lasansky, she made her reputation in the North Atlantic countries, and her major works are found in North American collections.

Her first art teachers were Howard Warshaw and Rico Lebrun at the Jepson School, which she attended while a student at the Westlake School for Girls in Los Angeles. After graduating from Westlake, she returned to Paris (where she had previously resided) for a year of study at the Ecole des Beaux-Arts and the Académie Julian. In 1950 she moved to New York, enrolled in Yasuo Kuniyoshi's class at the Art Students' League, and, through naïveté rather than intrepidity, became part of the art life in Greenwich Village. Of the artists she met, she most admired Jasper Johns and Robert Rauschenberg.

Within three years, Marisol taught herself the skills she needed to work in wood, metal, plaster, and paint. She perfected her drawing in classes at the New School in New York and in Hans Hofmann's summer sessions in Provincetown, Massachusetts.

In 1953 Marisol stopped painting and began to concentrate on making small figurative clay sculptures. They were shown in New York at the Tanager Gallery, a cooperative for young artists. Encouraged by the response to her work, she began to enlarge its scale, putting aside traditional carving and casting and using ready-made pieces she found in lumberyards and secondhand shops. Many of the artists she knew were exploring junkyards, ethnographic museums, and jukebox culture. The sculptor William King introduced her to Early American furniture and folk art. On her own, she found Mochica pots, painted Mexican boxes, and other forms of folk art whose simplicity influenced her work.

Marisol's career was launched by her exhibition at the Stable Gallery in 1962. The show was one of the smash hits of the season; this was the year the popular press "discovered" Pop Art. Marisol's work was soon shown at the Museum of Modern Art. She became a Pop celebrity when she starred in Andy Warhol's film *The Kiss*.

Leo Castelli, the principal champion of Pop Art among the New York dealers, held an exhibition of Marisol's work in 1957, the inaugural year of his gallery. Like the other Pop artists, she reacted against abstraction and used commonplace materials in a way that left considerable leeway for interpretive speculation. But there were important differences between her art and that of other artists. Marisol escaped the "vulgarian" label of Pop Art[1] by the elegance of her taste and craftsmanship. She did not use commercial techniques or imagery. Whereas mainstream Pop Art was a brash assault on the sensibilities, Marisol's message—and her humor—are elusive. In 1964 Lawrence Campbell asked Marisol about the plaster casts of her own face that she applied to almost every figure she made, regardless of sex, age, role, or physical type. They kept her, she replied, from feeling "as though she were blowing away."[2] Placing her own face on these wooden bodies literally externalized her self to the outer world.

Her sculpture deals with a variety of social themes: poor migrant workers, the idle rich, social caste, and male chauvinism. Speaking of her work in the 1960s, Marisol told Cindy Nemser: "It's criticism—social criticism. I'm surprised that, up to this day, some people never understood what I was saying . . . I always thought everybody knew it."[3]

In 1964 Marisol made her first print for

ULAE. "I was never interested in prints," she said in 1975. "People talked me into it. They talked me into making them. I felt, for a long time, that if people asked me to do something I should do it."[4] This diffidence may provide a perspective on the prints she made—their subject matter, their technique, and their relation to her larger works.

Marisol's work at ULAE falls into two distinct groups: five lithographs made in 1964-65 and sixteen lithographs and intaglios published after her return from Asia in 1970. The first two prints, *Furshoe* (cat. no. 1) and *Shoe and Hand* (cat. no. 2), set a pattern for the early group. She could have used the lithographic stones as sketches for, or reprises of, her larger work. Instead, she chose to elaborate on the body parts or accessories that actually bore a major part of the expressive message of the sculptures. As Leon Shulman pointed out, Marisol's sculpture seems calm, even monumental; the tension lies in the details, which are usually painted or drawn.[5] The five early lithographs all have a tracing of her hands, other body parts, or possessions—graphic equivalents of the plaster casts she used in her sculpture. They refer to reality, but at a distance. The hatching that "colors" these elements is correspondingly ambiguous: It has the texture, canniness, and promise of traditional volumetric modeling, yet it is used for a contrary purpose. The strokes are arranged in geometric bands or gathered into coloring-book-like islands. In short, the gestures deny the delicate verisimilitude of the outlines. The objectivity lies in Marisol's execution of these personal elements; the subjectivity lies in their juxtaposition.

By 1968 Marisol had become disenchanted with the art scene in New York, tired of the anger and despair she saw among her friends and in the Vietnam War protest movement. She decided to satisfy her curiosity about other cultures. She spent almost a year in Asia—India and Nepal, Indonesia and

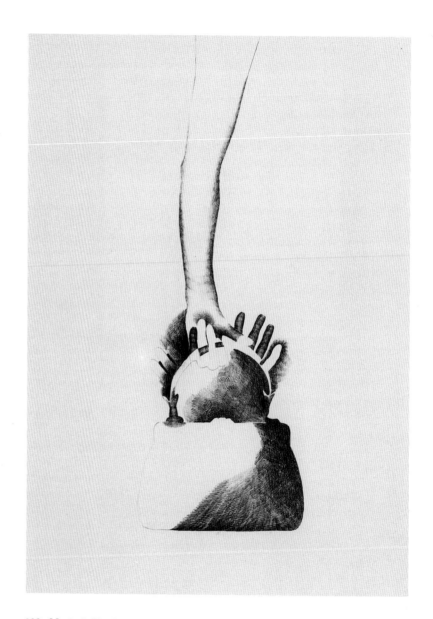

103. Marisol, *Hand and Purse*, 1965. See cat. no. 4.

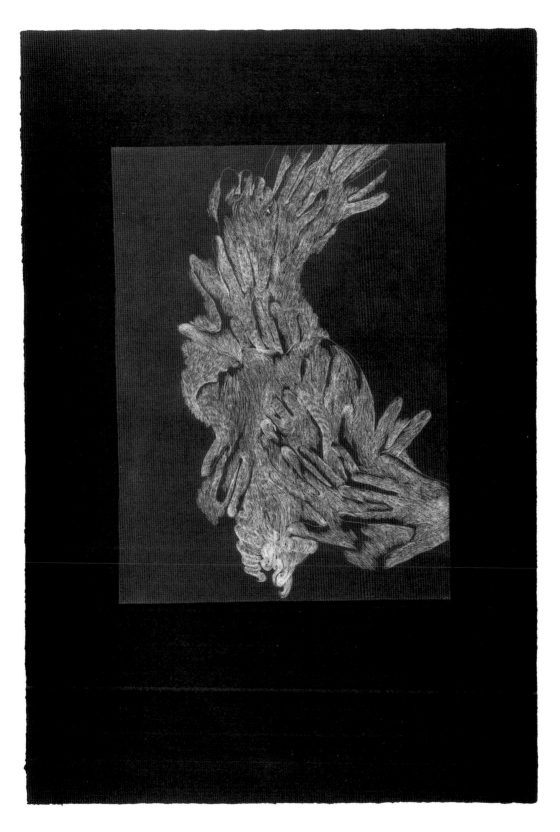

104. Marisol, *Pnom Penh, Two*, 1970. See
cat. no. 8.

105. Marisol, *Catalpa Maiden About to Touch Herself*, 1973. See cat. no. 17. Picnicking under the catalpa tree at West Islip was a frequent occurrence. For this print, Marisol used the catalpa leaves to trace her hands and arms, then inked the leaf-stencils and pressed them on the stone. She completed the image by employing additional leaves, her own hair, and a crayon.

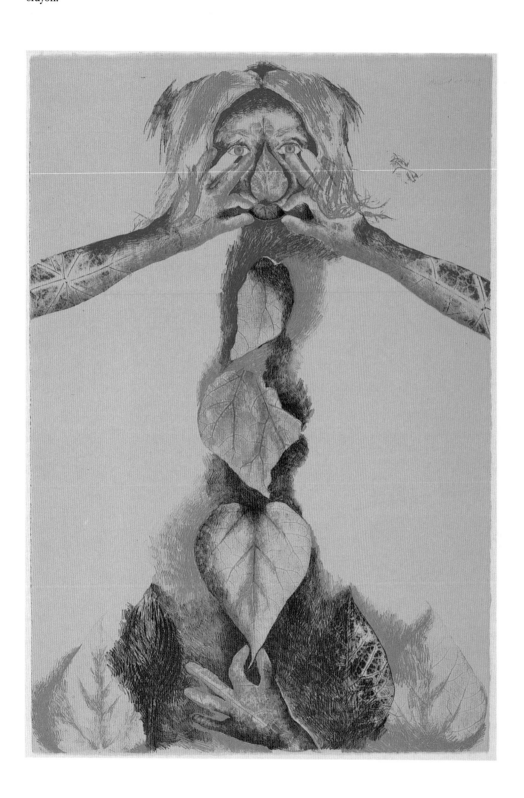

106. Marisol, *Cultural Head*, 1973. See cat. no. 21. This image, literally "speaking" her name in red, commemorates Marisol's first one-person exhibition in a New York museum (the Cultural Center).

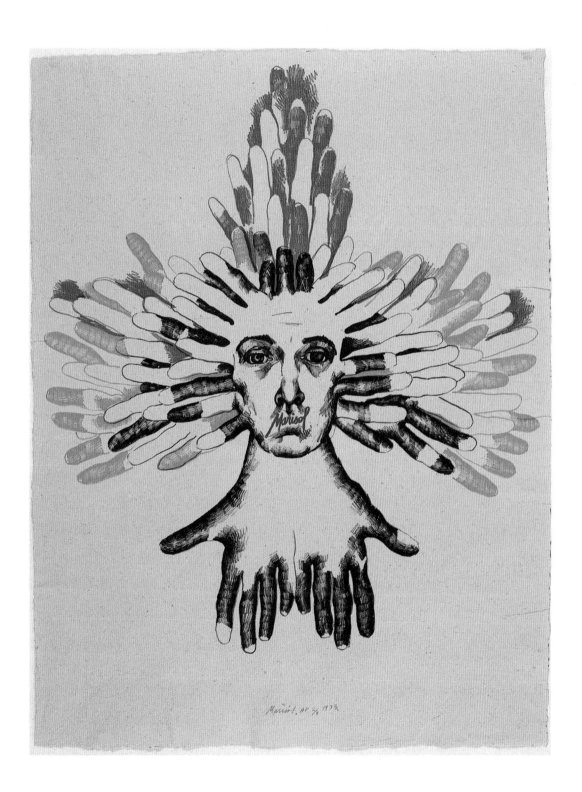

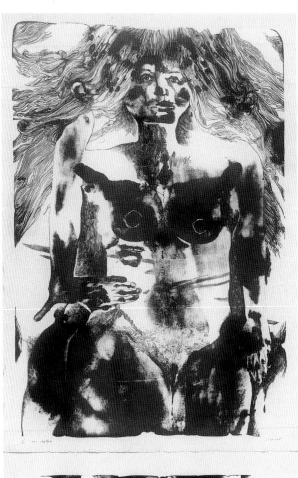

Micronesia—reveling in the exotic and elaborate carvings of temples and thousands of smaller objects. In 1969 she stopped for four months in Tahiti, where she learned to swim with fins and aqualung, an experience she described as being "reborn—cleansed and purified."[6] After her return to New York in January 1970, a "new" Marisol emerged. She cared less for public or critical attention and spent hundreds of hours carving, polishing, and varnishing wooden sculptures in the shape of fantastically elongated fish. Her graphic style also changed radically. The first etchings she did after her return seem almost to be by another artist. Curved bands of tight, parallel hatching gave way to a longer, looser stroke, similar to the gesture used in her post-Tahiti pastels. The familiar repertory of self-portraits and body tracings is present, reshaped into larger, undulating movements. The black paper versions of *Pnom Penh* and *Kalimpong* (cat. nos. 8, 9) were directly inspired by Tibetan *tankas*, especially those with metallic outlines on black cloth.

In *French Curve* (cat. no. 6), the draftsman's template and hands are arranged to overlap and cancel each other. In *Pnom Penh* (cat. nos. 7, 8) and *Kalimpong* (cat. nos. 9, 10), hands and feet create eddies and countereddies, their movements implied by the pattern of etched lines.

In 1971 Mrs. Grosman encouraged some of her artists to make large prints for a ULAE retrospective to be shown in the imposing galleries of the Corcoran Gallery in Washington, D.C. She suggested that Marisol use two stones for a giant female image to be made as a Japanese *gyotaku* print (a traditional way of keeping fishing records by pressing a fish against paper; its usage in fine art is documented as beginning in 1862). She tested her plan in *Five Hands and One Finger* (cat. no. 11) by oiling her hand and placing it on the stone as a sketch, then adding a considerable amount of drawing. Elaborate preparations were made for

the big diptych print (cat. no. 12).[7] Two large
and extremely heavy stones were laid on the
studio floor, windows were covered, and every-
one left Marisol alone as she disrobed, oiled
her body, and placed it against the stones. The
extra feet at the bottom were made when Mari-
sol literally walked out of her picture.

The etchings Marisol started in 1969,
working on small plates that Donn Steward
brought to her studio, are uniformly autobio-
graphical and usually—to use her own term—
"spooky." *The Death of Head and Leg* (cat.
no. 13) and *I Hate You* (cat. no. 19) have a Fran-
kensteinian quality. *Self-Portrait* (cat. no. 14)
and *The Spoon* (cat. no. 15) have often been
compared with Odilon Redon's more spectral
images. Even her celebrated color print
Catalpa Maiden About to Touch Herself (cat.
no. 17) transforms an erotic opportunity into a
hostile conundrum.

In her largest print at ULAE, Marisol
returned to the traced fingers she had started
with nine years earlier. *Cultural Head* (cat. no.
21) was designed as a poster for her retrospec-
tive of prints at the New York Cultural Center;
an edition of twelve was also published. It is a
startling image of the artist revealed: her
mouth has become her name; her hands have
made a cross surrounding her head like an
aureole or perhaps like a symbol of crucifixion.

Notes:

1. Kozloff, 1962, pp. 34-36.
2. Campbell, 1964, p. 41. Marisol has also acknowledged
that she had been deeply impressed by Jasper Johns's
painting *Target with Four Faces* (1955; The Museum of
Modern Art, New York).
3. Nemser, 1975, p. 187.
4. Ibid., p. 193.
5. Worcester, 1971, unpaged.
6. Athens, Ohio, 1974, unpaged.
7. Goldston, letter to Sparks, August 24, 1982; Marisol,
letter to Sparks, July 22, 1985.

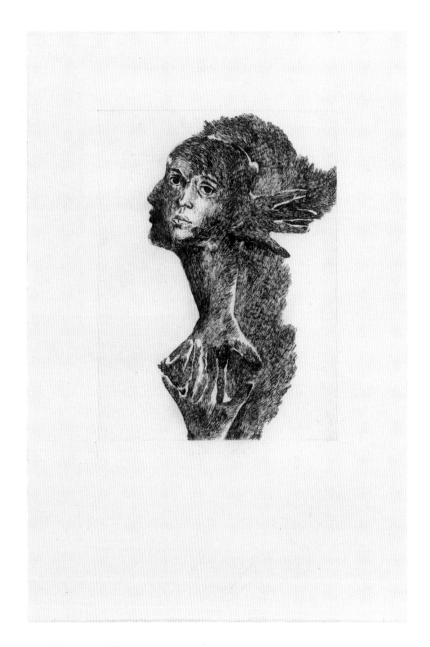

108. Marisol, *Self-Portrait*, 1970-73. See
cat. no. 14.

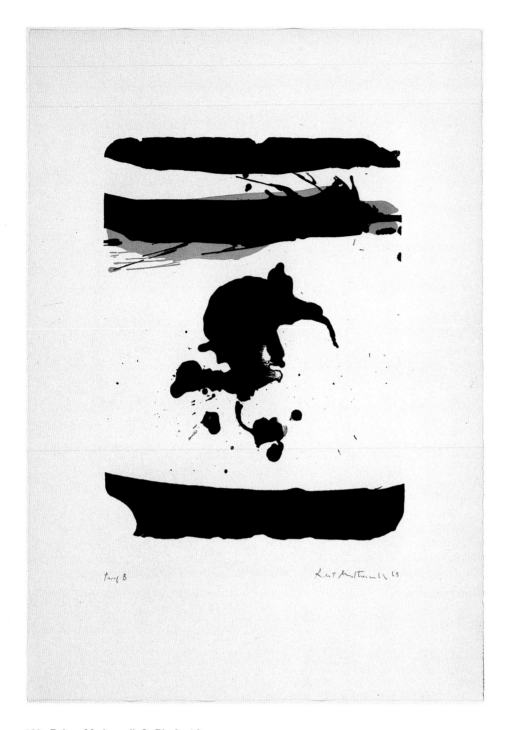

Proof B Robert Motherwell 63

109. Robert Motherwell, *In Black with
Yellow Ochre*, 1963. See cat. no. 3. For his
third print done at ULAE, Motherwell
wanted to re-create on paper the effect of a
painting with the same title done in 1960
(Mrs. Henry Cobb, New York). The print
is also related to a series of gestural ink
drawings done in Provincetown, Massa-
chusetts, during the summer of 1962. The
two upper, horizontal bands of color give
the lithograph a balance that pleased Mrs.
Grosman and also anticipated the
increased formality of Motherwell's prints
of the late 1960s.

Robert Motherwell

(American, b. Aberdeen, Washington, 1915)

Robert Motherwell is two people: an artist who interacts spontaneously and sensuously with his material and a man of letters. Trained as a philosopher, he was a professor for many years. Through lectures, writing, and editing the notable *Documents of Modern Art*, Motherwell has become one of the most eloquent spokesmen for abstract art. His study of Delacroix, then of Matisse, Picasso, Klee, and Miró, made him intensely aware of himself as an actor in the unfolding chronicle of modern art. Very early he had concluded that representational art—even the Surrealist variety—was a dead end. Only abstract art is modern, he said, because it is "a fundamentally romantic response to modern life—rebellious, individualistic, unconventional, sensitive, irritable."[1] The prints he made at ULAE from 1961 to 1965 are classic examples of Motherwell the Abstract Expressionist. But however brutal the component gestures, Motherwell's work essentially remains cooled by the refinement of an Apollonian taste.

Although the seventeen prints that Robert Motherwell did at ULAE represent less than a tenth of his graphic work, they comprise a synoptic view of the principal themes, sources, and methods of his art. Motherwell himself has consistently provided the most articulate analysis of his graphic work. "I recognize color before shape," he told Stephanie Terenzio.[2] Color is not only the most important element in his work, it is also symbolic: Motherwell associates red with blood, wine, and hunters' caps; ocher recalls the color of California hills; blue is a favorite because of his lifelong habit of summering by the sea; white is Mallarmé's white paper, awaiting a word. Black—signifying death, anxiety, Goya—has always been the alpha and omega of his palette. These associations reveal the intensity with which Motherwell immerses himself in the materials and elements of his work and the breadth of intellectual experience he brings to it.

110. Robert Motherwell, *Gauloises Bleues*, 1968. See cat. no. 4. Motherwell's collages were acclaimed even before his paintings. In 1968, the year his collages were exhibited at the Whitney Museum of American Art, New York, he concentrated at ULAE on transferring that sensibility to printmaking. The trial proofs for *Gauloises Bleues*, with their arrangements of discrete whole elements, reveal this collage approach. For the final result, Motherwell simplified the work even further, using a subtle, cream-colored background and hand-tearing each cigarette package label. The *Gauloises Bleues* aquatints (cat. nos. 4, 8-10) were the first prints in which Motherwell used product labels, either as collage or simulated.

When he was three, Motherwell's family moved from Aberdeen, Washington, to San Francisco. After graduating from preparatory school, he studied briefly at the Otis Art Institute, then entered Stanford University, where he majored in philosophy and began to delve into modern art, music, drama, as well as psychoanalysis and French literature. He attended a graduate program in philosophy at Harvard University and, in 1938-39, spent a year abroad writing a master's thesis on Eugène Delacroix. He also studied French art from Symbolism to Surrealism.

The Surrealist principle of psychic automatism—a way of disrupting everyday connections, of mining the unconscious for new, abstract forms to convey emotions and experiences—proved especially fruitful for Motherwell. For example, his *Beside the Sea* watercolors arise from and convey the direct experience of nature.[3] The same spirit informs his *Throw of the Dice* lithographs of 1962-63 (cat. nos. appendix 1-7), which followed immediately thereafter.

These spontaneous watercolors and prints of the early 1960s were but one facet of his work. At the same time, he was producing collages that have been ranked among the masterpieces of the genre. The first one was a piece of delightfully Surrealist chance. In 1943 Peggy Guggenheim asked Motherwell and Jackson Pollock to make collages for a group exhibition in her gallery. Pollock provided the studio and materials for the experiment. For Motherwell, the sensuous interaction with materials was a revelation, akin to play. Occasionally, and only in collage, autobiographical elements crept in. When he went to ULAE in 1968 to try the new etching press, his first effort was a "collage print" (cat. no. 4), using a hand-torn label from a French cigarette, Gauloises Bleues. In this way, he followed Pablo Picasso and Georges Braque, who incorporated into their work bits of daily newspapers and café souvenirs not because they were of sentimental value but

simply because they were objects that were *there*. Collage became more important than subject matter to Motherwell; it was a way of thinking, a technique of visualizing the next step in a work of art. Time and again, when experimenting in the ULAE workshop, Motherwell picked up scissors and paper instead of brush and crayon.

Motherwell's love for the materials of his profession was a powerful ally in Tatyana Grosman's campaign to get him to West Islip. She had been trying since 1957, when they met at the home of Pierre Chareau, an architect who designed Motherwell's studio in East Hampton. One year later, she reintroduced herself, mentioning the Chareaus. She tried a new lure: for some time, she said, we have been doing limited-edition portfolios "on which the artist and the poet work together."[4] Motherwell, the man of letters, was beguiled; he invited her to call. But the stones brought to his studio lay untouched for a year or more, and finally Mrs. Grosman came to retrieve them.

Motherwell had made two etchings at Stanley Hayter's Atelier 17 in 1943-44 but found it embarrassing to work in the same room with older and more famous artists. Despite Hayter's encouragement, Motherwell returned to his own studio. It was not until 1961, when Helen Frankenthaler, then his wife, added her voice to Mrs. Grosman's, that he agreed to try lithography.

Mrs. Grosman told Stephanie Terenzio the story of their first session. After Motherwell had painted a great "P" shape on the stone (see cat. no. 1), he said to the printer, "Please clean up the margins." "It's your stone, your margins," said Mrs. Grosman. "You'll have to clean up your own margins." He was taken aback but immediately understood her point. "It's important how the image and the paper go one into the other," she said. "Nobody can do your margins."[5] Motherwell had been thinking of printmaking as it was done in the

111. Robert Motherwell, *Poet I*, 1961-62.
See cat. no. 1.

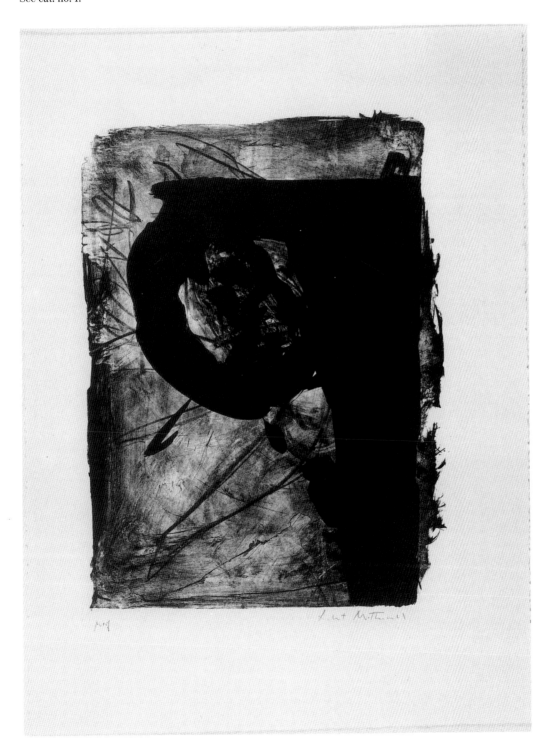

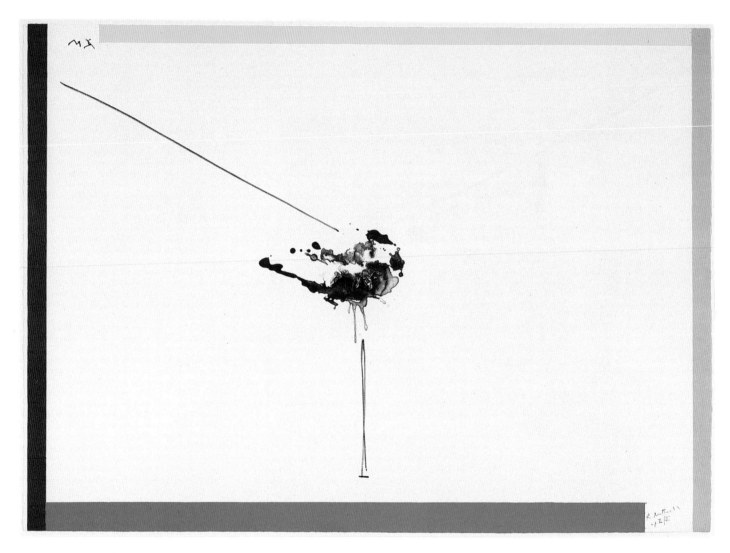

112. Robert Motherwell, *West Islip*, 1965-
70. See cat. no. 7. On each of the
impressions in the 1970 edition of twenty,
Motherwell covered the radiating line at the
right with opaque acrylic paint. Twenty-five
more impressions, signed in 1982, do not
have this color addition (see app. no. 9).

113. Robert Motherwell, *Gauloises Bleues
(Raw Umber Edge)*, 1971. See cat. no. 9.
The details of Motherwell's prints reveal
the artist's extraordinary sensitivity. Here,
the blue aquatint field appears to have an
undertone of cream; likewise, the "umber
edge" seems to have a second color
underneath. The illusory undertones are an
effect of the properties of the best quality
printing inks. The "mass tone" lies on top
and is the most apparent color; the
"undertone"—missing in thinner inks—
creates a depth analogous to the
underglazes in painting.

French "production houses." But his exacting publisher wanted what he later called "the graphics of a painter."[6]

Once the matter of the margins was settled, the *Poet* lithographs went smoothly. The image was one Motherwell had used several times in the recent past: in *NRF Collage No. 1*, 1959 (Whitney Museum of American Art, New York) and *Figure 4 on an Elegy*, 1960 (H. H. Arnason Estate, Roxbury, Connecticut). The next lithograph, *In Black with Yellow Ochre* (cat. no. 3), also related to several preceding works, especially a 1960 drawing of the same title (Mrs. Henry Cobb Collection, New York). The first two had been extensions of his ink drawings onto a new surface. For *In Black with Yellow Ochre*, he wanted the effect of a painting, and Zigmunds Priede printed the inks so that the colors would interact as wet paint.

The next project almost brought Motherwell's printmaking at ULAE to an end. In 1962 he had made a series of black-and-white gestural watercolors titled *Beside the Sea*,[7] and he wanted to create lithographs with the same spontaneity. Ben Berns prepared a number of stones on which Motherwell brushed and flung tusche as he had on paper. But Mrs. Grosman did not approve. In a classic illustration of how she handled the rare occasions when she disagreed with her artists, she avoided a direct confrontation. Her opinion, expressed evasively, was that "they were not for publishing."[8] Various trial proofs of *Throw of the Dice* (cat. nos. appendix 1-7) exist, some printed on colored paper and others printed with a second stone in ocher. They were signed and embossed with the ULAE seal but never announced as an official ULAE edition.

The next print was also aborted in mid-production. Two black stones were printed on generous sheets of Rives paper, a gestural drawing at the center with three lines radiating toward the edges. After one impression was signed and given to the Museum of Modern Art, the rest were wrapped and put away

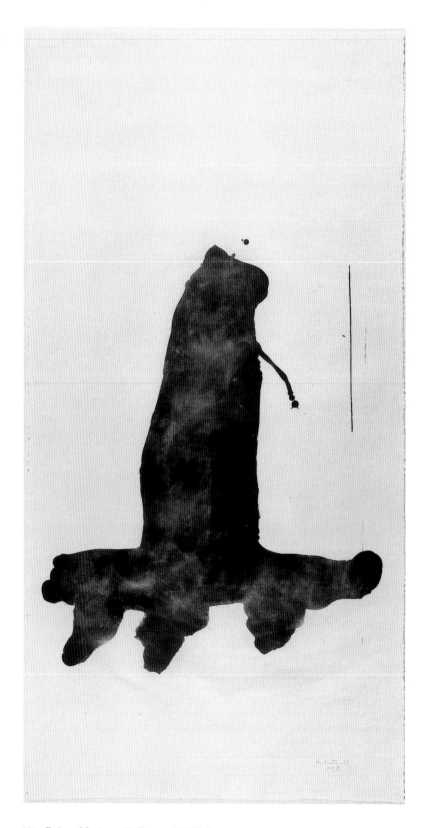

114. Robert Motherwell, *Samurai*, 1971. See cat. no. 11.

because Mrs. Grosman did not want to release them as an edition. In November 1970, when Ben Berns returned to work with Motherwell on the three *Stones* lithographs (cat. nos. 12-14), Motherwell added a plate to print a colored border on the untitled proofs and the result was *West Islip*, 1965-70 (cat. no. 7).

Given these frustrations, it is ironic that printmaking became for Motherwell— as it did for Barnett Newman—a medium that helped break a creative stalemate. In 1965, suffering from the slump that many artists feel after a major retrospective, Motherwell went to Irwin Hollander's New York workshop to make lithographs. He worked with the printer Emiliano Sorini in a collaboration that buoyed his spirits and provided the mental stimulus he needed. It was Mrs. Grosman's good fortune to have already issued the next challenge: When Motherwell returned to ULAE in 1968, it was to create the *livre d'artiste* she had proposed to him in 1957.

Motherwell was the only artist Mrs. Grosman had invited to create images for a text of his own composition. Motherwell demurred, waiting until 1967, when he found *A la pintura*, an ode to painting written by the Spanish poet Raphael Alberti. For many years, and most notably in his paintings *Elegies to the Spanish Republic*, Motherwell had acknowledged the visual severity and tragic vision he had learned from the land of Castile.

When Motherwell wrote to say that he wanted to use the Alberti poems, Mrs. Grosman made rapid and unusual arrangements. Motherwell and Helen Frankenthaler, contrary to all precedent, were invited to work in the studio on the same day at the same time. Frankenthaler preferred the lithography studio; Motherwell descended to the new etching press downstairs to work with Donn Steward. In three days, they finished *A la pintura: Black 1-3* (cat. no. 19), a page that became the criterion by which subsequent pages were judged.

With two pauses (September 1968 to February 1969 and December 1969 to January 1971), Motherwell worked with Steward quite steadily for the next four-and-one-half years. In forty or more sessions, they produced hundreds of sketches, collages, and printing samples. Initially, the archival material was kept because Motherwell prefers to work in his own environment. Steward created that environment for every visit by pinning up the work Motherwell had finished on his previous visit and starting each session with a careful review of the last.

As Motherwell has often said, the sympathetic relationship of artist and printer was not only a critical aesthetic determinant but one of the principal satisfactions of the work. Steward provided the techniques that minimized the differences between printmaking and Motherwell's customary media, paint and collage. He also satisfied Motherwell's demand for color of Venetian depth and sublety.

A la pintura is related to a series of paintings Motherwell titled the *Open* series, in which a U-shaped "window" is drawn on a field of rich color. Motherwell discovered the motif by accident in 1967 when he noticed a small canvas leaning against a larger one on the floor of his studio. He liked the relationship of the two rectangles and outlined the smaller one on the larger. When it was turned upside down, the U shape suggested scores of ideas: architectural, philosophic, poetic, and "an opening from an interior world to an external world."[9]

The idea of the "word in the painting" had originally drawn Mrs. Grosman to Motherwell's work. Their combination in *A la pintura* represented an ideal of visual and verbal union she had always cherished: as word interacts with image, image interacts with image. The last *Blue* (cat. no. 26), for example, restates the first (cat. no. 22). It also predicts the weight and flaglike crispness of the next page, *Red 1-3* (cat. no. 27). As each page is turned, new links emerge. Each subsequent

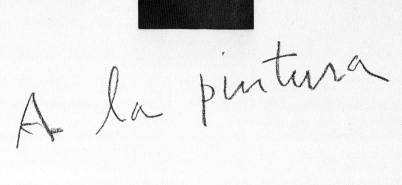

A la pintura

From 'La arboleda perdida,' 1959

Few have been as convinced as I was at fifteen that their true vocation
lay in the arts of painting and drawing....

In a few months I knew the Museo de Reproducciones by heart....
Without abandoning my drawing entirely, I went on to explore other
media whose difficulty I guessed at a glance: I set up my easel in
the Prado and worked as a copyist. For the first of my efforts I chose
a dead St. Francis, attributed to Zurbarán.

I have not yet spoken of the wonder I felt on the occasion of my first
visits to that treasure, the Prado. Nursed on the mediocrity of color
reproductions and some landscapes of the "school of Velázquez"
that found their way to our Andalusian village and the walls of my
grandfathers, I had thought–heaven knows why–that all the
painting of the past was by nature murky, sallow as a clod, alien
to all the sky blues, the reds and the pinks, the golds, the green
and the white that suddenly burst like a revelation in the paintings
of Velázquez, Titian, Tintoretto, Rubens, Zurbarán, Goya...
Disclosed to that innocent gaze–not without an initial indefinable
blush–were the opulescent splendors of the flesh tints of Rubens,
the power of the Graces, overflowing Pomonas, nymphs fleeing
through forests, Dianas adorned with trumpets and dogs,
tall Veroneses with girdles unbound, nude goddesses, flooding the
nocturnal watches of an adolescent and filling him with unrest....
In the whole school of Venice, in Titian, in the Maytime of Veronese
murals, in the hot golds of Tintoretto, I recognized, without puzzling
it through, how much sky blue and white, how much sun and
Mediterranean air had been packed into the marrow of my Italian-
Andalusian bones. These paintings raced day by day in a ripened
fulfillment of naked refinement, the golden age of color, the
unutterable image of erotic desire, of passion unfettered and crammed
with the whole of our senses. I had thought, calling to mind the few
reproductions in books and magazines I had seen at my Aunt Lola's,
that not only the gloom of the colors, but the subject of classical
painting itself was religious, and that nothing but devils and angels,
virgins, Christs, saints, popes, monks and nuns of all orders filled the
walls of museums. How shockingly the immense central gallery of
the Prado was to alter that provincial illusion!...For I came to
understand that, notwithstanding the airy grays, the silvers and sky
blues and pinks of Velázquez, the heavenly nebulosities of Murillo, the
incandescent blues of El Greco, the ivories and whites of Zurbarán,
the chromatic intensities of Goya, my blood and my vision belonged
wholly to that world of green and gold paganism, of which Titian
above all others–¡oh Tiepolo!–was absolute master. It was he, more
than all other painters, his exact feeling for radiance in art, who
confirmed in me, beyond all possible doubt, that my roots went down
to those civilizations of sky blues and whites–all I had soaked up
since childhood in the common facades of El Puerto, in the doorframes
and windows of the villages there by the bay, darkened a little by
those bluer transparencies which come to us from the frescoes of Crete,
traversing all Italy, blueing the whole Mediterranean seashore
of Spain and the Atlantic, from Cádiz as far up as Huelva and the
boundaries of Portugal.

Rafael Alberti

Opposite above:
115. Robert Motherwell, *A la pintura: Frontispiece*, 1971. See cat. no. 15. Eleven years after Mrs. Grosman suggested a collaborative book to him, Motherwell found a text "whose every line set into motion my innermost painterly feelings" (New York, MMA, 1972, unpaged). It was a book of poems by the Spanish writer Raphael Alberti, a providential discovery to Motherwell, who had long been inspired by Spain and its Civil War. Technically and aesthetically, *A la pintura* stands as one of ULAE's most significant publications.

Opposite below:
116. Robert Motherwell, *A la pintura: Preface Page*, 1968-69. See cat. no. 17. These lines, from the poem *La Arboleda Perdida (The Vanished Grove)*, constitute one of the few instances in which alterations were made in the original text. Motherwell considered at least ten samples of typography before he made the final arrangements of letters, words, and paragraphs.

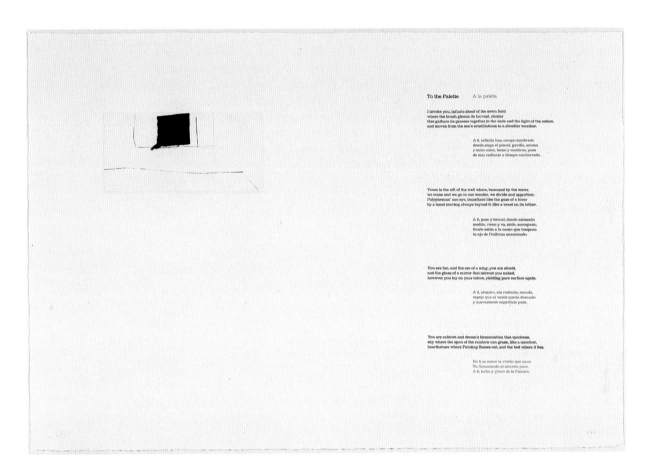

117. Robert Motherwell, *A la pintura: To the Palette*, 1968-71. See cat. no. 18. From a beginning marked by experimentation with complex and somewhat literal ideas of "Spanish color" and sketches of palettes, Motherwell moved toward a more simplified image. The black square was made from a piece of Japanese paper, which Motherwell pressed into the soft ground, etched, and preserved. Thus, collage as well as painting and drawing were employed in realizing this print. The palette-spectrum of color was eliminated from the image as too literal but reappeared as inking for the type in this page as well as *To the Paintbrush* (cat. no. 35).

viewing-and-reading enriches and illuminates the whole.

Long before it was officially finished, *A la pintura* had met its public. Many important visitors had seen the work in progress, six pages had been exhibited, and an exhibition at the Metropolitan Museum had been planned. Subsequent exhibitions of the book and its archives were held in seven cities, and its fame spread by a Blackwood Productions film made while Motherwell and Steward were still at work.

Starting in 1968, Motherwell also worked on the four collage prints *Gauloises Bleues* (cat. nos. 4, 8-10) and the two *Mezzotints* (cat. nos. 5, 6). In 1970 and 1971, his intaglio work was interrupted for three lithographs that are variations on the same stone: *The Celtic Stone*, *The Black Douglas Stone*, and *The Aberdeen Stone* (cat. nos. 12-14). The *Stones* are of an intermediate type: basically an *Open* image but having a composition as complex as a collage. Working with Berns again, Motherwell finished the *West Islip* lithograph (cat. no. 7) and made the monumental *Samurai* (cat. no. 11) in anticipation of a ULAE retrospective in the high-ceilinged galleries of the Corcoran Gallery of Art in Washington, D.C. When *Samurai* was finished, according to Ben Berns, Motherwell set aside "several large portfolios filled with all kinds of proofs and trials, some of which were very interesting."[10]

The success of *A la pintura* was particularly gratifying; Motherwell's other collaborations had not worked. The first project was a group of illustrations for Marianne Moore's translation of La Fontaine's *Fables*, which was stopped when the publisher, Curtice Hitchcock, died.[11] In the summer of 1967, Motherwell made a number of small black paintings for a new translation of Rimbaud's *Season in Hell* for the Museum of Modern Art.[12] He was very disappointed when that project was cancelled. While he was working at ULAE, the poet Tony Towle discussed a collaboration using some of his current work. Motherwell did make a drawing that was reproduced on the cover of Towle's book; the larger project was never started.

In 1978, when Mrs. Grosman returned from what proved to be a futile European "cure," she wrote to Motherwell, "The poem by Octavio Paz dedicated to you is marvelous. We have to discuss ideas how to publish it; it could be an exciting collaboration between you and the poet."[13] Sadly, it was too late to start again.

Notes:

1. Motherwell, 1951, p. 12.
2. Terenzio, 1984, p. 13.
3. For the location of these watercolors, see New York, MOMA, 1965, pp. 32-33 (ill.).
4. T. Grosman, letter to Motherwell, October 31, 1958.
5. Terenzio, 1984, p. 52.
6. Colsman-Freyberger, 1974, p. 129.
7. See New York, MOMA, 1965, pp. 32-33 (ill.).
8. Terenzio, 1984, p. 55.
9. Blackwood Productions, 1973.
10. Berns, letter to Sparks, February 9, 1985.
11. Düsseldorf, 1976, p. 99.
12. Arnason, 1982, pp. 221-26.
13. T. Grosman, letter to Motherwell, September 29, 1978.

118. Robert Motherwell, *The Celtic Stone*,
1970-71. See cat. no. 12.

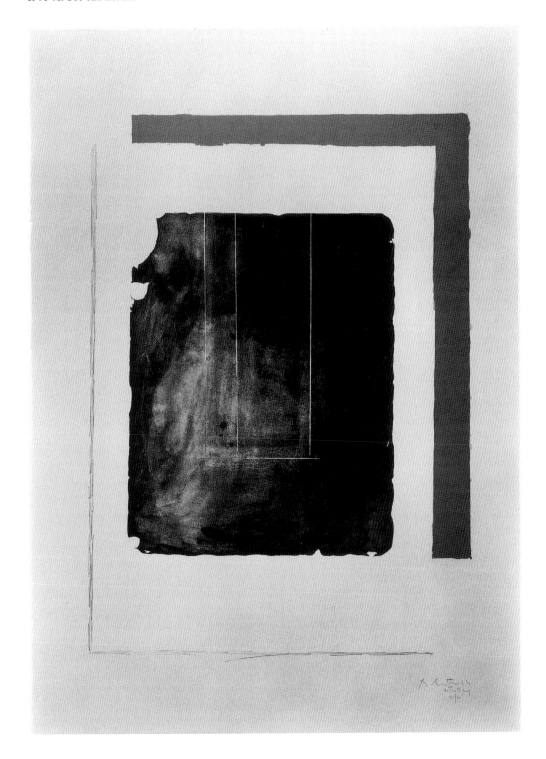

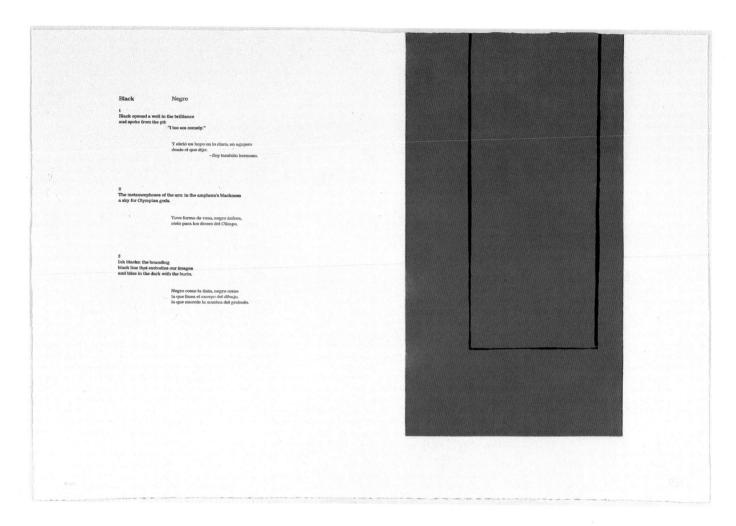

Black Negro

1
Black opened a well in the brilliance
and spoke from the pit:
 "I too am comely."

 Y abrió un hoyo en lo claro, un agujero
 desde el que dijo:
 —Soy también hermoso.

2
The metamorphoses of the urn: in the amphora's blackness
a sky for Olympian gods.

 Tuve forma de vaso, negro ánfora,
 cielo para los dioses del Olimpo.

3
Ink blacks: the bounding
black line that embodies our images
and bites in the dark with the burin.

 Negro como la tinta, negro como
 la que linea el cuerpo del dibujo,
 la que muerde la sombra del grabado.

119. Robert Motherwell, *A la pintura: Black 1-3*, 1968. See cat. no. 19. In creating this page, completed in the first three days he worked (May 15-17, 1968), Motherwell established his working sequence, starting with a full-scale painted sketch and ending with a plate related to his series of paintings titled *Open*.

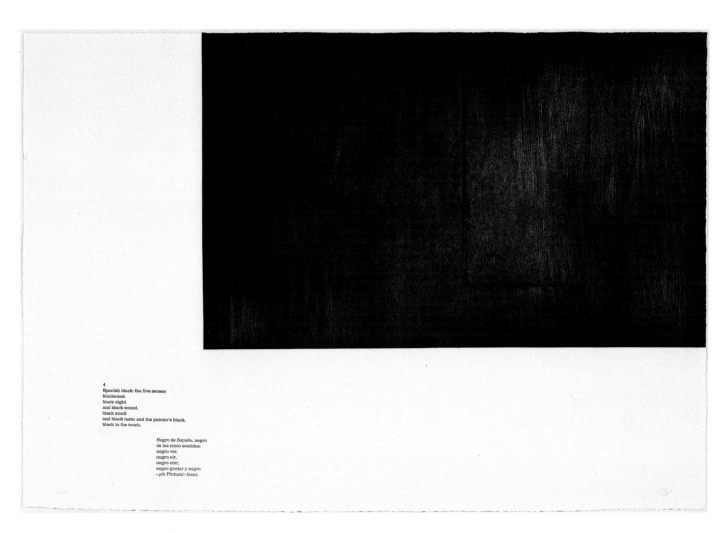

120. Robert Motherwell, *A la pintura:
Black 4*, 1968-69. See cat. no. 20. The two
colored rectangles here began as two pieces
of Japan paper. Changing the text from
gray to brown brought out the warm
undertones of the black aquatint.

5
Black of the burial cloths:
the sleep of my woven eternity
will not outlive
the yellowing horn of the bones.

Soy un negro mortaja sepultado.
Mi entretejida eternidad yacente
finará mucho antes
que la amarilla y dura de los huesos.

6
The black smell of ritual candles—blown out.

El negro olor a cirios apagados.

7
High Mass in the blackness of Zurbarán.

Negro misa solemne Zurbarán.

8
The personae of light. Unmask.
Still the blackness looks out of your eyes.

Tú eres la luz con antifaz. Lo quitas.
Pero sus ojos siguen siendo negro.

9
I blaze out of pulp, with a
parallel path for my papery brother.

Soy el hermano del papel, refuzco
en él como caminos paralelos.

10
There was always that tremor, that airy
caress in the hand of Manet.

Tuve siempre un temblor, una caricia
vaporosa en la mano de Manet.

11
Most purely of all,
intact and entire like the white of a wall,
I answer Juan Gris and Picasso and Braque.

Cuando soy puro, cuando
soy tan total como una pared blanca,
respondo por Juan Gris, Braque, o Picasso…

121. Robert Motherwell, *A la pintura: Black 5-11*, 1968-71. See cat. no. 21. This image is more illustrative than most pages: Alberti's verses *Black 5-8* mention the color in the text as well as the title. The ivory hue is the color of Alberti's cloth, paper, bones, and candles.

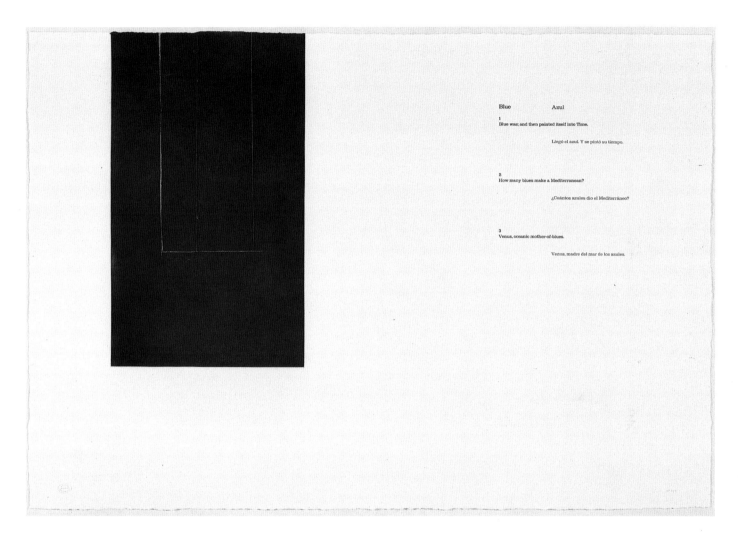

Blue Azul

1
Blue was; and then painted itself into Time.

 Llegó el azul. Y se pintó su tiempo.

2
How many blues make a Mediterranean?

 ¿Cuántos azules dio el Mediterráneo?

3
Venus, oceanic mother-of-blues.

 Venus, madre del mar de los azules.

122. Robert Motherwell, *A la pintura: Blue 1-3*, 1968-69. See cat. no. 22. In formulating his image for *Blue 1-3*, Motherwell drew an *Open* motif in white pastel on a piece of deep-blue tarlatan. This cloth sketch was also used in his experimentation for the *Blue 5* page (cat. no. 24).

4
The blue of the Greeks:
columnar, asleep upon plinths like a god.

El azul de los griegos
descansa, como un dios, sobre columnas.

123. Robert Motherwell, *A la pintura: Blue 4*, 1968-71. See cat. no. 23. *Blue 4* is one of Motherwell's most complex compositions. Unlike the pages for which a number of developmental proofs exist, all the preliminary work that Motherwell used came from the first collages.

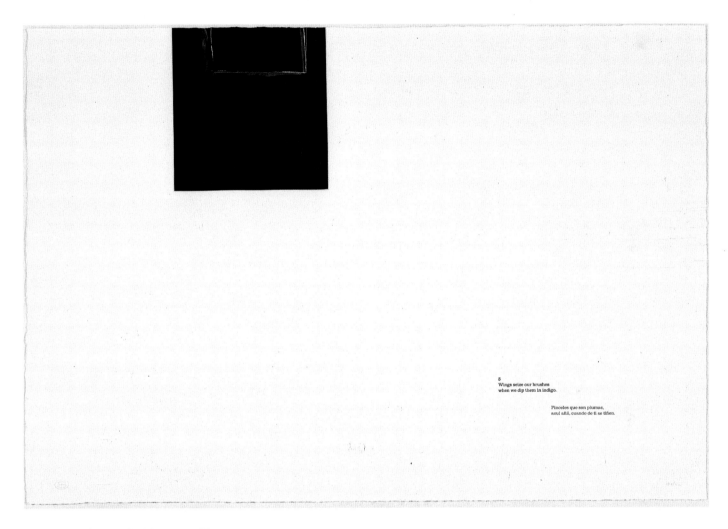

5
Wings seize our brushes
when we dip them in indigo.

Pinceles que son plumas,
azul añil, cuando de ti se tiñen.

124. Robert Motherwell, *A la pintura: Blue 5*, 1968-69. See cat. no. 24. In three intense sessions, Motherwell and Steward produced dozens of experimental steps leading to *Blue 5*. They constantly consulted previous trials, which were pinned to the walls of the studio. Until the very end of the proofing, a change in any element—color, texture, size, type—provoked a reconsideration of all others.

6
The Venice of Titian: a blueness gone gold.

Venecia del azul Tiziano en oro.

7
I poison myself with the blue Tintoretto.

Me enveneno de azules Tintoretto.

8
The phosphors and alcohol blues of El Greco.
The venom-and-verdigris blues.

Azul azufre alcohol fósforo Greco.
Greco azul ponzoñoso cardenillo.

9
In azure explosions: the allegories.

Explosiones de azul en las alegorías.

10
The blues of Manet: Spanish blue, sung
like a faraway echo.

En el azul Manet cantan los ecos
de un azul español en lejanía.

11
Sometimes the sea overflows
on the palette, and surrenders its secret
in sky-color, washes of heaven.

El mar invade a veces la paleta
del pintor y le pone
un cielo azul que sólo da en secreto.

125. Robert Motherwell, *A la pintura:
Blue 6-11*, 1968-71. See cat. no. 25. While
working on *A la pintura*, Motherwell and
Steward worked on single prints as well.
Blue 6-11 is closely related to *Gauloises
Bleues (Raw Umber Edge)* (cat. no. 9).

126. Robert Motherwell, *A la pintura: Blue
12-13*, 1969-71. See cat. no. 26. There were
several false starts for *Blue 12-13*, including
a very literal illustration of the geometric
figures mentioned in Alberti's poem
Blue 13.

Red Rojo

1
I strike through the greens of the fruit, and prevail.

Lucho en el verde de la fruta y venzo.

2
The apple's full flush in the round.

Pleno rubor redondo en la manzana.

3
Red in the shoulder's repose
and the haunches of Venus
–Giorgione–asleep.

Rojo para el descanso de los hombros
y la espalda de Venus
–Giorgione–dormida.

127. Robert Motherwell, *A la pintura: Red 1-3*, 1969-71. See cat. no. 27. Like Alberti's verses describing colors that evoke multiple images, Motherwell's black line plate suggests his loose gestural drawings as well as the severe *Open* motif.

128. Robert Motherwell, *A la pintura: Red
4-7*, 1968-69. See cat. no. 28.

8
Carnation explosions, erect
in the ivory round of the tightening nipple.

Como el clavel que estalla en los ceñidos
marfiles de unos senos apretados.

9
The poppy in fugitive cochineal.

Como el grana fugaz de una amapola.

10
Think how I dwindle away
in the least of the violets.

Pensad que ando perdido en la más mínima,
humilde violeta.

11
Brueghel's and Bosch's inferno:
the night-hag that stares
from the eyes of insomniac children.

Soy el infierno–Brueghel,
Bosch–y el nocturno espanto
en los ojos insomnes de los niños.

129. Robert Motherwell, *A la pintura: Red
8-11*, 1968-71. See cat. no. 29. This image
changed completely between its original
conception and the printing. For three
years, Motherwell had maintained the
austere mood of his *Open* series, although
his painting had become much looser and
more gestural. But here, inspired by the
"explosions" and "inferno" in the text, he
made *Red 8-11* one of the most dramatic
images in the book, thus signifying that his
"Florentine" mood had passed.

White Blanco

1
Walls are my history. To recover
that wonder, feast your eyes
on the thrust of those surfaces.

Mi vieja historia es la pared. Si buscas
deslumbrarte conmigo,
recréate los ojos en su tirante frente.

2
The whiteness of Crete: ablaze or lukewarm,
almost blue in its backward reflections.

Blanco de Creta, tibio,
caliente, casi azul, reverberante.

130. Robert Motherwell, *A la pintura: White 1-2*, 1968-71. See cat. no. 30. Following Alberti's phrase "almost blue in its backward reflections," Motherwell proceeded "backward" in several respects. He started with a Mediterranean blue and white, reversed to black, then opposed the blue with its complementary color, orange. Usually, he simplified his image: Here, the passage of fine marks at the lower left was added at the end.

3
I–Rafael Alberti–have seen it:
light lives in the popular whites.

Yo vi–Rafael Alberti–
la luz entre los blancos populares.

4
My childhood: a whitewashed
rectangle, wet quicklime
and the joy of my shadow that prints it alone.

Mi infancia fué un rectángulo
de cal fresca, de viva
cal con mi alegre solitaria sombra.

5
Call me quicklime's immaculate son.

Yo soy el hijo de la cal más pura.

6
I: master builder of colors.

Soy el más albañil de los colores.

131. Robert Motherwell, *A la pintura: White 3-6*, 1969-71. See cat. no. 31. "Yo" is the Spanish word for "I," here printed in reverse, as if it were the "whitewashed shadow" from Alberti's verse. The reversal also suggests an open book, which Motherwell was still sketching in the experimental stages of *White 3-6*, as the format for *A la pintura*.

7
One line or one letter
above me: indelible marvell

Una línea, una letra,
sobre mi. ¡Inolvidable maravilla!

8
One line or one letter,
one chalk stroke
compact in the blackboard's mute nocturno.

Una línea, una letra,
un rayón solamente en blanco tiza
sobre el terso nocturno mudo de las pizarras.

9
I fall swiftly like a cloud or a drapery.

De pronto caigo como traje o nube.

132. Robert Motherwell, *A la pintura: White 7-9*, 1968-71. See cat. no. 32.

10
At times, the agile arc of a colt
seen against limitless blue.

Soy a veces el arco ágil de un potro
contra el azul sin límites.

11
Uccello, that old one, that bird
dead in the nets of perspective,
made me hurdle the hedge like a thoroughbred.

Aquel –Uccello– viejo pajarillo,
muerto en la araña de la perspectiva,
me hizo saltar en forma de caballo.

12
I am an altarcloth, white, the needlepoint
inserted in snow crystals.

Soy mantel, alba, níveo
encaje en el cristal de las heladas.

13
I take shape like a breath in a dream
in the ivory shadows of Zurbarán:
on a platter, a cloth, or a monk.

Aparezco en el sueño como hálito,
como sombra marfil
de plato –Zurbarán–, mantel o monje.

133. Robert Motherwell, *A la pintura:
White 10-13*, 1968-72. See cat. no. 33.

14
Pure white – the whole of the white – is most jailed
by the circle, the square, and the triangle.

Blanco puro, total, mas prisionero
en un cuadrado, un círculo, un triángulo.

15
Never forget: white is also the rose.

Recordad que también yo soy la rosa.

134. Robert Motherwell, *A la pintura:*
White 14-15, 1968-72. See cat. no. 34.

To the Paintbrush Al pincel

Baton that conducts us to music, sea's
virtuoso that tacks toward an ocean of canvas—to you,
pilgrim of silence and wayfarer drenched in a voyage
whose time is the midnight's, the dusk's, and the dawn's.

A ti, vara de música rectora,
concertante del mar que te abre el lino,
silencioso, empapado peregrino
de la noche, el crepúsculo y la aurora.

Caress that the colors have colored,
stylus that tempers its point for a master's employment,
broom to sweep clean and open the way to a journey,
enlarging, confining, diminishing itself for your pleasure.

A ti, caricia que el color colora,
fino estilete en el operar fino,
escoba barredera del camino
que te ensancha, te oprime y te aminora.

You are wheat in the tassel, that ripens for summer and winter,
tossed and returned by the gust that moves under my hands,
live coal for a furnace of shadow, or banked conflagration.

A ti, espiga en invierno y en verano,
cabeceante al soplo de la mano,
brasa de sombra o yerta quemadura.

Whatsoever resists or opposes, grows resplendent in you,
who live like the stalk of a flower and thrive beyond earth
and stand comely and tall on the stem, master builder of Painting.

La obstinación en ti se resplandece.
Tu vida en tallo que sin tierra crece.
A ti, esbelto albañil de la Pintura.

135. Robert Motherwell, *A la pintura:
To the Paintbrush*, 1972. See cat. no. 35.

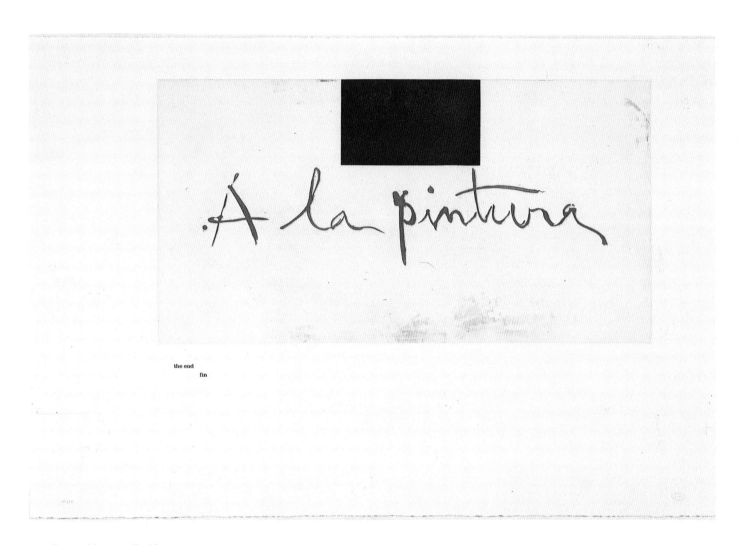

136. Robert Motherwell, *A la pintura:
End Page*, 1971. See cat. no. 36. The plate
originally made for the *Frontispiece* (cat.
no. 15) was moved to the *End Page*. Its
ultramarine blue is cooled and stabilized
on a field of ocher.

137. Barnett Newman, *18 Cantos: Title Page*, 1964. See cat. no. 1. In 1977 Zigmunds Priede and Tony Towle reconstructed the sequence and documented the materials of the *18 Cantos*. Newman made at least nine stones for the *Cantos* but used only seven: four as background stones and three for over- or underprintings. The small changes in outline are primarily the result of the stones' deterioration; Newman frequently elaborated on such accidents. He also settled on nine papers. As he did in his paintings, Newman made color the subject matter of his lithographs. Color creates chapters within his book, as well as variations within a given cluster.

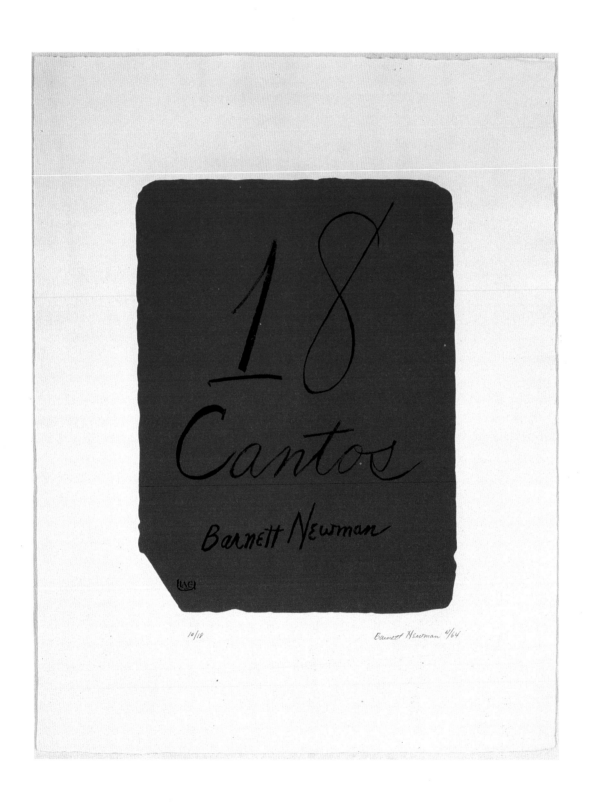

Barnett Newman

(American, 1905 New York 1970)

In the generation of artists that came to the fore after World War II, only Robert Motherwell and Barnett Newman gave genuine attention to prints. Motherwell had been making collages and drawings on paper for years and easily transferred that scale and sensibility to his prints. Newman, on the other hand, was an unlikely candidate for the printshop. Unlike most of the artists Tatyana Grosman invited to ULAE, Newman went in 1963 as a hero of proven power, "the outstanding metaphysical painter of the postwar era," according to Harold Rosenberg.[1] He had been damned or ignored by most critics until well into the 1950s. After an exhibition of his work at Bennington College in 1959 and the slightly reduced showing that followed it at French and Co. in New York, the tide turned. The most respected critics paid him the compliment of attention and analysis; younger artists paid him the compliment of imitation.

Newman painted on a grand scale; his goal was both revolutionary and Olympian. He considered himself the pioneer of a new abstraction, indebted neither to the Cubists nor to Mondrian. He disdained painting for "self-expression," using color for sentimental or emotional titillation, or calculating his compositions to satisfy extraneous (if elegant) mathematical formulas. He spent almost twenty years searching for his own subject matter, a formal language that would "catch the basic truth of life which is the sense of tragedy."[2]

Newman was a thorough intellectual, having read the Hebrew lawgivers and Kabbalists, French literature from Corneille to the Surrealists, Greek, German, and Latin writers in translation, and the literature and criticism of his own day. In his thirties, he studied botany, geology, and ornithology and became known as an articulate writer on art. Numerology and mysticism fascinated him. Material success did not.

Newman's search for the Absolute

138. Barnett Newman, *18 Cantos: Preface Page*, 1963-64. See cat. no. 2. In his preface, Newman emphasized the musical, rather than the literary, implications of the title. Coincidentally, Robert Rauschenberg was concurrently doing drawings with the same title for a new edition of Dante's *Inferno*. There was no connection between the two projects.

Continued on page 206

139. Barnett Newman, *18 Cantos: Canto I*, 1963. See cat. no. 3. *Cantos I-IV* (cat. nos. 3-6) present the motif that marked the beginning of Newman's mature career: the vertical "zip" down the middle of a field of color. *Canto I* most resembles his black-and-white drawings of 1960-61 and also the first prints he made at Pratt Graphics in New York.

Canto I ¹⁷/₁₈ Barnett Newman 9/63

140. Barnett Newman, *18 Cantos: Canto II*,
1963. See cat. no. 4.

Barnett Newman
197

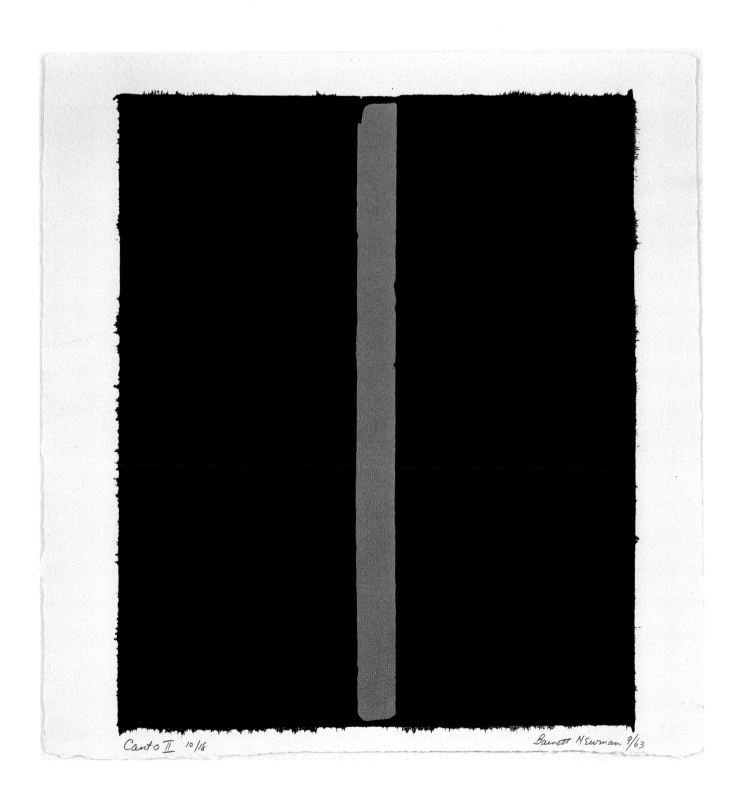

Canto II 10/18 Barnett Newman 9/63

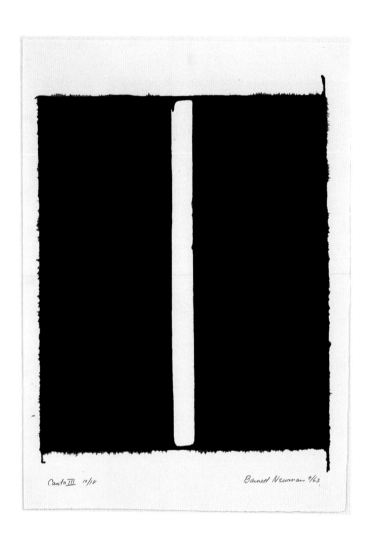

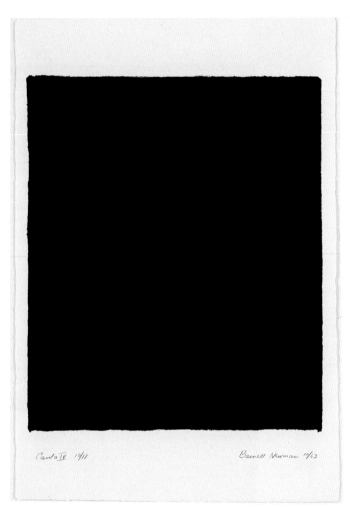

141. Barnett Newman, *18 Cantos: Canto III*, 1963. See cat. no. 5.

142. Barnett Newman, *18 Cantos: Canto IV*, 1963. See cat. no. 6.

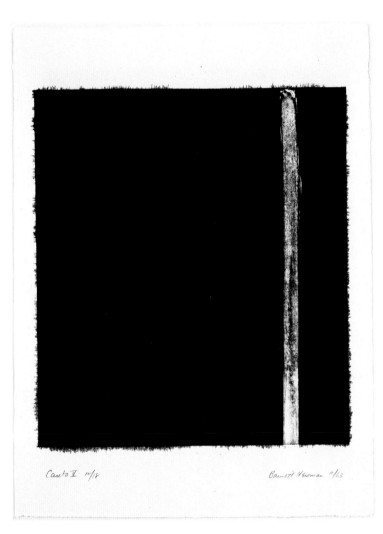

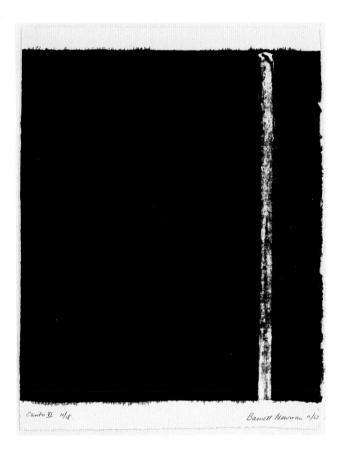

143. Barnett Newman, *18 Cantos: Canto V*, 1963. See cat. no. 7.

144. Barnett Newman, *18 Cantos: Canto VI*, 1963. See cat. no. 8.

145. Barnett Newman, *18 Cantos: Canto VII*, 1963. See cat. no. 9.

146. Barnett Newman, *18 Cantos: Canto VIII*, 1963. See cat. no. 10.

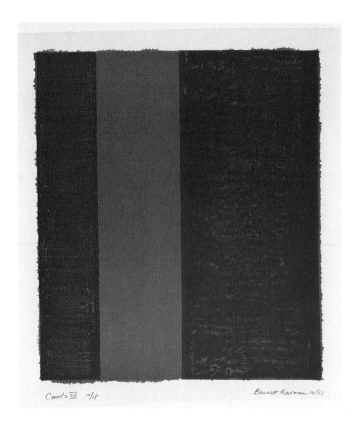

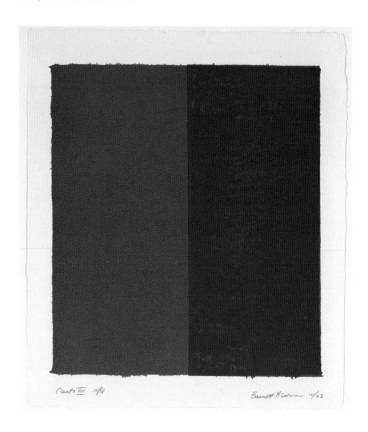

147. Barnett Newman, *18 Cantos: Canto IX*, 1963-64. See cat. no. 11.

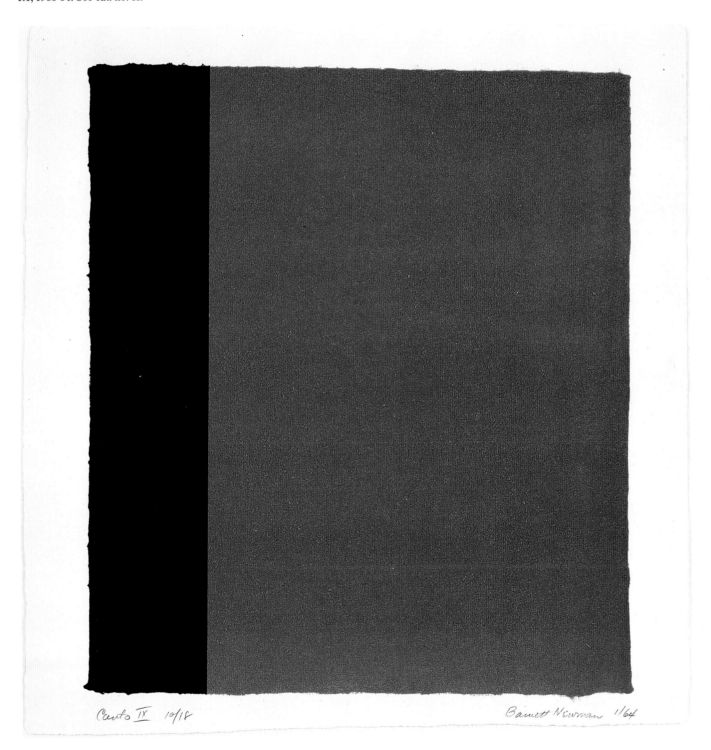

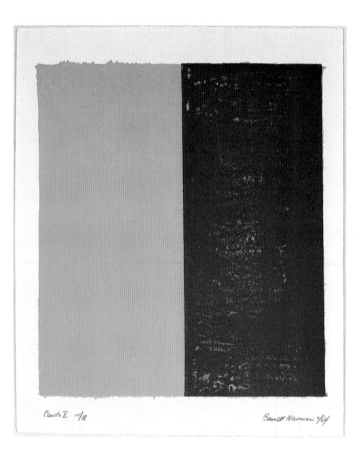

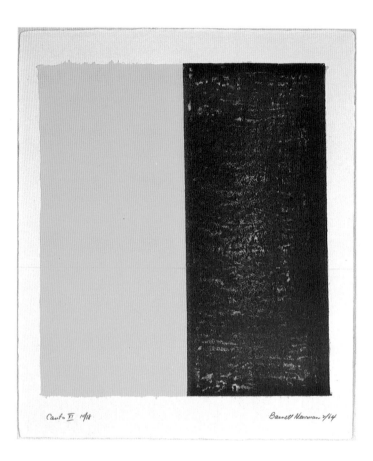

148. Barnett Newman, *18 Cantos: Canto X*,
1964. See cat. no. 12. The apparent variety
of colors in *Cantos X-XIII*, often called
"The Four Seasons," is actually an effect
created by changing the order of printing
the yellow and the blue.

149. Barnett Newman, *18 Cantos: Canto
XI*, 1964. See cat. no. 13.

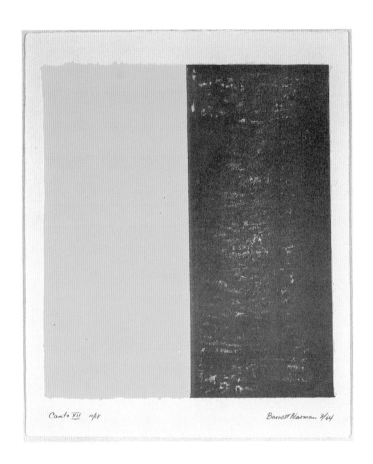

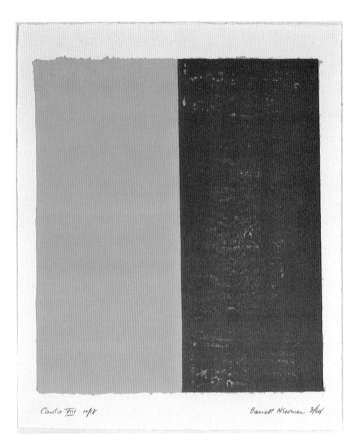

150. Barnett Newman, *18 Cantos: Canto XII*, 1964. See cat. no. 14.

151. Barnett Newman, *18 Cantos: Canto XIII*, 1964. See cat. no. 15.

152. Barnett Newman, *18 Cantos: Canto XIV*, 1964. See cat. no. 16. Newman planned to conclude the *Cantos* at fourteen, the same number as his monumental painting series *The Fourteen Stations of the Cross*, which was nearing completion. But when he saw the proofs for *Title Page* (cat. no. 1) and *Canto XIV*, both printed in dazzling red, he decided to add four more pages.

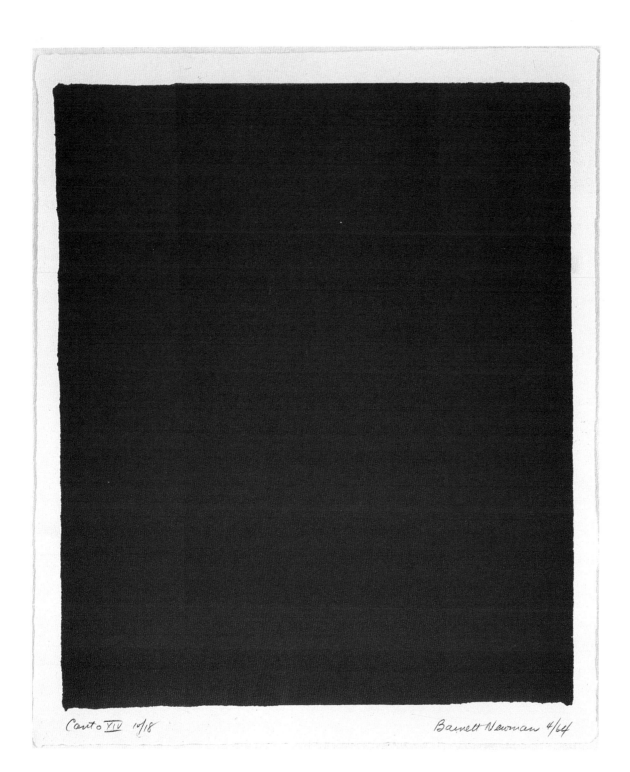

Canto XIV 14/18 Barnett Newman 4/64

153. Barnett Newman, *18 Cantos: Canto XV*, 1964. See cat. no. 17.

Barnett Newman
205

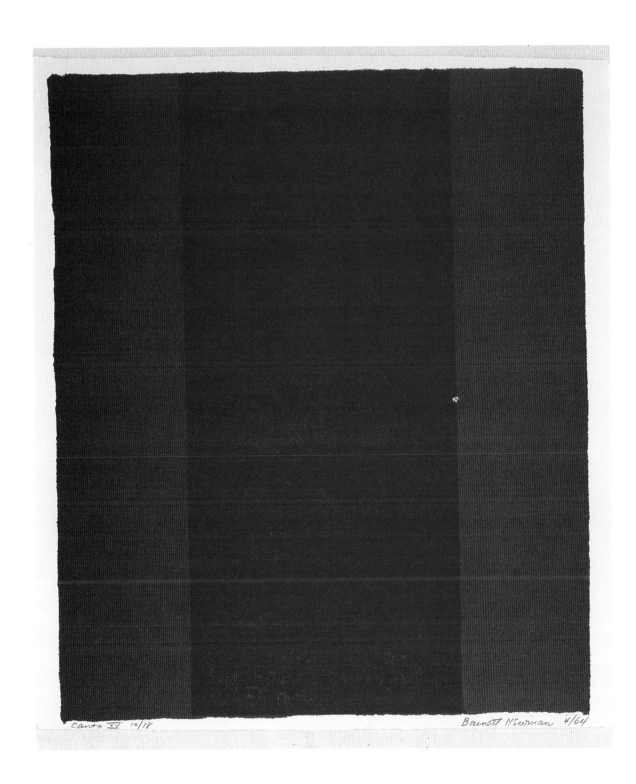

required openmindedness, change. Change
was not only a matter of making something
new but the obligation to reassess the acts of
making and looking at art. He wanted others
to do the same. A sign on the wall at his 1950
exhibition at the Betty Parsons Gallery, New
York, asked visitors to stand close to the pic-
ture "to make the same intimate contact with
the large color fields . . . to feel as drenched as
he had in the chaos of red, and then feel
touched by the organizing power of the vertical
division."[3] Patient and warmly encouraging to
other artists, Newman was relentlessly critical
of his own work. In 1940 he destroyed almost
twenty years' work. From 1951 to 1962, he disci-
plined himself by limiting his palette to black
and white. Three times (1939-40, 1944-45, and
1956-57), he stopped painting entirely, starting
again only when he saw a way to discard old
ideals for new ones.

William S. Lieberman, then curator of
prints at the Museum of Modern Art, had for
some time been urging Newman to accept
Tatyana Grosman's invitation to work at
ULAE. He was also encouraged by friends
such as Larry Rivers, who had worked at
ULAE since 1957, and the painter Cleve Gray,
who had introduced Newman to lithography at
the Pratt Graphics Center in 1957. Pratt pro-
vided Newman with a good introduction to
making prints. Newman liked the stone, the
surface, the way the ink and the paper interact.
But he did not like the noise and distraction of
a busy shop. Although many asked, Mrs.
Grosman was the only print publisher who was
able to entice Newman to come. In his eyes,
she was "serious" about her work. She had
high standards, and, above all, she recognized
how difficult it was for him to work in a strange
environment. "Studio is sanctuary," he always
said. Within his own sanctuary, Newman cre-
ated inner sanctuaries for each picture. Before
a canvas was begun, both floor and wall were
covered with fresh brown paper so that the
painting could be developed within its own
pristine space. Therefore, Newman was pleased

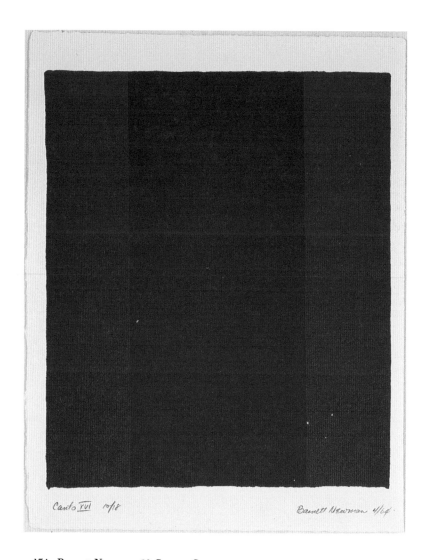

154. Barnett Newman, *18 Cantos: Canto
XVI*, 1964. See cat. no. 18.

to find that Mrs. Grosman assumed he wanted to work on the stones in his own studio, without hovering printers or other distractions.

In 1963, when he went to West Islip to meet the ULAE staff and to work with Zigmunds Priede, Newman was delighted to find that the shop was totally his. There were no other artists or other artists' work to be seen. In fact, ULAE was like the Jewish households Newman knew so well. Visitors were fed, immediately and abundantly, and then the business of the day proceeded. It was a home: hospitable, comfortable, and in Annalee Newman's words, "warm, warm."[4] Newman also found that he and Mrs. Grosman tacitly agreed that a printer should be a technician and not a cohort. The artist is to command; the printer is to mix the ink, operate the press, to serve but not to suggest. Under any circumstances, Newman was stubbornly disinclined to ask anyone for help. He had learned all of the craftsmanship of his profession by trial and error. Both pride and habit prevented him from asking either Priede or the Grosmans for their opinions, no matter how much he liked them as friends or respected them as professionals.

This painter of large-scale canvases might well have scorned the idea of making cabinet-sized prints, but to him it was a new totality. The necessity to change, to reexamine basic premises, became his central challenge in his prints, which he called the *Cantos* (cat. nos. 1-21). The three lithographs he had done at Pratt had whetted his appetite, but Newman still regarded the margins as an inherent defect, which he proposed to solve by trimming off the paper around the printed image. None of his paintings had margins, he told Mrs. Grosman. But this is a lithograph, she said, ink and paper. It was a reproof gently spoken but perfectly placed. Suddenly, he saw that the margin need not be a dead skin to be sloughed off the emergent body of the image but a vital and interactive element of the whole. In the trial proofs for the *Cantos*, one sees that the margin

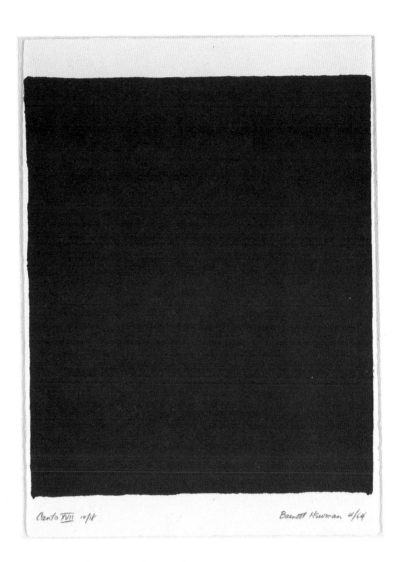

155. Barnett Newman, *18 Cantos: Canto XVII*, 1964. See cat. no. 19.

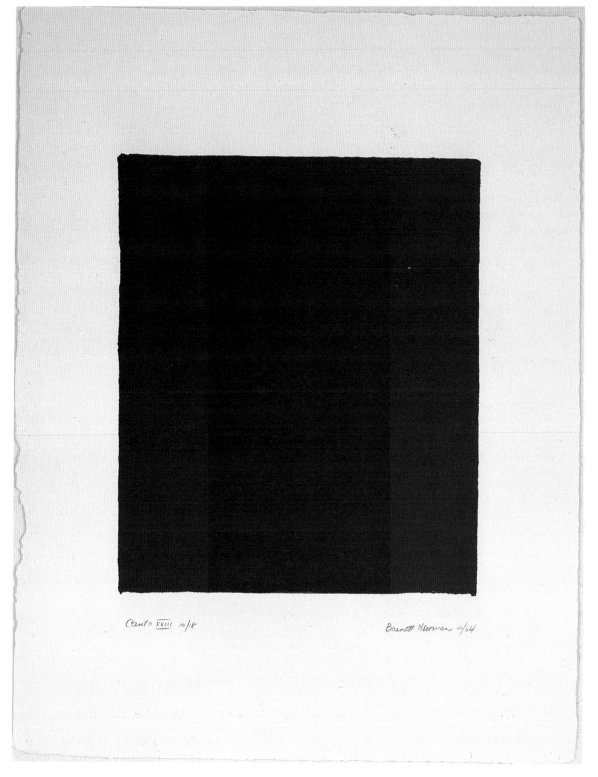

Canto XVIII 10/18 Barnett Newman 4/64

156. Barnett Newman, *18 Cantos: Canto
XVIII*, 1964. See cat. no. 20. The number
eighteen had unique connotations for
Newman, including the eighteen
benedictions of the Old Testament, the
number of traditional Hebrew blessings,
the essential vertebrae, and the Hebrew
letters that spell "life" and that are also
the numbers for eighteen.

was tested as often as color and shape. There were, of course, proofs pulled to judge color alone. But, more often, Newman wanted to see the interaction of color and color, or color(s) and margin, or the effect of a different paper on the whole. A change in any of those elements might occur at any point in the proofing. Without Priede's insight and skill, without the unlimited supply of time and materials available to him at ULAE, the *Cantos* would not have had the "totality" Newman required of his art.

Newman was always willing to see the advantage of obstacles and accidents. For example, he had wanted to start the *Cantos* with a white-on-white print. He was not satisfied with the first experiments but could not find a better solution—a more opaque ink, for example—in the art-supply shops. Then Priede suggested mixing a bit of asphaltum to make a warm white to contrast with the white of the paper, and Newman liked the result. He also liked some of the shapes made when the tusche ran under the masking tape. On a later stone, Newman had laid down an extra thick layer of crayon and some of the surplus washed away. Looking at the trial proof of that "mistake," Newman realized that such a porous band could be used to create color variations simply by changing the sequence of printing inks of the same color. Even the number of the series was changed. When he saw the dazzling red of *Title Page* (cat. no. 1) and *Canto XIV* (cat. no. 16), he decided to add another sequence of four in subtle variations of red, thus reaching a total of eighteen prints, which was a number with special significance for the artist.

Shortly after Martin Luther King, Jr.'s, assassination in 1968, Vera List asked Newman to contribute to a portfolio of prints to be published in King's honor. The portfolio was to have an introduction by art historian Meyer Schapiro, who, like Newman, had long been identified with progressive political causes.

List had commissioned artists to make posters for many worthy causes and had a reputation for publishing work of high quality. It seemed like an ideal occasion to introduce Newman to etching. Donn Steward prepared several three-by-six-inch plates with etching ground and went with Mrs. Grosman to show Newman how to use the tools.

The Pratt prints had been Newman's incunabula of lithography; his etchings, called the *Notes*, became his juvenalia of intaglio printing. He started by dividing the first seven plates into triptychs, the composition that had closed the series of *Cantos* in 1964. These first seven plates reveal his investigations: crosshatching, making flicks, curves, lines, and circles, altering the direction and density of his strokes, creating a range of patterns that are closer to his drawings than anything he had ever attempted in a print shop.

The change to a new medium held other pleasures. In his studio during the daylight, Newman was wrestling with the heroic canvases *The Fourteen Stations of the Cross*. Like Pablo Picasso had done in 1904-5, Newman worked on the plates at night. The little copper plates were both a challenge and a diversion. Second, Newman loved the tools of his craft as passionately as he loved its polemics. In 1950 he had experimented with one of the first acrylic resin paints, the Magna colors that were sent to him by Leonard Bocour, a manufacturer of artist's materials. Soon after Steward showed him the rudiments of etching, Newman indulged himself in a fine, handsomely boxed set of German tools.

Without pausing to sign the *Notes* or to design a box for them, Newman started on the large plate for *Untitled Etching #1* (cat. nos. 40A and B). Steward took infinite pains with the plate, strengthening the aquatint in a series of cautious steps and printing it with more than the usual number of difficulties. Small batches of impressions that passed their inspection were torn to the size specified for

Note I 1968
3/7

157. Barnett Newman, *Notes: Note I*, 1968.
See cat. no. 22.

the King portfolio. But before the full complement had been finished, it had become apparent that the King portfolio was not going to have the roster of distinguished contributors who were originally proposed. Newman decided to withdraw; *Untitled Etching # 1 (cat. no. 40A)* was signed posthumously by Annalee Newman and distributed by Harry N. Abrams, Inc. Newman printed a new edition (cat. no. 40B) on the larger sheet he had specified at the outset and followed it with a series of large-format etchings that would eventually be pub-

lished as a portfolio. *Untitled Etching # 2* (cat. no. 41) returns to the vertical, tripartite format of the red *Cantos*. A second state of *Untitled Etching No. 2* would have produced a black-on-black triptych, but Newman's death prevented its completion.

Notes:

1. Rosenberg, *Newman*, 1978, p. 23.
2. Hess, 1971, p. 38.
3. Ibid., pp. 58-59.
4. Sparks, A. Newman interview, 1985.

158. Barnett Newman, *Untitled Etching
1*, 1968. See cat. no. 40B.

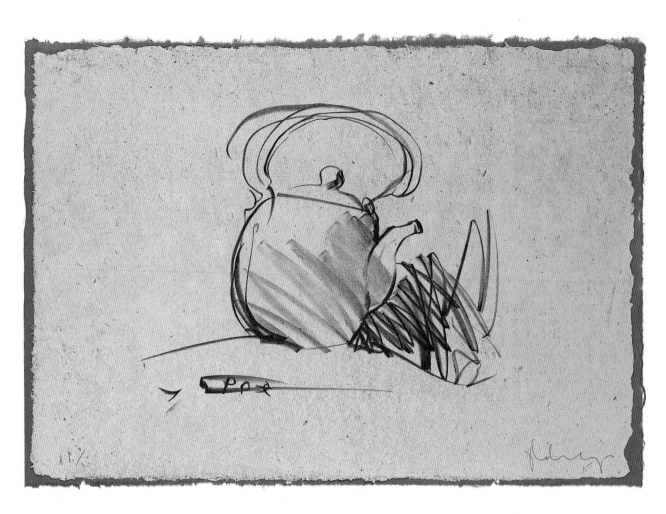

159. Claes Oldenburg, *Tea Pot*, 1975.
See cat. no. 1.

Claes Oldenburg

(American, b. Stockholm, 1929)

Claes Oldenburg's printmaking has been sporadic but audacious. When Tatyana Grosman finally persuaded him to come to ULAE in 1974, she had every reason to think that he might write a new chapter in the history of the studio. If we can redefine the print as a species of the genus *multiple*, then Claes Oldenburg was a veteran. His first multiples were monoprint posters made on a mimeograph machine for his "Ray Gun Show" at the Judson Gallery, New York, in 1960. Oldenburg, Allan Kaprow, Jim Dine, Red Grooms, and other artists who began to stage Happenings around 1957 gathered at the Judson. Oldenburg's first Happening was produced there in 1960.

Pratt Graphics Center was nearby, and, like many other artists he knew, Oldenburg used their excellent facilities in 1961 to make his first formally editioned prints. The three Pratt editions were small (six to twelve), but the process was congenial. Within the next few years, Oldenburg made lithographs for two innovative books: *1¢ Life*, 1963, published by Eberhard Kornfeld in Bern, and etchings for the series *The International Avant-Garde*, 1964, published by Arturo Schwartz in Milan. He also worked in Irwin Hollander's New York workshop, where he did a lithograph, *Flying Pizza*, in 1964, and several posters.

At the same time Oldenburg was pioneering in a new field: editions of three-dimensional objects known as multiples. Multiples were sculpture for the numerous collectors who fueled the print boom of the 1960s. Oldenburg's Pop imagery and technical bravado soon put him in the forefront of the movement. His first multiple was the *Soft Toaster* of 1963, made of vinyl, kapok, and wood. The ones that followed, such as *Tea Bag* of 1965 and *London Knees* of 1968, were great successes. The most spectacular, however, was *Profile of a Chrysler Airflow*, made at Gemini G.E.L. in 1968. It was a large, blue-green, semisoft amalgamation of lithography, embossing, and vacuum-formed plastic. *Chrysler Airflow* was not only one of the clas-

sic statements of Pop Art's deadpan homage to popular culture but a triumphant solution to harrowing technical problems.

Like many other artists of his generation, Oldenburg was fascinated with commonplace objects. His subjects were drawn from every corner of daily life, and he devoted a good deal of attention to food and drink. In fact, the masterpiece of his early career was a complex installation called *The Store*. It was first shown at the Martha Jackson Gallery, New York, in 1961. Then, Oldenburg moved it into a run-down storefront on Second Avenue. It was part exhibition, part studio, and part Happening. Oldenburg stayed there, amidst cases full of gaudily painted imitation foodstuffs he had made, while children gawked and collectors sampled—or stocked up on—his ersatz delicacies.

During the 1960s, several of Oldenburg's friends worked at ULAE, including his next-door neighbor Larry Rivers, his Happenings colleague Jim Dine, and his friend Frank O'Hara. Oldenburg had known Tatyana Grosman for several years before he responded to her repeated invitations to work at ULAE.[1] She tempted him with the possibility of a splendid book, a collaboration with no less than the internationally famous novelist Vladimir Nabokov. Nabokov, who, like Oldenburg, worked in Europe and America, may not have known of his candidacy. Mrs. Grosman spoke of a tennis match between the two artists—not as a subject but as a metaphor for the serve-and-return of ideas possible between two artists working in different places on the same project. (The same metaphor could be applied to the Rauschenberg/Robbe-Grillet collaboration, *Traces Suspectes et Surfaces*.) But Oldenburg was not lured by her choice of a famous writer as a creative partner. He kept postponing his visit to the ULAE studio.

In West Islip at last on Tuesday, November 5, 1974, Oldenburg found himself "short

of inspiration" and decided to scour the house and grounds for subject matter.[2] He made a number of drawings on that day and the next: a landscape and some leaves outside, as well as the samovar, scale, and teapot in the kitchen. On the third day he began to work on stone. By the time Tony Towle came to work on Monday, "a very beautiful 'Teapot' had been set up to print."[3]

Although in the 1960s Tatyana Grosman would never have been so bold as to suggest subject matter to an artist, by 1974 she played the role of director with considerably more confidence. She told Oldenburg of a dream she had had in which a colossal teapot was coming down the street. Even though he did not appear in the dream, she was certain that the teapot was his. It was uncanny. Oldenburg had wanted to choose a subject for his first lithograph that "summarized" her. He had done teapots before, and, even though he did not connect those previous uses at the moment, her dream had suggested the perfect portrait-object.

The most closely related teapot was one he had drawn as an illustration in a book published by the Museum of Modern Art in 1967. The book, *In Memory of My Feelings: Frank O'Hara*, was an anthology of O'Hara's poems and a tribute to the poet and curator whose brilliant career had been cut short by his accidental death in 1966. As editor of the book, Bill Berkson (also a poet and friend of several ULAE artists) commissioned several artists to illustrate the poems. Oldenburg's poem was "Image of the Buddha Preaching" (from *Lunch Poems*), for which he drew a classically round teapot with one perfect drop hanging from its spout. Oldenburg's notes on the project connected tea to poetic inspiration.[4] The teapot, the hospitality, the inspiration, the doyenne of the house and studio—they all came together on his only stone done at ULAE.

Fate had another coincidence to offer. On January 10, 1975, when Oldenburg was at the studio working on new stones and proofing the *Tea Pot*, an envelope arrived with a piece of strange paper. It came from Fred Siegenthaler, a Swiss papermaker and supplier of fine papers, with a letter saying that it was toilet paper, handmade in Bali. It was rough and irregular, but intriguing, and the printers pulled a proof on it. Oldenburg decided that the drawing stone looked so well that he would not use the four stones he had made to add color.[5] (One proof, with all the four stones, is still in his collection.) For support as well as depth of color, the Balinese paper was tipped onto a second sheet of Japanese Moriki in a darker and warmer shade of brown. The color stones were no mean sacrifice. Black-and-white prints were generally less salable, and Oldenburg had spent a good deal of time on the color stones. In other studios, the printers generally mixed the colors for the artists. Mrs. Grosman had insisted, however, that Oldenburg mix his own.

Soon after he signed the editions, on June 2, 1975, Oldenburg left for a two-year stay in Holland. A few months later, he decided to abandon two other prints he had started at ULAE,[6] having lost interest in projects he deemed too stale; in 1976 he gave Mrs. Grosman (or ULAE) permission to efface and reuse his stones.

Notes:

1. Sparks, Oldenburg interview, 1985.
2. Ibid.
3. Towle, Diary, 1963-78, November 11, 1974.
4. Amsterdam, 1977, p. 26.
5. Wittrock, 1981, unpaged.
6. Oldenburg, letter to T. Grosman, January 7, 1976.

Robert Rauschenberg

(American, b. Port Arthur, Texas, 1925)

The strata of our culture from which Robert Rauschenberg has extracted the ingredients of his art parallel the layers of images in his work. Underneath the glaze of pop culture and in his insouciant talent for the new, his work has a formal structure much indebted to the high traditions of Western art. He attributes the development of this sense of order to Joseph Albers, with whom he studied at Black Mountain College from 1948 to 1950. But although Albers supplied the early guidance, it was John Cage and Merce Cunningham who confirmed Rauschenberg's ideas about imagery, method, and the very nature of beauty.

With no disrespect for the Abstract Expressionists, Rauschenberg absorbed little of their ethos. He agreed that a painting was a diary of the artist's interaction with materials, but he kept such things as *angst* and introspection at bay. Like Cage and Cunningham, he located art in the external and accidental. Cage ignored the old distinction between "noise" and "music"; in Cunningham's view, any movement could be part of a dance and the most mundane objects became a setting for choreography. Their work shared an open and impersonal character that encouraged Rauschenberg to use common materials in a way that would expand their meaning, to create *cinema verité* on canvas.

From the point of view of materials per se, there are precedents for Rauschenberg's work in Surrealist collages. But by the time he discovered Marcel Duchamp and Kurt Schwitters, they only confirmed his direction and his desire to keep away from polemics, politics, or personality. "I like images to be as general-looking as possible," he told Brian O'Doherty.[1] Within a few years of his discovery of Surrealist collage, Rauschenberg was recognized as one of the most innovative and talented of the younger generation. Where the Abstract Expressionists had used paint and cloth, Rauschenberg made use of his immediate world. Neighborhood streets and shops provided an

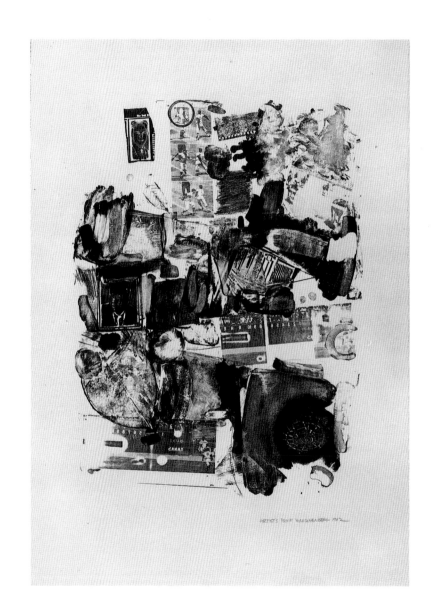

160. Robert Rauschenberg, *Urban*, 1962.
See cat. no. 3.

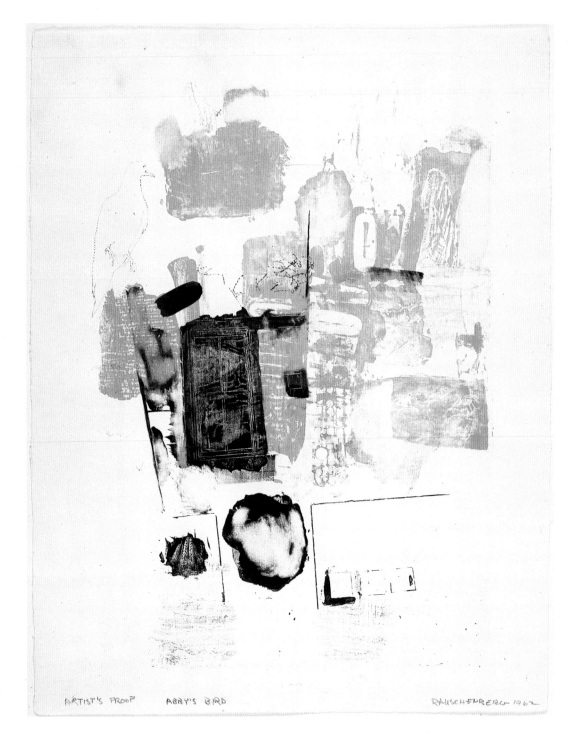

ARTIST'S PROOF ABBY'S BIRD RAUSCHENBERG 1962

161. Robert Rauschenberg, *Abby's Bird*,
1962. See cat. no. 1. Rauschenberg's first
print was one of several editions
commissioned by the public relations firm
Ruder and Finn for the New York Hilton at
Rockefeller Center. The "Abby" in the title
refers to the wife of B. H. Friedman, a
writer who consistently championed the
second generation of post-World War II
artists.

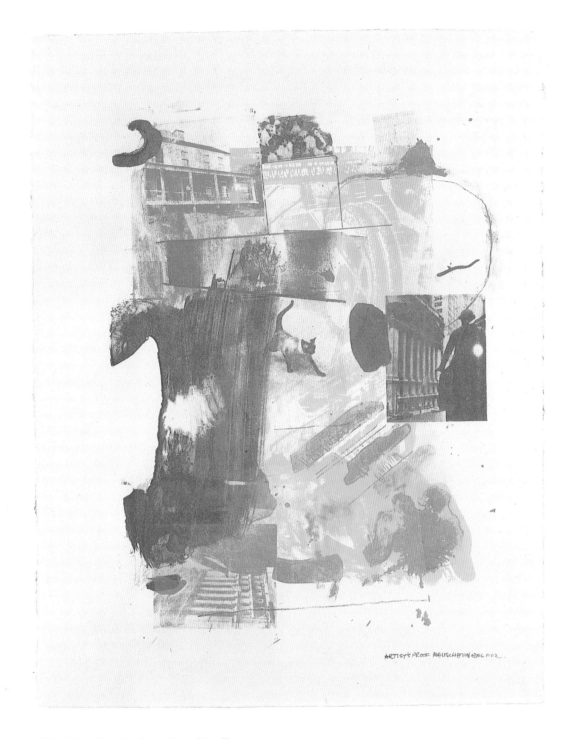

162. Robert Rauschenberg, *Stunt Man II*,
1962. See cat. no. 7. Rauschenberg always
has maintained that the world provides him
with an endless stream of images. His close
friend Jasper Johns generally made prints
that are variations on his familiar repertory
of images. Rauschenberg's *Stunt Man*
series (cat. nos. 6-8) is one of the few
occasions in which Rauschenberg reused
imagery in a manner usually associated
with his friend: All of the images in *Stunt
Man II* appear in earlier prints; *Stunt Man
I* and *III* are nearly as cross-referential.

163. Robert Rauschenberg, *Accident*, 1963.
See cat. no. 9.

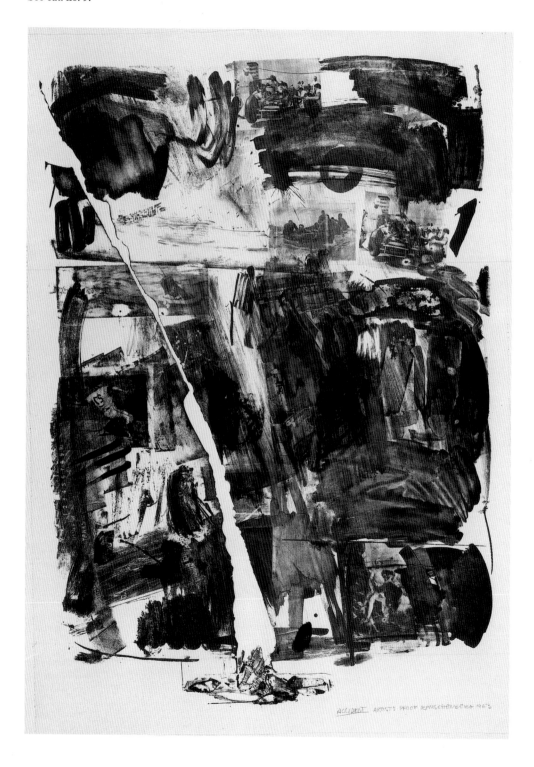

endless supply of castoffs and oddments for paintings and his particular contribution, the new medium he named "combines." When he started making prints, the newsstand and the Grosmans' house were his supply box. He did more than act "in the gap between art and life"[2]—he denied it.

Tatyana Grosman and Rauschenberg met one day in 1961 when she brought a batch of stones to Rauschenberg's close friend Jasper Johns. A nice young man who lived on the floor below helped carry the stones up four flights of stairs to Johns's studio; the nice young man was Robert Rauschenberg. The task amused him ("I didn't know modern art was that heavy," he told Tony Towle[3]), but to her, the meeting was pure providence. She had wanted to meet him but had not yet tried. "He was so dynamic, I could not bring myself to approach him."[4] Having done so, Mrs. Grosman entered into one of the richest relationships of her life. "For every artist," said Rauschenberg, "there was a different shape to her affection." Maternal to some, deferential to others, she was somewhat exotic to all of them. But to Rauschenberg, she was the Cerberus he could whisk out of the studio (if only temporarily) as well as the uncanny eye who could always see what was wrong. She responded to his antic ways; he loved her for her fanatic sense of quality.

She could not have chosen a more exciting or productive time in Rauschenberg's career to introduce him to lithography. His experiments with new materials had just touched the printmaking media: He had started using silkscreens to apply photographic images to canvas. His experiments in other media escalated: He became director and stage manager for the Merce Cunningham Dance Company. His work was beginning to attract international attention: He was chosen to represent the younger generation in a panel discussion sponsored by the Museum of Modern Art for its exhibition "The Art of Assemblage."

Most important for Mrs. Grosman, he had finished the *XXXIV Drawings for Dante's Inferno*, a series (two-and-a-half years in the making) that told her, in no uncertain terms, that he was destined to work on stone. As he remembered twenty years later, "She reminded me of it about three times a week for a year, and I thought, 'I'm awfully tired of that old lady calling me.' So one day I said, 'I'll fix her, I'll just say yes.' And I was on my way."[5]

Rauschenberg was uniquely predisposed to a collaborative approach to printmaking. He brought no sketches to follow, no formal problems to work out in print, and only rarely a preconceived notion of what the finished work would be. The materials of the day were potentially infinite: any printed image, what he saw on the way to the studio, objects in the shop—in a word, everything. Because he has dyslexia, working in reverse is easy for Rauschenberg; he sees reversals of every kind—right/left, mirror images, and the positive/negative of photography. Most important, he relishes the human drama of creativity: "It's revitalizing to my sensibility to get to know strangers. I'd much rather go in the direction of bringing out things in somebody else. That's more fun for both of us."[6] A friend or visitor can be his catalyst, but, most often, it has been the printer. "You knew," said Tom Cox, "that the print was different because you were there."[7]

Rauschenberg arrived in West Islip in April 1962. His first two prints were fairly modest efforts: *Abby's Bird* (cat. no. 1), one of several prints destined for the New York Hilton at Rockefeller Center, and *Merger* (cat. no. 2), a collaboration with Jim Dine and Jean Tinguely (which Rauschenberg finished alone) for the "Dynamische Labyrinte" exhibition in Amsterdam. From the beginning, Rauschenberg's titles were the last layer to be added, in no conceptual way different from the visual layers. *Merger*, for example, refers to several mergers: Dine plus Tinguely plus Rauschenberg, an exhibition of artists plus scientists, America

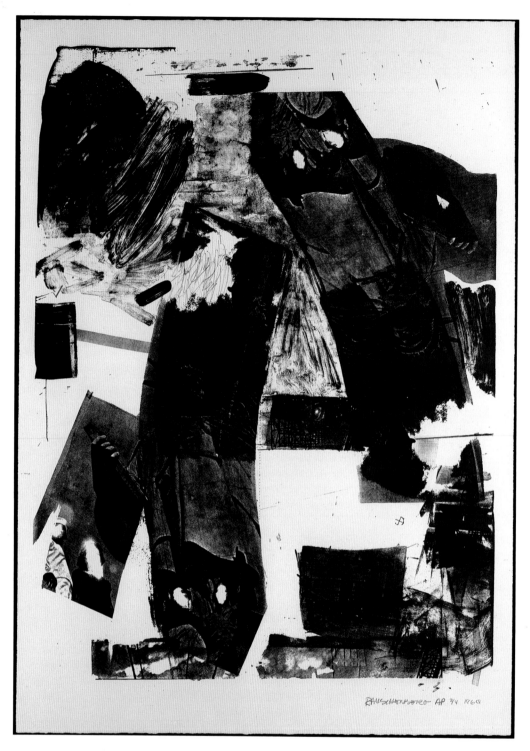

164. Robert Rauschenberg, *Front Roll*,
1964. See cat. no. 21. *Front Roll* (the title a
phrase used by dancers and printers) was
awarded the major prize of the 2nd Bienal,
Museo de Arte Contemporaneo, Santiago.

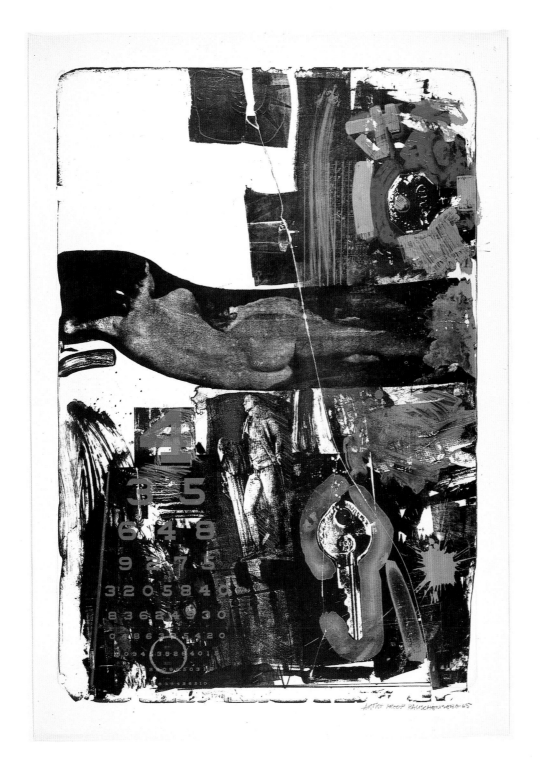

165. Robert Rauschenberg, *Breakthrough
II*, 1965. See cat. no. 23. After finishing
Breakthrough I (cat. no. 22), Rauschenberg
went on a worldwide tour with the Merce
Cunningham Dance Company. Upon his
return, he again took up the stone, added
three colors, and rotated the orientation
forty-five degrees. By this time, the stone
had begun to disintegrate quite rapidly, so
each impression of *Breakthrough II* is
slightly different.

plus Holland, artist plus printer plus publisher, as well as prefabricated plus handmade elements. The word "with" in the image is an equivalent for "merger" and, typically, does not title the picture. Rauschenberg had used words in his paintings as early as 1950 (e.g., *The Lily White*, Mrs. Victor W. Ganz Collection, New York). Unlike Robert Motherwell, Rauschenberg used letters and words simply to activate the surface and not to clarify the subject.

With *Urban* (cat. no. 3) and *Suburban* (cat. no. 4), it became evident that Rauschenberg could and would change the very definitions of lithography and that, in turn, lithography would influence his work in other media. Commercial processes had always interested him. Producing printed images was one more means of multiplying the interactions between an artist and his surroundings. Even the additive nature of lithography was not without precedent. In 1960 Rauschenberg made a series of four paintings, *Summer Rental*,[8] in which a new color was added to successive canvases, unknowingly anticipating the layering of color that is unique to lithography. In fact, Rauschenberg shared none of the reservations other artists had about the press and all of its technical pitfalls. Printshop traditions could hardly intimidate a man who had used X-rays and tire treads to make his first prints or had invented a new genre—combine painting—by using a bed quilt and real stuffed animals in works that bring painting and sculpture together. His printmaking was the same blithe interaction with the here and now.

Ever since the days he spent at Black Mountain College, Rauschenberg had trusted the small incidents of each day to bring the materials and ideas for his work. There are hundreds of examples in his ULAE prints: the paper bags in *Treaty* (cat. no. 50), Mrs. Grosman's kerchief in *Veils* (cat. nos. 46-49), photographs from *Life* magazine for *Landmark* (cat. no. 34), and his own jewelry for *Inta-*

glio Watch (cat. no. 37). What other people considered impediments, such as the damaged graph-paper pattern on the back of an old stone, Rauschenberg cheerfully appropriated for *Visitation I* (cat. no. 25).

For Rauschenberg, the graphic equivalent of the infinite world of objects in which we live are the millions of photographs that roll off the press every day. He gave his first prints a *cinema verité* look by helping himself to a supply of used printers' mats from the *New York Times*. The critic Brian O'Doherty, who urged him to take them, said that Rauschenberg did not go through the bins looking for tasteful or interesting photographs. "If it is interesting by itself," Rauschenberg later said, "it doesn't need me."[9] The photographic transfers and films he used in later prints are equally anonymous. For example, the baseball players in *Urban* (cat. no. 3) are rarely identifiable nor is the outcome of their actions clear. But the work itself is interesting.

Rival (cat. no. 10) was a milestone for Rauschenberg, for ULAE, and for art itself in America. *Rival* established the poster formula for ULAE: Rauschenberg wrote the text; the stones that printed the limited edition were transferred to offset plates for the poster; a fixed number of posters were signed; and, finally, the reproductive work was supervised and controlled as carefully as the limited edition.

In the 1940s and 1950s, no avant-garde artist could reasonably have expected wealth or celebrity. A retrospective exhibition was traditionally the summary of, or a posthumous tribute to, an artist's career. Yet, Alan Solomon, then curator at the Jewish Museum, New York, organized a retrospective for Rauschenberg at the unprecedented age of thirty-eight. This show was by no means the only factor that inserted money and fame into the New York art scene, but afterward, neither the cast nor the crew nor the audience was the same.

The year 1963 was a banner one for

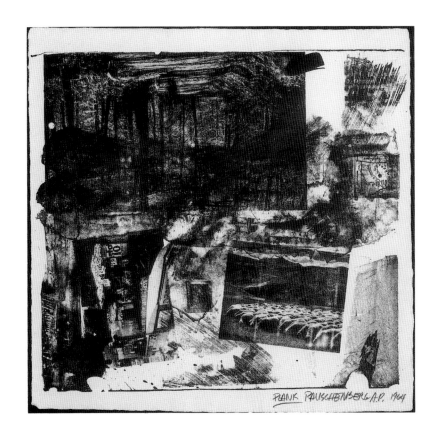

166. Robert Rauschenberg, *Plank*, 1964.
See cat. no. 11.

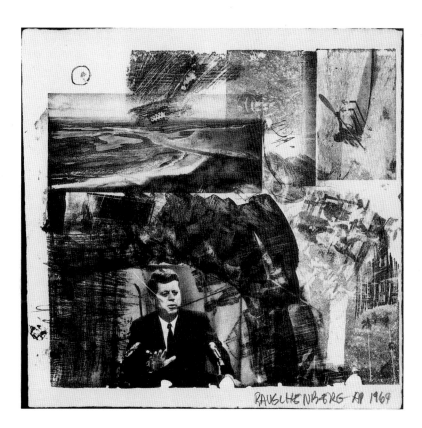

167. Robert Rauschenberg, *Ark*, 1964. See
cat. no. 14.

168. Robert Rauschenberg, *Lawn*, 1965.
See cat. no. 27.

169. Robert Rauschenberg, *Night Grip*,
1966. See cat. no. 29. The images for *Night
Grip* were made directly from film
transferred to the stone through a
photosensitive emulsion.

Robert Rauschenberg
225

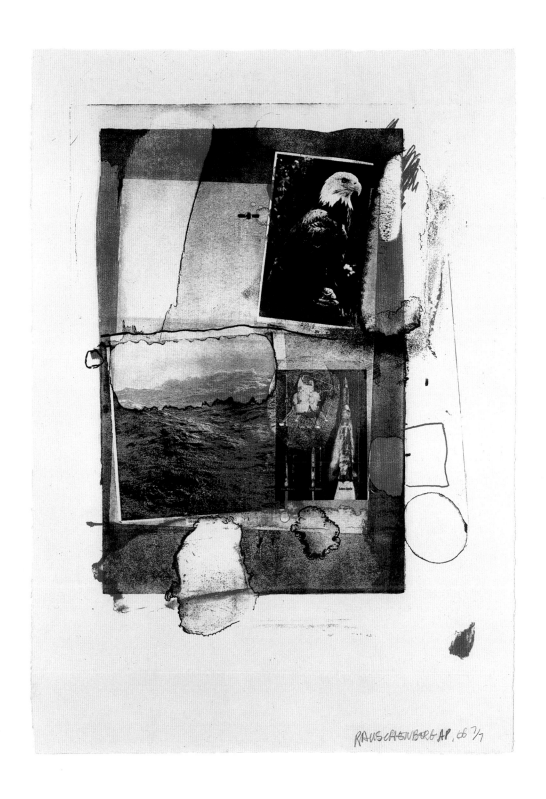

170. Robert Rauschenberg, *Shades*, 1964.
See cat. no. 18.

Rauschenberg and ULAE. Mrs. Grosman, who declined to enter her prints in competitive exhibitions at home, was eager to show her artists in Europe. When the director of the Ljubljana print biennale wrote to request work, she responded immediately, sending Rauschenberg's *Accident* (cat. no. 9) as her entry. For both European and American graphics workshops, Ljubljana was the most prestigious competition. When *Accident* won the Grand Prize, it was a turning point in Mrs. Grosman's personal and professional life: ULAE had attained international recognition.

Contrasting color did not appear in Rauschenberg's prints until *Front Roll* (cat. no. 21), done late in 1964, and did not become an important factor in his oeuvre for the next ten years. His primary source materials, newspaper and magazine photographs, were black and white. With rare exceptions, Rauschenberg's ULAE prints are muted in color, from *Front Roll* to *The Razorback Bunch* of 1980-82 (cat. nos. 106-110), or confined to primaries, as in *Centennial Certificate MMA* (cat. no. 42). Artists from Dürer to Pollock have practiced the discipline of black and white. Rauschenberg followed suit. As Calvin Tomkins observed, Rauschenberg learned from Albers that one color was as good as another.[10] It was never the main issue.

Drizzle, *Gamble*, and *Water Stop* (cat. nos. 30-32) are classic Rauschenberg: delicate yet strong, each element straightforward fact, and the whole multivalent and mysterious. With the rarest exceptions, none of his prints can be analyzed, image by image, into an iconographically consistent program. There are some groups, such as the *Booster* series (published by Gemini) and the *Glacial Decoy* series (cat. nos. 96-104), that use photographs taken within a limited area or time. But Rauschenberg has always avoided the programmatic and narrative. Elements of widely varying importance, from a symbolic or polemical point of view, are combined with the utmost disregard for any

171. Robert Rauschenberg, *Glacial Decoy
Series: Etching III*, 1979. See cat. no. 98.

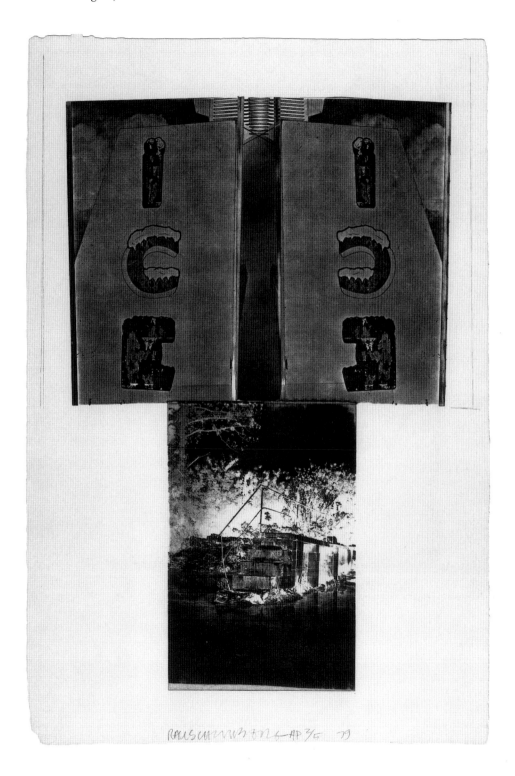

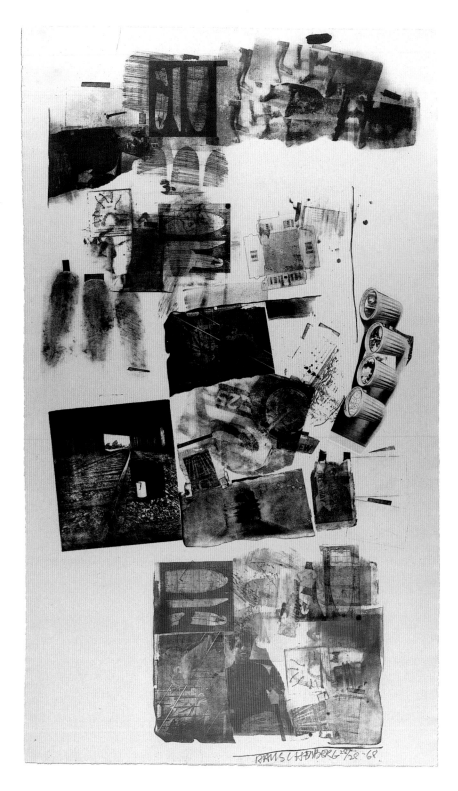

172. Robert Rauschenberg, *Water Stop*,
1968. See cat. no. 32. A detail of the lower
left section of the stone with Robert
Kennedy's photograph was printed in two
colors as a postcard by Telamon Editions.
Some of the elements were later etched in
softground and used for the preface page
for Edwin Schlossberg's *Wordswordswords*
(Schlossberg, cat. no. 2).

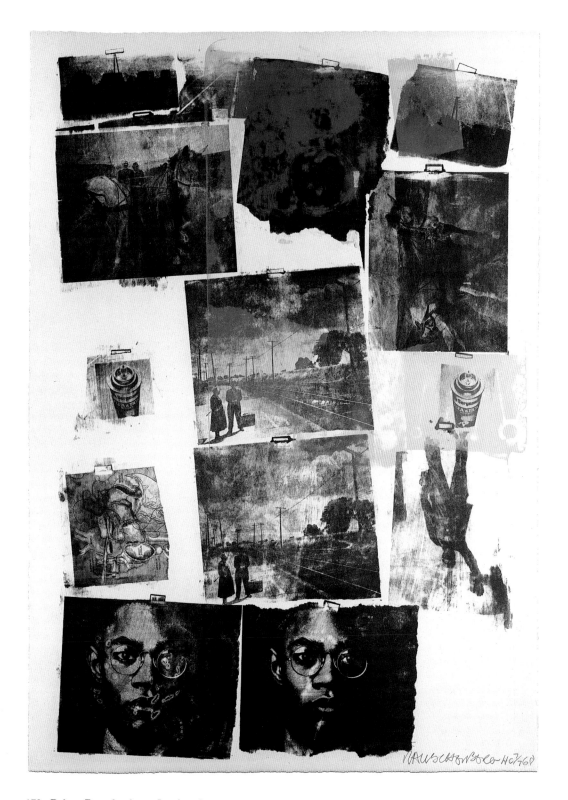

173. Robert Rauschenberg, *Landmark*,
1968. See cat. no. 34. Rauschenberg's
predilection for noncommittal imagery is
amply demonstrated in *Landmark*, which
features images from two copies of the
same issue of *Life* magazine. Fidelity of
transfer was another factor Rauschenberg
left to chance.

174. Robert Rauschenberg, *Echo When*,
1978. See cat. no. 94.

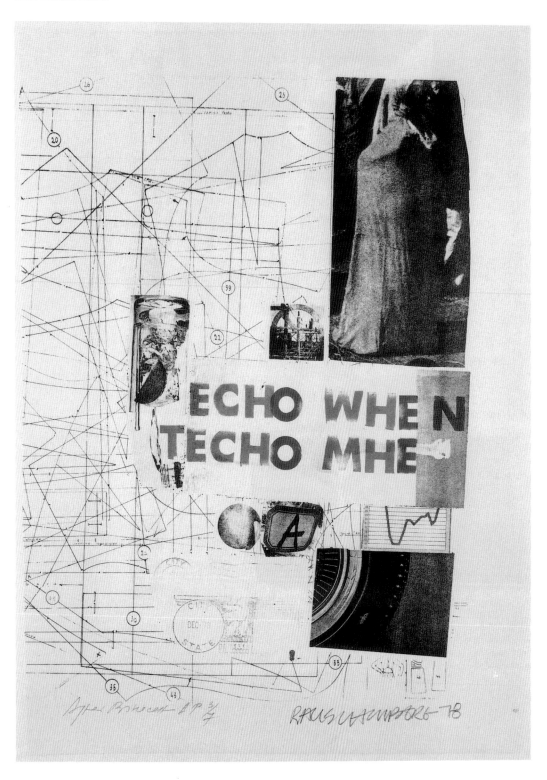

worldly hierarchy of value. And those images are transferred to the stone (or plate) in a way that deliberately obscures their meaning. Indeed, ambiguity *is* the message.

In 1976, Mrs. Grosman sent Rauschenberg's design for his retrospective poster to the Museum of Modern Art, and the museum sent back its standard form asking about the imagery, meaning, and so forth. She took the questionnaire seriously, but Rauschenberg balked. Anyone with enough time could locate the red house in the photograph used in *Urban* or the place where President Kennedy might have been. But Rauschenberg was impatient with such pedantry: "Why do they always want to spoil the mystery?" he asked.[11]

By 1980 Rauschenberg's graphic work showed a marked tendency to draw on images from specific places. There were precedents, including the magnificently dramatic *Booster* series, done in 1967 at the invitation of the United States Space Program. In his ULAE prints of the 1980s, Rauschenberg most often chose a place, or occasionally an event, on which to focus. This is not to say that there is a rigid iconographic program within each work but simply that a new consistency is discernible. The *Glacial Decoy* series (cat. nos. 96-104) is based on photographs taken to create a stage set for the Trisha Brown Dance Company. *The Razorback Bunch* series (cat. nos. 106-110) is based on photographs taken in the South that range from the panoramic to the trivial and convey an uncanny sense of place. There are prints whose imagery can be precisely located. A passenger going from New York's Pennsylvania Station to ULAE gets off at Bay Shore, Long Island; the 5:29 is a rush-hour train. All of the images in *5:29 Bay Shore* (cat. no. 111) are photographs taken on the way to, or near, the studio in West Islip. Rauschenberg took the photographs and made the print in one day.

His iconography may be generally noncommittal, but not the man. Rauschenberg has supported dozens of causes: education, ecol-

ogy, artists' rights, political issues, and world peace. More than any other artist of his generation, he is a multimedia activist, performing, since his 1949 appearances with John Cage, with several dance companies, including Merce Cunningham, Yvonne Rainer, Paul Taylor, and Trisha Brown.

Collaboration is the essential and distinguishing ingredient in Rauschenberg's *modus vivendi*. "It flattens the ego," he told Douglas Davis.[12] In the process of "collaborating with the neighborhood," Rauschenberg used mechanical items (radios, fans, clocks) in his combine paintings. It was only a short step to higher technology. In 1966, stimulated by European artists' work with light and kinetics, Rauschenberg and engineer Billy Klüver founded Experiments in Art and Technology (EAT). EAT had no stylistic program; it sought to bring together artists and scientists to sponsor events that fit into no existing categories. Rauschenberg used audio and video technology with the same spontaneity he employed with the offset press and cameras at ULAE.

Rauschenberg now collaborates on a global scale. He has made ceramics in China and Japan, paper in India. He is traveling throughout the world for the Rauschenberg Overseas Culture Interchange, a foundation dedicated to artistic exchange and world peace. These communal efforts are symptomatic of his larger synthesis: The artist works *with*, not *on*, his world; he has made the world into his palette.

Notes:

1. Ljubljana, 1965, unpaged.
2. New York, Jewish Museum, 1963, unpaged.
3. Sparks, Towle interviews and correspondence, 1982-85.
4. Davis, 1969, p. 90.
5. Lyon, 1982, p. 12.
6. Sparks, Rauschenberg interview, 1985.
7. Cox, letter to Sparks, August 25, 1982.
8. Washington, 1976, cat. nos. 82-85.
9. Sparks, Rauschenberg interview, 1985.
10. Tomkins, 1980, p. 33.
11. Sparks, Towle interviews and correspondence, 1982-85.
12. Davis, 1974, p. 145.

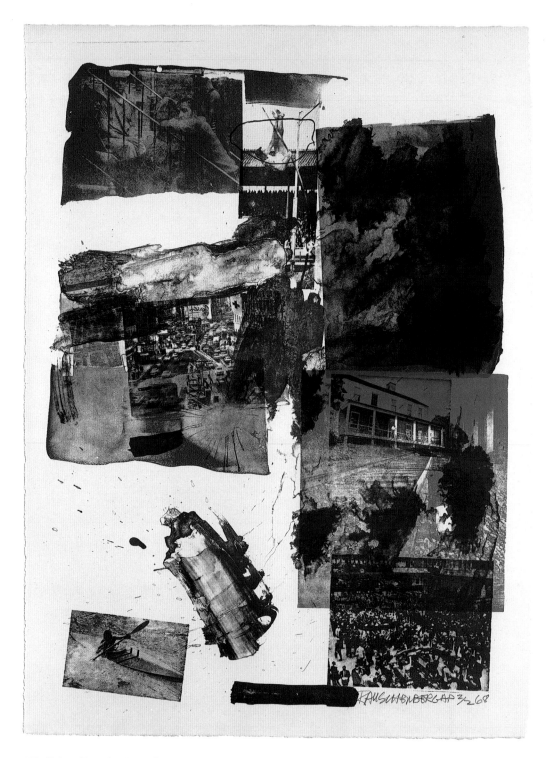

175. Robert Rauschenberg, *Promise*, 1968.
See cat. no. 36. In 1968, Rauschenberg
created two monumental sculptures for the
"Documenta 4 International Ausstellung"
in Kassel, West Germany. Although the
participating artists were not required to
contribute financially to the exhibition,
Rauschenberg (as he had done and would
do on many other occasions) agreed to do
so. *Pledge* (cat. no. 35) and *Promise* were
his gift to "Documenta."

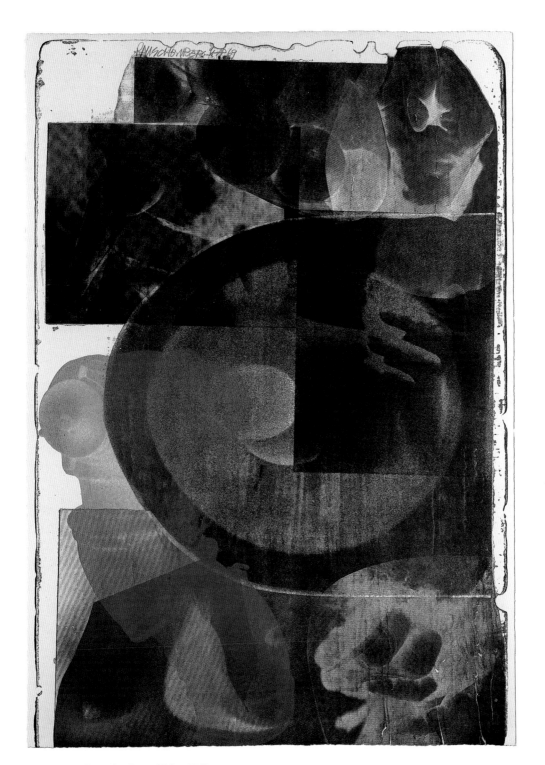

176. Robert Rauschenberg, *Tides*, 1969.
See cat. no. 38. Some of the photographs
used for *Tides*, *Drifts*, and *Gulf* (cat. nos.
38-40), Rauschenberg took in Florida. The
hydrant and the artist's turtle, Rocky, were
also used for *Unit (Turtle)* and *Unit
(Hydrant)* (cat. nos. 43, 44). Using infrared
lights to transfer film to stone, and the
night itself as a darkroom, Rauschenberg
created the underwater look he wanted.

177. Robert Rauschenberg, *Centennial Certificate MMA*, 1969. See cat. no. 42. Although he was honored by the commission to create a poster for the Metropolitan Museum of Art's centennial in 1970, Rauschenberg had serious reservations about the project, since he valued historic art for its sensuous qualities, not its educational or historical merits. Initially the images and text were to be chosen by the curatorial staff. In the end, Rauschenberg selected the images and wrote the text himself.

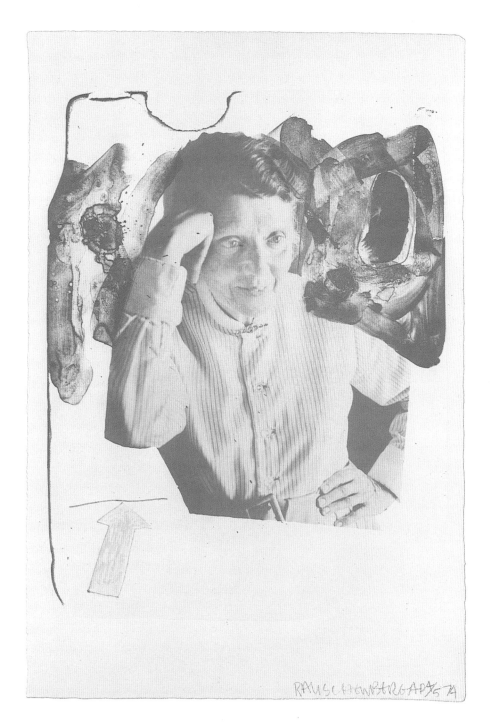

178. Robert Rauschenberg, *Tanya*, 1974.
See cat. no. 45. Special in many ways, *Tanya*
was Rauschenberg's contribution to the
press's fifteenth anniversary commemora-
tion, the artist's only graphics portrait, and
the only portrait of Mrs. Grosman ever
published at ULAE. The basis of the
likeness is a photograph taken some years
earlier by a visiting photographer. In 1982
Rauschenberg created by photographic
transfer seven ceramic panels titled *Tanya
Litho HC 2/18* for the Otsuka-Ohmi Ceramic
Co., Shigaragi, Japan. The artist does not
consider the panels an edition.

179. Robert Rauschenberg, *Glacial Decoy Series: Lithograph I*, 1979. See cat. no. 101. The *Glacial Decoy Series* (cat. nos. 96-104) were the first prints to use only Rauschenberg images. Choreographer Trisha Brown asked him to design sets and costumes for *Glacial Decoy*, which was first performed in New York on June 20-24, 1979. Rauschenberg took thousands of slides from which he selected several hundred to be run on multiple projectors, creating a changing, wavelike succession of images on a wall behind the dancers. From the unused slides, he selected images for the prints in this series.

Left:
180. Robert Rauschenberg, *The Razorback Bunch: Etching IV*, 1981. See cat. no. 109. The sumptuous qualities and tactility of the *The Razorback Bunch* (cat. nos. 106-110) series belie the poverty and decay caught by Rauschenberg's camera and transferred to printing plates. The images are closely related in time and place. But their randomness and their glancing humor are more important—as well as their references to the past. Both the neon letters and the window shade, for example, refer to his famous multiple *Shades* (cat. no. 18). Such reuse of old images inevitably invites comparison with Jasper Johns's work at ULAE (and elsewhere). Rauschenberg's approach, however, is profoundly different. He does not manually invade the component images but resizes, recolors, and recontextualizes them.

Below:
181. Robert Rauschenberg, *5:29 Bay Shore*, 1981. See cat. no. 111. The Long Island Railroad train marked "Bay Shore" left Manhattan at 5:29 P.M., taking many artists, printers, and visitors to ULAE. The photographic elements in this print were made from photographs Rauschenberg took from the train.

182. Larry Rivers, *Jack of Spades*, 1960.
See cat. no. 25. *Jack of Spades* was Larry
Rivers's largest, boldest, and most
painterly print to date. He was attracted to
playing cards for their decorative, abstract
qualities, not for any symbolic associations.

Larry Rivers

(American, b. Bronx, New York, 1923)

Larry Rivers was the first artist Tatyana Grosman invited to work at ULAE. She had heard of him through William S. Lieberman, then curator of prints at the Museum of Modern Art, New York. When they met by chance on the *Vollendam*, en route to Paris in 1950, Rivers was on his first trip to Europe and the Grosmans were going to look for the studio the Nazis had forced them to leave in 1942.

The artist Nell Blaine, then a drummer in an all-girl band, was the first to encourage Rivers to leave his career as a jazz musician and become an artist. Jane Freilicher, whose husband was also a professional musician, had taken him to Blaine's class and then to Hans Hofmann's classes. Hofmann, never blinded by his own devotion to Abstract Expressionism, recognized Rivers's great gift: a conspicuous and fluent Old-Masterish talent for drawing. After a year and a half with Hofmann in New York and Provincetown, Rivers enrolled in William Baziotes's classes at New York University, where he earned a Master of Fine Arts degree in 1951.

Hofmann had advised Rivers to follow his bent for realism, but it was hardly possible for a young artist in the late 1940s and early 1950s to close his eyes and mind to New York abstraction. Rivers absorbed two basic tenets of Abstract Expressionism: the Surrealist idea that accident should be honored and the correlative notion that the aim of Action Painting, as Harold Rosenberg termed it, "was not to produce a new kind of abstract art—[but] to redefine art as the activity intellectual, psychic, physical—of the artist."[1] In his work of the 1950s and early 1960s, from *Stones* (cat. nos. 11-24) to the giant *Billboard for the First New York Film Festival* (1963; Hirshhorn Museum and Sculpture Garden, Washington, D.C.), Rivers filled paper and canvases with clearly recognizable images while he simultaneously revealed the process of making them. Thus, in 1957, when he encountered the problem of correcting marks on a lithographic stone, it was

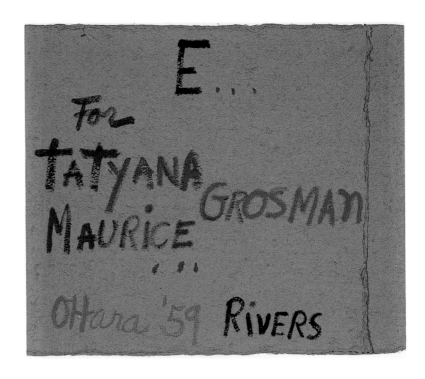

183. Larry Rivers, *Stones* (cover), 1957-60. See cat. nos. 11-24. *Stones*, the first great collaborative project produced at ULAE, had its origins in Tatyana Grosman's memories of illustrated books. In the beginning, Larry Rivers and Frank O'Hara were totally unprepared for the problems of making lithographs; they made full-size drawings on paper and used a hand mirror to reverse everything. The real subject of *Stones* is the two men themselves; the portfolio is autobiographical and diaristic, a compendium of private jokes and shared enthusiasms. Douglass Morse Howell made the papers: rough-edged linen rag sheets for the collaborative prints and a heavy folder (colored with blue-jean cuttings) which Rivers painted individually.

184. Larry Rivers, *Last Civil War Veteran II*, 1961. See cat. no. 28. This image is based on the earlier of two photographs of Walter Williams, the last surviving veteran of the Civil War, published in *Life* magazine May 11, 1959, and January 11, 1960, respectively. In this print, Rivers added color stones to the black drawing stone with a new assurance.

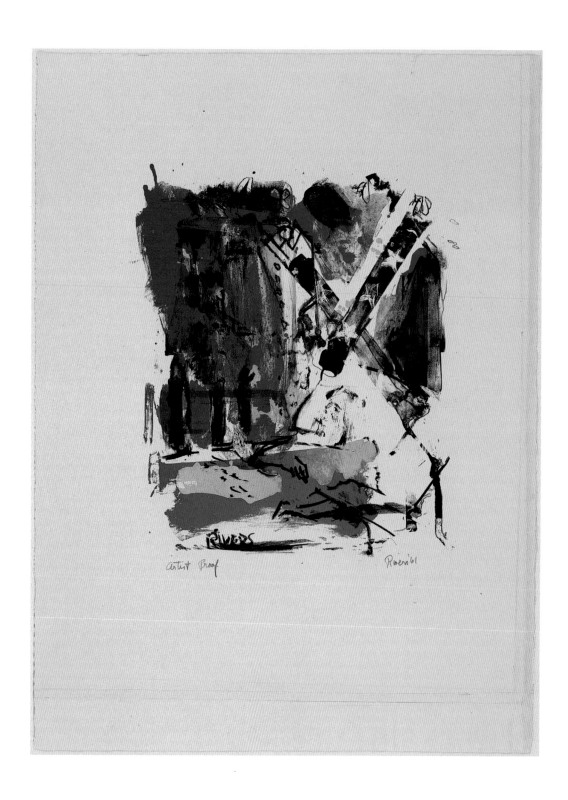

185. Larry Rivers, *French Money*, 1963. See cat. no. 35. This print probably marks the first appearance of Napoleon in Larry Rivers's work, a subject that was to become one of his most important themes. Rivers found this obsolete hundred-franc note to be a mine of ornamental and iconographic ideas. Using ten stones to print fourteen colors, Rivers and Master Printer Zigmunds Priede created the most complex color print Rivers had ever made.

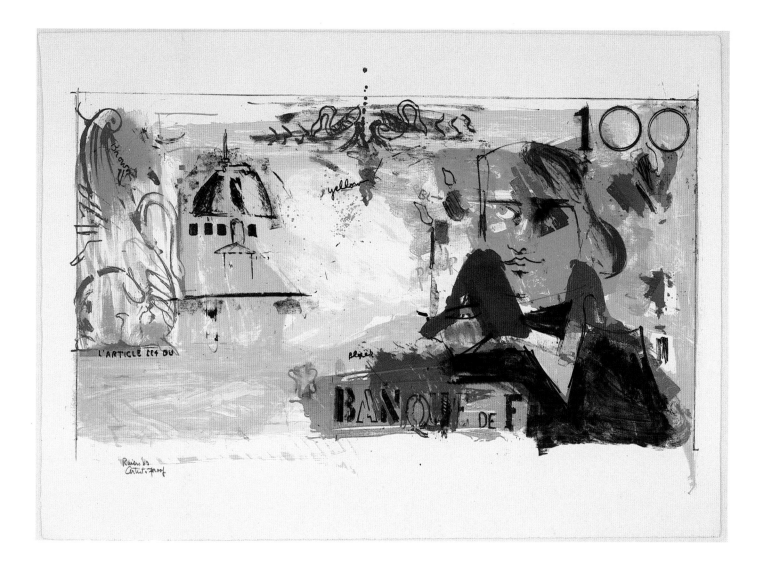

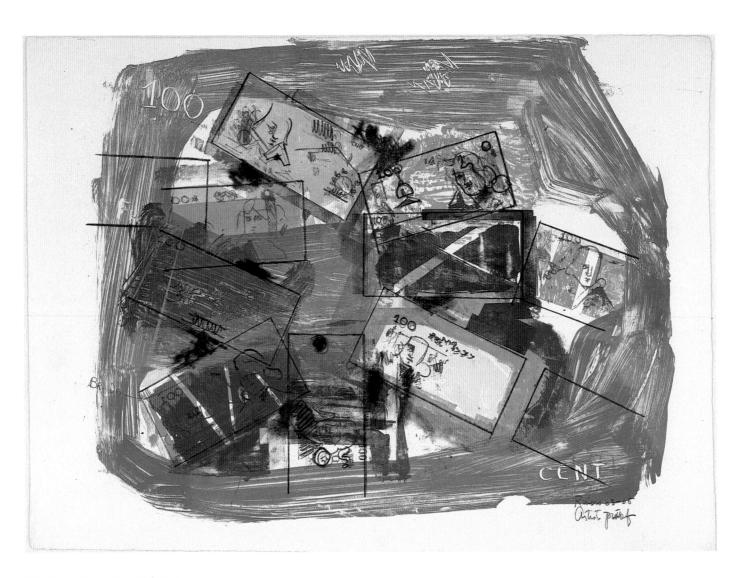

186. Larry Rivers, *Nine French Bank Notes, II*, 1963-65. See cat. no. 39.

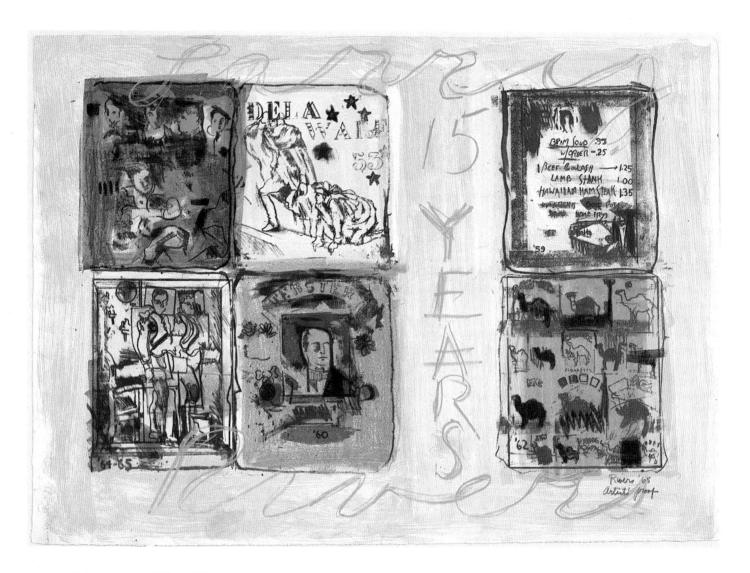

187. Larry Rivers, *15 Years*, 1965. See cat.
no. 40. This reprise of Rivers's most
famous images was created for the fifteen-
year retrospective exhibition of his work
which was organized by Brandeis
University's Rose Art Museum and
subsequently shown in Pasadena, New
York, Detroit, and Minneapolis. This print
was Rivers's first "retrospective in a single
frame," although others were to follow.
While doing *15 Years*, Rivers designed a
variant composition in a vertical format to
be used as a poster; Telamon Editions
printed 3,000 for Brandeis and 2,000 (or
more) for ULAE.

not intimidating. Erasures and pentimenti had long been a part of Rivers's style.

Rivers's reputation grew quickly, His first one-person exhibition was at the Jane Street Gallery in 1949. Clement Greenberg and Meyer Schapiro chose him for the watershed "New Talent 1950" exhibition at the Kootz Gallery. The dealer John Bernard Myers took him into the Tibor de Nagy Gallery in 1951.

Rivers was the first of a growing number of renegades from the Abstract Expressionist fold. Abstraction was a dead end to him; subject matter was his inspiration. Rivers's realism, however, was not simply a revival of old-fashioned Regionalism and social-protest painting nor even of the styles of the Old Masters whom he deeply admired. What made Rivers's work unique was his prescient eye for the telling detail. "I thought of a picture as the surface the eye travels over in order to find delicacies to munch on," he said.[2]

His pictures occasionally resemble giant sketchbooks; the best of them have the cohesion of a good jam session. This is true of the large autobiographical paintings, such as *The Studio* (Minneapolis Institute of Arts), and of the early lithographs, such as *Marriage Photograph* (cat. no. 10), *Purim* (cat. no. 36), *Last Civil War Veterans* (cat. nos. 27, 28), and the *French Money* series (cat. nos. 35, 37, 39).

These lithographs also serve as examples of the kind of subject matter that has identified Rivers as a precursor of Pop Art. His were the very same sources that inspired Pop artists in the 1960s. Rivers drew flags and movie stars and used advertisements and magazine photographs as a matter of course. The difference between his work and that of Dine, Rosenquist, and Lichtenstein lies in their respective sensibilities and styles, not in their ideas of what constituted acceptable content.

Rivers's brand of realism, a fundament of fact well-laced with fragments and suggestions, has usually misled viewers and critics alike into too-literal interpretations of his work. It has

188. Larry Rivers, *Ford Chassis II*, 1961. See cat. no. 30.

always been easier to talk about the subject, as Rivers himself usually does, rather than the formal problems that he finds just as absorbing. Consistently he has selected images that have an aura of history about them: *Marriage Photograph* (cat. no. 10) is a memento of his own past; *Webster* (cat. no. 26) uses a cigar-box reproduction of a nineteenth-century painting; *French Money* and *Nine French Bank Notes* (cat. nos. 35, 37, 39) employ images and ornament from the bank-note engravers' venerable inventory. About 1965-66, when his style had become "tougher" in subject matter and finish, the imagery became correspondingly more contemporary. All visual encounters were raw material for the artist, and none was intrinsically better than another.

Rivers's interest in poetry made him the perfect candidate for Mrs. Grosman's collaborations. Most of his friends were literary: O'Hara, Koch, Ashbery, and Schuyler. In the small world of the avant-garde, Rivers was a

liaison between artists and poets and jazz musicians. He had already collaborated with Frank O'Hara in a play presented by the Artist's Theatre, *Try, Try,* in 1952, produced by his dealer, John Bernard Myers. It was later published by Grove Press, whose publisher, Barney Rosset, recommended O'Hara to Mrs. Grosman. Rivers had also appeared in several of Rudolph Burckhardt's films and subsequently worked in direct collaboration with many artists, poets, filmmakers, musicians, and theatrical producers.

In 1957 the Grosmans brought the first two stones to Rivers's Southampton studio and left Rivers and O'Hara to figure out the rest. Mrs. Grosman could not offer any technical instruction; Maurice Grosman's experience was mostly in screenprinting. They carried more stones up the long flights of stairs to Rivers's Manhattan studio. Mindful of Maurice Grosman's heart condition, Rivers began to go to their studio. Grosman pulled the proofs with the occasional help of a local printer, Emanuel Edelman. At best, the first ten single prints may be considered satisfactory experiments. Many different papers were tried, including rough and/or tinted sheets that Douglass Howell made by hand. For example, five impressions of *The Bird and the Circle* (cat. no. 1) were printed on a standard Rives sheet, three on hard-to-handle Tokugawa, and nine on the precious Howell papers (Rivers hand-colored two of these). Rivers believes that many of the marks he made on the stone simply did not print.[3] The style of these works, even more sketchy and anecdotal than his paintings, and the fact that the artist was not present when they were printed made for very casual results.

After the death of his mother-in-law, Berdie, in 1957, Rivers moved back to Manhattan and began a series of paintings depicting objects in his studio. The single prints, as well as some pages of *Stones* (cat. nos. 11-24), depict the same things: a plant, a study for sculpture,

a photograph pinned to the wall, and, of course, the people who came to visit. Ink clinging to the edge of the stone was allowed to remain, thus providing a picturesque "frame."

In 1959 Rivers's paintings became simpler, bolder, and more expressionistic. Franz Kline has often been mentioned as Rivers's major influence during this period, although an early passion for the work of Chaim Soutine may have been rekindled then. *Jack of Spades* (cat. no. 25) is the most dramatic example of this stylistic moment, which, in its bravado, looks back to the expressive brushwork that preceded it, although in smaller scale. In its simplifications and color, the print looks forward to the collage style of prints such as *Don't Fall* (cat. no. 41) and *For Adults Only* (cat. no. 52). *Don't Fall* represented an abrupt stylistic change. It was created not by drawing and painting on the stone but by using cutouts as well as stencils in combination with drawings that were proofed and used as additional collage elements. The change in Rivers's printmaking method was part of his new interest in three-dimensional construction: in the early 1960s, he began to make giant constructions using wood, metal, synthetics, electric lights, and other real objects.

The *Stravinsky* prints (cat. nos. 43-45) brought Rivers's collage method to a new level of complexity. They incorporate photography (as does the *O'Hara Reading*, cat. no. 46) and represent hundreds of hours of experimentation and proofing.

A decade after it was founded, ULAE had the printers and the facilities to accomplish technically ambitious projects. Printmaking in general had expanded technically, qualitatively, and financially. In subsequent prints, Rivers took advantage of this new state of affairs in the workshop.

The passage of time inevitably brought a change in Rivers's relationship with Mrs. Grosman. In the beginning, she was the petitioner, relying on Rivers's sympathy for her as

Continued on page 254

189. Larry Rivers, *Stravinsky II*, 1966.
See cat. no. 44. For the New York
Philharmonic's production of Stravinsky's
Oedipus Rex at Lincoln Center in 1966,
Lucas Foss asked Larry Rivers to design the
costumes and sets. *Stravinsky I-III* (cat.
nos. 43-45) also pay tribute to the composer,
who, in Rivers's eyes, had the appearance
and courage of a lion. The circled numbers
refer to Moscow, Paris, and the United
States, places Stravinsky lived. The three
lithographs required the sustained
attention of two master printers, Zigmunds
Priede and Donn Steward. *Stravinsky II*
received a prize at the 5th International
Biennial Exhibition of Prints in Tokyo.

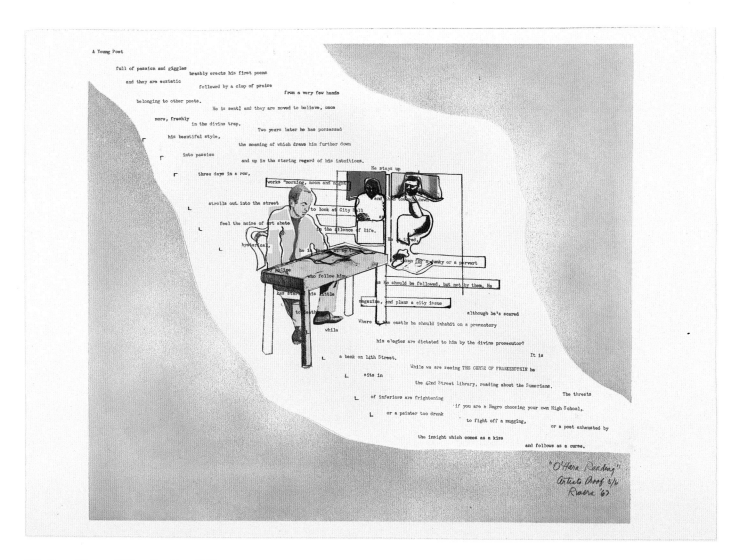

190. Larry Rivers, *O'Hara Reading*, 1967.
See cat. no. 46. On November 2, 1959, Fred
McDarrah photographed Frank O'Hara
reading his poetry at a Living Theatre
Benefit for the Yugan Press. In 1966,
shortly after O'Hara was killed in an
accident on Fire Island, Rivers made this
print in honor of his friend and
collaborator, basing it on McDarrah's 1959
photograph of Ray Bremser, Frank O'Hara,
Allen Ginsberg, and LeRoi Jones. The text
is "A Young Poet," one of many poems
O'Hara had sent him through the years.

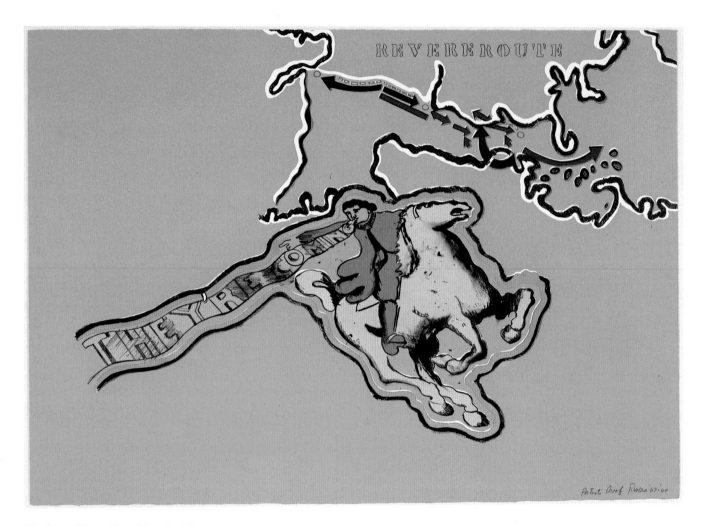

191. Larry Rivers, *Once More Paul Revere
I*, 1967-69. See cat. no. 48. The subject here
is the same as a section of *The Boston
Massacre*, a mural Rivers completed in
1968 for the New England Merchants
National Bank of Boston. The lithograph
maintains the painting's angular and
hieratic view of the horse and rider. The
proofs that span two years manifest a
decisive change from a casual and highly
chromatic style toward a more formal
presentation with the colors reduced and
intensified. This polished and aggressive
print makes an abrupt change from the
sensitive etching that preceded it
(cat. no. 47).

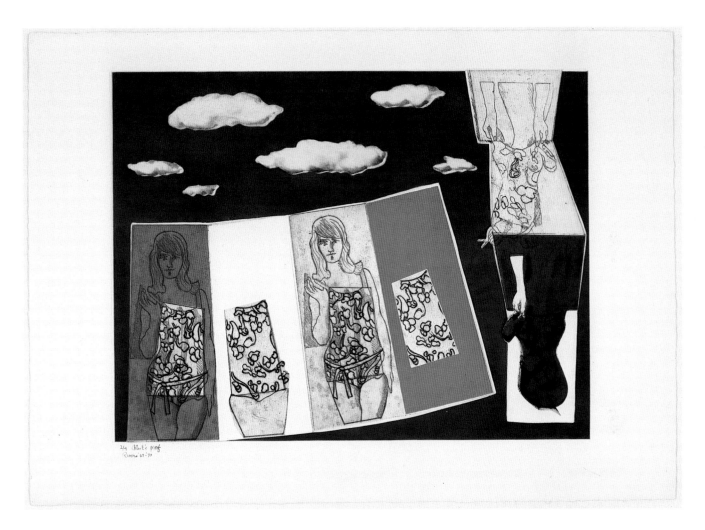

192. Larry Rivers, *For the Pleasures of
Fashion (Summer Unit)*, 1967-70. See cat.
no. 50. Although Rivers had not liked pure
etching, he found the tonal intaglio process
more congenial. He could work with small
elements in aquatint, alter and rearrange
them as he did in collage, and, finally, use
the printing process itself as a major factor
in the final result.

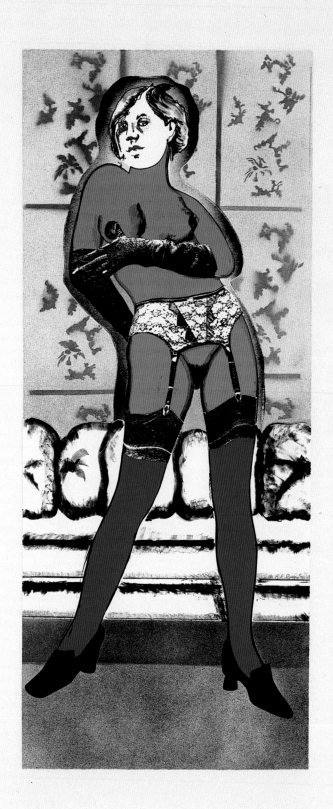

193. Larry Rivers, *For Adults Only*, 1971.
See cat. no. 52. *For Adults Only* started
with a photograph of a girl that was then
redone as a high-contrast print on acetate
and transferred to the stone. Rivers covered
his initial drawing with a flat layer of ink,
making the effect more baldly commercial,
more tawdry, and provocative. Although
Mrs. Grosman was pleased that the
lithograph had been selected for inclusion
in the Whitney Museum of American Art's
exhibition "Oversized Prints," her old-
fashioned notions of propriety were
offended by the subject. She insisted on the
temporizing title, *For Adults Only*.

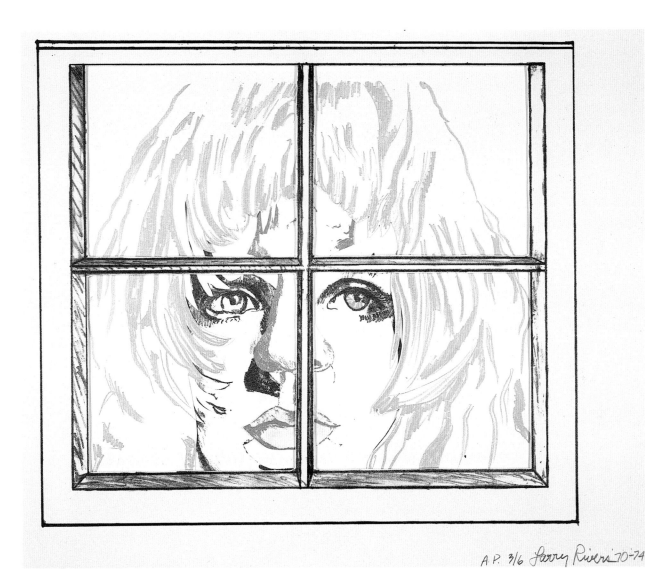

A.P. 3/6 Larry Rivers 70-74

194. Larry Rivers, *Diana with Poem*,
1970-74. See cat. no. 57. When Larry Rivers
began the *Diane Raised* series (cat. nos.
53-56), he intended to create a three-
dimensional work in paper, similar in
feeling to his mixed-media constructions.
The title heralded his intention. In this
print, Rivers created an elegant pop-up toy
for adults: Four sheets of paper are cleverly
laminated and hinged so that it appears as
if the face is pressed against a window pane.

195. Larry Rivers, *Don't Fall*, 1966. See cat. no. 41.

There are in the wide wide world around a group of things apart, and these are
called Tiny Splendid Things. Of such, for example, are

196. Larry Rivers, *The Donkey and the Darling, Page 1*, 1967-77. See cat. no. 63. Ever since *Stones* (cat. nos. 11-24), Mrs. Grosman had been looking for another well-known poet to collaborate on a book with Larry Rivers. Rivers had reservations about "illustrating" a text, but he was intrigued with the idea of doing a fairy tale that was a parody of fairy tales. The project was the most difficult and expensive publication ever undertaken by ULAE, consuming enormous quantities of paper, labor, and time. By June 1976, 105 stones, with a total of 126 printings, had been used for the images; 82 plates, with a total of 310 printings, had been used for the text; the box was still to come.

197. Larry Rivers, *The Donkey and the
Darling: Page 4*, 1967-77. See cat. no. 66.

a person and on their common interests, such
as Gypsy music, which Rivers's father had
played for him on the violin. Rivers recalled
that, "When she began to play Russian gypsy
music for me while I worked, I'm afraid I was
hers forever."[4]

Later, after Mrs. Grosman had realized
her ambition to publish the work of outstand-
ing artists of her day, theirs became more a
friendship of equals. Their last project
together was done beginning in 1977, before ill
health began to sap her vigor. She asked Terry
Southern for a manuscript—*The Donkey and
the Darling* (cat. nos. 59-115)—that would
become the most demanding and complicated
publication ULAE ever produced.

In the ten years of its production, it
became impossible to compute the reams of
paper, the number of printers, typographers,
and other technicians, or the cost. In 1977,
Rivers signed the first five books and remi-
nisced with Tony Towle about the work. They
agreed that it would never have happened with-
out Mrs. Grosman's unrelenting faith. "She
pulled me to water," Rivers said, "and I
drank."[5]

Notes:

1. Rosenberg, 1965, p. 37.
2. Rivers, 1961, p. 54.
3. Sparks, Rivers interview, 1985.
4. Rivers, 1982, p. 102.
5. Towle, Rivers interview, 1977.

198. Larry Rivers, *The Donkey and the
Darling: Page 7*, 1967-77. See cat. no. 69.

199. James Rosenquist, *Campaign*, 1965.
See cat. no. 1. The title of this print refers
to an intense twenty-day printmaking
"campaign" at the ULAE press as well as
military campaigns. Rosenquist had used
these images in a twenty-four-foot painting
made for the Spring Mobilization Against
the War in Vietnam in 1967. The black
flowers, made with a wallpaper roller,
express his fears about environmental
pollution. The war, he felt, was a hand
pouring salt on a dove's tail.

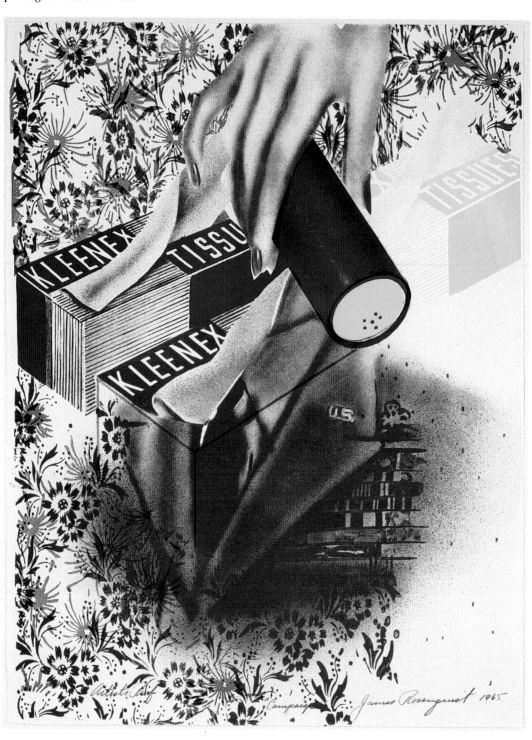

James Rosenquist

(American, b. Grand Forks, North Dakota, 1933)

Like many others who—often unwillingly—
bore the Pop Art banner, James Rosenquist
maintained an attitude toward Abstract
Expressionism that was neither rebellious nor
deprecating. He admired such disparate tal-
ents as Mark Rothko and Barnett Newman,
Hans Hofmann and Willem de Kooning, and,
from their example, drew inspiration to find his
own way with little regard to public recogni-
tion. Rosenquist very quickly became one of
the leading figures in a generation of realists,
acting simultaneously but not in concert, who
chose a radically impersonal approach to put-
ting subject matter back into art.

The distinctive features of Rosenquist's
style have often been linked to the accidental
events of his youth. Born in North Dakota, he
and his family moved frequently before settling
in Minneapolis. When he enrolled at the Uni-
versity of Minnesota, Rosenquist had no clues
as to his future, no experience as a fine artist,
and no friends or family to support such an
ambition. Encouraged in a drawing class, he
won a scholarship to the Art Students' League
and moved to New York in 1955. He supported
himself through a number of odd jobs, includ-
ing sign painting. He talked his way into the
New York union; by 1958 he had a job painting
gigantic billboards of food and movie stars for
Artkraft Strauss.

As soon as he had saved enough to live on
for a year, Rosenquist found a loft on Coenties
Slip and turned his full attention to art. In the
winter of 1959-60, everything fell into place.
Rosenquist had been working in an Abstract
Expressionist style that had proved to be a
blind alley. Suddenly, with no transitional pas-
sage, he painted *Zone* (Mr. and Mrs. Burton
Tremaine, New York), his first canvas in a "bill-
board" style, totally unlike anything he had
ever done before. Rosenquist had found his
own voice. His first one-person show, held at
Richard Bellamy's Green Gallery in February
1962, sold out. The flood tide of Pop Art had
started, and, from the beginning, Rosenquist

rode the crest. He chose contemporary images
—cars, heads, hands, food, and machines from
everyday life—blew them up to billboard scale
and doused them with the abrasive colors of
tabloid reproductions. But more than the ele-
ments themselves, it was the way he juxtaposed
them that puzzled, outraged, excited, or fasci-
nated his audience.

By inflating real things and drawing them
so that they seem at odds with each other,
Rosenquist delineates his feelings about his
material surroundings. Cubism, Expression-
ism, Futurism, Surrealism, Purism, and a host
of other movements in the twentieth century
had addressed the same task. But Rosenquist
thinks in the present tense, and his Surrealism
is neither literary nor theoretical; the odd con-
junctions are his own amalgamations of imme-
diate sensations and memories as well as
deeply held principles. Rosenquist has donated
his work, lectured, marched, lobbied, and even
been jailed for his political convictions, but he
has rarely propounded them in his work.

Even in the small body of prints produced
at ULAE, it is clear that the most exhaustive
analysis of his iconography does not account
for the enigma and blatancy of Rosenquist's
work. In 1962 Max Kozloff railed against
Rosenquist and other Pop artists for appealing
to the "pinheaded and contemptible style of
gum chewers, bobby soxers, and worse, delin-
quents."[1] His wrath only puzzled Rosenquist,
who had selected images he believed to be
emotionally neutral, nonhistorical, and anony-
mous. For example, he thought the car trim in
Dusting Off Roses (cat. no. 3), *Roll Down* (cat.
no. 8), and dozens of other works was a benign
image—too old to excite acquisitiveness, too
new for nostalgia. He also had other aims: to
wrench things from their ordinary context in
order to show that "real things are caustic to
one another"[2] and to experience the feeling of
oceanic immersion, such as he had done on
billboard scaffolds. And ironically and ulti-
mately, he wished to create works of art whose

Continued on page 264

200. James Rosenquist, *Spaghetti and Grass*, 1964-65. See cat. no. 2. Spaghetti and grass were two of Rosenquist's signature images of the 1960s. Thus, it was natural for the artist to select these subjects for his first encounter with the stone at ULAE. Dissatisfied with the lithographic crayon, Rosenquist turned to the airbrush, which became his primary tool at ULAE. In this print, he used airbrush for the spaghetti and an eraser for the grass.

201. James Rosenquist, *Circles of Confusion I*, 1965-66. See cat. no. 5. The glowing effects Rosenquist achieved in this print relate it to his epic painting *F-111* (1965; Collection of Mr. and Mrs. Robert Scull, New York) and reflect his fascination with all sources, sensations, and illusions of light. Using tusche and airbrush, Rosenquist made lithographic ink give the illusion of fluorescent as well as incandescent light.

Circles of Confusion I artist proof James Rosenquist 1965 - 66

202. James Rosenquist, *Expo 67 Mural—Firepole 33' x 17'*, 1964-66. See cat. no. 9. For many years an admirer of Buckminster Fuller, Rosenquist was delighted to be among the small group of artists invited to make pieces for Fuller's geodesic dome for the 1967 Montreal World's Fair. Rosenquist's huge mural, repeated with no substantial changes for this lithograph, gave the impression that the fireman was sliding down through the dome. The image of the fireman also referred in a negative fashion to President Lyndon B. Johnson's intention of "rescuing" Vietnam from the Communists.

203. James Rosenquist, *Horse Blinders*,
1968. See cat. no. 10. Rosenquist had begun
the painting of the same title as this print
in a mood of euphoria. But in 1968, he
became depressed by the assassinations of
President John F. Kennedy and Martin
Luther King, Jr., as well as the riots at the
Democratic Convention in Chicago, and
the print changed from an experiment
in reflective materials to a figurative
composition related to Rosenquist's
painting *Trophies of an Old Soldier*
(1961-62).

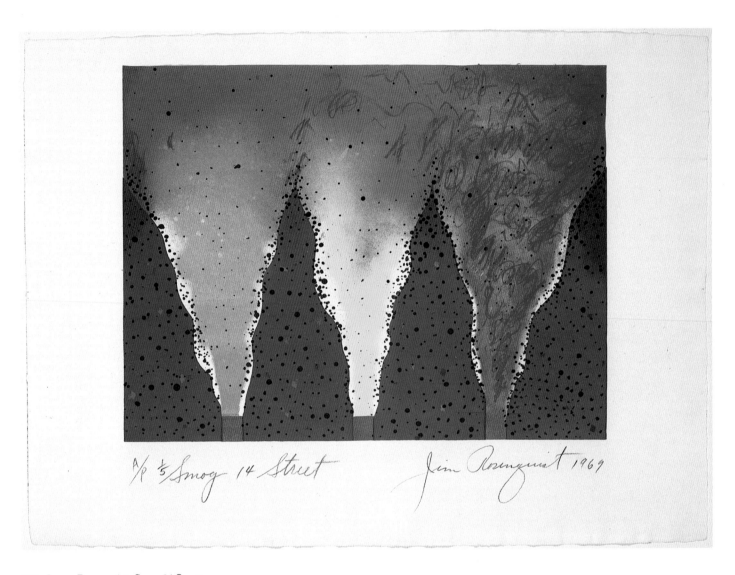

a/p 1/5 Smog 14 Street *Jim Rosenquist 1969*

204. James Rosenquist, *Smog 14 Street*,
1969. See cat. no. 13. Almost fifteen years
after he first saw the power plant
smokestacks on 14th Street in New York,
Rosenquist committed his impressions to
paper. The thirty-two working proofs that
Mrs. Grosman kept record an extraordinary
outpouring of ideas, both pictorial and
technical. Ultimately, eight stones were
made for the three "Con Ed" prints (cat.
nos. 13-15). *Smog 14 Street* is the lightest
and most luminous; *Night Smoke I* has the
gritty glow of industrial wastelands at
night; and *Night Smoke II* is the most
dramatic and fluorescent.

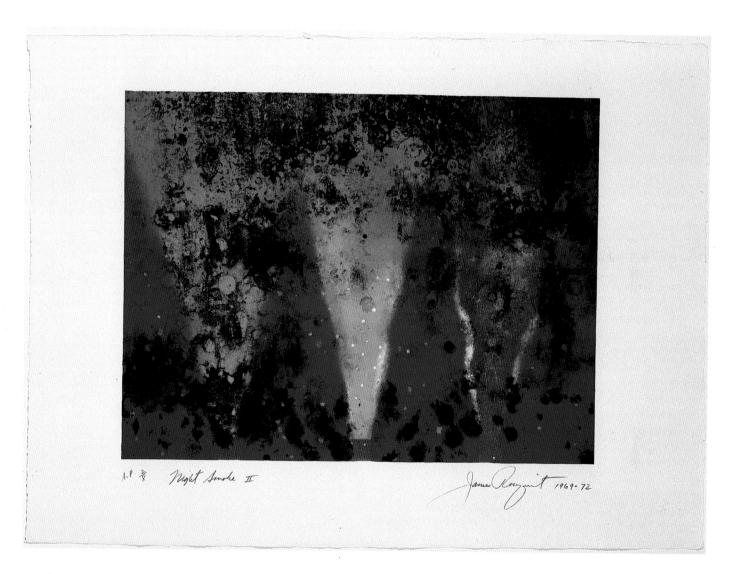

A.P. 3/8 Night Smoke II James Rosenquist 1969-72

205. James Rosenquist, *Night Smoke II*,
1969-72. See cat. no. 15.

meanings change from viewer to viewer and from year to year.

By distorting actual color and relative size, Rosenquist controls the rate at which we recognize things. The flowers in *Dusting Off Roses* are clear; the car trim—reduced, inverted, and out of context—takes longer to identify. In *Circles of Confusion* (cat. no. 5), the General Electric logo is common parlance; the shapes in the background must be deciphered. Rosenquist was entranced by this phenomenon when he painted billboards. "I could set the fragments of these images in a time-recognition space, and the mystery of it would be that the largest exact fragment would be recognized at last."[3]

Whether constructing environmental canvases or calculating inks for a modest lithograph, Rosenquist's palette has always been intense, superficially simple, and abstract. In print after print, the trial proofs show a rising level of chromatic intensity, inks as well as papers moving toward vividness and contrast and away from naturalism. Rosenquist chooses colors "to get as far away from the nature as possible."[4]

When Tatyana Grosman approached Rosenquist in 1962 about working at ULAE, she had seen his work at Richard Bellamy's Green Gallery. Jasper Johns and Robert Rauschenberg, whom he knew well, had already been to the West Islip workshop, and she thought that their example might attract him. But prints had little appeal for Rosenquist. To him, with one exception, they seemed more like craft than art. The one exception was *Target* (Johns, cat. no. 1) by Jasper Johns, which Rosenquist remembered from an exhibition at the Museum of Modern Art as the color in a sea of black and white. And he remembered that it had been printed at ULAE. In 1964 Johns telephoned Rosenquist to speak on Mrs. Grosman's behalf, referring to her as a nice old lady whom Rosenquist should help.

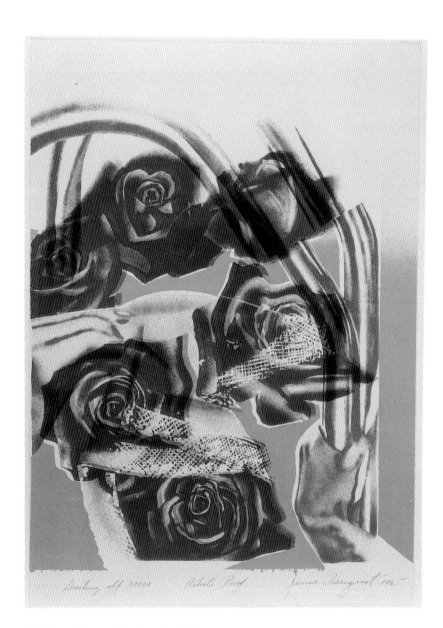

206. James Rosenquist, *Dusting Off Roses*, 1965. See cat. no. 3.

Finally, after a long and harrowing drive out the Long Island expressways, Rosenquist arrived at Skidmore Place, was greeted with the ritual food and conversation, and given a small stone, crayons, and some tusche. He tried a drawing of spaghetti; the stone went through the press and Rosenquist was appalled at the result. Still, he was intrigued with the process. He could draw anything, could get the colors he wanted in paint as well as in four-color commercial printing, could manage crayon and liquid color on paper. But the lithographic crayon would not behave. It clogged and smeared, appearing to be one thing on the stone and another when printed. To make matters worse, he found that the drawing might deteriorate before he was ready to print an edition.

He came back to try again, and this time, despite Mrs. Grosman's preference for crayon and tusche, he used an airbrush to put down the color and an eraser to lighten it. Thus, he applied a modern tool to what he considered an outmoded procedure. "I was using the original technique of lithography before it got sophisticated," he said.[5] The colors he saw in *Life* magazine—which established the palette of his earliest paintings—had to be remade in thick inks and put on archival papers so they would last the ages.

Rosenquist soon discovered that the process of making color separations in lithography was another way he could emphasize the abstract. He knew from his commercial work that layers of airbrushed color can act as another form of separation, or abstraction, between two compositional elements. To the limited tools of stone lithography, he adroitly added airbrush and other effects analogous to the painted illusions, fluorescent color, and reflective materials in his paintings. He used the blended roll, another antirealistic device, for the first time in *Firepole* (cat. no. 9) and many times thereafter to make realistic elements more ambiguous.

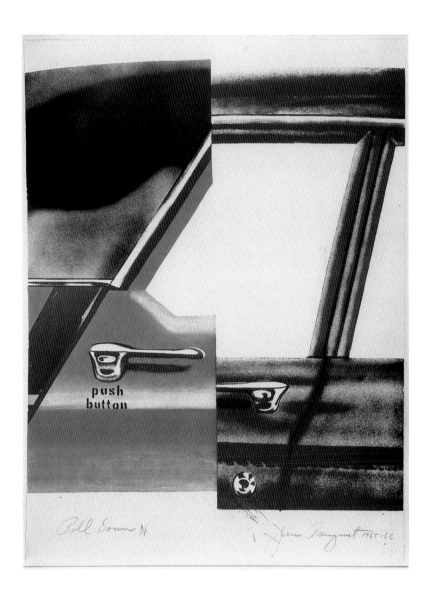

207. James Rosenquist, *Roll Down*, 1964-66. See cat. no. 8.

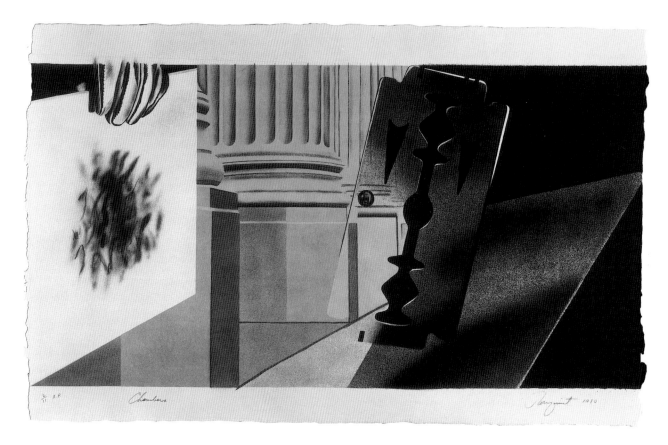

208. James Rosenquist, *Chambers*, 1980.
See cat. no. 19.

Time after time, the sequence of his trial proofs shows an almost playful, provocative approach to color. Rosenquist often set aside a color, and enhanced or changed it to something more upscale, assertive, or caustic. On at least one occasion, he made a mock ceremony of the procedure, laying out all his prints and deciding the names of the colors.[6]

Throughout the 1960s and 1970s, Rosenquist's painted compositions grew more complex and disjunctive. In prints, however, he rarely used more than three compositional components. The pattern imposed upon an image or area often acts like another image, complicating and enriching the composition. For example, the mottled pattern of the right-hand sphere in *High-pool* (cat. no. 7) appears repeatedly in the prints of the next fifteen years, often applied to objects that normally have another sort of texture. There are a dozen or more single-image compositions in all of Rosenquist's prints; a mere handful of single-image paintings. In any case, whether painted or printed, complex or simple, the components

of a Rosenquist image are locked into an abstract totality that belies and dignifies their life as everyday objects.

According to Bill Goldston, who has printed with Rosenquist since 1969, the artist has always gone to the studio with a precise idea in mind. Then he does what he calls a "clutch drawing," a small colored sketch of the composition. Sometimes Rosenquist brings clippings (he has saved thousands of them) or photographs as stimuli but never incorporates them into the picture as is. A newspaper clipping that Mrs. Grosman saved along with the trial proofs of *Dusting Off Roses* is an excellent example of Rosenquist's procedure. With one hand, the woman in the clipping holds a box of Cut-Rite wax paper and, with her other, tears a piece from the roll; in the print, the wax paper was replaced by a handkerchief. Rosenquist wrote on a later proof, "wiping the dust off the rose," indicating that he had maintained the artificiality of gesture but changed the context, giving it a characteristically ironic twist.

209. James Rosenquist, *15 Years Magnified Through a Drop of Water*, 1972-73. See cat. no. 16. The year 1972 was an important one for both Rosenquist and Tatyana Grosman. A scant decade after his first one-person show, two retrospectives of Rosenquist's work were planned: by the Wallraf-Richartz Museum in Cologne and the Whitney Museum of American Art in New York. ULAE also had a retrospective to look forward to, an exhibition at the Corcoran Gallery of Art in Washington (although it never took place). For this occasion, Mrs. Grosman had a special seal designed, which Rosenquist incorporated in his first watercolor sketch for *15 Years....* Atypically, Rosenquist's first sketch remained substantially intact in the final design.

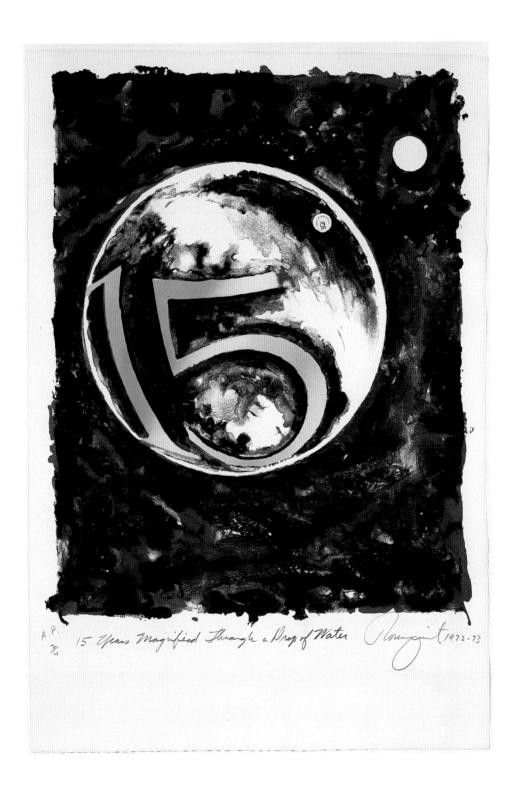

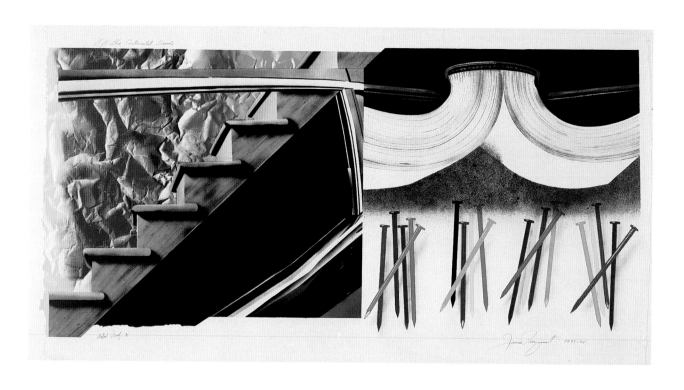

Artist Proof James Rosenquist 1973-74

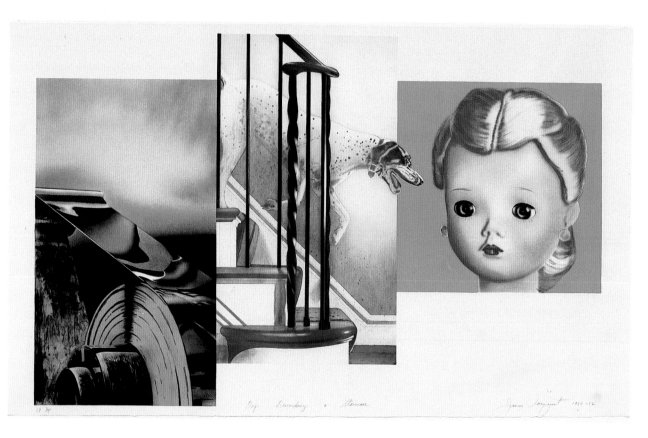

18/78 Dog Descending a Staircase James Rosenquist 1980-82

Opposite above:
210. James Rosenquist, *Off the Continental Divide*, 1973-74. See cat. no. 17. Rosenquist worked on *Off the Continental Divide* for more than a year, creating forty-six plates to be printed by the new offset press and finally printing from twenty-nine. It was the largest print ever made at ULAE, and a watershed for the "big print" boom. It is a richly auto-biographical print, with images relating to his past, his interest in Eastern philosophy, and the tools of his trade.

Opposite below:
211. James Rosenquist, *Dog Descending a Staircase*, 1980-82. See cat. no. 20. This print and a painting of the same title were started at the same time. The painting was painted as three separate canvases and mounted together; the distinctive qualities of stone lithography, offset lithography, and etching differentiate the three parts of the print. Rosenquist's title is a tribute to Marcel Duchamp, who had flattered the young artist by suggesting that they exchange prints.

An oil painting conceals false starts under the final layer of paint, but a succession of trial proofs allows us to follow an artist's lines of thought. Rosenquist's working proofs—sketches, color trials, proofs reworked in pastel—show a bold and unself-conscious creativity. He was often distressed that weeks and months elapsed between doing the work and seeing the results. He wished that Mrs. Grosman did not insist that only one artist at a time work at ULAE so that he could continue. The delays distanced him from the work, making him feel that printmaking was "just a release" from the more serious business of painting.[7]

The delays, however, forced Rosenquist always to start over, to look at previous work with a fresh eye. Hundreds of proofs were made, many destroyed, until the print was as vivid, bright, and fine as he wanted. In almost every print, there were significant compositional and color changes until the very last moment. Several "final trial proofs" marked "O.K." were again changed for the edition.

Rosenquist, from the very first, has been an undaunted experimenter: making bedfellows of billboard and "high art," using unorthodox materials, exploring film and video as well as all of the print media, and, today, printing on nontraditional surfaces. From a graphic oeuvre of more than one hundred forty prints dating from 1962 to 1982, Rosenquist made only twenty at ULAE. That score of prints, hampered by the irritations but helped by the objectivity of delay, stands as his finest work in the printmaking media.

Notes:

1. Kozloff, 1962, p. 36.
2. Swenson, 1964, p. 63.
3. Cummings, 1983, p. 33.
4. Swenson, 1964, p. 63, n.4.
5. Sparks, Rosenquist interview, 1985.
6. Towle, Diary, 1963-78, March 1, 1972.
7. Sparks, Rosenquist interview, 1985.

212. Edwin Schlossberg,
Wordswordswords: 1967-68. See cat.
nos. 1-20.

Edwin Schlossberg

(American, b. New York, 1945)

In June 1967, Jasper Johns took Edwin Schlossberg with him to see Tatyana Grosman. Mrs. Grosman lost no time in addressing the young visitor: "Jasper tells me you are a poet. What do you write?"[1] Schlossberg had met Johns, as well as Rauschenberg, Twombly, and Warhol, through the critic Suzi Gablik but he knew little about art outside this circle. A disciple of Buckminster Fuller, Schlossberg was then rapidly digesting courses in literature and linguistics as well as anthropology and physics at Columbia University. He had been making handmade books for some time and described some of his experiments to Mrs. Grosman. The next week, Schlossberg brought a box of his "things": poems that Tony Towle helped Tatyana Grosman to read as well as eccentric and provocative ideas for books. Some were typed, for example, on plastic wrap and aluminum foil; in some, both the sheets and the verses were arranged in—to her—unprecedented ways. Schlossberg loved making interesting *things*.

Mrs. Grosman was drawn to Schlossberg and wanted him to start to work immediately on a book he titled *Wordswordswords* (cat. no. 1-20). The timing was bad; Schlossberg was scheduled to teach in Buckminster Fuller's program at Southern Illinois University at Carbondale in the fall of 1967, but he did manage to spend three or four weekends that winter at West Islip. Disappointed to find that Fuller spent very little time in Carbondale, Schlossberg returned to Columbia in the spring of 1968. He took up the book again with great energy, working on many pages at once.

Schlossberg had prepared carefully for his first visit by making a complete prototype by hand. But no artist was invited to ULAE to make printed reproductions. "These are good starting points," Mrs. Grosman said. "But you must work with the people here and make everything happen here." Schlossberg responded as she hoped every artist would, by falling in love with the stone and eagerly trying all of the available presses. Eventually, he even misplaced the handmade prototype.

The form of *Wordswordswords* follows directly from Schlossberg's conviction that education and entertainment are best achieved in tandem. His design projects of the last ten years (such as the Hanna-BarbaraLand Funsonian in Spring, Texas, of 1984 or the Brooklyn Children's Museum Learning Environment of 1977) feature state-of-the-art technology, handsome graphic design, and sheer freewheeling invention, all focused on what Schlossberg perceives to be an increasingly sophisticated and discriminating public. Although *Wordswordswords* is a very small and intimate object, it follows the same principle, using artistry to pique curiosity and make people think. In his view, the message and the materials, form and content, and education and entertainment should be inextricable.

Working from Schlossberg's cardboard prototype, Louis Leibl, Jr., made an aluminum box that opens to reveal a soft brown paper folder. Inside the folder the printing surfaces are paper, foil, and plastic: high-quality versions of Schlossberg's Saran Wrap and kitchen foil. The qualities intrinsic to the materials determined the form of the work: the grain of the stone added new textures; inkless embossing created images that appear and disappear according to available light; printing on cut or folded sheets makes it possible to change the poems themselves; and poems divided among several sheets of Plexiglas invite their own destruction.

Christopher Pullman, who printed the letterpress for *Wordswordswords*, told Schlossberg that the book was almost a checklist of every flaw a printer is trained to avoid: misalignment, misspelling, reversals, accidental masking, creased paper, blind embossing, and fragmented letters. Schlossberg was delighted.

Poem for Jasper

Paradox is a way of seeing
and this too
is somewhat true
as the words you read say
that light is not seeing
but a part.

Next to light, next to the words about it
is your face ungraven.

Dream life is chaotic

and begins to slip ordered

when the light foretold

bends and breaking is clear

We are born
we are told

Seeing is a way of paradox.

213. Edwin Schlossberg,
Wordswordswords: Poem for Jasper,
1967-68. See cat. no. 4.

Magic of saying what is
left apart from my eyes
what strains of sight
what parts of words
lie hidden in order
what rumors of future
lie waiting in patterns
unlinked to my eyes
As the black lines
dissemble wishes
broken waves of thought
attract the motion
that we meant to be
and scatter it
a multitude to the wind
made of leaves
of let leaves
of the atoms of our sight.

214. Edwin Schlossberg,
Wordswordswords: Magic of Saying,
1967-68. See cat. no. 13.

215. Edwin Schlossberg,
Wordswordswords: These Words, 1967-68.
See cat. no. 19.

Wordswordswords is poetry that is constructed (and deconstructed) so that "the act of reading would become part of the content of reading."[2] All of Pullman's "classic printing errors" contribute to the process. A gap in a line, for example, is perceived according to the predisposition of the reader/viewer. A gap can be construed as an error to be rectified, an invitation to create a new whole, to make new connections, or an opportunity to disregard the verbal information and enjoy the visual for its own sake.

Typeface is a key factor. Schlossberg chose a cluster of related styles: typewriter Elite, Caslon, Bulmer, and packing-crate stencil. He was admittedly influenced by Johns's stencil letters, but the primary reason was perceptual. Schlossberg discovered that sans-serif letters break apart into unintelligible lines and curves. When serifed characters are fragmented, the original letters can usually be recognized. For a poet investigating the cohesive power of words, these Roman letters are a perfect instrument.

In a totally different way from his friends Johns, Rauschenberg, and Twombly, Schlossberg labored to make the process identical with the art itself. He did not intend to create another elaborate visual/verbal hybrid of Concrete Poetry (which he did not read until the late 1970s). Instead he wanted something at once simpler and more comprehensive. Verse 14, *In Each*, says "putting all the parts / together / we see poetry / comes from the / steps in letters."

Fragments from a Place was one of the "anniversary" prints of 1974. Like the others (Rauschenberg's *Tanya*, cat. no. 45, and Rosenquist's *15 Years Magnified Through a Drop of Water*, cat. no. 16), it is of a distinctly personal nature. Like many other ULAE artists, Schlossberg had enjoyed the beach near the studio and originally planned to put the pattern of ocean waves behind the words. When he saw a proof on the handmade Angoumois paper, he decided that the paper

itself read like a miniscule wave pattern. Perhaps by chance, the push-pull of ink textures created another sort of wavelike effect.

About 1961 Schlossberg read about the production of Liquid Crystal, which will change color in the presence of heat, even that of a nearby hand, and then revert to its original color in a few seconds. Liquid Crystal was extremely expensive at first, but by 1972, a mylar and alcohol medium had been developed that would stabilize the color and bond it to paper. The series of three prints (cat. nos. 22-24) shown at Ronald Feldman's gallery in New York in October 1981 were the result of that chance discovery. Tatyana Grosman was delighted. Never had there been a print that would change colors and return to its original state. The process was a new tool in Schlossberg's eternal play on, and with, the mutable art of poetry.

Notes:

1. Sparks, Schlossberg interview, 1985.
2. Ibid.

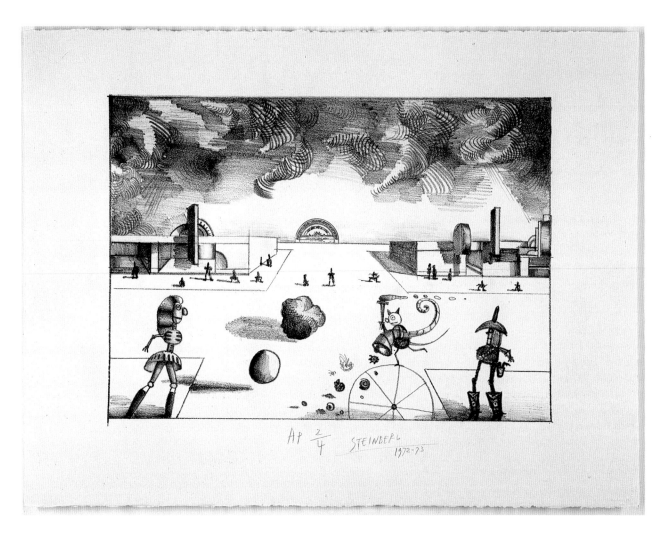

216. Saul Steinberg, *Main Street*, 1972-73.
See cat. no. 3. Although accustomed to
drawing in black ink on smooth paper, here
Steinberg chose a rough-grained stone and
a correspondingly soft lithographic crayon.
The resulting calligraphy evokes the
archaic mannerisms of penmanship
exercises, which Steinberg often uses to
effect a liaison between words and pictures.

Saul Steinberg

(American, b. Ramnicul-Sarat, Rumania, 1914)

At the age of eighteen, Saul Steinberg left his native Rumania to enroll in the architecture school of the Politecnico in Milan. After receiving his doctorate in 1941, he decided to leave Mussolini's Italy and come to the United States. He had already published drawings in *Life* and *Harper's Bazaar*, and he began to contribute drawings to *The New Yorker*, an association that continues to this day.

For more than forty years, Steinberg has elected to be what Harold Rosenberg called "a writer of pictures,"[1] in the tradition of Daumier, Hogarth, and Feininger; an artist, calligrapher, satirist, populist, and storyteller. His sympathies lie with the common man, and he uses the commonplace as the raw material of his art. In this respect, he has been considered a prophet of Pop Art.

Tatyana Grosman had long admired his work and may have been aware of the lithographs Steinberg had produced at the Hollander Workshop in 1968. With Bill Goldston, she went to an opening in late 1971 or early 1972 at the Betty Parsons Gallery in New York (where Steinberg had exhibited since 1943) to meet him and invite him to make lithographs at ULAE. The timing was fortuitous. Steinberg, like Robert Motherwell, had just been asked to make a benefit print for the Spanish Refugee Aid (Motherwell, cat. no. 39).

On July 5, 1972, Steinberg came to work at ULAE, bringing a drawing titled *Main Street*, which he had done on rough-textured paper. Bill Goldston worked with him to produce a stone with a coarser texture than was customarily used. The result can be seen in *Main Street* (cat. no. 3), which recedes to an embossed-stamp sun. Work on both *The Museum* (cat. nos. 1, 2) and *Main Street* proceeded simultaneously, but the edition for Spanish Refugee Aid was published first to meet their deadline.

Steinberg chose two of his favorite subjects for his ULAE prints: the American landscape for *Main Street* and the art scene for *The Museum*. He had taken his first trip through the United States by bus in 1942. Subsequent trips inspired hundreds of drawings in which one feature is exaggerated to become a hyperbolic portrait of an entire city. *Main Street* might well be Los Angeles, which Steinberg called "the avant-garde city of parody."[2]

In the late 1960s and early 1970s, Steinberg was fascinated with rubber stamps and included them in most of his drawings. Both ULAE prints include examples from his vast collection. The setting sun in *Main Street* is the product of one of the many round stamps used to give an officious look to costumes, buildings, and pseudodocuments or to serve as stand-ins or stray puzzles in the whole range of Steinberg's subjects. The same bleak little figure that populates the rooms of *The Museum* (cat. no. 1) appeared in Steinberg's 1969 drawing *Rain on Bridge*[3] and other drawings he showed in the Parsons exhibition of 1969. In these "sinister little figures," the poet John Ashbery wrote, "the medium becomes the message which in turn becomes the medium again."[4]

Notes:

1. Rosenberg, *Steinberg*, 1978, p. 10.
2. Ibid., p. 238.
3. Ibid., pl. 158.
4. Ashbery, 1969, p. 72.

AP2-5 (J67

217. Cy Twombly, *Untitled I*, 1967-74. See cat. no. 2.

Cy Twombly

(American, b. Lexington, Virginia, 1928)

Cy Twombly made his first prints in the summer of 1967 at ULAE almost by accident. He had planned a casual visit to Long Island, a day's excursion to accompany his old friend Robert Rauschenberg, who was working in the lithographic studio. On Rauschenberg's advice, Twombly had spent two summers and a winter at Black Mountain College in North Carolina; they had exhibited together in New York at Samuel Kootz's gallery in 1951; and they had traveled together in Italy and North Africa. In the early 1950s, Twombly showed in Eleanor Ward's Stable Gallery in New York. After he married and moved permanently to Rome in 1957, his work was exhibited in a succession of Italian and German galleries. By 1960, when he joined many of his artist-friends in the stable of Leo Castelli, Twombly had become an important figure in the mainstream of American and European art.

Like many other alumni of Black Mountain College, Twombly evolved his distinctive style at the school. There he met three artists who deeply influenced his art, Robert Motherwell, Franz Kline, and Ben Shahn. In the work of these three seemingly disparate men, Twombly encountered two approaches that would become fundamentals of his own style: first, composition in which the "voids" are fully active, and, second, an insistent graphism that makes color almost superfluous. For Twombly, like other young artists of his generation, Abstract Expressionism was a rich heritage; it was also a parent to outgrow. But, unlike Rauschenberg, Johns, and other contemporaries who used figuration to create a new visual language, Twombly eschewed imagery of any sort in his work over the next decade.

For Twombly, painting is synonymous with writing: He practiced his calligraphy until it had lost any lissome Orientalism, and also lost any connection to the salon, the gallery, or any other place where "culture" is purveyed. His calligraphy was allied to Pop Art in sympa-

218. Cy Twombly, *Untitled Mezzotint*, 1968. See cat. no. 1.

219. Cy Twombly, *Note I*, 1967-75. See cat.
no. 4. Cy Twombly's *Notes* (cat. nos. 4-7)
are the most formal images in his graphic
oeuvre. To match the elegance of the
artist's calligraphy, Mrs. Grosman chose a
pale orange handmade paper whose grainy
texture is analogous to the rough surfaces
of Twombly's "blackboard" paintings.

thy, if not in form. The writing and the occasional pictograms he added are reminiscent of graffiti scrawled on the walls of subways, phone booths, and public lavatories. But by the mid-1950s, some critics found beauty in the crudity and, ironically, thus condemned Twombly's work as anti-intellectual or merely decorative. Five years later, Twombly's "grapho-painting"[1] had a small army of imitators on both continents.

The first series Twombly made at ULAE was *Sketches* (cat. nos. 8-14), six small, vital etchings that encompass virtually the whole range of his imagery. Of all his prints, *Sketches* exposes Twombly's historicism most openly. Stylistically, they are closely related to Arshile Gorky's automatic drawings of 1944-45. Their elements include words, numbers, and figures gathered into relationships that suggest the spatial devices of Twombly's favorite Italian Baroque painters, Guido Reni and Pietro da Cortona.

Even before *Sketches* was proofed, Twombly started two other, more ambitious projects: the *Note* series (cat. nos. 4-7) and two untitled aquatints (cat. nos. 2, 3). Each constituted a new investigation of scale and medium. The two untitled prints relate to Twombly's black-and-white "blackboard" paintings. The four *Note*s, printed on the kind of luxurious, handmade paper that Mrs. Grosman loved, are perhaps the most decorously formal compositions in his oeuvre.

All of Twombly's plates were completed within the space of a few months. Because he spent very little time in the United States, the untitled prints were released in 1974 and the *Note*s and *Sketches* in 1975.

Note:

1. Dorfles, 1962, p. 65.

220. Cy Twombly, *Sketches: F*, 1967-75. See cat. no. 13.

221. Andrei Voznesensky, *Seagull—Bikini of God*, 1977. See cat. no. 2.

Andrei Voznesensky

(Russian, b. Moscow, 1933)

Whenever the Russian poet Andrei Voznesensky reads his work, the crowd turns the occasion into a semipolitical event. His books, which the State will not publish in editions of more than 100,000, sell out in a few hours. In 1966, 500,000 people ordered his book *An Achilles Heart* in advance of its publication. Neither the international honors he has received nor his adamant refusal to discuss politics have protected him from official censure: Nikita Khrushchev publicly denounced Voznesensky in 1963; the Komsomol accused him of "obscurity"; and the Soviet Writers Union, of which he is a member, has repeatedly castigated him for failure to adhere to "the heroic standards of Soviet realism." Within hours of receiving the State Prize for Poetry in 1977, he was forbidden to publish or read publicly and informed that his name had been removed from the official list of Soviet writers.

Nevertheless, Voznesensky has been allowed to travel extensively in the West. It was during his fifth visit to New York in sixteen years, in 1977, that he met Tatyana Grosman. While she had been interested in Russian literary activities for years, she had a specific reason in wishing to meet Voznesensky. She had seen a word-poem that he had composed in honor of the first landing on the moon and was eager to invite him to work at ULAE. The poet's friends Tatiana and Alexander Liberman invited her to join them and Voznesensky at dinner, and before the evening was over, she was planning two projects. The first was decided on the spot: Liberman would illustrate Voznesensky's *Nostalgia for the Present* (Liberman, cat. nos. 1-20). The second would be a collaboration between the poet and Robert Rauschenberg.

Voznesensky's creativity was not limited to poetry. He wrote the libretto for a rock opera and the script for the successful play *Antiworlds*. He was trained in architectural drawing and had considered a career in painting.

When he was in the United States in 1973, Voznesensky showed Herbert Lottman a group of "blackboard pictures," small metal sheets on which he had arranged magnetized letters (Lottman, 1973, p. 8). These word-poems were like the concrete poetry of the 1920s but, he said, with more meaning. On one he had arranged the names of four Russian composers to make a composition of piano keys. On others he used the letters to make a tree, a wheel, and birds in flight.

Voznesensky was the third "nonartist" whom Mrs. Grosman had invited to make lithographs at ULAE. All three—Voznesensky, Edwin Schlossberg, and Buckminster Fuller—had considered a career as a painter. Of the three, only Fuller elected to draw on the stone. Both Voznesensky and Schlossberg ultimately decided to create compositions that were essentially collages of preformed letters.

For his first lithographs at ULAE, Voznesensky wanted to re-create two designs that had appeared in Russian publications: *Darkness Mother Darkness Mother* (cat. no. 1) and *Seagull—Bikini of God* (cat. no. 2). At first he wanted *Darkness Mother* to be printed on plastic and mounted with a flashing light behind it. But after some discussion with Mrs. Grosman and a demonstration of Rauschenberg's *Shades* (cat. no. 18), which was now thirteen years old, Voznesensky agreed that perhaps conventional lithography would be best.

After a long search, Bill Goldston found a wooden Cyrillic alphabet at the American Type Foundry in Queens that was exactly what the poet had in mind; the letters needed only a few alterations. The work went well; when Robert Rauschenberg arrived in the middle of the afternoon, black-and-white proofs were drying in the workshop.

Although Mrs. Grosman did not have a specific project in mind, she was convinced that these two artists would want to work together if only she could arrange for their

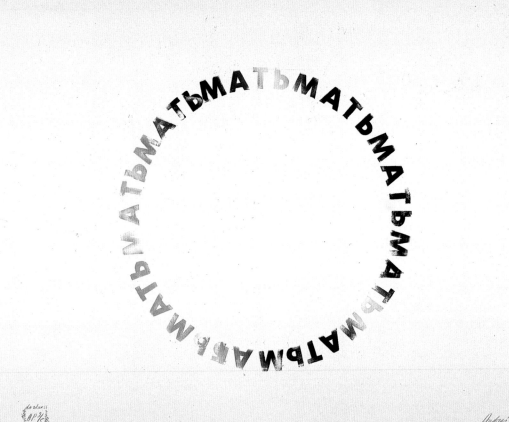

222. Andrei Voznesensky, *Darkness Mother Darkness Mother*, 1977. See cat. no. 1. Voznesensky's two lithographs of 1977 were based on experiments with word-pictures, using magnetized letters against a small blackboard. He described them as his *maga*, from мáгия, the Russian word for "magic" and a punning reference to МАХА, the Russian word for Goya's nude and clothed majas. Meaning had not been a necessary part of the Surrealists' concrete poetry; to Voznesensky, the word and the form were inextricable. In this print, the continuous circle of letters can be broken down to "МАТЬ" (meaning "mother") or "ТЬМА" (meaning "darkness")—or both.

meeting. On the appointed day, Rauschenberg thought he had been invited to bring a few friends and meet her Russian celebrity. But after a few minutes' conversation, the two men were in the studio, going over the day's work, trading stories and jokes, often overriding Mrs. Grosman's translations, and deciding—together—on the colors for Voznesensky's two prints. A few hours later, they had decided that Voznesensky would provide some unpublished poems and had resolved most of the details of combining them with Rauschenberg's images (see Rauschenberg, cat. nos. 90-95).

Voznesensky's time at ULAE was limited but very productive. While the printers were finishing the editions of *Darkness Mother* and *Seagull—Bikini of God*, he worked on the text for *Nostalgia for the Present*, as well as six poems for Rauschenberg. He was able to approve and sign his work before being ordered back to the Soviet Union.

Max Weber

(American, Byelostock, Russia, 1881-1961 Great Neck, New York)

Several of the prints by Max Weber that were published by ULAE are still problematic. *Reclining Figure, On the Shore, The Mirror,* and *The Rabbi* are listed in Daryl Rubenstein's catalogue raisonné.[1] In addition, there are entries in the early account books at ULAE (many in Mrs. Grosman's handwriting) indicating that others may have been published. However, only one print not listed by Rubenstein, *Seated Figure* (cat. no. 5), is included in the present catalogue since evidence for other publications was deemed insufficient.

Between 1905 and 1907, Weber tried etching and monotype; in 1910 he cut a linoleum block to make *Nude Figure* (Rubenstein, 1980, no. 3). In 1914 he illustrated his own book, *Cubist Poems*, with small but very expressive woodcuts. In 1916 he began to experiment in lithography and, during the next sixteen years, produced sixty figure studies, landscapes (including Long Island subjects), and a variety of compositions, many derived from his previous paintings. In 1920, inspired by his visits to New York's American Museum of Natural History, he carved twenty-four woodcuts; these are generally considered to be his most original contribution to the graphic arts.

It was, however, the reproductive possibilities that interested the Grosmans. In June 1956, Tatyana Grosman wrote to Weber at his home in Great Neck, Long Island, asking for permission to reproduce his painting *Reclining Figure* because she understood that museum shops preferred to sell reproductions of works in their own collections. She told him that the New York Graphic Society had distributed silkscreens printed by her husband that were reproductions of paintings lent to them by private collectors, including Mr. and Mrs. Roy Neuberger, and by the "Modern Art Museum in Paris." She proposed to print a Weber edition of one hundred on handmade British paper. They would be clearly stamped as reproductions and sold in the shops of the Metropolitan and Brooklyn museums.[2]

Weber answered immediately, saying that he had seen several examples of the Grosmans' work and "was deeply impressed by the accuracy and beauty of [their] reproductions." He gave his permission cordially and asked no fee.[3]

In the next two years, the Grosmans published one screenprint reproduction (cat. no. 1) and reprinted four lithographic plates Weber had made in the late 1920s (cat. nos. 2-5). Their estimate of the market is reflected in the size of the editions: ninety-six for the colored reproductions but only ten of the black-and-white lithographs.

Notes:

1. Rubenstein, 1980.
2. T. Grosman, letter to Weber, June 24, 1956.
3. Weber, letter to T. Grosman, June 27, 1956. Weber was able to give permission because he still owned the painting. It was shown as catalogue number 47, *Reclining Figure,* 1955 (collection of the artist) in "An Exhibition of oil and tempera paintings, gouaches, pastels, woodcuts, lithographs and drawings, celebrating the artist's 75th birthday," at the Jewish Museum, March-May 1956.

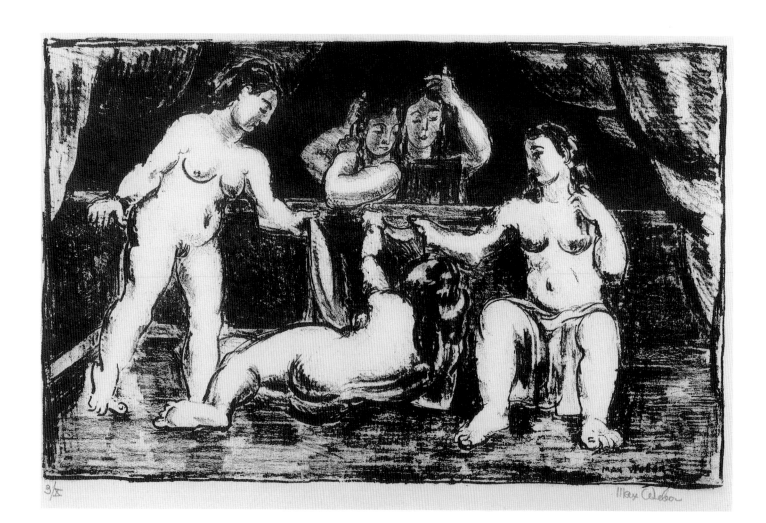

3/X Max Weber

Catalogue of Prints

A Note to the Reader

In documenting the prints in this catalogue, there were several obstacles to assembling the kind of factual information now routinely provided by responsible print publishers. These include the fragmentary nature of shop records at ULAE (particularly in the beginning), the fact that no standardized terminology was ever imposed on the artists, and, finally, the reluctance of this writer to rely on speculative reconstruction of processes and materials. At an early stage, those most intimately involved with the production of this catalogue agreed that ascertaining the sequence of printing matrices and the names of ink colors involved too much guesswork. In the absence of convincing records, other gaps in documentation—such as the number of stones or the existence of artist's proofs—have simply been left unfilled. In addition, several of the artists who worked at ULAE established systems of nomenclature that differ from that of the Glossary. In such cases, the artists' own curatorial records have been used as the final authority.

Prints are listed in chronological order of publication, according to studio records. Since the Art Institute of Chicago's holdings consist largely of the artist's proofs customarily given to the publisher, all of the data concerning measurements and inscriptions has been taken largely from the edition records kindly put at our disposal by the Museum of Modern Art, New York. Measurement of plates is given for intaglio prints, as well as the measurement of the sheet of paper. Because the unprinted areas of a lithograph are often an essential part of the composition, only the sheet measurement is given for lithographs. The word "signed" indicates the artist's handwriting; "inscribed" indicates another person's writing, usually that of a printer. Published catalogues raisonnés are listed in abbreviated form at the end of the documentation of a print; a full citation for each of those catalogues appears in the Bibliography. Unless otherwise specified, all signatures are in pencil, all print-ing matrices have been effaced, and all prints are embossed with the publisher's seal in the lower left corner of the print. Printers have been listed according to the level of their responsibility for each print.

In 1981 the Art Institute of Chicago acquired Tatyana Grosman's personal collection of edition prints and the archival material (drawings, trial proofs, working proofs, etc.) that had been stored at ULAE. Those edition prints and archival pieces are recorded in each catalogue entry as "AIC."

1. FIRST STONE, 1962
Lithograph from one stone
Paper: ivory laid
Sheet: 495×645 mm (19½×25⅜ in.)
Numbered, signed, dated; lower right: x/8
Bontecou 1962
Edition: 8
 Plus: artist's proofs (1 AIC)
Printer: Zigmunds Priede
Catalogue reference: Field 1

2. SECOND STONE, 1962
Lithograph from one stone
Paper: white wove Japan
Watermark: JAPAN
Sheet: 450×576 mm (17⅜×22⅝ in.)
Numbered, signed, dated; lower right: x/12
Bontecou 62
Edition: 12
 Plus: artist's proofs (1 AIC)
Printer: Zigmunds Priede
Catalogue reference: Field 2

3. THIRD STONE, 1963
Lithograph from one stone
Paper: white laid
Watermark: AUVERGNE A LA MAIN; RICHARD DE BAS
Sheet: 649×502 mm (25½×19¾ in.)
Numbered, signed, dated; lower right: x/28
Bontecou 63
Edition: 28
 Plus: 2 artist's proofs (1 AIC)
 3 trial proofs (3 AIC)
Printer: Zigmunds Priede
Catalogue reference: Field 3
This was the first of Bontecou's lithographs that
in its cohesive character fully satisfied both the
artist and Mrs. Grosman.

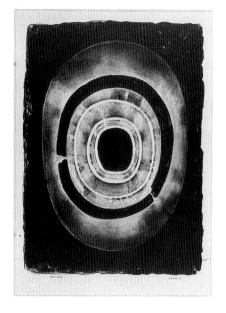

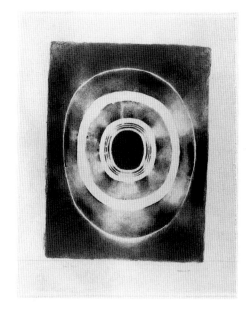

4. FOURTH STONE, 1963
Lithograph from two stones
Paper: white wove
Watermark: BFK RIVES
Sheet: 1051×745 mm (41⅜×29¹¹/₁₆ in.)
Numbered, signed, dated; lower right: x/19
Bontecou 63
Edition: 19 (1 AIC)
 Plus: 2 artist's proofs
 6 trial proofs (4 AIC)
 working proofs (2 AIC)
Printer: Zigmunds Priede
One stone preserved and used for
Rauschenberg, *Breakthrough I* and *II*
(Rauschenberg cat. nos. 22 and 23)
Catalogue reference: Field 4
Here Bontecou deliberately chose to use a
cracked stone, depending upon the skill of
Master Printer Zigmunds Priede to preserve it
from further deterioration. Although all the
revisions were accomplished in only two days,
printing took nineteen days.
See plate 1

5. FIFTH STONE, 1964
Lithograph from two stones
Paper: cream wove
Watermark: RIVES BFK
Sheet: 1051×752 mm (41¾×29⅝ in.)
Signed, dated; lower right: Bontecou-64
Numbered; lower left: x/27
Edition: 27
 Plus: 7 artist's proofs (1 AIC)
 7 trial proofs (6 AIC)
 working proofs (1 AIC)
 3 proofs H.C.
Printer: Zigmunds Priede
Catalogue reference: Field 5
See plate 2

5A. FIFTH STONE (BLACK), 1964
Lithograph from one stone
Paper: cream wove BFK Rives
Sheet: 1050×755 mm (41×29¾ in.)
Signed, dated; lower right: Bontecou '64
Numbered; lower left: x/5
Edition: 5
 Plus: 7 trial proofs
Printer: Zigmunds Priede
Bontecou's dealer, Leo Castelli, saw a proof of
the black stone for *Fifth Stone* (cat. no. 5) in
Bontecou's studio. He persuaded Mrs. Grosman
to send him five impressions, which she did with
reluctance several months later, since she
preferred the colored impressions.
Not illustrated

6. SIXTH STONE I, 1964
Lithograph from four stones
Paper: tan laid Japan
Sheet: 1185×937 mm (46⅝×36⅞ in.)
Signed, dated; lower right: Bontecou-64
Numbered; lower left: x/27
Edition: 27
 Plus: artist's proofs (1 AIC)
 2 trial proofs (2 AIC)
Printer: Zigmunds Priede
Catalogue reference: Field 6-A
Bontecou had experimented with colored ink for
Fourth Stone (cat. no. 4), tried colored paper for
Third Stone (cat. no. 3), and added ocher to
Fifth Stone (cat. no. 5), but she did not make a
fully colored print until the triad *Sixth Stone I-
III* (cat. nos. 6-8). The basic color scheme was
the same as her sculpture; the real breakthrough
was the addition of yellow, red, and brown to
Sixth Stone I. Sixth Stone II (cat. no. 7) is even
bolder because of its strong brown background
and an extra white stone added to intensify the
contrast between image and paper.

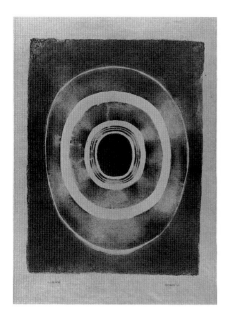

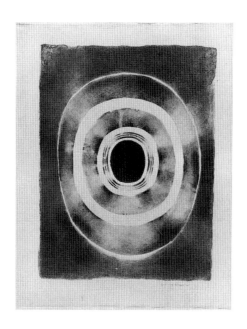

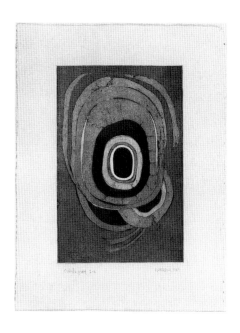

7. SIXTH STONE II, 1964
Lithograph from five stones
Paper: brown wrapping
Sheet: 1125×813 mm (44¼×32 in.)
Signed, dated; lower right: Bontecou-64
Numbered; lower left: x/14
Edition: 14
 Plus: 2 artist's proofs (1 AIC)
 1 trial proof
Printer: Zigmunds Priede
Catalogue reference: Field 6-B

8. SIXTH STONE III, 1964
Lithograph from five stones
Paper: unbleached Indian Head muslin on
stretcher
Sheet: 1120×918 mm (44⅛×36⅛ in.)
Numbered, signed, dated; lower right: x/6
Bontecou-1964
Edition: 6
 Plus: artist's proofs (1 AIC)
Printer: Zigmunds Priede
Catalogue reference: Field 6-C
Just as Mrs. Grosman had serious misgivings
about Bontecou's use of brown wrapping paper
for *Sixth Stone II* (cat. no. 7), she also objected
to printing on cloth for *Sixth Stone III*, fearing
that the images would look like deliberate
reproductions.

9. ETCHING ONE, 1967
Etching and aquatint from one plate
Paper: cream wove French handmade
Plate: 452×302 mm (17¹³⁄₁₆×11¹⁵⁄₁₆ in.)
Sheet: 657×497 mm (25⅞×19⁹⁄₁₆ in.)
Signed, dated; lower right: Bontecou 67
Numbered; lower left: x/35
Edition: 35
 Plus: 3 artist's proofs (1 AIC)
 1 printer's proof
 3 trial proofs (3 AIC)
Printer: Donn Steward
Catalogue reference: Field 10
Although *Fifth Stone*, *Sixth Stone* (cat. nos. 11-
20) was begun before *Etching One* and *Untitled
Etching* (cat. no. 10), the two single prints were
published first. Master Printer Donn Steward
worked closely with Bontecou to vary the
granular qualities of the aquatint and enrich its
linear vocabulary. The paper used here, which
once bore the double watermark COCTEAU and
PICASSO was bought in Paris in the late 1950s
when Maurice Grosman was making
screenprints. Out of respect and guilt, Mrs.
Grosman postponed using it, and even here she
effaced its true identity by trimming off the
watermark.

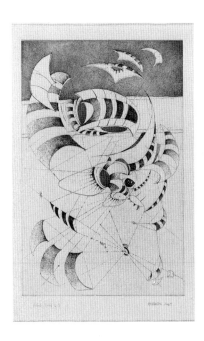

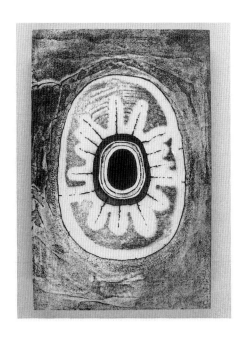

10. UNTITLED ETCHING, 1967
Etching and aquatint from two plates
Paper: white wove
Watermark: MADE IN ENGLAND 1964/Samuel Flax
Plate: 667×436 mm (26¼×17⅜₆ in.)
Sheet: 764×498 mm (30⅟₁₆×19⅝ in.)
Signed, dated; lower right: Bontecou 1967
Numbered; lower left: x/144
Edition: 144
　　Plus: 8 artist's proofs (1 AIC)
　　　　1 printer's proof
　　　　8 trial proofs (8 AIC)
　　　　working proofs (1 AIC)
Printer: Donn Steward
Catalogue reference: Field 11
Untitled Etching was commissioned by the List
Art Foundation, Inc., for a portfolio of six prints
commemorating the opening of the National
Collection of Fine Arts, Washington, D. C.
Bontecou was the first artist to complete her
work. After Bontecou signed the editions on
Flax paper, offset plates were made for an
unlimited poster edition, which somehow
acquired the title "Wish Well." *Untitled
Etching* was a stylistic counterpart of
Bontecou's new, lighter sculpture. Like the
print, these pieces impose no fixed viewpoint on
the viewer and do not imply physical attachment
to a wall.

11-20. FIFTH STONE, SIXTH STONE, 1967-68
Six etchings with aquatint from six plates;
introduction by Tatyana Grosman; prose and
poem by Tony Towle; colophon page; the cloth-
bound volume is wrapped in a cloth folder and
placed in a wooden box made by Carolyn
Horton
Paper: ivory laid
Watermark: AUVERGNE A LA MAIN; RICHARD DE BAS
Sheet: 508×666 mm (20×26¼ in.) (unfolded)
Numbered, signed, dated; lower center of each
print: x/33 BONTECOU 1967-68
ULAE embossed stamp lower right
Edition: 33
　　Plus: 7 artist's proofs (1 AIC)
　　　　2 printer's proofs
　　　　trial proofs (73 AIC)
　　　　working proofs (24 AIC)
　　　　trials for box (7 AIC)
　　　　1 unique proof of page one on
　　　　German Copperplate paper, tipped on
　　　　HMP paper 610×787mm (24×31 in.)
　　　　1 wooden box in AIC collection inlaid
　　　　with copper plate used to print
　　　　etching on cloth for the cover
Printer: Etchings printed by Donn Steward; text
hand-set and hand-printed by Christopher
Pullman
Catalogue reference: Field 13
See plate 3

11. FIFTH STONE, SIXTH STONE: TITLE
PAGE, 1967-68
Letterpress

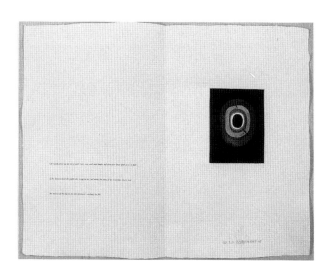

**12. FIFTH STONE, SIXTH STONE:
INTRODUCTION, 1967-68**
Letterpress

**13. FIFTH STONE, SIXTH STONE: PLATE I,
1967-68**
Letterpress, etching, and aquatint from one
plate
Plate: 160×122 mm (6¼×5 in.)

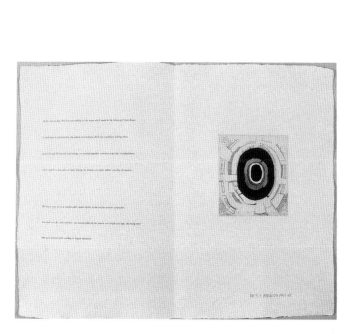

**14. FIFTH STONE, SIXTH STONE: PLATE II,
1967-68**
Letterpress, etching, and aquatint from one
plate
Plate: 165×145 mm (6½×5¾ in.)

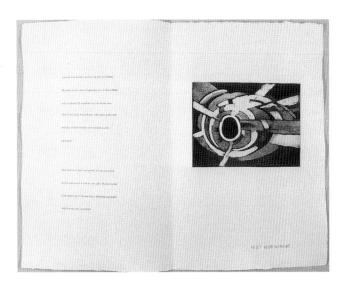

**15. FIFTH STONE, SIXTH STONE: PLATE III,
1967-68**
Letterpress, etching, and aquatint from one
plate
Plate: 171×231 mm (6¾×9⅛ in.)

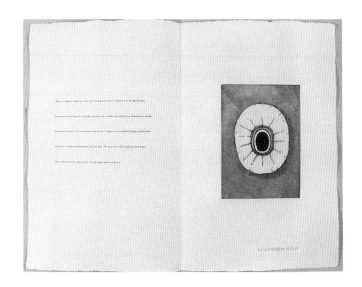

**16. FIFTH STONE, SIXTH STONE: PLATE IV,
1967-68**
Letterpress, etching, and aquatint from one
plate
Plate: 232×166 mm (9⅛×6½ in.)

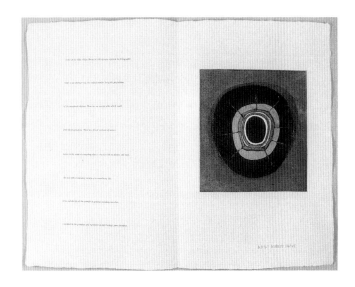

**17. FIFTH STONE, SIXTH STONE: PLATE V,
1967-68**
Letterpress, etching, and aquatint from one
plate
Plate: 250×230 mm (9⅞×9 in.)

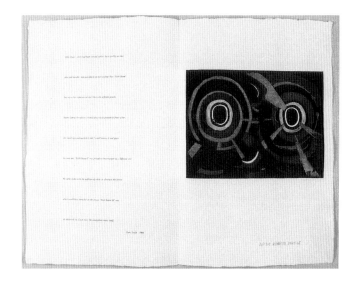

**18. FIFTH STONE, SIXTH STONE: PLATE VI,
1967-68**
Letterpress, etching, and aquatint from one
plate
Plate: 220×293 mm (8⅝×11½ in.)

**19. FIFTH STONE, SIXTH STONE: POEM
PAGE, 1967-68**
Letterpress
Signed, dated; lower right: Tony Towle/1968
Numbered; lower left: x/33
ULAE embossed stamp lower right

**20. FIFTH STONE, SIXTH STONE:
COLOPHON PAGE, 1967-68**
Letterpress

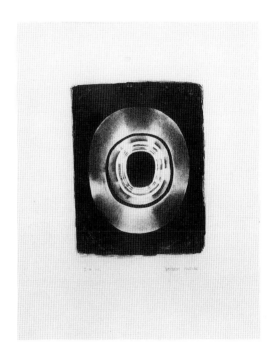

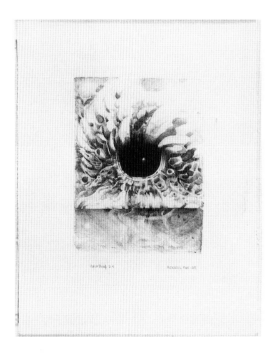

21. SEVENTH STONE, 1965-68
Lithograph from one stone
Paper: white wove Chatham British handmade
Sheet: 632×505 mm (24⅞×19⅞ in.)
Signed, dated; lower right: Bontecou 1965-68
Numbered; lower left: x/31
Edition: 31
 Plus: 4 artist's proofs
 1 printer's proof
 10 trial proofs (8 AIC)
 working proofs (2 AIC)
 6 proofs H.C. (1 AIC)
Printer: Fred Genis
Catalogue reference: Field 7

22. EIGHTH STONE, 1965-68
Lithograph from one stone
Paper: white wove Chatham British handmade
Sheet: 633×508 mm (24¹⁵⁄₁₆×20 in.)
Signed, dated; lower right: Bontecou 1965-68
Numbered; lower left: x/32
Edition: 32
 Plus: 5 artist's proofs (1 AIC)
 1 printer's proof
 5 trial proofs (5 AIC)
 1 proof H.C.
Printer: Fred Genis
Catalogue reference: Field 8

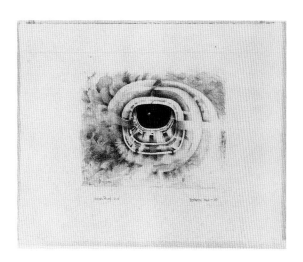

23. NINTH STONE, 1965-68
Lithograph from one stone
Paper: white wove Chatham British handmade
Sheet: 507×632 mm (19¹⁵/₁₆×24⅞ in.)
Signed, dated; lower right: Bontecou 1965-68
Numbered; lower left: x/34
Edition: 34
 Plus: 5 artist's proofs (1 AIC)
 1 printer's proof
 2 trial proofs (2 AIC)
 5 proofs H.C.
Printer: Fred Genis
Catalogue reference: Field 9

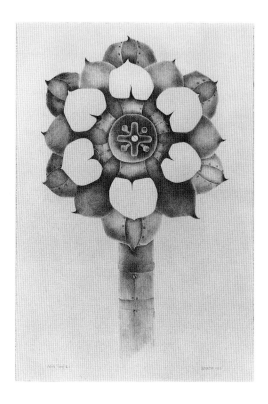

24. TENTH STONE, 1968
Lithograph from one stone
Paper: white wove Rives BFK
Sheet: 1044×710 mm (41⅛×27¹⁵/₁₆ in.)
Numbered, signed, dated; lower right: x/33
Bontecou 1968
Edition: 33
 Plus: 5 artist's proofs (1 AIC)
 1 printer's proof
 16 trial proofs in single colors, signed
 in 1973 (4 AIC)
 22 unsigned proofs
Printer: Fred Genis
Catalogue reference: Field 14
Tenth Stone combines two things Bontecou
admired, flowers and airplane wings, in an
image that symbolized her fears for the future
of the planet. Using the same fantasy—flowers
in gas masks—she created similar sculptures in
wood and plastic as well as a series of drawings.
The lithographic ink in this print has the
iridescent quality of silverpoint.

25. ELEVENTH STONE, 1966-70
Lithograph from one stone
Paper: white laid Kochi handmade
Sheet: 558×734 mm (21¹⁵/₁₆×28⅞ in.)
Signed, dated; lower right: Bontecou 1966-70
Numbered; lower left: x/23
Edition: 23
 Plus: 5 artist's proofs (1 AIC)
 1 printer's proof
 9 trial proofs (9 AIC)
Printer: Frank Akers
Catalogue reference: Field 15
Although her customary procedure was to
strengthen her images steadily, here Bontecou
softened the print in two ways: by using an
absorbent Kochi paper and an irregular stone,
whose imprint she allowed to remain on the
sheet. The image is directly related to the
striped and billowing Fiberglas sculptures
Bontecou exhibited at the Leo Castelli Gallery
in 1966.

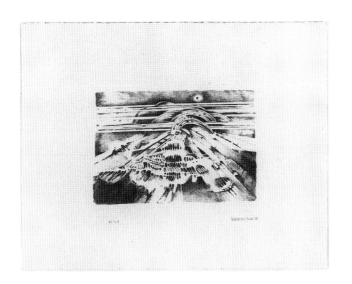

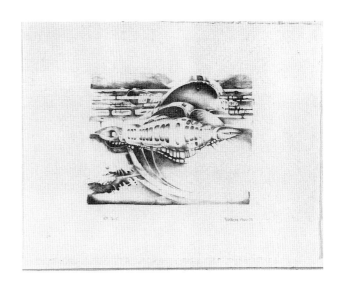

26. TWELFTH STONE, 1966-70
Lithograph from one stone
Paper: white laid Kochi handmade
Sheet: 524×675 mm (20⅝×26⁹⁄₁₆ in.)
Signed, dated; lower right: Bontecou 1966-70
Numbered; lower left: x/21
Edition: 21
 Plus: 5 artist's proofs (1 AIC)
 1 printer's proof
 12 trial proofs (12 AIC)
Printer: Frank Akers
Catalogue reference: Field 16

27. THIRTEENTH STONE, 1966-70
Lithograph from one stone
Paper: ivory wove Japan
Sheet: 570×727 mm (22⅜×28⅝ in.)
Signed, dated; lower right: Bontecou 1966-70
Numbered; lower left: x/22
Edition: 22
 Plus: 5 artist's proofs (1 AIC)
 1 printer's proof
 7 trial proofs (7 AIC)
Printer: Frank Akers
Catalogue reference: Field 17

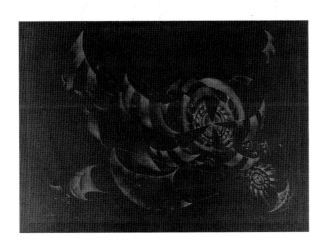

28. FOURTEENTH STONE, 1968-72
Lithograph from two stones
Paper: black laid Japan tipped onto ivory wove
Italia, overprinted in black
Watermark: (wove) Magnani emblem
Sheets: Japan, 655×954 mm (25¾×37½ in.)
 wove, 708×1021 mm (28×39¾ in.)
Numbered, signed, dated; lower left in silver
pencil: x-17 Bontecou 1968-72
Edition: 17
 Plus: 3 artist's proofs (1 AIC)
 1 printer's proof
 14 trial proofs (12 AIC)
 working proofs (2 AIC)
Printer: Zigmunds Priede
Catalogue reference: Field 18
Fourteenth Stone was achieved only after a
number of earlier experiments in printing with
white ink on black paper. The greatest problem
was the ink's tendency to turn blue. Finally, in
1972, Zigmunds Priede floated the now-
weakened and technically precarious image on a
cushion of Japan paper.

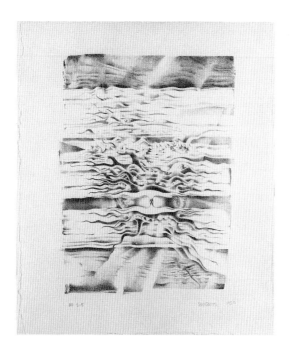

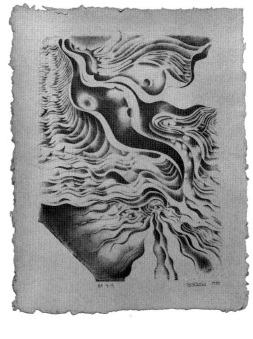

29. FIFTEENTH STONE, 1980
Lithograph from one stone
Paper: white wove Jeff Goodman handmade
Watermark: JG
Sheet: 568×452 mm (22⅜×17¹³⁄₁₆ in.)
Signed, dated; lower right: Bontecou 1980
Numbered; lower left: x/19
Edition: 19
 Plus: 4 artist's proofs (1 AIC)
 2 printer's proofs
 1 trial proof
Printer: Keith Brintzenhofe

30. SIXTEENTH STONE, 1980
Lithograph from one stone
Paper: ivory wove Jeff Goodman handmade
Watermark: JG
Sheet: 568×452 mm (22⅜×17¹³⁄₁₆ in.) (irreg.)
Signed, dated; lower right: Bontecou 1980
Numbered; lower left: x/24
Edition: 24
 Plus: 5 artist's proofs (1 AIC)
 2 printer's proofs
 1 trial proof
Printer: Keith Brintzenhofe

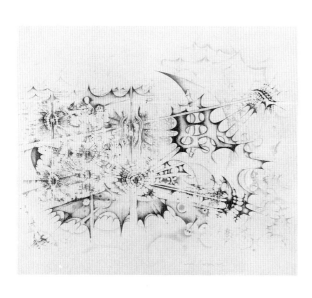

31. PIRATES, 1979-82
Lithograph from seven plates and three stones
Paper: ivory wove Arches
Sheet: 972×1156 mm (38¼×45½ in.)
Numbered, signed, dated; lower right: x/12
Bontecou 79-82
ULAE embossed stamp lower right
Edition: 12
 Plus: 5 artist's proofs (1 AIC)
 4 printer's proofs
Printers: Thomas Cox and James V. Smith
See plate 4

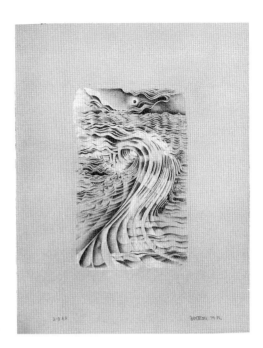

32. STUDY FOR AN UNTITLED PRINT,
1979-82
Lithograph from two stones
Paper: gray wove Twinrocker handmade
Sheet: 744×586 mm (29⁵/16×23¹/16 in.)
Signed, dated; lower right: Bontecou 79-82
Numbered; lower left: x/5
Edition: 5
 Plus: 3 artist's proofs (1 AIC)
 2 printer's proofs
Printer: Thomas Cox
One stone preserved and used for *Study for an*
Untitled Print (White on Black) (cat. no. 33)

33. STUDY FOR AN UNTITLED PRINT
(WHITE ON BLACK), 1979-82
Lithograph from one stone (previously used for
Study for an Untitled Print [cat. no. 32])
Paper: black wove Arches
Sheet: 570×382 mm (22⁷/16×15¹/16 in.)
Signed, dated; lower right: Bontecou 79-82
Numbered; lower left: x/5
Edition: 5
 Plus: 3 artist's proofs (1 AIC)
 2 printer's proofs
Printer: Keith Brintzenhofe

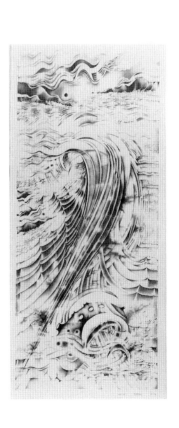

34. AN UNTITLED PRINT, 1981-82
Lithograph from fourteen plates
Paper: white wove Rives
Sheet: 2362×1068 mm (92¹⁵/16×42¹/16 in.)
Numbered, signed, dated; lower right: x-14
Bontecou 81-82
Edition: 14
 Plus: 5 artist's proofs (1 AIC)
 3 printer's proofs
Printers: Thomas Cox and James V. Smith

Mary Callery

1. VARIATIONS ON A THEME OF
"CALLERY-LÉGER," c. 1955
Screenprint
Printed on a variety of papers, including:
Paper: white wove
Watermark: A. MILLBOURN & CO./BRITISH HANDMADE
Sheet: 564×780 mm (22¼×30⅝ in.)
Paper: white wove Arches
Sheet: unknown
Signed; lower right: Mary Callery
Stamp on verso: LAE
Edition: 89 (a substantial part of this edition was
 not released)
Printer: Maurice Grosman
Labels printed on Douglass Howell handmade
paper: Limited Art Editions / 5 Skidmore Place /
Bay Shore, L.I.
From 1943 to 1949, Callery collaborated with
Fernand Léger on a series of mixed-media relief
sculptures. This print and the following *Sons of
Morning* (cat. no. 2) are based on designs for
bronze figures that were mounted in front of
backgrounds painted by Léger.
Not illustrated

2. SONS OF MORNING, 1955-56
Screenprint
Paper: gray wove Douglass Howell handmade
(color varies from almost white to a medium
gray); some impressions may have been printed
on white wove handmade paper watermarked:
A. MILLBOURN & CO./BRITISH HANDMADE
Sheet: 203×1372 mm (8×54 in.)
Signed; lower right, in pencil or black crayon:
Mary Callery
Stamp on verso: LAE
Edition: 48 (a substantial part of this edition was
 not released)
 (1 AIC)

Printer: Maurice Grosman
Labels printed on gray Douglass Howell paper:
Limited Art Editions / 5 Skidmore Place / Bay
Shore, L.I.
The dates and size of the edition given here
correct data that may have been mistyped on
ULAE invoices. The image shown here is of
Callery's proposal for a collaboration suggested
to her by Fernand Léger in 1949. The print was
shown at Margaret Lowengrund's New York
gallery, The Contemporaries. Lowengrund,
Tanya Grosman, and June Wayne are considered
the three pioneers of the American graphic
revival of the 1950s and 1960s.
See plate 5

3. TARA, 1958-59
Screenprint
Paper: 7 on white Iromachi
 17 on red or brown Omi
 8 (or more) on blue Moriki
 2 on pressed-grass paper
 6 on white wove Roma
 10 on blue Fabriano
 8 on gray Fabriano
Sheet: 512×336 mm (20×13¼ in.)
Signed; lower right: Mary Callery
Numbered; lower left
Edition: 58 (or more)
Printer: Maurice Grosman

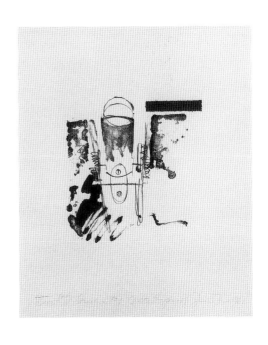

1. PLIERS, 1962
Lithograph from one stone
Paper: white wove Japan
Watermark: JAPAN
Sheet: 448×575 mm (17⅝×22⅝ in.)
Numbered, signed, dated; lower left:
x/16 Jim Dine 1962
Edition: 16
 Plus: artist's proofs (1 AIC)
Printer: Robert Blackburn
Catalogue reference: Mikro 18

2. FOUR C-CLAMPS, 1962
Lithograph from one stone
Paper: light orange laid handmade
Watermark: AUVERGNE A LA MAIN; RICHARD DE BAS
Sheet: 657×514 mm (25⅞×20¼ in.)
Signed; lower right: Jim Dine
Dated; lower center: 1962
Numbered; lower left: x/17
Edition: 17
 Plus: 1 artist's proof (1 AIC)
Printer: Robert Blackburn
Catalogue reference: Mikro 12
See plate 7

3. TOOTHBRUSHES #1, 1962
Lithograph from one stone
Paper: white wove Chatham British handmade
Sheet: 642×517 mm (25¼×20⅜ in.)
Inscribed, numbered, signed, dated; lower left to
lower right: Toothbrushes #1 x/16 Jim Dine 1962
Edition: 16
 Plus: 1 artist's proof (1 AIC)
Printer: Zigmunds Priede
Catalogue reference: Mikro 13
Dine's first show at the Sidney Janis Gallery,
New York, in 1963 featured bathrooms as
subject matter in paintings, collages, and
watercolors. The toothbrush and its holder
received special attention.

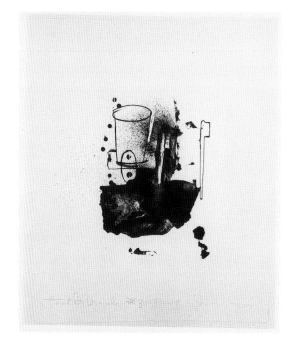

4. TOOTHBRUSHES #2, 1962
Lithograph from one stone
Paper: white wove Chatham British handmade
Sheet: 640×511 mm (25³⁄₁₆×20⅛ in.)
Inscribed, numbered, signed, dated; lower left to
lower right: Toothbrushes #2 x/17, Jim Dine
1962
Edition: 17
 Plus: 1 artist's proof (1 AIC)
Printer: Zigmunds Priede
Catalogue reference: Mikro 14

5. TOOTHBRUSHES #3, 1962
Lithograph from one stone
Paper: white wove Chatham British handmade
Sheet: 640×514 mm (25⁵⁄₁₆×20¼ in.)
Inscribed, numbered, signed, dated; lower left to
lower right: Toothbrushes #3 x/18 Jim Dine '62
Edition: 18
 Plus: 1 artist's proof (1 AIC)
Printer: Zigmunds Priede
Catalogue reference: Mikro 15

6. TOOTHBRUSHES #4, 1962
Lithograph from one stone
Paper: white wove Chatham British handmade
Sheet: 642×506 mm (25¼×19¹⁵⁄₁₆ in.)
Inscribed, numbered, signed, dated; lower left to
lower right: Toothbrushes #4 x/16 Jim Dine 1962
Edition: 16
 Plus: 1 artist's proof (1 AIC)
Printer: Zigmunds Priede
Catalogue reference: Mikro 16

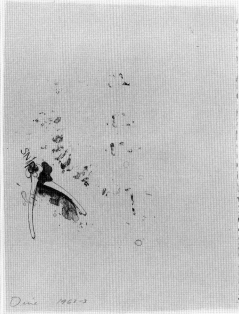

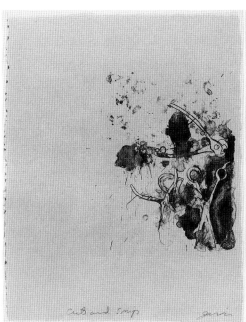

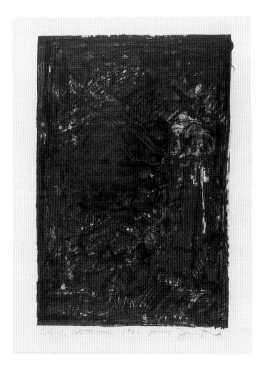

7. CUT AND SNIP, 1962-63

Diptych lithograph from two stones
Paper: gray-brown laid handmade
Watermark: AUVERGNE A LA MAIN; RICHARD DE BAS
Sheets: left, 628×500 mm (24¾×19¹¹/₁₆ in.)
 right, 637×498 mm (25¹/₁₆×19⅝ in.)
Inscribed; lower center left sheet: Cut & Snip
Numbered, signed; lower right left sheet:
x/21 Jim
Signed, dated; lower left right sheet: Dine
1962-3
Edition: 21

Plus: 1 artist's proof (1 AIC)
 trial proofs (1 AIC)
Printer: Zigmunds Priede
Catalogue reference: Mikro 19
Dine's first tool prints made a point of the
contrast between everyday object and luxurious
paper. In this final print of the series, he chose a
paper with the color and surface of aged
newspaper. Here, for the first time, he was
satisfied with the integration of color and paper,
as well as with the use of the stone itself as a
compositional element.

8. BLACK BATHROOM, 1963

Lithograph from two stones
Paper: white wove
Watermark: Crisbrook emblem/HANDMADE
ENGLAND
Sheet: 809×578 mm (31¹³/₁₆×22¾ in.)
Inscribed, numbered, dated, signed; lower left to
lower right: Black Bathroom x/14 1963 Jim Dine
Edition: 14
 Plus: artist's proofs (1 AIC)
 trial proofs (1 AIC)
 1 proof for Pratt benefit show
Printer: Zigmunds Priede
Stones preserved and used for *Pink Bathroom*
(cat. no. 9)
Catalogue reference: Mikro 20
Black Bathroom and *Pink Bathroom* (cat. no.
9), like Dine's large bathroom paintings, use
objects sparingly against a background of black
(his favorite color to emphasize the formal
qualities of his objects) and flesh color (to
emphasize the intimate functions of a
bathroom).

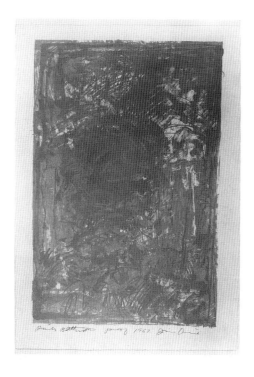

9. PINK BATHROOM, 1963
Lithograph from two stones (previously used for
Black Bathroom [cat. no. 8])
Paper: white wove
Watermark: Crisbrook emblem/HANDMADE
ENGLAND
Sheet: 802×578 mm (31⁹/₁₆×22¾ in.)
Inscribed, numbered, dated, signed; lower left to
lower right: Pink Bathroom x/20 1963 Jim Dine
Edition: 20
 Plus: 1 artist's proof (1 AIC)
 trial proofs (1 AIC)
Printer: Zigmunds Priede
Catalogue reference: Mikro 21

10. WHITE TEETH, 1963
Lithograph from one stone
Paper: black wove
Watermark: FABRIANO
Sheet: 292×252 mm (11½×9¹⁵/₁₆ in.)
Inscribed, dated, numbered, signed; lower left to
lower right: White Teeth 1963 x/24 Jim Dine
Edition: 24
 Plus: 1 artist's proof (1 AIC)
Printer: Zigmunds Priede
Catalogue reference: Mikro 22
White Teeth is as close as Dine came to human
habitation of his bathroom images.

11. BRUSH AFTER EATING, 1963
Lithograph from two stones
Paper: white wove German copperplate
Sheet: 759×1078 mm (29⅞×42⁷/₁₆ in.)
Numbered, signed, dated; lower right: x/28 Jim
Dine 1963
Edition: 28
 Plus: 1 artist's proof (1 AIC)
 working proofs (2 AIC)
Printer: Zigmunds Priede
Catalogue reference: Mikro 23
See plate 6

12. COLORED PALETTE, 1963
Lithograph from seven stones
Paper: white wove
Watermark: Crisbrook emblem
Sheet: 800×581 mm (31½×22⅞ in.)
Inscribed, dated, signed, numbered; lower
center: Colored Palette 1963/Jim Dine x/23
Edition: 23
 Plus: 1 artist's proof (1 AIC)
 trial proofs (5 AIC)
 working proofs (3 AIC)
Printer: Zigmunds Priede
Catalogue reference: Mikro 24
The palette as an artist's tool is a traditional
theme. But for Dine, the palette had many
meanings, including tradition, the artist's
formal arena of action, and the act of creation
itself. Most important, *Colored Palette* is the
first statement of a major self-portrait image,
and it announces the bright colors that
characterize Dine's prints for the next few years.

**13. ELEVEN PART SELF PORTRAIT
(RED PONY), 1964-65**
Lithograph from two stones
Paper: white wove
Watermark: BFK RIVES
Sheet: 1048×752 mm (41¼×29⅝ in.)
Inscribed, numbered, signed, dated; upper left
to upper right: Eleven Part Self Portrait (Red
Pony) x/13 Jim Dine 1965
ULAE embossed stamp upper left
Edition: 13
 Plus: 2 artist's proofs (1 AIC)
Printer: Ben Berns
Catalogue reference: Mikro 27
See plate 9

**14. FLESH PALETTE IN A LANDSCAPE,
1964-65**
Lithograph from four stones
Paper: cream laid
Watermark: AUVERGNE A LA MAIN; RICHARD DE BAS
Sheet: 653×502 mm (25¾×19¾ in.)
Inscribed, numbered, signed, dated; lower left to
lower right: Flesh Palette in a Landscape x/22
Jim Dine 1965
Edition: 22
 Plus: 2 artist's proofs (1 AIC)
Printer: Ben Berns
Third stone preserved and used for *Night
Palette* (cat. no. 15)
Catalogue reference: Mikro 29
See plate 10

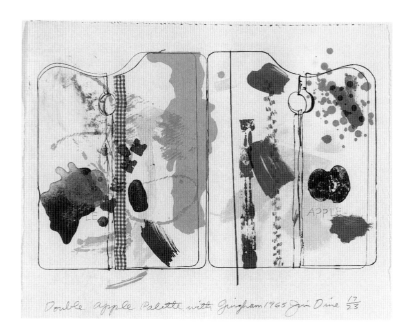

Double apple Palette with Gingham 1965 Jim Dine 17/23

15. NIGHT PALETTE, 1965

Lithograph from one stone (previously used for
Flesh Palette in a Landscape [cat. no. 14])
Paper: black wove Fabriano
Sheet: 612×518 mm (24 1/16×20 3/8 in.)
Inscribed, numbered, signed, dated; lower left to
lower center: Night Palette, x/11, Jim Dine 1965
Edition: 11
 Plus: 1 artist's proof (1 AIC)
Printer: Ben Berns
Catalogue reference: Mikro 30
Here the bluish-white ink is slightly iridescent
on the light-absorbing black paper. The paper,
as rough as coarse linen sheets, took the ink
only on its high points, stippling the
background "landscape" with tiny shadows.

16. DOUBLE APPLE PALETTE WITH GINGHAM, 1965

Lithograph from fifteen stones with gingham
collage applied by the artist
Paper: grayish-white wove East Indian
handmade
Watermark: P
Sheet: 592×710 mm (23 5/16×27 15/16 in.)
Inscribed, dated, signed, numbered; lower left to
lower right: Double Apple Palette with Gingham
1965 Jim Dine x/23
ULAE embossed stamp lower right
Edition: 23 (1 AIC)
 Plus: 4 artist's proofs (1 with additions of
 paint and collage)
 trial proofs (8 AIC)
 working proofs (7 AIC)
Printer: Ben Berns
Catalogue reference: Mikro 31
Many of the objects depicted in Dine's ULAE
prints came from the Grosmans' kitchen and
workshops. After *Flesh Palette in a Landscape*
(cat. no. 14) was printed, Dine added paint and
collage to one of his own artist's proofs and
presented it to the Grosmans as a token of
affection. It was hung in a place of honor, over
the table where guests were served an elaborate
afternoon tea.
See plate 11

17. BOOT SILHOUETTES, 1965

Lithograph from one stone
Paper: white wove
Watermark: BFK RIVES
Sheet: 1054×758 mm (41 9/16×29 13/16 in.)
Inscribed, dated, signed, numbered; along
left side of left boot: Boot Silhouettes 1965
Jim Dine x/20
Edition: 20
 Plus: 1 artist's proof (1 AIC)
Printer: Ben Berns
Catalogue reference: Mikro 28
This lithograph was the first sign of a new
signature subject for Dine. In his third (and
final) exhibition at Sidney Janis Gallery in New
York in 1966, he showed a group of cast-
aluminum sculptures in which boots, legs, and
feet take on startling new roles.

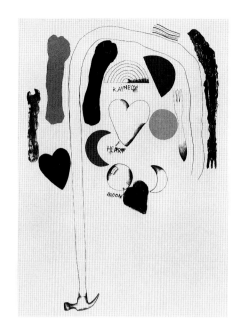

18. BIRTHDAY 3-7-65, 1965
Lithograph from one stone
Paper: ivory wove Auvergne à la main
Watermark: ULAE
Sheet: 250×197 mm (9⅞×7¾ in.)
Inscribed, signed, numbered; lower left to lower
right: Birthday 3-7-65 Jim Dine x/23
Edition: 23
 Plus: 1 artist's proof (1 AIC)
Printer: Ben Berns
Catalogue reference: Mikro 32
Birthday 3-7-65, drawn from life, announced the
arrival of the Dines' third son, Nicholas.

19. MIDSUMMER WALL or MIDSUMMER
STUDY, 1966
Lithograph from seven stones
Paper: white wove
Watermark: BFK RIVES
Sheet: 1051×756 mm (41⅜×29¾ in.)
Inscribed, dated, signed, numbered; upper
center: Midsummer Wall 1966 Jim Dine x/26
Edition: 26
 Plus: 3 artist's proofs (1 AIC)
 trial proofs (2 AIC)
 working proofs (1 AIC)
Printer: Ben Berns
Catalogue reference: Mikro 41
See plate 14

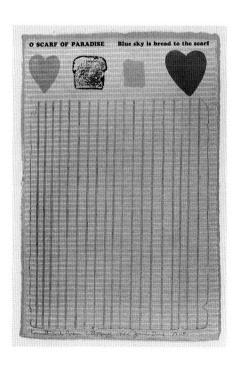

20. KENNETH KOCH POEM LITHOGRAPH,
1966
Lithograph from five stones
Paper: grayish-blue mulberry overlaid with
Takeyagu mulberry
Sheet: 930×625 mm (36⅝×24⅝ in.)
Inscribed, numbered, signed, dated; lower left to
lower right: Kenneth Koch Poem Lithograph
x/31 Jim Dine 1966
ULAE embossed stamp lower right
Edition: 31
 Plus: 5 artist's proofs (1 AIC)
 1 printer's proof
 trial proofs (7 AIC)
 working proofs (1 AIC)
Printer: Donn Steward
Catalogue reference: Mikro 39
See plate 15

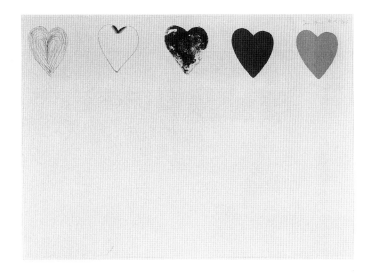

21. UNTITLED, 1966
Lithograph from three stones
Paper: white wove Italia
Watermark: Magnani emblem
Sheet: 706×1008 mm (27¹³/₁₆×39¹¹/₁₆ in.)
Signed, numbered, dated; upper right: Jim Dine
x/32 1966
ULAE embossed stamp upper right
Edition: 32
 Plus: 1 artist's proof (1 AIC)
 trial proofs (2 AIC)
 working proofs (1 AIC)
Printer: Donn Steward
Catalogue reference: Mikro 40

22. PLIERS 2, 1969-70
Lithograph from one stone
Paper: white wove Chatham British handmade
Sheet: 513×643 mm (20³/₁₆×25⁵/₁₆ in.)
Signed, numbered, dated; lower center: Jim
Dine x/21 1969
Edition: 21
 Plus: 4 artist's proofs (1 AIC)
Printer: Zigmunds Priede
Several years after *Pliers* (cat. no. 1), an image of
the tool suddenly reappears in this print.
According to Tony Towle (Sparks, Towle
interviews and correspondence, 1982-85), Dine
agreed to contribute the proceeds of this print
to a project documenting ULAE publications
with high-quality reproductions. Although a new
offset press and a separate corporation were set
up, like many other of Mrs. Grosman's plans to
make a more popular product, this one was
never realized.

**23. FLAUBERT FAVORITES, EDITION A:
THE MARSHAL, 1972**
Lithograph from one aluminum plate
Paper: tan Nepalese handmade
Sheet: 628×485 mm (24³/₄×19¹/₈ in.) (irreg.)
Signed, dated, numbered; lower right: Jim Dine
1972 x/8 A
ULAE embossed stamp lower right
Edition: 8
 Plus: 2 artist's proofs (1 AIC)
 2 printer's proofs
 working proofs (1 AIC)
 2 unsigned proofs (printed recto and
 verso)
Printers: Bill Goldston and James V. Smith
Plate preserved and used for *Edition B*
Catalogue reference: Williams 95
Despite Dine's love of poetry, Mrs. Grosman
could never persuade him to undertake a
collaborative book. He was very inspired by
Gustave Flaubert at this period, and the titles of
the Flaubert prints (cat. nos. 23-30) refer
obliquely to the novels. The drawings on the
plate were made first, and the titles applied by
free association, a Dada approach that Dine
considered both amusing and poetic.
 Flaubert Favorites, Edition A was printed
on a craggy, handmade tissue Mrs. Grosman
found in Switzerland. Made in Nepal for
windowpanes, and still carrying particles of the
earth on which it was left to dry, it is extremely
fragile. *Edition A* was printed on a lamination
of three sheets.

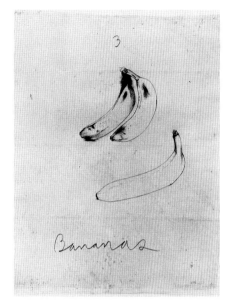

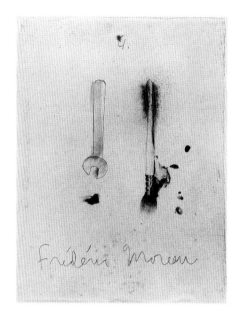

24. FLAUBERT FAVORITES, EDITION A: MADAM ARNOUX, 1972
Lithograph from one aluminum plate
Paper: tan Nepalese handmade
Sheet: 645×505 mm (25¼×20 in.)
Signed, dated, numbered; lower right: Jim Dine 1972 x/8 A
ULAE embossed stamp lower right
Edition: 8
 Plus: 2 artist's proofs (1 AIC)
 2 printer's proofs
 working proofs (1 AIC)
 2 unsigned proofs (printed recto and verso)
Printers: Bill Goldston and James V. Smith
Plate preserved and used for *Edition B*
Catalogue reference: Williams 96

25. FLAUBERT FAVORITES, EDITION A: BANANAS, 1972
Lithograph from one aluminum plate
Paper: tan Nepalese handmade
Sheet: 630×483 mm (24¾×19⅛ in.)
Signed, dated, numbered; lower right: Jim Dine 1972 x/8 A
ULAE embossed stamp lower right
Edition: 8
 Plus: 2 artist's proofs (1 AIC)
 2 printer's proofs
 working proofs (1 AIC)
 2 unsigned proofs (printed recto and verso)
Printers: Bill Goldston and James V. Smith
Plate preserved and used for *Edition B*
Catalogue reference: Williams 97

26. FLAUBERT FAVORITES, EDITION A: FREDERIC MOREAU, 1972
Lithograph from one aluminum plate
Paper: tan Nepalese handmade
Sheet: 632×481 mm (24⅞×18⅞ in.)
Signed, dated, numbered; lower right: Jim Dine 1972 x/8 A
ULAE embossed stamp lower right
Edition: 8
 Plus: 2 artist's proofs (1 AIC)
 2 printer's proofs
 working proofs (1 AIC)
 2 unsigned proofs (printed recto and verso)
Printers: Bill Goldston and James V. Smith
Plate preserved and used for *Edition B*
Catalogue reference: Williams 98

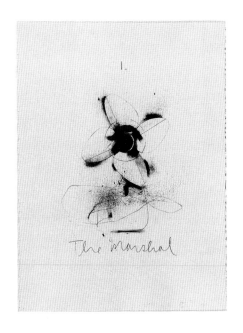

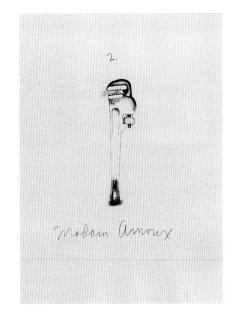

27. FLAUBERT FAVORITES, EDITION B:
THE MARSHAL, 1972
Lithograph from one aluminum plate
(previously used for *Edition A*)
Paper: white wove
Watermark: ARCHES FRANCE
Sheet: 760×570 mm (30×22¼ in.)
Signed, numbered, dated; lower right: Jim Dine
x/18B 1972
ULAE embossed stamp lower right
Edition: 18
　　Plus: 5 artist's proofs (1 AIC)
　　　　1 printer's proof
Printers: Bill Goldston and James V. Smith
Catalogue reference: Williams 99
Unlike *Edition A, Flaubert Favorites, Edition
B* was printed on standard white wove paper.

28. FLAUBERT FAVORITES, EDITION B:
MADAM ARNOUX, 1972
Lithograph from one aluminum plate
(previously used for *Edition A*)
Paper: white wove
Watermark: ARCHES FRANCE
Sheet: 764×568 mm (30⅛×22⅜ in.)
Signed, numbered, dated; lower right: Jim Dine
x/18B 1972
ULAE embossed stamp lower right
Edition: 18
　　Plus: 5 artist's proofs (1 AIC)
　　　　1 printer's proof
Printers: Bill Goldston and James V. Smith
Catalogue reference: Williams 100

29. FLAUBERT FAVORITES, EDITION B:
BANANAS, 1972
Lithograph from one aluminum plate
(previously used for *Edition A*)
Paper: white wove
Watermark: ARCHES FRANCE
Sheet: 764×568 mm (30⅛×22⅜ in.)
Signed, numbered, dated; lower right: Jim Dine
x/18B 1972
ULAE embossed stamp lower right
Edition: 18
　　Plus: 5 artist's proofs (1 AIC)
　　　　1 printer's proof
Printers: Bill Goldston and James V. Smith
Catalogue reference: Williams 101

30. FLAUBERT FAVORITES, EDITION B: FREDERIC MOREAU, 1972
Lithograph from one aluminum plate
(previously used for *Edition A*)
Paper: white wove
Watermark: ARCHES FRANCE
Sheet: 764×568 mm (30⅛×22⅜ in.)
Signed, numbered, dated; lower right: Jim Dine
x/18B 1972
ULAE embossed stamp lower right
Edition: 18
 Plus: 5 artist's proofs (1 AIC)
 1 printer's proof
Printers: Bill Goldston and James V. Smith
Catalogue reference: Williams 102

31. 2 HEARTS (THE DONUT), 1970-72
Diptych lithograph from twelve stones and eight
plates, each section printed from six stones and
four plates
Paper: white wove
Watermark: ENGLAND 1961/J WHATMAN
Sheet: 1372×806 mm (54×31¾ in.)
Numbered, signed; lower right left sheet:
x/17 Jim
Signed, dated; lower left right sheet: Dine 1972
Edition: 17
 Plus: 4 artist's proofs (1 AIC)
 1 printer's proof
 trial proofs (18 AIC)
 working proofs (7 AIC)
 3 proofs H.C.
Printer: Bill Goldston
Catalogue reference: Williams 1
See plate 18

32. A HAND-PAINTED SELF-PORTRAIT, 1975
Etching, drypoint, and monotype, with
additions of pastel and paint, from one copper
plate
Paper: ivory wove J. Green paper
Plate: 516×455 mm (20⁵⁄₁₆×17¹⁵⁄₁₆ in.)
Sheet: 1043×697 mm (41¹⁄₁₆×27⁷⁄₁₆ in.)
Numbered, signed, dated; lower left: x/6 Jim
Dine 1975
Edition: 6
 Plus: 2 artist's proofs (1 AIC)
 trial proofs (4 AIC)
 working proofs (1 AIC)
Printer: Zigmunds Priede
Plate preserved and used for *Self-Portrait As a
Negative* and *Positive Self-Portrait, State 2*
(cat. nos. 33, 34).
Catalogue reference: Williams 194
See plate 19

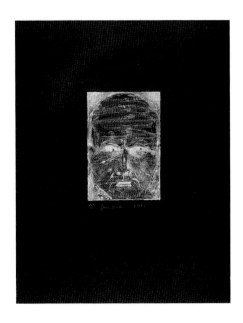

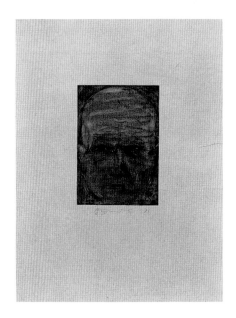

33. SELF-PORTRAIT AS A NEGATIVE, 1975
Etching, drypoint, and power tool from one
copper plate (previously used for *A Hand-
Painted Self-Portrait* [cat. no. 32] and cut down)
Paper: black wove Fabriano
Plate: 254×180 mm (10×7¹/₁₆ in.)
Sheet: 662×513 mm (26×20³/₁₆ in.)
Numbered, signed, dated; lower center: x/39 Jim
Dine 1975
Edition: 39
 Plus: 1 artist's proof (1 AIC)
 1 printer's proof
 trial proofs (12 AIC)
 working proofs (1 AIC)
Printer: Zigmunds Priede
Plate preserved and used for *Positive Self-
Portrait, State 2* (cat. no. 34)
Catalogue reference: Williams 196

34. POSITIVE SELF-PORTRAIT, STATE 2, 1975
Etching from one copper plate (previously used
for *A Hand-Painted Self-Portrait* [cat. no. 32]
cut down and also used for *Self-Portrait As a
Negative* [cat. no. 33]).
Paper: light green-gray wove J. Goodman
handmade
Watermark: JG
Plate: 248×173 mm (9³/₄×16¹³/₁₆ in.)
Sheet: 606×444 mm (23⁷/₈×17¹/₂ in.)
Numbered, signed, dated; lower center: x/11 Jim
Dine 1975
Edition: 11
 Plus: 1 artist's proof (1 AIC)
 trial proofs (3 AIC)
 working proofs (1 AIC)
Printer: Zigmunds Priede
Plate temporarily preserved
Catalogue reference: Williams 195

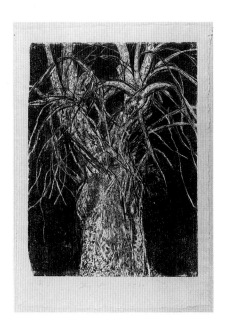

35. THE BIG BLACK AND WHITE
WOODCUT TREE, 1981
Woodcut from one block
Paper: white wove Japanese Toyoshi
Sheet: 1466×1066 mm (57³/₄×42 in.) (irreg.)
Signed; lower center: Jim Dine
Dated; lower right: 1981
Numbered; lower left: x/25
Edition: 25
 Plus: 6 artist's proofs (1 AIC)
 2 printer's proofs
Printers: Keith Brintzenhofe and Bill Goldston
Woodblock temporarily preserved
The "block" used for this print was an old
drafting table Dine found in a studio he rented
in New York; the white flecks come from the
innumerable thumbtack holes made by a
previous owner. The apple tree, an old one near
Dine's house in Vermont, has been one of his
principal themes since 1980.

36. THE JERUSALEM PLANT #1 (WHITE ON BLACK), 1982
Lithograph from one stone and one plate
Paper: black wove Fabriano
Sheet: 1029×666 mm (40½×26¼ in.)
Numbered, signed, dated; lower center: x/10 Jim Dine 1982
Edition: 10
 Plus: 4 artist's proofs (1 AIC)
 3 printer's proofs
Printer: Thomas Cox
Stone and plate temporarily preserved
In facture and color, *The Jerusalem Plant* prints (cat. nos. 36-38) are related to the large still-life paintings shown at Pace Gallery in 1978 and the *Nancy Outside in July* series printed by Crommelynck in 1981-83.

37. THE JERUSALEM PLANT #2, 1982
Diptych woodcut from one block
Paper: cream wove Japanese Chiri
Sheets: left (A), 949×641 mm (37⅜×25¼ in.)
 right (B), 953×646 mm (37½×25⁷⁄₁₆ in.)
Numbered, signed, dated; lower right sheet B: x/11 Jim Dine 1982
ULAE embossed stamp lower left sheet A
Edition: 11
 Plus: 4 artist's proofs (1 AIC)
 2 printer's proofs
Printer: Thomas Cox
Woodblock temporarily preserved.
After *The Jerusalem Plant #1 (White on Black)*

lithograph (cat. no. 36) was finished, Dine and Bill Goldston transferred a photoscreenprint of the drawing to a piece of heavy-grain plywood. Dine redrew this ''sketch'' with a Dremel tool. Unlike most of his contemporaries, Dine takes a painterly, rather than linear, approach to woodcut. Furthermore, in the prints done twenty years after Dine's first experiences at ULAE, painting, drawing, and printmaking are fully integrated. Even the Chiri paper chosen for this print and the darker Kozo paper selected for *The Jerusalem Plant #3* (cat. no. 38) reinforce the grainy quality of the woodcut and the earthy quality of the subject.

38. THE JERUSALEM PLANT #3, 1982
Diptych woodcut from one block
Paper: gray-yellow laid Japanese Kozo
Sheets: left (A), 971×654 mm (38¼×25¾ in.)
 right (B), 965×657 mm (38×25⅞ in.)
Signed, dated, numbered; lower left sheet A: Jim Dine/1982 x/11
ULAE embossed stamp lower right sheet B
Edition: 11
 Plus: 4 artist's proofs (1 AIC)
 2 printer's proofs
Printer: Thomas Cox
Woodblock temporarily preserved

Sam Francis

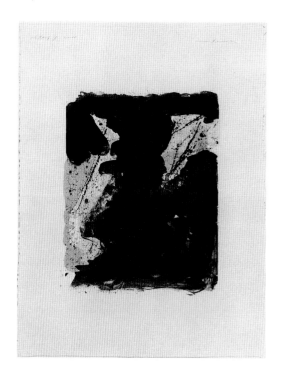

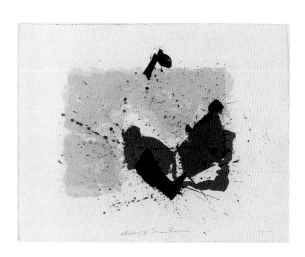

1. VERY FIRST STONE, 1959-68
Lithograph from two stones
Paper: white wove Crisbrook
Watermark: HANDMADE
Sheet: 796×570 mm (31⁵/₁₆×22⁷/₁₆ in.)
Signed; lower right: Sam Francis
Numbered, inscribed, dated; lower left: x/25
Very First Stone 1959-68
Edition: 25
 Plus: 4 artist's proofs (1 AIC)
 1 printer's proof
 4 trial proofs
Printers: Robert Blackburn and Fred Genis

2. FOUR STONE UNTITLED, 1959-68
Lithograph from four stones
Paper: grayish-white Kochi
Sheet: 725×559 mm (28½×22 in.)
Signed; upper right: Sam Francis
Numbered; upper left: x/25
Edition: 25
 Plus: 4 artist's proofs (1 AIC)
 1 printer's proof
 3 trial proofs
Printers: Robert Blackburn and Fred Genis
See plate 21

3. FIVE STONE UNTITLED, 1959-68
Lithograph from five stones
Paper: grayish-white wove handmade
Watermark: ANGOUMOIS A LA MAIN;
ULAE emblem
Sheet: 470×612 mm (18½×24⅛ in.)
Numbered, signed; lower center: x/26
Sam Francis
Dated; lower right: 1959-68
Edition: 26
 Plus: 4 artist's proofs (1 AIC)
 1 printer's proof
 3 trial proofs
Printers: Robert Blackburn and Fred Genis
This print clearly reveals its kinship with
Francis's mural for the Chase Manhattan Bank.
The shape, scale, and color of its compositional
elements make the lithograph seem to be an
extract from the larger work.

Helen Frankenthaler

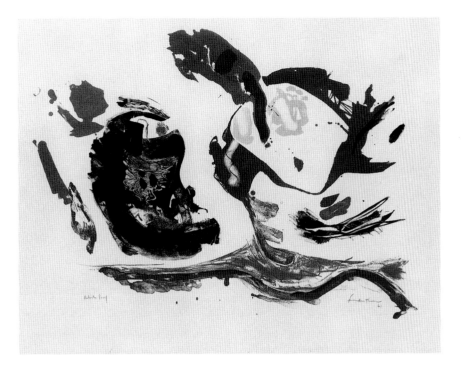

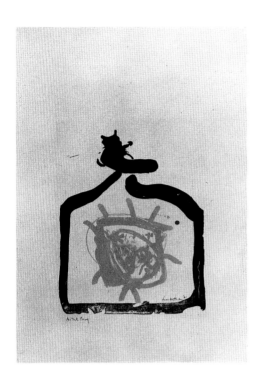

1. FIRST STONE, 1961
Lithograph from five stones
Paper: white wove
Watermark: Arches FRANCE
Sheet: 565×760 mm (22¼×29⅞ in.)
Signed, dated; lower right: Frankenthaler/61
Numbered; lower left: x/12
Edition: 12
 Plus: 2 marked artist's proofs (1 AIC)
 unmarked artist's proofs
 1 trial proof
 1 working proof (1 AIC)
Printer: Robert Blackburn
Catalogue reference: Williams 1
See plate 23

2. MAY 26, BACKWARDS, 1961
Lithograph from three stones
Paper: gray wove unbleached British handmade
Watermark: Crisbrook (emblem) HANDMADE
Sheet: 790×568 mm (31⅛×22⅜ in.)
Signed, dated; lower right: Frankenthaler '61
Numbered; lower left: x/20
Edition: 20
 Plus: 2 marked artist's proofs (1 AIC)
 unmarked artist's proofs
 2 trial proofs
 3 working proofs
Printer: Robert Blackburn
Catalogue reference: Williams 2
See plate 24

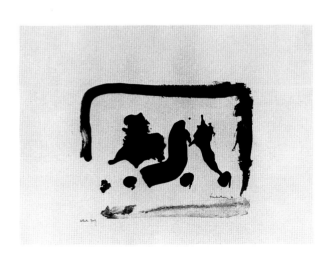

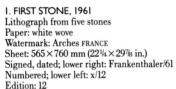

3. BROWN MOONS, 1961
Lithograph from two stones
Paper: gray wove unbleached British
Watermark: CRISBROOK HANDMADE
Sheet: 568×787 mm (22⅜×31 in.)
Signed, dated; lower right: Frankenthaler '61
Numbered; lower left: x/23
Edition: 23
 Plus: 2 artist's proofs (1 AIC)
 1 trial proof
 working proofs (1 AIC)
Printer: Robert Blackburn
Catalogue reference: Williams 3

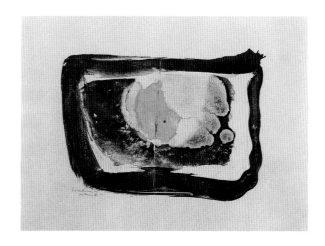

4. SKY FRAME, 1964
Lithograph from one stone, printed as a
monotype
Paper: white wove
Watermark: ARCHES
Sheet: 570 × 759 mm (22⁷/₁₆ × 29⁷/₈ in.)
Signed, dated, inscribed, numbered; lower left:
Frankenthaler '64/Sky Frame X (I-VIII)
Edition: 8 monotypes (I-VIII)
 Plus: 1 working proof (1 AIC)
Printer: Zigmunds Priede
Catalogue reference: Williams 4

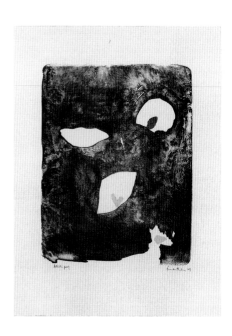

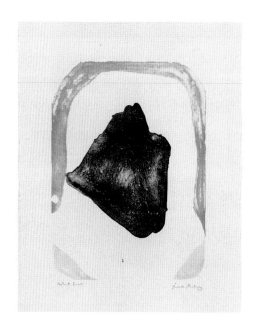

5. SOLARIUM, 1964
Lithograph from two stones
Paper: white laid Rives BFK handmade
Sheet: 655 × 490 mm (25¾ × 19¼ in.)
Signed, dated; lower right: Frankenthaler '64
Numbered; lower left: x/18
Edition: 18
 Plus: 5 proofs of the blue stone only were
 hand-colored in 1974 and released as
 Solarium Plus Color Variations
 1 artist's proof (1 AIC)
Printer: Zigmunds Priede
Catalogue reference: Williams 5
See plate 25

6. ORANGE HOOP, 1965
Lithograph from three stones
Paper: cream wove
Watermark: AUVERGNE A LA MAIN; RICHARD DE BAS
Sheet: 652 × 508 mm (25¹¹/₁₆ × 20 in.)
Signed, dated; lower right: Frankenthaler/1965
Numbered; lower left: x/24
Edition: 24
 Plus: 1 artist's proof (1 AIC)
 4 trial proofs (1 AIC)
 working proofs (3 AIC)
Printer: Zigmunds Priede
Catalogue reference: Williams 7
Orange Hoop marks a change in
Frankenthaler's approach to composition, away
from the recorded marks of a painter toward the
additive nature of collage. Frankenthaler
rearranged the shapes in this image and varied
the colors in the final edition, thus assembling
"found objects" of her own creation.

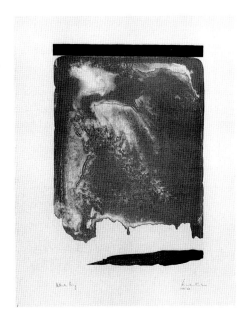

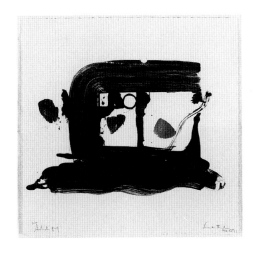

7. PERSIAN GARDEN, 1965-66
Lithograph from three stones
Paper: cream wove
Watermark: AUVERGNE A LA MAIN; RICHARD DE BAS
Sheet: 655×510 mm (25¾×20 in.)
Signed, dated; lower right: Frankenthaler/
1965-66
Numbered; lower left: x/24
Edition: 24
 Plus: 1 artist's proof (1 AIC)
 2 trial proofs (2 AIC)
 1 trial proof hand-colored by the artist
 in 1976 and titled *Persian Garden
 with Crayon and Colored Pencils*
 1 working proof (1 AIC)
Printer: Ben Berns
Catalogue reference: Williams 8
See plate 26

8. POST CARD FOR JAMES SCHUYLER,
1962-65-67
Lithograph from two stones
Paper: gray laid
Watermark: ANGOUMOIS A LA MAIN
Sheet: 400×414 mm (15¹¹/₁₆×16⅛ in.)
Signed, dated; lower right: Frankenthaler/
1962-65-67
Numbered; lower left: x/19
Edition: 19
 Plus: 5 artist's proofs (1 AIC)
 5 trial proofs
 3 working proofs (3 AIC)
Printer: Robert Blackburn
Catalogue reference: Williams 9
This print was begun in 1962 as part of a
planned collaborative portfolio by Frankenthaler
and James Schuyler, which never was realized.
Three years later a small number of impressions
of the black stone were printed. Early in 1967 a
second stone (the three spots of color) was added
and the edition released.

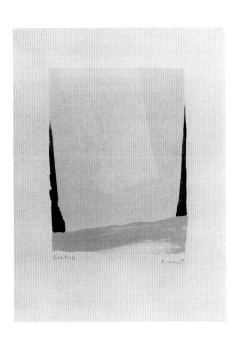

9. WHITE PORTAL, 1967
Lithograph from five stones
Paper: pinkish-cream wove
Watermark: Arches
Sheet: 761×568 mm (30×22⅜ in.)
Signed, dated; lower right: Frankenthaler '67
Numbered; lower left: x/18
Edition: 18
 Plus: 4 artist's proofs (1 AIC)
 1 printer's proof
 7 trial proofs (6 AIC)
 2 working proofs (1 AIC)
 7 proofs H.C.
Printer: Donn Steward
Two stones preserved and used for *Silent
Curtain* (cat. no. 11)
Catalogue reference: Williams 11
This U-shaped composition reflects the
Minimalist Art of the 1960s. Frankenthaler first
drew the large "brush stroke" but found it
unresolved (though she later changed her mind
about its self-sufficiency [see *Silent Curtain*, cat.
no. 11]). The other elements were composed by a
collage approach that involved experimentation
with numerous papers and plastics.
See plate 29

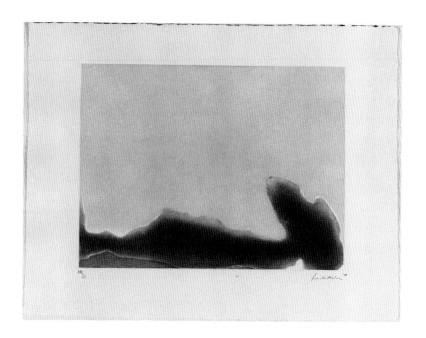

10. YELLOW SPAN, 1968
Sugar-lift aquatint from two copper plates
Paper: ivory laid
Watermark: AUVERGNE A LA MAIN; RICHARD DE BAS
Plate: 355×478 mm (14×18¹³⁄₁₆ in.)
Sheet: 501×670 mm (19⅞×26⅜ in.)
Signed, dated; lower right: Frankenthaler '68
Numbered; lower left: x/75
Edition: 75
 Plus: 15 artist's proofs (1 AIC)
 1 printer's proof
 5 trial proofs in unique variation
 (2 AIC)
 2 working proofs (2 AIC)
Printer: Donn Steward
Catalogue reference: Williams 14
Yellow Span was done for the benefit of The
Jewish Museum in New York, at the suggestion
of Mrs. Vera List, to celebrate their Purim
Spring Festival. It was Frankenthaler's first
intaglio print, fortuitously guided by ULAE's
new Master Printer Donn Steward.
See plate 30

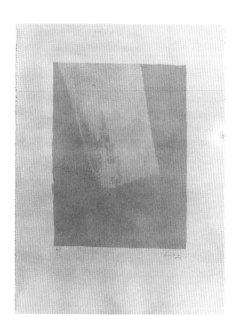

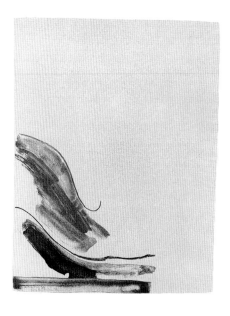

11. SILENT CURTAIN, 1967-69
Lithograph from two stones (previously used for
White Portal [cat. no. 9])
Paper: pinkish-cream wove
Watermark: ARCHES
Sheet: 764×567 mm (30¹⁄₁₆×22⁵⁄₁₆ in.)
Signed, dated; lower right: Frankenthaler 67-69
Numbered; lower left: x/25
Edition: 25
 Plus: 4 artist's proofs (1 AIC)
 1 printer's proof
Printer: Donn Steward
Catalogue reference: Williams 15
In 1969 Frankenthaler reviewed some of the
experimental proofs of *White Portal* (cat. no. 9)
and decided to use its first two stones for a new
print, *Silent Curtain*. The artist brought
forward the ghostly white central image by
contrasting it with a light brown ink on a rosy
cream Arches paper. The edition was signed for
release on July 23, 1969.

12. SOUTHWEST BLUES, 1969
Lithograph from three stones
Paper: white wove
Watermark: ULAE; ANGOUMOIS A LA MAIN
Sheet: 609×469 mm (23¹⁵⁄₁₆×18⁷⁄₁₆ in.)
Numbered, signed, dated; lower left: x/19
Frankenthaler/'69
ULAE embossed stamp upper left
Edition: 19
 Plus: 4 artist's proofs (1 AIC)
 2 printer's proofs
 11 trial proofs (4 AIC)
 working proofs (13 AIC)
 2 proofs H.C.
Printers: Zigmunds Priede and Fred Genis
Catalogue reference: Williams 16

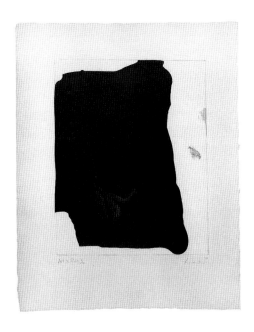

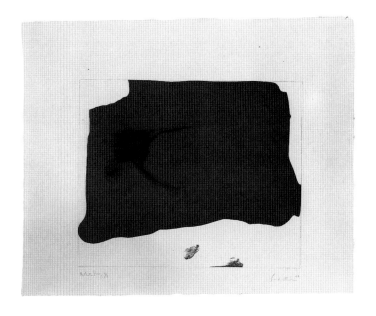

13. VARIATION I ON MAUVE CORNER,
1969
Lithograph from fourteen stones
Paper: white wove Chatham British handmade
Watermark: ENGLAND
Sheet: 639×511 mm (25⅛×20⅛ in.)
Signed, dated; lower right: Frankenthaler '69
Numbered; lower left: x/8
Inscribed; lower left: Variation I on 'Mauve
Corner'
Edition: 8
 Plus: artist's proofs (1 AIC)
 10 trial proofs, reworked and retitled
 by the artist in 1976 (see *Variation II
 on Mauve Corner* [cat. no. 14])
 7 trial proofs (1 AIC)
 working proofs (7 AIC)
 The trial proofs and working proofs
 of this print also relate to *Variation II
 on Mauve Corner* (cat. no. 14)
Printer: Fred Genis
Stones temporarily preserved
Catalogue reference: Williams 17

14. VARIATION II ON MAUVE CORNER,
1969
Lithograph from four stones
Paper: ivory wove Chatham British handmade
Sheet: 508×636 mm (20×25¹/₁₆ in.)
Signed, dated; lower right: Frankenthaler '69
Numbered; lower left: x/21
Edition: 21
 Plus: 4 artist's proofs (1 AIC)
 2 printer's proofs
 Trial proofs and working proofs for
 this print are listed under *Variation I
 on Mauve Corner* (cat. no. 13)
Printers: Zigmunds Priede and Bill Goldston
Catalogue reference: Williams 18
This was the first print Frankenthaler reused in
a manner practiced by Degas: as the basis for a
more elaborate image. ULAE released the
following variations: *Variation II on Mauve
Corner with Yellow Acrylic*, 1969-70 (three
proofs reworked with yellow acrylic); *Mauve
Corner Electric*, 1969-70 (four proofs reworked
with pink crayon); and *Mauve Corner with
Plum*, 1969-76 (three proofs reworked with plum
crayon and acrylic).
See plate 32

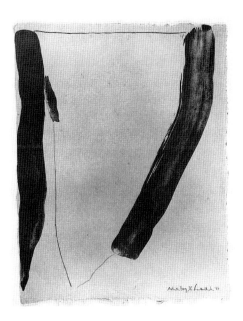

15. A SLICE OF THE STONE ITSELF, 1969
Lithograph from two stones
Paper: brown-gray laid French handmade
Sheet: 484×380 mm (19¹/₁₆×14¹⁵/₁₆ in.)
Numbered, signed, dated; lower right: x/24
Frankenthaler '69
Edition: 24
 Plus: 4 artist's proofs (1 AIC)
 2 printer's proofs
 3 trial proofs
 working proofs (3 AIC)
 1 proof H.C.
Printers: Zigmunds Priede and Bill Goldston
Catalogue reference: Williams 19
See plate 33

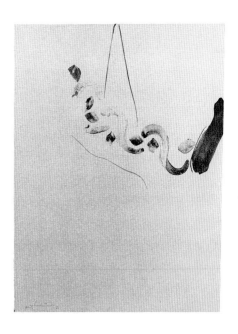

16. VENICE I, 1969
Lithograph from three stones
Paper: white wove Chatham British handmade
Sheet: 789×587 mm (31 1/16 × 23 1/8 in.)
Numbered, signed, dated; lower left: x/16
Frankenthaler '69
Edition: 16
 Plus: 4 artist's proofs (1 AIC)
 2 printer's proofs
 11 trial proofs (9 AIC)
 1 working proof
Printers: Zigmunds Priede and Bill Goldston
Catalogue reference: Williams 20
In 1972 Frankenthaler reworked with crayon and
paint four unsigned impressions of *Venice I.*

17. OCEAN FLOOR, 1969-76
Lithograph from three stones
Paper: yellow wove handmade
Watermark: J E HEAD
Sheet: 787×533 mm (31×21 in.)
Signed, dated; lower left: Frankenthaler '69-'76
Edition: 4 trial proofs with additions of orange
 crayon
 2 trial proofs: "1/2" marked "(Ocean
 Floor)"
 "2/2" marked "(with
 Tony's orange, Ocean
 Floor)"
 5 unmarked trial proofs
 (2 AIC)
 working proofs (1 AIC)
Printers: Bill Goldston and Zigmunds Priede
Catalogue reference: Williams 21

18. WEATHER VANE, 1969-70
Aquatint from two copper plates
Paper: pinkish-cream wove
Watermark: ARCHES
Plate: 486×359 mm (19 1/8 × 14 1/8 in.)
Sheet: 758×568 mm (29 7/8 × 22 3/8 in.)
Signed, dated; lower right: Frankenthaler/
1969-70
Numbered; lower left: x/23
Edition: 23
 Plus: 4 artist's proofs (1 AIC)
 1 artist's proof turned 180° and
 marked "Artist's Proof 1969"
 1 printer's proof
 3 trial proofs (3 AIC)
 working proofs (1 AIC)
Printer: Donn Steward
Catalogue reference: Williams 22
See plate 34

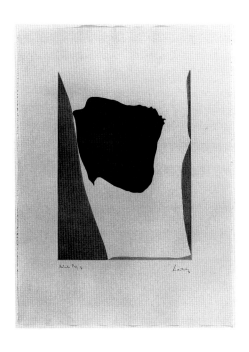

19. LILAC ARBOR, 1970
Aquatint from two copper plates
Paper: cream wove
Watermark: ARCHES
Plate: 484×357 mm (19¹/₁₆×14¹/₁₆ in.)
Sheet: 756×565 mm (29¾×22¼ in.)
Signed, dated; lower right: Frankenthaler/'70
Numbered; lower left: x/20
Edition: 20
 Plus: 5 artist's proofs (1 AIC)
 1 printer's proof
 11 trial proofs
 working proofs (4 AIC)
 2 proofs H.C. marked "Etching
 Plus"
Printer: Donn Steward
Catalogue reference: Williams 23

20. LOT'S WIFE, 1970-71
Triptych lithograph from three stones
Paper: white wove Japanese handmade
Sheets: top, 1065×930 mm (41¹⁵/₁₆×35⅝ in.)
 middle, 1274×930 mm (50⅛×36⅝ in.)
 bottom, 1157×933 mm (45⁹/₁₆×36¾ in.)
Signed, dated; lower right bottom sheet:
Frankenthaler/'71
Numbered; lower left bottom sheet: x/17
ULAE embossed stamp upper right top sheet,
lower left middle and bottom sheets
Edition: 17
 Plus: 4 artist's proofs (triptych) (1 AIC)
 1 printer's proof (triptych)
 2 triptychs in horizontal format
 marked "Lot's Wife with Crayon and
 Paint 1971-76"
 7 trial proofs
 working proofs (7 AIC)
Printers: Frank Akers and David Umholz
Catalogue reference: Williams 34
Although here Frankenthaler originally planned
a horizontal triptych, in the process of working
on this print, it assumed a columnar appearance
in her eyes, reminding her of Lot's wife who,
looking back at the burning city of Sodom, was
transformed into a pillar of salt.
See plate 36

21. FREE WHEELING, 1971
Etching from one copper plate with additions of
acrylic paint
Paper: white wove German Copperplate
Plate: 775×555 mm (30½×21¾ in.)
Sheet: 1067×767 mm (42×30³/₁₆ in.)
Dated, signed, numbered; lower right: '71
Frankenthaler x/21
Edition: 21
 Plus: 2 artist's proofs (1 AIC)
 1 printer's proof
 2 trial proofs (2 AIC)
Printer: Donn Steward
Plate preserved and used for *Sky Frame Orbit*
(cat. no. 27)
Catalogue reference: Williams 35
According to the Williams catalogue, *Free
Wheeling* was printed on sheets that had been
used to blot excess acrylic used in the printing
of *Wind Directions* (a pochoir print published
by Abrams Original Editions in 1970). *Wind
Directions* followed the four-corner composition
of *Weather Vane* (cat. no. 18), done at ULAE in
1969-70. The cartwheel of etched lines had a
precedent in Frankenthaler's painting (see
Sesame, 1970, Private Collection).
See plate 37

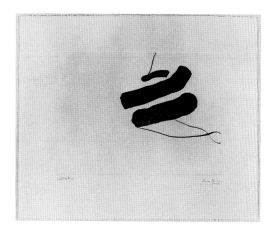

22. CRETE, 1969-72
Etching and sugar-lift aquatint from two copper plates
Paper: white wove J.B. Green
Watermark: MADE IN ENGLAND; HAYLE MILL G
Plate: 343×479 mm (13½×18⅞ in.)
Sheet: 568×689 mm (22⅜×27⅛ in.)
Signed, dated; lower right: Frankenthaler/ 1969-'72
Numbered; lower left: x/18
Edition: 18
 Plus: 4 artist's proofs (1 AIC)
 2 printer's proofs
 6 trial proofs (1 AIC)
 1 working proof (1 AIC)
Printer: Donn Steward
Catalogue reference: Williams 39

23. VENICE II, 1969-72
Lithograph from three stones and two aluminum plates
Paper: white wove English handmade
Sheet: 790×597 mm (31⅛×23½ in.)
Signed, inscribed, numbered, dated; lower left:
Frankenthaler/Venice II x/8 1969-72
Edition: 8
 Plus: 2 trial proofs (2 AIC)
 2 working proofs, with additions of
 orange and green crayon, that served
 as prototypes for *Venice II*
Printers: Bill Goldston and Zigmunds Priede
Catalogue reference: Williams 40
Pleased with her reworked impressions of *Venice I* (cat. no. 16), Frankenthaler made new plates to add similar lines to other unsigned proofs; an edition of eight was released as *Venice II*.

24. I NEED YELLOW, 1973
Lithograph from three stones (some previously used for unpublished print tentatively titled "Postcard Variations" and related to *Post Card for James Schuyler* [cat. no. 8])
Paper: white wove Chatham British handmade
Sheet: 626×497 mm (24¹¹/₁₆×19⁹/₁₆ in.)
Signed, dated; lower right: Frankenthaler/'73
Numbered; lower left: x/29
Edition: 29
 Plus: 5 artist's proofs (1 AIC)
 trial proofs (14 AIC)
 2 trial proofs reworked with orange
 crayon, 1976
 2 trial proofs reworked with yellow
 crayon, 1976
 1 trial proof (in orange) reworked with
 crayon and paint, 1976
 working proofs (2 AIC)
Printers: Bill Goldston and John A. Lund
Catalogue reference: Williams 43
See plate 38

25. EAST AND BEYOND, 1972-73
Woodcut from eight lauan mahogany plywood
blocks by the artist
Paper: light brown laminated Nepalese
handmade
Sheet: 811×561 mm (31⅞×22¹/₁₆ in.)
Signed, dated; lower right: Frankenthaler/'73
Numbered; lower left: x/18
Edition: 18
 Plus: 6 artist's proofs (1 AIC)
 8 trial proofs (1 AIC)
 working proofs (2 AIC)
Printers: Bill Goldston, James V. Smith, and
Juda Rosenberg
Woodblocks temporarily preserved
Catalogue reference: Williams 44
See plate 39

26. CONNECTED BY JOY, 1969-73
Etching and aquatint from two copper plates
Paper: brown wove Jeff Goodman handmade
Watermark: JG
Plate: 361×485 mm (14³/₁₆×19⅛ in.)
Sheet: 420×588 mm (16½×21³/₁₆ in.)
Signed, dated; lower right: Frankenthaler/'69-73
Numbered; lower left: x/27
Edition: 27
 Plus: 4 artist's proofs (1 AIC)
 1 printer's proof
 5 trial proofs (1 AIC)
 working proofs (4 AIC)
Printer: Donn Steward
Plates temporarily preserved
Catalogue reference: Williams 48
See plate 41

27. SKY FRAME ORBIT, 1964-73
Lithograph, etching, and aquatint from one
stone and one oval plate (plate previously used
for *Free Wheeling* [cat. no. 21])
Paper: pinkish-cream wove
Watermark: ARCHES
Plate: oval, 415×230 mm (16¼×9 in.)
Sheet: 759×571 mm (29⅞×22½ in.)
Signed, dated; lower right: Frankenthaler/
'64-'73
Numbered; lower left: x/6
Edition: 6
 Plus: 2 artist's proofs (1 AIC)
 1 printer's proof
 4 trial proofs (3 printed with plate
 only) (2 AIC)
 working proofs (1 AIC)
 1 stone (lithograph) and 1 plate
 (center oval in etching and aquatint)
 printed twice
Printers: Zigmunds Priede and Donn Steward
Stone preserved and used for *Sky Frame* (cat.
no. 4); plate temporarily preserved
Catalogue reference: Williams 49
The blue enframing shape appearing here was
made in 1964 for *Sky Frame* (cat. no. 4); the oval
etching was added in February 1972. This was
the first time Frankenthaler combined two
media on a single sheet: lithography and
intaglio.

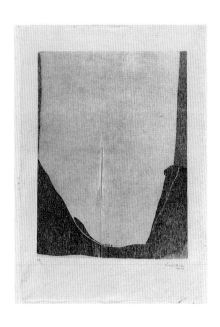

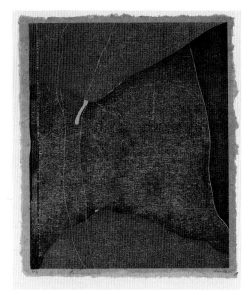

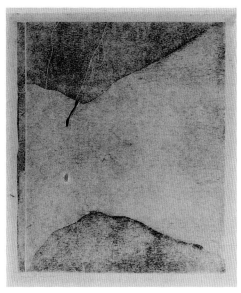

28. EAST AND BEYOND WITH ORANGE, 1973-74
Woodcut from eight lauan mahogany plywood blocks
Paper: light brown laminated Nepalese with additions of acrylic paint handmade
Sheet: 812×567 mm (32×22⁵/₁₆ in.)
Signed, dated; lower right: Frankenthaler/'73-'74
Numbered; lower left: x/12
Edition: 12
 Plus: 2 artist's proofs (1 AIC)
 1 trial proof
Printers: Bill Goldston, James V. Smith, and Juda Rosenberg
Woodblocks temporarily preserved
Catalogue reference: Williams 50
Frankenthaler selected fourteen imperfectly registered proofs of *East and Beyond* (cat. no. 25), touched them with cadmium red acrylic, and released them as *East and Beyond with Orange*.

29. SAVAGE BREEZE, 1974
Woodcut from eight lauan mahogany blocks hand-cut by the artist
Paper: light brown laminated Nepalese handmade
Sheet: 800×692 mm (31½×27¼ in.)
Signed, dated; lower right: Frankenthaler '74
Numbered; lower left: x/31
ULAE embossed stamp lower right
Edition: 31
 Plus: 4 artist's proofs (1 AIC)
 3 printer's proofs
 12 trial proofs
 1 trial proof reworked with crayon, 1976
 1 trial proof reworked with crayon and paint, 1976
 3 working proofs
 4 proofs H.C.
Printers: Bill Goldston and Juda Rosenberg
Woodblocks temporarily preserved
Catalogue reference: Williams 51
East and Beyond (cat. no. 25), Frankenthaler's first woodcut, took five hours to print; *Savage Breeze*, on the same Nepalese paper, took forty-four days' press time.
See plate 42

30. VINEYARD STORM, 1974-76
Woodcut from four lauan mahogany plywood blocks
Paper: light brown laminated Nepalese handmade
Sheet: 800×686 mm (31½×27 in.)
Edition: 2 artist's proofs
 4 trial proofs
Printers: Bill Goldston and Juda Rosenberg
Catalogue reference: Williams 52
In 1976 Frankenthaler found several trial proofs in the studio that had been printed with only four of the eight blocks used for *Savage Breeze* (cat. no. 29). She recut one of them, reassembled the original four, and printed *Vineyard Storm* in new colors.

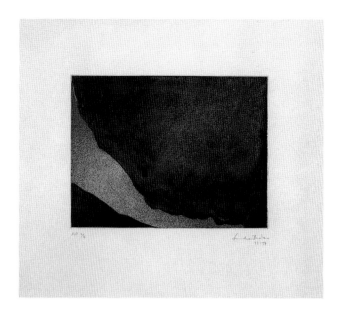

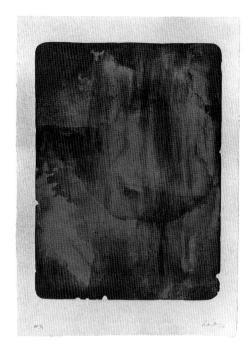

31. MESSAGE FROM DEGAS, 1972-74
Etching, aquatint, and liquid (brandy) aquatint
from three copper plates
Paper: ivory wove
Watermark: HANDMADE; J. WHATMAN 1956; ENGLAND
Plate: 189×250 mm (7⁷/₁₆×9¹³/₁₆ in.)
Sheet: 349×435 mm (13¹³/₁₆×17¹/₈ in.)
Signed, dated; lower right: Frankenthaler/
'72-'74
Numbered; lower left: x/36
Edition: 36
 Plus: 4 artist's proofs (1 AIC)
 1 printer's proof
 13 trial proofs marked A/B
 9 trial proofs marked B/B
 4 proofs H.C.
Printer: Donn Steward
Catalogue reference: Williams 53
The "message" for Degas was an aquatint
formula developed by Donn Steward after he
had seen a print made by Edgar Degas that was
given to Mary Cassatt. To re-create the effect,
Steward consulted an old technical manual and
experimented with various combinations of
brandy and other alcohol. In her paintings,
Frankenthaler often used free-flowing, very
liquid paint. Steward's brandy aquatint,
therefore, was a most congenial medium.
See plate 43

32. BRONZE SMOKE, 1978
Lithograph from two stones
Paper: red-brown-pink wove J.B. Green Katusah
handmade
Sheet: 794×575 mm (31¹/₄×22⁵/₈ in.)
Signed, dated; lower left: Frankenthaler/'78
Numbered; lower right: x/38
Edition: 38
 Plus: 4 artist's proofs (1 AIC)
 2 printer's proofs
 trial proofs (7 AIC)
Printers: Bill Goldston and Thomas Cox
Catalogue reference: Williams 66
See plate 44

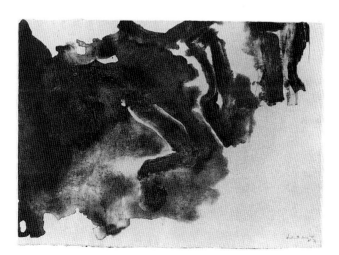

33. ALTITUDES, 1976-78
Lithograph from two stones
Paper: light yellow-pink wove J.B. Green/Hayle
Mill Bodlah handmade
Sheet: 572×778 mm (22¹/₂×30⁵/₈ in.) (irreg.)
Signed, dated, numbered; lower right:
Frankenthaler '78/x/42
Edition: 42
 Plus: 4 artist's proofs (1 AIC)
 2 printer's proofs
 11 working proofs
Printers: Bill Goldston and John A. Lund
Catalogue reference: Williams 67

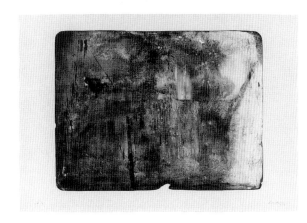

34. DOOR, 1976-79
Lithograph from two stones
Paper: heavy blue wove
Watermark: HANDMADE; J. WHATMAN 1927; ENGLAND
Sheet: 727×1054 mm (25⅝×41½ in.)
Signed, dated; lower right: Frankenthaler
'76-'79
Numbered; lower left: x/34
Edition: 34
 Plus: 6 artist's proofs (1 AIC)
 3 printer's proofs
 19 trial proofs
 3 proofs H.C.
Printers: Bill Goldston and John A. Lund
Catalogue reference: Williams 69

APPENDIX
The following small editions were printed from
blocks made for previous prints, but inked and
printed differently. They were not distributed
through customary channels to dealers and
collectors.

TRIAL PREMONITION I/III, 1974-76
Woodcut from five mahogany plywood blocks
Paper: Japan Suzuki
Sheet: 814×686 mm (32×27 in.)
Signed; lower left: Frankenthaler
Edition: 3
Printers: Bill Goldston and Juda Rosenberg
Catalogue reference: Williams 54

TRIAL PREMONITION II/III, 1974-76
Woodcut from five mahogany plywood blocks
Paper: Japan Suzuki
Sheet: 814×686 mm (32×27 in.)
Signed; lower left: Frankenthaler
Edition: 5
 Plus: 4 trial proofs
Printers: Bill Goldston and Juda Rosenberg
Catalogue reference: Williams 55
Not illustrated

TRIAL PREMONITION III/III, 1974-76
Woodcut from five mahogany plywood blocks
Paper: Japan Suzuki
Sheet: 814×686 mm (32×27 in.)
Signed; lower left: Frankenthaler
Edition: 2
Printers: Bill Goldston and Juda Rosenberg
Catalogue reference: Williams 56
Not illustrated

1-26. TETRASCROLL, 1975-77
A book of twenty-one lithographs with text, a
title page, a preface page, an epilever, and a
colophon page made from twenty-five stones
and twenty-seven plates; there are twenty-six
sections, each an equilateral triangle, bound by
Richard Minsky and Peter Seidler in Dacron
polyester sailcloth, hinged to form a continuous
single object
Paper: white wove Rives BFK
Sheet: 900×900×900 mm (35½×35½×35½ in.)
Edition: 34
 Plus: 6 artist's proofs
 2 printer's proofs
Printers: John Lund, Keith Brintzenhofe, Bill
Goldston, and Zigmunds Priede; typography by
Juda Rosenberg
See plates 45-48

TETRASCROLL: COVER, 1975-77
Lithograph from one plate on paper encased in
Dacron polyester sailcloth

1. TETRASCROLL: TITLE PAGE, 1975-77
Lithograph from one plate
Not illustrated

2. TETRASCROLL: PREFACE PAGE, 1975-77
Lithograph from three plates
Signed, dated, and numbered; lower center:
Buckminster Fuller / Nov 15 1975 / Anne
Hewlett Fuller / Alexandra (for Goldy) / Aug. 6,
1976 / x/34
Not illustrated

3. TETRASCROLL: PAGE 1, 1975-77
Lithograph from an unknown number of plates
Signed; lower right: BF
Not illustrated

4. TETRASCROLL: PAGE 2, 1975-77
Lithograph from an unknown number of stones
and plates
Signed; upper right: BF
Not illustrated

5. TETRASCROLL: PAGE 3, 1975-77
Lithograph from an unknown number of stones
and plates
Signed; lower right: BF
Not illustrated

6. TETRASCROLL: PAGE 4, 1975-77
Lithograph from an unknown number of stones
and plates
Signed; upper right: BF
Not illustrated

7. TETRASCROLL: PAGE 5, 1975-77
Lithograph from an unknown number of stones
and plates
Signed; lower right: BF
Not illustrated

8. TETRASCROLL: PAGE 6, 1975-77
Lithograph from an unknown number of stones
and plates
Signed; upper right: BF
Not illustrated

9. TETRASCROLL: PAGE 7, 1975-77
Lithograph from an unknown number of stones
and plates
Signed; lower right: BF
Not illustrated

10. TETRASCROLL: PAGE 8, 1975-77
Lithograph from an unknown number of stones
and plates
Signed; upper right: BF
Not illustrated

11. TETRASCROLL: PAGE 9, 1975-77
Lithograph from an unknown number of stones
and plates
Signed; lower right: BF
Not illustrated

12. TETRASCROLL: PAGE 10, 1975-77
Lithograph from an unknown number of stones
and plates
Signed; upper right: BF
Not illustrated

13. TETRASCROLL: PAGE 11, 1975-77
Lithograph from an unknown number of stones
and plates
Signed; lower right: BF
Not illustrated

14. TETRASCROLL: PAGE 12, 1975-77
Lithograph from an unknown number of stones
and plates
Signed; upper right: BF
Not illustrated

15. TETRASCROLL: PAGE 13, 1975-77
Lithograph from an unknown number of stones
and plates
Signed; lower right: BF
Not illustrated

16. TETRASCROLL: PAGE 14, 1975-77
Lithograph from an unknown number of stones
and plates
Signed; upper right: BF
Not illustrated

17. TETRASCROLL: PAGE 15, 1975-77
Lithograph from an unknown number of stones
and plates
Signed; lower right: BF
Not illustrated

18. TETRASCROLL: PAGE 16, 1975-77
Lithograph from an unknown number of stones
and plates
Signed; upper right: BF
Not illustrated

19. TETRASCROLL: PAGE 17, 1975-77
Lithograph from an unknown number of stones
and plates
Signed; lower right: BF
Not illustrated

20. TETRASCROLL: PAGE 18, 1975-77
Lithograph from an unknown number of stones
and plates
Signed; upper right: BF
Not illustrated

21. TETRASCROLL: PAGE 19, 1975-77
Lithograph from an unknown number of stones
and plates
Signed; lower right: BF
Not illustrated

22. TETRASCROLL: PAGE 20, 1975-77
Lithograph from an unknown number of stones
and plates
Signed; upper right: BF
Not illustrated

23. TETRASCROLL: PAGE 21, 1975-77
Lithograph from an unknown number of stones
and plates
Signed; lower right: BF
Not illustrated

24. TETRASCROLL: PAGE 22, 1975-77
Lithograph from an unknown number of stones
and plates
Signed; upper right: BF
Not illustrated

**25. TETRASCROLL: EPILEVER TO
TETRASCROLL, 1975**
Written by Edwin Schlossberg
Lithograph
Signed; lower center: Edwin Schlossberg
Not illustrated

**26. TETRASCROLL: COLOPHON PAGE,
1975-77**
Lithograph
Not illustrated

Fritz Glarner

1. DRAWING FOR TONDO 1958, 1958
Lithograph from one stone
Paper: cream wove
Watermark: RIVES
Sheet: 490×460 mm (19¹⁵/₁₆×18⁷/₁₆ in.)
Signed, dated; lower right: Fritz Glarner 1958
Numbered; lower left: x/7
Edition: 7
 Plus: 1 artist's proof (1 AIC)
Printers: Robert Blackburn and Ben Berns
Glarner had obviated the problem of placing a
circle within a rectangle in his paintings by
using circular stretchers. In lithography, he tried
using a circular acetate mask, larger than the
horizontal dimension of the sheet, to create a
subtle halo to "frame" the circle. The mask also
created a crescent-shaped line incised into the
paper above and below the tondo. Glarner did
not repeat this procedure.

2. DRAWING FOR RELATIONAL PAINTING
1958, 1958
Lithograph from one stone
Paper: ivory wove
Watermark: RIVES
Sheet: 365×555 mm (14¼×22¾ in.)
Signed, dated; lower right: Fritz Glarner 1958
Numbered; lower left: x/12
Edition: 12 (1 AIC)
 Plus: 1 artist's proof
 trial proof (2 AIC)
Printer: Robert Blackburn
Although this print and Glarner's
contemporaneous mural for the Time-Life
Building in New York have frequently been seen
as alike in style, the differences are considerable.
The mural is huge, the lithograph small; the
painting is bright, the print a Whistlerian range
of grays. The only valid similarity is the
horizontal format.

3. DRAWING FOR TONDO NO. 1, 1959
Lithograph from one stone
Paper: cream wove
Watermark: ARCHES
Sheet: 760×565 mm (29¹⁵/₁₆×22¼ in.)
Signed, dated; lower right: Fritz Glarner 1959
Numbered; lower left: x/16
Edition: 16 (1 AIC)
Printer: Robert Blackburn

4. DRAWING FOR TONDO NO. 2, 1959
Lithograph from one stone
Paper: gray wove
Watermark: FABRIANO (ITALY)
Sheet: 512×478 mm (20³/₁₆×18¹³/₁₆ in.)
Signed, dated; lower right: Fritz Glarner 1959
Numbered; lower left: x/14
Edition: 14
 Plus: 2 artist's proofs (1 AIC)
Printers: Robert Blackburn and Ben Berns

5. DRAWING FOR TONDO NO. 3, 1959
Lithograph from one stone
Paper: ivory laid Kochi
Sheet: 520×512 mm (20½×20¼ in.)
Signed, dated; lower right: Fritz Glarner 1959
Numbered; lower left: x/20
Edition: 20 (1 AIC)
Printers: Robert Blackburn and Ben Berns

6. DRAWING FOR TONDO NO. 4, 1959
Lithograph from one stone
Paper: ivory wove
Watermark: RIVES
Sheet: 509×662 mm (20¹/₁₆×26¹/₁₆ in.)
Signed, dated; lower right: Fritz Glarner 1959
Numbered; lower left: x/22
Edition: 22 (1 AIC)
Printers: Robert Blackburn and Ben Berns

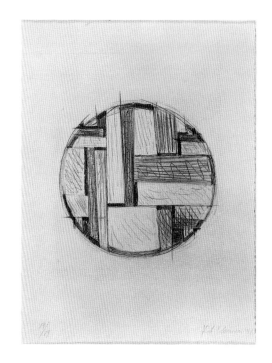

7. DRAWING FOR TONDO NO. 5, 1959
Lithograph from one stone
Paper: cream wove
Watermark: RIVES
Sheet: 658×502 mm (25⅞×19¾ in.)
Signed, dated; lower right: Fritz Glarner 1959
Numbered; lower left: x/24
Edition: 24 (1 AIC)
Printers: Robert Blackburn and Ben Berns

8. DRAWING FOR TONDO NO. 6, 1959
Lithograph from one stone
Paper: ivory laid Kochi handmade
Sheet: 673×520 mm (26½×20½ in.)
Signed, dated; lower right: Fritz Glarner 1959
Numbered; lower left: x/19
Edition: 19 (1 AIC)
 Plus: 2 artist's proofs
Printers: Robert Blackburn and Ben Berns

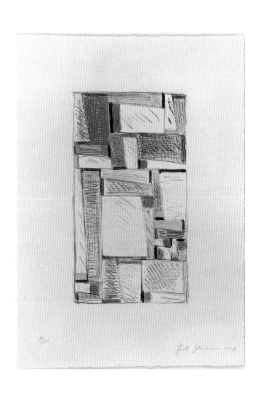

9. COLOR DRAWING FOR RELATIONAL PAINTING, 1963
Lithograph from six stones
Paper: white wove
Watermark: Crisbrook emblem
Sheet: 805×585 mm (31¾×23 in.)
Signed, dated; lower right: Fritz Glarner 1963
Numbered; lower left: x/35
Edition: 35 (1 AIC)
 Plus: 2 artist's proofs
 trial proofs (7 AIC)
Printer: Zigmunds Priede
See plate 49

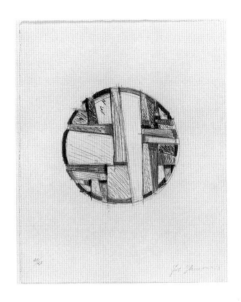

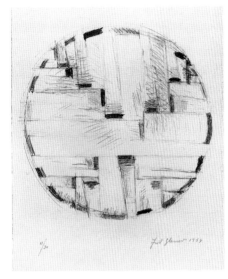

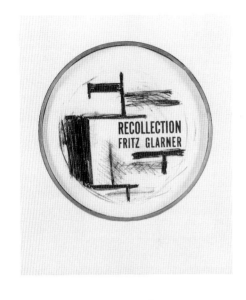

10. COLORED DRAWING, 1963
Lithograph from six stones
Paper: white wove Chatham British handmade
Sheet: 629×507 mm (24¾×20 in.)
Signed, dated; lower right: Fritz Glarner 1963
Numbered; lower left: x/23
Edition: 23 (1 AIC)
 Plus: 2 artist's proofs
 trial proofs (6 AIC)
 1 proof H.C. (black stone only)
Printer: Zigmunds Priede
See plate 50

11. COLOR DRAWING FOR TONDO, 1964
Lithograph from five stones
Paper: light gray laid Angoumois (made for the edition)
Watermark: ANGOUMOIS A LA MAIN; Fritz Glarner (signature)
Sheet: 660×512 mm (26×20³/₁₆ in.)
Signed, dated; lower right: Fritz Glarner 1964
Numbered; lower left: x/30
Edition: 30 (1 AIC)
 Plus: 2 artist's proofs
 trial proofs (7 AIC)
Printer: Zigmunds Priede
Here, for the first time, Glarner used heavy sheets of fine Angoumois paper watermarked with his signature, an indication of Mrs. Grosman's confidence in the artist's commitment to lithography as a continuing part of his life's work.

12-28. RECOLLECTION, 1964-68
Portfolio containing fourteen lithographs from sixty stones, a title page, a preface page, and a colophon page, contained in a lacquered wooden box with a hand-blown glass disk by Frank Gray set into the cover; text written by the artist, typeset if previously published, and handwritten if unpublished, printed from stone
Paper: ivory laid
Watermark: Fritz Glarner (signature);
ANGOUMOIS A LA MAIN
Sheet: folded, approx. 366×290 mm
 (14¾×11⁷/₁₆ in.)
 unfolded, approx. 366×580 mm
 (14¾×22⅞ in.)
Signed, dated; lower right: Fritz Glarner 1964-68
Numbered; lower left: x/14
Edition: 30
 Plus: 6 sets artist's proofs (1 set AIC)
 2 sets printer's proofs
 trial proofs (162 AIC)
 working proofs (48 AIC)
Printers: Ben Berns and Donn Steward;
typography by Herbert Matter
The design of *Recollection*'s pale gray lacquer box, with a glass "porthole," recalls the medieval glass windows Glarner had painted as a boy. It took two years to finalize a case for the portfolio, and even then Mrs. Grosman had to accept a glass that was slightly irregular.

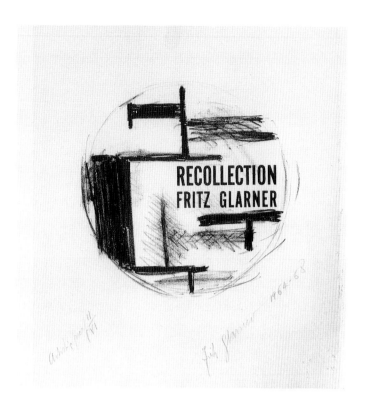

12. RECOLLECTION: TITLE PAGE, 1964-68
Letterpress on lithograph from an unknown
number of stones

**13. RECOLLECTION: PREFACE PAGE,
1964-68**
Letterpress
The text was originally published by Glarner as
"What Abstract Art Means to Me," *Museum of
Modern Art Bulletin* (New York) 18, 3 (Spring
1951).

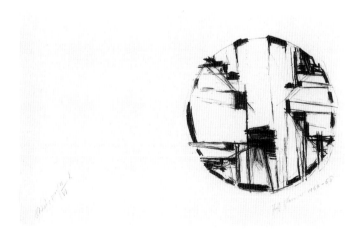

14. RECOLLECTION, PAGE 1, 1964-68
Lithograph from an unknown number of stones

**15. RECOLLECTION, PAGE 2: "POINT
CENTER 1941," 1964-68**
Lithograph from an unknown number of stones
This seminal page illustrates visually and
verbally the "point-center" idea Glarner
formulated in the early 1940s. Both the stones
and the text appear in many subsequent pages.

16. RECOLLECTION, PAGE 3: "THE SLANT OR OBLIQUE CREATED...," 1964-68
Lithograph from an unknown number of stones
Here, Glarner demonstrated his "slant" principle in four different blacks that vary from a cold graphite to velvety grease crayon to wet brownish-black.

17. RECOLLECTION, PAGE 4, 1964-68
Lithograph from an unknown number of stones

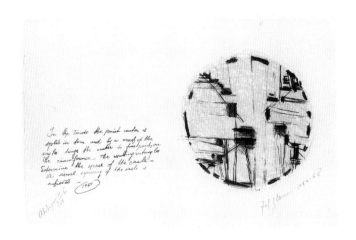

18. RECOLLECTION, PAGE 5, 1964-68
Lithograph from an unknown number of stones
This image underwent a long series of trial proofs during which Glarner made subtle adjustments to balance the space and open black stone against the dense, rough texture of the ocher.

19. RECOLLECTION, PAGE 6: "IN THE TONDO...," 1964-68
Lithograph from an unknown number of stones
The "point-center" in this text refers to the center of the circle. Glarner's "march of angles" creates the push-pull of balance against imbalance, stasis against motion.

20. RECOLLECTION, PAGE 7, 1964-68
Lithograph from an unknown number of stones

21. RECOLLECTION, PAGE 8:
"A RE-FORMING UNITY…," 1964-68
Letterpress and lithograph from an unknown
number of stones
This text was taken from an exhibition (with
Georges Vantongerloo) at the Rose Fried
Gallery, New York, in 1954.

22. RECOLLECTION, PAGE 9: "LES POINTS
CENTREAUX 1941-44," 1964-68
Lithograph from an unknown number of stones

23. RECOLLECTION, PAGE 10: "FROM
UCCELLO ON…," 1964-68
Letterpress and lithograph from an unknown
number of stones
Glarner finally chose a text made for an
exhibition, "Painting Prophecy 1950," at the
David Porter Gallery, Washington, D.C., in 1945.
This page is the first instance of primary colors
in *Recollection*.

24. RECOLLECTION, PAGE 11: "NEW YORK NEW YORK 1945-49," 1964-68
Lithograph from an unknown number of stones
The words "New York, New York," written in
the hospital in the wavering handwriting of a
man struggling against age and pain, is as close
to autobiography as Glarner ever permitted.
See plate 53

25. RECOLLECTION, PAGE 12, 1964-68
Lithograph from an unknown number of stones

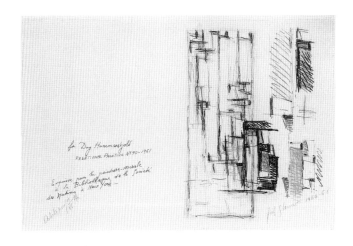

26. RECOLLECTION, PAGE 13: "TIME-LIFE MURAL," 1964-68
Lithograph from an unknown number of stones
A commemoration rather than a reproduction of
Glarner's most successful mural, this double-
fold page diverges in both composition and
color distribution from the painting.

27. RECOLLECTION, PAGE 14: "FOR DAG HAMMARSKJOLD," 1964-68
Lithograph from an unknown number of stones
Just as in the *Time-Life Mural* (cat. no. 26), this
print does not faithfully reproduce Glarner's
United Nations mural. With his mental
condition deteriorating, Glarner inscribed the
print inaccurately, lapsing into French and
referring to the institution as the League of
Nations.

**28. RECOLLECTION: COLOPHON PAGE,
1964-68**
Letterpress

Robert Goodnough

1. THE SPEAKER, 1961
Lithograph from two stones
Paper: white wove
Watermark: JAPAN
Sheet: 447×541 mm (17⅝×22½ in.)
Signed, dated; lower right: Goodnough '61
Numbered; lower left: x/23
Edition: 23
Printer: Robert Blackburn

2. THE CHIEF I, 1961
Lithograph from three stones
Paper: ivory wove
Watermark: ARCHES
Sheet: 768×574 mm (30¼×22⅝ in.)
Signed, dated; lower right: Goodnough '61
Numbered; lower left: x/25 I
Edition: 25
Printer: Robert Blackburn

3. THE CHIEF II, 1961
Lithograph from two stones
Paper: ivory wove
Watermark: ARCHES
Sheet: 764×570 mm (30 1/16 × 22 7/16 in.)
Signed, dated; lower right: Goodnough '61
Numbered; lower left: x/15 II
Edition: 15
Printer: Robert Blackburn

4. THE CHIEF III, 1961
Lithograph from one stone
Paper: ivory wove
Watermark: ARCHES
Sheet: 764×570 mm (30 × 22 3/4 in.)
Signed, dated; lower right: Goodnough '61
Numbered; lower left: x/10 III
Edition: 10
Printer: Robert Blackburn
See plate 57

5. THREE FIGURES, 1961
Lithograph from one stone
Paper: ivory laid handmade
Watermark: AUVERGNE A LA MAIN
Sheet: 503×642 mm (19 13/16 × 25 1/4 in.)
Signed, dated; lower right: Goodnough '61
Numbered; lower left: x/24
Edition: 24
Printer: Robert Blackburn

Maurice Grosman

1-17. FROM JEWISH POEMS, 1959-65
Thirteen lithographs, each from one stone, with
a preface, a title page, a translation page, and a
colophon page; contained in a prayer-shawl
folder within a wooden box; preface written by
Larry Rivers; English translation by Rose
Rosenfeld; box made by Carolyn Horton in 1968
Paper: white wove Shogun handmade
Watermark: JAPAN
Sheet: approx. 445×572 mm (17½×22½ in.)
Edition: 20 (5 signed, 15 unsigned)
 Plus: 2 artist's proofs (1 AIC)
 8 proofs H.C.
Printers: Zigmunds Priede, Maurice Grosman,
Frank Akers, Ben Berns, and Marve Cooper;
typography by Herbert Matter

**1. FROM JEWISH POEMS: PREFACE PAGE,
1959-65**
Letterpress
Dated; lower left in type: Fall, 1965

The lithographs that Maurice Grosman made to be seen while reading these poems by Jewish poets are perfect. It is a combination that is sweet & softening. The imposed limitation of black white & gray & the manner in which it enters in & around the poem matches the simplicity & delicate quality of the few lines he chose which would represent each poet. Poems by Jews arranged & accompanied by the marks of an artist who is Jewish from Europe then looked at by another artist who thinks he is Jewish & feels compelled to write about it is a tricky road which could lead to the wailing wall. However it will be a short road & considering how much tough writing we are subjected to it might relieve me to wail a little. These poems or the few lines that were chosen can hardly be placed in an historical time sequence. "Women sew"; there are some "pale faces" or "fingers" & the "heart flutters" etc. They seemed to have been written by men who sat around the fires of Europe in small houses & lived their lives travelling no more than 10 ft. from it, for all the functions & necessities & things that go into a life. Whatever seems necessary & a procedure for fulfillment in my own life becomes coarse in the presence of these lines & what Maurice Grosman made. In all probability Maurice Grosman left Poland because he was bored hearing every winter about "roite backen (red cheeks)" & winter & summer "bitarah (rehrhen (bitter tears)" & all the other cliches mostly lingual & culinary that we have come to associate with small town Jewish life. But 25 years later, in 1940, after having studied art in Berlin & having worked as a painter in Paris & thinking about everything a full time artist thinks about, he becomes a Jewish fox in a dog hunt which brings him back to what he was never interested in and had nearly forgotten. It was that he was born a Jew & for that accident of fate might die in some disgusting circumstance before he or nature decides. From my point of view that fact, that absurdity of birth transformed by the necessity to make something in relation to the poems by Jewish poets is the extra marvelous something that emerges from these pages.

Fall, 1965 Larry Rivers

**2. FROM JEWISH POEMS: TITLE PAGE,
1959-65**
Letterpress

FROM JEWISH POEMS

MAURICE GROSMAN

[AC]

3. FROM JEWISH POEMS: PAGE I, 1959-65
Translation: Dedicated to my parents, my
 brothers, and my sister, who
 perished during the years 1939-
 1945.
Numbered, signed, dated; lower left to lower
center: x/20 I Maurice Grosman 1959-1965

4. FROM JEWISH POEMS: PAGE II, 1959-65
Translation: The eyes red, the lips blue,
 No drop of blood in the cheek
 shows through.
 On the pale faces the sweat-beads
 lie,
 The breath is hot, the tongue is dry.
Poet: I. L. Peretz
Signed, dated; lower right: Maurice Grosman
1959-1965
Numbered; lower left: x/20 II

5. FROM JEWISH POEMS: PAGE III, 1959-65
Translation: My hands are swollen.
 My brow darkly beaded with sweat.
 Could not rest reward me
 With a four-foot descent into her
 lap?
Poet: M. Leib
Signed, dated; lower right: Maurice Grosman
1959-1965
Numbered; lower left: x/20 III

6. FROM JEWISH POEMS: PAGE IV, 1959-65
Translation: Night intoxicates me with
 forgetfulness
 As a weary bearer carries burdens
 without weight.
Poet: K. Malodovsky
Numbered, signed, dated; lower left vertically:
x/20 IV Maurice Grosman 1959-1965

7. FROM JEWISH POEMS: PAGE V, 1959-65
Translation: He forged the daggers.
 Vengeance, sacred and red, was in
 his steel.
 The hammers pounding in rhythm
 with the soul,
 A struggle to death! A struggle to
 death!
Poet: A. Leisin
Signed, dated; lower right: Maurice Grosman
1959-1965
Numbered, lower left: x/20 V

8. FROM JEWISH POEMS: PAGE VI, 1959-65
Translation: The ships' stacks are no longer
 smoking.
 The siren no longer wails.
 The Sabbath has come to my land.
 Serenely resting like a grandmother
 reading her Holy Book.
Poet: A. Shlansky
Signed, dated; lower right: Maurice Grosman
1959-1965
Numbered; lower left: x/20 VI

9. FROM JEWISH POEMS: PAGE VII, 1959-65
Translation: There is no dying on earth.
 No before and no after.
 No sunrise and no sunset.
 Nothing but circles, rings, wheels.
Poet: M. Ravitch
Signed, dated; lower right: Maurice Grosman
1959-1965
Numbered; lower left: x/20 VII

10. FROM JEWISH POEMS: PAGE VIII, 1959-65
Translation: Lightninglike, your feet carry you
 In the joyful wedding dance.
Poet: P. Markush
Signed, dated; lower right: Maurice Grosman
1959-1965
Numbered; lower left: x/20 VIII

11. FROM JEWISH POEMS: PAGE IX, 1959-65
Translation: They came armed with clubs,
 Forced the worshippers against the
 walls,
 Struck at faces and at prayer
 shawls.
 The slaughter left only the dead for
 the Sabbath.
Poet: B. Weinstein
Signed, dated; lower right: Maurice Grosman
1959-1965
Numbered; lower left: x/20 IX

12. FROM JEWISH POEMS: PAGE X, 1959-65
Translation: *My Song to the Sorrowful Maiden*
　　　　Beneath your eyes, your years are
　　　　weeping.
　　　　Cold glimmerings of the moon are
　　　　in your hair.
　　　　Where are the thieves of your days
　　　　and nights?
Poet: J. Glatstein
Numbered, signed, dated; lower right: x/20 X
Maurice Grosman 1959-1965

13. FROM JEWISH POEMS: PAGE XI, 1959-65
Translation: My flesh afire! My head snowy!
　　　　On my shoulders a sackful of
　　　　lament.
Poet: H. Leivick
Signed, dated; lower right: Maurice Grosman
1959-1965
Numbered; lower left: x/20 XI

14. FROM JEWISH POEMS: PAGE XII, 1959-65
Translation: I felt the Yiddish words
　　　　As pure doves,
　　　　As pure doves,
　　　　Flutter within my heart.
Poet: M. Kulbak
Signed, dated; lower right: Maurice Grosman
1959-1965
Numbered; lower left: x/20 XII
See plate 61

**15. FROM JEWISH POEMS: PAGE XIII,
1959-65**
Translation: Intimate with the clouds and the
　　　　rain,
　　　　They are old sworn comrades,
　　　　Following straight and crooked
　　　　roads.
Poet: I. Manger
Signed, dated; lower right: Maurice Grosman
1959-1965
Numbered; lower center: x/20 XIII

TRANSLATIONS

I Dedicated to my parents, my brothers, and my sister, who perished during the years 1939-1945.

II The eyes red, the lips blue, No drop of blood in the cheek shows through. On the pale faces the sweat-beads lie, The breath is hot, the tongue is dry. — I. L. Peretz

III My hands are swollen. My brow darkly beaded with sweat. Could not rest reward me With a four-foot descent into her lap? — M. Leib

IV Night intoxicates me with forgetfulness As a weary bearer carries burdens without weight. — K. Malodovsky

V He forged the daggers. Vengeance, sacred and red, was in his steel. The hammers pounding in rhythm with the soul. A struggle to death! A struggle to death! — A. Leisin

VI The ships' stacks are no longer smoking. The siren no longer wails. The Sabbath has come to my land, Serenely resting like a grandmother reading her Holy Book. — A. Shlansky

VII There is no dying on earth. No before and no after. No sunrise and no sunset. Nothing but circles, rings, wheels. — M. Ravitch

VIII Lightning-like, your feet carry you In the joyful wedding dance. — P. Markush

IX They came armed with clubs. Forced the worshippers against the walls. Struck at faces and at prayer shawls. The slaughter left only the dead for the Sabbath. — B. Weinstein

X My Song to the Sorrowful Maiden Beneath your eyes, your years are weeping. Cold glimmerings of the moon are in your hair. Where are the thieves of your days and nights? — J. Glatstein

XI My flesh afire! My head snowy! On my shoulders a sackful of lament. — H. Leivick

XII I felt the Yiddish words As pure doves, As pure doves, Flutter within my heart. — M. Kulbak

XIII Intimate with the clouds and the rain. They are old sworn comrades. Following straight and crooked roads. — I. Manger

Translated by Rose Rosenfeld

16. FROM JEWISH POEMS: TRANSLATION
PAGE, 1959-65
Letterpress

17. FROM JEWISH POEMS: COLOPHON
PAGE, 1959-65
Letterpress

1. THE HERO LEAVES HIS SHIP I (HERO),
1960
Lithograph from one stone
Paper: ivory wove German Copperplate
handmade
Sheet: 755×535 mm (29¾×21⅛ in.)
Signed, dated; lower right: Hartigan '60
Numbered; lower left: x/27
Edition: 27 (1 AIC)
Printer: Robert Blackburn
Hartigan based her *The Hero Leaves His Ship*
quartet (cat. nos. 1-4) on poems written by her
friend Barbara Guest. Many heroes in Greek
and Roman mythology, an important source of
inspiration for the poet at this time, left their
ships. Guest does not identify the hero or the
literary source, choosing to write of what such a
hero might have seen or felt. Similarly, Hartigan
did not depict a person or place but created
abstract equivalents of feelings engendered by
the poetry.
See plate 63

2. THE HERO LEAVES HIS SHIP II (HERO),
1960
Lithograph from one stone
Paper: ivory wove German Copperplate
handmade
Sheet: 756×540 mm (29¾×21¼ in.)
Signed, dated; lower right: Hartigan '60
Numbered; lower left: x/26
Edition: 26 (1 AIC)
Printer: Robert Blackburn

3. THE HERO LEAVES HIS SHIP III (SHIP),
1960
Lithograph from one stone
Paper: ivory wove German Copperplate
handmade
Sheet: 536×755 mm (21⅛×29¾ in.)
Signed, dated; lower right: Hartigan '60
Numbered; lower left: x/26
Edition: 26 (1 AIC)
Printer: Robert Blackburn

4. THE HERO LEAVES HIS SHIP IV (SHIP),
1960
Lithograph from one stone
Paper: ivory wove German Copperplate
handmade
Sheet: 536×755 mm (21⅛×29¾ in.)
Signed, dated; lower right: Hartigan '60
Numbered; lower left: x/28
Edition: 28 (1 AIC)
Printer: Robert Blackburn
See plate 62

5. PALLAS ATHENE, 1961
Lithograph from six stones
Paper: white wove satiné
Watermark: ARCHES FRANCE Veritable Papier
Arches Satiné
Sheet: 764×567 mm (30¹/₁₆×22⁵/₁₆ in.)
Signed, dated; lower right: Hartigan '61
Numbered; lower left: x/30
Edition: 30
 Plus: 1 artist's proof in color (1 AIC)
 10 proofs of black stone only
Printer: Robert Blackburn
One stone preserved and used to print *Pallas
Athene: Black Stone* (cat. no. 5A)
See plate 64

5A. PALLAS ATHENE: BLACK STONE, 1961
Lithograph from one stone (previously used for
Pallas Athene [cat. no. 5])
Paper: white wove
Watermark: ARCHES FRANCE
Sheet: 763×568 mm (30×22⅜ in.)
Signed, dated; lower right: Hartigan '61
Numbered; lower left: x/10
Edition: 10 trial proofs
Printer: Robert Blackburn
Not illustrated

6. INSIDE OUTSIDE, 1962
Lithograph from one stone
Paper: white wove
Watermark: J. Green/HANDMADE
Sheet: 631×506 mm (24⅞×19¹⁵/₁₆ in.)
Signed, dated; lower right: Hartigan '62
Numbered; lower left: x/15
Edition: 15
 Plus: 1 artist's proof (1 AIC)
Printer: Robert Blackburn

7. THE ARCHAICS: ATALANTA IN
ARCADIA, 1962-66
Lithograph from one stone
Paper: white wove Italia handmade
Watermark: Magnani emblem
Sheet: 700×505 mm (27½×19⅞ in.)
Numbered, signed, dated; lower right: x/20 /
Hartigan 1962-'66
Inscribed; lower left: "Atalanta in Arcadia"
Edition: 20
 Plus: 1 artist's proof (1 AIC)
Printer: Frank B. Burnham

8. THE ARCHAICS: DIDO TO AENEAS,
1962-66
Lithograph from one stone
Paper: white wove Italia handmade
Watermark: Magnani emblem
Sheet: 505×700 mm (19⅞×27½ in.)
Inscribed, numbered, signed, dated; from lower
left to lower right: "Dido to Aeneas" x/18
Hartigan 1962-'66
Edition: 18
 Plus: 1 artist's proof (1 AIC)
 1 printer's proof
Printers: Donn Steward and Frank B. Burnham

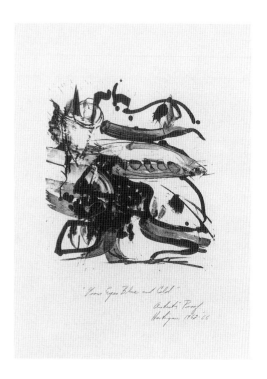

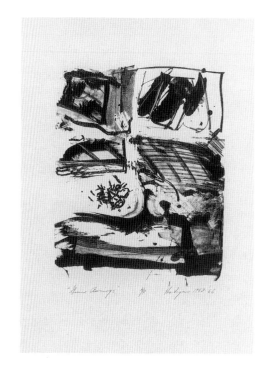

9. THE ARCHAICS: FROM EYES BLUE AND
COLD, 1962-66
Lithograph from one stone
Paper: white wove Italia handmade
Watermark: Magnani emblem
Sheet: 700×505 mm (27½×19⅞ in.)
Inscribed, numbered, signed, dated; lower
center to lower right: "From Eyes Blue and
Cold" x/20 / Hartigan 1962-'66
Edition: 20
 Plus: 1 artist's proof (1 AIC)
Printer: Frank B. Burnham

10. THE ARCHAICS: GREEN AWNINGS,
1962-66
Lithograph from one stone
Paper: white wove Italia handmade
Watermark: Magnani emblem
Sheet: 700×505 mm (27½×19⅞ in.)
Inscribed, numbered, signed, dated; lower left to
lower right: "Green Awnings" x/18 Hartigan
1962-'66
Edition: 18
 Plus: 1 artist's proof (1 AIC)
Printers: Donn Steward and Frank B. Burnham

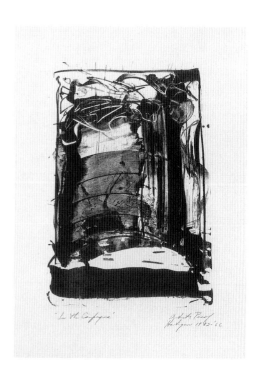

11. THE ARCHAICS: IN THE CAMPAGNA,
1962-66
Lithograph from one stone
Paper: white wove Italia handmade
Watermark: Magnani emblem
Sheet: 700×504 mm (27½×19¹⁵/₁₆ in.)
Numbered, signed, dated; lower right: x/20 /
Hartigan 1962-'66
Inscribed; lower left: "In the Campagna"
Edition: 20
 Plus: 1 artist's proof (1 AIC)
Printer: Frank B. Burnham

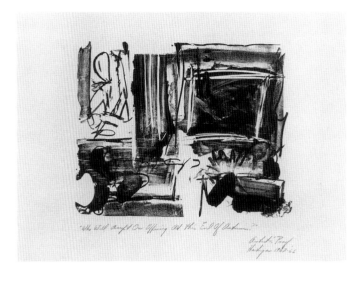

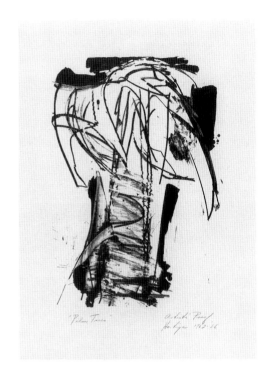

12. THE ARCHAICS: PALM TREES, 1962-66
Lithograph from one stone
Paper: white wove Italia handmade
Watermark: Magnani emblem
Sheet: 700×504 mm (27½×19¹⁵⁄₁₆ in.)
Numbered, signed, dated; lower right: x/23 /
Hartigan 1962-'66
Inscribed; lower left: ''Palm Trees''
Edition: 23
 Plus: 1 artist's proof (1 AIC)
Printer: Frank B. Burnham

13. THE ARCHAICS: WHO WILL ACCEPT
OUR OFFERING AT THIS END OF
AUTUMN?, 1962-66
Lithograph from one stone
Paper: white wove Italia handmade
Watermark: Magnani emblem
Sheet: 510×690 mm (20×27 in.)
Inscribed; lower left: ''Who Will Accept Our
Offering At This End Of Autumn?''
Numbered, signed, dated; lower right: x/19
Hartigan 1962-'66
Edition: 19
 Plus: 1 artist's proof (1 AIC)
 1 printer's proof
Printers: Donn Steward and Frank B. Burnham

Jasper Johns

1. TARGET, 1960
Lithograph from one stone
Paper: ivory wove
Watermark: JAPAN
Sheet: 575 × 447 mm (22⅝ × 17⅝ in.)
Signed, dated; lower right: J. Johns '60
Numbered; lower left: x/30
Edition: 30
 Plus: 3 artist's proofs (1 AIC)
 trial proofs (3 AIC)
Printer: Robert Blackburn
Catalogue reference: Field 1
Johns's debut exhibition (Leo Castelli Gallery, 1958) included *Target with Plaster Casts* (1955; Mr. and Mrs. Leo Castelli, New York), a painting surmounted by nine compartments, each containing a plaster body part. The many target paintings and drawings that followed included *Broken Target*, 1958 (repro. Kozloff, 1967, pl. 109), which served as a prototype for this, Johns's first lithograph. Johns also painted a second target in tusche but finally decided to print the first stone alone.

2. COAT HANGER I, 1960
Lithograph from one stone
Paper: white wove German Copperplate
Sheet: 914 × 686 mm (36 × 27 in.)
Signed, dated; lower right: J. Johns '60
Numbered; lower left: x/35
Edition: 35
 Plus: 2 artist's proofs (1 AIC)
 trial proofs (2 AIC for *Coat Hanger I* and *II*)
Printer: Robert Blackburn
Catalogue reference: Field 2
Stone preserved and used for *Coat Hanger II* (cat. no. 3)

3. COAT HANGER II, 1960
Lithograph from one stone (previously used for *Coat Hanger I* [cat. no. 2])
Paper: cream wove Japan
Sheet: 900 × 630 mm (35½ × 24¾ in.)
Signed, dated; lower right: J. Johns '60
Numbered; lower left: x/8
Edition: 8
 Plus: artist's proofs (1 AIC)
 trial proofs (2 AIC for *Coat Hanger I* and *II*)
Printer: Robert Blackburn
Catalogue reference: Field 3
Johns's first statement of this theme was an encaustic painting of 1959 (Dr. and Mrs. André Esselier, Zurich), on which Johns had affixed a peg and hung a wire hanger. After the edition of *Coat Hanger I* (cat. no. 2) was finished, Johns reworked the stone for this print. This approach established a pattern for subsequent pairs, in which the second version both negates and preserves the first.

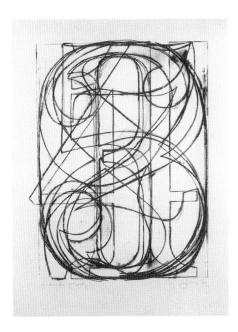

4. 0 THROUGH 9, 1960
Lithograph from one stone
Paper: cream wove
Watermark: ARCHES
Sheet: 759×572 mm (29⅞×22½ in.)
Signed, dated; lower right: J. Johns '60
Numbered; lower left: x/35
Edition: 35
 Plus: artist's proofs (1 AIC)
Printer: Robert Blackburn
Catalogue reference: Field 4
0 Through 9 is closely derived from a drawing
of 1960 (Collection of the artist) stating one of
Johns's preoccupations: images in which the
idea is identical to its form. In the early 1960s,
he created a brilliant series of improvisations on
the theme of numbers seen through one
another, ranging from this austere print to
pointillist canvases of startling color.

5. FLAG I, 1960
Lithograph from one stone
Paper: ivory wove
Watermark: ARCHES
Sheet: 565×762 mm (22¼×30 in.)
Signed, dated; lower right: J. Johns '60
Numbered; lower left: x/23
Edition: 23
 Plus: 3 artist's proofs (1 AIC)
 trial proofs (1 AIC)
Printer: Robert Blackburn
Stone preserved and used for *Flag II* and *III*
(cat. nos. 6, 7)
Catalogue reference: Field 5
When his *Flag* paintings were first shown,
Johns was criticized for offending patriotic
sentiment. But Johns insisted that he chose the
image because it had become impersonal—
recognized but no longer seen. The early *Flags*
were distinctly drawn and boldly colored. Many
subsequent variations led to this trio done in a
minor key. The flag itself is muffled in the first
version (cat. no. 5), all but disappears in the
second (cat. no. 6), and reappears in the last (cat.
no. 7), physically drawn out of the stone with a
scraper.

6. FLAG II, 1960
Lithograph from one stone (previously used for
Flag I [cat. no. 5])
Paper: tan Kraft wrapping
Sheet: 600×815 mm (23½×32 in.)
Signed, dated; lower right: J. Johns '60
Numbered; lower left: x/7
Edition: 7
 Plus: 2 artist's proofs (1 AIC)
 trial proofs (1 AIC)
Printer: Robert Blackburn
Stone preserved and used for *Flag III*
(cat. no. 7).
Catalogue reference: Field 6

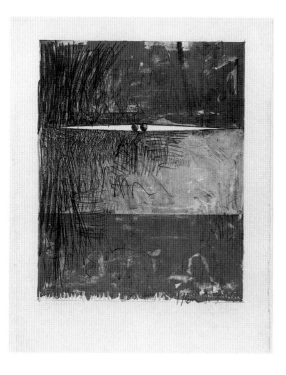

7. FLAG III, 1960
Lithograph from one stone (previously used for
Flag I and *II* [cat. nos. 5, 6])
Paper: cream wove
Watermark: ARCHES
Sheet: 570×765 mm (22⁷/₁₆×30⅛ in.)
Signed, dated; lower right: J. Johns '60
Numbered, inscribed; lower left: x/10 III
Edition: 10 (1 AIC)
 Plus: 2 artist's proofs
 trial proofs (1 AIC)
Printer: Robert Blackburn
Catalogue reference: Field 7

8. PAINTING WITH TWO BALLS I, 1962
Lithograph from three stones
Paper: white wove Kochi handmade
Sheet: 675×518 mm (26⁹/₁₆×20⅜ in.)
Signed; lower right in red pencil: J. Johns / '62
Numbered; lower left: x/37 I
Edition: 37
 Plus: 1 artist's proof (1 AIC)
 trial proofs (3 AIC)
 1 working proof (1 AIC)
 5 proofs of elements
Printer: Robert Blackburn
Stones preserved and used for *Painting with
Two Balls II* (cat. no. 9)
Catalogue reference: Field 8
See plate 66

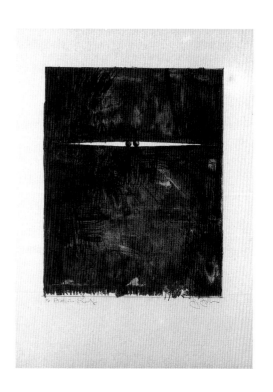

9. PAINTING WITH TWO BALLS II, 1962
Lithograph from two stones (previously used for
Painting with Two Balls I [cat. no. 8])
Paper: unbleached tan wove
Watermark: DIXON & DAVID CO. DRAWING
Sheet: 777×573 mm (30⁹/₁₆×22⁹/₁₆ in.)
Signed, dated; lower right: J. Johns '62
Numbered; lower left: x/13
Edition: 13
 Plus: 5 artist's proofs (1 AIC)
 trial proofs (1 AIC)
 2 proofs of elements
Printer: Robert Blackburn
Catalogue reference: Field 9
Painting with Two Balls I and *II* (cat. nos. 8, 9)
constitute the first of many pairs of lithographs
in which a chromatic version is followed by one
in Johns's favorite color, gray.

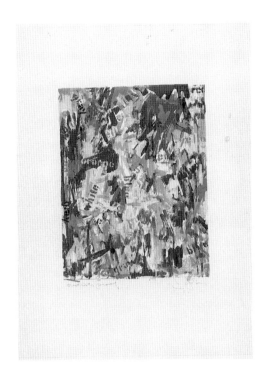

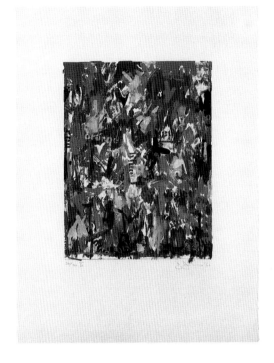

10. FALSE START I, 1962
Lithograph from eleven stones
Paper: ivory wove
Watermark: BFK RIVES
Sheet: 767×565 mm (30³/₁₆×22¼ in.)
Signed, dated; lower right: J. Johns/'62
Numbered; lower left: x/38
Edition: 38
 Plus: 6 artist's proofs (1 AIC)
 3 working proofs (2 AIC)
 proofs of elements (11 AIC)
Printer: Robert Blackburn
Stones preserved and used for *False Start II*
(cat. no. 11)
Catalogue reference: Field 10
See plate 67

11. FALSE START II, 1962
Lithograph from eleven stones (previously used
for *False Start I* [cat. no. 10])
Paper: white wove
Watermark: A. MILBOURN & CO. BRITISH HANDMADE
Sheet: 778×556 mm (30⅝×21⅞ in.)
Signed, dated; lower right in blue pencil:
J. Johns '62
Numbered; lower left: x/30
Edition: 30 (1 AIC)
 Plus: 6 artist's proofs
Printer: Robert Blackburn
Catalogue reference: Field 11

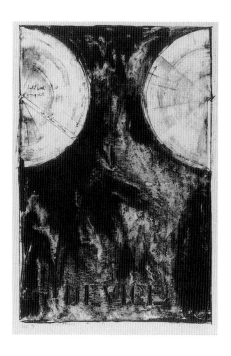

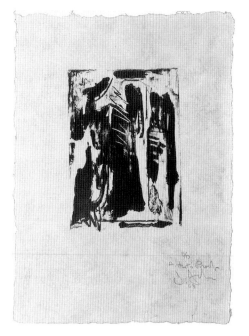

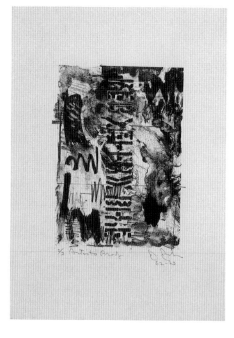

12. DEVICE, 1962
Lithograph from one stone
Paper: white wove British handmade
Watermark: Crisbrook emblem
Sheet: 800×575 mm (31½×22⅝ in.)
Signed, dated; lower right in brown pencil:
J. Johns/62
Numbered; lower left: x/6
Edition: 6
 Plus: 1 artist's proof
 8 proofs H. C. (1 AIC)
Printer: Robert Blackburn
Catalogue reference: Field 12
Since the mid-1950s, Johns had used art
materials as pure subject matter and
occasionally incorporated them physically into
paintings or constructions. The ruler, as an
artist's device or tool, dates back to *Device
Circle* (1959; Mr. and Mrs. Burton Tremaine,
New York).

13. FIGURE I, 1963
Lithograph from one stone
Paper: ivory-white Jeff Goodman linen
handmade
Watermark: JG JJ
Sheet: 438×321 mm (17¼×12⅝ in.)
Numbered, signed, dated; lower right: x/8 /
J. Johns / '63
Edition: 8
 Plus: 4 artist's proofs (A/D-D/D) (1 AIC)
Printer: Zigmunds Priede
Catalogue reference: Field 13
While working on the monumental *0-9* project
(cat. nos. 17-55), Johns made another *Figure 1*
stone and printed it in graphite ink, which he
described as having the "memory" of drawing.
The edition, small even by ULAE standards, was
limited by Johns's choice of paper, a small
number of feltlike sheets that had been
proposed for the portfolios.

14. RED, YELLOW, BLUE, 1962-63
Lithograph from two stones
Paper: ivory wove handmade
Watermark: ANGOUMOIS A LA MAIN
Sheet: 459×324 mm (18¹/₁₆×12¾ in.)
Signed, dated; lower right: J. Johns / '62-'63
Numbered; lower left: x/25
Edition: 25
 Plus: 3 artist's proofs (1 AIC)
 1 working proof
 4 proofs of elements (2 AIC)
Printer: Zigmunds Priede
Catalogue reference: Field 14
This print and *Device* (cat. no. 12) both have
background stones printed in black in textures
that are specifically lithographic rather than
translations of a surface of encaustic or oil or
water-soluble paint. In addition, these two prints
were made within a year of their larger
prototypes, shortening the customary pause
between painting and print.

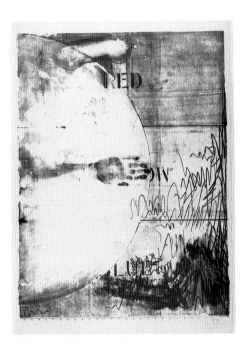

15. HATTERAS, 1963
Lithograph from one stone
Paper: white wove
Watermark: BFK RIVES
Sheet: 1051×749 mm (41⅜×29½ in.)
Numbered, signed, dated; lower right: x/30
J. Johns / '63
Edition: 30 (1 AIC)
 Plus: 5 artist's proofs
 trial proofs (2 AIC)
 10 proofs H. C.
Printer: Zigmunds Priede
Catalogue reference: Field 15
See plate 69

16. HAND, 1963
Lithograph from one stone
Paper: white wove Shogun
Watermark: JAPAN
Sheet: 571×445 mm (22½×17½ in.)
Signed, dated; upper right: J. Johns/'63
Numbered; upper left: x/29
Edition: 29
 Plus: 4 artist's proofs (1 AIC)
Printer: Zigmunds Priede
Catalogue reference: Field 16
This is the simplest of several body prints made
in 1963. It depicts the essential elements of the
art of lithography: the artist's hand, a tool to
move the ink across the surface, and the
chemical antipathy of oil and water. The reversal
of the hands and words is another elementary
fact of the printing process.

17-29. 0-9: EDITION A/C, 1960-63
Portfolio of ten lithographs from one stone,
printed in black, with a title page, a preface
page by Robert Rosenblum, and a colophon
page; a second set of overprinting stones was
made
Paper: cream laid handmade
Watermark: J. Johns (signature); ANGOUMOIS
A LA MAIN
Sheet: 521×394 mm (20½×15½ in.)
Signed, dated; lower right: J. Johns / '60 (0)
 J. Johns / '63 (1-9)
Numbered; lower left: A/C / x/10
Balsa wood box (580×449 mm [22¹³/₁₆×17¹¹/₁₆
in.]) containing the portfolio is incised lower left
edge: A/C x/10
Edition: 10 (each portfolio contains one numeral
 printed with an extra stone in gray; that
 numeral corresponds to the edition
 number of the portfolio)
 Plus: 3 sets of artist's proofs with no extra
 stones in gray (l set AIC)
 9 trial proofs
 4 trial proofs marked "H.C."
 2 sets of trial proofs for overprinting
 stones (1 AIC)
 1 set proofs H. C. in which each
 numeral is printed with the extra
 stone
Printer: Zigmunds Priede
Catalogue reference: Field 17-26

17. 0-9: EDITION A/C, TITLE PAGE, 1960-63
Letterpress

18. 0-9: EDITION A/C, PREFACE PAGE,
1960-63
Letterpress

19. 0-9: EDITION A/C, PAGE 0, 1960-63
Lithograph from one stone

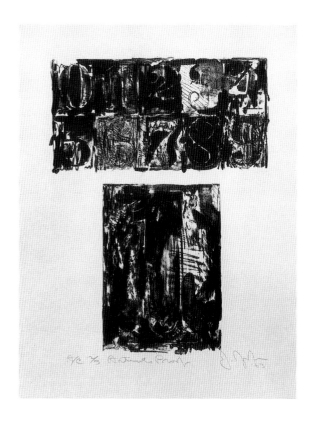

20. 0-9: EDITION A/C, PAGE 1, 1960-63
Lithograph from one stone

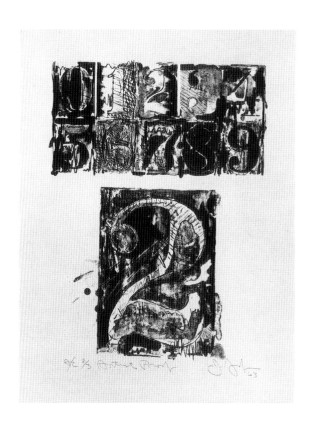

21. 0-9: EDITION A/C, PAGE 2, 1960-63
Lithograph from one stone

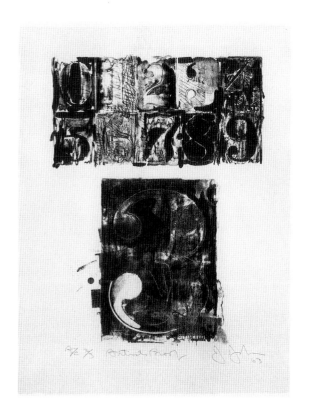

22. 0-9: EDITION A/C, PAGE 3, 1960-63
Lithograph from one stone

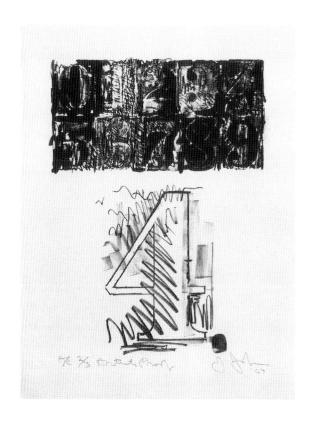

23. 0-9: EDITION A/C, PAGE 4, 1960-63
Lithograph from one stone

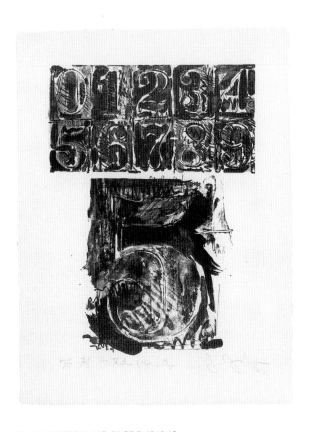

24. 0-9: EDITION A/C, PAGE 5, 1960-63
Lithograph from one stone

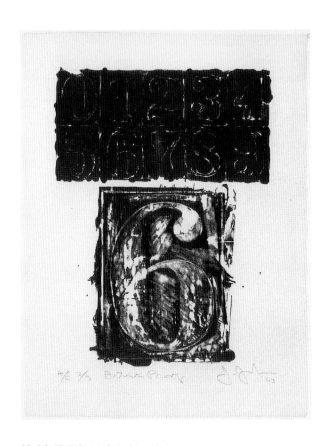

25. 0-9: EDITION A/C, PAGE 6, 1960-63
Lithograph from one stone

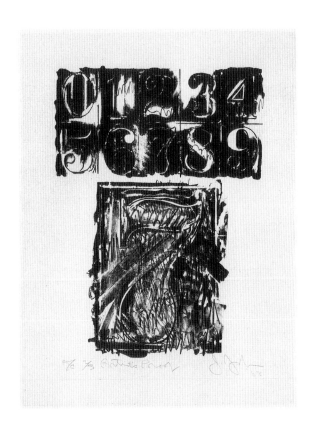

26. 0-9: EDITION A/C, PAGE 7, 1960-63
Lithograph from one stone

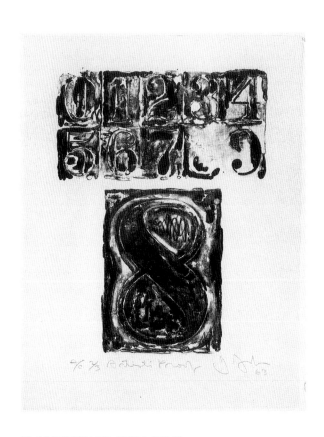

27. 0-9: EDITION A/C, PAGE 8, 1960-63
Lithograph from one stone

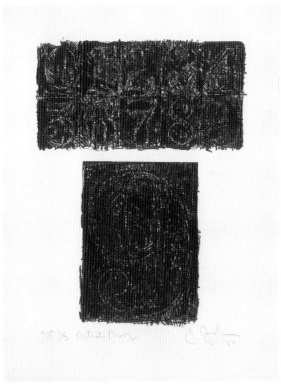

30-42. 0-9: EDITION B/C, 1960-63
Portfolio of ten lithographs, each from one stone, printed in gray, with a title page, a preface page by Robert Rosenblum, and a colophon page
Paper: unbleached gray wove handmade
Watermark: J. Johns (signature); ANGOUMOIS A LA MAIN
Sheet: 521×394 mm (20½×15½ in.)
Signed, dated; lower right: J. Johns '60 (0)
 J. Johns '63 (1-9)
Numbered; lower left: B/C / x/10
Balsa wood box (580×449 mm [22¹³/₁₆×17¹¹/₁₆ in.]) containing the portfolio is incised lower left edge: B/C x/10
Edition: 10 (each portfolio contains one numeral printed with an extra stone in gray; that numeral corresponds to the edition number of the portfolio)
 Plus: 3 sets of artist's proofs with no extra stones in gray (1 set AIC)
 1 set of proofs H. C. in which each numeral is printed with the extra stone
Printer: Zigmunds Priede
Catalogue reference: Field 27-36

28. 0-9: EDITION A/C, PAGE 9, 1960-63
Lithograph from one stone

29. 0-9: EDITION A/C, COLOPHON PAGE, 1960-63
Letterpress

30. 0-9: EDITION B/C, TITLE PAGE, 1960-63
Letterpress

JASPER

0-9

JOHNS

31. 0-9: EDITION B/C, PREFACE PAGE,
1960-63
Letterpress

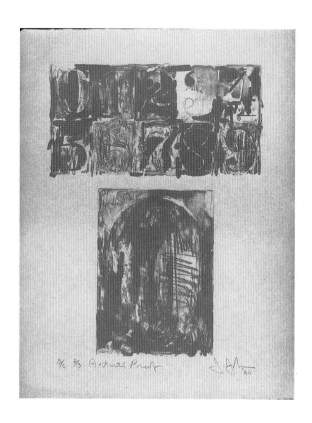

32. 0-9: EDITION B/C, PAGE 0, 1960-63
Lithograph from one stone

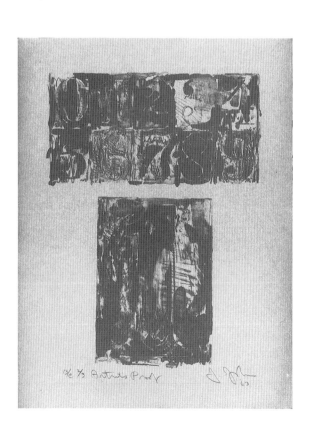

33. 0-9: EDITION B/C, PAGE 1, 1960-63
Lithograph from one stone

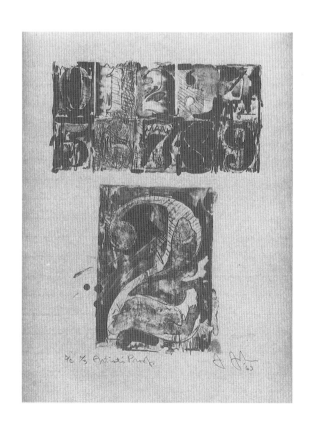

34. 0-9: EDITION B/C, PAGE 2, 1960-63
Lithograph from one stone

35. 0-9: EDITION B/C, PAGE 3, 1960-63
Lithograph from one stone

36. 0-9: EDITION B/C, PAGE 4, 1960-63
Lithograph from one stone

37. 0-9: EDITION B/C, PAGE 5, 1960-63
Lithograph from one stone

38. 0-9: EDITION B/C, PAGE 6, 1960-63
Lithograph from one stone

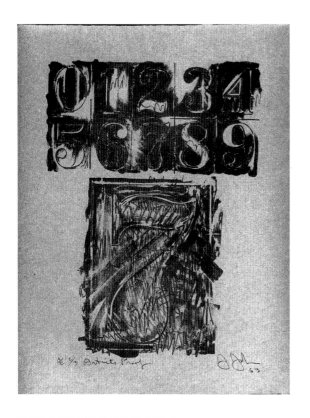

39. 0-9: EDITION B/C, PAGE 7, 1960-63
Lithograph from one stone

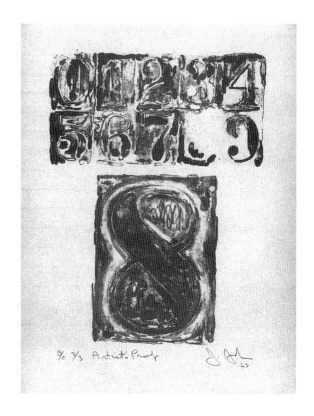

40. 0-9: EDITION B/C, PAGE 8, 1960-63
Lithograph from one stone

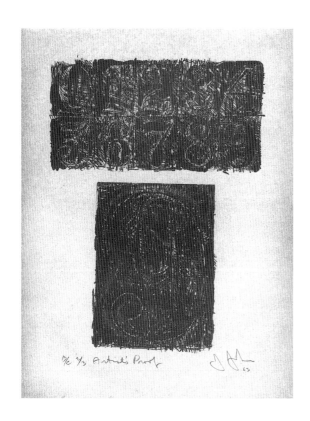

41. 0-9: EDITION B/C, PAGE 9, 1960-63
Lithograph from one stone

42. 0-9: EDITION B/C, COLOPHON PAGE,
1960-63
Letterpress

43-55. 0-9: EDITION C/C, 1960-63
Portfolio of ten lithographs, each from one
stone, printed in colors:
 0=Yellow 3=Purple 6=Brown 9=White
 1=Green 4=Red 7=Black
 2=Blue 5=Orange 8=Gray
Also included is a title page, a preface page by
Robert Rosenblum, and a colophon page
Paper: white laid handmade
Watermark: J. Johns (signature); ANGOUMOIS
A LA MAIN
Sheet: 521×394 mm (20½×15½ in.)
Signed, dated; lower right: J. Johns '60 (0)
 J. Johns '63 (1-9)
Numbered; lower left: C/C / x/10
Balsa wood box (580×449 mm [22¹³/₁₆×17¹¹/₁₆
in.]) containing the portfolio is incised lower left
edge: C/C x/10
Edition: 10 (each portfolio contains one numeral
 printed with an extra stone in a more
 transparent or opaque shade of the
 same color; that numeral corresponds
 to the edition number of the portfolio)
 Plus: 3 sets of artist's proofs with no extra
 stone (1 set AIC)
 1 set of trial proofs marked "H.C.
 1/1" in which each numeral is printed
 with the extra stone
Printer: Zigmunds Priede
Catalogue reference: Field 37-46

43. 0-9: EDITION C/C, TITLE PAGE, 1960-63
Letterpress

44. 0-9: EDITION C/C, PREFACE PAGE,
1960-63
Letterpress

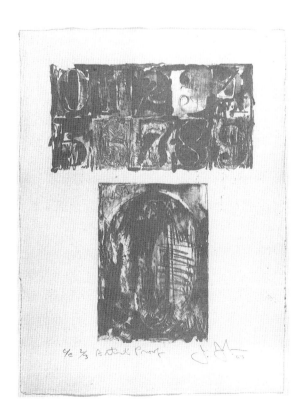

45. 0-9: EDITION C/C, PAGE 0, 1960-63
Lithograph from one stone
See plate 70

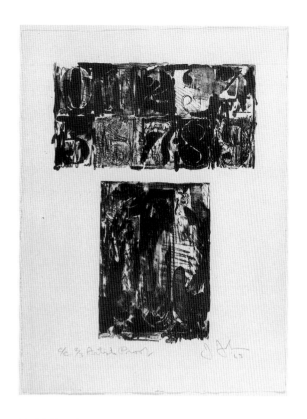

46. 0-9: EDITION C/C, PAGE 1, 1960-63
Lithograph from one stone
See plate 71

47. 0-9: EDITION C/C, PAGE 2, 1960-63
Lithograph from one stone
See plate 73

48. 0-9: EDITION C/C, PAGE 3, 1960-63
Lithograph from one stone
See plate 74

49. 0-9: EDITION C/C, PAGE 4, 1960-63
Lithograph from one stone
See plate 75

50. 0-9: EDITION C/C, PAGE 5, 1960-63
Lithograph from one stone
See plate 76

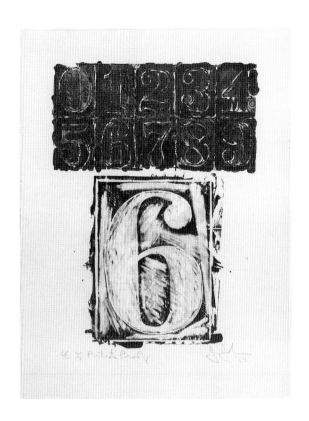

51. 0-9: EDITION C/C, PAGE 6, 1960-63
Lithograph from one stone
See plate 77

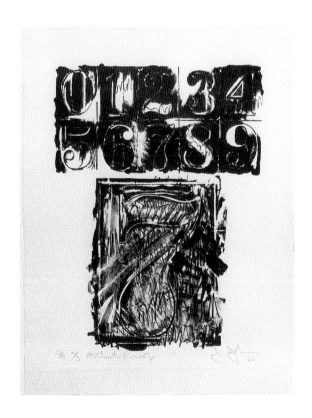

52. 0-9: EDITION C/C, PAGE 7, 1960-63
Lithograph from one stone
See plate 78

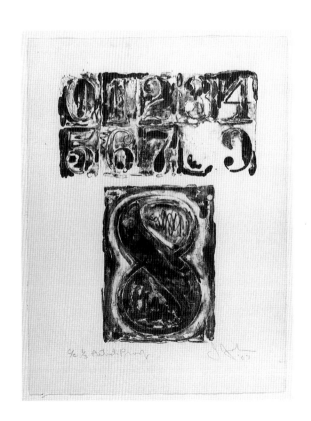

53. 0-9: EDITION C/C, PAGE 8, 1960-63
Lithograph from one stone
See plate 79

54. 0-9: EDITION C/C, PAGE 9, 1960-63
Lithograph from one stone
See plate 80

55. 0-9: EDITION C/C, COLOPHON PAGE, 1960-63
Letterpress

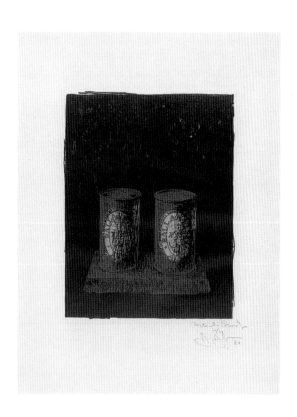

56. ALE CANS, 1964
Lithograph from seven stones
Paper: white wove Shogun
Watermark: JAPAN
Sheet: 581 × 451 mm (22⅞ × 17¾ in.)
Numbered, signed, dated; lower right: x/31 /
J. Johns / '64
Edition: 31
 Plus: 6 artist's proofs (1 AIC)
 3 or more trial proofs (1 AIC)
 7 working proofs (1 AIC)
Printer: Zigmunds Priede
Catalogue reference: Field 47
See plate 81

57. SKIN WITH O'HARA POEM, 1963-65
Lithograph from two stones
Paper: white wove KE Albanene Engineers
Standard Form
Sheet: 559×864 mm (22×34 in.)
Signed, inscribed, dated, numbered; lower right:
J. Johns / Frank O'Hara / SKIN WITH
O'HARA POEM / '63-'65 / x/30
Edition: 30 (1 AIC)
 Plus: 8 artist's proofs
 4 trial proofs
 working proofs (1 AIC)
Printers: Zigmunds Priede and Ben Berns
Catalogue reference: Field 48
Frank O'Hara wrote six poems (later published
in his *Collected Poems*) for a possible
collaborative book with Jasper Johns. Johns
made two body print stones in 1963 for the
project, but *Skin with O'Hara Poem* was the
only collaboration completed; O'Hara was
accidentally killed in 1965.

58. PINION, 1963-66
Lithograph from two stones and one aluminum
plate
Paper: white wove Italia handmade
Watermark: Magnani emblem
Sheet: 1019×713 mm (40⅛×28 1/16 in.)
Signed, dated; upper right: J. Johns / '63-'66
Numbered; lower left: x/36
Edition: 36
 Plus: 6 artist's proofs (1 AIC)
 trial proofs (8 AIC)
 5 working proofs (2 AIC)
 13 proofs of elements
Printers: Zigmunds Priede and Ben Berns;
typography by Herbert Matter
Catalogue reference: Field 49
See plate 82

59. RECENT STILL LIFE, 1965-66 (Poster for
the Rhode Island School of Design)
Lithograph from one stone and one aluminum
plate
Paper: white wove Italia handmade
Watermark: Magnani emblem
Sheet: 888×509 mm (35×20 1/16 in.)
Signed, dated; lower right: J. Johns '65
Numbered; lower left: x/100
Edition: 100 without printed text (1 AIC)
 Plus: 15 artist's proofs without printed text
 on white wove Italia handmade paper
 (1016×711 mm [40×28 in.])
 15 artist's proofs with text on Italia
 handmade paper (1016×711 mm
 [40×28 in.])
 5 artist's proofs
 5 printer's proofs
 4 trial proofs (2 AIC)
 2 working proofs
 4 proofs H. C.
 5 proofs for the American Federation
 of Arts
Printer: Ben Berns
Poster edition: 2,100 unsigned copies were
printed in collotype by Meriden Gravure Co.
with text: "Jasper Johns/commissioned by the
List Art Poster Programs of The American
Federation of Arts 1966"
Catalogue reference: Field 50
Like the flag, the light bulb, for Johns, though
an indispensable means of seeing, is an object
we no longer see. Johns was commissioned to
produce a poster for the List Art Poster
Program. After the poster edition was made,
ULAE printed the stone and plate on handmade
paper in the largest edition they had yet
published.

60. TWO MAPS I, 1965-66
Lithograph from one stone and one aluminum
plate
Paper: black laid Fabriano
Sheet: 848×673 mm (33⅜×26½ in.)
Signed, dated; lower right in white pencil:
J. Johns/'65-'66
Numbered; lower left in white pencil: I x/30
Edition: 30
 Plus: 6 artist's proofs (1 AIC)
 7 trial proofs for *Two Maps I* and
 Two Maps II (cat. no. 61) (5 AIC)
 3 working proofs for *Two Maps I* and
 Two Maps II (cat. no. 61) (2 AIC)
Printer: Ben Berns
Stone and plate preserved and used for *Two
Maps II* (cat. no. 61)
Catalogue reference: Field 51
Two Maps I looks like a positive, but graphically
it is a negative: the lines are what is not drawn.

61. TWO MAPS II, 1966
Lithograph from one stone (previously used for
Two Maps I [cat. no. 60])
Paper: white Japan chine collé on black laid
Fabriano
Sheets: Japan, 643×513 mm (25½×20⅛ in.)
 Fabriano, 856×670 mm (33¾×26⅜ in.)
Signed, dated; lower right: J. Johns/1966
Numbered; lower left: x/30 II
Edition: 30
 Plus: 4 artist's proofs (1 AIC)
 7 trial proofs for *Two Maps I* (cat. no.
 60) and *Two Maps II* (5 AIC)
 1 trial proof of uncorrected margin
 3 working proofs for *Two Maps I* (cat.
 no. 60) and *Two Maps II* (2 AIC)
 1 cancellation proof, 1967
Printer: Ben Berns
Catalogue reference: Field 52
Two Maps II looks like a photographic negative
but is printed as a positive, that is, black ink on
white paper.

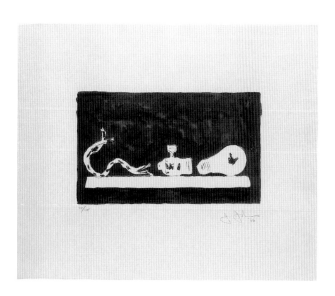

62. LIGHT BULB, 1966
Lithograph from two stones
Paper: white wove
Watermark: J WHATMAN 1952 HANDMADE ENGLAND
Sheet: 495×620 mm (19½×24⅜ in.)
Signed, dated; lower right: J. Johns / '66
Numbered; lower left: x/45
Edition: 45 (1 AIC)
 Plus: 4 artist's proofs
 3 trial proofs (3 AIC)
 3 proofs of elements
Printer: Ben Berns
Catalogue reference: Field 53
The prototype for this print was Johns's
sculpture *Bronze* of 1960-61 (Mr. and Mrs.
Robert C. Scull, New York), in which the three
separated elements rest on a thin rectangular
metal base.

63. THE CRITIC SMILES, 1966
Lithograph from one stone; hand-colored in
silver, gold, and aluminum by the artist
Paper: white wove Chatham British handmade
Sheet: 641×511 mm (25¼×20⅛ in.)
Inscribed, numbered, signed, dated; lower left:
THE CRITIC SMILES / x/40 / J. Johns/ '66
Edition: 40
 Plus: 8 artist's proofs (1 AIC)
 trial proofs (1 AIC)
 2 working proofs (2 AIC)
Printer: Ben Berns
Catalogue reference: Field 54
The prototype for this print was a Sculpmetal
object made soon after Johns's first one-person
exhibition at the Castelli Gallery in 1958.

64. RULER, 1966
Lithograph from two stones
Paper: white wove Italia handmade
Watermark: Magnani emblem
Sheet: 711×508 mm (28×20 in.)
Signed, dated; lower center: J. Johns / 1966
Numbered; lower right: x/25
Edition: 25 (1 AIC)
 Plus: 6 artist's proofs
 4 trial proofs (2 AIC)
 1 working proof
 6 proofs of elements (4 AIC)
Printer: Zigmunds Priede
Catalogue reference: Field 56

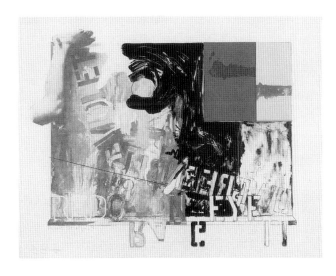

65. PASSAGE I, 1965-66
Lithograph from five stones and one aluminum
photographic plate
Paper: white wove Italia handmade
Sheet: 714×924 mm (28⅛×36⅜ in.)
Signed, dated; lower left: J. Johns / '66
Numbered; lower left: I x/21
Edition: 21
 Plus: 4 artist's proofs (1 AIC)
 1 printer's proof
 4 trial proofs (3 AIC)
 3 working proofs (1 AIC)
 3 progressive proofs
 2 proofs of elements
Printers: Zigmunds Priede and Donn Steward
Plate and stones preserved and used for
Passage II and *Decoy* (cat. nos. 66, 108).
Catalogue reference: Field 57
See plate 83

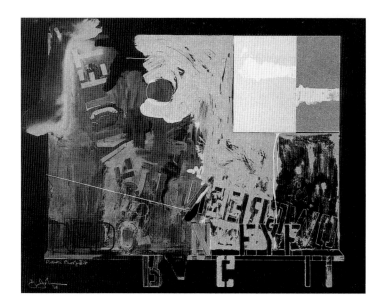

66. PASSAGE II, 1966
Lithograph from four stones and one plate
(previously used for *Passage I* [cat. no. 65])
Paper: black laid Fabriano
Sheet: 710×916 mm (27¹⁵/₁₆×36⅛ in.)
Signed, dated; lower left in white pencil:
J. Johns / '66
Numbered; lower left: II x/20
ULAE embossed stamp upper left
Edition: 20
 Plus: 5 artist's proofs (1 AIC)
 2 trial proofs (1 AIC)
 1 working proof
Printers: Zigmunds Priede and Donn Steward
Catalogue reference: Field 58

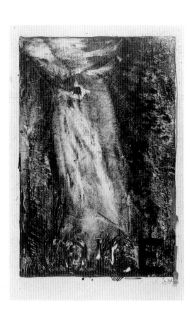

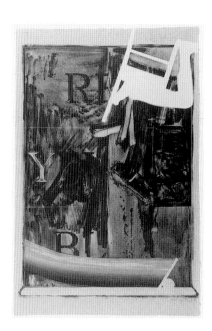

67. VOICE, 1966-67
Lithograph from one stone, one aluminum plate,
and one aluminum photographic plate
Paper: white wove handmade
Watermark: J. WHATMAN 1957
Sheet: 1229×805 mm (48⅜×31¹¹/₁₆ in.)
Signed, dated; lower right in black ink: J. Johns/
'66-'67
Numbered; lower left: x/30
Edition: 30
 Plus: 5 artist's proofs (1 AIC)
 3 printer's proofs
 2 trial proofs
 6 working proofs (1 AIC)
 11 progressive proofs (5 AIC)
Printers: Zigmunds Priede, Donn Steward, and
Fred Genis
Catalogue reference: Field 59
In the painted diptych *Voice* of 1964-67, Johns
attached a spoon and fork to the canvas with a
long wire. In the lithograph, he made a separate
plate to print the fork and spoon in silver ink.

68. WATCHMAN, 1967
Lithograph from five stones
Paper: unbleached grayish-tan laid handmade
Watermark: J. Johns (signature); ANGOUMOIS A LA
MAIN
Sheet: 916×614 mm (36¹/₁₆×24³/₁₆ in.)
Signed, dated; upper right:
J. Johns / '67
Numbered; lower right: x/40
Edition: 40
 Plus: 7 artist's proofs (1 AIC)
 1 printer's proof
 2 trial proofs (2 AIC)
 1 working proof
 8 progressive proofs (4 AIC)
 6 proofs of elements (3 AIC)
Printer: Zigmunds Priede
Catalogue reference: Field 60
See plate 84

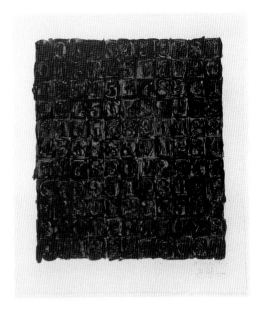

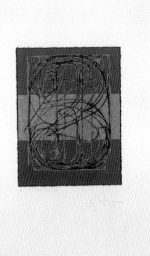

69. NUMBERS, 1967
Lithograph from one stone and one aluminum
plate
Paper: cream laid ANGOUMOIS A LA MAIN
handmade
Watermark: ULAE
Sheet: 708×600 mm (27⅞×23⅝ in.)
Numbered, signed, dated; lower right: x/35 /
J. Johns / '67
Edition: 35
 Plus: 5 artist's proofs (1 AIC)
 2 printer's proofs
 6 trial proofs (4 AIC)
 9 proofs H. C.
 4 progressive proofs (2 AIC)
Printers: Zigmunds Priede and Fred Genis
Catalogue reference: Field 61

70. 0-9, 1967 (For the benefit of the
Committee to Rescue Italian Art)
Lithograph from three stones
Paper: black Japan laid down on white wove
Chatham British handmade
Sheets: Japan, 308×241 mm (12⅛×9½ in.)
 wove, 635×511 mm (25×20⅛ in.)
Signed, dated; lower right: J. Johns / '67
Numbered; lower left: x/50
Edition: 50
 Plus: 10 artist's proofs (1 AIC)
 1 printer's proof
 11 trial proofs (1 AIC)
 6 progressive proofs (3 AIC)
 4 proofs of elements (4 AIC)
Printers: Zigmunds Priede and Donn Steward
Catalogue reference: Field 62
Johns made this print as his contribution to the
Committee to Rescue Italian Art, which was
formed in response to the disastrous flood in
1966. Mrs. Grosman contributed by handling
production and sales. The edition was
distributed by the end of the year.

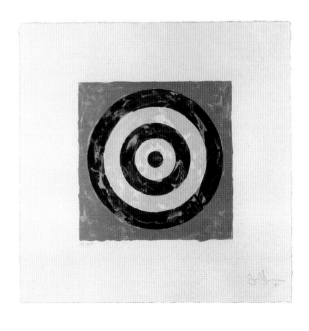

71. TARGET, 1967
Lithograph from six stones
Paper: white wove handmade
Watermark: J WHATMAN 1956 ENGLAND
Sheet: 585×581 mm (23¹¹/₁₆×22⅞ in.)
Signed, dated; lower right: J. Johns / '67
Numbered; lower left: x/28
Edition: 28
 Plus: 6 artist's proofs (1 AIC)
 1 printer's proof
 2 trial proofs (2 AIC)
 1 working proof
Printers: Zigmunds Priede and Fred Genis
Stones preserved and used for *White Target*
(cat. no. 98)
Catalogue reference: Field 63
On June 20, 1961, when Johns was one of the
guests invited to perform at the American
Embassy Theatre in Paris, at the last moment
he sent a waist-high flower arrangement in his
stead. This lithograph closely resembles the
watercolor model he made for the florist. Johns
is a founding director of the Foundation for
Contemporary Performance Arts. This
lithograph was made as a benefit print for the
organization.

72. TARGET I, 1967
Etching from one plate
Paper: white wove Jeff Goodman handmade
Watermark: JG JJ
Plate: 98×99 mm (3⅞×3⅞ in.)
Sheet: 146×140 mm (5¾×5½ in.) (irreg.)
Signed, dated; lower right: J. Johns / '67
Numbered; lower left: x/8
Edition: 8 (1 AIC)
 Plus: 1 artist's proof
 8 proofs H. C.
Printer: Donn Steward
Plate preserved and used for *Target II*
(cat. no. 99)
Catalogue reference: Field 64
Johns's first lithograph had been a target (cat.
no. 1); he chose the same subject for his first
etching. Radically transformed by the active—
even mutinous—character of the etched line,
this target is a classic example of the
transformations induced by Johns's immediate
mastery of the graphic media.

73. LIGHT BULB, 1967
Etching and open bite from one plate
Paper: white wove
Watermark: ANGOUMOIS A LA MAIN
Plate: 211×311 mm (8⁵⁄₁₆×12¼ in.)
Sheet: 325×419 mm (12¹³⁄₁₆×16½ in.)
Signed, dated; lower right: J. Johns '67
Numbered; lower left: x/12
Edition: 12
 Plus: 4 artist's proofs
 1 printer's proof
 1 cancellation proof (1 AIC)
 cancelled plate (AIC)
Printer: Donn Steward
Catalogue reference: Field 66
This print and *Figure 4* (cat. no. 74) may be
considered preludes to Johns's portfolio *1st
Etchings* (cat. nos. 77-83). Both of these small
prints use a technique called "open bite," in
which, instead of drawing through a varnish
ground into the copper plate, the artist paints
with varnish directly on the plate.

74. FIGURE 4, 1967
Open-bite etching from one plate
Paper: white wove Douglass Howell handmade
Watermark: H
Plate: 229×152 mm (9×6 in.)
Sheet: 437×341 mm (17³⁄₁₆×13⁷⁄₁₆ in.)
Signed, dated; lower right: J. Johns / '67
Numbered; lower left: x/12
Edition: 12
 Plus: 6 artist's proofs (1 AIC)
 1 printer's proof
 1 trial proof (1 AIC)
 1 cancellation proof (1 AIC)
 cancelled plate (AIC)
Printer: Donn Steward
Catalogue reference: Field 67

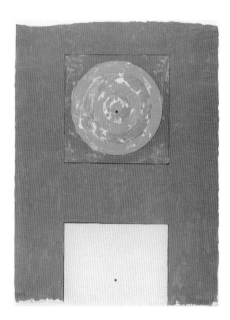

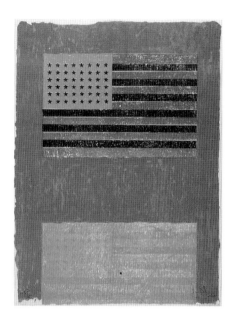

75. TARGETS, 1967-68
Lithograph from nine stones, two aluminium
plates, and a rubber stamp
Paper: white wove East Indian handmade
Sheet: 876×660 mm (34½×26 in.) (irreg.)
Signed, dated; lower right: J. Johns / '67-'68
Numbered; lower left: x/42
Edition: 42
 Plus: 5 artist's proofs (1 AIC)
 2 trial proofs (1 AIC)
 1 working proof
 2 proofs H. C. (1 AIC)
 18 progressive proofs (9 AIC)
Printers: Zigmunds Priede and Fred Genis
Catalogue reference: Field 69
See plate 85

76. FLAGS, 1967-68
Lithograph from five stones, one aluminum
plate, and two rubber stamps
Paper: white wove East Indian handmade
Sheet: 879×657 mm (34⅝×25⅞ in.)
Signed, dated; lower right in black ink:
J. Johns / '67-'68
Numbered; lower left in black ink: x/43
Edition: 43
 Plus: 5 artist's proofs (1 AIC)
 2 printer's proofs
 2 trial proofs (2 AIC)
 18 progressive proofs (7 AIC)
Printers: Zigmunds Priede and Fred Genis
Catalogue reference: Field 70
This is one of the most complex examples of the
conservation and reuse of matrices at ULAE.
Johns first used the gray background plate in
Targets, 1967-68 (cat. no. 75). Many of the stones
for *Targets* had been used in *Target*, 1967 (cat.
no. 71).
See plate 86

77-83. IST ETCHINGS, 1967-68
A portfolio of seven etchings, each printed with
an etching plate and a photoengraving plate;
the portfolio covers are blond wood, with an
inlaid Ballantine Ale can and a line-cut of the
artist's handwriting on the front; the etchings
are laid between hinged cardboard "pages"
covered in translucent beige wove Tokugawa
paper; cover and pages are hinged in accordion-
fashion and can be opened to a thirty-six-foot
length; the title page has an etching of a
Ballantine Ale can hinged to it and is signed: 1st
etchings / J. Johns '67; the colophon page is
printed in relief from the same plate; the
number and title of each etching is printed in
letterpress on the page facing it; a balsa wood
box was made for shipment of the portfolio
Paper: unbleached tan linen rag wove
Watermark: J. Johns (signature); ANGOUMOIS
A LA MAIN
Edition: 26
 Plus: 2 sets of artist's proofs (1 set AIC)
 1 set of printer's proofs
 10 sets of proofs H. C. on white
 Auvergne à la Main paper
 2 sets of proofs on white Auvergne à
 la Main paper, printed without the
 photoengraved plates
Printer: Donn Steward
Plates preserved and used for the portfolio *1st
Etchings, 2nd State* (cat. nos. 84-97)
Portfolios bound by Carolyn Horton; plastic
mold and relief of the Ballantine label made by
John Campioni; use of the Ballantine label
authorized by the manufacturer
Catalogue reference: Field 71-77a and b
The photoengravings used for *1st Etchings* were
made from Johns's casts of six small sculptures
he made between 1958 and 1961. Johns made
artistry itself the subject of this portfolio. The
photoengravings are addressed to the
stereoscopic eye; the diagrammatic etchings to
the symbol- and pattern-making cortex. He
wanted the pages arranged to turn over, as in a
Western book, but to open accordion-fashion as
well, like an Oriental handscroll. Finally,
separate sheets were placed in an accordian-
folded inner construction, which was laid in a
wooden box.

77a. IST ETCHINGS: ALE CANS, TITLE PAGE, 1967-68
Etching and open-bite
Plate: 125×209 mm (4⅞×8¼ in.)
Sheet: 153×236 mm (6×9⁵⁄₁₆ in.)
Inscribed, signed, dated; lower center in black ink: 1st ETCHINGS J. Johns '67
Numbered; lower right: x/26
Plate preserved and used for *1st Etchings, 2nd State: Ale Cans, Title Page* (cat. no. 84).
Catalogue reference: Field 77a

77b. IST ETCHINGS: ALE CANS, COLOPHON PAGE, 1967-68
Etching and open-bite printed in relief; letterpress
Paper: beige wove Tokugawa
Plate: 127×212 mm (5×8⅜ in.)
Sheet: 710×563 mm (28×22⅜ in.)
The plate is situated above the letterpress of the colophon page
Catalogue reference: Field 77b

78. 1ST ETCHINGS: FLASHLIGHT, 1967-68
Etching and photoengraving from two plates
Plates: etching, 236×335 mm (9⁵⁄₁₆×13³⁄₁₆ in.);
 photoengraving, 100×122 mm
 (3¹⁵⁄₁₆×4¹³⁄₁₆ in.)
Sheet: 645×498 mm (25³⁄₈×19⁵⁄₈ in.)
Signed, dated; upper right below upper plate:
J. Johns / '67
Numbered; lower left: x/26
Etching plate preserved and used for *1st
Etchings, 2nd State: Flashlight* (cat. no. 85);
photoengraving plate preserved and used for *1st
Etchings, 2nd State: Flashlight* (cat. no. 86)
Catalogue reference: Field 71

79. 1ST ETCHINGS: LIGHT BULB, 1967-68
Etching and photoengraving from two plates
Plates: etching, 169×225 mm (6¹¹⁄₁₆×8⁷⁄₈ in.);
 photoengraving, 102×124 mm
 (4×4⁷⁄₈ in.)
Sheet: 661×511 mm (26×20⅛ in.)
Signed, dated; lower right: J. Johns '67
Numbered; lower left: x/26
Etching plate preserved and used for *1st
Etchings, 2nd State: Light Bulb* (cat. no. 87);
photoengraving plate preserved and used for *1st
Etchings, 2nd State: Light Bulb* (cat. no. 88)
Catalogue reference: Field 72

80. 1ST ETCHINGS: ALE CANS, 1967-68
Etching and photoengraving from two plates
Plates: etching, 285×285 mm (11¼×11¼ in.);
 photoengraving, 90×89 mm
 (3⁹⁄₁₆×3½ in.)
Sheet: 645×500 mm (25³⁄₈×19¹¹⁄₁₆ in.)
Signed, dated; lower right: J. Johns / '67
Numbered; lower left: x/26
Etching plate preserved and used for *1st
Etchings, 2nd State: Ale Cans* (cat. no. 89);
photoengraving plate preserved and used for *1st
Etchings, 2nd State: Ale Cans* (cat. no. 90)
Catalogue reference: Field 73

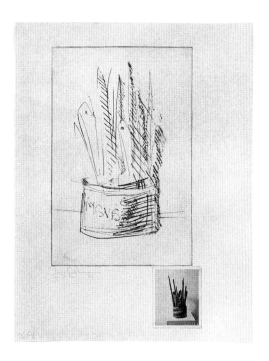

81. 1ST ETCHINGS: PAINTBRUSHES, 1967-68
Etching and photoengraving from two plates
Plates: etching, 442×297 mm
 (17⁷/₁₆×11¹¹/₁₆ in.);
 photoengraving, 125×103 mm
 (4¹⁵/₁₆×4¹/₁₆ in.)
Sheet: 641×496 mm (25¹/₄×19¹/₂ in.)
Signed, dated; lower right below upper plate:
J. Johns / '67
Numbered; lower right: x/26
Etching plate preserved and used for *1st
Etchings, 2nd State: Paintbrushes* (cat. no. 91);
photoengraving plate preserved and used for *1st
Etchings, 2nd State: Paintbrushes* (cat. no. 92)
Catalogue reference: Field 74

82. 1ST ETCHINGS: FLAG, 1967-68
Etching and photoengraving from two plates.
Plates: etching, 300×449 mm
 (11¹³/₁₆×17¹¹/₁₆ in.);
 photoengraving, 85×119 mm
 (3⁵/₁₆×4¹¹/₁₆ in.)
Sheet: 660×510 mm (26×20¹/₁₆ in.)
Signed, dated; lower center below upper plate:
J. Johns / '67
Numbered; lower left: x/26
Etching plate preserved and used for *1st
Etchings, 2nd State: Flag* (cat. no. 93);
photoengraving plate preserved and used for *1st
Etchings, 2nd State: Flag* (cat. no. 94)
Catalogue reference: Field 75

83. 1ST ETCHINGS: NUMBERS, 1967-68
Etching and photoengraving from two plates
Plates: etching, 337×251 mm (13¹/₄×9⁷/₈ in.);
 photoengraving, 122×95 mm
 (4¹³/₁₆×3¾ in.)
Sheet: 660×510 mm (26×20¹/₁₆ in.)
Signed, dated; lower left: J. Johns / '67
Numbered; lower left: x/26
Etching plate preserved and used for *1st
Etchings, 2nd State: Numbers* (cat. no. 95);
photoengraving plate preserved and used for *1st
Etchings, 2nd State: Numbers* (cat. no. 96)
Catalogue reference: Field 76

84-97. IST ETCHINGS, 2ND STATE, 1967-69

A portfolio of thirteen etchings and photoengravings and a colophon page printed from the second state of the plates used in *1st Etchings* (cat. nos. 77-83); the prints are loosely laid in a hinged box made of heavy board, laminated with silvered synthetic film made by Minnesota Mining and Mfg. Co. and printed with the number of the edition
Edition: 40 portfolios
 Plus: 9 sets of artist's proofs (1 set AIC)
 1 set of printer's proofs
 trial proofs (30 AIC)
 2 sets of cancellation proofs, 1970
 (1 set AIC)
 cancelled plates (13 AIC)
Paper: rough white laid
Watermark: AUVERGNE A LA MAIN; RICHARD DE BAS
Printer: Donn Steward; colophon handset and printed by Esther Pullman; portfolios bound by Carolyn Horton
Photoengraving plates cancelled but used for *Decoy* (cat. no. 108)
Catalogue reference: Field 78-90

84. IST ETCHINGS, 2ND STATE: ALE CANS, TITLE PAGE, 1967-69

Etching and aquatint (etching plate previously used for *1st Etchings: Ale Cans, Title Page* [cat. no. 77a])
Plate: 127×210 mm (5×8¼ in.)
Sheet: 662×493 mm (26¹/₁₆×19⁷/₁₆ in.)
Signed, dated; lower right in pen and ink:
J. Johns / '67-'69
Numbered; lower left corner: x/40
Catalogue reference: Field 84

85. IST ETCHINGS, 2ND STATE: FLASHLIGHT, 1967-69

Etching and aquatint (etching plate previously used for *1st Etchings: Flashlight* [cat. no. 78])
Plate: 236×334 mm (9⁵/₁₆×13³/₁₆ in.)
Sheet: 661×494 mm (26¹/₁₆×19⁷/₁₆ in.)
Signed, dated; lower right: J. Johns '67-'69
Numbered; lower left: x/40
Catalogue reference: Field 78

**86. 1ST ETCHINGS, 2ND STATE:
FLASHLIGHT, 1967-69**
Etching and photoengraving (photoengraving
plate previously used for *1st Etchings:
Flashlight* [cat. no. 78])
Plate: 99×124 mm (3¹⁵/₁₆×4⅞ in.)
Sheet: 668×505 mm (26⁵/₁₆×19⅞ in.)
Signed, dated; lower right: J. Johns '67-'69
Numbered; lower left: x/40
Catalogue reference: Field 85

**87. 1ST ETCHINGS, 2ND STATE: LIGHT
BULB, 1967-69**
Etching and aquatint (etching plate previously
used for *1st Etchings: Light Bulb* [cat. no. 79])
Plate: 169×222 mm (6⅝×8¾ in.)
Sheet: 663×495 mm (26⅛×19½ in.)
Signed, dated; lower right: J. Johns '67-'69
Numbered; lower left: x/40
Catalogue reference: Field 79

**88. 1ST ETCHINGS, 2ND STATE: LIGHT
BULB, 1967-69**
Etching and photoengraving (photoengraving
plate previously used for *1st Etchings: Light
Bulb* [cat. no. 79])
Plate: 99×120 mm (3⅞×4¾ in.)
Sheet: 660×496 mm (26×19⁹/₁₆ in.)
Signed, dated; lower right: J. Johns '67-'69
Numbered; lower left: x/40
Catalogue reference: Field 86

**89. 1ST ETCHINGS, 2ND STATE: ALE CANS,
1967-69**
Etching and aquatint (etching plate previously
used for *1st Etchings: Ale Cans* [cat. no. 80])
Plate: 285×285 mm (11³/₁₆×11³/₁₆ in.)
Sheet: 658×496 mm (25⅞×19½ in.)
Signed, dated; lower center: J. Johns '67-'69
Numbered; lower left: x/40
Catalogue reference: Field 80

**90. 1ST ETCHINGS, 2ND STATE: ALE CANS,
1967-69**
Etching and photoengraving (photoengraving
plate previously used for *1st Etchings: Ale Cans*
[cat. no. 80])
Plate: 90×90 mm (3½×3½ in.)
Sheet: 657×495 mm (25⅞×19½ in.)
Signed, dated; lower center: J. Johns / '67-'69
Numbered; lower left: x/40
Catalogue reference: Field 87

**91. 1ST ETCHINGS, 2ND STATE:
PAINTBRUSHES, 1967-69**
Etching and aquatint (etching plate previously
used for *1st Etchings: Paintbrushes*
[cat. no. 81])
Plate: 444×300 mm (17½×11⁹/₁₆ in.)
Sheet: 660×495 mm (26×19½ in.)
Signed, dated; lower right: J. Johns '67-'69
Numbered; lower right: x/40
Catalogue reference: Field 81

92. 1ST ETCHINGS, 2ND STATE: PAINTBRUSHES, 1967-69
Photoengraving and open-bite (photoengraving plate previously used for *1st Etchings: Paintbrushes* [cat. no. 81])
Plate: 125×103 mm (4⅞×4¹/₁₆ in.)
Sheet: 660×496 mm (26×19½ in.)
Signed, dated; lower right: J. Johns '67-'69
Numbered; lower right: x/40
Catalogue reference: Field 88

93. 1ST ETCHINGS, 2ND STATE: FLAG, 1967-69
Etching and open-bite (etching plate previously used for *1st Etchings: Flag* [cat. no. 82])
Plate: 296×443 mm (11⅝×17⁷/₁₆ in.)
Sheet: 657×499 mm (25⅞×19¹¹/₁₆ in.)
Numbered, signed, dated; upper right: x/40 / J. Johns '67-'69
Catalogue reference: Field 82

94. 1ST ETCHINGS, 2ND STATE: FLAG, 1967-69
Etching and photoengraving (photoengraving plate previously used for *1st Etchings: Flag* [cat. no. 82])
Plate: 83×120 mm (3⁵/₁₆×4¾ in.)
Sheet: 660×499 mm (26×19¹¹/₁₆ in.)
Numbered, signed, dated; lower right: x/40 / J. Johns '67-'69
Catalogue reference: Field 89

95. IST ETCHINGS, 2ND STATE: NUMBERS, 1967-69
Etching and open-bite (etching plate previously used for *1st Etchings: Numbers* [cat. no. 83])
Plate: 335×249 mm (13³/₁₆×9¹³/₁₆ in.)
Sheet: 661×500 mm (26×19¹¹/₁₆ in.)
Signed, dated; lower right: J. Johns '67-'69
Numbered; lower left: x/40
Catalogue reference: Field 83

96. IST ETCHINGS, 2ND STATE: NUMBERS, 1967-69
Etching and photoengraving (etching plate previously used for *1st Etchings: Numbers* [cat. no. 83])
Plate: 120×94 mm (4³/₄×3¹¹/₁₆ in.)
Sheet: 660×500 mm (26×19¹¹/₁₆ in.)
Signed, dated; lower right: J. Johns '67-'69
Numbered; lower left: x/40
Catalogue reference: Field 90

97. IST ETCHINGS, 2ND STATE: COLOPHON PAGE, 1967-69
Letterpress

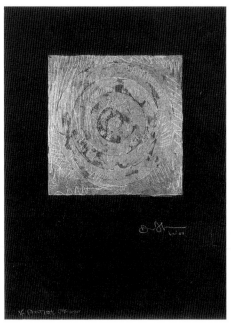

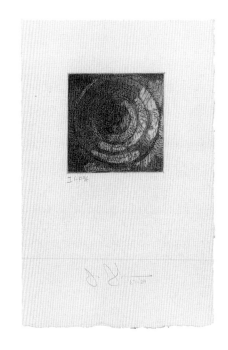

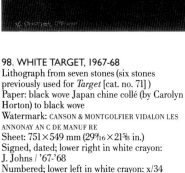

98. WHITE TARGET, 1967-68
Lithograph from seven stones (six stones
previously used for *Target* [cat. no. 71])
Paper: black wove Japan chine collé (by Carolyn
Horton) to black wove
Watermark: CANSON & MONTGOLFIER VIDALON LES
ANNONAY AN C DE MANUF RE
Sheet: 751×549 mm (29⁹⁄₁₆×21⅝ in.)
Signed, dated; lower right in white crayon:
J. Johns / '67-'68
Numbered; lower left in white crayon: x/34
Edition: 34
 Plus: 5 artist's proofs (1 AIC)
 1 printer's proof
 6 trial proofs (3 AIC)
 5 proofs marked "Trigram"
Printers: Zigmunds Priede and Fred Genis
Catalogue reference: Field 91
The six painted stones were used in *Target*, 1967
(cat. no. 71). The drawing stone was printed last;
all were printed in white.

99. TARGET II, 1967-69
Etching and aquatint from one plate (the sixth
state of *Target I* [cat. no. 72])
Paper: white wove handmade
Watermark: ANGOUMOIS A LA MAIN
Plate: 98×99 mm (3⅞×3⅞ in.)
Sheet: 293×293 mm (11⁹⁄₁₆×11⁹⁄₁₆ in.)
Signed, dated; lower center: J. Johns/'67-'69
Numbered; lower left: x/29
Edition: 29
 Plus: 5 artist's proofs (1 AIC)
 1 printer's proof
 trial proofs (7 AIC)
 cancellation proof (1 AIC)
 cancelled plate (1 AIC)
Printer: Donn Steward
Catalogue reference: Field 65
Target I (cat. no. 72) was the second state of this
plate. With several changes in the drawing and
the addition of aquatint, the sixth state was
published as *Target II*.

100. UNTITLED, 1969
Etching from one plate
Paper: unbleached gray-beige wove handmade
Watermark: J. Johns (signature); ANGOUMOIS
A LA MAIN
Plate: 740×502 mm (29⅛×19¾ in.)
Sheet: 927×616 mm (36½×24¼ in.)
Signed, dated; lower right: J. Johns '69
Numbered; lower left: x/16
Edition: 16
 Plus: 3 artist's proofs (1 AIC)
 1 printer's proof
Printer: Donn Steward
Catalogue reference: Field 123

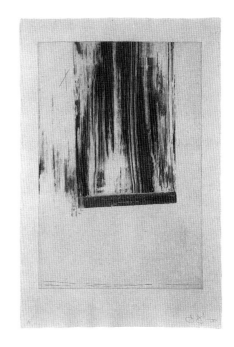

101. UNTITLED, SECOND STATE, 1969
Etching and aquatint from one plate
Paper: white wove Barcham Green
Plate: 738×505 mm (29¹/₁₆×19⁷/₈ in.)
Sheet: 1048×710 mm (41¹/₄×27¹⁵/₁₆ in.)
Signed, dated; lower right: Jasper Johns / 69
Numbered; lower left: x/9
Edition: 9
　　Plus: 7 artist's proofs (1 AIC)
　　　　1 printer's proof
　　　　1 trial proof (1 AIC)
Printer: Donn Steward
Catalogue reference: Field 124

102. UNTITLED, 1969
Etching and aquatint from one plate
Paper: unbleached tan wove handmade
Watermark: J. Johns (signature); ANGOUMOIS
A LA MAIN
Plate: 737×498 mm (29×19⁵/₈ in.)
Sheet: 924×611 mm (36³/₈×24¹/₁₆ in.)
Signed, dated; lower right: J. Johns '69
Numbered; lower left: x/11
Edition: 11
　　Plus: 3 artist's proofs (1 AIC)
　　　　1 printer's proof
Printer: Donn Steward
Catalogue reference: Field 125

103. UNTITLED, SECOND STATE, 1969
Etching and aquatint from one plate
Paper: white wove Barcham Green
Plate: 738×503 mm (29¹/₁₆×19¹³/₁₆ in.)
Sheet: 1052×710 mm (41⁷/₁₆×27¹⁵/₁₆ in.)
Numbered, signed, dated; lower right: x/15
J. Johns 1969
Edition: 15
　　Plus: 6 artist's proofs (1 AIC)
　　　　1 printer's proof
　　　　1 trial proof (1 AIC)
Printer: Donn Steward
Catalogue reference: Field 126

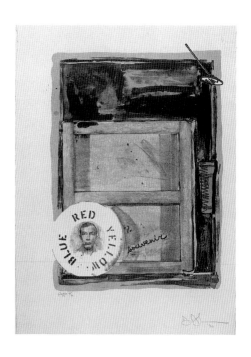

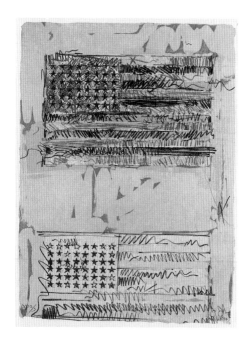

104. SOUVENIR, 1970
Lithograph from nine stones
Paper: white wove handmade
Watermark: A. MILBOURN & CO. BRITISH HANDMADE
Sheet: 779×566 mm (30¹¹/₁₆×22⁵/₁₆ in.)
Signed, dated; lower right: J. Johns / '70
Numbered; lower left: x/50
Edition: 50
　　　Plus: 6 artist's proofs (1 AIC)
　　　　　1 printer's proof
　　　　　1 trial proof (1 AIC)
　　　　　2 working proofs
　　　　　16 progressive proofs (8 AIC)
　　　　　20 proofs of elements (18 AIC)
Poster edition: unlimited quantity printed in
four-color process offset lithography by the
Ealcon Press, Philadelphia; two hundred were
signed by the artist
Printers: Zigmunds Priede and Frank Akers
Catalogue reference: Field 127
See plate 87

105. LIGHT BULB (ENGLISH), 1970
Lithograph from three stones and one rubber
stamp
Paper: white laid Fred Siegenthaler handmade
Watermark: J. JOHNS
Sheet: 484×305 mm (19¹/₁₆×12 in.)
Signed, dated; lower right: J. Johns / '70
Numbered; lower left: x/40
Edition: 40
　　　Plus: 6 artist's proofs (1 AIC)
　　　　　8 trial proofs (3 AIC)
　　　　　1 working proof
　　　　　6 progressive proofs (3 AIC)
　　　　　6 proofs of elements (3 AIC)
Printer: Frank Akers
Catalogue reference: Field 128
Two artists used stamped logos from light bulbs
at ULAE: James Rosenquist used the General
Electric symbol in his lithograph *Circles of
Confusion* (cat. no. 5), and Johns used the
Luxram rubber stamp to "pin" this image to
the paper.

106. FLAGS II, 1967-70
Lithograph from five stones, five plates, and two
rubber stamps
Paper: white wove East Indian handmade
Sheet: 848×622 mm (33³/₈×24¹/₂ in.)
Signed, dated; lower right in black crayon:
J. Johns / '67-'70
Numbered; lower left in black crayon: x/9
Edition: 9
　　　Plus: 3 artist's proofs (1 AIC)
　　　　　1 printer's proof
Printer: Bill Goldston
Catalogue reference: Field 130
In *Flags II*, and later in the *Savarin* monotypes
published after Mrs. Grosman's death, proofs
from a previous edition served as the basis for a
new one. Johns took proofs of *Flags* (cat. no. 76)
that Mrs. Grosman had stored; he added four
more plates, thereby radically altering the
image. He subsequently reused three of these
new plates in *Two Flags (Gray)* (cat. no. 109).

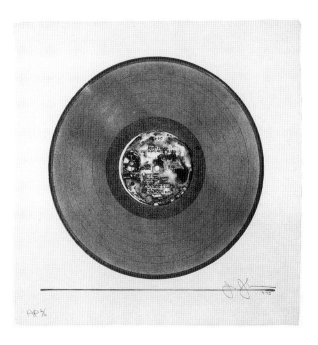

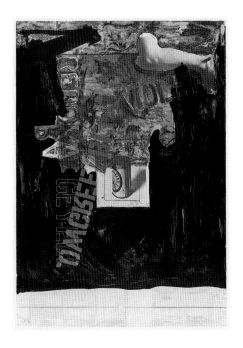

107. SCOTT FAGAN RECORD, 1970
Lithograph from two stones and one
phonograph record
Paper: cream laid
Watermark: ANGOUMOIS A LA MAIN
Sheet: 411×399 mm (16³/₁₆×15¹¹/₁₆ in.)
Signed, dated; lower right: J. Johns '70
Numbered; lower left: x/20
Edition: 20
　　　Plus: 6 artist's proofs (1 AIC)
　　　　　2 printer's proofs
　　　　　2 trial proofs (2 AIC)
　　　　　1 working proof
Printers: Bill Goldston and Zigmunds Priede
Catalogue reference: Field 131
Although Johns used found objects extensively
in his paintings, he preferred to use
photographs to represent objects in his
printmaking. This lithograph is the most direct
reference to a real object: Johns brought a
record from his own collection to lay on the
press bed to print its own "record" on the
paper.

108. DECOY, 1971
Lithograph from one stone, hand-printed, and
eighteen plates, using images transferred from
the cancelled photoengravings of *1st Etchings,
2nd State* (cat. nos. 84-97), printed on a hand-
fed offset proofing press
Paper: white wove
Watermark: BFK RIVES
Sheet: 1054×751 mm (41¹/₂×29⁹/₁₆ in.)
Signed, dated; lower right: J. Johns/'71
Numbered; lower left: x/55
Edition: 55
　　　Plus: 4 artist's proofs (1 AIC)
　　　　　4 printer's proofs
　　　　　19 trial proofs (3 AIC)
　　　　　3 working proofs (1 AIC)
　　　　　38 progressive proofs (19 AIC)
　　　　　74 proofs of elements (36 AIC)
　　　　　2 proofs of unused plates
　　　　　drawings (2 AIC)
Printers: Bill Goldston, James V. Smith,
Zigmunds Priede, and Steve Anderson
Catalogue reference: Field 134
See plate 88

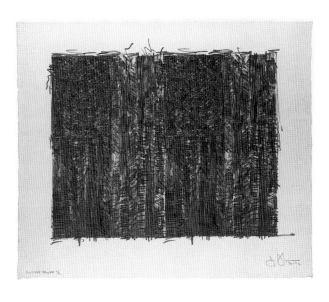

109. TWO FLAGS (GREY), 1970-72
Lithograph from two stones and three plates
(plates previously used for *Flags II* [cat. no.
106])
Paper: cream laid Japan
Sheet: 700×833 mm (27⁹/₁₆×32¹³/₁₆ in.)
Signed, dated; lower right: J. Johns/'70-'72
Numbered; lower left: x/36
Edition: 36
　　　Plus: 9 artist's proofs (1 AIC)
　　　　　2 printer's proofs
　　　　　4 trial proofs
　　　　　8 progressive proofs (5 AIC)
　　　　　6 proofs of elements
Printers: Bill Goldston and James V. Smith
Catalogue reference: Field 164
Johns made two stones for this print that were
to be printed on the offset press—ULAE's first
use of the offset press to print from stone. These
sheets were then overprinted on the offset press
with three of the plates he had made for *Flags
II* (cat. no. 106). The left flags were printed first,
then the plates were slightly altered for the
right. All of the printings were done in gray
graphite inks made for this edition.

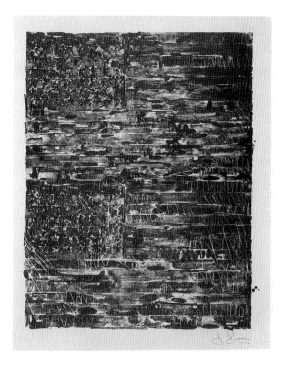

110. TWO FLAGS (BLACK), 1970-72
Lithograph from two stones
Paper: white wove Indian
Sheet: 799×591 mm (31½×23¼ in.)
Signed, dated; lower right: J. Johns/'70-'72
Numbered; lower left: x/40
Edition: 40
 Plus: 9 artist's proofs (1 AIC)
 18 trial proofs (12 AIC)
 progressive proofs (2 AIC)
 10 proofs of elements (3 AIC)
Printer: Bill Goldston
Catalogue reference: Field 165
Although Mrs. Grosman had seen that an offset press could produce fine art (*Decoy* and *Two Flags [Grey]* [cat. nos. 108, 109]), she was pleased to see Johns return in this print to hand lithography.

111. A CARTOON FOR TANYA, 1972
Lithograph from one plate
Paper: white laid Japanese Suzuki
Sheet: 618×943 mm (24¼×37 in.)
Signed, dated; lower right: J. Johns / '72
Inscribed on the plate: A CARTOON/FOR
TATYANA/WITH LOVE/FROM JASPER/
1 OCT. 1972
Numbered; lower left: x/10
Edition: 10
 Plus: 3 artist's proofs (1 AIC)
 2 printer's proofs
 2 trial proofs (1 AIC)
 1 working proof
 2 cancellation proofs (1 AIC)
Printers: Bill Goldston and James V. Smith
Catalogue reference: Field 166
Aside from *Souvenir* (cat. no. 104), Johns did no self-portraits for publication. This small edition was a surprise for Mrs. Grosman, done for the house and not for distribution.

112. CUPS 4 PICASSO, 1972
Lithograph from four plates
Paper: white laid Japan
Sheet: 565×819 mm (22½×32¼ in.)
Numbered, signed, dated; lower right: x/39 /
J. Johns/'72
Edition: 39
 Plus: 5 artist's proof (1 AIC)
 2 printer's proofs
 4 trial proofs (each one-half of the
 plate) (4 AIC)
 16 proofs of elements (8 AIC)
Printers: Bill Goldston and James V. Smith
Catalogue reference: Field 167
See plate 89

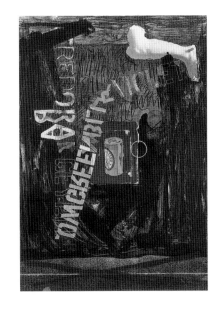

113. CUP 2 PICASSO, 1973
Lithograph from three plates
Paper: glass paper made by Fred Siegenthaler
in Basel, Switzerland
Watermark: J. Johns
Sheet: 502×308 mm (19¾×12⅛ in.)
Signed, dated; lower right: J. Johns '73
Numbered; lower left: x/11 '
Edition: 11
 Plus: 4 artist's proofs (1 AIC)
 2 printer's proofs
 2 trial proofs
Printers: Bill Goldston and James V. Smith
Catalogue reference: Field 168
In this print, Johns raised his "Cup 2 Picasso"
in honor of the Spanish artist's ninetieth
birthday. The plates for this lithograph and
Robert Motherwell's *Tricolor* (app. no. 8) were
made for a special issue on American art
published by the French magazine *XXe Siècle*
(June 1973). The plates were prepared by ULAE,
printed by Mourlot, and bound into the
magazine preceding an article on Johns by
Jean-Louis Ferrier.

114. DECOY II, 1971-73
Lithograph from one stone and twenty-five
plates
Paper: white wove
Watermark: BFK RIVES
Sheet: 1053×752 mm (41⁷⁄₁₆×29⅝ in.)
Signed, dated; lower right in silver crayon:
J. Johns / '71-'73
Numbered; lower left in silver crayon: x/31
Edition: 31
 Plus: 5 artist's proofs (1 AIC)
 2 printer's proofs
 11 trial proofs
 4 working proofs
 26 proofs of elements (14 AIC)
Printers: Bill Goldston and James V. Smith
Catalogue reference: Field 169
Decoy II restates an earlier theme in more
baroque language. Flawed impressions of *Decoy*
(cat. no. 108) served as the basic sheets; Johns
added seven more plates, which brought in new
elements, and removed some of the smaller
elements from the earlier print.

115. PAINTING WITH A BALL, 1972-73
Lithograph from three plates
Paper: white wove handmade
Watermark: J. WHATMAN 1962 ENGLAND
Sheet: 792×578 mm (31³⁄₁₆×22¾ in.)
Numbered, signed, dated; lower right: x/42 /
J. Johns / '72-'73
ULAE embossed stamp lower right
Edition: 42
 Plus: 5 artist's proofs (1 AIC)
 2 printer's proofs
 6 trial proofs (3 AIC)
 2 working proofs
 2 progressive proofs (1 AIC)
 6 proofs of elements (3 AIC)
Printers: Bill Goldston and James V. Smith
Plates temporarily preserved
Catalogue reference: Field 170

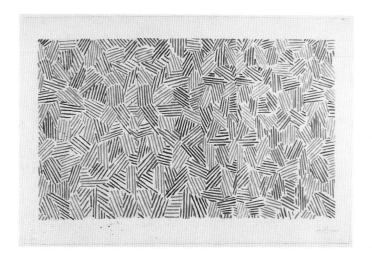

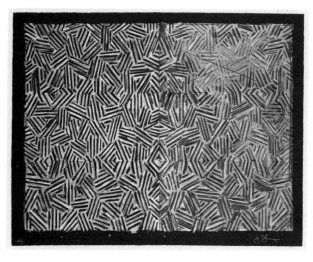

116. SCENT, 1975-76
Lithograph from four plates; linecut from four
blocks; woodcut from four blocks (left, offset;
center, linocut; right, woodcut)
Paper: white wove Twinrocker handmade
Watermark: SCENT
Sheet: 797×1192 mm (31⅜×46¹⁵/₁₆ in.)
Signed, dated; lower right: J. Johns / '75-'76
Numbered; lower left: x/42
Edition: 42
 Plus: 7 artist's proofs (1 AIC)
 3 printer's proofs
 2 trial proofs (1 AIC)
 6 proofs H. C.
Printers: Bill Goldston, James V. Smith, and
Juda Rosenberg
Plates temporarily preserved
Catalogue reference: Field 208
See plate 90

117. CORPSE AND MIRROR, 1976
Lithograph from twelve plates
Paper: black wove German etching
Sheet: 781×1006 mm (30¾×39⅝ in.)
Signed, dated; lower right: J. Johns / '76
Numbered; lower left in white chalk: x/58
Edition: 58
 Plus: 11 artist's proofs (1 AIC)
 2 printer's proofs
 2 trial proofs (2 AIC)
 22 progressive proofs (11 AIC)
 24 proofs of elements (12 AIC)
Printers: Bill Goldston and James V. Smith
Catalogue reference: Field 210
This "folded" composition (six panels, each of
which is book-matched to its neighbor) derives
from the game Exquisite Corpse, invented by
the Surrealists, in which each player draws part
of a figure on a piece of paper folded to mask
the other players' drawings. The hatching
pattern has been compared to Picasso's proto-
Cubist brushwork, to the bedspread in Edvard
Munch's *Between the Clock and the Bed* (1940-
42; Munchmuseet, Oslo), and, by Johns himself,
to a Mexican barber's sign he saw in *National
Geographic*.

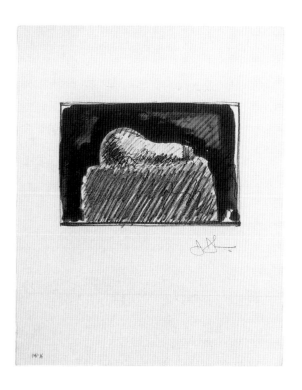

118. LIGHT BULB, 1976
Lithograph from three plates
Paper: white wove
Watermark: J. WHATMAN 1956 HANDMADE ENGLAND
Sheet: 433×351 mm (17¹/₁₆×13¹³/₁₆ in.)
Signed, dated; lower right: J. Johns '76
Numbered; lower left: x/48
Edition: 48
 Plus: 5 artist's proofs (1 AIC)
 2 printer's proofs
 6 trial proofs
 7 proofs H. C.
 6 proofs of elements (3 AIC)
Printers: Bill Goldston and James V. Smith
Catalogue reference: Field 212

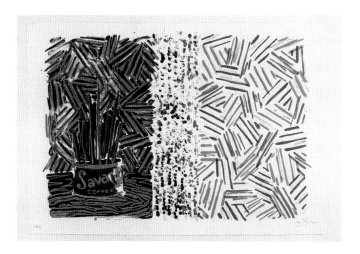

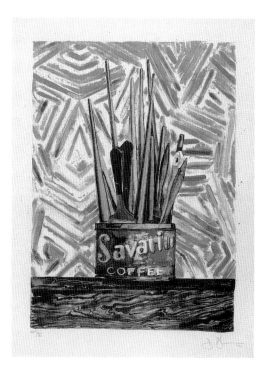

119. UNTITLED, 1977
Lithograph from twelve plates
Paper: white wove
Watermark: J. GREEN
Sheet: 698×1015 mm (27½×39¹⁵⁄₁₆ in.)
Signed, dated; lower right: J. Johns / '77
Numbered; lower left: x/53
Edition: 53
 Plus: 9 artist's proofs (1 AIC)
 2 printer's proofs
 6 trial proofs (3 AIC)
 24 progressive proofs (11 AIC)
 48 proofs of elements (24 AIC)
Printers: Bill Goldston and James V. Smith
Catalogue reference: Field 258
See plate 91

120. SAVARIN, 1977 (Whitney Museum of
American Art Poster)
Lithograph from seventeen plates
Paper: off-white Twinrocker handmade
Watermark: ULAE
Sheet: 1143×889 mm (45×35 in.)
Signed, dated; lower right: J. Johns / '77
Numbered; lower left: x/50
Edition: 50 without text
 Plus: 10 artist's proofs (1 AIC)
 2 printer's proofs
 trial proofs (2 AIC)
 2 proofs H. C.
 36 progressive proofs (17 AIC)
 98 proofs of elements (49 AIC)
Printers: Bill Goldston and James V. Smith
Catalogue reference: Field 259
See plate 92

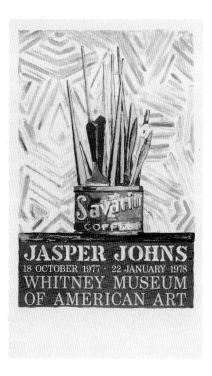

EDITIONS WITH TEXT

EDITION A/B:
Lithograph from original seventeen plates plus
five plates for the text: Jasper Johns / 18 October
1977 • 22 January 1978 / Whitney Museum / of
American Art
Paper: cream wove
Watermark: J B WHATMAN
Sheet: 1360×791 mm (53⅝×31⅛ in.)
Signed, dated; lower right: J. Johns '77
Numbered; lower left: x/14
Edition: 14
Catalogue reference: Field 259
Not illustrated

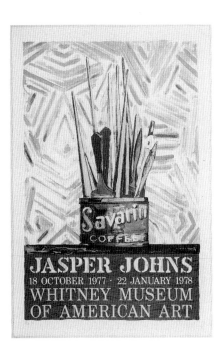

EDITION B/B:
Lithograph from original seventeen plates plus
five plates for the text used in *Edition A/B*
Paper: ivory wove
Watermark: ARCHES FRANCE
Sheet: 1212×805 mm (47¾×31⅝ in.)
Signed, dated; lower right: J. Johns / '77
Numbered; lower left: x/8
Catalogue reference: Field 259
Edition: 8

COMMERCIAL EDITION:
Four-color process, offset lithography
Edition: unlimited quantity
Published by the Whitney Museum of American
Art; printed under the supervision of Telamon
Editions
Printers: Bill Goldston and James V. Smith
Catalogue reference: Field 259

121. SAVARIN I, 1978
Lithograph from three aluminum plates
Paper: white wove
Watermark: AUVERGNE A LA MAIN; RICHARD DE BAS
Sheet: 657×511 mm (25⅞×20⅛ in.)
Signed, dated; lower right: J. Johns / '78
Numbered; lower left: x/42
Edition: 42
 Plus: 5 artist's proofs (1 AIC)
 8 trial proofs (4 AIC)
 4 progressive proofs (2 AIC)
 13 proofs of elements (6 AIC)
Printers: James V. Smith, Keith Brintzenhofe,
and Bill Goldston
Plates temporarily preserved
Catalogue reference: Segal 5
Each of the six lapidary *Savarin*s of 1978 speaks
in a distinct stylistic idiom. This one and
numbers 2 and 4 (cat. nos. 122, 124) were done
in Johns's studio on St. Martin's Island. Here
the background was made by pressing a local
cookie on the matrix.

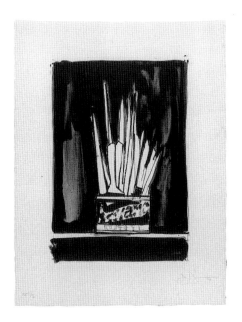

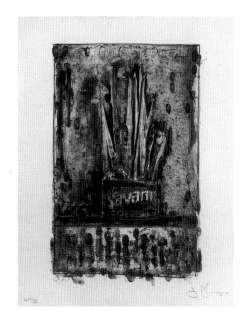

122. SAVARIN 2, 1978
Lithograph from two aluminum plates
Paper: white laid
Watermark: AUVERGNE A LA MAIN; RICHARD DE BAS
Sheet: 659×509 mm (25¹⁵/₁₆×20¹/₁₆ in.)
Signed, dated; lower right: J. Johns / '78
Numbered; lower left: x/42
Edition: 42
 Plus: 5 artist's proofs (1 AIC)
 5 printer's proofs
 2 trial proofs (2 AIC)
 4 proofs H. C., titled "Celine"
 2 progressive proofs (1 AIC)
 8 proofs of elements (4 AIC)
Printers: James V. Smith, Keith Brintzenhofe,
and Bill Goldston
Plates temporarily preserved
Catalogue reference: Segal 6
Johns started *Savarin 2* as a much larger
composition, with the words "Celine" and "St.
Martin's" in the margins.

123. SAVARIN 3, 1978
Lithograph from six aluminum plates
Paper: white wove
Watermark: AUVERGNE A LA MAIN; RICHARD DE BAS
Sheet: 662×510 mm (26¹/₆×20¹/₁₆ in.)
Signed, dated; lower right: J. Johns / '78
Numbered; lower left: x/40
Edition: 40
 Plus: 7 artist's proofs (1 AIC)
 3 printer's proofs
 14 trial proofs
 10 progressive proofs (5 AIC)
 24 proofs of elements (12 AIC)
Printers: Bill Goldston, Keith Brintzenhofe, and
James V. Smith
Plates temporarily preserved
Catalogue reference: Segal 7
See plate 93

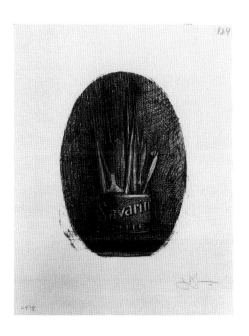

124. SAVARIN 4, 1978
Lithograph from two aluminum plates
Paper: white wove
Watermark: AUVERGNE A LA MAIN; RICHARD DE BAS
Sheet: 657×509 mm (25⁷/₈×20¹/₁₆ in.)
Signed, dated; lower right: J. Johns / '78
Numbered; lower left: x/42
Edition: 42
 Plus: 5 artist's proofs (1 AIC)
 3 printer's proofs
 6 trial proofs (2 AIC)
 2 progressive proofs (1 AIC)
 proofs of elements (4 AIC)
Printers: Bill Goldston, James V. Smith, and
Keith Brintzenhofe
Plates temporarily preserved
Catalogue reference: Segal 8

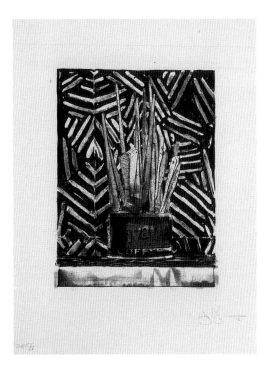

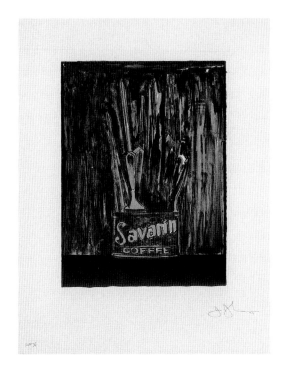

125. SAVARIN 5, 1978
Lithograph from five aluminum plates
Paper: white wove
Watermark: AUVERGNE A LA MAIN; RICHARD DE BAS
Sheet: 660×506 mm (26×19¹⁵/₁₆ in.)
Signed, dated; lower right: J. Johns / '78
Numbered; lower left: x/42
Edition: 42
 Plus: 5 artist's proofs (1 AIC)
 3 printer's proofs
 6 trial proofs (1 AIC)
 8 progressive proofs (4 AIC)
 20 proofs of elements (10 AIC)
Printers: Bill Goldston, Keith Brintzenhofe, and
James V. Smith
Plates temporarily preserved
Catalogue reference: Segal 9

126. SAVARIN 6, 1979
Lithograph from three aluminum plates
Paper: white laid
Watermark: AUVERGNE A LA MAIN; RICHARD DE BAS
Sheet: 660×506 mm (26×19¹⁵/₁₆ in.)
Signed, dated; lower right: J. Johns / '79
Numbered; lower left: x/42
Edition: 42
 Plus: 8 artist's proofs (1 AIC)
 3 printer's proofs
 1 trial proof
 1 working proof
 4 progressive proofs (2 AIC)
 12 proofs of elements (6 AIC)
Printers: Bill Goldston, James V. Smith, and
Thomas Cox
Plates temporarily preserved
Catalogue reference: Segal 12

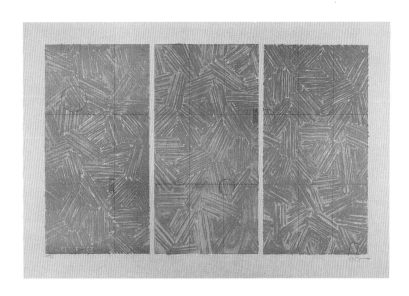

127. USUYUKI, 1979
Lithograph from ten aluminum plates
Paper: white wove Arches
Sheet: 875×1278 mm (34⁷/₁₆×50⁵/₁₆ in.)
Signed, dated; lower right: J. Johns / '79
Numbered; lower left: x/49
Edition: 49
 Plus: 7 artist's proofs (1 AIC)
 3 printer's proofs
 5 trial proofs (5 AIC)
 32 progressive proofs (16 AIC)
 68 proofs of elements in color
 (26 AIC)
Printers: Bill Goldston, James V. Smith, and
Thomas Cox
Plates temporarily preserved
Catalogue reference: Segal 16
See plate 96

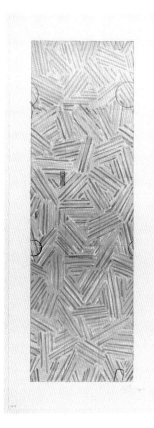

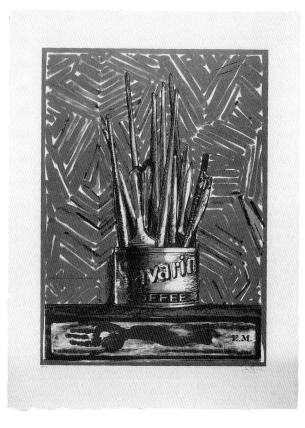

128. USUYUKI, 1980
Lithograph from thirteen aluminum plates in
seventeen printings
Paper: white wove Double BFK
Sheet: 1342×519 mm (52¹³/₁₆×20⁷/₁₆ in.)
Signed, dated; lower right: J. Johns / '80
Numbered; lower left: x/57
Edition: 57
 Plus: 11 artist's proofs (1 AIC)
 3 printer's proofs
 12 trial proofs (3 AIC)
 2 working proofs
 34 progressive proofs (17 AIC)
 72 proofs of elements (34 AIC)
Printers: Bill Goldston, James V. Smith, and
Thomas Cox
Catalogue reference: Segal 26
See plate 97

129. SAVARIN (GREY), 1977-81
Lithograph from seven plates
Paper: white wove Rives BFK
Sheet: 1276×973 mm (50¼×38⁵/₁₆ in.)
Signed, dated; lower right: J. Johns '77-'81
Numbered; lower left: x/60
Edition: 60
 Plus: 9 artist's proofs (1 AIC)
 3 printer's proofs
Printers: Bill Goldston, James V. Smith, and
Thomas Cox
Plates temporarily preserved
In the cross-hatched pattern known as the *Scent*
motif (see cat. no. 116), Johns had paid homage
to Edvard Munch. Here his tribute takes the
form of an adaptation of Munch's *Self-Portrait*
lithograph of 1895, in which a skeletal arm
occupies the bottom panel of the composition.
Munch's face is at the center of his composition;
Johns's self-portrait is the familiar Savarin can.

Alexander Liberman

I-20. NOSTALGIA FOR THE PRESENT,
1977-79
Unbound book of seventeen lithographs in a
lacquered box with a lithograph on the cover; a
title page, translation page, and a colophon
page; poem in Russian by Andrei Voznesensky
Paper: white wove
Sheet: 1035×694 mm (40¾×27⁵/₁₆ in.)
Signed, numbered; lower left: Andrei
Voznesensky (in Cyrillic) x/28
Signed, dated; lower right: Alexander Liberman
1977-79
Edition: 28
 Plus: 6 artist's proofs (1 AIC)
 2 printer's proofs
Printers: Keith Brintzenhofe and Bill Goldston
English translation of the poem by Vera
Dunham and J. W. Tjalsma
The English translation of the title "Nostalgia
for the Present" would seem to be a paradox,
but in Russian, the word for "present" also
means "true" or "genuine."

NOSTALGIA FOR THE PRESENT: COVER
OF LACQUERED BOX, 1977-79
Lithograph on lacquered wood box

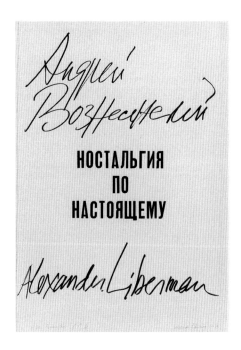

1. NOSTALGIA FOR THE PRESENT: TITLE
PAGE, 1977-79
Lithograph from one plate

2. NOSTALGIA FOR THE PRESENT: PAGE 1,
1977-79
Lithograph from one stone and one plate
Translation: I don't know about the rest of you,
 But I feel the cruellest
 Nostalgia—not for the past—
 But nostalgia for the present.

3. NOSTALGIA FOR THE PRESENT: PAGE 2,
1977-79
Lithograph from one stone
Translation: A novice desires to approach the
 Lord
 But is permitted only to do so by
 her superior.
 I beg to be joined, without
 intermediary,
 To the present.

4. NOSTALGIA FOR THE PRESENT: PAGE 3,
1977-79
Lithograph from one plate

5. NOSTALGIA FOR THE PRESENT: PAGE 4,
1977-79
Lithograph from one stone
Translation: It's as if I had done something
 wrong,
 Not I even—but others.
 I fall down in a field and feel
 Nostalgia for the living earth.

6. NOSTALGIA FOR THE PRESENT: PAGE 5,
1977-79
Lithograph from one plate

**7. NOSTALGIA FOR THE PRESENT: PAGE 6,
1977-79**
Lithograph from one stone
Translation: No one will cut us asunder,
But when I embrace you,
I do so with such anguish
As if someone takes you away.

**8. NOSTALGIA FOR THE PRESENT: PAGE 7,
1977-79**
Lithograph from one plate

**9. NOSTALGIA FOR THE PRESENT: PAGE 8,
1977-79**
Lithograph from one stone and one plate
Translation: When I hear the nasty tirades
Of a friend who has taken a false
step,
I don't look for what he seems to
be,
I grieve for what he really is.

**10. NOSTALGIA FOR THE PRESENT: PAGE
9, 1977-79**
Lithograph from one plate

11. NOSTALGIA FOR THE PRESENT: PAGE 10, 1977-79
Lithograph from one stone
Translation: A window opening on a garden
 Will not redeem loneliness.
 I long not for art—I choke
 On my craving for reality.

12. NOSTALGIA FOR THE PRESENT: PAGE 11, 1977-79
Lithograph from one stone and one plate
Translation: All is made of plastic, even tatters,
 I am tired of exposure.
 You and I, we'll be no more,
 But this small church . . .

13. NOSTALGIA FOR THE PRESENT: PAGE 12, 1977-79
Lithograph from one plate

14. NOSTALGIA FOR THE PRESENT: PAGE 13, 1977-79
Lithograph from one stone and one plate
Translation: And when the Mafia laughs in my
 face
 Idiotically, I say:
 "Idiots are all in the past, the
 present
 Calls for fuller understanding."
See plate 101

15. NOSTALGIA FOR THE PRESENT: PAGE
14, 1977-79
Lithograph from one plate

16. NOSTALGIA FOR THE PRESENT: PAGE
15, 1977-79
Lithograph from two stones and one plate
Translation: Black water spurts from the faucet,
Brackish water, stale water,
Red water flows from the faucet—
I'll wait
For the real water to come.

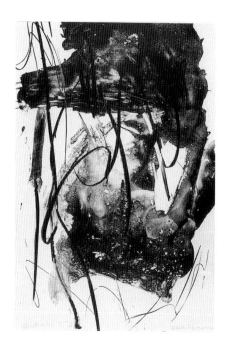

17. NOSTALGIA FOR THE PRESENT: PAGE
16, 1977-79
Lithograph from one stone
Translation: Whatever is past, so much the
better.
But I bite at it as at a mystery,
Nostalgia for the impending
present.
And I'll never catch hold of it.

18. NOSTALGIA FOR THE PRESENT: PAGE
17, 1977-79
Lithograph from one stone

19. NOSTALGIA FOR THE PRESENT:
TRANSLATION PAGE, 1977-79
Lithograph from one plate

20. NOSTALGIA FOR THE PRESENT:
COLOPHON PAGE, 1977-79
Lithograph from one plate

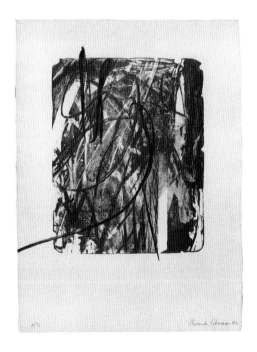

21. VORTEX I, 1980
Lithograph from one stone and one plate
Paper: white wove India
Sheet: 806 × 594 mm (31¾ × 23⅜ in.)
Signed, dated; lower right: Alexander Liberman
1980
Numbered; lower left: x/28
Edition: 28
 Plus: 6 artist's proofs (1 AIC)
Printer: Keith Brintzenhofe

Jacques Lipchitz

Marisol

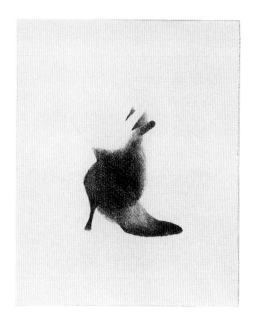

1. THE COUPLE, 1957
Screenprint
Paper: white wove A. Millbourn
Sheet: 560×765 mm (22×30 in.)
Edition: 98
 Plus: 11 proofs
Note: On 5 impressions and 11 proofs, the
screenprinted signature was not filled in by
hand
Printer: Maurice Grosman
According to a memorandum dated January 24,
1967, written in Maurice Grosman's
handwriting, labels for *The Couple* were
printed by Douglass Howell on handmade
paper.
Not illustrated

1. FURSHOE, 1964
Lithograph from one stone
Paper: white wove Chatham British handmade
Sheet: 643×510 mm (25⁵/₁₆×20¹/₁₆ in.)
Numbered, signed, dated; lower center: x/25
Marisol 1964
ULAE embossed stamp lower center
Edition: 25
 Plus: unrecorded artist's proofs (1 AIC)
Printers: Ben Berns and Frank B. Burnham
The hand and shoe in Marisol's first three
prints (cat. nos. 1-3) were her own.

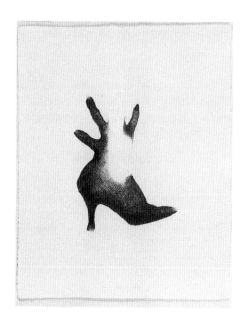

2. SHOE AND HAND, 1964
Lithograph from one stone
Paper: ivory wove Chatham British handmade
Sheet: 642×510 mm (25¹/₄×20¹/₁₆ in.)
Numbered, signed, dated; lower center: x/27
Marisol 1964
ULAE embossed stamp lower center
Edition: 27
 Plus: unrecorded artist's proofs (1 AIC)
Printers: Ben Berns and Frank B. Burnham

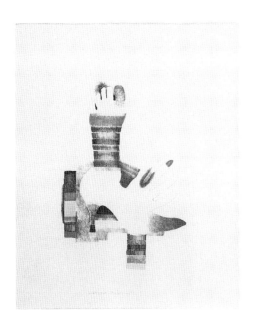

3. PAPPAGALLO, 1965
Lithograph from three stones
Paper: ivory wove Chatham British handmade
Sheet: 643×513 mm (25¹¹/₁₆×19¹/₁₆ in.)
Numbered, signed, dated; lower center: x/20
Marisol 1965
ULAE embossed stamp lower center
Edition: 20
 Plus: 1 artist's proof (1 AIC)
Printers: Ben Berns and Frank B. Burnham
See plate 102

4. HAND AND PURSE, 1965
Lithograph from one stone
Paper: ivory wove
Watermark: BFK RIVES
Sheet: 1054×752 mm (41½×29⅝ in.)
Signed, numbered, dated; lower center: Marisol
x/21 1965
ULAE embossed stamp lower center
Edition: 21
 Plus: 6 artist's proofs (1 AIC)
 6 proofs H. C.
Printers: Ben Berns and Mike Kuhno
This is one of Marisol's best-known graphics.
The purse was the one Marisol carried to work
at ULAE; the arm and fingers are traced from
her own.

5. THE KISS, 1965
Lithograph from three stones
Paper: white wove
Watermark: JAPAN
Sheet: 570×444 mm (22⁷/₁₆×17½ in.)
Numbered, signed, dated; lower center: x/26
Marisol 1965
ULAE embossed stamp lower center
Edition: 26 (1 AIC)
Printers: Ben Berns and Mike Kuhno
In 1965 Marisol's drawings took up a new
theme: Outlines of faces and hands are
interwoven to create perceptual reverses, thus
creating psychological as well as formal
ambiguities. Throughout the 1960s, Marisol
continued to elaborate on the decorative and
erotic implications of this early example.

6. FRENCH CURVE, 1970
Etching from one copper plate
Paper: white wove Dutch Etching
Plate: 200×267 mm (7⅞×10½ in.)
Sheet: 654×485 mm (25¾×19 in.)
Signed, dated, numbered; lower center: Dr.
Marisol 1970 x/26
ULAE embossed stamp lower center
Edition: 26
 Plus: 2 artist's proofs (1 AIC)
 1 printer's proof
Printer: Donn Steward
French Curve was Marisol's first published
intaglio print. The signature celebrates the
artist's recent honorary doctorate from Moore
College of Art in Philadelphia.

7. PNOM PENH, ONE, 1970
Etching from one plate
Paper: white wove Chatham British handmade
Plate: 600×454 mm (23⅝×17⅞ in.)
Sheet: 1051×708 mm (41⅜×27⅞ in.)
Numbered, signed, dated; lower right: x/19
Marisol 1970
Edition: 19
 Plus: 4 artist's proofs (1 AIC)
 1 printer's proof
 2 trial proofs
Printer: Donn Steward
Plate preserved and used for *Pnom Penh, Two*
(cat. no. 8)

8. PNOM PENH, TWO, 1970
Etching from one plate (previously used for
Pnom Penh, One [cat. no. 7])
Paper: black wove Murillo
Plate: 601×454 mm (23¹¹/₁₆×17⅞ in.)
Sheet: 1016×699 mm (40×27½ in.)
Numbered, signed, dated; lower right: x/19
Marisol 1970
Edition: 19
 Plus: 4 artist's proofs (1 AIC)
 1 printer's proof
 2 trial proofs
Printer: Donn Steward

9. KALIMPONG 1, 1970
Etching from one plate
Paper: black wove Murillo
Plate: 452×299 mm (17¹³⁄₁₆×11¾ in.)
Sheet: 699×513 mm (27½×20³⁄₁₆ in.)
Numbered, signed, dated; lower right: x/17
Marisol 1970
Edition: 17
 Plus: 4 artist's proofs (1 AIC)
 1 printer's proof
Printer: Donn Steward
Plate temporarily preserved

10. KALIMPONG 2, 1970
Etching from one plate
Paper: white wove
Watermark: HANDMADE/HAYLE MILL 8/ENGLAND 1968
Plate: 448×298 mm (17⅝×11¾ in.)
Sheet: 795×564 mm (31⁵⁄₁₆×22³⁄₁₆ in.)
Numbered, signed, dated; lower right: x/22
Marisol 1970
Edition: 22
 Plus: 4 artist's proofs (1 AIC)
 1 printer's proof
 4 trial proofs on various papers
Printer: Donn Steward
Plate temporarily preserved
The titles for *Pnom Penh, One* and *Two* and
Kalimpong 1 and *2* (cat. nos. 7-10)
commemorate places Marisol visited during the
eight months she spent touring Thailand,
Cambodia, India, Indonesia, and Nepal just
prior to making these etchings.

11. FIVE HANDS AND ONE FINGER, 1971
Lithograph from one stone
Paper: white wove Jeff Goodman handmade
Watermark: JG
Sheet: 460×629 mm (18⅛×24¾ in.)
Numbered, signed, dated; lower left: x/18
Marisol 1971
ULAE embossed stamp lower right
Edition: 18
 Plus: 5 artist's proofs (1 AIC)
 2 printer's proofs
Printers: Zigmunds Priede and Glenn Lee
In a rare instance of overt participation, Mrs.
Grosman suggested that Marisol press her
hands directly on the stone.

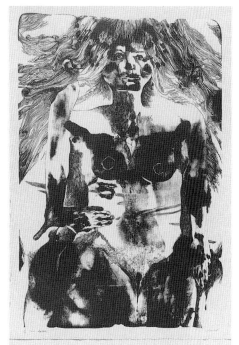

13. THE DEATH OF HEAD AND LEG, 1969-73
Etching from one plate
Paper: ivory wove J. Green handmade
Watermark: J
Plate: 602×895 mm (23¹¹/₁₆×35¼ in.)
Sheet: 703×1033 mm (27¹¹/₁₆×40¹¹/₁₆ in.)
Signed, dated, numbered; lower right: Marisol
1973 x/16
Edition: 16
　　Plus: 4 artist's proofs (1 AIC)
　　　　1 printer's proof
Printer: Donn Steward
Plate temporarily preserved
This was Marisol's first attempt at etching,
though it was not published until 1973.

12. DIPTYCH, 1971
Lithograph from two stones
Paper: white wove Arches
Sheet: two sheets, each 1213×804 mm
(47¾×31⅝ in.)
Signed; lower right, top sheet: Marisol
Numbered, dated, inscribed; lower left, top
sheet: x/33 1971 diptych
Signed; lower right, bottom sheet: Escobar
Numbered, dated, inscribed; lower left, bottom
sheet: x/33 1971 diptych
ULAE embossed stamp lower right, each sheet
Edition: 33 (12 signed [1 AIC]; 21 unsigned)
　　Plus: 1 trial proof
Printers: Zigmunds Priede and Steve Anderson
Stones temporarily preserved

14. SELF-PORTRAIT, 1970-73
Etching from one plate
Paper: white wove Chatham British handmade
Plate: 598×449 mm (23⁹/₁₆×17¹¹/₁₆ in.)
Sheet: 1043×697 mm (41¹/₁₆×27⁷/₁₆ in.)
Signed, dated, numbered; lower center: Marisol
1973 x/15
ULAE embossed stamp lower center
Edition: 15
 Plus: 4 artist's proofs (1 AIC)
 1 printer's proof
Printer: Donn Steward
Plate temporarily preserved
With its reference to the head of Queen
Nefertiti, this self-portrait is Marisol's most
accomplished etching of the early 1970s. The
metamorphosis from full-face to profile is
accomplished without outline, using the
increasingly expressive graphic style typical of
her portraits of the next decade.

15. THE SPOON, 1970-73
Etching and aquatint from one plate
Paper: white wove Chatham British handmade
Plate: 547×436 mm (21¹/₂×17³/₁₆ in.)
Sheet: 1046×699 mm (41³/₁₆×27¹/₂ in.)
Signed, dated, numbered; lower right: Marisol
1973 x/10
Edition: 10
 Plus: 2 artist's proofs (1 AIC)
 1 printer's proof
Printer: Donn Steward
Plate temporarily preserved

16. MORNING GLORY, 1970-73
Etching from one plate
Paper: white wove Italia
Watermark: Magnani emblem
Plate: 210×182 mm (8¹/₂×7¹/₈ in.)
Sheet: 513×353 mm (20¹/₈×13⁷/₈ in.)
Signed; lower left: Marisol
Numbered, dated; lower right: x/27 1970-73
Edition: 27
 Plus: 4 artist's proofs (1 AIC)
 1 printer's proof
 2 trial proofs (on Auvergne à la Main
 paper)
Printer: Donn Steward

17. CATALPA MAIDEN ABOUT TO TOUCH
HERSELF, 1973
Lithograph from four stones and one plate
Paper: gray wove Murillo handmade
Sheet: 1019×705 mm (40⁵⁄₁₆×27¾ in.)
Signed, dated, numbered; upper right: Marisol
1973 x/24
ULAE embossed stamp upper left
Edition: 24
 Plus: 4 artist's proofs (1 AIC)
 2 printer's proofs
 1 trial proof
 4 proofs H. C.
Printers: Bill Goldston and John A. Lund
See plate 105

18. HAND IN LEAF, 1973
Lithograph from one stone
Paper: tan laid Japan
Sheet: 771×638 mm (30⅜×25⅛ in.)
Signed, dated, numbered; lower center: Marisol
1973 x/30
ULAE embossed stamp lower center
Edition: 30
 Plus: 5 artist's proofs (1 AIC)
 2 printer's proofs
Printers: Bill Goldston and John A. Lund

19. I HATE YOU, 1973
Etching from one plate
Paper: white wove Dutch Etching
Plate: 303×301 mm (11¹⁵⁄₁₆×11⁷⁄₈ in.)
Sheet: 755×565 mm (29¾×22¼ in.)
Signed, numbered, dated; lower right: Marisol
x/25 1973
Edition: 25
 Plus: 4 artist's proofs (1 AIC)
 1 printer's proof
Printer: Donn Steward
This etching precedes a series of drawings on
the same theme done during the mid-1970s. The
rage expressed here is not mollified by the
seductive colors used in the drawings.

20. FOREST, 1973
Lithograph from one stone
Paper: white wove
Watermark: HANDMADE J WHATMAN 1952 ENGLAND
Sheet: 494×617 mm (19⁷⁄₁₆×24⁵⁄₁₆ in.)
Signed, numbered, dated; lower right: Marisol
x/25 1973
Edition: 25
 Plus: 4 artist's proofs (1 AIC)
 2 printer's proofs
Printers: Bill Goldston and John A. Lund

21. CULTURAL HEAD, 1973
Lithograph from five plates
Paper: tan wove Jeff Goodman handmade
Watermark: JG
Sheet: 736×581 mm (28¹⁵⁄₁₆×22⁷⁄₈ in.)
Signed, numbered, dated; lower center: Marisol
x/12 1973
ULAE embossed stamp lower right
Edition: 12
 Plus: 3 artist's proofs (1 AIC)
 1 printer's proof
 1 trial proof
 3 proofs marked "Litho + 1/3-3/3"
Printers: Bill Goldston and James V. Smith
Plates temporarily preserved and transferred to
offset plates printed as an unlimited poster
edition by Telamon Editions, a subsidiary of
ULAE
See plate 106

Robert Motherwell

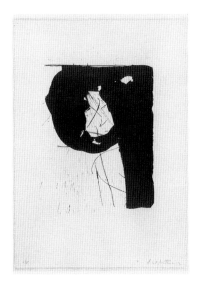

1. POET I, 1961-62
Lithograph from one stone
Paper: white wove
Watermark: ARCHES
Sheet: 764×564 mm (30¹/₁₆ × 22³/₁₆ in.)
Signed, numbered; lower right: R Motherwell
x/22
Edition: 22
 Plus: 2 artist's proofs
 trial proofs (1 AIC)
 cancellation proof (1 AIC)
Printer: Robert Blackburn
Catalogue reference: Belknap 2
Mrs. Grosman often said that it was "the word
in the painting" that attracted her to
Motherwell's work—a preference the artist
discovered after he began to work at ULAE. The
"P" shape used here first appeared in a 1959
collage, without any intention on the part of the
artist to exploit its sign value.

2. POET II, 1961-62
Lithograph from one stone
Paper: white wove German Copperplate
Sheet: 755×537 mm (29¾ × 21⅛ in.)
Signed; lower right: Robert Motherwell
Numbered; lower left: x/35
Edition: 35 (1 AIC)
 Plus: 4 artist's proofs
 1 cancellation proof (1 AIC)
Printer: Robert Blackburn
Catalogue reference: Belknap 3

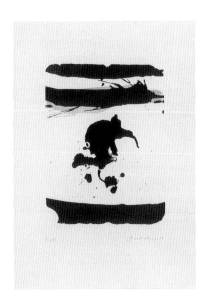

3. IN BLACK WITH YELLOW OCHRE, 1963
Lithograph from two stones
Paper: white wove German Copperplate
Sheet: 761×540 mm (29¹⁵/₁₆ × 21¼ in.)
Signed, dated; lower right: Robert Motherwell
63
Numbered; lower left: x/21
Edition: 21
 Plus: 2 proofs inscribed "Proof A" and
 "Proof B" (1 AIC "Proof B")
 trial proofs (8 AIC)
 working proofs (2 AIC)
Printer: Zigmunds Priede
Catalogue reference: Belknap 4
After a good-sized edition had already been
printed, Zigmunds Priede discovered that the
"layered look" was not what Motherwell
wanted. The edition was printed again, this time
rapidly so that the second color was printed
before the first had dried.
See plate 109

4. GAULOISES BLEUES, 1968
Aquatint from one copper plate and hand-torn
collage of Gauloises cigarette label
Paper: white wove Dutch Copperplate Etching
Plate: 253×138 mm (9¹⁵⁄₁₆×5⁷⁄₁₆ in.)
Sheet: 563×364 mm (22³⁄₁₆×14⁵⁄₁₆ in.)
Signed; lower right: Motherwell
Numbered; lower left: x/75
Edition: 75 (50 impressions printed in 1968;
 25 impressions printed in 1972)
 Plus: 4 artist's proofs (numbered I/IV to
 IV/IV) (1 AIC)
 1 printer's proof
 17 trial proofs, 5 unsigned (12 AIC)
 working proofs (2 AIC)
Printer: Donn Steward
Catalogue reference: Belknap 33
A large edition of *Gauloises Bleues* was under
way before Motherwell realized that a contract
with Marlborough Gallery limited the edition to
fifty. In 1972, after Motherwell changed dealers,
twenty-five unfinished prints were completed.
There are significant variations in the torn
labels in the second half of this
last set.
See plate 110

5. MEZZOTINT IN INDIGO, 1968-69
Mezzotint from one copper plate
Paper: white laid handmade
Watermark: AUVERGNE A LA MAIN; RICHARD DE BAS
Plate: 223×149 mm (8¾×5⅞ in.)
Sheet: 508×407 mm (20×16 in.)
Signed; lower right: Motherwell
Numbered; lower left: x/5
Edition: 5 (1 AIC)
 Plus: 2 artist's proofs
 1 printer's proof
 4 proofs H. C. (numbered H.C. 1-4)
Printer: Donn Steward
Plate preserved and used for *Mezzotint in
Crimson* (cat. no. 6)
Catalogue reference: Belknap 34
In their sensitive interaction with materials, a
result of copper's capacity to print the richest
and most sonorous color possible, the
Mezzotints (cat. nos. 5, 6) are related to the
plates Motherwell and Donn Steward were then
making for *A la pintura* (cat. nos. 15-38).

6. MEZZOTINT IN CRIMSON, 1968-69
Mezzotint from one copper plate (previously
used for *Mezzotint in Indigo* [cat. no. 5])
Paper: white wove Chatham British handmade
Plate: 226×151 mm (8⅞×5¹⁵⁄₁₆ in.)
Sheet: 630×502 mm (24¹³⁄₁₆×19¾ in.)
Signed; lower right: Motherwell
Numbered; lower left: x/9
ULAE embossed stamp upper right
Edition: 9 (1 AIC)
 Plus: 1 artist's proof on Dutch Etching
 paper torn to 22½×14 in.
 1 printer's proof on Dutch Etching
 paper torn to 20½×14 in.
 trial proofs (1 AIC)
Printer: Donn Steward
Catalogue reference: Belknap 35
The needle-sharp lines made by the mezzotint
tool for *Mezzotint in Indigo* (cat. no. 5) soon
began to wear and the hand-rocked plate had to
be reworked. The second state was used to print
Mezzotint in Crimson.

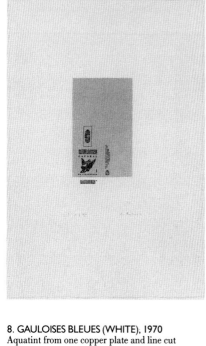

7. WEST ISLIP, 1965-70
Lithograph from two stones and two aluminum
plates with additions of semiopaque white
acrylic paint
Paper: white wove
Watermark: BFK RIVES
Sheet: 754×1057 mm (29¹¹/₁₆×41⅝ in.)
Signed, numbered; lower right: Motherwell /
x/20
Edition: 20
 Plus: 2 artist's proofs (1 AIC)
 1 printer's proof
 trial proofs (2 AIC)
 working proofs (1 AIC)
Printers: Ben Berns and David Umholz
Stones preserved and used for *Untitled*
(Appendix 9)
Catalogue reference: Belknap 36
See plate 112

8. GAULOISES BLEUES (WHITE), 1970
Aquatint from one copper plate and line cut
from one copper plate
Paper: white wove
Watermark: AUVERGNE A LÁ MAIN; RICHARD DE BAS
Plate: 295×165 mm (11⅝×6½ in.)
Sheet: 576×393 mm (22¹¹/₁₆×15½ in.)
Signed, numbered; lower right: R. Motherwell
x/40
Edition: 40
 Plus: 4 artist's proofs (numbered I-IV)
 (1 AIC)
 1 printer's proof
 trial proofs (4 AIC)
 working proofs (1 AIC)
Printer: Donn Steward
Plates temporarily preserved
Catalogue reference: Belknap 37
In the first *Gauloises Bleues* print (cat. no. 4),
the cigarette labels were torn and applied by
hand. In the subsequent ones (cat. nos. 8-10), the
collage was simulated by a linecut plate.

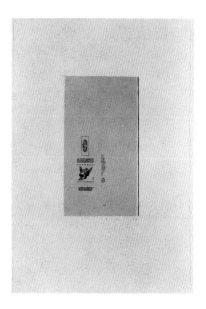

**9. GAULOISES BLEUES (RAW UMBER EDGE),
1971**
Aquatint from two copper plates and line cut
from one copper plate
Paper: white wove
Watermark: AUVERGNE A LA MAIN; RICHARD DE BAS
Plate: 295×167 mm (11⅝×6⁹/₁₆ in.)
Sheet: 583×393 mm (22¹⁵/₁₆×5½ in.)
Signed, numbered; lower right: R. Motherwell
x/38
Edition: 38
 Plus: 6 artist's proofs (numbered 1/6-6/6)
 1 printer's proof
 trial proofs (14 AIC)
 working proofs (1 AIC)
 3 proofs H. C. (numbered I/III-III/III)
 (1 AIC)
Printer: Donn Steward
Plates temporarily preserved
Catalogue reference: Belknap 70
See plate 113

10. GAULOISES BLEUES (YELLOW WITH
BLACK SQUARE), 1971
Aquatint from two copper plates and line cut
from one copper plate
Paper: white wove
Watermark: AUVERGNE A LA MAIN; RICHARD DE BAS
Plate: 295×165 mm (11⅝×6½ in.)
Sheet: 578×392 mm (22¾×15⁷⁄₁₆ in.)
Signed, numbered; lower right: R. Motherwell
x/35
Edition: 35
 Plus: 6 artist's proofs (numbered 1/6-6/6)
 (1 AIC)
 1 printer's proof
 trial proofs (4 AIC)
Printer: Donn Steward
Plates temporarily preserved
Catalogue reference: Belknap 71

11. SAMURAI, 1971
Lithograph from one plate
Paper: white wove Japanese Suzuki handmade
Sheet: 1845×937 mm (72⅝×36⅞ in.) (approx.)
Signed, numbered; lower right: R. Motherwell/
Proof X
ULAE embossed stamp lower right
Edition: 16 marked "Proof A" through "Proof
 P" (1 AIC)
 Plus: 2 trial proofs (1 AIC overpainted with
 gouache)
 3 unsigned proofs
Printers: Ben Berns and David Umholz
Plate temporarily preserved
Catalogue reference: Belknap 75
Samurai should properly be described as a
monoprint. The paper was not measured as it
was cut from the roll, so the size varies. In
addition, Motherwell decided to see how the
image would vary if it were not fixed with
lacquer and therefore produced an "edition of
proofs."

12. THE CELTIC STONE, 1970-71
Lithograph from one stone and two aluminum
plates
Paper: white wove
Watermark: BFK RIVES
Sheet: 1051×752 mm (41⅜×29⅝ in.)
Signed, numbered; lower right: R. Motherwell
x/25
Edition: 25
 Plus: 4 artist's proofs (numbered I/IV-IV/
 IV) (1 AIC)
 2 printer's proofs
 trial proofs (4 AIC)
 3 proofs H. C. (numbered H. C.
 1/3-3/3)
Printers: Ben Berns and David Umholz
Stone and plates preserved and used for *The
Black Douglas Stone* and *The Aberdeen Stone*
(cat. nos. 13, 14)
Catalogue reference: Belknap 72
The titles for catalogue numbers 12-14 are
autobiographical: "Celtic" and "Douglas"
refer to Motherwell's ancestry and "Aberdeen"
to his birthplace. For *The Celtic Stone*,
Motherwell matched the color of the ink to a
glass of Cinzano from the Grosmans' kitchen.

13. THE BLACK DOUGLAS STONE, 1970-71

Lithograph from one stone and one aluminum plate (previously used for *The Celtic Stone* [cat. no. 12])
Paper: white wove Arches
Watermark: Arches
Sheet: 1219×806 mm (47¹⁵/₁₆×31¾ in.)
Signed, numbered; lower right: R. Motherwell x/18
Edition: 18
 Plus: 2 artist's proofs (1 AIC)
 1 printer's proof
 8 proofs H. C. (numbered 1/8-8/8 H. C.)
 2 proofs H. C. (numbered AP I/II-II/II H. C.)
 trial proofs (5 AIC)
Printers: Ben Berns and David Umholz
Stone and plate preserved and used for *The Aberdeen Stone* (cat. no. 14)
Catalogue reference: Belknap 73

15-38. A LA PINTURA, 1968-72

A book of twenty-four unbound pages consisting of twenty-one intaglio prints, a frontispiece, a title page, a preface page by Raphael Alberti, an end page, a table of contents page, and a colophon page; the box, designed by the artist, is made of wood and Plexiglas faced with Formica and fastened with nautical fittings; the text is excerpted from *Selected Poems* written by Raphael Alberti, edited and translated by Ben Belitt, and published with the permission of the poet, the translator, the University of California Press, and the Regents of the University of California
Paper: white wove J. B. Green mold-made
Sheet: 655×970 mm (25¾×38³/₁₆ in.)
Box: 710×1106×153 mm (28×40×6 in.)
Signed; right center of colophon page in sepia ink: Robert Motherwell
Numbered; right center of colophon page in sepia ink: x/40
Each page is marked with the impression number and stamped in yellow ocher ink: "ROBERT MOTHERWELL/a la pintura."
Placement of impression number and stamp vary, but they are always in the lower margins.
Edition: 40
 Plus: 8 sets of artist's proofs (numbered I-VIII and signed: RM Trial 1972-79) (1 AIC)
 2 sets of printer's proofs (marked PP x/2)
 1 set of poet's proofs (marked R.A. 1/1)
 1 set of translator's proofs (marked B.B. 1/1)
 trial proofs (172 AIC)
 working proofs (141 AIC)
 2 "trial sets"
 21 practice trial proofs, artist's copies
 2 sets of cancellation proofs
 17 single dedication proofs
Printers: Donn Steward (intaglio plates), Juda Rosenberg (text hand-set and printed on letterpress), and Esther Pullman (first set of typography proofs)
Catalogue reference: Belknap 82-102

14. THE ABERDEEN STONE, 1970-71

Lithograph from one stone and two plates (previously used for *The Celtic Stone* and *The Black Douglas Stone* [cat. nos. 12, 13])
Paper: light gray wove Murillo
Sheet: 1022×708 mm (40¼×27⅞ in.)
Signed, numbered; lower right in yellow pencil: R Motherwell/x/10
ULAE embossed stamp lower right
Edition: 10
 Plus: 2 artist's proofs (numbered I & II) (1 AIC)
 1 printer's proof
 trial proofs (5 AIC)
 working proofs (1 AIC)
Printers: Ben Berns and David Umholz
Stone and plates temporarily preserved
Catalogue reference: Belknap 74

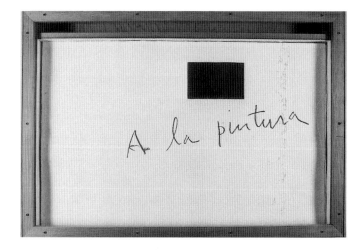

15. A LA PINTURA: FRONTISPIECE, 1971

Line block of artist's handwriting printed by letterpress and aquatint
Plate: 124×200 mm (4⅞×7⅞ in.)
See plate 115

16. A LA PINTURA: TITLE PAGE, 1971
Letterpress

17. A LA PINTURA: PREFACE PAGE, 1968-69
Letterpress, aquatint with lines varnished, lift-
ground etching, and aquatint from two plates
Plates: each 398 × 444 mm (15¾ × 17½ in.)
Text from *La Arboleda Perdida* by Raphael
Alberti
See plate 116

18. A LA PINTURA: TO THE PALETTE,
1968-71
Letterpress, lift-ground aquatint with etching,
and soft-ground etching from two plates
Plates: each 126 × 258 mm (4¹⁵⁄₁₆ × 10⅛ in.)
See plate 117

19. A LA PINTURA: BLACK 1-3, 1968
Letterpress, lift-ground etching, and aquatint
from two plates
Plates: each 570 × 308 mm (22½ × 12⅛ in.)
See page 119

20. A LA PINTURA: BLACK 4, 1968-69
Letterpress, lift-ground aquatint with etched
lines, and brushed aquatint from one plate
Plate: 444×736 mm (17½×29 in.)
See plate 120

21. A LA PINTURA: BLACK 5-11, 1968-71
Letterpress, aquatint, and lift-ground aquatint
with etching from two plates
Plates: each 137×231 mm (5⅜×9⅛ in.)
See plate 121

22. A LA PINTURA: BLUE 1-3, 1968-69
Letterpress, lift-ground etching, and aquatint
from two plates
Plates: each 469×272 mm (18½×10¾ in.)
See plate 122

23. A LA PINTURA: BLUE 4, 1968-71
Letterpress, lift-ground etching, and aquatint
from two plates
Plates: aquatint, 353×167 mm (13¹⁵⁄₁₆×6⅝ in.)
 lift-ground etching and aquatint,
 275×98 mm (10⅞×3⅞ in.)
See plate 123

24. A LA PINTURA: BLUE 5, 1968-69
Letterpress; aquatint with lines varnished,
printed with retroussage; and lift-ground with
etching and aquatint from two plates
Plates: each 218×218 mm (8⅝×8⅝ in.)
See plate 124

25. A LA PINTURA: BLUE 6-11, 1968-71
Letterpress, brushed aquatint, aquatint, and lift-
ground with etching and aquatint from three
plates
Plates: each 262×476 mm (10⁹/₁₆×18¾ in.)
See plate 125

26. A LA PINTURA: BLUE 12-13, 1969-71
Letterpress, double aquatint, and etching from
two plates
Plates: double aquatint, 196×123 mm
 (7¾×4⅞ in.)
 etching, 296×187 mm (11⅝×7⅜ in.)
See plate 126

27. A LA PINTURA: RED 1-3, 1969-71
Letterpress, aquatint, and lift-ground aquatint
from two plates
Plates: each 136×249 mm (5⅜×9¹³/₁₆ in.)
See plate 127

28. A LA PINTURA: RED 4-7, 1968-69
Letterpress, several aquatints, and lift-ground
with etching and aquatint from two plates
Plates: each 368×645 mm (14½×25⁷⁄₁₆ in.)
See plate 128

29. A LA PINTURA: RED 8-11, 1968-71
Letterpress, aquatint and brushed aquatint, and
lift-ground aquatint from two plates
Plates: each 609×698 mm (24×27½ in.)
See plate 129

30. A LA PINTURA: WHITE 1-2, 1968-71
Letterpress and lift-ground with etching and
aquatint with etched lines from one plate
Plate: 313×595 mm (12³⁄₈×23½ in.)
See plate 130

31. A LA PINTURA: WHITE 3-6, 1969-71
Letterpress and etching from one plate
Plate: 263×473 mm (10³⁄₈×18⁵⁄₈ in.)
See plate 131

Robert Motherwell
413

32. A LA PINTURA: WHITE 7-9, 1968-71
Letterpress, aquatint, and lift-ground etching
from three plates
Plates: each 356×322 mm (14×12¹¹/₁₆ in.)
See plate 132

33. A LA PINTURA: WHITE 10-13, 1968-72
Letterpress and soft-ground from two plates
Plates: 494×183 mm (19½×7³/₁₆ in.)
98×258 mm (3⅞×10³/₁₆ in.)
See plate 133

34. A LA PINTURA: WHITE 14-15, 1968-72
Letterpress, etching, and aquatint from two
plates
Plates: 457×610 mm (18×24 in.)
140×246 mm (5½×9¾ in.)
See plate 134

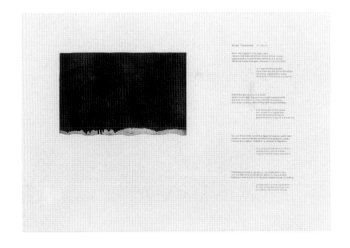

**35. A LA PINTURA: TO THE PAINTBRUSH,
1972**
Letterpress and soft-ground etching with
aquatint from one plate
Plate: 251×398 mm (9¹⁵/₁₆×15¹¹/₁₆ in.)
See plate 135

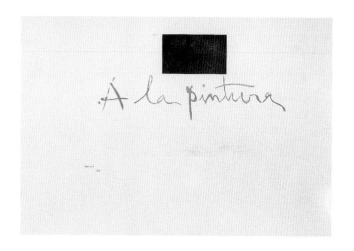

36. A LA PINTURA: END PAGE, 1971
Letterpress, several aquatints, and soft-ground
etching from two plates
Plates: 118×199 mm (4¹¹/₁₆ × 7⅝ in.)
364×700 mm (14⅜ × 27⁹/₁₆ in.)
See plate 136

**37. A LA PINTURA: TABLE OF CONTENTS
PAGE, 1971-72**
Letterpress

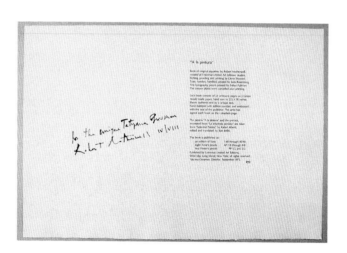

**38. A LA PINTURA: COLOPHON PAGE,
1968-72**
Letterpress
Signed, numbered; right center in sepia ink:
Robert Motherwell x/40

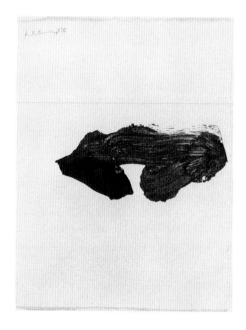

39. UNTITLED, 1972
Lithograph from one stone
Paper: pale pink wove Jeff Goodman handmade
Watermark: RM JG
Sheet: 590×455 mm (23¼ × 18 in.)
Signed, numbered; upper left: R. Motherwell
x/25
Stamped; lower right: Robert Motherwell
Spanish Refugee Art
ULAE embossed stamp lower right
Edition: 25
 Plus: 3 artist's proofs (numbered I/III-III/
 III) (1 AIC)
 1 printer's proof
 trial proofs (3 AIC)
 working proofs (1 AIC)
Printer: Bill Goldston
Catalogue reference: Belknap 81
This print is related to Motherwell's
monumental painting series *Elegies to the
Spanish Republic*, which bonded the artist's
name to Spain's culture and travails.

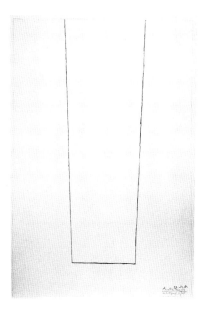

40. OPEN ON TWO WHITES, 1971-73
Lithograph from one stone and one aluminum
plate
Paper: white wove Arches Cover
Sheet: 1219×805 mm (47¹⁵/₁₆×31¹¹/₁₆ in.)
Signed, dated; lower right in colored pencils:
R. Motherwell/x/30
Edition: 30
 Plus: 4 artist's proofs (numbered I/IV-IV/
 IV) (1 AIC)
 trial proofs (6 AIC)
 working proofs (2 AIC)
Printer: Ben Berns
Stone and plate temporarily preserved
Catalogue reference: Belknap 103
The "two whites" are that of the paper and that
of the white ink; the signature reads as a flash of
color.

**Appendix 1-7. THROW OF THE DICE,
1962-63**
A series of seven lithographs, each from one
stone
Paper: white wove BFK Rives
Sheet: 762×560 mm (30×22 in.)
Signed; lower left: Robert Motherwell
Edition: A consistent edition was not published;
 impressions (some on colored papers)
 inscribed "trial proof" and "unique
 proof" were signed; each image was
 also proofed with a second stone
 printed in ocher
 Plus: trial proofs (15 AIC)
 working proofs (6 AIC)
Printer: Zigmunds Priede
Catalogue reference: Belknap appendix 2-8
These lithographs were done in the same spirit
as the series of spontaneous, flung-ink drawings
Motherwell did in 1962. This abandonment to
chance reminded Motherwell of the French
Symbolist poet Stéphane Mallarmé's poem,
from which Motherwell borrowed his title.

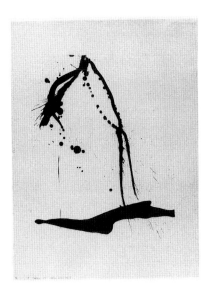

**Appendix 1. THROW OF THE DICE #1,
1962-63**
Lithograph from one stone
Catalogue reference: Belknap appendix 2

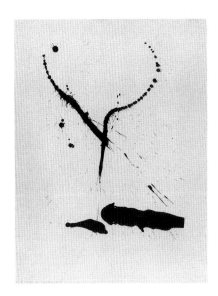

**Appendix 2. THROW OF THE DICE #2,
1962-63**
Lithograph from one stone
Catalogue reference: Belknap appendix 3

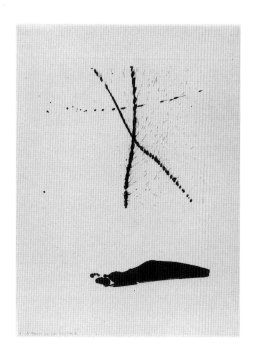

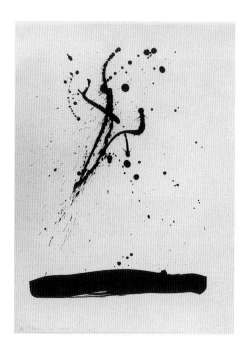

Appendix 3. THROW OF THE DICE #3,
1962-63
Lithograph from one stone
Catalogue reference: Belknap appendix 4

Appendix 4. THROW OF THE DICE #4,
1962-63
Lithograph from one stone
Catalogue reference: Belknap appendix 5

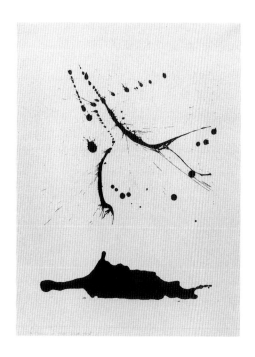

Appendix 5. THROW OF THE DICE #5,
1962-63
Lithograph from one stone
Catalogue reference: Belknap appendix 6

Appendix 6. THROW OF THE DICE #6,
1962-63
Lithograph from one stone
Catalogue reference: Belknap appendix 7

Appendix 7. THROW OF THE DICE #7,
1962-63
Lithograph from one stone
Catalogue reference: Belknap appendix 8

Appendix 8. TRICOLOR, 1973
Offset lithograph
Paper: white wove Arches
Sheet: 571×355 mm (22½×14 in.)
Signed; lower right: Motherwell
Initialed, dated; upper right: RM 73
Edition: 125
 Plus: 15 artist's proofs (numbered 1-15)
 (1 AIC)
 trial proofs (1 AIC)
Printer: Printed at Mourlot, Paris, from a plate
prepared and proofed by Bill Goldston at ULAE
Catalogue reference: Belknap appendix 24

Appendix 9. UNTITLED, 1982
Lithograph from two stones (previously used for
West Islip [cat. no. 7])
Paper: white wove
Watermark: BFK RIVES
Sheet: 756×1056 mm (29¾×41⁹⁄₁₆ in.)
Numbered, signed; lower right in colored pencil:
x/20 Motherwell
ULAE embossed stamp upper right
Edition: 20
 Plus: 5 artist's proofs (marked "A Proof"
 through "F Proof") (1 AIC)
Printer: Ben Berns

Barnett Newman

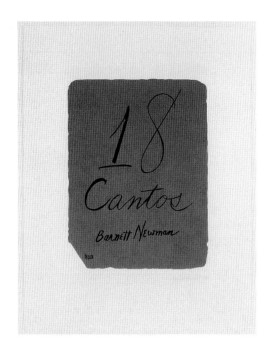

1-21. 18 CANTOS, 1963-64
Portfolio of eighteen lithographs printed from
seven stones and a title page, preface page with
text written by the artist, and a colophon page
contained in a handmade box bound in vellum
embossed with the initials "BN"; each print is
in a folder of Japan nacré paper; the box was
designed by the artist and made by Carolyn
Horton
Edition: 18 portfolios (1 AIC)
 Plus: 6 artist's proofs (single sheets)
 trial proofs (22 AIC)
 working proofs (10 AIC)
Printer: Zigmunds Priede

1. 18 CANTOS: TITLE PAGE, 1964
Paper: white wove
Watermark: ANGOUMOIS A LA MAIN/ULAE
Sheet: 643×500 mm (25¼×19¾ in.)
Signed, dated; lower right: Barnett Newman
4/64
Numbered; lower left: x/18
See plate 137

2. 18 CANTOS: PREFACE PAGE, 1963-64
Paper: ivory wove Shogun
Watermark: JAPAN
Sheet: 573×445 mm (22½×17½ in.)
Signed, dated; lower right: Barnett Newman
Numbered; lower left: x/18
See plate 138

3. 18 CANTOS: CANTO I, 1963
Paper: white wove British Chatham handmade
Sheet: 640×510 mm (25¼×20 in.)
Signed, dated; lower right: Barnett Newman
9/63
Numbered; lower left: x/18
See plate 139

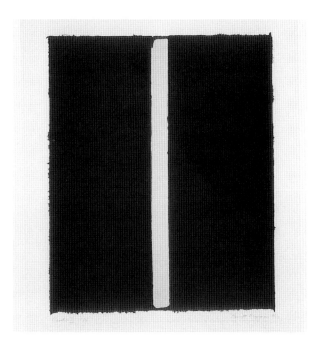

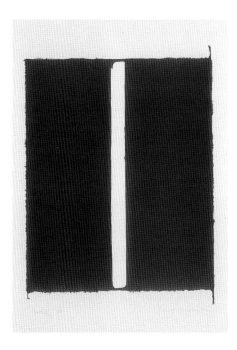

4. 18 CANTOS: CANTO II, 1963
Paper: gray laid
Watermark: ANGOUMOIS A LA MAIN
Sheet: 420×400 mm (16½×15¾ in.)
Signed, dated; lower right: Barnett Newman
9/63
Numbered; lower left: x/18
See plate 140

5. 18 CANTOS: CANTO III, 1963
Paper: white wove Shogun
Watermark: JAPAN
Sheet: 500×350 mm (19¾×13¾ in.)
Signed, dated; lower right: Barnett Newman
9/63
Numbered; lower left: x/18
See plate 141

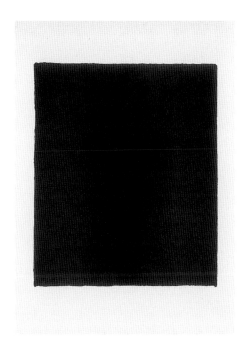

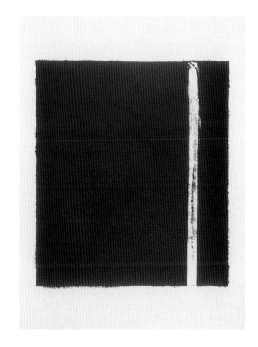

6. 18 CANTOS: CANTO IV, 1963
Paper: white wove British Chatham handmade
Sheet: 515×350 mm (20¼×13¾ in.)
Signed, dated; lower right: Barnett Newman
10/63
Numbered; lower left: x/18
See plate 142

7. 18 CANTOS: CANTO V, 1963
Paper: white laid
Watermark: ANGOUMOIS A LA MAIN
Sheet: 500×372 mm (19¾×14⅝ in.)
Signed, dated; lower right: Barnett Newman
11/63
Numbered; lower left: x/18
See plate 143

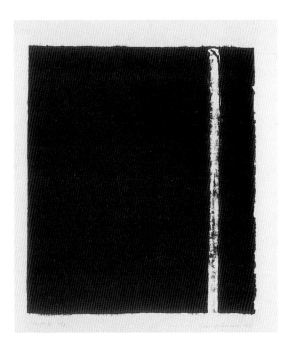

8. 18 CANTOS: CANTO VI, 1963
Paper: grayish white wove
Watermark: ANGOUMOIS A LA MAIN
Sheet: 420×322 mm (16½×12¾ in.)
Signed, dated; lower right: Barnett Newman
11/63
Numbered; lower left: x/18
See plate 144

9. 18 CANTOS: CANTO VII, 1963
Paper: grayish white wove
Watermark: ANGOUMOIS A LA MAIN
Sheet: 415×402 mm (16⅜×15⅞ in.)
Signed, dated; lower right: Barnett Newman
12/63
Numbered; lower left: x/18
See plate 145

10. 18 CANTOS: CANTO VIII, 1963
Paper: white wove
Watermark: ANGOUMOIS A LA MAIN/ULAE
Sheet: 448×384 mm (17⅝×15⅛ in.)
Signed, dated; lower right: Barnett Newman
12/63
Numbered; lower left: x/18
See plate 146

11. 18 CANTOS: CANTO IX, 1963-64
Paper: grayish white wove
Watermark: ANGOUMOIS A LA MAIN
Sheet: 412×400 mm (16¼×15¾ in.)
Signed, dated; lower right: Barnett Newman
1/64
Numbered; lower left: x/18
See plate 147

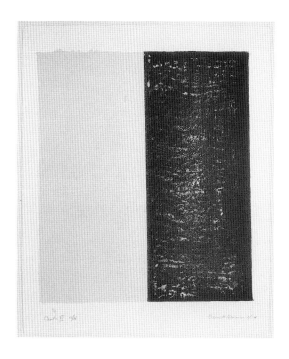

12. 18 CANTOS: CANTO X, 1964
Paper: white wove Shogun
Watermark: JAPAN
Sheet: 455×375 mm (18×14¾ in.)
Signed, dated; lower right: Barnett Newman
2/64
Numbered; lower left: x/18
See plate 148

13. 18 CANTOS: CANTO XI, 1964
Paper: white wove Shogun
Watermark: JAPAN
Sheet: 455×380 mm (18×15 in.)
Signed, dated; lower right: Barnett Newman
2/64
Numbered; lower left: x/18
See plate 149

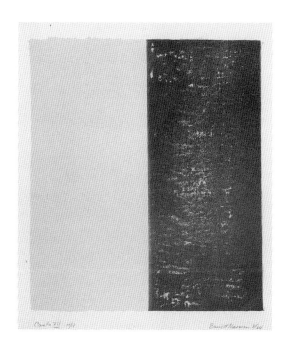

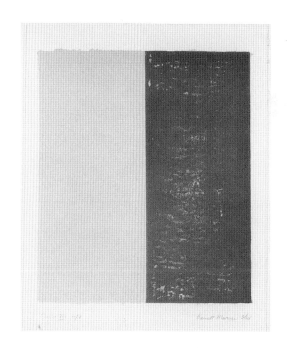

14. 18 CANTOS: CANTO XII, 1964
Paper: white wove Shogun
Watermark: JAPAN
Sheet: 452×370 mm (17¾×14⅝ in.)
Signed, dated; lower right: Barnett Newman
3/64
Numbered; lower left: x/18
See plate 150

15. 18 CANTOS: CANTO XIII, 1964
Paper: white wove Shogun
Watermark: JAPAN
Sheet: 450×375 mm (17¾×14¾ in.)
Signed, dated; lower right: Barnett Newman
3/64
Numbered; lower left: x/18
See plate 151

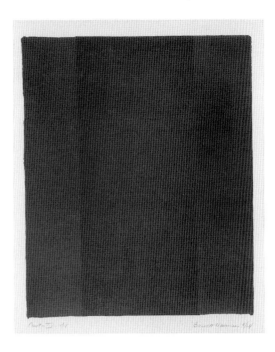

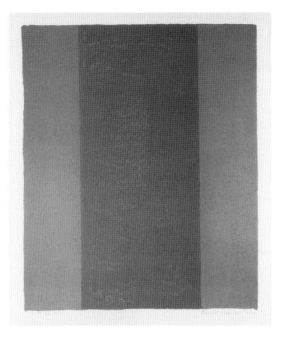

16. 18 CANTOS: CANTO XIV, 1964
Paper: grayish white laid
Watermark: ANGOUMOIS A LA MAIN
Sheet: 412×349 mm (16¼×13¾ in.)
Signed, dated; lower right: Barnett Newman
4/64
Numbered; lower left: x/18
See plate 152

17. 18 CANTOS: CANTO XV, 1964
Paper: white wove Shogun
Watermark: JAPAN
Sheet: 390×350 mm (15⅜×13¾ in.)
Signed, dated; lower right: Barnett Newman
4/64
Numbered; lower left: x/18
See plate 153

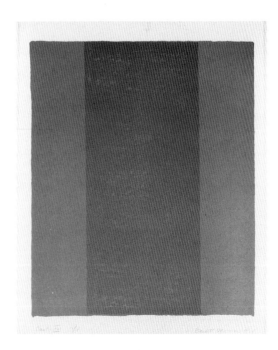

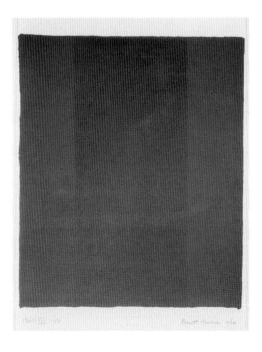

18. 18 CANTOS: CANTO XVI, 1964
Paper: white laid
Watermark: ANGOUMOIS A LA MAIN/ULAE
Sheet: 442×346 mm (17½×13⅝ in.)
Signed, dated; lower right: Barnett Newman
4/64
Numbered; lower left: x/18
See plate 154

19. 18 CANTOS: CANTO XVII, 1964
Paper: white wove Shogun
Watermark: JAPAN
Sheet: 447×325 mm (17⅝×12¾ in.)
Signed, dated; lower right: Barnett Newman
4/64
Numbered; lower left: x/18
See plate 155

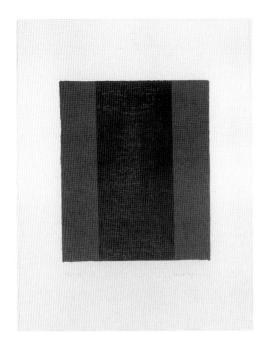

20. 18 CANTOS: CANTO XVIII, 1964
Paper: white laid
Watermark: ANGOUMOIS A LA MAIN/ULAE
Sheet: 640×500 mm (25¼×19¾ in.)
Signed, dated; lower right: Barnett Newman
4/64
Numbered; lower left: x/18
See plate 156

21. 18 CANTOS: COLOPHON PAGE, 1964
Paper: white laid
Watermark: ANGOUMOIS A LA MAIN/ULAE
Sheet: 572×443 mm (22½×17⅜ in.)

22-39. NOTES, 1968
A portfolio of eighteen etchings and aquatints
from twelve copper plates, contained in a
handmade box bound in vellum, embossed with
the initials "BN"; the box was made by Carolyn
Horton, following the design of the *Cantos* (cat.
nos. 1-21)
Paper: white wove Italia
Watermark: Magnani emblem
Signed; on the verso: Annalee A. Newman / May
16, 1978
Embossed; lower right: BN
Edition: 7 portfolios (1 AIC)
 Plus: 2 artist's proofs
 3 sets of proofs H. C.
 4 proofs H. C. of *Note IX-State III*
 (cat. no. 33)
Printer: Donn Steward
The eighteen *Notes* record Newman's self-
guided initiation into printing from copper
plates. In the first seven plates, he experimented
with marks; *Notes VIII* through *XII* are full-
fledged compositions, several closely related to
previous paintings. *Notes VIII* through *XII*
were a close collaboration with ULAE's Master
Printer Donn Steward, stimulating Newman
immediately to begin more ambitious plates
(cat. nos. 40, 41). Newman died before the
editions were signed; his widow authenticated
them ten years later.

22. NOTES: NOTE I, 1968
Etching from one plate
Plate: 150×74 mm (5¾×2⅞ in.)
Sheet: 505×355 mm (19⅞×14 in.)
Inscribed, dated, numbered; lower left: Note I
1968 / x/7

23. NOTES: NOTE II, 1968
Etching from one plate
Plate: 150×74 mm (5¾×2⅞ in.)
Sheet: 505×355 mm (19⅞×14 in.)
Inscribed, dated, numbered; lower left: Note II
1968 / x/7

24. NOTES: NOTE III, 1968
Etching from one plate
Plate: 150×74 mm (5¾×2⅞ in.)
Sheet: 505×355 mm (19⅞×14 in.)
Inscribed, dated, numbered; lower left: Note III
1968 / x/7

25. NOTES: NOTE IV, 1968
Etching from one plate
Plate: 150×74 mm (5¾×2⅞ in.)
Sheet: 505×355 mm (19⅞×14 in.)
Inscribed, dated, numbered; lower left: Note IV
1968 / x/7

26. NOTES: NOTE V, 1968
Etching from one plate
Plate: 150×74 mm (5¾×2⅞ in.)
Sheet: 505×355 mm (19⅞×14 in.)
Inscribed, dated, numbered; lower left: Note V
1968 / x/7

27. NOTES: NOTE VI, 1968
Etching from one plate
Plate: 150×74 mm (5¾×2⅞ in.)
Sheet: 505×355 mm (19⅞×14 in.)
Inscribed, dated, numbered; lower left: Note VI
1968 / x/7

28. NOTES: NOTE VII, 1968
Etching from one plate
Plate: 150×74 mm (5¾×2⅞ in.)
Sheet: 505×355 mm (19⅞×14 in.)
Inscribed, dated, numbered; lower left: Note VII
1968 / x/7

29. NOTES: NOTE VIII–STATE I, 1968
Etching and aquatint from one plate
Plate: 74×150 mm (2⅞×5¾ in.)
Sheet: 355×505 mm (14×19⅞ in.)
Inscribed, dated, numbered; lower left: Note
VIII–State I 1968 / x/7
Plate preserved and used for *Note VIII–State
II* (cat. no. 30)

30. NOTES: NOTE VIII–STATE II, 1968
Etching and aquatint from one plate (previously
used for *Note VIII–State I* [cat. no. 29])
Plate: 74×150 mm (27⁄8×53⁄4 in.)
Sheet: 355×505 mm (14×197⁄8 in.)
Inscribed, dated, numbered; lower left: Note
VIII–State II 1968 / x/7

31. NOTES: NOTE IX–STATE I, 1968
Etching and aquatint from one plate
Plate: 150×74 mm (53⁄4×27⁄8 in.)
Sheet: 505×355 mm (197⁄8×14 in.)
Inscribed, dated, numbered; lower left: Note
IX–State I 1968 / x/7
Plate preserved and used for *Note IX–State II*
and *Note IX–State III* (cat. nos. 32, 33)

32. NOTES: NOTE IX–STATE II, 1968
Etching and aquatint from one plate (previously
used for *Note IX–State I* [cat. no. 31])
Plate: 150×74 mm (53⁄4×27⁄8 in.)
Sheet: 505×355 mm (197⁄8×14 in.)
Inscribed, dated, numbered; lower left: Note IX
–State II 1968 / x/7
Plate preserved and used for *Note IX–State III*
(cat. no. 33)

33. NOTES: NOTE IX–STATE III, 1968
Etching and aquatint from one plate (previously
used for *Note IX–State I* and *Note IX–State II*
[cat. nos. 31, 32])
Plate: 150×74 mm (53⁄4×27⁄8 in.)
Sheet: 505×355 mm (197⁄8×14 in.)
Inscribed, dated, numbered; lower left: Note
IX–State III 1968 / x/7
Four proofs H.C. were printed of this plate, in
addition to the regular edition.

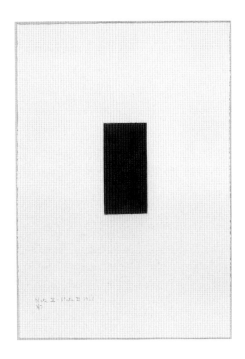

34. NOTES: NOTE X–STATE I, 1968
Etching and aquatint from one plate
Plate: 150×74 mm (5¾×2⅞ in.)
Sheet: 505×355 mm (19⅞×14 in.)
Inscribed, dated, numbered; lower left: Note
X–State I 1968 / x/7
Plate preserved and used for *Note X–State II*
(cat. no. 35)

35. NOTES: NOTE X–STATE II, 1968
Etching and aquatint from one plate (previously
used for *Note X–State I* [cat. no. 34])
Plate: 150×74 mm (5¾×2⅞ in.)
Sheet: 505×355 mm (19⅞×14 in.)
Inscribed, dated, numbered; lower left: Note
X–State II 1968 / x/7

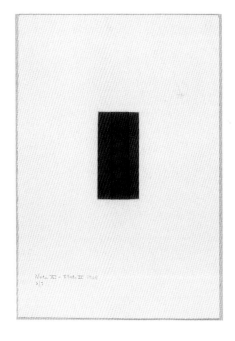

36. NOTES: NOTE XI–STATE I, 1968
Etching and aquatint from one plate
Plate: 150×74 mm (5¾×2⅞ in.)
Sheet: 505×355 mm (19⅞×14 in.)
Inscribed, dated, numbered; lower left: Note
XI–State I 1968 / x/7
Plate preserved and used for *Note XI–State II*
(cat. no. 37)

37. NOTES: NOTE XI–STATE II, 1968
Etching and aquatint from one plate (previously
used for *Note XI–State I* [cat. no. 36])
Plate: 150×74 mm (5¾×2⅞ in.)
Sheet: 505×355 mm (19⅞×14 in.)
Inscribed, dated, numbered; lower left: Note
XI–State II 1968 / x/7

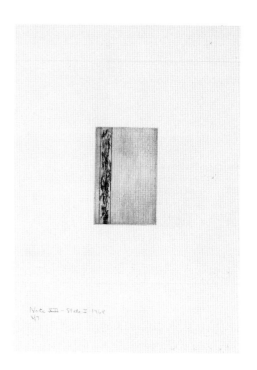

38. NOTES: NOTE XII–STATE I, 1968
Etching and aquatint from one plate
Plate: 150×99 mm (5¾×3⅞ in.)
Sheet: 505×355 mm (19⅞×14 in.)
Inscribed, dated, numbered; lower left: Note
XII–State I 1968 / x/7
Plate preserved and used for *Note XII–State II*
(cat. no. 39)

39. NOTES: NOTE XII–STATE II, 1968
Etching and aquatint from one plate (previously
used for *Note XII–State II* [cat. no. 38])
Plate: 150×99 mm (5¾×3⅞ in.)
Sheet: 505×355 mm (19⅞×14 in.)

40A. UNTITLED ETCHING #1, 1968
Etching from one plate
Paper: white wove J. Green handmade
Plate: 373×593 mm (14¾×23⅜ in.)
Sheet: 485×750 mm (19×29½ in.)
Signed; lower left verso, posthumously by
Annalee Newman
Numbered; lower left: x/27
Edition: 27
Printer: Donn Steward
This edition, printed at the end of 1968, was
intended for a Martin Luther King, Jr.,
Memorial Portfolio and the paper was hand-torn
to the specified size. After twenty-seven
impressions had been printed, Mrs. Grosman
and Newman decided not to participate in the
project since many of the original contributors
had withdrawn. This edition was authenticated
by Mrs. Newman and distributed by Harry N.
Abrams, Inc.
Not illustrated

40B. UNTITLED ETCHING #1, 1968-69
Etching from one plate
Paper: white wove J. B. Green
Watermark: HANDMADE HAYLE MILL 8
ENGLAND 1968
Plate: 370×590 mm (14½×23¼ in.)
Sheet: 575×805 mm (22½×31¾ in.)
Signed, dated; lower right: Barnett Newman
1969
Numbered; lower left: x/28
ULAE embossed stamp lower right
Edition: 28
 Plus: 4 artist's proofs (1 AIC)
 1 printer's proof
 trial proofs (8 AIC)
Printer: Donn Steward

41. UNTITLED ETCHING #2, 1969
Etching from one plate
Paper: ivory wove
Watermark: J. GREEN HAND-MADE
Plate: 594×373 mm (23⅜×14¹¹/₁₆ in.)
Sheet: 792×575 mm (31³/₁₆×22⅝ in.)
Signed, dated; lower right: Barnett Newman
1969
Numbered; lower left: x/27
ULAE embossed stamp lower right
Edition: 27
 Plus: 4 artist's proofs (1 AIC)
 1 printer's proof
 trial proofs (4 AIC)
Printer: Donn Steward
Plate temporarily preserved

1. TEA POT, 1975
Lithograph from one stone
Paper: coarse brown Balinese handmade
mounted on brown Moriki Japanese
Sheet: Balinese, 450×645 mm (17¾×25¼ in.)
 Japan, 465×665 mm (18¼×26¼ in.)
Signed, dated; lower right: Oldenburg/75
Numbered; lower left: x/34
Edition: 34
 Plus: 5 artist's proofs (1 AIC)
 2 printer's proofs
 12 proofs H. C.
Printers: Bill Goldston and John A. Lund
See plate 159

Robert Rauschenberg

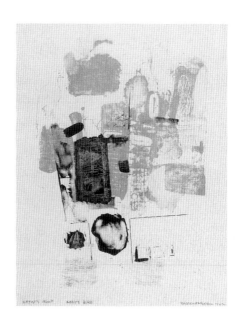

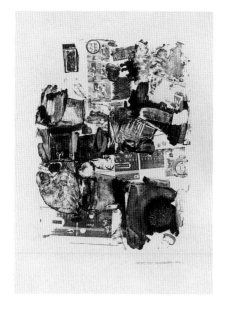

1. ABBY'S BIRD, 1962
Lithograph from three stones
Paper: white wove
Watermark: Strathmore use either side
Sheet: 585×457 mm (23×17¹⁵⁄16 in.)
Signed, dated; lower right: RAUSCHENBERG
1962
Numbered, inscribed; lower left: x/50 ABBY'S
BIRD
Edition: 50
 Plus: 4 or more artist's proofs (1 AIC)
 trial proofs (2 AIC)
Printer: Robert Blackburn
Catalogue reference: Foster 4
See plate 161

2. MERGER, 1962
Lithograph from one stone
Paper: white wove
Watermark: JAPAN
Sheet: 571×445 mm (22½×17½ in.)
Numbered, signed, dated; lower right: x/16
RAUSCHENBERG 1962
Edition: 16
 Plus: artist's proofs (1 AIC)
 trial proofs (1 AIC)
Printer: Robert Blackburn
Catalogue reference: Foster 5
Conceived as a collaboration between
Rauschenberg, Jim Dine, and Jean Tinguely,
Merger was to be used as a poster for "Dylaby"
(Dynamische Labyrinte), an exhibition at the
Stedelijk Museum, Amsterdam, in 1962.
Rauschenberg was the only artist to complete
his work on the stone.

3. URBAN, 1962
Lithograph from one stone
Paper: white wove
Watermark: BFK RIVES
Sheet: 1048×755 mm (41¼×29¾ in.)
Numbered, signed, dated; lower right: x/38
RAUSCHENBERG 1962
Edition: 38
 Plus: artist's proofs (1 AIC)
Printer: Robert Blackburn
Catalogue reference: Foster 6

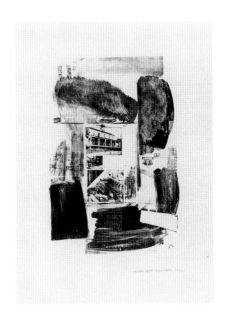

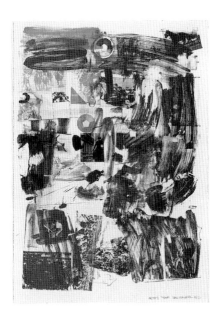

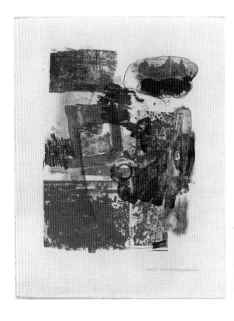

4. SUBURBAN, 1962
Lithograph from one stone
Paper: white wove
Watermark: BFK RIVES
Sheet: 1048×750 mm (41¼×29½ in.)
Numbered, signed, dated; lower right: x/25
RAUSCHENBERG 1962
Edition: 25
 Plus: artist's proofs (1 AIC)
Printer: Robert Blackburn
Catalogue reference: Foster 7

5. LICENSE, 1962
Lithograph from four stones
Paper: white wove
Watermark: BFK RIVES
Sheet: 1048×750 mm (41¼×29½ in.)
Numbered, signed, dated; lower right: x/16
RAUSCHENBERG 1962
Edition: 16
 Plus: 3 or 4 artist's proofs (1 AIC)
 trial proofs (2 AIC)
Printer: Robert Blackburn
Catalogue reference: Foster 8
In 1962 the large stone for *License* was one of
several that broke because of uneven pressure in
the press bed, thus limiting the edition to only
sixteen. The smaller stones were saved and used
as elements in the *Stunt Man* series (cat. nos.
6-8).

6. STUNT MAN I, 1962
Lithograph from two stones
Paper: white wove
Watermark: JAPAN
Sheet: 575×448 mm (25⅝×17⅝ in.)
Numbered, signed, dated; lower right: x/37
RAUSCHENBERG 1962
Edition: 37
 Plus: 3 or 4 artist's proofs (1 AIC)
 trial proofs (1 AIC)
 working proofs (2 AIC)
Printer: Robert Blackburn
Catalogue reference: Foster 9

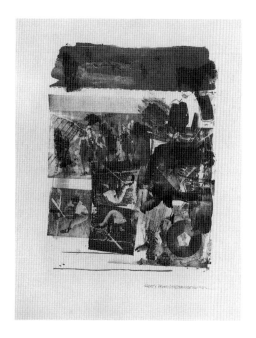

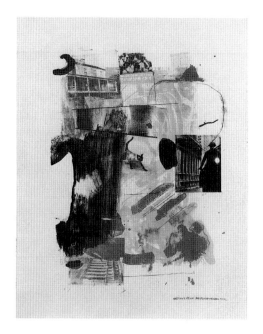

7. STUNT MAN II, 1962
Lithograph from three stones
Paper: white wove
Watermark: JAPAN
Sheet: 577×450 mm (22¹¹/₁₆×17¹¹/₁₆ in.)
Numbered, signed, dated; lower right: x/35
RAUSCHENBERG 1962
Edition: 35
 Plus: artist's proofs (1 AIC)
 3 trial proofs (3 AIC)
Printer: Robert Blackburn
Catalogue reference: Foster 10
See plate 162

8. STUNT MAN III, 1962
Lithograph from two stones
Paper: white wove
Watermark: JAPAN
Sheet: 578×448 mm (22¾×17⅝ in.)
Numbered, signed, dated; lower right: x/36
RAUSCHENBERG 1962
Edition: 36
 Plus: artist's proofs (1 AIC)
 4 trial proofs (3 AIC)
Printer: Robert Blackburn
Catalogue reference: Foster 11

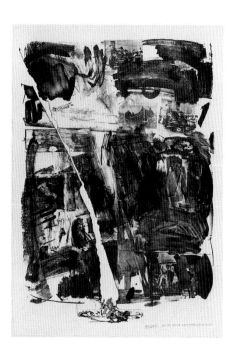

9. ACCIDENT, 1963
Lithograph from two stones
Paper: white wove
Watermark: BFK RIVES
Sheet: 1048×750 mm (41¼×29½ in.)
Inscribed, numbered, signed, dated; lower right:
ACCIDENT x/29 RAUSCHENBERG 1963
Edition: 29
 Plus: 3 artist's proofs of State 1 (before the
 stone broke) (2 AIC)
 1 artist's proof of State II
 trial proofs
Printers: Robert Blackburn and Zigmunds
Priede
Catalogue reference: Foster 12
Accident, awarded the Grand Prize at the Fifth
International Print Exhibition at Ljubljana,
Yugoslavia, was the result of a disaster during
printing. After a few impressions, the stone
broke in two pieces. Both the stone and proofs
were discarded. Rauschenberg made another,
which broke after three impressions.
Rauschenberg placed the two fragments back
on the press bed, added another stone he called
"the debris," and printed the edition.

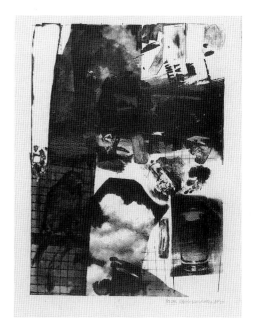

10. RIVAL, 1963
Lithograph from two stones
Paper: white laid
Sheet: 670×521 mm (26⅜×20½ in.)
Numbered, signed, dated; lower right: x/38
RAUSCHENBERG 1963
Edition: 38
 Plus: 3 or more artist's proofs (1 AIC)
 trial proofs (2 AIC)
A poster edition was also made in two colors,
printed by Daniel Murphy & Co.; the stones
were transferred to offset plates by Daniel
Edelman
Edition: 3000 (200 of the 3000 were signed)
Text of the poster, written by the artist:
RAUSCHENBERG / MAR. 31 → MAY 8 /
JEWISH MUSEUM / UNDER THE
AUSPICES OF THE JEWISH
THEOLOGICAL SEMINARY / OF AMERICA
/ 1109 FIFTH AVE / HOURS: SUNDAY 11 AM-6
PM / MON-THURS 12 NOON TO 5 / CLOSED
FRI-SAT
Printer: Frank B. Burnham
Catalogue reference: Foster 13

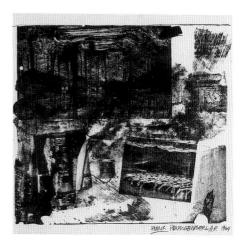

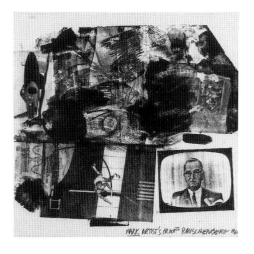

11. PLANK, 1964
Lithograph
Paper: white laid
Watermark: ANGOUMOIS A LA MAIN
Sheet: 397×413 mm (15⅝×16¼ in.)
Inscribed, numbered, signed, dated; lower right:
PLANK x/43 RAUSCHENBERG 1964
Edition: 43
 Plus: 1 or more artist's proofs (1 AIC)
 trial proofs (1 AIC)
 working proofs (1 AIC)
Printer: Frank B. Burnham
Catalogue reference: Foster 15
One impression of the Dante series (cat. nos. 11-
17) was included in each of the 300 copies of
*Rauschenberg's XXXIV Drawings for Dante's
Inferno*, a deluxe book published by Harry N.
Abrams, Inc., in 1964. The prints differ
considerably from the delicate drawings: harsh,
grainy, dense black-and-white imbrications of
mundane news photos, they contrast with the
velvety textures, delectable colors, and open
compositions of the drawings. The change in
medium prompted a change in mood.

12. MARK, 1964
Lithograph
Paper: white laid
Watermark: ANGOUMOIS A LA MAIN
Sheet: 400×413 mm (15¾×16¼ in.)
Inscribed, numbered, signed, dated; lower
center to lower right: MARK x/42
RAUSCHENBERG 1964
Edition: 42
 Plus: 2 artist's proofs (1 AIC)
 trial proofs (1 AIC)
 working proofs (1 AIC)
Printer: Frank B. Burnham
Catalogue reference: Foster 16

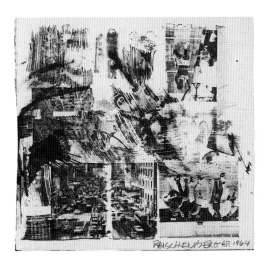

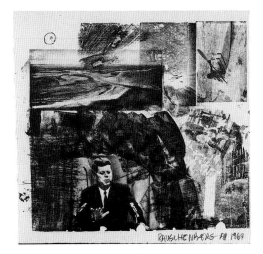

13. SINK, 1964
Lithograph
Paper: white laid
Watermark: ANGOUMOIS A LA MAIN
Sheet: 400×410 mm (15¾×16⅛ in.)
Signed, numbered, dated; lower right:
RAUSCHENBERG x/43 1964
Edition: 43
 Plus: 2 artist's proofs (1 AIC)
 working proofs (1 AIC)
Printer: Frank B. Burnham
Catalogue reference: Foster 17

14. ARK, 1964
Lithograph
Paper: white laid
Watermark: ANGOUMOIS A LA MAIN
Sheet: 396×410 mm (15⁹/16×16⅛ in.)
Signed, numbered, dated; lower right:
RAUSCHENBERG x/44 1964
Edition: 44
 Plus: 2 artist's proofs (1 AIC)
 trial proofs (1 AIC)
 working proofs (1 AIC)
Printer: Frank B. Burnham
Catalogue reference: Foster 18

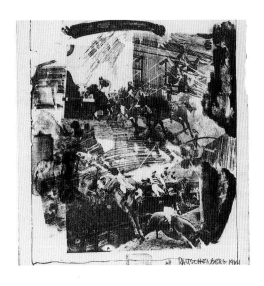

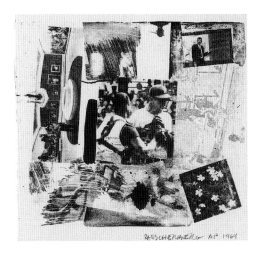

15. KAR, 1964
Lithograph
Paper: white laid
Watermark: ANGOUMOIS A LA MAIN
Sheet: 419×400 mm (16½×15¾ in.)
Signed, numbered, dated; lower right:
RAUSCHENBERG x/44 1964
Edition: 44
 Plus: 2 artist's proofs (1 AIC)
 working proofs (1 AIC)
Printer: Frank B. Burnham
Catalogue reference: Foster 19

16. RANK, 1964
Lithograph
Paper: white laid
Watermark: ANGOUMOIS A LA MAIN
Sheet: 398×407 mm (15¹¹/16×16 in.)
Inscribed, signed, numbered, dated; lower right:
RANK RAUSCHENBERG x/43 1964
Edition: 43
 Plus: 2 artist's proofs (1 AIC)
 trial proofs (1 AIC)
 working proofs (1 AIC)
Printer: Frank B. Burnham
Catalogue reference: Foster 20

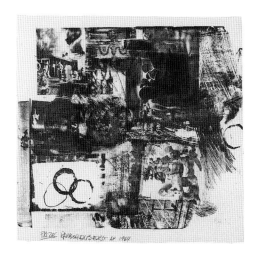

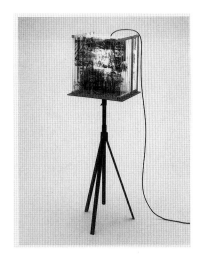

17. PRIZE, 1964
Lithograph
Paper: white laid
Watermark: ANGOUMOIS A LA MAIN
Sheet: 398×407 mm (15¹¹/₁₆×16 in.)
Inscribed, signed, numbered, dated; lower left:
PRIZE RAUSCHENBERG x/43 1964
Edition: 43
 Plus: 2 artist's proofs (1 AIC)
 working proofs (1 AIC)
Printer: Frank B. Burnham
Catalogue reference: Foster 21

18. SHADES, 1964
Six lithographs printed on Plexiglas "plates,"
mounted (five interchangeably) in a slotted
aluminum box, and illuminated by a movable
light bulb; an optional iron stand was designed
by the artist
Plates: each 355×355 mm (14×14 in.)
Box: 380×365×295 mm (15×14⅜×11⅝ in.)
Signed; lower right of colophon plate, engraved:
RAUSCHENBERG
Numbered; lower left of colophon plate: x/24
Edition: 24
 Plus: 3 artist's proofs numbered 0/24, 00/
 24, 000/24 (1 AIC)
Printer: Zigmunds Priede
Catalogue reference: Foster 22
Often called the first multiple of the 1960s,
Shades refers back to a history more European
than American, with the work of Marcel
Duchamp as its best-known precedent. Printing
on Plexiglas was Rauschenberg's innovation.
The five printed sheets have no fixed order, no
top or bottom; the viewer is free to arrange and
rearrange them. The light bulb is another
variable: It blinks or burns steadily, as the
viewer directs.

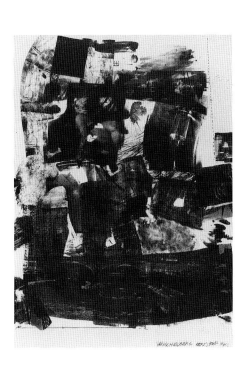

19. KIP-UP, 1964
Lithograph from one stone
Paper: white wove
Watermark: BFK RIVES
Sheet: 1045×756 mm (41⅛×29¾ in.)
Signed, numbered, dated; lower right:
RAUSCHENBERG x/33 1964
Edition: 33
 Plus: artist's proofs (1 AIC)
 working proofs (1 AIC)
Printer: Frank B. Burnham
Catalogue reference: Foster 23
The large black-and-white prints Rauschenberg
made in 1964-65 are very closely related to his
paintings of the period. The city view in *Kip-Up*
appeared in *Tideline* (1963; Louisiana Museum,
Humlebaek, Denmark); the Statue of Liberty
can be found in many paintings of the time.

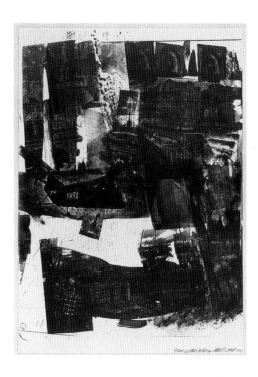

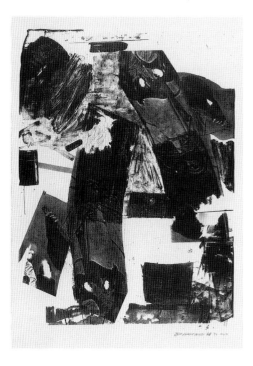

20. SPOT, 1964
Lithograph from one stone
Paper: white wove
Watermark: BFK RIVES
Sheet: 1047×753 mm (41¼×29⅝ in.)
Signed, numbered, dated; lower right:
RAUSCHENBERG x/37 1964
Edition: 37
 Plus: 3 or more artist's proofs (1 AIC)
 working proofs (1 AIC)
Printer: Frank B. Burnham
Catalogue reference: Foster 24
The title, "Spot," is intended by Rauschenberg
to convey its ambiguous meaning as both a
noun and verb: "spot" as a place and "spot" as
the act of fixing with the eye.

21. FRONT ROLL, 1964
Lithograph from two stones
Paper: white wove
Watermark: BFK RIVES
Sheet: 1048×758 mm (41¼×29¹³⁄₁₆ in.)
Inscribed, signed, numbered, dated; lower right:
FRONT ROLL RAUSCHENBERG x/39 1964
Edition: 39
 Plus: 4 artist's proofs (1 AIC)
 trial proofs (1 AIC)
 working proofs (1 AIC)
Printer: Frank B. Burnham
Catalogue reference: Foster 25
See plate 164

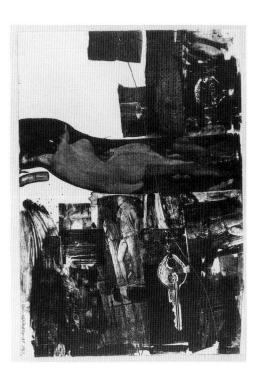

22. BREAKTHROUGH I, 1964
Lithograph from one stone
Paper: white wove
Watermark: BFK RIVES
Sheet: 1054×759 mm (41½×29⅞ in.)
Signed, dated; lower left: RAUSCHENBERG
1964
Numbered; lower right: x/20
ULAE embossed stamp lower right
Edition: 20
 Plus: artist's proofs (1 AIC)
 trial proofs (1 AIC)
Printer: Ben Berns
Stone preserved and used for *Breakthrough II*
(cat. no. 23)
Catalogue reference: Foster 26
Rauschenberg transferred only a few images
from paintings to prints; several of them appear
in *Breakthrough I* and *II* (cat. nos. 22, 23). The
painting most closely related is *Barge* (1963;
Walker Art Center, Minneapolis). The stone
used here was previously used by Lee Bontecou
for *Fourth Stone* (Bontecou, cat. no. 4). After
only twenty-odd impressions, the surface was no
longer intact; Rauschenberg liked the erosion
and used the crack through the face of
the Statue of Liberty as the basis for
Breakthrough II.

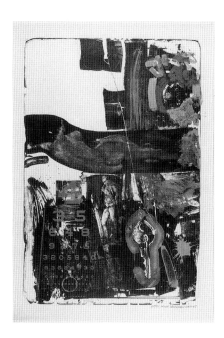

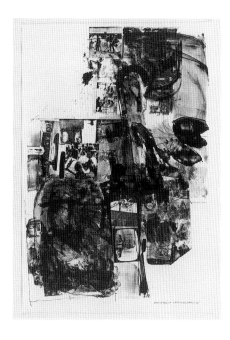

23. BREAKTHROUGH II, 1965
Lithograph from four stones (one stone
previously used for *Breakthrough I* [cat. no.
22])
Paper: white wove
Sheet: 1229×863 mm (48⅜×33¹⁵/₁₆ in.)
Signed, numbered, dated; lower right:
RAUSCHENBERG x/34 65
Edition: 34
 Plus: artist's proofs (1 AIC)
 trial proofs (9 AIC)
Printer: Ben Berns
First stone destroyed in printing; second and
third stones temporarily preserved; fourth stone
effaced
Catalogue reference: Foster 27
See plate 165

24. POST RALLY, 1965
Lithograph from five stones
Paper: white wove
Sheet: 1163×794 mm (45¾×31¼ in.)
Signed, numbered, dated; lower right:
RAUSCHENBERG x/42 65
Edition: 42
 Plus: artist's proofs (1 AIC)
 trial proofs (3 AIC)
 working proofs (2 AIC)
Printer: Ben Berns
Catalogue reference: Foster 28
In a rare example of autobiography,
Rauschenberg depicted the cane he was using
while recovering from a broken foot, injured
during a Merce Cunningham Dance Company
performance.

25. VISITATION I, 1965
Lithograph from two stones
Paper: white wove
Watermark: BFK RIVES
Sheet: 763×562 mm (30×22⅛ in.)
Signed, numbered, dated; lower right:
RAUSCHENBERG x/42 1965
Edition: 42 (1 AIC)
 Plus: trial proofs (5 AIC)
Printers: Ben Berns and Maurice Grosman
One stone preserved and used for *Visitation II*
(cat. no. 26)
Catalogue reference: Foster 29
When metal plates and offset printing replaced
cumbersome stones after World War II, fine
Bavarian limestones were thrown away. All of
ULAE's stones were commercial discards.
The back side of the two stones used for the
backgrounds of *Visitation I* and *Lawn* (cat. no.
27) had a graph paper pattern that Ben Berns
restored so Rauschenberg could use it.

26. VISITATION II, 1965
Lithograph from two stones (one stone
previously used for *Visitation I* [cat. no. 25])
Paper: white wove
Watermark: BFK RIVES
Sheet: 764×563 mm (30¹/₁₆×22³/₁₆ in.)
Signed, numbered, dated; lower right:
RAUSCHENBERG x/44 65
Edition: 44 (1 AIC)
 Plus: trial proofs (2 AIC)
Printer: Ben Berns
Catalogue reference: Foster 30

27. LAWN, 1965
Lithograph from two stones
Paper: white wove
Watermark: BFK RIVES
Sheet: 889×673 mm (35×26½ in.)
Signed, numbered, dated; lower right:
RAUSCHENBERG x/41 65
Edition: 41
 Plus: 2 artist's proofs
 9 proofs H.C. numbered
 1/9 to 9/9 HC (1 AIC)
 trial proofs (3 AIC)
Printer: Ben Berns
One stone temporarily preserved
Catalogue reference: Foster 31
See plate 168

28. SMART WEED, 1966
Lithograph from one stone
Paper: white wove
Watermark: Crisbrook emblem
Sheet: 795×573 mm (31¼×22½ in.)
Signed; lower left: RR
Edition: not editioned
 Plus: trial proofs (1 AIC)
Printer: Frank B. Burnham
The "Weed" of the title was Rauschenberg's
son Christopher, a student at the new Lincoln
School, for which this print was intended as a
benefit. The print was set aside after a few
proofs were pulled, and *Night Grip* (cat. no. 29)
took its place.

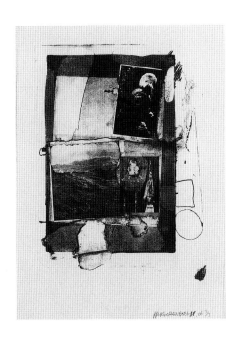

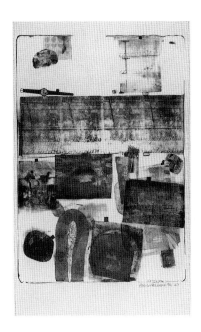

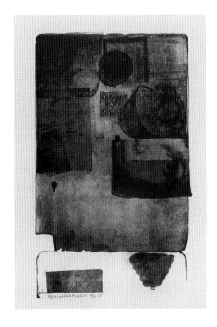

29. NIGHT GRIP, 1966
Lithograph from two stones
Paper: white wove British Crisbrook handmade
Sheet: 796×569 mm (31⅜×22⅜ in.)
Signed, numbered, dated; lower right:
RAUSCHENBERG x/35 66
Edition: 35
　　　Plus: 7 artist's proofs (1 AIC)
　　　　　1 printer's proof
　　　　　10 proofs H.C.
　　　　　trial proofs (5 AIC)
Printer: Donn Steward
See plate 169

30. DRIZZLE, 1967
Lithograph with embossing from three stones
and one plate
Paper: white wove
Watermark: J WHATMAN ENGLAND 1955
Sheet: 1359×782 mm (53½×30¾ in.)
Signed, numbered, dated; lower right:
RAUSCHENBERG x/29 67
Edition: 29
　　　Plus: 3 artist's proofs (1 AIC)
　　　　　1 printer's proof
　　　　　1 printer's proof H.C.
　　　　　14 proofs H.C.
　　　　　trial proofs (12 AIC)
Printer: Fred Genis
Catalogue reference: Foster 48
Drizzle, Gamble, and *Water Stop* (cat. nos.
30-32) were done soon after Rauschenberg
completed the monumental *Booster* series
lithographs on advanced equipment at Gemini
G.E.L. Returning to simpler procedures at
ULAE, Rauschenberg created this triad notable
for its delicacy of tone and imagery.

31. GAMBLE, 1968
Lithograph from four stones and one plate
Paper: white wove
Watermark: ENGLAND J WHATMAN 1958
Sheet: 1038×706 mm (40⅞×27¹³⁄₁₆ in.)
Signed, numbered, dated; lower left:
RAUSCHENBERG x/41 68
Edition: 41 (1 AIC)
　　　Plus: 3 artist's proofs
　　　　　1 printer's proof
　　　　　14 proofs H.C.
　　　　　trial proofs (15 AIC)
Printer: Fred Genis
Catalogue reference: Foster 49

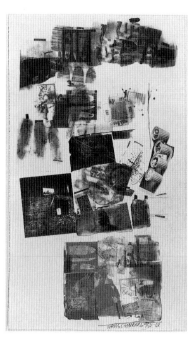

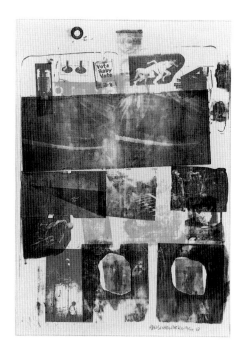

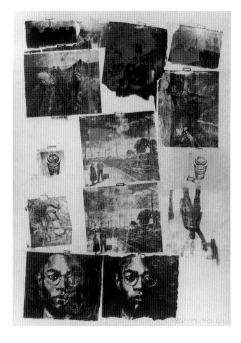

32. WATER STOP, 1968
Lithograph from nine stones and one intaglio
plate
Paper: ivory wove
Watermark: J WHATMAN ENGLAND 1961
Sheet: 1375×805 mm (54⅛×31¹¹/₁₆ in.)
Signed, numbered, dated; lower right:
RAUSCHENBERG x/28 '68
Edition: 28 (1 AIC)
 Plus: 4 artist's proofs
 3 printer's proofs
 4 proofs H. C.
 trial proofs (19 AIC)
Printers: Fred Genis, Donn Steward, and
Timothy Huchthausen
Stones and plate temporarily preserved
Catalogue reference: Foster 50
See plate 172

33. GUARDIAN, 1968
Lithograph with embossing from three stones
Paper: white wove German Copperplate
Sheet: 1080×767 mm (42½×30³/₁₆ in.)
Signed, numbered, dated; lower right:
RAUSCHENBERG x/44 68
ULAE embossed stamp lower right
Edition: 44 (1 AIC)
 Plus: 4 artist's proofs
 8 proofs H. C.
 trial proofs (8 AIC)
 5 proofs marked "Trigram"
Printer: Fred Genis
Catalogue reference: Foster 58

34. LANDMARK, 1968
Lithograph from two stones
Paper: white wove German Copperplate
Sheet: 1080×765 mm (42½×30⅛ in.)
Signed, numbered, dated; lower right:
RAUSCHENBERG x/40 68
ULAE embossed stamp lower right
Edition: 40
 Plus: 4 artist's proofs
 1 printer's proof
 7 proofs H. C. (1 AIC)
 trial proofs (3 AIC)
 5 proofs marked "Trigram"
 2 proofs marked "Litho +"
Printer: Fred Genis
Catalogue reference: Foster 59
See plate 173

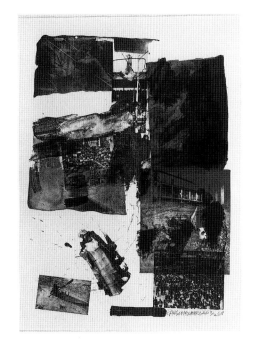

35. PLEDGE, 1968
Lithograph from two stones
Paper: white wove
Watermark: J WHATMAN 1956 ENGLAND
Sheet: 803×580 mm (31⅝×22¹³⁄₁₆ in.)
Signed, numbered, dated; lower right:
RAUSCHENBERG x/35 68
ULAE embossed stamp lower right
Edition: 35
 Plus: 4 artist's proofs
 1 printer's proof
 11 proofs H. C. (1 AIC)
 trial proofs (5 AIC)
Printer: Fred Genis
Catalogue reference: Foster 64

36. PROMISE, 1968
Lithograph from four stones
Paper: white wove
Watermark: J WHATMAN 1961 ENGLAND
Sheet: 785×582 mm (30⅞×22¹⁵⁄₁₆ in.)
Signed, numbered, dated; lower right:
RAUSCHENBERG x/35 68
ULAE embossed stamp lower right
Edition: 35
 Plus: 2 artist's proofs (1 AIC)
 1 printer's proof
 14 proofs H. C.
 trial proofs (3 AIC)
Printer: Fred Genis
Catalogue reference: Foster 65
See plate 175

37. INTAGLIO WATCH, 1968
Inkless intaglio from one plate
Paper: white wove
Watermark: ANGOUMOIS A LA MAIN
Plate: irregular
Sheet: 600×195 mm (23½×7⅝ in.)
Signed, numbered, dated; lower right:
RAUSCHENBERG x/13 68
Edition: 13
 Plus: 2 artist's proofs (1 AIC)
 trial proofs (1 AIC)
Printer: Donn Steward
Plate preserved in AIC archives
Catalogue reference: Foster 66
A copper plate with a pattern taken from the
artist's watch had been used in *Drizzle* (cat. no.
30). Thirteen impressions of the watch alone
were embossed on small sheets of handmade
paper, titled *Intaglio Watch*, and given as gifts
to guests at Maurice Grosman's birthday
luncheon.

38. TIDES, 1969
Lithograph from five stones
Paper: white wove German Copperplate
Sheet: 1068×740 mm (42¹/₁₆×29¹/₈ in.)
Signed, numbered, dated; upper left:
RAUSCHENBERG x/28 69
Edition: 28
 Plus: 5 artist's proofs (1 AIC)
 3 printer's proofs
 5 proofs H. C.
 trial proofs (4 AIC)
 1 proof marked "Litho +"
Printers: Zigmunds Priede and Bill Goldston
One stone preserved and used for *Unit
(Hydrant)* (cat. no. 44)
Catalogue reference: Foster 68
See plate 176

39. DRIFTS, 1969
Lithograph from four stones
Paper: white wove German Copperplate
Sheet: 1080×759 mm (42½×29⅞ in.)
Signed, numbered, dated; upper left:
RAUSCHENBERG x/35 69
Edition: 35 (1 AIC)
 Plus: 5 artist's proofs
 3 printer's proofs
 trial proofs (3 AIC)
 1 proof marked "Litho +"
Printers: Zigmunds Priede and Bill Goldston
One stone temporarily preserved
Catalogue reference: Foster 69

40. GULF, 1969
Lithograph from three stones
Paper: white wove German Copperplate
Sheet: 1080×758 mm (42½×29³/₁₆ in.)
Signed, numbered, dated; lower left:
RAUSCHENBERG x/31 69
Edition: 31 (1 AIC)
 Plus: 5 artist's proofs
 3 printer's proofs
 3 proofs H. C.
 trial proofs (6 AIC)
 2 proofs marked "Litho +"
Printers: Zigmunds Priede and Bill Goldston
One stone preserved and used for *Unit (Turtle)*
(cat. no. 43)
Catalogue reference: Foster 70

41. UNIT (BUFFALO), 1969
Lithograph from one stone
Paper: white wove Italia handmade
Watermark: Magnani emblem
Sheet: 508×709 mm (20×27^{15}/$_{16}$ in.)
Signed, numbered, dated; lower left:
RAUSCHENBERG x/25 69
ULAE embossed stamp lower right
Edition: 25
 Plus: 4 artist's proofs (1 AIC)
 1 printer's proof
 trial proofs (2 AIC)
Printers: Dan Socha and Jim Webb
Catalogue reference: Foster 105

42. UNIT (TURTLE), 1970
Lithograph from one stone (previously used for
Gulf [cat. no. 40])
Paper: white wove Italia handmade
Watermark: Magnani emblem
Sheet: 506×710 mm (19^{15}/$_{16}$×27^{15}/$_{16}$ in.)
Signed, numbered, dated; lower right:
RAUSCHENBERG x/30 70
Edition: 30
 Plus: 6 artist's proofs (1 AIC)
 3 printer's proofs
Printers: Zigmunds Priede, Bill Goldston, and
Dan Socha
Catalogue reference: Foster 106
The stone used in this print was made from a
photograph of Rauschenberg's pet turtle, Rocky.

43. UNIT (HYDRANT), 1970
Lithograph from one stone (previously used for
Tides [cat. no. 38])
Paper: white wove Italia handmade
Watermark: Magnani emblem
Sheet: 711×506 mm (27^{15}/$_{16}$×19^{15}/$_{16}$ in.)
Signed, numbered, dated; lower right:
RAUSCHENBERG x/27 70
Edition: 27
 Plus: 7 artist's proofs (1 AIC)
 3 printer's proofs
 7 proofs H. C.
Printers: Zigmunds Priede, Bill Goldston, and
Dan Socha
Catalogue reference: Foster 107

44. CENTENNIAL CERTIFICATE MMA, 1969
Lithograph from two stones and two plates
Paper: white laid Angoumois à la Main paper
made for this edition
Watermark: Metropolitan Museum of Art stamp
(Department of Prints and Drawings)
Note: also blind stamped with the seal of the
Metropolitan Museum of Art, lower right
Sheet: 900×630 mm (35¼×25¾ in.)
Signed, numbered, dated; lower left:
RAUSCHENBERG x/45 69
Edition: 45 (all delivered to the Metropolitan)
 Plus: 4 artist's proofs (1 AIC)
 2 printer's proofs
 6 proofs H. C.
 2 trial proofs
A poster edition of unrecorded size was printed
by offset lithography on white wove paper,
985×657 mm (38⅞×25⅞ in.); published by
Telamon Editions and printed by Frank Akers
and Bill Goldston
Printers: Frank Akers, Zigmunds Priede, Donn
Steward, and Dan Socha
Catalogue reference: Foster 71
See plate 177

45. TANYA, 1974
Lithograph from three stones with embossing
Paper: ivory wove handmade
Watermark: RICHARD DE BAS with 1326 and a
heart
Sheet: 571×391 mm (22½×15⅜ in.)
Signed, numbered, dated; lower left in brown
pencil: RAUSCHENBERG x/50 74
ULAE embossed "15 years" commemorative
stamp lower center; ULAE embossed stamp
lower right
Edition: 50
 Plus: 5 artist's proofs (1 AIC)
 1 printer's proof
 18 proofs H. C.
 3 trial proofs
Printers: Bill Goldston and John A. Lund
Stones temporarily preserved
See plate 178

46. VEILS I, 1974
Lithograph from one plate, created by light
transfer
Paper: white wove
Watermark: HAND MADE J WHATMAN 1949 ENGLAND B
Sheet: 575×779 mm (22⅝×30¹¹/₁₆ in.)
Signed, numbered, dated; lower right:
RAUSCHENBERG x/20 74
ULAE embossed stamp lower right
Edition: 20
 Plus: 5 artist's proofs (1 AIC)
 1 printer's proof
Printers: Bill Goldston and James V. Smith
In 1974 Rauschenberg began to work with
fabrics, most notably in his *Hoarfrost* series.
The *Veils* (cat. nos. 46-49) and *Treaty* (cat. no.
50) were made from Mrs. Grosman's kerchief,
which Rauschenberg dropped onto five
lithographic plates coated with photographic
emulsion; the result is almost pure abstraction.

47. VEILS 2, 1974
Lithograph from one plate, created by light
transfer
Paper: white wove
Watermark: HAND MADE J WHATMAN 1949 ENGLAND B
Sheet: 568×778 mm (22⅜×30⅝ in.)
Signed, numbered, dated; lower right:
RAUSCHENBERG x/21 74
ULAE embossed stamp lower right
Edition: 21
 Plus: 5 artist's proofs (1 AIC)
 1 printer's proof
Printers: Bill Goldston and James V. Smith

48. VEILS 3, 1974
Lithograph from one plate, created by light
transfer
Paper: white wove
Watermark: HAND MADE J WHATMAN 1949 ENGLAND
Sheet: 567×775 mm (22⁵⁄₁₆×30½ in.)
Signed, numbered, dated; lower right:
RAUSCHENBERG x/23 74
ULAE embossed stamp lower right
Edition: 23
 Plus: 5 artist's proofs (1 AIC)
 1 printer's proof
Printers: Bill Goldston and James V. Smith

49. VEILS 4, 1974
Lithograph from one plate, created by light
transfer
Paper: white wove
Watermark: HAND MADE J WHATMAN 1949 ENGLAND B
Sheet: 567×762 mm (22⁵⁄₁₆×30 in.)
Signed, numbered, dated; lower right:
RAUSCHENBERG x/18 74
ULAE embossed stamp lower right
Edition: 18
 Plus: 5 artist's proofs (1 AIC)
 1 printer's proof
Printers: Bill Goldston and James V. Smith

50. TREATY, 1974

Lithograph (vertical diptych); upper sheet from three stones, lower sheet from four stones
Paper: white wove
Watermark: ENGLAND J WHATMAN MOULD MADE 1952
Sheets: upper, 686×1021 mm (27¹/₁₆×40³/₁₆ in.)
lower, 686×1014 mm (27¹/₁₆×39¹⁵/₁₆ in.)
Signed; upper left upper sheet:
RAUSCHENBERG
Numbered, dated; lower left lower sheet: x/31 74
ULAE embossed stamp upper left upper sheet; lower left lower sheet
Edition: 31
 Plus: 5 artist's proofs (1 AIC)
 2 printer's proofs
 4 proofs H. C.
 2 special proofs
Printers: Bill Goldston and John A. Lund
Stones preserved and used for *Kitty Hawk* and *Killdevil Hill* (cat. nos. 51, 52)
Rauschenberg's 1971 exhibition at Leo Castelli's gallery in New York featured his *Cardboards*—sculptures made from cartons and other packing materials. At the same time, he made his *Cardbirds* multiples at Gemini G.E.L. These projects provided the imagery for his monumental prints of 1974-75: *Treaty, Kitty Hawk,* and *Killdevil Hill* (cat. nos. 50-52). For *Treaty,* the artist used paper bags found near the railroad tracks in West Islip, a child's shirt, printer's cheesecloth, and an unused plate made from Mrs. Grosman's kerchief.

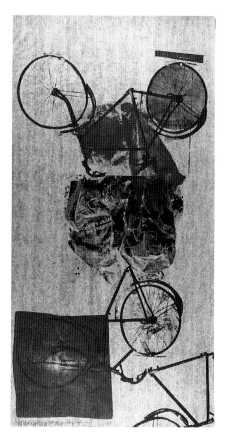

52. KILLDEVIL HILL, 1974-75

Lithograph (horizontal diptych) from five stones (previously used for *Treaty* and *Kitty Hawk* [cat. nos. 50, 51])
Paper: white wove handmade
Watermark: ENGLAND J WHATMAN MOULD MADE 1952
Sheets: left, 532×1017 mm (26¹⁵/₁₆×40¹/₁₆ in.)
 right, 532×1019 mm (26¹⁵/₁₆×40¹/₈ in.)
Signed; lower right left sheet and lower left right sheet, in reverse: RAUSCHENBERG
Numbered; lower left left sheet: x/42
Dated; lower right right sheet: 75
ULAE embossed stamp lower left left sheet and lower right right sheet
Edition: 42
 Plus: 5 artist's proofs (1 AIC)
 2 printer's proofs
 3 proofs H. C.
 1 trial proof
Printers: Bill Goldston and John A. Lund
Stones temporarily preserved

51. KITTY HAWK, 1974

Lithograph from eight stones (two stones previously used for *Treaty* [cat. no. 50])
Paper: brown Kraft wrapping
Sheet: 1998×1019 mm (78¹¹/₁₆×40¹/₈ in.)
Signed, numbered; lower left in black China marker: RAUSCHENBERG x/28
Dated; lower center: 74
Edition: 28
 Plus: 5 artist's proofs (1 AIC)
 2 printer's proofs
 2 proofs H. C.
 1 trial proof
Printers: Bill Goldston and John A. Lund
Stones preserved for use in *Killdevil Hill* (cat. no. 52)
This print and *Killdevil Hill* (cat. no. 52) pay oblique tribute to the Wright brothers and their historic flight. The imagery used here refers to an abandoned bicycle that Rauschenberg saw and tracked down in Paris, eventually attaching it to cardboard boxes as a "combine," which was exhibited in the Musée Galleria. He used photographs of it for *Kitty Hawk* and *Killdevil Hill.*

54-89. TRACES SUSPECTES EN SURFACE, 1972-78

36 lithographs, from 37 stones and 27 plates, printed on 31 pages plus a title page and 4 colophon pages, in a cloth-bound box designed by the artist and made by Carolyn Horton; text by Alain Robbe-Grillet
Paper: white wove handmade Twinrocker, in folders
Watermark: Robbe-Grillet RAUSCHENBERG (signatures)
Sheets: folded, 690×521 mm (27³/₁₆×20½ in.)
 unfolded, 690×1042 mm (27³/₁₆×41 in.)
Numbered, signed, dated; lower center unfolded sheet: x/36 Robbe-Grillet RAUSCHENBERG 72-78; page number embossed lower right margin folded sheet
ULAE embossed stamp lower right
Edition: 36
 Plus: 7 artist's proof portfolios (1 AIC)
 3 printer's proof portfolios
 1 portfolio H. C.
Printers: John A. Lund and James V. Smith
Long enamored of French literature and language, Tatyana Grosman attended a lecture by Alain Robbe-Grillet in April 1972. When the writer mentioned Robert Rauschenberg's work, Mrs. Grosman, already aware of stylistic similarities between the two, felt that a collaboration was fated. Two days later, it was under way. During the next four years, Mrs. Grosman sent offset plates to Paris and proofed and translated Robbe-Grillet's text in West Islip; Rauschenberg added images one chapter at a time. The completed pages were sent back to Robbe-Grillet with plates for the next chapter.

It soon became clear that Robbe-Grillet was not working in the spirit of sympathetic collaboration but providing a massive text that presented great problems in page design. Rauschenberg responded with images that are much more aloof than in previous books yet responsive to the elegance of the text.

53. 1977 PRESIDENTIAL INAUGURATION, 1977

Lithograph from four stones; text written by Rauschenberg for President Jimmy Carter's inauguration
Paper: white wove Twinrocker handmade
Watermark: around four sides of sheet: 1977 / PRESIDENTIAL / INAUGURATION / RAUSCHENBERG (signature)
Sheet: 774×540 mm (30½×21¾ in.)
Signed, numbered, dated; lower right:
RAUSCHENBERG x/100 77
Edition: 100
 20 special edition for President Carter and other officials
 Plus: 10 artist's proofs (1 AIC)
 2 printer's proofs
 2 trial proofs
Printers: Bill Goldston and Keith Brintzenhofe
Because it was for a unique occasion, Mrs. Grosman and Rauschenberg agreed to publish an edition considerably larger than usual. Rauschenberg received the honor of designing the inaugural poster by virtue of both his artistic reputation and his commitment to causes espoused by President Carter.

TRACES SUSPECTES EN SURFACE: COVER, 1972-78

54. TRACES SUSPECTES EN SURFACE:
TITLE PAGE, 1972-78

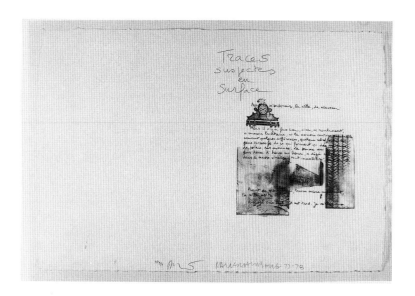

55. TRACES SUSPECTES EN SURFACE:
PAGE I, 1972-78

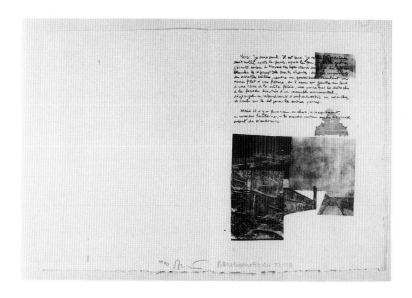

56. TRACES SUSPECTES EN SURFACE:
PAGE 2, 1972-78

57. TRACES SUSPECTES EN SURFACE:
PAGE 3, 1972-78

58. TRACES SUSPECTES EN SURFACE:
PAGE 4, 1972-78

59. TRACES SUSPECTES EN SURFACE:
PAGE 5, 1972-78

60. TRACES SUSPECTES EN SURFACE:
PAGE 6, 1972-78

61. TRACES SUSPECTES EN SURFACE:
PAGE 7, 1972-78

62. TRACES SUSPECTES EN SURFACE:
PAGE 8, 1972-78

63. TRACES SUSPECTES EN SURFACE:
PAGE 9, 1972-78

64. TRACES SUSPECTES EN SURFACE:
PAGE 10, 1972-78

65. TRACES SUSPECTES EN SURFACE:
PAGE 11, 1972-78

66. TRACES SUSPECTES EN SURFACE:
PAGE 12, 1972-78

67. TRACES SUSPECTES EN SURFACE:
PAGE 13, 1972-78

68. TRACES SUSPECTES EN SURFACE:
PAGE 14, 1972-78

69. TRACES SUSPECTES EN SURFACE:
PAGE 15, 1972-78

70. TRACES SUSPECTES EN SURFACE:
PAGE 16, 1972-78

71. TRACES SUSPECTES EN SURFACE:
PAGE 17, 1972-78

72. TRACES SUSPECTES EN SURFACE:
PAGE 18, 1972-78

72. TRACES SUSPECTES EN SURFACE:
PAGE 18, 1972-78

73. TRACES SUSPECTES EN SURFACE:
PAGE 19, 1972-78

74. TRACES SUSPECTES EN SURFACE:
PAGE 20, 1972-78

75. TRACES SUSPECTES EN SURFACE:
PAGE 21, 1972-78

76. TRACES SUSPECTES EN SURFACE:
PAGE 22, 1972-78

77. TRACES SUSPECTES EN SURFACE:
PAGE 23, 1972-78

78. TRACES SUSPECTES EN SURFACE:
PAGE 24, 1972-78

79. TRACES SUSPECTES EN SURFACE:
PAGE 25, 1972-78

80. TRACES SUSPECTES EN SURFACE:
PAGE 26, 1972-78

81. TRACES SUSPECTES EN SURFACE:
PAGE 27, 1972-78

82. TRACES SUSPECTES EN SURFACE:
PAGE 28, 1972-78

83. TRACES SUSPECTES EN SURFACE:
PAGE 29, 1972-78

84. TRACES SUSPECTES EN SURFACE:
PAGE 30, 1972-78

85. TRACES SUSPECTES EN SURFACE:
PAGE 31, 1972-78

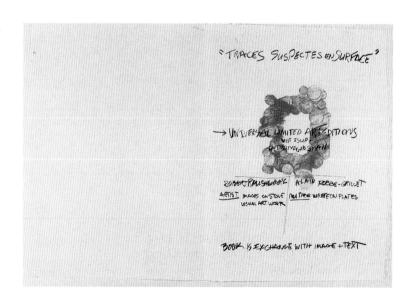

86. TRACES SUSPECTES EN SURFACE:
COLOPHON PAGE I, 1972-78

**87. TRACES SUSPECTES EN SURFACE:
COLOPHON PAGE II, 1972-78**

**88. TRACES SUSPECTES EN SURFACE:
COLOPHON PAGE III, 1972-78**

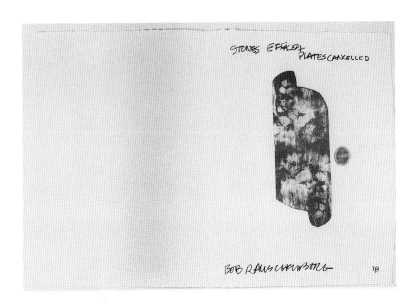

**89. TRACES SUSPECTES EN SURFACE:
COLOPHON PAGE IV, 1972-78**

90. DARKNESS MOTHER, 1978
Lithograph from three stones
Paper: cream wove
Watermark: UMBRIA ITALIA CM F
Sheet: 703×509 mm (27¹¹/₁₆×20 in.)
Signed, numbered; lower left: Andrei
Voznesensky (in Cyrillic) x/42
Signed, dated; lower right: RAUSCHENBERG
78
ULAE embossed stamp lower right
Edition: 42
 Plus: 7 artist's proofs (1 AIC)
 2 printer's proofs
Printers: Thomas Cox and Bill Goldston
Rauschenberg collaborated with Andrei
Voznesensky on this print.
The wheel of words here is Voznesensky's
metaphor for the life cycle—death and rebirth,
night and day. "Mat" is the Russian word for
mother; "T'mat" is the word for darkness.
The auditory life of poetry—represented here
as a continuum of sound—is particularly
important to Voznesensky, whose readings draw
millions of listeners in the Soviet Union.

91. PICTURE GALLERY, 1978
Lithograph from two stones
Paper: cream wove
Watermark: UMBRIA ITALIA CM F
Sheet: 702×503 mm (27⅝×19¹³/₁₆ in.)
Signed, numbered; lower left: Andrei
Voznesensky (in Cyrillic) x/40
Signed, dated; lower right: RAUSCHENBERG
78
ULAE embossed stamp lower right
Edition: 40
 Plus: 7 artist's proofs (1 AIC)
 2 printer's proofs
 4 proofs H. C.
Printers: Bill Goldston and John A. Lund
Rauschenberg collaborated with Andrei
Voznesensky on this print.
In an art museum in the Soviet Union, Andrei
Voznesensky overheard a conversation between
a mother and her son in front of a crucifixion.
Baffled by the subject, the child questioned his
mother as to what the man was doing; the
mother, a product of the approved educational
system, guessed that it must be a gymnastics
instructor "showing off."

92. SEAGULL—BIKINI OF GOD, 1978
Lithograph from three stones
Paper: cream wove
Watermark: UMBRIA ITALIA CM F
Sheet: 701×506 mm (27⁹/₁₆×9¹⁵/₁₆ in.)
Signed, numbered; lower left: Andrei
Voznesensky (in Cyrillic) x/40
Signed, dated; lower right: RAUSCHENBERG
78
ULAE embossed stamp lower right
Edition: 40
 Plus: 7 artist's proofs (1 AIC)
 2 printer's proofs
Printers: Bill Goldston and John A. Lund
Rauschenberg collaborated with Andrei
Voznesensky on this print.
Inspired by the imprint of a gull's foot in the
sand at Jones Beach, Voznesensky concluded
that the shape resembled the bathing suit of a
superhuman figure.

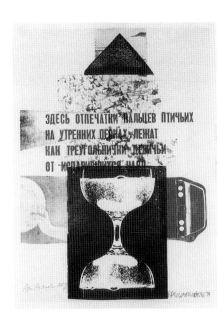

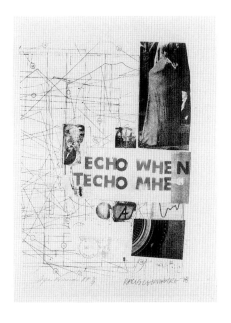

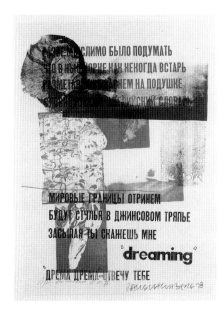

93. LONG ISLAND BEACH, 1978
Lithograph from three stones
Paper: cream wove
Watermark: UMBRIA ITALIA CM F
Sheet: 703×508 mm (27 11/16 × 20 in.)
Signed, numbered; lower left: Andrei
Voznesensky (in Cyrillic) x/39
Signed, dated; lower right: RAUSCHENBERG
78
ULAE embossed stamp lower right
Edition: 39
 Plus: 7 artist's proofs (1 AIC)
 2 printer's proofs
Printers: Bill Goldston and John A. Lund
Rauschenberg collaborated with Andrei
Voznesensky on this print.
When printing was over, Mrs. Grosman had a
box made for Voznesensky's proofs. At his
request, an hourglass filled with Long Island
sand was attached to the cover.

94. ECHO WHEN, 1978
Lithograph from three stones
Paper: cream wove
Watermark: UMBRIA ITALIA CM F
Sheet: 700×508 mm (27 9/16 × 20 in.)
Signed, numbered; lower left: Andrei
Voznesensky (in Cyrillic) x/41
Signed, dated; lower right: RAUSCHENBERG
78
ULAE embossed stamp lower right
Edition: 41
 Plus: 7 artist's proofs (1 AIC)
 2 printer's proofs
Printers: Bill Goldston and John A. Lund
Rauschenberg collaborated with Andrei
Voznesensky on this print.
Echo When is a visual and verbal exchange.
The Russian words "Techo Mhe" ("I feel
cramped") mirror the English words. For
Voznesensky, their juxtaposition involves
content as well as shape since he feels an echo
implies the limits of space (and, by extension,
human life) rather than its boundlessness.

95. FROM A DIARY, 1978
Lithograph from two stones
Paper: cream wove
Watermark: UMBRIA ITALIA CM F
Sheet: 699×504 mm (27 1/2 × 19 5/8 in.)
Signed, numbered; lower left: Andrei
Voznesensky (in Cyrillic) x/28
Signed, dated; lower right: RAUSCHENBERG
78
ULAE embossed stamp lower right
Edition: 28
 Plus: 7 artist's proofs (1 AIC)
 2 printer's proofs
Printers: Bill Goldston and John A. Lund
Rauschenberg collaborated with Andrei
Voznesensky on this print.
This print recalls a girl Voznesensky
encountered in Moscow and again in the United
States. They lay on two pillows like the open
pages of a Russian-English dictionary.

96. GLACIAL DECOY SERIES: ETCHING I, 1979
Etching and photoetching from one plate
Paper: white laid Fred Siegenthaler handmade
Plate: plate wider than sheet; 597 × 459 mm
(23½ × 18 in.) (irreg.)
Sheet: 625 × 425 mm (24⅝ × 16¾ in.) (irreg.)
Signed, numbered, dated; lower left:
RAUSCHENBERG x/22 79
Edition: 22
 Plus: 5 artist's proofs (1 AIC)
 2 printer's proofs
Printers: Keith Brintzenhofe and John A. Lund
Plate temporarily preserved

97. GLACIAL DECOY SERIES: ETCHING II, 1979
Etching and photoetching from one plate
Paper: white laid Fred Siegenthaler handmade
Plate: plate wider than sheet; 597 × 459 mm
(23½ × 18 in.) (irreg.)
Sheet: 630 × 425 mm (24¾ × 16¾ in.) (irreg.)
Signed, numbered, dated; lower left:
RAUSCHENBERG x/22 79
ULAE embossed stamp lower right
Edition: 22
 Plus: 5 artist's proofs (1 AIC)
 2 printer's proofs
Printers: Keith Brintzenhofe and John A. Lund
Plate temporarily preserved

98. GLACIAL DECOY SERIES: ETCHING III, 1979
Etching and photoetching from one plate
Paper: white laid Fred Siegenthaler handmade
Plate: plate wider than sheet; 597 × 457 mm
(23½ × 18 in.) (irreg.)
Sheet: 625 × 430 mm (24⅝ × 16⅞ in.) (irreg.)
Signed, numbered, dated; lower center:
RAUSCHENBERG x/22 79
Edition: 22
 Plus: 5 artist's proofs (1 AIC)
 2 printer's proofs
Printers: Keith Brintzenhofe and John A. Lund
Plate temporarily preserved

99. GLACIAL DECOY SERIES: ETCHING IV, 1979
Etching and photoetching from one plate
Paper: white laid Fred Siegenthaler handmade
Plate: plate wider than sheet; 597×457 mm
(23½×18 in.) (irreg.)
Sheet: 625×427 mm (24⅝×16¾ in.)
Signed, numbered, dated; lower left:
RAUSCHENBERG x/23 79
Edition: 23
 Plus: 5 artist's proofs (1 AIC)
 2 printer's proofs
Printers: Keith Brintzenhofe and John A. Lund
Plate temporarily preserved

100. GLACIAL DECOY SERIES: ETCHING V, 1979
Etching and photoetching from one plate
Paper: white laid Fred Siegenthaler handmade
Plate: plate wider than sheet; 597×457 mm
(23½×18 in.) (irreg.)
Sheet: 626×428 mm (24⅝×16⅞ in.) (irreg.)
Signed, numbered, dated; lower center:
RAUSCHENBERG x/22 79
ULAE embossed stamp lower right
Edition: 22
 Plus: 5 artist's proofs (1 AIC)
 2 printer's proofs
Printers: Keith Brintzenhofe and John A. Lund
Plate temporarily preserved

101. GLACIAL DECOY SERIES: LITHOGRAPH I, 1979
Lithograph from five stones
Paper: white wove
Watermark: ARCHES / FRANCE
Sheet: 802×1211 mm (31⁹⁄₁₆×47¹¹⁄₁₆ in.)
Signed, numbered, dated; upper left:
RAUSCHENBERG x/28 79
ULAE embossed stamp upper left
Edition: 28
 Plus: 5 artist's proofs (1 AIC)
 2 printer's proofs
Printers: Bill Goldston and Thomas Cox
Stones temporarily preserved
See plate 179

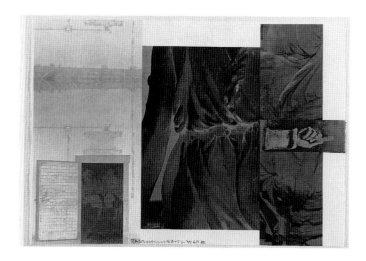

102. GLACIAL DECOY SERIES:
LITHOGRAPH II, 1980
Lithograph from four stones
Paper: white wove Arches
Sheet: 1677×1019 mm (66×40⅛ in.)
Signed, numbered, dated; lower center:
RAUSCHENBERG x/25 80
Edition: 25
 Plus: 5 artist's proofs (1 AIC)
 2 printer's proofs
Printers: Bill Goldston and Thomas Cox
Stones temporarily preserved

103. GLACIAL DECOY SERIES:
LITHOGRAPH III, 1980
Lithograph from four stones
Paper: white wove
Watermark: ARCHES / FRANCE
Sheet: 628×908 mm (24¾×35¾ in.)
Signed, numbered, dated; lower center:
RAUSCHENBERG x/22 80
ULAE embossed stamp lower right
Edition: 22
 Plus: 5 artist's proofs (1 AIC)
 2 printer's proofs
Printers: Bill Goldston and Thomas Cox

104. GLACIAL DECOY SERIES:
LITHOGRAPH IV, 1980
Lithograph from seven stones and two plates
Paper: white wove Arches
Sheet: 1678×1020 mm (66 1/16×40⅛ in.)
Signed, numbered, dated; lower left:
RAUSCHENBERG x/25 80
ULAE embossed stamp lower right
Edition: 25
 Plus: 5 artist's proofs (1 AIC)
 2 printer's proofs
Printers: Bill Goldston and Thomas Cox

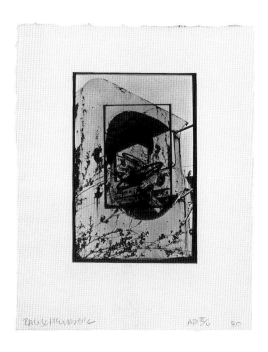

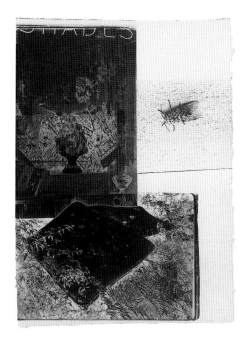

105. WHITE PENDULUM, 1980
Lithograph from two stones
Paper: ivory wove
Watermark: HAND MADE J WHATMAN 1956 ENGLAND
Sheet: 437×352 mm (17¹³⁄₁₆×13⅞ in.)
Signed; lower left in brown pencil:
RAUSCHENBERG
Numbered, dated; lower right in brown pencil:
x/33 / 80
ULAE embossed stamp lower center
Edition: 33
 Plus: 5 artist's proofs (1 AIC)
Printers: Bill Goldston and Thomas Cox

106. THE RAZORBACK BUNCH: ETCHING I, 1980
Photoetching from three plates
Paper: white wove handmade
Watermark: Twinrocker emblem
Plates: irregular due to overlapping and
 running off of sheet
 upper left, 475×308 mm (18¾×12¼ in.)
 upper right, 225×245 mm (8¾×9½ in.)
 lower, 315×470 mm (12⅜×18½ in.)
Sheet: 730×579 mm (28¾×27³⁄₁₆ in.) (irreg.)
Signed, numbered, dated; lower left:
RAUSCHENBERG x/24 80
ULAE embossed stamp lower right
Edition: 24
 Plus: 5 artist's proofs (1 AIC)
 2 printer's proofs
Printers: Bill Goldston and John A. Lund
Plates temporarily preserved

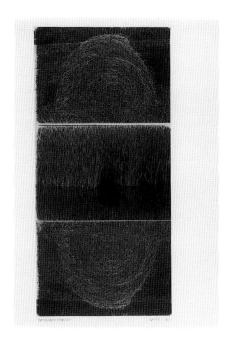

107. THE RAZORBACK BUNCH: ETCHING II, 1980
Photoetching from three plates
Paper: three sheets of cream Japanese Kitakata
wove tissue chine collé on one sheet of white
wove
Watermark: ARCHES / FRANCE
Plates: upper 315×465 mm (12½×18½ in.)
 middle 318×465 mm (12⅝×18½ in.)
 lower 313×465 mm (12½×18½ in.)
Sheets of Kitakata: upper, 315×467 mm
 (12½×18½ in.)
 middle, 318×467 mm
 (12⅝×18½ in.)
 lower, 313×465 mm
 (12½×18½ in.)
Arches: 1210×795 mm (47⅞×31½ in.)
Signed; lower left: RAUSCHENBERG
Numbered, dated; lower right: x/24 80
Edition: 24
 Plus: 5 artist's proofs (1 AIC)
 2 printer's proofs
Printers: Bill Goldston and John A. Lund

108. THE RAZORBACK BUNCH: ETCHING
III, 1981
Photoetching from three plates
Paper: white wove handmade
Watermark: Twinrocker emblem
Plates: upper left, 345×309 mm (13¾×12⅜ in.)
 upper right, 345×202 mm (13¾×8¼ in.)
 lower, 515×345 mm (20½×13¾ in.)
Sheet: 1104×775 mm (43¾×30¾ in.) (irreg.)
Signed, numbered, dated; lower center:
RAUSCHENBERG x/26 81
Edition: 26
 Plus: 5 artist's proofs (1 AIC)
 2 printer's proofs
Printers: Bill Goldston and John A. Lund

109. THE RAZORBACK BUNCH: ETCHING
IV, 1981
Photoetching from three plates
Paper: white wove Hosho handmade chine collé
on white wove
Watermark: ARCHES FRANCE
Plates: upper, 315×570 mm (12½×22½ in.)
 middle, 445×600 mm (17½×23½ in.)
 lower, 375×475 mm (14¾×18½ in.)
Sheets: Hosho, 445×600 mm (17½×23½ in.)
 Arches, 1210×800 mm (47¾×31½ in.)
Signed; lower left: RAUSCHENBERG
Numbered, dated; lower right: x/26 81
ULAE embossed stamp lower right
Edition: 26
 Plus: 5 artist's proofs (1 AIC)
 3 printer's proofs
Printer: John A. Lund
See plate 180

110. THE RAZORBACK BUNCH: ETCHING
V, 1982
Photoetching from three plates
Paper: ivory wove
Watermark: Twinrocker emblem
Plates: upper, 160×240 mm (6½×9½ in.)
 middle, 348×517 mm (13⅞×20½ in.)
 lower, 350×515 mm (14×20½ in.) (irreg.)
Sheet: 1110×770 mm (44×30¼ in.) (irreg.)
Signed, numbered, dated; lower right:
RAUSCHENBERG x/28 82
Edition: 28
 Plus: 5 artist's proofs (1 AIC)
 2 printer's proofs
Printer: John A. Lund

III. 5:29 BAY SHORE, 1981
Lithograph from ten stones with collage
Paper: ivory wove Japanese Kitakata chine collé
on ivory wove Arches 88
Sheet: 1148×2367 mm (45³/₁₆×93³/₁₆ in.)
Signed, numbered, dated; lower center:
RAUSCHENBERG x/30 81
Edition: 30
 Plus: 5 artist's proofs (1 AIC)
 3 printer's proofs
Printers: Bill Goldston and Thomas Cox
See plate 181

112. AQUAFIX, 1981
Lithograph and photoetching from three stones
and one zinc plate
Paper: white wove handmade
Watermark: Twinrocker emblem
Plate: 165×242 mm (6½×9½ in.)
Sheet: 1015×750 mm (40¼×29½ in.) (irreg.)
Signed, numbered, dated; lower right:
RAUSCHENBERG x/25 81
ULAE embossed stamp lower right
Edition: 25
 Plus: 5 artist's proofs (1 AIC)
Printers: Keith Brintzenhofe and John A. Lund

113. CARILLON, 1981
Lithograph from five stones
Paper: cream wove British handmade in 1938
Watermark: HANDMADE J WHATMAN ENGLAND B
Sheet: 1017×681 mm (40×26¹³/₁₆ in.)
Signed, numbered, dated; lower center:
RAUSCHENBERG x/29 81
Edition: 29
 Plus: 5 artist's proofs (1 AIC)
 2 printer's proofs
Printers: Bill Goldston and Thomas Cox

Larry Rivers

1. THE BIRD AND THE CIRCLE, 1957
Lithograph from one stone
Signed, dated; lower right: Rivers '57
Numbered; lower left: x/x (followed by the edition number)
Edition: Edition I: 7 impressions on Douglass Howell handmade paper, sheet size unknown
Edition II: 3 impressions on Tokugawa paper, sheet 360×438 mm (12⅛×17¼ in.)
Edition III: 2 impressions (hand-colored) on Douglass Howell handmade paper, sheet size unknown
Edition IV: 5 impressions on white wove paper, watermarked RIVES, sheet 331×507 mm (13×20 in.) (1 AIC)
Printer: Robert Blackburn
While waiting for the printing of *Stones* (cat. nos. 11-24), Rivers made single prints. *The Bird and the Circle* was thus the first lithograph to be published by ULAE. Rivers owned several exotic birds; the stuffed Cooper's Hawk in this print also appeared in several large autobiographical paintings of 1956-57.

2. THE AFTERNOON, 1957
Lithograph from one stone
Signed, dated; lower right: Rivers '57
Numbered; lower left: x/x (followed by the edition number)
Edition: Edition I: 6 impressions on white wove Rives paper, sheet 331×508 mm (13×20 in.)
Edition II: 4 impressions on brown laid Tokugawa paper, sheet 315×400 mm (12⅜×16 in.) (1 AIC)
Edition III: 7 impressions on white wove handmade paper, watermarked with the Douglass Howell emblem, sheet 340×435 mm (13⅜×17⅛ in.) (1 AIC)
Edition IV: 2 impressions on Douglass Howell handmade paper, with additions of watercolor, sheet size unknown
Printer: Robert Blackburn
The Afternoon is unlike any of Rivers's finished portrait drawings; its casual look is attributable both to the artist's style and in part to the primitive state of lithography at ULAE at this time.

3. MOLLY, 1957
Lithograph from one stone
Signed, dated; lower right: Rivers '57
Numbered; lower left: x/x (followed by the edition number)
Edition: Edition I: 4 impressions on white wove Rives paper, sheet size unknown
Edition II: 6 impressions on white wove paper, watermarked with the Douglass Howell emblem, with additions of watercolor, sheet 340×435 mm (13⅜×17 in.) (1 AIC)
Edition III: 2 impressions on Douglass Howell handmade paper, sheet size unknown
Edition IV: 4 impressions on brown laid Tokugawa paper, sheet 301×405 mm (11¾×16 in.) (1 AIC)
Printer: Robert Blackburn
Molly was one of Rivers's favorite models in the year he started lithography.

4. THE WINGED GIRL, 1958
Lithograph from one stone
Signed, dated; lower right: Rivers '58
Numbered; lower left: x/x (followed by the edition number)
Edition: Edition I: 2 impressions on Douglass
Howell handmade paper, with
additions of watercolor, sheet size
unknown
Edition II: 3 impressions on white wove
handmade paper, watermarked with
the Douglass Howell emblem, sheet
345 × 435 mm (13⅜ × 17⅛ in.) (1 AIC)
Edition III: 6 impressions on Tokugawa
paper, sheet size unknown
Edition IV: 1 impression on ivory laid
Tokugawa paper, sheet size unknown
Plus: working proof (1 AIC)
Printer: Robert Blackburn
Many of the marks Rivers made along the bottom and at the right did not print in *The Winged Girl*; still, he was satisfied with the print as an *object*.

5. DARK PLANT, 1958
Lithograph from one stone
Signed, dated; lower right: Rivers '58
Numbered; lower left: x/x (followed by the edition number)
Edition: Edition I: 2 impressions on Douglass
Howell handmade paper, with
additions of watercolor, sheet size
unknown
Edition II: 4 impressions on Douglass
Howell handmade paper, sheet size
unknown
Edition III: 4 impressions on Arches
paper, sheet size unknown
Plus: trial proof (1 AIC)
Printer: Robert Blackburn
Rivers began in 1954 to make sculpture modeled in clay and cast in bronze; this gave way in 1957 to welded metal sculpture. The image here is related to these later works, although Rivers's *Steel Plant* (1958; Mr. and Mrs. Thomas B. Hess, New York) was not actually the model.

6. THE IRON FIGURE, 1958
Lithograph from one stone
Signed, dated; lower right: Rivers '58
Numbered; lower left: x/x (followed by the edition number)
Edition: Edition I: 7 impressions on white wove
handmade paper, watermarked with
the Douglass Howell emblem, sheet
435 × 340 mm (17 × 13⅜ in.) (1 AIC)
Edition II: 2 impressions on white wove
Rives paper, sheet size unknown
Edition III: 3 impressions on Douglass
Howell handmade paper, with
additions of oil paint, sheet size
unknown
Printer: Robert Blackburn
This print is of Rivers's sculpture *The Iron Maiden (Ford Fender)* (1957; Collection of the artist), although the two-dimensional version restores softer surface qualities of the human model.

7. THE CIRCLED GIRL, 1958
Lithograph from one stone
Signed, dated; lower right: Rivers '58
Numbered; lower left: x/x (followed by the edition number)
Edition: Edition I: 2 impressions on Douglass Howell handmade paper, with additions of oil paint, sheet size unknown
Edition II: 9 impressions on white wove Rives paper, sheet 331×483 mm (13×19 in.)
Edition III: 5 impressions on white wove handmade paper, watermarked with the Douglass Howell emblem, sheet 342×432 mm (13⅜×17 in.) (1 AIC)
Edition IV: 1 impression on white wove Rives paper, with additions of oil paint, sheet size unknown, and 1 impression on brown laid Tokugawa paper, sheet size unknown
Printer: Robert Blackburn

8. THE BIKE GIRL I, 1958
Lithograph from one stone
Signed, dated; lower right: Rivers '58
Numbered; lower left: x/x (followed by the edition number)
Edition: Edition I: 4 impressions on white laid handmade paper, watermarked HOWELL, sheet 385×483 mm (15⅛×19 in.) (1 AIC)
Plus: 1 artist's proof
Edition II: 7 impressions on white wove Rives paper, sheet size unknown
Plus: 1 artist's proof
Printer: Robert Blackburn
Stone preserved and used for *The Bike Girl II* (cat. no. 9)
After printing a small edition of *The Bike Girl* in black, Rivers added six stones, each with a color, to make *The Bike Girl II* (cat. no. 9).

9. THE BIKE GIRL II, 1958
Lithograph from seven stones (one previously used for *The Bike Girl I* [cat. no. 8])
Paper: white wove
Watermark: RIVES
Sheet: 508×665 mm (20×26¼ in.)
Signed, dated; lower right: Rivers '58
Numbered; lower left: x/30
Edition: 30 (1 AIC)
Plus: 3 proofs H. C.
Printer: Robert Blackburn

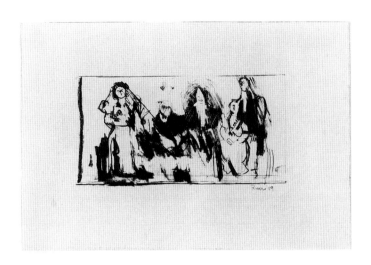

10. MARRIAGE PHOTOGRAPH, 1959
Lithograph from one stone
Paper: ivory wove Douglass Howell
Sheet: 380×565 mm (15×22¼ in.)
Signed, dated; lower right: Rivers '59
Numbered; lower left: x/15
Edition: 15
 Plus: Edition of 3 printed in black on ivory
 wove paper, watermarked SPECIAL MBM
 (FRANCE) TRAIT
 trial proofs (5 AIC)
 unmarked impressions (1 AIC)
Printer: Robert Blackburn
The inspiration for this print was a snapshot
taken at the wedding of Rivers's sister in 1938.
The lithograph underwent considerable change
and expansion from its original conception:
Rivers expanded the composition horizontally,
omitted using the rough edges of the stone, and
considered a colored version, as indicated by
trial proofs in the archives of The Art Institute
of Chicago.

11-24. STONES, 1957-60
A portfolio of twelve lithographs, a title page,
and a colophon page with poetry by Frank
O'Hara, contained in a wood box; the inner
folder is made from linen cuttings and blue
denim (these inner folders frequently bear
personal dedications in addition to the
signature); an outer folder is made of white
cardboard and screenprinted: Stones/Rivers
'57-59 O'Hara
Paper: white wove Douglass Howell handmade
Sheet: each 482×590 mm (19×23¼ in.)
 (approx.)
Edition: 25 numbered from I to XXV
 Plus: 5 artist's proof portfolios marked
 from A to E (1 AIC)
 trial proofs (11 AIC)
Printer: Robert Blackburn; typography by
Herbert Matter
Trial proofs for *Stones* were pulled by Maurice
Grosman and a local printer, Emanuel Edelman.
Mrs. Grosman hired Robert Blackburn, a
master printer from New York, to print the
editions.

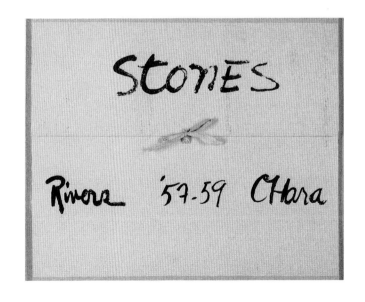

STONES: WOOD BOX AND OUTER
FOLDER, 1957-60
Screenprint
Wood and white cardboard
See plate 183

STONES: INNER FOLDER, 1957-60
Linen cuttings and blue denim

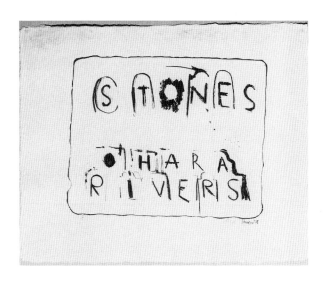

11. STONES: TITLE PAGE, 1959
Lithograph from one stone
Signed, numbered; lower left: O'Hara X/XXV
Signed, dated; lower right: Rivers '59

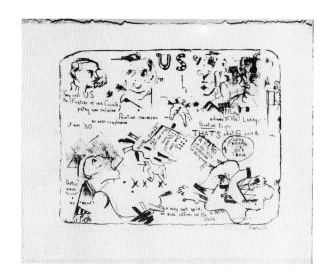

12. STONES: US, 1957
Lithograph from one stone
Signed, numbered; lower left: O'Hara X/XXV
Signed, dated; lower right: Rivers '57

13. STONES: SPRINGTEMPS, 1958
Lithograph from one stone
Signed, number; lower left: O'Hara X/XXV
Signed, dated; lower right: Rivers '58

**14. STONES: THE END OF ALL
EXISTENCES, 1957**
Lithograph from one stone
Signed, numbered; lower left: O'Hara X/XXV
Signed, dated; lower right: Rivers '57

15. STONES: LOVE, 1958
Lithograph from one stone
Signed, numbered; lower left: O'Hara X/XXV
Signed, dated; lower right: Rivers '58

16. STONES: BERDIE, 1959
Lithograph from one stone
Signed, numbered; lower left: O'Hara X/XXV
Signed, dated; lower right: Rivers '59

17. STONES: STUDENTS, 1958
Lithograph from one stone
Signed, numbered; lower left: O'Hara X/XXV
Signed, dated; lower right: Rivers '58

18. STONES: TO THE ENTERTAINMENT OF PATSY AND MIKE GOLDBERG, 1958
Lithograph from one stone
Signed, numbered; lower left: O'Hara X/XXV
Signed, dated; lower right: Rivers '58

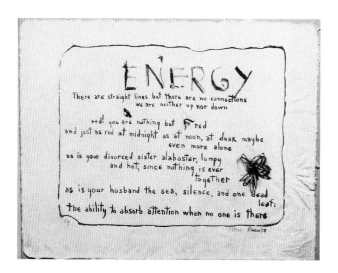

19. STONES: MELANCHOLY BREAKFAST,
1958
Lithograph from one stone
Signed, numbered; lower left: O'Hara X/XXV
Signed, dated; lower right: Rivers '58

20. STONES: ENERGY, 1959
Lithograph from one stone
Signed, numbered; lower left: O'Hara X/XXV
Signed, dated; lower right: Rivers '59

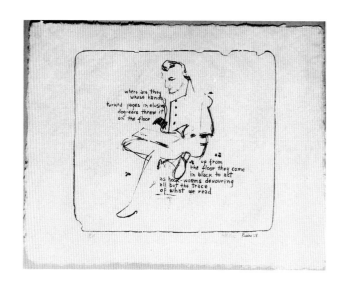

21. STONES: FIVE O'CLOCK, 1958
Lithograph from one stone
Signed, numbered; lower left: O'Hara X/XXV
Signed, dated; lower right: Rivers '58

22. STONES: WHERE ARE THEY, 1958
Lithograph from one stone
Signed, numbered; lower left: O'Hara X/XXV
Signed, dated; lower right: Rivers '58

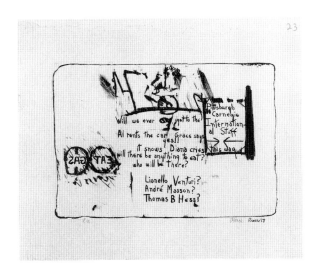

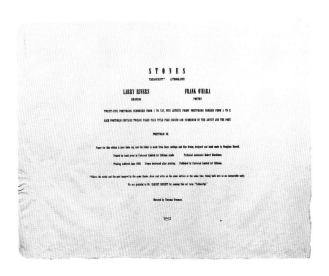

23. STONES: WILL WE EVER GET, 1958
Lithograph from one stone
Signed, numbered; lower left: O'Hara X/XXV
Signed, dated; lower right: Rivers '58

24. STONES: COLOPHON PAGE, 1959
Letterpress

25. JACK OF SPADES, 1960
Lithograph from six stones
Paper: ivory wove Rives BFK
Sheet: 1077×760 mm (42⅜×29¹⁵/₁₆ in.)
Signed, dated; lower right: Rivers '60
Numbered; lower left: x/35
Edition: 35
 Plus: 1 AIC artist's proof inscribed: For
 Tanya / Love & Energy / Rivers '60
Printer: Robert Blackburn
See plate 182

26. WEBSTER, 1961
Lithograph from one stone
Paper: ivory wove
Watermark: JAPAN
Sheet: 447×573 mm (17⅝×22⅝ in.)
Signed, dated; lower right: Rivers '61
Numbered; lower left: x/50
Edition: 50
 Plus: artist's proofs (1 AIC)
 cancellation proof (1 AIC)
Printer: Robert Blackburn
Webster, the stony-faced character who stared
out from boxes of twenty-five cent cigars, makes
frequent appearances in Rivers's repertory.

27. LAST CIVIL WAR VETERAN I, 1961
Lithograph from one stone
Paper: white wove
Watermark: ARCHES
Sheet: 763×568 mm (30×22⅜ in.)
Signed, dated; lower right: Rivers '61
Numbered; lower left: x/20 I
Edition: 20 (1 AIC)
 Plus: 1 artist's proof
Printer: Robert Blackburn
A photograph published in *Life* magazine on
January 11, 1960, shows Walter Williams, the last
Civil War veteran, lying in state in his coffin.
Rivers, who had clipped this photograph (along
with another of Williams taken a year earlier),
based this print closely on the photograph.

28. LAST CIVIL WAR VETERAN II, 1961
Lithograph from four stones
Paper: cream wove
Watermark: ARCHES
Sheet: 763×568 mm (30×22⅜ in.)
Signed, dated; lower right: Rivers '61
Numbered; lower left: x/33
Edition: 33
 Plus: artist's proofs (1 AIC)
 trial proofs (2 AIC)
Printer: Robert Blackburn
See plate 184

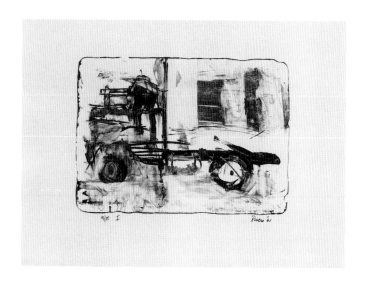

29. FORD CHASSIS I, 1961
Lithograph from one stone
Paper: white wove
Watermark: ARCHES
Sheet: 569×766 mm (22⅜×30⅛ in.)
Signed, dated; lower right: Rivers '61
Numbered; lower left: x/15 I
Edition: 15 (1 AIC)
 Plus: 1 artist's proof
Printer: Robert Blackburn
Stone preserved and used for *Ford Chassis II*
(cat. no. 30)

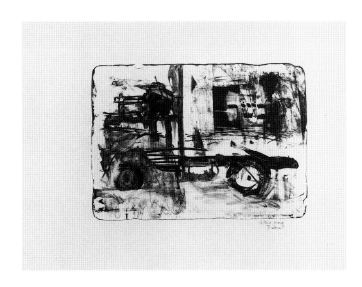

30. FORD CHASSIS II, 1961
Lithograph from one stone (previously used for
Ford Chassis I [cat. no. 29])
Paper: white wove
Watermark: ARCHES
Sheet: 565×763 mm (22¼×30 in.)
Signed, dated; lower right: Rivers '61
Numbered; lower left: x/19 II
Edition: 19
 Plus: artist's proofs (1 AIC)
Printer: Robert Blackburn
In a pointed acknowledgment of Henry Ford's
notorious anti-Semitism, Larry Rivers painted
the Hebrew word for "Kosher" on the side of
the Ford truck pictured here.

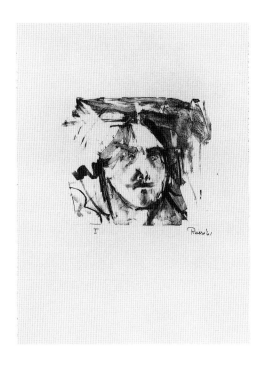

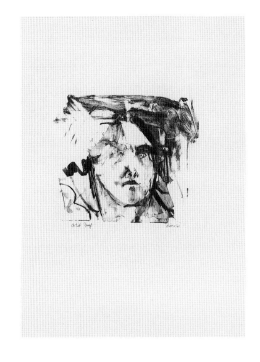

31. FACE OF CLARICE I, 1961
Lithograph from one stone
Paper: white wove
Watermark: ARCHES
Sheet: 765×568 mm (30⅛×22⅜ in.)
Signed, dated; lower right: Rivers '61
Numbered; lower left: x/15 I
Edition: 15
 Plus: artist's proofs (1 AIC)
Printer: Robert Blackburn
Stone preserved and used for *Face of Clarice II*
(cat. no. 32)
Early in 1961, Rivers married his second wife,
Clarice Price, who became the subject of many
portraits. Rivers's portrait style had long been
founded on sharp penciled outlines softened
with fingers, erasers, and hatchwork. In 1960-61,
his style became more painterly; this shift
affected his drawing on stone as well as on
paper.

32. FACE OF CLARICE II, 1961
Lithograph from one stone (previously used for
Face of Clarice I [cat. no. 31])
Paper: white wove
Watermark: ARCHES
Sheet: 764×566 mm (30¹⁄₁₆×22¼ in.)
Signed, dated; lower right: Rivers '61
Numbered; lower left: x/15 II
Edition: 15
 Plus: artist's proofs (1 AIC)
Printer: Robert Blackburn

33. LUCKY STRIKE IN THE MIRROR
(LUCKY STRIKE I), 1961
Lithograph from one stone
Paper: white wove
Watermark: ARCHES
Sheet: 769×565 mm (30¼×22¼ in.)
Signed, dated; lower right: Rivers '61
Numbered; lower left: x/20 I
Edition: 20 (1 AIC)
 Plus: 2 artist's proofs
Printer: Robert Blackburn
Stone preserved and used for *Lucky Strike II*
(cat. no. 34)

34. LUCKY STRIKE II, 1960-63
Lithograph from three stones (one previously
used for *Lucky Strike I* [cat. no. 33])
Paper: white wove
Watermark: RIVES
Sheet: 753×527 mm (29⅝×20¾ in.)
Signed, dated, numbered; lower right:
Rivers '60-'63 x/29 II
Edition: 29 (1 AIC)
 Plus: 2 artist's proofs
Printer: Robert Blackburn

35. FRENCH MONEY, 1963
Lithograph from ten stones
Paper: white wove
Watermark: Crisbrook emblem
Sheet: 570×800 mm (22⁷⁄₁₆×31½ in.)
Signed, dated, numbered; lower left:
Rivers '63 / x/32
Edition: 32
 Plus: artist's proofs (1 AIC)
 trial proofs (18 AIC)
 working proofs (2 AIC)
Printer: Zigmunds Priede
See plate 185

36. PURIM, 1963
Lithograph from three stones, with additions of
pencil and crayon
Paper: ivory laid handmade
Watermark: AUVERGNE A LA MAIN; RICHARD DE BAS
Sheet: 500×645 mm (19¹¹⁄₁₆×25⅜ in.)
Signed, dated; lower right: Rivers '63
Numbered; lower left: x/45
Edition: 45
 Plus: artist's proofs (1 AIC)
 trial proofs (2 AIC)
 working proofs (2 AIC)
Printer: Robert Blackburn
Purim, Larry Rivers's version of the Old
Testament story of Esther and King Ahasuerus,
was created for the Jewish Museum in New
York.

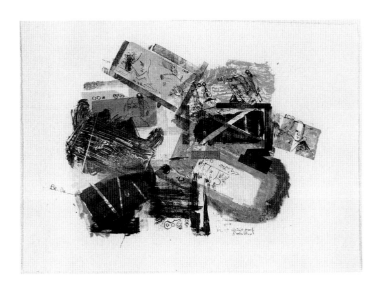

37. NINE FRENCH BANK NOTES I, 1963-64
Lithograph from seven stones
Paper: white wove
Watermark: Crisbrook emblem
Sheet: 575×800 mm (22⅝×31½ in.)
Numbered, signed, dated; lower right: x/26
Rivers '63-'64
Edition: 26
 Plus: artist's proofs (1 AIC)
Printer: Robert Blackburn
Stones preserved and used for *Nine French
Bank Notes II* (cat. no. 39)

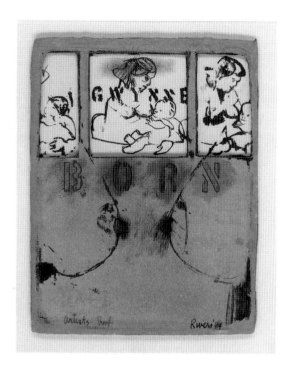

38. GWYNNE, 1964-65
Lithograph from two stones, each impression modified by the artist in oil paint and pencil
Paper: white wove Angoumois à la Main mounted on cardboard
Sheet: 254×203 mm (10×7¹⁵/₁₆ in.)
Signed, dated, numbered; lower right:
Rivers '64 / x/16
Edition: 16
 Plus: 1 artist's proof (1 AIC)
 trial proofs (3 AIC)
Printer: Robert Blackburn

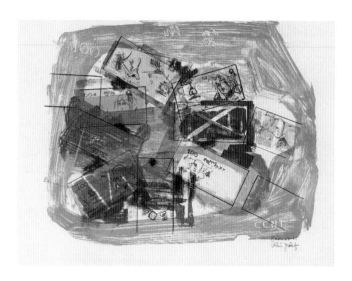

39. NINE FRENCH BANK NOTES II, 1963-65
Lithograph from nine stones (seven previously used for *Nine French Bank Notes I* [cat. no. 37])
Paper: white wove
Watermark: Crisbrook emblem
Sheet: 590×802 mm (23¼×31⁹/₁₆ in.)
Signed, dated, numbered; lower right:
Rivers 63-65 / x/7 II
Edition: 7
 Plus: 2 artist's proofs (1 AIC)
 trial proofs (2 AIC)
 working proofs (4 AIC)
Printer: Robert Blackburn
See plate 186

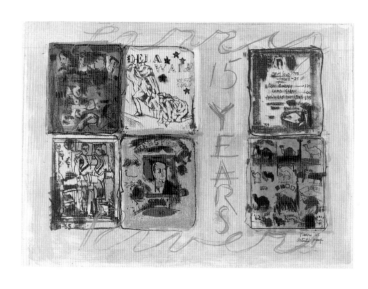

40. 15 YEARS, 1965
Lithograph from eleven stones
Paper: white wove Crisbrook
Watermark: HAND MADE
Sheet: 571×804 mm (22½×31⅝ in.)
Signed, dated, numbered; lower right:
Rivers '65 x/35
Edition: 35
 Plus: 2 artist's proofs (1 AIC)
 trial proofs (12 AIC)
 working proofs (6 AIC)
Unlimited poster edition printed in 1965-66 by Telamon Editions
 Plus: trial proofs (7 AIC)
 working proofs (5 AIC)
Printers: Robert Blackburn and Ben Berns
See plate 187

41. DON'T FALL, 1966
Lithograph from three stones
Paper: white wove Italia handmade
Sheet: 630×507 mm (24¹³/16×19¹⁵/16 in.)
Signed, dated; center in black crayon: Rivers '66
Numbered; lower right: x/25
ULAE embossed stamp lower right
Edition: 25
 Plus: 4 artist's proofs (1 AIC)
 9 proofs H. C. with rubber bath mat
 collage applied after printing
 trial proofs (6 AIC)
Printer: Ben Berns
Perhaps its inspiration—an advertisement for a
bath mat—accounts for the slickly commercial
look of this print, emphasized by its uninflected
colors and counterdisplay shape. Rivers and
Mrs. Grosman donated the edition to a nearby
museum, the Awixa Pond Art Center.

42. DRAWING ANNOUNCEMENT, 1966
Lithograph from one stone plus four-color
stencil (hand-sprayed)
Paper: K&E graph paper mounted on white
wove
Watermark: HANDMADE J WHATMAN 1952 ENGLAND
(mount sheet)
Sheets: graph paper, 280×420 mm (11×16½ in.)
 J. Whatman, 492×615 mm (19⅜×24³/16
 in.)
Signed, numbered; lower right: Rivers x/15
Edition: 15 (1 AIC)
 Plus: trial proofs (1 AIC)
Printer: Frank Akers
For the short-lived magazine *Location*, Rivers
wrote a long article on his collaboration with
Frank O'Hara (see *Stones*, cat. nos. 11-24) and
also made a design for the cover (vol. 1, no. 1,
Spring 1963). The spectacles on the magazine's
cover became the double-O motif that Rivers
had used for an exhibition announcement.

43. STRAVINSKY I, 1966
Lithograph from ten stones and one
photographic plate
Paper: white wove Italia handmade
Watermark: Magnani emblem
Sheet: 712×1021 mm (28×40³/16 in.)
Signed, dated, numbered; lower right: Rivers
'66 x/5 I
Edition: 5 (1 AIC)
 Plus: trial proofs for *Stravinsky I, II, III*
 (cat. nos. 43-45) (13 AIC)
Printers: Zigmunds Priede and Donn Steward
Stones and plate preserved and used for
Stravinsky II and *III* (cat. nos. 44, 45)

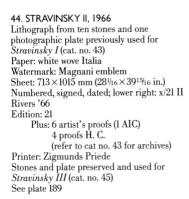

44. STRAVINSKY II, 1966
Lithograph from ten stones and one
photographic plate previously used for
Stravinsky I (cat. no. 43)
Paper: white wove Italia
Watermark: Magnani emblem
Sheet: 713×1015 mm (28$^1/_{16}$×39$^{15}/_{16}$ in.)
Numbered, signed, dated; lower right: x/21 II
Rivers '66
Edition: 21
 Plus: 6 artist's proofs (1 AIC)
 4 proofs H. C.
 (refer to cat no. 43 for archives)
Printer: Zigmunds Priede
Stones and plate preserved and used for
Stravinsky III (cat. no. 45)
See plate 189

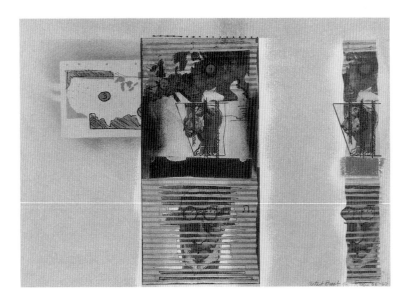

45. STRAVINSKY III, 1966-67
Lithograph from twelve stones and one
photographic plate (ten stones and plate
previously used for *Stravinsky I* and *II* [cat. nos.
43, 44])
Paper: white wove
Watermark: BFK RIVES
Sheet: 712×1019 mm (28×40$^1/_8$ in.)
Numbered, signed, dated; lower right: x/36 III
Rivers 1966-'67
ULAE embossed stamp lower right
Edition: 36
 Plus: 4 artist's proofs (1 AIC)
 1 printer's proof
 8 proofs H. C.
 3 proofs marked "WP"
 (refer to cat. no. 43 for archives)
Printer: Donn Steward

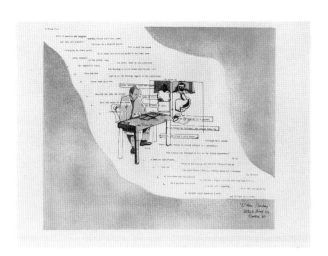

46. O'HARA READING, 1967
Lithograph from eight stones and one
photographic plate
Paper: white wove Italia chine collé on white
wove Rives
Watermark: Italia: Magnani emblem
Rives: BFK RIVES
Sheet: 753×1048 mm (29⅝×41¼ in.)
Inscribed, signed, dated; lower right: O'Hara
Reading / Rivers '67
Numbered; lower left: x/31
Edition: 31
 Plus: 6 artist's proofs (1 AIC)
 1 printer's proof
 4 proofs H. C.
 trial proofs (14 AIC)
 working proofs (9 AIC)
Printer: Donn Steward
See plate 190

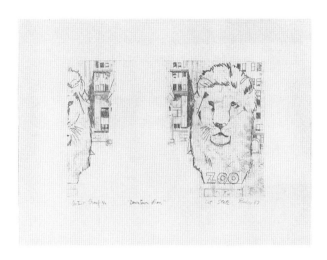

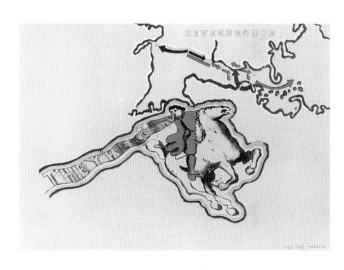

47. DOWNTOWN LION, 1967
Etching and embossing from one plate
Paper: white wove
Watermark: AUVERGNE A LA MAIN; RICHARD DE BAS
Plate: 297×444 mm (11¹¹/₁₆×17½ in.)
Sheet: 507×655 mm (19¹⁵/₁₆×25¾ in.)
Signed, dated; lower right: Rivers '67
Numbered, inscribed; lower left: x/24
"Downtown Lion"
Edition: 24
 Plus: 4 artist's proofs (1 AIC)
 1 printer's proof
 2 proofs H. C.
 4 trial proofs (4 AIC)
Printer: Donn Steward
Plate temporarily preserved
Since 1964 Rivers had been making paintings of
the bronze lions on the portico of the Dreyfus
Fund Building on Wall Street. When ULAE
bought an etching press in 1967, just as he had
been its first lithographer Rivers became the
first to publish a ULAE etching. He did not like
the technique and never used it again.

48. ONCE MORE PAUL REVERE I, 1967-69
Lithograph from five stones and six plates
Paper: white wove Italia
Watermark: Magnani emblem
Sheet: 717×1014 mm (28¼×39¹⁵/₁₆ in.)
Signed, dated; lower right: Rivers '67-'69
Numbered; lower left: x/12
Edition: 12
 Plus: 1 artist's proof (1 AIC)
 1 printer's proof
 trial proofs (22 AIC for *Once More
 Paul Revere I* and *Once More Paul
 Revere II* [cat. no. 51])
Printer: Fred Genis
Stones and plates preserved and used for *Once
More Paul Revere II* (cat. no. 51)
See plate 191

49. ENTER EMMA, 1966-69
Etching, aquatint, and open bite with pencil
additions from two plates
Paper: ivory wove
Watermark: Arches FRANCE and an embossed
stamp; lower right margin: Veritable Papier
d'Arches Satiné
Plates: each 299×452 mm (11¾×17¹³/₁₆ in.)
Sheet: 578×760 mm (22¾×29¹⁵/₁₆ in.)
Signed, dated, numbered; lower right: Rivers
1966-'69 / x/27
Edition: 27
 Plus: 4 artist's proofs (1 AIC)
 1 printer's proof
 trial proofs (3 AIC)
Printer: Donn Steward
Plates preserved and used for *Emma II—
Mixed Emotion* (cat. no. 58)
Based on a Polaroid photograph of his first
daughter, *Enter Emma* reflects Rivers's
ambivalence toward demonstrations of parental
pride and his tacit acknowledgment of the
dangers that menace children. A knife was one
of Rivers's favorite tools at this time, used in
numerous collages as well as the cut-out sections
of his lithographs.

**50. FOR THE PLEASURES OF FASHION
(SUMMER UNIT), 1967-70**
Etching and aquatint from eight plates
Paper: ivory wove
Watermark: HAND MADE ENGLAND 1964 F / FLAX
SAMUEL FLAX
Plate: 453×600 mm (17¹³/₁₆×23⅝ in.)
Sheet: 571×806 mm (22½×31¾ in.)
Numbered, signed, dated; lower left:
x/18 / Rivers '67-'70
Edition: 18
 Plus: 4 artist's proofs (1 AIC)
 1 printer's proof
 3 color proofs
 trial proofs (1 AIC)
 working proofs (6 AIC)
 1 proof marked "ETCHING +"
Printer: Donn Steward
Plates temporarily preserved
See plate 192

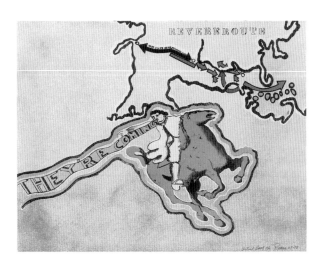

51. ONCE MORE PAUL REVERE II, 1968-70
Lithograph from twelve stones (five previously
used for *Once More Paul Revere I* [cat. no. 48])
Paper: white wove Italia
Sheet: 672×883 mm (26⁷/₁₆×34¾ in.)
Numbered, signed, dated; lower right:
x/20 Rivers 68-70
Edition: 20
 Plus: 4 artist's proofs (1 AIC)
 1 printer's proof
 trial proofs (22 AIC for *Once More
 Paul Revere I* [cat. no. 48] and *Once
 More Paul Revere II*)
Printer: Frank Akers

52. FOR ADULTS ONLY, 1971
Diptych lithograph from three stones, six plates,
and two stencils
Paper: white wove
Watermark: BFK RIVES
Sheets: upper, 1052×750 mm (41⅜×29½ in.)
 lower, 934×750 mm (36¾×29½ in.)
 (irreg.)
 assembled, 1780×750 mm
 (70½×29½ in.)
Numbered, signed, dated; center right lower
sheet: x/35 Rivers '71
ULAE embossed stamp lower left upper sheet,
center left lower sheet
Edition: 35
 Plus: 4 artist's proofs (1 AIC)
 3 printer's proofs
 trial proofs (34 AIC)
 working proofs (11 AIC)
Printers: Zigmunds Priede, Bill Goldston, and
Steve Anderson
Stones, plates, and stencils temporarily
preserved
See plate 193

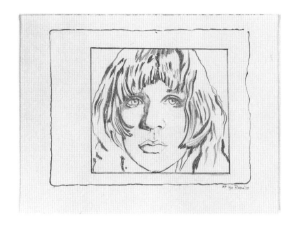

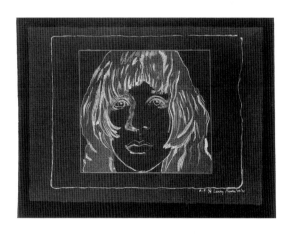

53. DIANE RAISED I, 1970
Lithograph from four stones
Paper: white wove
Watermark: ARCHES
Sheet: 616×762 mm (24¼×30 in.)
Numbered, signed, dated; lower right:
x/20 Rivers '70
Edition: 20
 Plus: 4 artist's proofs (1 AIC)
 1 printer's proof (1 AIC)
 trial proofs for *Diane Raised I* (5
 AIC) and trial variations for *Diane
 Raised II* (cat. no. 54) (10 AIC)
Printer: Frank Akers
Stones preserved and used for *Diane Raised
II-IV* (cat. nos. 54-56)
Although Rivers had for some time been
concentrating on constructions, this sensitive
portrait of Diane Molinari (who had
collaborated with him on several videotapes)
shows his undiminished powers as a draftsman.
The word "Raised" was added to the title when
Rivers decided to reuse the plates in a three-
dimensional work. Mrs. Grosman unwittingly
pointed the way when she gave Bill Goldston's
children pop-up books for Christmas. See *Diana
with Poem* (cat. no. 57).

**54. DIANE RAISED II (BLACK DIANE), 1970-
71**
Lithograph from three stones (previously used
for *Diane Raised I* [cat. no. 53])
Paper: blue-gray laid Japan tipped onto black
laid Fabriano
Sheets: Japan, 515×723 mm (20¼×28½ in.)
 Fabriano, 610×798 mm (24×31½ in.)
Numbered, signed, dated; lower right: x/36
Rivers '70-'71
Edition: 36
 Plus: 4 artist's proofs (1 AIC)
 3 printer's proofs
 trial proofs (4 AIC)
 working proofs (2 AIC)
 (see cat. no. 53 for trial variations)
Printer: Ben Berns, Frank Akers, and Glenn Lee
Stones preserved and used for *Diane Raised III
and IV* (cat. nos. 55, 56)

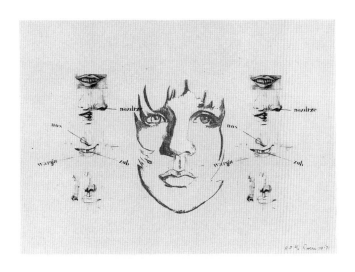

55. DIANE RAISED III, 1970-71
Lithograph from five stones with collage (some previously used for *Diane Raised I* and *II* [cat. nos. 53, 54])
Paper: light tan laid Japan mounted on pale green wove Japan
Sheets: laid, 516×724 mm (20⁵/16 × 28½ in.)
 wove, 584×775 mm (23×30½ in.)
Numbered, signed, dated; lower right: x/12
Rivers '70-'71
Edition: 12
 Plus: 2 artist's proofs (1 AIC)
 1 printer's proof
 trial proofs for *Diane Raised III* and
 IV (cat. no. 56) (15 AIC)
 working proofs for *Diane Raised III*
 and *IV* (cat. no. 56) (14 AIC)
Printer: Frank Akers
Stones preserved and used for printing *Diane Raised IV* (cat. no. 56)
In this print, Rivers revived his sculpture series from 1961-62, *Parts of the Body/Vocabulary Lesson*, in which words were cut out of metal and welded at angles to the body parts.

56. DIANE RAISED IV (POLISH VOCABULARY), 1970-74
Lithograph from six stones and six plates (some stones previously used for *Diane Raised I, II, and III* [cat. nos. 53-55])
Paper: light tan laid Okawara tipped onto ivory wove Wampu
Sheets: Okawara, 514×722 mm (20¼×28⁷/16 in.)
 Wampu, 641×832 mm (25¼×32¾ in.)
Numbered, signed, dated; lower right: x/38
Rivers '70-'74
Edition: 38
 Plus: 4 artist's proofs (1 AIC)
 3 printer's proofs
 (see cat. no. 55 for trial and working
 proofs)
Printers: John A. Lund, Glenn Lee, and Steve Anderson
Stones and plates temporarily preserved

57. DIANA WITH POEM, 1970-74
Three-dimensional lithograph from seven stones
and one plate; poem by Kenneth Koch, printed
in letterpress on white laid Japan paper, and
bound in linen folder (printed on outside:
"DIANA" and "Rivers"); when the top is
raised, a box is formed; box made by H. Wayne
Ely
Paper: four sheets of white wove Rives BFK
Sheets: Rives BFK, 575×675 mm
 (22⅝×26⅝ in.)
 Japan, 445×504 mm (17½×19½ in.)
Folder (closed): 620×715 mm (24½×28¼ in.)
Box: 525×675×56 mm (22⅝×26⅝×2¼ in.)
Numbered, signed, dated; lower right: x/19
Rivers '70-'74
Edition: 19
 Plus: 6 artist's proofs (1 AIC)
 1 proof H.C.
 working proofs (3 AIC)
 1 artist's proof marked "For Diana
 at 21"
Printer: Frank Akers and James V. Smith;
letterpress by Juda Rosenberg
Stones and plate temporarily preserved
See plate 194

58. EMMA II—MIXED EMOTION, 1967-75
Etching, aquatint, and open bite from three
plates (two previously used for *Enter Emma*
[cat. no. 49])
Paper: cream wove mounted on white wove
Watermark: Arches (mount sheet)
Plates: cream, 300×453 mm (11¹³/₁₆×17¹³/₁₆ in.)
 white, 300×456 mm (11¹³/₁₆×17¹⁵/₁₆ in.)
Sheets: cream, 562×759 mm (22⅛×29⅞ in.)
 white, 559×752 mm (22×29⅝ in.)
Numbered, signed, dated; lower right cream
sheet: x/22 Rivers '67-75
Edition: 22
 Plus: 4 artist's proofs (1 AIC)
 trial proofs (9 AIC)
 working proofs (3 AIC)
Printer: Donn Steward

59-115. THE DONKEY AND THE DARLING,
1967-77
Collaborative ''book'' with Terry Southern that
contains 52 lithographs, a blank ''cover'' page, a
title page, dedication page, table of contents,
and colophon page housed in a green lacquered
wood box with a hand-blown glass inset on the
top over the title and names of the artist and
poet printed on a mirror
Paper: ivory laid handmade
Watermark: Terry Southern Larry Rivers (both
as signatures)
Sheet: each 470×547 mm (18½×24½ in.)
Box: 525×602×128 mm (20⅝×23⅝×5 in.)
Signed, numbered; lower left in lavender pencil:
Terry Southern x/XXXV
Signed, dated; lower right in lavender pencil:
Larry Rivers 1968-77
Edition: 35 (1 AIC)
 Plus: 2 sets trial proofs
Printers: Keith Brintzenhofe, Bill Goldston,
John A. Lund, and Steve Anderson; letterpress
by H. Wayne Ely; inlaid glass on box cover
printed by James V. Smith

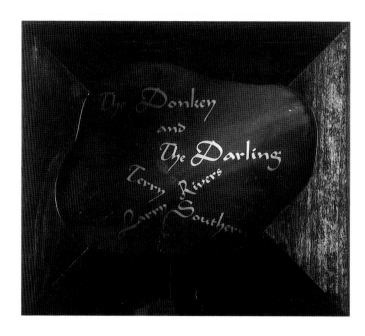

59. THE DONKEY AND THE DARLING:
BOX, 1967-77
Lacquered wood box with hand-blown glass
inset

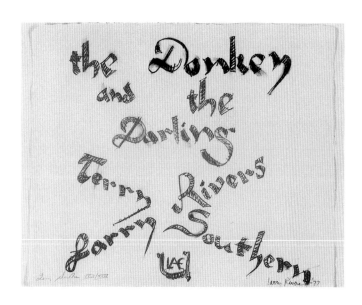

60. THE DONKEY AND THE DARLING:
TITLE PAGE, 1967-77
Lithograph from two stones

61. THE DONKEY AND THE DARLING:
DEDICATION PAGE, 1967-77
Lithograph from one plate

62. THE DONKEY AND THE DARLING:
TABLE OF CONTENTS, 1967-77
Lithograph from one plate

63. THE DONKEY AND THE DARLING:
PAGE 1, 1967-77
Lithograph from thirteen stones and two plates

64. THE DONKEY AND THE DARLING:
PAGE 2, 1967-77
Lithograph from nine stones and two plates

65. THE DONKEY AND THE DARLING:
PAGE 3, 1967-77
Lithograph from sixteen stones and three plates

66. THE DONKEY AND THE DARLING:
PAGE 4, 1967-77
Lithograph from sixteen stones and two plates
See plate 197

67. THE DONKEY AND THE DARLING:
PAGE 5, 1967-77
Lithograph from sixteen stones and two plates

68. THE DONKEY AND THE DARLING:
PAGE 6, 1967-77
Lithograph from six stones and three plates

69. THE DONKEY AND THE DARLING:
PAGE 7, 1967-77
Lithograph from thirteen stones and two plates
See plate 198

70. THE DONKEY AND THE DARLING:
PAGE 8, 1967-77
Lithograph from nine stones and two plates

71. THE DONKEY AND THE DARLING:
PAGE 9, 1967-77
Lithograph from seven plates

72. THE DONKEY AND THE DARLING:
PAGE 10, 1967-77
Lithograph from six plates

73. THE DONKEY AND THE DARLING:
PAGE 11, 1967-77
Lithograph from ten stones and two plates

74. THE DONKEY AND THE DARLING:
PAGE 12, 1967-77
Lithograph from ten stones and two plates

75. THE DONKEY AND THE DARLING:
PAGE 13, 1967-77
Lithograph from eight plates

76. THE DONKEY AND THE DARLING:
PAGE 14, 1967-77
Lithograph from five stones and two plates

77. THE DONKEY AND THE DARLING:
PAGE 15, 1967-77
Lithograph from seven plates

78. THE DONKEY AND THE DARLING:
PAGE 16, 1967-77
Lithograph from one stone and two plates

79. THE DONKEY AND THE DARLING:
PAGE 17, 1967-77
Lithograph from six plates

80. THE DONKEY AND THE DARLING:
PAGE 18, 1967-77
Lithograph from four stones and three plates

81. THE DONKEY AND THE DARLING:
PAGE 19, 1967-77
Lithograph from five plates

82. THE DONKEY AND THE DARLING:
PAGE 20, 1967-77
Lithograph from five plates

83. THE DONKEY AND THE DARLING:
PAGE 21, 1967-77
Lithograph from six plates

84. THE DONKEY AND THE DARLING:
PAGE 22, 1967-77
Lithograph from four plates

85. THE DONKEY AND THE DARLING:
PAGE 23, 1967-77
Lithograph from three plates

86. THE DONKEY AND THE DARLING:
PAGE 24, 1967-77
Lithograph from two plates

87. THE DONKEY AND THE DARLING:
PAGE 25, 1967-77
Lithograph from one stone and two plates

88. THE DONKEY AND THE DARLING:
PAGE 26, 1967-77
Lithograph from twelve stones and four plates

89. THE DONKEY AND THE DARLING:
PAGE 27, 1967-77
Lithograph from five plates

90. THE DONKEY AND THE DARLING:
PAGE 28, 1967-77
Lithograph from three plates

91. THE DONKEY AND THE DARLING:
PAGE 29, 1967-77
Lithograph from five plates

92. THE DONKEY AND THE DARLING:
PAGE 30, 1967-77
Lithograph from six plates

93. THE DONKEY AND THE DARLING:
PAGE 31, 1967-77
Lithograph from three stones and eight plates

94. THE DONKEY AND THE DARLING:
PAGE 32, 1967-77
Lithograph from ten plates

95. THE DONKEY AND THE DARLING:
PAGE 33, 1967-77
Lithograph from ten plates

96. THE DONKEY AND THE DARLING:
PAGE 34, 1967-77
Lithograph from eleven plates

97. THE DONKEY AND THE DARLING:
PAGE 35, 1967-77
Lithograph from sixteen plates

98. THE DONKEY AND THE DARLING:
PAGE 36, 1967-77
Lithograph from fifteen plates

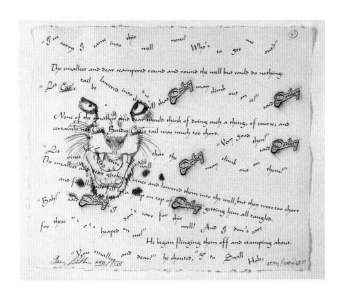

99. THE DONKEY AND THE DARLING:
PAGE 37, 1967-77
Lithograph from one stone and eight plates

100. THE DONKEY AND THE DARLING:
PAGE 38, 1967-77
Lithograph from seven plates

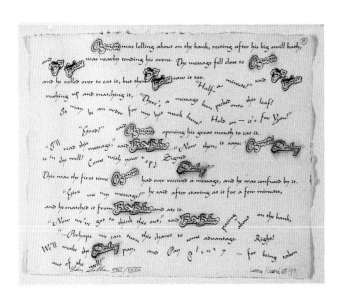

101. THE DONKEY AND THE DARLING:
PAGE 39, 1967-77
Lithograph from seventeen stones

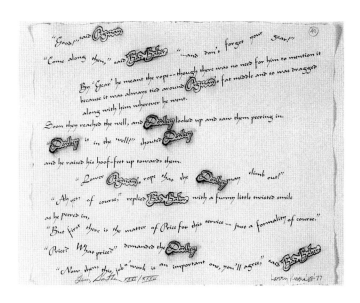

102. THE DONKEY AND THE DARLING:
PAGE 40, 1967-77
Lithograph from ten plates

103. THE DONKEY AND THE DARLING:
PAGE 41, 1967-77
Lithograph from ten plates

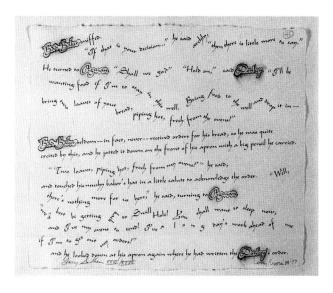

104. THE DONKEY AND THE DARLING:
PAGE 42, 1967-77
Lithograph from six plates

105. THE DONKEY AND THE DARLING:
PAGE 43, 1967-77
Lithograph from twelve plates

106. THE DONKEY AND THE DARLING:
PAGE 44, 1967-77
Lithograph from one stone and thirteen plates

107. THE DONKEY AND THE DARLING:
PAGE 45, 1967-77
Lithograph from five plates

108. THE DONKEY AND THE DARLING:
PAGE 46, 1967-77
Lithograph from nine plates

109. THE DONKEY AND THE DARLING:
PAGE 47, 1967-77
Lithograph from two stones and seven plates

**110. THE DONKEY AND THE DARLING:
PAGE 48, 1967-77**
Lithograph from one stone and twelve plates

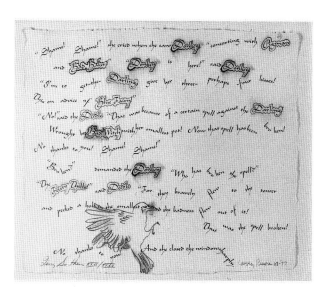

**111. THE DONKEY AND THE DARLING:
PAGE 49, 1967-77**
Lithograph from nine plates

**112. THE DONKEY AND THE DARLING:
PAGE 50, 1967-77**
Lithograph from eight plates

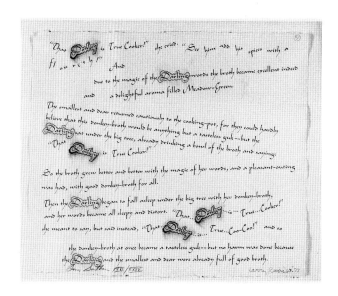

**113. THE DONKEY AND THE DARLING:
PAGE 51, 1967-77**
Lithograph from nine plates

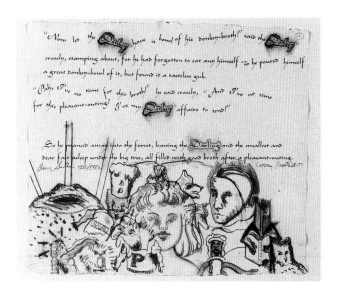

114. THE DONKEY AND THE DARLING:
PAGE 52, 1967-77
Lithograph from one plate

115. THE DONKEY AND THE DARLING:
COLOPHON PAGE, 1967-77
Lithograph from one plate

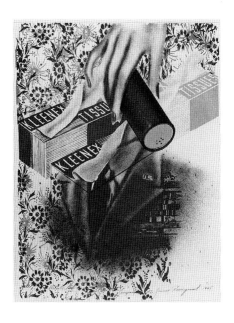

1. CAMPAIGN, 1965
Lithograph from four stones
Paper: white wove
Watermark: HANDMADE CRISBROOK BRITISH
Sheet: 746×569 mm (29⅜×22⅜ in.)
Signed, dated; lower right: James Rosenquist
1965
Numbered; lower left: x/26
Inscribed; lower center: Campaign
Edition: 26
 Plus: 1 artist's proof (1 AIC)
 7 proofs H.C.
 trial proofs (1 AIC)
 working proofs (5 AIC)
Printer: Ben Berns
See plate 199

2. SPAGHETTI AND GRASS, 1964-65
Lithograph from five stones
Paper: white wove handmade
Watermark: Crisbrook emblem; HANDMADE
Sheet: 795×567 mm (31⁵/₁₆×22⁵/₁₆ in.)
Inscribed, numbered, signed, dated; center left
to center right: Spaghetti and Grass x/23 James
Rosenquist 1965
ULAE embossed stamp lower center
Edition: 23
 Plus: 2 artist's proofs (1 AIC)
 trial proofs (17 AIC)
 working proofs (4 AIC)
Printers: Frank Burnham and Zigmunds Priede
See plate 200

3. DUSTING OFF ROSES, 1965
Lithograph from three stones
Paper: white wove Italia handmade
Sheet: 781×551 mm (30¾×21¹¹/₁₆ in.)
Signed, dated; lower right: James Rosenquist
1965
Numbered; lower center: x/35
Inscribed; lower left: Dusting off Roses
Edition: 35
 Plus: artist's proofs (1 AIC)
 trial proofs (1 AIC)
 working proofs (5 AIC)
Printers: Zigmunds Priede and Ben Berns
Catalogue reference: Varian 2
The starting point for this print was a
newspaper clipping from Rosenquist's
collection of thousands.

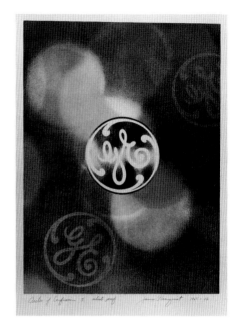

4. JOHN ADAMS ROSENQUIST, HEIR APPARENT, 1965
Lithograph from two stones
Paper: Douglass Howell handmade
Sheet: 433×345 mm (17×13½ in.)
Signed, dated; lower right: James Rosenquist 1965
Numbered; lower left: x/28
Edition: 28
 Plus: proofs
Printer: Zigmunds Priede

5. CIRCLES OF CONFUSION I, 1965-66
Lithograph from four stones
Paper: white wove Italia handmade
Sheet: 975×712 mm (38⅜×28 in.)
Signed, dated; lower right: James Rosenquist 1965-66
Inscribed, numbered; lower left: Circles of Confusion I x/12
ULAE embossed stamp lower right
Edition: 12
 Plus: 8 artist's proofs (1 AIC)
 trial proofs (9 AIC)
 working proofs (17 AIC)
Printers: Ben Berns and Zigmunds Priede
Second and fourth stones temporarily preserved
See plate 201

6. A DRAWING WHILE WAITING FOR AN IDEA, 1966
Lithograph
Paper: tan paper towel
Sheet: 377×237 mm (14⅞×9⅝ in.)
Signed, dated; lower right: Jim Rosenquist 1966
Numbered; lower left: x/52
ULAE embossed stamp lower center to lower right
Edition: 52 (1 AIC)
 Plus: artist's proofs
 1 printer's proof
Printer: Donn Steward
Catalogue reference: Varian 3
An excellent example of Rosenquist's mystical turn of thought, this print was made on a paper towel to convey the Eastern philosophical attitude of wiping away the events of the day. The cigarette burns, made with an airbrush, stand for the stars on the edge of the universe, thus contrasting the infinite with the insignificant.

7. HIGH-POOL, 1964-66
Lithograph from five stones
Paper: white wove Italia handmade
Sheet: 677×1022 mm (26⅝×40¼ in.)
Signed, dated; lower right: Jim Rosenquist
1964-66
Inscribed, numbered; lower left: high-pool x/25
Edition: 25
 Plus: 6 artist's proofs (1 AIC)
 1 printer's proof
 trial proofs (24 AIC)
 working proofs (8 AIC)
Printer: Donn Steward
First stone temporarily preserved
Catalogue reference: Varian 1
Disturbed by a widespread chauvinistic reaction
to Russia's first satellite, Rosenquist considered
these spheres to be metaphors for ideas that
should be used for the benefit of all mankind.

8. ROLL DOWN, 1964-66
Lithograph from four stones and one plate
Paper: white wove
Watermark: BFK RIVES
Sheet: 977×737 mm (38⁷⁄₁₆×29 in.)
Signed, dated; lower right: Jim Rosenquist
1964-66
Inscribed, numbered; lower left: Roll Down 1/29
Edition: 29
 Plus: 3 artist's proofs (1 AIC)
 trial proofs (1 AIC)
 working proofs (4 AIC)
Printer: Donn Steward
In the 1960s, cars appeared in Rosenquist's
work more often than any other subject. They
provided a repertory of evocative shapes but
were not intended to sentimentalize or satirize
one of the most visible objects in the
contemporary landscape.

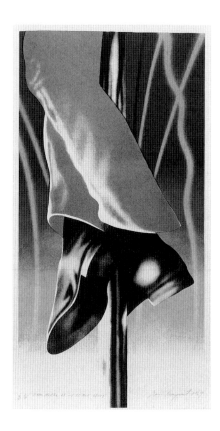

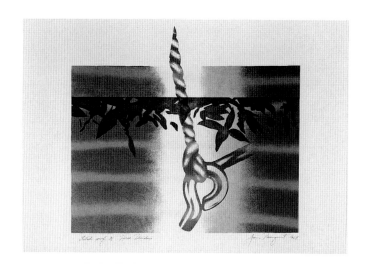

9. EXPO 67 MURAL—FIREPOLE 33′×17′, 1967
Lithograph from six stones
Paper: white wove Italia handmade
Sheet: 862×478 mm (33¹⁵/₁₆×18¹³/₁₆ in.)
Signed, dated; lower right: Jim Rosenquist 1967
Numbered, inscribed; lower left: x/41 EXPO 67
MURAL—FIREPOLE 33′×17′
Edition: 41
 Plus: 5 artist's proofs (1 AIC)
 2 printer's proofs
 6 proofs H.C.
 trial proofs (7 AIC)
 working proofs (7 AIC)
Printers: Fred Genis and Donn Steward
Catalogue reference: Varian 5
See plate 202

10. HORSE BLINDERS, 1968
Lithograph from five stones
Paper: white wove Italia handmade
Watermark: Magnani emblem
Sheet: 713×1013 mm (17⁷/₁₆×22⅜ in.)
Signed, dated; lower right: Jim Rosenquist 1968
Numbered, inscribed; lower left: x/41 Horse
Blinders
Edition: 41
 Plus: 4 artist's proofs (1 AIC)
 1 printer's proof
 6 proofs H.C.
 trial proofs (8 AIC) Note: AIC
archives also include 1 AIC trial proof
and 5 working proofs of "Horse
Blinders" Projected Variation, 1968-
69, and 6 AIC trial proofs and 4
working proofs of "Horse Blinders
Left, Right," 1969 (not released)
working proofs (2 AIC)
5 unclassified proofs marked
"Trigram"
1 unclassified proof marked "Litho
+"
Printer: Fred Genis
See plate 203

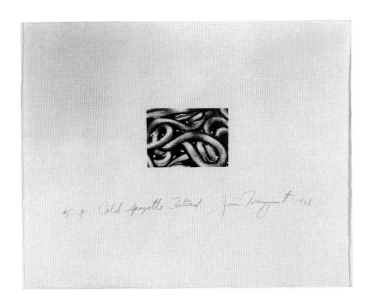

11. COLD SPAGHETTI POSTCARD, 1968

Lithograph from one stone
Paper: white wove British Chatham
Sheet: 506×629 mm (19¹⁵⁄₁₆×24¾ in.)
Signed, dated; lower right: Jim Rosenquist 1968
Numbered, inscribed; lower left: x/18 Cold
Spaghetti Postcard
Edition: 18
 Plus: 3 artist's proofs (1 AIC)
 2 printer's proofs
 1 trial proof
 3 unclassified proofs marked
 "Trigram"
Printer: Fred Genis
Stone temporarily preserved
Neither *Cold Spaghetti Postcard* nor *Horse Blinders Flash Card* (cat. no. 12) were literal titles but tongue-in-cheek demonstrations of "the billboard painter's" ability to work in small format.

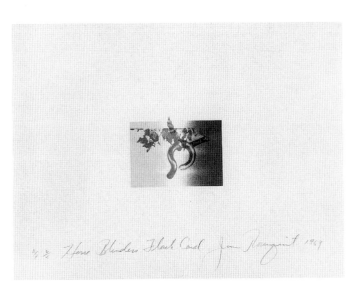

12. HORSE BLINDERS FLASH CARD, 1969

Lithograph from four stones
Paper: white wove
Watermark: JAPAN
Sheet: 443×568 mm (17⁷⁄₁₆×22⅜ in.)
Numbered, inscribed, signed, dated; lower left
to lower right: x/21 Horse Blinders Flash Card
Jim Rosenquist 1969
ULAE embossed stamp lower right
Edition: 21
 Plus: 5 artist's proofs (1 AIC)
 1 printer's proof
 5 proofs marked "Trigram"
Printer: Fred Genis
Catalogue reference: Varian 10

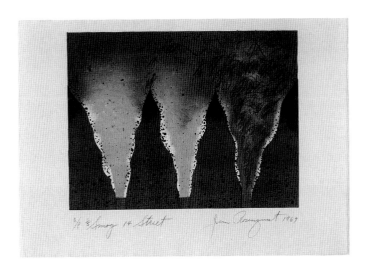

13. SMOG 14 STREET, 1969

Lithograph from six stones
Paper: white wove
Sheet: 570×785 mm (22½×31 in.)
Signed, dated; lower right: Jim Rosenquist 1969
Numbered; lower left: x/5
Edition: 5 artist's proofs (1 AIC)
Printer: Fred Genis
Catalogue reference: Varian 11
See plate 204

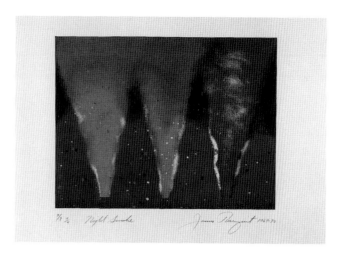

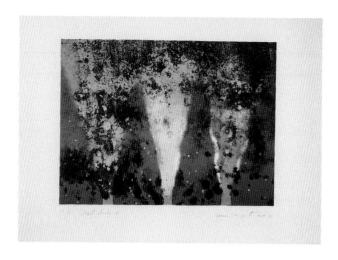

14. NIGHT SMOKE, 1969-70
Lithograph from six stones
Paper: white wove British A. Milbourn
Watermark: J. GREEN HAND MADE 2
Sheet: 568×794 mm (22⅜×31¼ in.)
Signed, dated; lower right: James Rosenquist
1969-70
Numbered, inscribed; lower left: x/18 Night
Smoke
ULAE embossed stamp lower center
Edition: 18
 Plus: 4 artist's proofs (1 AIC)
 2 printer's proofs
 trial proofs (32 AIC)
Printers: Frank Akers, Zigmunds Priede, and
Bill Goldston
Stones temporarily preserved
Catalogue reference: Varian 12

15. NIGHT SMOKE II, 1969-72
Lithograph from six stones
Paper: white wove British A. Milbourn
Watermark: J. GREEN HAND MADE 2
Sheet: 572×790 (22½×31⅛ in.)
Signed, dated; lower right: Rosenquist 1969-72
Numbered, inscribed; lower left: x/27 Night
Smoke
ULAE embossed stamp lower center
Edition: 27
 Plus: 8 artist's proofs (1 AIC)
 1 printer's proof
 trial proofs (3 AIC)
Printers: Frank Akers, Bill Goldston, and
Zigmunds Priede
See plate 205

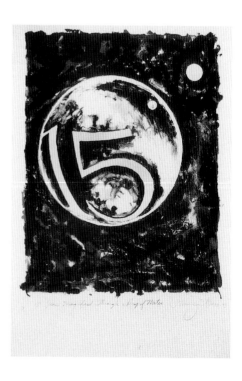

16. 15 YEARS MAGNIFIED THROUGH A
DROP OF WATER, 1972-73
Lithograph from three stones and one plate
Paper: white wove
Watermark: AUVERGNE A LA MAIN; RICHARD DE BAS
Sheet: 570×389 mm (22⁷⁄₁₆×15⁵⁄₁₆ in.)
Signed, dated; lower right: Rosenquist 1972-73
Numbered; lower left: x/50
Inscribed; lower center: 15 Years Magnified
Through a Drop of Water
ULAE embossed stamp lower center
Edition: 50
 Plus: 4 artist's proofs (1 AIC)
 2 printer's proofs
 8 proofs H.C.
 trial proofs (14 AIC)
 working proofs (14 AIC)
Printers: John A. Lund and Bill Goldston
Catalogue reference: Varian 46
See plate 209

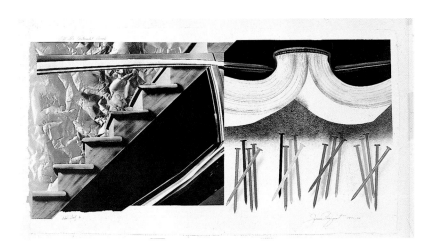

**17. OFF THE CONTINENTAL DIVIDE,
1973-74**
Lithograph from twenty-nine plates
Paper: ivory wove Japan
Sheet: 1090×2012 mm (42^{15}/$_{16}$×79^{3}/$_{16}$ in.)
Signed, dated; lower right: James Rosenquist
1973-74
Numbered; lower left: x/43
Inscribed; upper left: Off The Continental
Divide
ULAE embossed stamp lower right
Edition: 43
 Plus: 5 artist's proofs (1 AIC)
 2 printer's proofs
 8 proofs H.C.
 4 trial proofs
 1 study drawing (1 AIC)
Printers: Bill Goldston and James V. Smith
Catalogue reference: Varian 61
See plate 210

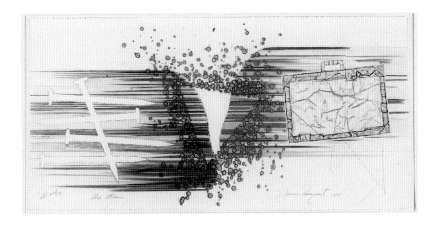

18. SLIP STREAM, 1975
Intaglio collograph from three plates
Paper: white wove British J. Green
Watermark: Crisbrook emblem
Sheet: 449×924 mm (17^{11}/$_{16}$×36^{3}/$_{8}$ in.)
Signed, dated; lower right: James Rosenquist
1975
Numbered, inscribed; lower left: x/38 Slip
Stream
ULAE embossed stamp lower right
Edition: 38
 Plus: 5 artist's proofs (1 AIC)
 1 printer's proof
 4 trial proofs
 2 proofs marked "Special"
Printer: Zigmunds Priede
Plates temporarily preserved
Catalogue reference: Varian 67

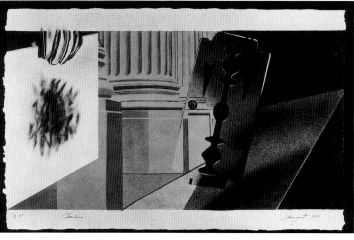

19. CHAMBERS, 1980
Lithograph from sixteen plates
Paper: white wove Twinrocker handmade
Watermark: UNIVERSAL LIMITED ART EDITIONS /
James Rosenquist (signature)
Sheet: 762×1197 mm (30×47⅛ in.)
Signed, dated; lower right: Rosenquist 1980
Numbered, inscribed; lower left: x/45 Chambers
ULAE embossed stamp lower right
Edition: 45
 Plus: 11 artist's proofs (1 AIC)
 3 printer's proofs
Printers: James V. Smith, Thomas Cox, and Bill
Goldston
After a five-year absence from ULAE,
Rosenquist began work on *Chambers*, a mural
print done while he was working on a painting
of the same title. He had just moved into a new
studio at the end of Chambers Street in New
York. In the print, at the left, are elements that
relate to the artist; at the right are images that
relate to City Hall, which is located at the other
end of Chambers Street.

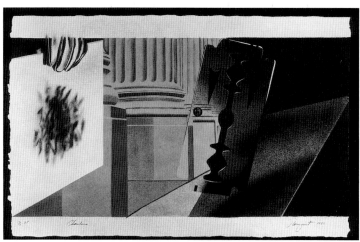

20. DOG DESCENDING A STAIRCASE, 1980-82
Lithograph and intaglio from ten plates, ten
stones, and one etching plate
Paper: cream wove Arches
Sheet: 1068×1778 mm (42×70 in.)
Signed, dated; lower right: James Rosenquist
1980-82
Numbered; lower left: x/33
Inscribed; lower center: Dog Descending a
Staircase
ULAE embossed stamp lower right
Edition: 33
 Plus: 5 artist's proofs (1 AIC)
 4 printer's proofs
Printers: James V. Smith, Thomas Cox, John A.
Lund, and Bill Goldston
See plate 211

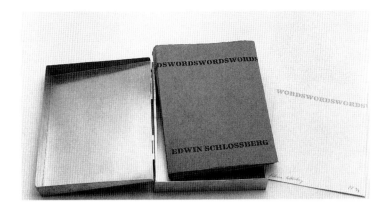

I-20. WORDSWORDSWORDS, 1967-68
An unbound book of seventeen poems with a
preface by Robert Rauschenberg, a title page,
and a colophon page wrapped in a folder of
brown laid laminated Oriental paper made by
Carolyn Horton and contained in an aluminum
box made by Louis Leibl, Jr.
Lithograph, etching, embossing, and letterpress
Sheet unless otherwise noted: 280×215 mm
(11×8½ in.)
Box: 312×235×50 mm (12¼×9¼×1⅞ in.)
Edition: 25
 Plus: 3 poet's proofs (1 AIC)
Printers: Donn Steward and Fred Genis;
letterpress hand-set and hand-printed by
Christopher Pullman
See plate 212

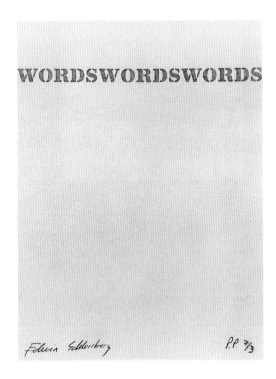

1. WORDSWORDSWORDS: TITLE PAGE,
1967-68
Letterpress
Paper: white wove Italia
Sheet: 280×430 mm (11×17 in.) (unfolded)
Signed; lower left: Edwin Schlossberg
Numbered; lower right: x/25
ULAE embossed stamp lower right

2. WORDSWORDSWORDS: PREFACE,
1967-68
Letterpress and blind embossing from one plate,
using elements from Robert Rauschenberg's
Water Stop (Rauschenberg, cat. no. 32)
Paper: white wove German Copperplate
Sheet: 280×430 mm (11×17 in.) (unfolded)
Numbered, signed; lower right: x/25
RAUSCHENBERG
ULAE embossed stamp lower right

3. WORDSWORDSWORDS: ALPHABET,
1967-68
Lithograph from one stone
Paper: white wove Shogun
Watermark: JAPAN

4. WORDSWORDSWORDS: POEM FOR
JASPER, 1967-68
Letterpress on aluminum foil

5. WORDSWORDSWORDS: CLARITY,
1967-68
Letterpress blind embossed
Paper: five sheets of white wove Italia

6. WORDSWORDSWORDS: OPEN PAGE,
1967-68
Letterpress blind embossed on aluminum foil

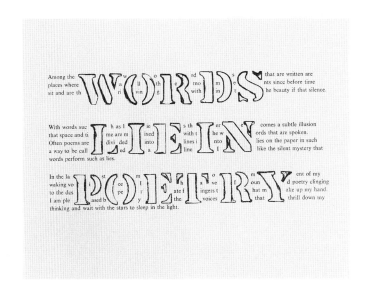

7. WORDSWORDSWORDS: CLOSE TO THIS PAGE, 1967-68
Letterpress blind embossed
Paper: white wove Italia

8. WORDSWORDSWORDS: AMONG THE WORDS, 1967-68
Lithograph from one stone and letterpress
Paper: white wove British Chatham

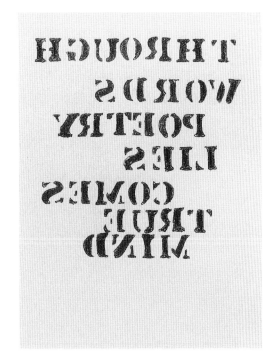

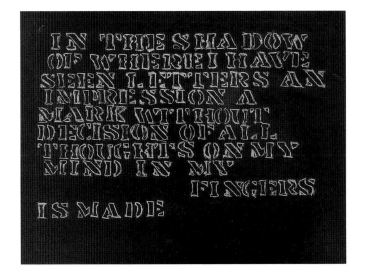

9. WORDSWORDSWORDS: THROUGH, 1967-68
Lithograph from one stone
Paper: white wove British Chatham

10. WORDSWORDSWORDS: IN THE SHADOW, 1967-68
Etching from one plate
Paper: black wove Fabriano

11. WORDSWORDSWORDS: NEXT TO
THIS PAGE, 1967-68
Letterpress blind embossed
Paper: white wove Italia
Watermark: Magnani emblem

12. WORDSWORDSWORDS: LOOKING
THROUGH, 1967-68
Letterpress
Paper: three sheets of acetate

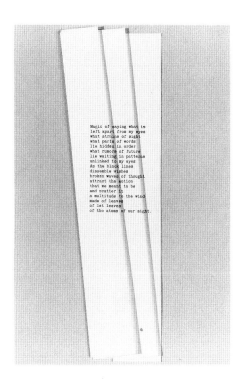

13. WORDSWORDSWORDS: MAGIC OF
SAYING, 1967-68
Letterpress
Paper: white wove Mohawk Superfine, folded

14. WORDSWORDSWORDS: THE
ALPHABET WE KNOW, 1967-68
Letterpress
Paper: gray wove Studio Bristol

15. WORDSWORDSWORDS: IN THINKING, 1967-68
Letterpress
Paper: two sheets of white wove Mead Mark I cover
Sheets: upper, 278×47 mm (10⅞×1¾ in.)
　　　　lower, 278×213 mm (10⅞×8⅜ in.)

16. WORDSWORDSWORDS: IN EACH, 1967-68
Letterpress
Paper: white wove Mohawk Superfine, folded

17. WORDSWORDSWORDS: IN FINDING PLACE, 1967-68
Letterpress
Paper: two sheets of white wove Mead Mark I cover
Sheets: upper, 215×89 mm (8½×3½ in.)
　　　　lower, 278×215 mm (10⅞×8½ in.)

18. WORDSWORDSWORDS: THOUGHTS LIE, 1967-68
Lithograph from four stones
Paper: four sheets of Plexiglas

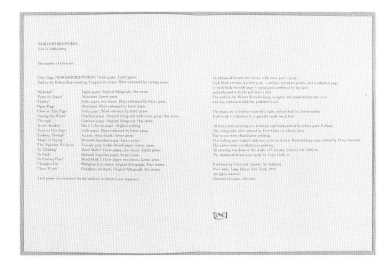

19. WORDSWORDSWORDS: THESE
WORDS, 1967-68
Lithograph from six stones
Paper: six sheets of Plexiglas

20. WORDSWORDSWORDS:
DESCRIPTION OF CONTENTS, 1967-68
Letterpress
Paper: white wove Italia
Sheet: 280×432 mm (11×17 in.) (unfolded)

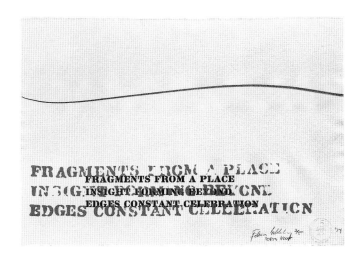

21. FRAGMENTS FROM A PLACE, 1974
Lithograph from two stones
Paper: white wove handmade
Watermark: ANGOUMOIS A LA MAIN; RICHARD DE BAS
Sheet: 392×576 mm (15⁷/₁₆×22⁷/₁₆ in.)
Signed, numbered, dated; lower right in red
pencil: Edwin Schlossberg x/50 '74
ULAE embossed stamp lower right; ULAE
anniversary embossed stamp lower right
Edition: 50
 Plus: 2 printer's proofs
 5 poet's proofs (1 AIC)
Printer: John A. Lund; type hand-set by Juda
Rosenberg

22. AT FIRST LIGHT, 1981
Lithograph from one stone in Liquid Crystal
Paper: black wove Arches
Sheet: 760×554 mm (29¹⁵/₁₆×21¹³/₁₆ in.)
Signed, dated, numbered; lower right in white
pencil: Edwin Schlossberg 81 x/24
Edition: 24
 Plus: 2 printer's proofs
 4 poet's proofs (1 AIC)
Printers: Bill Goldston and Thomas Cox

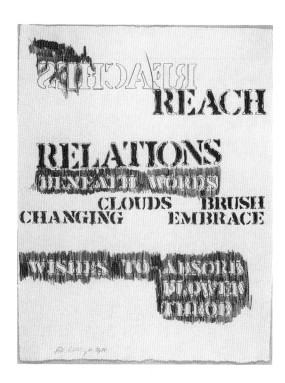

23. EDGES STRENGTHEN, 1981
Lithograph from two stones in Liquid Crystal
Paper: white wove
Watermark: BFK RIVES FRANCE
Sheet: 1064×754 mm (41⅞×29¹¹/₁₆ in.)
Signed, dated, numbered; lower left: Edwin
Schlossberg 81 x/23
ULAE embossed stamp lower right
Edition: 23
 Plus: 2 printer's proofs
 4 poet's proofs (1 AIC)
Printers: Bill Goldston and Thomas Cox

24. REACHES RELATIONS, 1981
Lithograph from one stone in Liquid Crystal
Paper: ivory wove Richard de Bas handmade
Sheet: 664×513 mm (26⅛×20³/₁₆ in.)
Signed, dated, numbered; lower left: Edwin
Schlossberg 81' x/23
Edition: 23
 Plus: 2 printer's proofs
 4 poet's proofs (1 AIC)
Printers: Bill Goldston and Keith Brintzenhofe

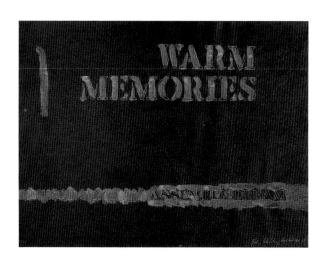

25. WARM MEMORIES, 1981
Lithograph from one stone
Paper: dark gray wove Duchene
Sheet: 486×654 mm (19⅛×25¾ in.)
Signed, numbered, dated; lower right in white
pencil: Edwin Schlossberg x/21 81'
Edition: 21
 Plus: 2 printer's proofs
 4 poet's proofs (1 AIC)
Printers: Bill Goldston and Keith Brintzenhofe

1. THE MUSEUM, 1972
Lithograph from one stone and one plate with
an embossed seal hand-stamped by the artist
Paper: ivory wove Barcham Green
Watermark: Crisbrook emblem
Sheet: 527×714 mm (20¾×28⅛ in.)
Numbered, signed, dated; lower center: x/34
STEINBERG / 72
ULAE embossed stamp lower right
Edition: 34 stamped "Spanish Refugee Aid"
 Plus: 8 artist's proofs without stamp (1 AIC)
Printer: Zigmunds Priede
The edition of thirty-four was printed as a
benefit print for Spanish Refugee Aid; eight
impressions on gray paper (cat. no. 2) were
printed as a ULAE publication.

2. THE MUSEUM (H.C.), 1972
Lithograph from one stone and one plate, with
embossed seal hand-stamped by the artist
Paper: gray laid
Watermark: Fabriano (Italy)
Sheet: 508×672 mm (20×26½ in.)
Numbered, signed, dated; lower center: x/8
STEINBERG / 72
ULAE embossed stamp lower right
Edition: 8 (hors commerce edition)
 Plus: 4 artist's proofs (1 AIC)
 2 printer's proofs
Printers: Zigmunds Priede and Dick Sonnen

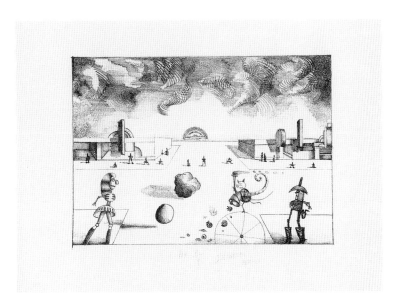

3. MAIN STREET, 1972-73
Lithograph from one stone and one plate, with
embossed seal hand-stamped by the artist
Paper: ivory wove
Watermark: Arches FRANCE; embossed stamp:
VERITABLE PAPIER D'ARCHES / FIN / FIN
Sheet: 575×763 mm (22⅝×30 in.)
Numbered, signed, dated; lower center: x/40
STEINBERG 1972-73
Edition: 40
 Plus: 4 artist's proofs (1 AIC)
 2 printer's proofs
Printers: John A. Lund and Bill Goldston
See plate 216

Cy Twombly

1. UNTITLED MEZZOTINT, 1968
Mezzotint and drypoint from one plate
Paper: ivory laid handmade Richard de Bas
Watermark: AUVERGNE A LA MAIN
Plate: 224×151 mm (8¹³/16 × 5¹⁵/16 in.)
Sheet: 510×406 mm (20¹/16 × 15¹⁵/16 in.)
Signed, dated; lower right: Cy Twombly 68
Numbered; lower left: x/12
Edition: 12
　　　Plus: 4 artist's proofs (1 AIC)
　　　　　 1 printer's proof
Printer: Donn Steward
Catalogue reference: Bastian 19
This print is one of a handful of mezzotints
published by ULAE in 1967-68. The image
is rare as well: Twombly hardly ever centered
his forms within the picture plane nor did he
give them the three-dimensional treatment
accorded here.
See plate 218

2. UNTITLED I, 1967-74
Etching, open bite, and aquatint from one plate
Paper: ivory wove
Watermark: J. GREEN
Plate: 598×717 mm (23⁹/16 × 28¼ in.)
Sheet: 700×1032 mm (27⁹/16 × 40⅝ in.)
Numbered, signed, dated; lower right: x/19
CT 67
ULAE embossed stamp lower right
Edition: 19
　　　Plus: 5 artist's proofs (1 AIC)
　　　　　 1 printer's proof
Printer: Donn Steward
Catalogue reference: Bastian 10
When Twombly made *Untitled I* and *II* (cat.
nos. 2, 3), aquatint was virtually unknown in
American printmaking outside of a few
university workshops. But at ULAE, Master
Printer Donn Steward was able to introduce a
number of artists—among them, Bontecou,
Frankenthaler, Johns, Motherwell, and Twombly
—to the medium's capabilities. For Twombly's
gestural drawing, Steward prepared an aquatint
plate on which Twombly drew with an open-bite
liquid.

3. UNTITLED II, 1967-74
Etching, open bite, and aquatint from one plate
Paper: ivory wove
Watermark: J. GREEN
Plate: 600×717 mm (23⅝ × 28¼ in.)
Sheet: 695×1025 mm (27⅜ × 40⅜ in.)
Numbered, signed, dated; lower right: x/23
CT 67
ULAE embossed stamp lower right
Edition: 23
　　　Plus: 5 artist's proofs (1 AIC)
　　　　　 1 printer's proof
Printer: Donn Steward
Catalogue reference: Bastian 11

4. NOTE I, 1967-75
Etching from one plate
Paper: orange-buff laid handmade
Watermark: RICHARD DE BAS; AUVERGNE A LA MAIN
Plate: 226×277 mm (8⅞×10⅞ in.)
Sheet: 655×517 mm (25¹³⁄₁₆×20⅜ in.) (irreg.)
Signed; lower right: Cy Twombly
Numbered, dated; lower left: x/14 I 1967
Edition: 14
 Plus: 4 artist's proofs (1 AIC)
 1 printer's proof
Printer: Donn Steward
Catalogue reference: Bastian 6
See plate 217

5. NOTE II, 1967-75
Etching from one plate
Paper: orange-buff laid handmade
Watermark: RICHARD DE BAS; AUVERGNE A LA MAIN
Plate: 225×276 mm (8⅞×10⅞ in.)
Sheet: 648×516 mm (25½×20⁵⁄₁₆ in.) (irreg.)
Signed; lower right: Cy Twombly
Numbered, dated; lower left: x/14 II, 1967
Edition: 14
 Plus: 4 artist's proofs (1 AIC)
 1 printer's proof
Printer: Donn Steward
Catalogue reference: Bastian 7

6. NOTE III, 1967-75
Etching from one plate
Paper: orange-buff laid handmade
Watermark: RICHARD DE BAS; AUVERGNE A LA MAIN
Plate: 225×276 mm (8⅞×10⅞ in.)
Sheet: 653×518 mm (25¹¹⁄₁₆×20⅜ in.) (irreg.)
Signed; lower right: Cy Twombly
Numbered, dated; lower left: x/14 III, 1967
Edition: 14
 Plus: 4 artist's proofs (1 AIC)
 1 printer's proof
Printer: Donn Steward
Catalogue reference: Bastian 8

7. NOTE IV, 1967-75
Etching from one plate
Paper: orange-buff laid handmade
Watermark: RICHARD DE BAS; AUVERGNE A LA MAIN
Plate: 225×278 mm (8⅞×10¹⁵/₁₆ in.)
Sheet: 645×514 mm (25³/₈×20¼ in.) (irreg.)
Signed; lower right: Cy Twombly
Numbered, dated; lower left: x/14 IV, 1967
Edition: 14
 Plus: 4 artist's proofs (1 AIC)
 1 printer's proof
Printer: Donn Steward
Catalogue reference: Bastian 9

8-14. SKETCHES, 1967-75
A portfolio of six etchings, each from one plate,
and a title-colophon page enclosed in a folder
and an envelope made by Carolyn Hornton
Paper: ivory wove Fred Siegenthaler. Handmade
folder, ivory wove British Chatham. Outer
envelope, mottled tan wove waterproof
Sheet: 215×310 mm (8½×12¼ in.)
Printed on flap of folder: Cy Twombly—
Sketches
Numbered, inscribed, signed; lower center all
sheets: x/18 (a-f) Cy Twombly
Edition: 18
 Plus: 5 sets artist's proofs (1 AIC)
 1 set printer's proof
 3 sets "special proofs"
Printer: Donn Steward; typography for colophon
page by Herbert Matter.

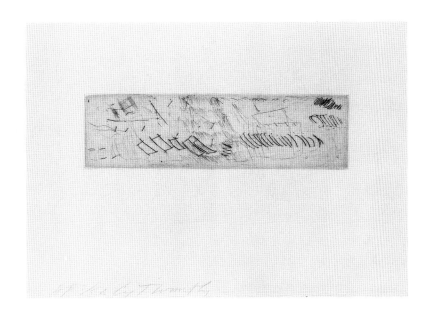

8. SKETCHES: A, 1967-75
Plate: 58×209 mm (2¼×8¼ in.)
Catalogue reference: Bastian 12

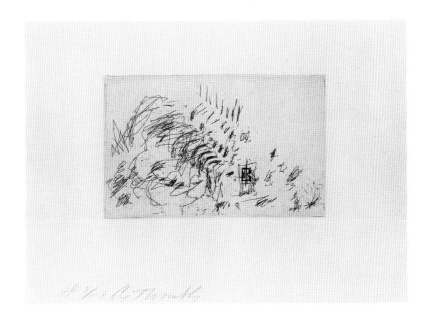

9. SKETCHES: B, 1967-75
Plate: 107×174 mm (4¼×6¾ in.)
Catalogue reference: Bastian 13

10. SKETCHES: C, 1967-75
Plate: 120×173 mm (4¾×6¾ in.)
Catalogue reference: Bastian 14

11. SKETCHES: D, 1967-75
Plate: 127×173 mm (5×6¾ in.)
Catalogue reference: Bastian 15

12. SKETCHES: E, 1967-75
Plate: 173×124 mm (6¾×4⅞ in.)
Catalogue reference: Bastian 16

13. SKETCHES: F, 1967-75
Plate: 173×108 mm (6¾×4¼ in.)
Catalogue reference: Bastian 17

14. SKETCHES: COLOPHON PAGE, 1967-75
Letterpress
Sheet: 222×307 mm (5⅝×7¾ in.)

Andrei Voznesensky

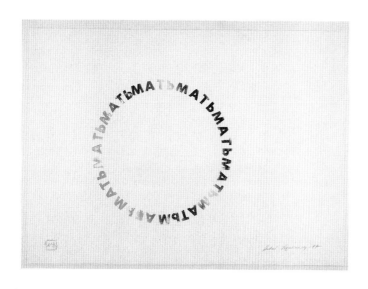

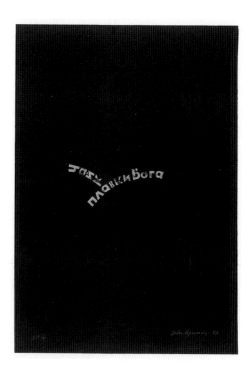

1. DARKNESS MOTHER DARKNESS
MOTHER, 1977
Lithograph from two stones (Russian type hand-stamped by the poet on two stones)
Paper: ivory wove
Watermark: BFK RIVES FRANCE
Sheet: 755×1054 mm (29¾×41½ in.)
Signed, dated; lower right: Andrei Voznesensky
—77
Inscribed, numbered; lower left: darkness
Mother darkness Mother (in a square around
the number) x/26
Edition: 26
　　　Plus: 5 artist's proofs (1 AIC)
Printers: Thomas Cox and Bill Goldston
Stones temporarily preserved
See plate 163
See Rauschenberg (cat. no. 90) for comparison

2. SEAGULL—BIKINI OF GOD, 1977
Lithograph from one stone (Russian type hand-stamped by the poet on the stone)
Paper: black laid Japan tipped onto black wove
Arches
Sheets: Japan, 957×651 mm (37¹¹/₁₆×25⅝ in.)
　　　(irreg.)
　　　Arches, 1019×710 mm (40⅛×28 in.)
Signed, dated; lower right of Japan in white
pencil: Andrei Voznesensky—77
Numbered; lower left of Japan in white pencil:
x/21
Title stamped on Arches; lower right in white
ink: SEAGULL—BIKINI OF GOD
Edition: 21
　　　Plus: 5 artist's proofs (1 AIC)
　　　　　2 printer's proofs
Printers: Keith Brintzenhofe and Bill Goldston
Stone temporarily preserved
See Rauschenberg (cat. no. 92) for comparison

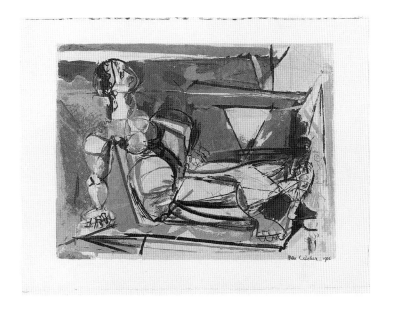

1. RECLINING FIGURE, 1956
Screenprint
Paper: white wove
Watermark: A MILLBOURN & CO. /
BRITISH HAND MADE
Sheet: 575 × 760 mm (22⅝ × 30 in.)
Signed, dated; lower right: Max Weber 1956
Numbered; lower left: x/96
Edition: 96
Printer: Maurice Grosman
Catalogue reference: Rubenstein 110
This screenprint reproduces the painting
Reclining Figure, 1955, which was lent by the
artist to his retrospective exhibition at The
Jewish Museum, New York, in 1956. It was
distributed with a label on handmade paper by
Douglass Howell: MAX WEBER / "Reclining
Figure" / UNIVERSAL LIMITED ART
EDITIONS, Bay Shore, N.Y.

2. ON THE SHORE or ON THE SEASHORE,
1957
Lithograph from one plate
Paper: white wove
Watermark: RIVES
Sheet: 333 × 481 mm (13⅛ × 19 in.)
Signed; lower right: Max Weber
Numbered; lower left: x/10
Edition: 10
Printer: Maurice Grosman
Catalogue reference: Rubenstein 64
This is a reprint of *On the Shore* (Cole 25),
which Weber probably drew on transfer paper in
1928.

3. THE MIRROR, 1957
Lithograph from one plate
Paper: white wove Rives
Sheet: 206 × 327 mm (8 × 12¾ in.)
Edition: 10
Printer: Maurice Grosman
Catalogue reference: Rubenstein 80
See plate 223

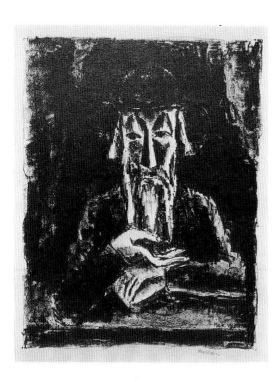

4. THE RABBI, 1958
Lithograph from one plate
Paper: ivory wove
Edition: 10
Printer: Maurice Grosman
Catalogue reference: Rubenstein 72
The impression reproduced here is the
lithograph published in 1928 (Rubenstein 72).

5. SEATED FIGURE, c. 1957-58
Lithograph from one plate
Paper: unknown
Sheet: 254×178 mm (10×7 in.)
Edition: unknown
Printer: Maurice Grosman
Catalogue reference: Rubenstein 76
The impression reproduced here was printed
around 1928-30. As of this printing, we have not
been able to locate an impression from the
second edition printed by Maurice Grosman.

The language of printmaking, particularly in a workshop of distinctive character, often tends to become a patois. The aesthetic biases of its director and its artists often reshape the accepted definitions of words. The noun "edition," for example, has become a printshop verb meaning "to print an edition." When new methods are developed, old words are usually stretched to encompass new meanings.

The public aspect of workshop language was more important to Tatyana Grosman than its technical precision. For the sake of style and proper order, she would gladly rewrite a documentary sheet a dozen times, but the names of ink colors, their sequence or method of application, were of little moment. Although she was exhilarated by her artists' innovations, it was the image and not the technique that was, for her, the raison d'être of every print. Therefore, the definitions that follow will not serve as a general glossary for contemporary printmaking but are limited to their application at Universal Limited Art Editions (ULAE).

AIRBRUSH

A spray gun that applies liquid lithographic ink. It produces an area of color with an exceptionally smooth gradation of tone.

AQUATINT

An intaglio process used to print areas of color. Powdered resin is fused by heat to a plate. The interstices between the resin particles are then bitten by acid, producing a distinctive grained pattern that is visible under magnification. Areas can be reserved from the action of the acid by applying a "stop-out" solution before the acid comes in contact with the plate. Both the density and pattern of the aquatint grain vary according to the nature of the particles and the action of the acid.

DRAWING STONE / PLATE

The first stone or plate, usually printed in black, that prints the basic design. This printed "drawing" is then used as a guide in the addition of subsequent colors.

DRYPOINT

An intaglio method in which lines are produced by drawing on a bare plate with a sharp instrument. As the instrument abrades the surface, rough edges are thrown up on both sides of the line. This fragile "burr" holds much more ink than the clean edges of an engraved line and thereby prints the characteristically velvety line of drypoint. The path of the cutting tool may be visible under magnification as a narrow, white scratch within the wider drypoint line. A lighter pressure in the printing will extend its life, but the burr rarely stays fresh for more than a few impressions.

EDITION

The finite number of identical prints published with a common title and date. At ULAE, the size of an edition was rarely planned and was often determined by exigencies of weather, paper supply, or the mood of the principals involved. Every edition print was approved by Mrs. Grosman, the artist, and the printer. With few exceptions, edition prints were signed and numbered by the artist. For example, an impression inscribed "3/23" is the third impression signed in a total of twenty-three; it does not necessarily mean that it was the third impression printed.

ENGRAVING

The oldest of intaglio techniques in which lines are carved into a bare metal plate with a graver, burin, or gouge. The tool cuts a groove

into the surface and the displaced metal, thrown up as a "burr" on either side of the groove, is removed. Under magnification, the ends of an engraved line often taper to a point, revealing the entry and exit of the tool.

ETCHING

An intaglio process that begins with the application of a "ground," or coating, to a metal plate. The artist draws on the ground with a sharp tool. When the plate is immersed in acid, the incisions scratched expose the bare metal to the acid, which opens, or "bites," the grooves and pits made by the tool. The quality of the line varies according to the strength of the acid and the length of time the acid is allowed to bite the plate.

In softground etching, paper or cloth is placed between the tool and the ground. The lines are therefore more blurred than in direct etching.

H.C.

From the French "hors commerce," that is, outside of commercial distribution. H.C. proofs differ from edition impressions in some verifiable respect: paper, color of ink, inscription, etc.

IMPRESSION

Any print taken from a block, plate, stone, or other matrix. The term is useful in distinguishing original prints made by artists from the photographic reproductions that are commonly sold as "prints."

INTAGLIO

Intaglio prints (see aquatint, etching, engraving, mezzotint) are usually produced from metal plates. Lines, or microscopic areas, are cut or bitten into the surface of the plate. Ink is applied to the plate and wiped off, leaving a deposit only in the incisions. When dampened paper is placed on the plate and the two are fed through the rollers of a high-pressure press, ink from the incisions is transferred to the paper. Intaglio prints can be distinguished by their platemark and by the ridges of ink, which stand above the surface of the paper in discernible relief.

LAID PAPER

With a light source behind it, a sheet of laid paper reveals the woven "fabric" of wires making up the mold in which the sheet was formed. The closely parallel lines are the "laid" lines. The more distantly spaced lines running at ninety degrees to the laid lines are formed by the "chain" wires that bind the laid wires into a screen.

LIFT-GROUND ETCHING

See Sugar-lift Aquatint.

LITHOGRAPHY

A planographic method by which an image is drawn or painted on stone (or stone substitute) with greasy ink. The image is subsequently washed with an "etch" of acid and gum arabic to fix the image and to make the unmarked areas of the stone receptive to water. When the greasy printing ink is rolled over the damp stone, the ink adheres only to the marks made by the artist. Paper is placed against the stone, and the image is transferred by means of a scraper-bar press. Although there is no platemark, as in intaglio printing, the impress of the stone often flattens or "polishes" the surface of the paper. Lithography was the primary method of publishing prints at ULAE. See Offset Lithography.

MATRIX

The "mother" surface—wood, stone, metal, fabric, cardboard, etc.—on which the artist works. Paper is placed against the matrix and, through pressure, the image is transferred to the paper.

MEZZOTINT

An intaglio process in which the plate is pitted with toothed instruments to produce minute pockmarks that will hold printing ink. A plate completely covered with mezzotint will print a solid black. White-to-gray areas are produced by smoothing back the roughened plate according to the lightness desired. At ULAE, the indentations were made with traditional steel rockers and roulettes. The texture of this handmade surface is richer than the mezzotint produced by photomechanically etched mezzotint screens. Like drypoint, the mezzotint surface is fragile, and, unless reinforced with steel coating, it yields very few impressions for the great amount of preparatory work required.

OFFSET LITHOGRAPHY

A process adapted from commercial photolithography in which the image is drawn or painted by the artist on a metal plate, then inked and transferred to a flexible blanket roller, which in turn prints it on paper. As it was developed at ULAE in 1969-70, the offset process offered several advantages over traditional stone lithography. The images did not have to be reversed, as in the past; the plates are lighter, more portable, and less fragile than stone. Because less ink is required, impressions dry quickly. Offset eliminates many of the other irksome delays in lithography and therefore encourages the artist's spontaneity. The problems of inaccurate registration are all but eliminated. The plate is easily photosensitized, facilitating the inclusion of preexistent images.

OPEN BITE

An intaglio process whereby the aquatint particles are manipulated to reduce the ink-holding capacity of a given area of aquatint. It modulates, usually reducing, the intensity of the color to be printed.

PHOTOETCHING / PHOTOLITHOGRAPH / PHOTOSCREENPRINT

Processes developed for sensitizing printing matrices to receive and print photographic images. This is usually done by means of a grid of dots, 150 or more to the inch, in which the illusion of continuous tone is produced by the dots, which are below the threshold of the human eye. If the dots are smaller and farther apart, they deposit less ink and the color is perceived as less intense.

PROOF

Any image printed from stone, block, or plate to record the image from that matrix. A *trial proof* is an experimental impression made to test the image from one or more matrices. An *artist's proof* is an impression identical to those in the edition but printed for the personal use of the artist. A *printer's proof* is traditionally given to each printer who worked on the edition. A *working proof* is a trial proof, with the addition of handwork (such as drawing, watercolor, collage, written instructions) by the artist. A *progressive proof* records the incremental stages in printing a multimatrix edition.

SCREENPRINT

A stencil process using a screen (usually cloth) through which ink is deposited onto paper. Areas to be printed are left unmasked, allowing the ink to pass through the screen. The sten-

ciled areas—the areas through which the ink does *not* pass—may be painted or photo-printed on the screen. "Serigraphy" was the term used by Maurice and Tatyana Grosman to distinguish artists' screenprints from the commercial product. Until the 1970s, when the technology improved dramatically, screenprints were characterized by dense layers of unmodulated color.

STATE PROOF

A term used by a few of the artists at ULAE for an intermediate and experimental stage in the development of a more complex composition. It is not to be confused with a progressive proof, which records a stage in the development of an edition approved by artist and publisher.

SUGAR-LIFT AQUATINT

An intaglio process in which the artist paints an image on the grounded plate using a solution in which sugar is dissolved. A coat of asphaltum solution is then applied and, after drying, the plate is soaked in water. The sugar dissolves and lifts the asphaltum. The exposed metal is then etched as an aquatint. This method is particularly suitable for the spontaneous brushwork of expressionist and gestural art. Also called lift-ground etching.

TRIGRAM

A short-lived project whereby the proceeds of a few prints from selected editions were set aside to finance the publication of a catalogue raisonné of ULAE prints. The plan did not come to fruition.

TUSCHE

The liquid medium used for drawing and painting on lithographic stones or plates.

WOODCUT

A method in which the artist, using knives, gouges, or electric tools, cuts away the areas of a piece of wood that he does not want to print. Ink is rolled on the surface of the ridges and areas left standing. The image is pressed onto paper. At ULAE, woodcuts were printed by rubbing as well as by presswork.

WOVE PAPER

A smooth paper in which no "laid" or "chain" lines appear. Such papers are usually machine-made. Handmade wove papers can be made in molds in which the horizontal and vertical wires are invisible or are aligned in evenly spaced rows in both directions.

BIBLIOGRAPHY

Amherst, 1983
See Davies, 1983.

Amsterdam, 1973
Amsterdam, Stedelijk Museum. *James Rosenquist*. Exh. cat. by Wim A. L. Beeren. Amsterdam, 1973.

Amsterdam, 1977
Amsterdam, Stedelijk Museum. *Claes Oldenburg*. Exh. cat. by Coosje van Bruggen and Claes Oldenburg. Amsterdam, 1977.

Arnason, 1982
Arnason, H. H. *Robert Motherwell*. Intro. by Dore Ashton and interview with Robert Motherwell by Barbaralee Diamonstein. 2nd ed., new and rev. New York: Harry N. Abrams, Inc., Publishers, 1982.

Arts Council, 1974
Arts Council of Great Britain. *Jasper Johns Drawings*. Interview with Jasper Johns by David Sylvester. London, 1974.

Ashbery, 1969
Ashbery, John. "Saul Steinberg: The Stamp of Genius." *Art News* 68, 7 (Nov. 1969): 45, 72, 74.

Ashton, 1963
Ashton, Dore. "Fritz Glarner," *Art International* 7, 1 (Jan. 25, 1963): 49-51, 53-54.

Ashton, 1967
Ashton, Dore. "Art—with irony." *Studio International* 173, 885 (Jan. 1967): 40-43.

Athens, Ohio, 1974
Athens, Ohio, Trisolini Gallery of Ohio University. *Marisol*. Exh. cat. by José L. Barrio-Garay. Athens, 1974.

Belknap, 1984
See Terenzio, 1984

Bern, 1970
Bern, Kammerkunsthalle. *Barnett Newman, Das Lithographische Werk.* Exh. cat. by Carlo Huber. Bern, 1970.

Blackwood Productions, 1973
Blackwood Productions. *Motherwell/ Alberti: To Painting/A la pintura.* 1973.

Blake, 1972
Blake, Peter. "The World of Buckminster Fuller." *Architectural Forum* 136, 1 (Jan.-Feb. 1972): 49.

Boston, Segal Gallery, 1981
Boston, Thomas Segal Gallery. *Jasper Johns: Prints 1977-1981.* Exh. cat. with an essay by Judith Goldman. Boston, 1981.

Buffalo, 1972
Buffalo, New York, Albright-Knox Art Gallery. *Sam Francis Paintings 1947-1972.* Exh. cat. by Robert T. Buck, Jr., with essays by Franz Meyer and Wieland Schmied. Buffalo: Buffalo Fine Arts Academy, 1972.

Buffalo, 1983
Buffalo, New York, Albright-Knox Art Gallery. *Robert Motherwell.* Exh. cat. with an intro. by Robert T. Buck and essays by Dore Ashton and Jack D. Flam. New York: Abbeville Press, 1983.

Burrows, 1961
Burrows, Carlyle. "Art Reviews: Current Exhibits." *New York Herald Tribune,* Dec. 30, 1961, n.p.

Camera Three, 1976
"Camera Three: The Print World of Tatyana Grosman." CBS program, narrated by Rosamond Bernier, produced and directed by John Musilli. Shown in two parts: Apr. 4, 11; Aug. 22, 29, 1976.

Campbell, 1964
Campbell, Lawrence. "Marisol's Magic

Mixtures." *Art News* 63, 1 (Mar. 1964): 38-41, 64-65.

Chicago, 1972
Chicago, Museum of Contemporary Art. *Lee Bontecou.* Exh. cat. with an intro. by Carter Ratcliff. Chicago, 1972.

Cole, 1970
See New York, Associated American Artists, 1970

Colsman-Freyberger, 1974
Colsman-Freyberger, Heidi. "Robert Motherwell: Words and Images." *The Print Collector's Newsletter* 4, 6 (Jan.-Feb. 1974): 125-29.

Cummings, 1970
Cummings, Paul. Interview with Tatyana Grosman. Mar. 31, 1970. Archives of American Art.

Cummings, 1983
Cummings, Paul. "Interview: James Rosenquist Talks with Paul Cummings." *Drawing* 5, 2 (July-Aug. 1983): 30-34.

Davies, 1983
Amherst, Massachusetts, University Gallery, University of Massachusetts. *The Prints of Barnett Newman.* Exh. cat. by Hugh M. Davies, with an essay by Riva Castleman. New York: The Barnett Newman Foundation, 1983.

Davis, 1969
Davis, Douglas M. "Rauschenberg's Recent Graphics." *Art in America* 57, 4 (July-Aug. 1969): 90-95.

Davis, 1974
Davis, Douglas. *Art and the Future.* New York: Praeger Publishers, Inc., 1974.

Dorfles, 1962
Dorfles, Gillo. "Written Images of Cy Twombly." *Metro 6*, June 1962, pp. 63-71.

Düsseldorf, 1976
Düsseldorf, Stadtische Kunsthalle. *Robert Motherwell.* Exh. cat. by Jürgen Harten with texts by Robert Motherwell and Robert C. Hobbs. Düsseldorf, 1976-77.

Field, *Johns Prints 1960-70*
Field, Richard S. *Jasper Johns Prints 1960-70.* Philadelphia: Philadelphia Museum of Art, 1970.

Field, *Johns Prints 1970-77*
Field, Richard S. *Jasper Johns Prints 1970-1977.* Middletown, CT: Wesleyan University, 1978.

Field, 1982
Field, Richard S. "On Recent Woodcuts." *The Print Collector's Newsletter* 13, 1 (Mar.-Apr. 1982): 2.

Fort Wayne, 1981
Fort Wayne, Indiana, Fort Wayne Museum of Art. *Hartigan: Thirty Years of Painting 1950-1980.* Exh. cat. by Joseph D. Ketner II. Fort Wayne, 1981.

Fried, 1971
Fried, Michael. *Morris Louis.* New York: Harry N. Abrams, Inc., Publishers, 1971.

Fuller, 1981
Fuller, R. Buckminster. *Tetrascroll. Goldilocks and the Three Bears, a Cosmic Fairy Tale.* West Islip, Long Island, NY: ULAE, Inc., 1981.

Fuller, 1982
Fuller, R. Buckminster. *Tetrascroll. Goldilocks and the Three Bears, a Cosmic Fairy Tale.* New York: St. Martins Press, 1982.

Geldzahler, 1969
Geldzahler, Henry. *New York Painting and Sculpture: 1940-1970.* New York: Dutton, 1969.

Gilbert and Moore, 1981
Gilbert, Lynn, and Moore, Gaylen.
Particular Passions. New York: Clarkson
N. Potter, Inc., 1981, pp. 10-20.

Glarner, 1951
Glarner, Fritz. "What Abstract Art Means
to Me." *Museum of Modern Art Bulletin*
18, 3 (Spring 1951): 10.

Glueck, 1982
Glueck, Grace. "The Doyenne of
Printmaking." *The New York Times*,
July 4, 1982, p. H19.

Goldman, 1975
Goldman, Judith. "Painting in Another
Language." *Art News* 74, 7 (Sept. 1975):
28-31.

Gray, 1963
Gray, Cleve. "A New Venture—The
Hilton Hotel Collection." *Art in America*
51, 2 (Apr. 1963): 124-25.

Gray, 1965
Gray, Cleve. "Tatyana Grosman's
Workshop." *Art in America* 53, 6 (Dec.
1965): 83-85.

Guest and Friedman, 1962
Guest, Barbara, and Friedman, B. H.
Goodnough. Paris: The Pocket Museum,
Editions Georges Fall, 1962.

Hempstead, Long Island, 1970
Hempstead, Long Island, New York,
Emily Lowe Gallery, Hofstra University.
*Graphics from Long Island Collections
from the Studio of Universal Limited Art
Editions*. Exh. cat. with an intro. by
Diane Kelder. Hempstead, 1970.

Hempstead, Long Island, 1972
Hempstead, Long Island, New York,
Emily Lowe Gallery, Hofstra University.
*Jasper Johns' Decoy: The Print and the
Painting*. Exh. cat. by Roberta Bernstein.
Hempstead, 1972.

Herrmann, 1977
Herrmann, Rolf-Dieter. "Jasper Johns'
Ambiguity: Exploring the Hermeneutical
Implications." *Arts Magazine* 52, 3 (Nov.
1977): 124-29.

Hess, 1971
Hess, Thomas B. *Barnett Newman*. New
York: The Museum of Modern Art, 1971.

Hoelterhoff, 1977
Hoelterhoff, Manuela. "The Vasari Diary:
Goldilocks' Cosmic Teach-In." *Art News*
76, 3 (Mar. 1977): 19-21.

Jacksonville, 1978
Jacksonville, Florida, Jacksonville Art
Museum. *Helen Frankenthaler*. Exh. cat.
by Christian Geelhaar. Jacksonville, 1978.

Jones, 1978
Jones, Elizabeth. "Robert Blackburn: An
Investment in an Idea." *The Tamarind
Papers* 6, 1 (Winter 1982-83): 10-14.

Kaprow, 1966
Kaprow, Allan. *Assemblage,
Environments, Happenings*. New York:
Harry N. Abrams, Inc., Publishers, 1966.

Kozloff, 1962
Kozloff, Max. "'Pop' Culture,
Metaphysical Disgust, and the New
Vulgarians." *Art International* 6, 2 (Mar.
1962): 34-36.

Kozloff, 1967
Kozloff, Max. *Jasper Johns*. New York:
Harry N. Abrams, Inc., Publishers, 1967.

Lada-Mocarski, et al., 1977
Lada-Mocarski, Polly; Minsky, Richard;
and Seidler, Peter. "Book of the Century:
Fuller's Tetrascroll." *Craft Horizons* 37, 5
(Oct. 1977): 18-21, 60-61.

Larson, 1974
Larson, Philip. "Words in Print." *The Print Collector's Newsletter* 5, 3 (July-Aug. 1974): 53-56.

Leverkusen, 1968
Leverkusen, Stadtisches Museum Schloss Morsbroich. *Lee Bontecou*. Exh. cat. with essays by Rolf Gunter Dienst, Rolf Wedewer, Wibke von Bonin, and Dore Ashton. Leverkusen, 1968.

London, 1978
London, Royal Academy of Arts. *Robert Motherwell: Paintings and Collages from 1941 to the Present*. Exh. cat. by Terence Maloon, with a preface by Norman Rosenthal. London, 1978.

Lottman, 1973
Lottman, Herbert R. "Work in Progress: Voznesensky Magic." *Intellectual Digest* 4, 3 (Nov. 1973): 8-12.

Ljubljana, 1965
Ljubljana, Yugoslavia, Moderna Galerija. *VI International Exhibition of Prints*. Exh. cat. with essays by Marko Bulc, Zoran Krzisnik, Brian O'Doherty, et al. Ljubljana, 1965.

Lynes, 1963
Lynes, Russell. "New York Hotels (with Reservations)." *Art in America* 51, 2 (Apr. 1963): 58-61.

Lyon, 1982
Lyon, Christopher. "Rauschenberg's Show a Work of Art." *Chicago Sunday Sun-Times*, Nov. 28, 1982, *Show* section, p. 12.

Middletown, 1975
Middletown, Connecticut, Davison Art Center, Wesleyan University. *Prints and Drawings by Lee Bontecou*. Exh. cat. by Richard S. Field. Middletown, 1975.

Mikro, 1970
West Berlin, Galerie Mikro. *Jim Dine: Complete Graphics*. Exh. cat. by John Russell, Tony Towle, and Wieland Schmied. West Berlin, 1970.

Motherwell, 1951
Motherwell, Robert. "What Abstract Art Means to Me." *Museum of Modern Art Bulletin* 18, 3 (Spring 1951): 12-13.

Motherwell, 1972
Motherwell, Robert. *A la pintura: The Genesis of a Book*. New York: The Metropolitan Museum of Art, 1972, "The Book's Beginning."

Motherwell and Reinhardt, 1951
Motherwell, Robert, and Reinhardt, Ad, eds. *Modern Artists in America: First Series*. New York: Wittenborn Schultz, Inc., 1951.

Munro, 1979
Munro, Eleanor. *Originals: American Women Artists*. New York: Simon & Schuster, 1979.

Myers, 1981
Myers, John Bernard. *Tracking the Marvelous: A Life in the New York Art World*. New York: Random House, 1981.

Nemser, 1975
Nemser, Cindy. *Art Talk: Conversations with 12 Women Artists*. New York: Charles Scribner's Sons, 1975.

Newsweek, 1959
"The Rawness of the Past." *Newsweek*, May 11, 1959, pp. 113-14.

New York, Alexander, 1979
New York, Brooke Alexander, Inc. *Sam Francis—The Litho Shop 1970-1979*. Exh. cat. New York, 1979.

New York, Assoc. of American Artists, 1970
New York, Association of American
Artists. *Max Weber Lithographs*. Exh.
cat. by Sylvan Cole, with a foreword by
Una E. Johnson. New York, 1970.

New York, Contemporaries Gallery, n.d.
New York, Contemporaries Gallery.
*TODAY—Exhibition of Sculpture and
Graphic Art*. New York, n.d.

New York, Grey Art Gallery, 1977
New York, Grey Art Gallery and Study
Center, New York University. *Tribute to
Maurice Grosman*. Exh. cat. by Robert R.
Littman. New York, 1977.

New York, Janis, 1963
New York, Sidney Janis Gallery. *Jim
Dine*. Exh. cat. with an intro. by Oyvind
Fahlstrom. New York, 1963.

New York, Jewish Museum, 1956
New York, The Jewish Museum. *Max
Weber: Celebrating the Artist's 75th
Birthday*. New York, 1956.

New York, Jewish Museum, 1963
New York, The Jewish Museum. *Robert
Rauschenberg*. Exh. cat. by Alan R.
Solomon. New York, 1963.

New York, Jewish Museum, 1964
New York, The Jewish Museum. *Jasper
Johns*. Exh. cat. by Alan R. Solomon.
New York, 1964.

New York, MMA, 1972
New York, The Metropolitan Museum of
Art. *Robert Motherwell's A la pintura:
The Genesis of a Book*. Exh. cat. by
John J. McKendry, with texts by Robert
Motherwell and Diane Kelder.
New York, 1972.

New York, MOMA, 1956
New York, The Museum of Modern Art.
12 Americans. Exh. cat. edited by
Dorothy C. Miller. New York, 1956.

New York, MOMA, 1964
New York, The Museum of Modern Art.
*American Painters As New
Lithographers*. Exh. cat. by William S.
Lieberman. New York, 1964.

New York, MOMA, 1965
New York, The Museum of Modern Art.
Robert Motherwell. Exh. cat. by Frank
O'Hara. New York, 1965.

New York, MOMA, 1968
New York, The Museum of Modern Art.
*Jim Dine Designs for A Midsummer
Night's Dream*. Exh. cat. with an intro.
by Virginia Allen. New York, 1968.

New York, MOMA, 1978
New York, The Museum of Modern Art.
Jim Dine's Etchings. Exh. cat. by Riva
Castleman. New York, 1978.

New York, New York Cultural Center, 1973
New York, New York Cultural Center, in
association with Fairleigh Dickinson
University. *Marisol: Prints 1961-1973*.
Exh. cat. by John Loring. New York, 1973.

New York, Niveau Gallery, 1947
New York, Niveau Gallery. *Maurice
Grosman, First Show in U.S.A.* Exh. cat.
with an intro. by Allan Ross MacDougall.
New York, 1947.

New York, Pace, 1979
New York, Pace Gallery, *Jim Dine*. Exh.
cat. with an intro. by James R. Mellow.
New York, 1979.

New York, Whitney, 1969
New York, Whitney Museum of American
Art. *Helen Frankenthaler*. Exh. cat. by
E. C. Goossen. New York, 1969.

New York, Whitney, 1970
New York, Whitney Museum of American
Art. *Jim Dine*. Exh. cat. by John Gordon.
New York, 1970.

New York, Whitney, 1971
New York, Whitney Museum of American Art. *Oversize Prints*. Exh. cat. by Elke M. Solomon. New York, 1971.

New York, Whitney, 1972
New York, Whitney Museum of American Art. *James Rosenquist*. Exh. cat. by Marcia Tucker, with notes on prints by Elke M. Solomon. New York, 1972.

New York, Whitney, 1977
New York, Whitney Museum of American Art. *Foirades/Fizzles*. Exh. cat. by Judith Goldman. New York, 1977.

New York, Whitney, 1981
New York, Whitney Museum of American Art. *American Prints: Process and Proofs*. Exh. cat. by Judith Goldman. New York, 1981.

Northampton, 1963
Northampton, Massachusetts, Smith College Museum of Art. *An Exhibition of the Work of Robert Motherwell*. Exh. cat. by Robert Motherwell and Margaret Paul. Northampton, 1963.

Ottawa, 1968
Ottawa, National Gallery of Canada. *James Rosenquist*. Exh. cat. by Brydon Smith, with an intro. by Ivan C. Karp. Ottawa, 1968.

Philadelphia, 1970
Philadelphia, Moore College of Art. *Marisol*. Exh. cat. by Roberta Bernstein, with an essay by Susan Hersch. Philadelphia, 1970.

Ratcliff, 1984
Ratcliff, Carter. "The Inscrutable Jasper Johns." *Vanity Fair* 47, 2 (Feb. 1984): 60-65.

Rivers, 1961
Rivers, Larry. "A Discussion of the Work of Larry Rivers." *Art News* 60, 1 (Mar. 1961): 44-46, 53-55.

Rivers, 1982
Rivers, Larry. "Tatyana Grosman." *Art News* 81, 8 (Oct. 1982): 101-2.

Robinson and Shapiro, 1976
Robinson, Frank, and Shapiro, Michael. "Jim Dine at 40." *The Print Collector's Newsletter* 7, 4 (Sept.-Oct. 1976): 101-5.

Rose, 1977
Rose, Barbara. "Jasper Johns: Pictures and Concepts." *Arts Magazine* 52, 3 (Nov. 1977): 148-53.

Rose, 1981
Rose, Barbara. *Alexander Liberman*. New York: Abbeville Press, 1981.

Rosenberg, 1965
Rosenberg, Harold. "Rivers' commedia dell' arte." *Art News* 64, 2 (Apr. 1965): 35-37, 62-63.

Rosenberg, *Newman*, 1978
Rosenberg, Harold. *Barnett Newman*. New York: Harry N. Abrams, Inc., Publishers, 1978.

Rosenberg, *Steinberg*, 1978
Rosenberg, Harold. *Saul Steinberg*. New York: Alfred A. Knopf in association with the Whitney Museum of American Art, 1978.

Rubenstein, 1980
Rubenstein, Daryl R. *Max Weber, A Catalogue Raisonné of His Graphic Work*. Chicago: The University of Chicago Press, 1980.

Russell, 1977
Russell, John. "Edward Avedisian, Richard Hennessy, Maurice Grosman." *New York Times*, Mar. 4, 1977.

Saint Louis, 1979
Saint Louis, University of Missouri, and
Columbia, Museum of Art and
Archaeology, University of Missouri.
Robert Motherwell: The Collage Prints,
1968-1978. Exh. cat. by Jean S. Tucker.
Saint Louis, 1979.

San Francisco, 1967
San Francisco Museum of Art. *Sam*
Francis—Exhibition of Drawings and
Lithographs. Exh. cat. by Anneliese
Hoyer. San Francisco, 1967.

San Francisco, 1970
San Francisco Museum of Art. *Fritz*
Glarner. Exh. cat. by Natalie Edgar,
1970-71.

Sarasota, 1979
Sarasota, Florida, John and Mable
Ringling Museum of Art, and Fort
Lauderdale, Fort Lauderdale Museum of
the Arts. *James Rosenquist Graphics*
Retrospective. Exh. cat. by Elayne H.
Varian. Sarasota, 1979.

Schuyler, 1962
Schuyler, James. "Is There an American
Print Revival?" *Art News* 60, 9 (Jan.
1962): 36-37.

Selz, 1982
Selz, Peter. *Sam Francis.* With essays on
his prints by Susan Einstein and Jan
Butterfield. Rev. ed. New York: Harry N.
Abrams, Inc., Publishers, 1982.

Seuphor, 1962
Seuphor, Michael. *Abstract Painting.*
New York: Harry N. Abrams, Inc.,
Publishers, 1962.

Shapiro, 1981
Shapiro, David. *Jim Dine.* New York:
Harry N. Abrams, Inc., Publishers, 1981.

Sparks, Aledort interview, 1985

Sparks, Esther. Interview with Dr. Louis
Aledort. Sept. 18, 1985.

Sparks, Blackburn interview, 1985
Sparks, Esther. Interview with Robert
Blackburn. Sept. 4, 1985.

Sparks, Bontecou interview, 1985
Sparks, Esther. Interview with Lee
Bontecou. June 17, 1985.

Sparks, Brintzenhofe interview, 1983
Sparks, Esther. Interview with Keith
Brintzenhofe. Mar. 23, 1983.

Sparks, Cox interview, 1985
Sparks, Esther. Interview with Thomas
Cox. July 25, 1985.

Sparks, Dine interview, 1985
Sparks, Esther. Interview with Jim Dine.
Jan. 29, 1985.

Sparks, Francis interview, 1985
Sparks, Esther. Interview with Sam
Francis. Nov. 8, 1985.

Sparks, Frankenthaler interview, 1983
Sparks, Esther. Interview with Helen
Frankenthaler. Sept. 22-23, 1983.

Sparks, Genis interview, 1985
Sparks, Esther. Interview with Fred
Genis, 1985

Sparks, Goldston interviews, 1981-86
Sparks, Esther. Interview with Bill
Goldston. Oct. 18, 1985.

Sparks, Johns interview, 1985
Sparks, Esther. Interview with Jasper
Johns. Oct. 17, 1985.

Sparks, Marisol interview, 1985
Sparks, Esther. Interview with Marisol.
July 22, 1985.

Sparks, Motherwell interview, 1985
Sparks, Esther. Interview with Robert
Motherwell. Sept. 5, 1985.

Sparks, A. Newman interview, 1985
Sparks, Esther. Interview with Annalee Newman. Mar. 20, 1985.

Sparks, Oldenburg interview, 1985
Sparks, Esther. Interview with Claes Oldenburg. Dec. 17, 1985.

Sparks, Priede interview, 1985
Sparks, Esther. Interview with Zigmunds Priede. July 25, 1985.

Sparks, Rauschenberg interview, 1985
Sparks, Esther. Interview with Robert Rauschenberg. Oct. 25, 1985.

Sparks, Rivers interview, 1985
Sparks, Esther. Interview with Larry Rivers. Mar. 21, 1985.

Sparks, Rosenquist interview, 1985
Sparks, Esther. Interview with James Rosenquist. Apr. 3, 1985.

Sparks, Schlossberg interview, 1985
Sparks, Esther. Interview with Edwin Schlossberg. July 23, 1985.

Sparks, Singer interview, 1985
Sparks, Esther. Interview with Dr. and Mrs. Joseph I. Singer, Apr. 6, 1985.

Sparks, Towle interviews and correspondence, 1982-85

Staber, 1976
Staber, Margit. *Fritz Glarner*. Zurich: ABC Verlag, 1976.

Stevens, 1971
Stevens, Elizabeth. "The Great Graphic Boom of the '50s and '60s." *The Wall Street Journal*, Jan. 5, 1971, p. 14.

Sweeney, 1980
Sweeney, Louise. "Helen Frankenthaler, Painter of the Light Within Light." *Christian Science Monitor* (Midwest Edition), Sept. 18, 1980, pp. B4-5, B22.

Swenson, 1963
Swenson, Gene R. "What Is Pop Art?" *Art News* 62, 7 (Nov. 1963): 24-25, 61-63.

Swenson, 1964
Swenson, Gene R. "What Is Pop Art: Part II." *Art News* 62, 10 (Feb. 1964): 40-41, 62-64.

Terenzio, 1984
Terenzio, Stephanie. *The Prints of Robert Motherwell*. With a catalogue raisonné, 1943-84, by Dorothy C. Belknap. New York: Hudson Press in association with the American Federation of Arts, 1984.

Tomkins, 1976
Tomkins, Calvin. "The Moods of a Stone." *The New Yorker*, June 7, 1976, pp. 42-76.

Tomkins, 1980
Tomkins, Calvin. *Off the Wall: Robert Rauschenberg and the Art World of Our Time*. New York: Doubleday & Co., 1980.

Tomkins, 1982
Tomkins, Calvin. "The Art World: Tatyana Grosman." *The New Yorker,* Aug. 9, 1982, p. 83

Art Gallery of Toronto, Ontario 1973
Toronto, Art Gallery of Ontario. *Contemporary American Prints from U.L.A.E./The Rapp Collection*. Exh. cat. by Peter Gale with an essay by Tony Towle. Toronto, 1973.

Toronto, York University 1973
Toronto, York University, Toronto Art Gallery. *A Selection of Graphic Art from the Rapp Collection*. Exh. cat. by Michael Greenwook. Toronto, 1973.

Towle, Diary, 1963-78
Towle, Tony. Manuscript diary 1963-1978. ULAE Records.

Towle, 1971
Towle, Tony. "Two Conversations with Lee Bontecou." *The Print Collector's Newsletter* 2, 2 (May-June 1971): 25-27.

Towle, Rivers interview, 1977
Towle, Tony. Interview with Larry Rivers. June 24, 1977.

Towle and Priede, 1977
Towle, Tony, and Priede, Zigmunds. *A Conversation at Universal Limited Art Editions.* Typescript of tape recording. 1977.

ULAE Files
Universal Limited Art Editions, West Islip, New York, files and documentation.

Varian, 1979
See Sarasota, 1979.

Voznesensky, 1978
Voznesensky, Andrei. *Nostalgia for the Present.* Intro. by Arthur Miller. Trans. by Richard Wilbur, William Jay Smith, Laurence Ferlinghetti, Allen Ginsburg, et al. New York: Doubleday & Co., 1978.

Wallach, 1972
Wallach, Amei. "The Miracle in West Islip." *Newsday,* Oct. 24, 1972, pp. 4a-5a.

Wallach, 1975
Wallach, Amei. "Donn Steward" A Great and Meticulous Craftsman." *Newsday,* Feb. 9, 1975, pp. 11-20.

Wallach, 1977
Wallach, Amei. "Bucky and Tatyana." *Newsday* (Part II), Feb. 6, 1977, cover and pp. 4, 5, 14.

Wallach, 1979
Wallach, Amei. "The Grande Dame of Printmaking." *LI Magazine, Newsday,* Aug. 5, 1979, p. 22.

Wallach, 1982
Wallach, Amei. "The Artist's Printmaker" *Newsday* (Part II), July 27, 1982, pp. 4-5.

Wallach, de Chochor interview, 1985
Wallach, Amei. Interview with Jorg de Chochor, Tatyana Grosman's cousin. Paris, Sept. 23, 1985.

Wallach, Fearer interview, 1985
Wallach, Amei. Interview with Eunice Fearer. Oct. 1, 1985.

Wallach, Goldston interview, 1985
Wallach, Amei. Interview with Bill Goldston. Aug. 1985.

Wallach, Johns interview, 1985
Wallach, Amei. Interview with Jasper Johns. Sept. 10, 1985.

Wallach, Rosenquist interview, 1985
Wallach, Amei. Interview with James Rosenquist. Dec. 16, 1985.

Wallach, Schlossberg interview, 1985
Wallach, Amei. Interview with Edwin Schlossberg, 1985.

Washington, 1976
Washington, National Collection of Fine Art, Smithsonian Institution. *Robert Rauschenberg.* Exh. cat. by Walter Hopps, with an essay by Lawrence Alloway. Washington, 1976.

West Berlin, 1970
See Mikro, 1970.

Wichita, 1973
Wichita, Kansas, Edwin A. Ulrich Museum of Art, Wichita State University. *Goodnough.* Exh. cat. by Martin H. Bush and Kenworth Moffett. Wichita, 1973.

Williamstown, 1977
Williamstown, Massachusetts, Williams

College Museum of Art. *Jim Dine Prints: 1970-1977*. Exh. cat. by Thomas Krens et al. London: Thames and Hudson in association with the Williams College Artist-in-Residence Program, 1977.

Williamstown, 1980
Williamstown, Massachusetts, Williams College Museum of Art. *Helen Frankenthaler Prints: 1961-1979*. Exh. cat. by Thomas Krens, et al. New York: Harper & Row, Publishers, in association with the Williams College Artist-in-Residence Program, 1980.

Wittrock, 1981
Wittrock, Wolfgang. *25 Jahre Universal Limited Art Editions 1957-1982*. Düsseldorf, 1981.

Woodward, 1967
Woodward, Washington, D.C., Gallery of Modern Art. *Art for Embassies Selected from the Woodward Foundation Collection*. Exh. cat. with foreword by Henry Geldzahler. Washington, D.C., 1967.

Worcester, 1971
Worcester, Massachusetts, Worcester Art Museum. *Marisol*. Exh. cat. by Leon Shulman. Worcester, 1971.

As with any project that takes years to realize, this history of the first quarter-century of Universal Limited Art Editions (ULAE) and of its founder and spiritual force, Tatyana Grosman, has been the product of considerable effort and dedication on the part of a number of individuals.

First, I should like to thank those people who actually were a part of the history itself. Bill Goldston, who now directs the presses and fortunes of ULAE guided me throughout the preparation of this manuscript with endless patience and generosity. To him and to the artists who agreed to be interviewed and later read pertinent sections of text, I am primarily and profoundly grateful. Tony Towle's diary and his incredible memory for detail have been indispensable. His history of ULAE, as yet unwritten, would flesh out this necessarily skeletal version.

I have attempted to treat Tatyana Grosman's private and business affairs with her own level of discretion. But even the most astringent chronicler must interpret, and in this precarious task I have been assisted and encouraged by many of her personal friends. Dr. Louis Aledort, Armand Bartos, Jr., Riva Castleman, Mr. and Mrs. Joseph Fearer, Barbara Fendrick, Helen Getler, Mr. and Mrs. Stanley Helfgott, William S. Lieberman, John Powers, Dr. Joseph I. Singer, William Spieller, William van Straaten, and Amei Wallach have been particularly helpful. In a less personal but essential way, scores of curators, dealers, and friends have generously responded. Members of Mrs. Grosman's staff, past and present, have answered questions with a frankness and gravity that were in themselves a homage to their former doyenne: Frank Akers, Steve Anderson, Robert Blackburn, Keith Brintzenhofe, Thomas Cox, Emanuel Edelman, Fred Genis, Eileen Kapler, John A. Lund, Zigmunds Priede, Juda Rosenberg, James V. Smith, and Donn Steward.

Index